WILLIAM GLACKENS

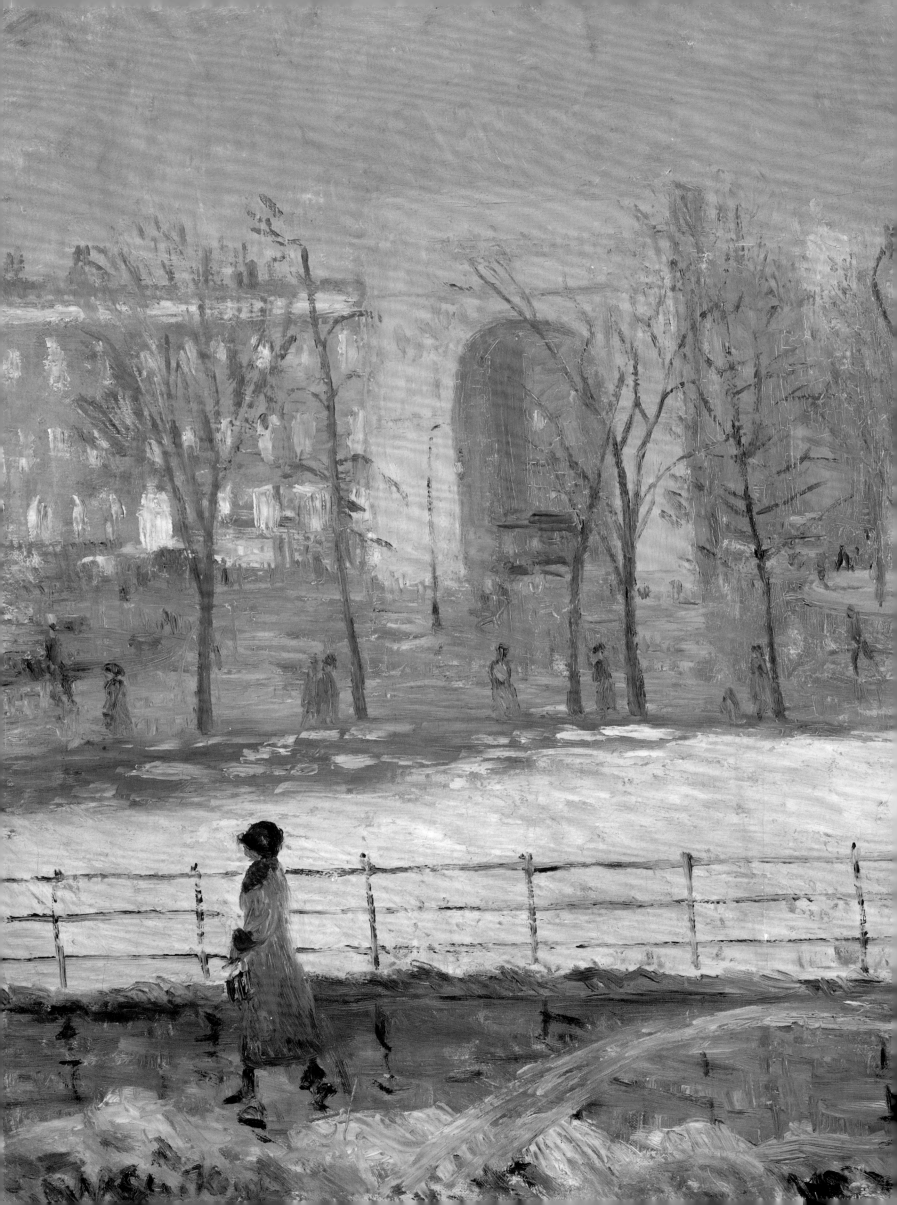

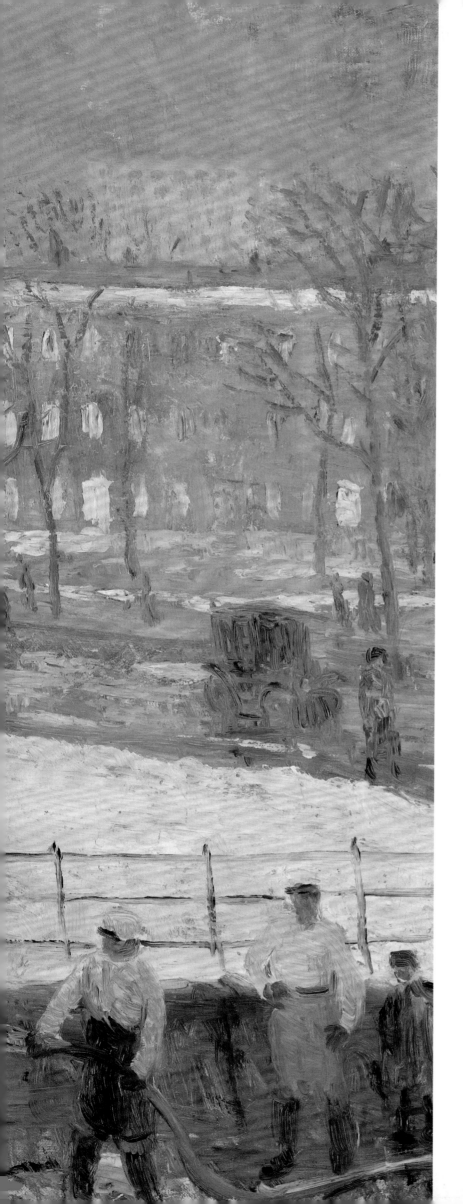

WILLIAM GLACKENS

Edited by
Avis Berman

Contributions by
Avis Berman
Elizabeth Thompson Colleary
Heather Campbell Coyle
Judith F. Dolkart
Alicia G. Longwell
Martha Lucy
Patricia Mears
Carol Troyen
Emily C. Wood

SkiraRizzoli
NEW YORK

IN ASSOCIATION WITH THE BARNES FOUNDATION

This publication accompanies the exhibition *William Glackens*. The exhibition is co-organized by Nova Southeastern University's Museum of Art | Fort Lauderdale; the Barnes Foundation; and the Parrish Art Museum. It has been made possible in part by the Sansom Foundation, the Henry Luce Foundation, the National Endowment for the Arts, and Christie's.

This exhibition is supported by an indemnity from the Federal Council on the Arts and the Humanities.

Additional support for the exhibition at the Barnes Foundation has been provided by Wilmington Trust.

The Parrish Art Museum also wishes to acknowledge the generous support of *William Glackens* by the Leadership Committee and its founding members, Elizabeth and David Granville-Smith.

EXHIBITION ITINERARY

The Museum of Art, Fort Lauderdale:
February 23–June 1, 2014

Parrish Art Museum, Water Mill, NY:
July 20–October 13, 2014

The Barnes Foundation, Philadelphia:
November 8, 2014–February 2, 2015

First published in the United States of America in 2014 by

Skira Rizzoli Publications, Inc.
300 Park Avenue South
New York, NY 10010
www.rizzoliusa.com

in association with
The Barnes Foundation
2025 Benjamin Franklin Parkway
Philadelphia, PA 19130
www.barnesfoundation.org

Library of Congress Control Number:
2013916282

ISBN: 978-0-8478-4261-2

2014 2015 2016 2017 / 10 9 8 7 6 5 4 3 2 1
Printed in China

FOR THE BARNES FOUNDATION
Director of Publications: Johanna Halford-MacLeod
Photo Editor: Deborah Lenert
Editor: Ulrike Mills

FOR SKIRA RIZZOLI
Associate Publisher: Margaret Rennolds Chace
Project Editor: Holly La Due

Designer: Binocular, New York
Color separations by Professional Graphics, Rockford, IL

On the jacket: *Cape Cod Pier* (detail of plate 60)

Frontispiece illustrations: Pages 2–3: *Street Cleaners, Washington Square*, c. 1910 (detail of plate 35); pages 26–27: *Autumn Landscape*, 1893–1895 (detail of plate 6); pages 42–43: *Christmas Shoppers, Madison Square*, 1912 (detail of plate 26); pages 68–69: *May Day, Central Park*, c. 1904 (detail of plate 31); pages 102–103: *Shop Girls*, c. 1900 (detail of plate 43); pages 126–127: *March Day, Washington Square*, 1912 (detail of plate 53); pages 140–141: *Bathers at Bellport*, c. 1912 (detail of plate 66); pages 172–173: *The Soda Fountain*, 1935 (detail of plate 82); pages 196–197: *Luxembourg Gardens*, 1906 (detail of plate 89); pages 220–221: *Still Life with Three Glasses*, mid-1920s (detail of plate 101)

Contents

Lenders to the Exhibition

Albright-Knox Art Gallery, Buffalo,
 New York
Arkansas Arts Center, Little Rock
The Art Institute of Chicago
The Barnes Foundation, Philadelphia
 and Merion, Pennsylvania
Bowdoin College Museum of Art,
 Brunswick, Maine
Brandywine River Museum,
 Chadds Ford, Pennsylvania
Brooklyn Museum, New York
The Butler Institute of American Art,
 Youngstown, Ohio
Carnegie Museum of Art, Pittsburgh
Cedarhurst Center for the Arts,
 Mount Vernon, Illinois
Chrysler Museum of Art,
 Norfolk, Virginia
The Cleveland Museum of Art
Corcoran Gallery of Art, Washington
Curtis Galleries, Minneapolis
Delaware Art Museum, Wilmington
Barney A. Ebsworth
The Fine Arts Museums of San Francisco
Georgia Museum of Art, University
 of Georgia, Athens
High Museum of Art, Atlanta
Gerald and Pearlann Horowitz
The Huntington Library, Art
 Collections, and Botanical Gardens,
 San Marino, California

Elaine and Alan Kolodkin
Kraushaar Galleries, New York
Library of Congress, Washington
London Family Collection
The Metropolitan Museum of Art,
 New York
Milwaukee Art Museum
Museum of American Illustration
 at the Society of Illustrators,
 New York
Museum of Art | Fort Lauderdale,
 Nova Southeastern University
The Museum of Modern Art,
 New York
National Gallery of Art, Washington
The Nelson-Atkins Museum of Art,
 Kansas City
New Britain Museum of American
 Art, Connecticut
New Jersey State Museum, Trenton
Newark Museum, New Jersey
Parrish Art Museum, Water Mill,
 New York
Patricia O'Donnell
Pennsylvania Academy of the Fine Arts,
 Philadelphia
The Phillips Collection, Washington
Private Collections
Sansom Foundation
Sheldon Museum of Art, University
 of Nebraska–Lincoln

Ted Slavin
Smithsonian American Art Museum,
 Washington
Snite Museum of Art, University of
 Notre Dame, South Bend, Indiana
John H. Surovek Gallery, Palm Beach
Terra Foundation for American Art,
 Chicago
Violette de Mazia Foundation
Wadsworth Atheneum Museum
 of Art, Hartford, Connecticut
Whitney Museum of American Art,
 New York

Contributors

AVIS BERMAN, an independent writer and art historian, is the author of *Rebels on Eighth Street: Juliana Force and the Whitney Museum of American Art*, *James McNeill Whistler*, and *Edward Hopper's New York*, and co-author and editor of Katharine Kuh's memoir *My Love Affair with Modern Art: Behind the Scenes with a Legendary Curator*. Her articles, essays, and reviews have appeared in numerous magazines, newspapers, encyclopedias, anthologies, and catalogues. Berman has also sustained a parallel career as an oral historian in the visual arts, conducting interviews for the Archives of American Art, the Metropolitan Museum of Art, the Museum of Modern Art, the Andy Warhol Museum, and the Roy Lichtenstein Foundation.

ELIZABETH THOMPSON COLLEARY is an independent scholar. She is the author of *My Dear Mr. Hopper* and she recently completed the guide *William Glackens: Highlights of the Collection* for the Museum of Art, Fort Lauderdale, Nova Southeastern University. Since 2002 she has been a research associate at the Whitney Museum of American Art, where she helped create the Hopper Research Collection, the largest repository of research materials on Edward and Josephine Nivison Hopper.

HEATHER CAMPBELL COYLE is curator of American art at the Delaware Art Museum. She received her PhD in art history from the University of Delaware. She is the editor and lead author of *Howard Pyle: American Master Rediscovered*, and co-editor and co-author of *John Sloan's New York*. In recent years, she has published and curated exhibitions on John Sloan, Robert Henri, Leonard Baskin, and Harold Edgerton.

JUDITH F. DOLKART is deputy director of art and archival collections and Gund Family Chief Curator at the Barnes Foundation. Dolkart helped plan the relocation of the collections from Merion, Pennsylvania, to Philadelphia, and under her stewardship the Barnes launched an exhibition program and published four books in 2012. Formerly at the Brooklyn Museum, Dolkart organized the exhibitions *"Michelangelo of the Menagerie": Bronzes by Antoine-Louis Barye* and *James Tissot: The Life of Christ*, and she coordinated *Gustave Caillebotte: Impressionist Paintings from Paris to the Sea*. In 2013, she was named a fellow of the Center for Curatorial Leadership. She serves on the Board of Trustees for the Association of Art Museum Curators.

ALICIA G. LONGWELL is the Lewis B. and Dorothy Cullman Chief Curator, Art and Education, at the Parrish Art Museum in Water Mill, New York. She has organized numerous exhibitions, including the recent *Malcolm Morley: Painting, Paper, Process*; *Dorothea Rockburne: In My Mind's Eye*; *Sand: Memory, Meaning and Metaphor*; and *North Fork/South Fork: East End Art Now*, as well as earlier exhibitions on the work of Barbara Bloom, Marsden Hartley, Frederick Kiesler, Alan Shields, Esteban Vicente, and Jack Youngerman. Longwell is the author of *American Landscapes: Treasures from the Parrish Art Museum* and *First Impressions: Nineteenth Century American Master Prints*, and co-author of *Photographs from the William Merritt Chase Archives at the Parrish Art Museum*.

MARTHA LUCY teaches in the art and art history department at Drexel University. After receiving her PhD from New York University's Institute of Fine Arts, she worked for seven years

at the Barnes Foundation, where she was associate curator. Lucy is the co-author of *Renoir in the Barnes Foundation*, the first scholarly catalogue of the Barnes's enormous Renoir collection, and co-author of *The Barnes Foundation: Masterworks*. She has published many essays and journal articles, on topics ranging from Renoir's critical reception in the twentieth century and evolutionary themes in the work of Odilon Redon and Edgar Degas to the art criticism of Leo Stein.

PATRICIA MEARS is a fashion historian. She is the deputy director at the Museum at the Fashion Institute of Technology, where she has worked since 2005. Prior to that, she was assistant curator of costumes and textiles at the Brooklyn Museum of Art. She has organized numerous exhibitions including *Fancy Feet* (1993); *A Slice of Schiaparelli* (1995); *Japonism in Fashion* (1998); *Millicent Rogers* (2002); *XXIème Ciel: Mode in Japan* (2003); *Ralph Rucci: The Art of Weightlessness* (2007); *Madame Grès: Sphinx of Fashion* (2008); *American Beauty: Aesthetics and Innovation in Fashion* (2009); *Impact: 50 Years of the Council of Fashion Designers of America*, and *Ivy Style* (both 2012). Her many publications include the catalogues for these exhibitions and a contribution to *Skin + Bones: Parallel Practices in Fashion and Architecture*.

CAROL TROYEN, Kristin and Roger Servison Curator Emerita of American Paintings at the Museum of Fine Arts, Boston, is an independent scholar. While at the museum, she organized many exhibitions, including *Charles Sheeler, Paintings and Drawings*; *Awash in Color: Homer, Sargent, and the Great American Watercolor*; and *Edward Hopper*. She has lectured at museums across the country, has taught at Wesleyan University and Williams College, and has published essays on artists ranging from John Singleton Copley to George Bellows.

EMILY C. WOOD is curatorial assistant at the Whitney Western Art Museum, Cody, Wyoming. She received an M.A. in art history at Indiana University, where she also worked in the curatorial department of the Indiana University Art Museum. She was previously a research assistant at the Museum of Art, Fort Lauderdale, Nova Southeastern University.

Directors' Foreword

Nearly fifty years have elapsed since the last comprehensive museum exhibition of the work of American artist William Glackens. The collaborative project undertaken by the Museum of Art, Fort Lauderdale; the Parrish Art Museum, Water Mill, New York; and the Barnes Foundation, Philadelphia and Merion, Pennsylvania—to consider anew this artist's estimable career—is a model for the cooperation that institutions can bring to a project of this scope.

Although Glackens was an influential figure in American art during his lifetime, his reputation contracted in the decades after his death. He was slotted as an early follower of Robert Henri or a late disciple of Pierre-Auguste Renoir, and yet the whole arc of Glackens's oeuvre reveals an artist of more ambition and breadth, one who combined an enchanting zest for life with an arsenal of sophisticated techniques. A gifted painter and draftsman, he was one of the liveliest artists on the American scene during the opening decades of the twentieth century. He was fascinated by the urban spectacle of New York City, and many of his paintings have become touchstones of American art.

Glackens's artistic career spanned five decades, from the 1890s through the 1930s. He was born in Philadelphia, studied at the Pennsylvania Academy of the Fine Arts, and became friends with Henri, George Luks, Everett Shinn, and John Sloan. Henri urged the men, who were all working on local newspapers, to think beyond punching the clock as illustrators. With his encouragement, they started painting and moved to New York. Glackens was consistently modern in attitude, participating in and championing landmark exhibitions of the American and European avant-garde. He was a member of The Eight, whose 1908 exhibition was the opening salvo in the struggle to democratize the process by which nonacademic artists could show and sell their work. After serving on the selection committee of the 1910 Independent Artists exhibition, the first large-scale invitational show of progressive American artists, Glackens was appointed chairman of domestic selections for the epochal Armory Show, which introduced vanguard art to this country in 1913. He painted the cafés and streets of Paris, the beaches and coves of Long Island, Cape Cod, and Connecticut, and the hills and towns of rural France. His beach scenes, teeming with incident, have been celebrated for their vivid interplay of men, women, and children at leisure against the natural movements of clouds, sky, light, and water; the paintings are equally seductive for their clear, scintillating color and vibrant architectural forms. He was just as successful as a painter of nudes, portraits, and still lifes.

The Museum of Art, Fort Lauderdale, is the largest repository of Glackens's work. With no historical links to Glackens, the museum received the cream of his artistic estate through a generous bequest from his son Ira in 1991 and further gifts from the Sansom Foundation. In 2010, Irvin Lippman, the museum's director at the time, conceived of a full-scale retrospective, including a major publication and national tour, to elicit renewed scholarly interest and audience appreciation of the artist's work. To that end, he sought out as partner institutions the Barnes Foundation and the Parrish Art Museum, each with close ties to Glackens's career: a boyhood friend of Albert Barnes, Glackens advised that renowned collector on his first art purchases, and the summers that Glackens and his family spent on the south shore of Long Island were among his most fruitful artistic sojourns. We thank both Mr. Lippman for setting this prodigious undertaking in motion and for his sustained interest and good will, and Jorge H. Santis, curator at Fort Lauderdale, for his enduring encouragement and assistance. We wish to express our gratitude to Dr. George L. Hanbury II, president and chief executive officer of Nova Southeastern University, for his unwavering commitment to this project.

Perhaps no decision of Mr. Lippman's was more essential to the success of this endeavor than his selection of the distinguished American art historian Avis Berman to steer the ship. Her intimate knowledge of the period, her keen curatorial eye, and her understanding of the complex negotiations necessary to bring about a book and exhibition of this scope attest to her consummate skills. Her ability to engage and support a dynamic roster of eight contributing authors required diplomacy and persistence and her great good humor helped to make the project a seamless one from conception to final execution. We are most grateful.

The staff at our respective institutions ably undertook the myriad logistics essential to produce a book and exhibition of this dimension. At Fort Lauderdale, Rachel Talent Ivers, director of exhibitions and curatorial services, was indispensable and, along

with Diana Blanco, Rachel Diana, Taylor Fowles, Freddy Jouwayed, AnToya Lowe, Carrie Peterson, Stacy Slavichak, and Emily C. Wood, worked diligently to ensure the project's realization. At the Barnes Foundation, Judith F. Dolkart, deputy director of art and archival collections and Gund Family Chief Curator, led the team of Claire Aelion-Moss, Barbara Beaucar, Eliza Bjorkman, Barbara Buckley, Andrea Cakars, Diana Duke Duncan, Sara Geelan, Timothy Gierschick, Johanna Halford-MacLeod, Michael Holland, Deborah Lenert, Doug Levering, Linda Scribner Paskin, Shara Pollie, Jan Rothschild, Anya Shutov, and Peg Zminda, all of whom made invaluable contributions. Dan Kershaw is to be thanked for the exhibition design at the Barnes. The success of this endeavor is also an outcome of the countless efforts of Alicia G. Longwell, Lewis B. and Dorothy Cullman Chief Curator, Art and Education, and the Parrish Art Museum staff, including Cara Conklin-Wingfield, Andrea Grover, Scott Howe, Christine McNamara, Michael Pintauro, Eliza Rand, Mark Segal, and Helen Warwick.

We are immensely grateful to the fifty-one major collections, both public and private, throughout the United States whose generosity in lending key Glackens works ensured the beauty and integrity of the exhibition. This project would not have been possible without the sustaining support of the Sansom Foundation, under the leadership of board president Frank Buscaglia. The Henry Luce Foundation and the National Endowment for the Arts were committed early on to the fullest realization of the project. Christie's has contributed invaluable professional support. Additionally, the Barnes Foundation is deeply grateful to Wilmington Trust for sponsoring the exhibition in Philadelphia. The Parrish Art Museum also wishes to acknowledge the generous support of *William Glackens* by the Leadership Committee and its founding members, Elizabeth and David Granville-Smith. We thank them all.

Bonnie Clearwater
Executive Director and Chief Curator,
Museum of Art, Fort Lauderdale,
Nova Southeastern University

Terrie Sultan
Director, Parrish Art Museum

Derek Gillman
Director, The Barnes Foundation

Acknowledgments

An exhibition of this magnitude requires the combined effort and enthusiasm of several hundred collaborators: museum and gallery colleagues, generous lenders, independent scholars, and friends and associates helped present the art of William Glackens in a comprehensive and vital manner, and it is my pleasure to express my profound gratitude. This endeavor was the brainchild of Irvin Lippman, former director of the Museum of Art, Fort Lauderdale, Nova Southeastern University—his guidance and vision kept the project on course during its first, critical year. William Stanton and Bonnie Clearwater, his successors, remained equally committed to the exhibition. Jorge H. Santis, the long-time curator of the Glackens collection at the museum, added his understanding of the artist and his unparalleled knowledge of the museum's Glackens holdings, answering questions graciously and looking for unlocated works of art. Roberta Kjelgaard, then the museum's development officer, was instrumental in laying a firm foundation to fund the show, and Anna Fornias Sorenson conscientiously continued this important work. These efforts would never have come to fruition without the immediate and unqualified support of the exhibition's first sponsor, the Sansom Foundation, which administers the estate of Ira Glackens, the artist's son. I owe an enormous debt of thanks to the Foundation's board and, in particular, to its president, Frank Buscaglia, who has been not only an early champion of a full-scale Glackens exhibition but also an active and sympathetic participant throughout the planning process.

The complex logistical orchestration of this large traveling exhibition was a task vigorously embraced and supervised by Rachel Talent Ivers, Fort Lauderdale's director of curatorial and exhibition services. Assisting her with equal drive and dedication were Diana Blanco, Rachel Diana, Taylor Fowles, AnToya Lowe, Carrie Peterson, Stacy Slavichak, and Emily C. Wood. Freddy Jouwayed developed the elegant exhibition design and met the challenge of the installation. Additional support came from the expert registrars at the partner institutions for the exhibition tour: Andrea Cakars at the Barnes Foundation and Christine McNamara at the Parrish Art Museum.

I thank the directors of the Barnes Foundation and the Parrish Art Museum, Derek Gillman and Terrie Sultan, for their ready support of this undertaking. The chief curators at these two institutions, Judith F. Dolkart at the Barnes Foundation and Alicia G. Longwell at the Parrish Art Museum, were forceful advocates and invaluable advisors in exhibition-related matters. I particularly appreciate Judith's early efforts to include three paintings from the Barnes Foundation in the exhibition. Her goodwill led to the rare opportunity to make these important canvases available to the public. The distinguished scholars and curators H. Barbara Weinberg and Carol Troyen were unwavering in their encouragement, and I was fortunate to have their guidance—only they know how much I owe them. Elizabeth Thompson Colleary, Heather Campbell Coyle, Judith F. Dolkart, Alicia G. Longwell, Martha Lucy, Patricia Mears, and Carol Troyen wrote incisive essays for the exhibition catalogue, each writer bringing a fresh perspective to Glackens's life and work, and each essay offering new insights and interpretations. Intern Allison Austin contributed historical photo research and found several key documentary images to reproduce in the publication. Emily C. Wood, who was initially responsible for providing research materials for the essays, went on to compile an exhaustive record of Glackens's exhibitions, from 1892 to the present. No such history has ever been assembled before, and I salute her industry.

All Glackens scholarship is built on the meticulous work of Richard J. Wattenmaker, who has published numerous books, articles, and catalogues on the artist since the 1960s. I am grateful for his authoritative counsel on stylistic and chronological analyses, the location of works of art, and other matters too numerous to name. I also thank Bob A. London, whose detailed examination of Glackens's oeuvre has enlarged my understanding as well. William H. Gerdts, the author of an essential monograph on Glackens, unstintingly opened his archives and allowed me the use of pertinent materials. Other colleagues who went out of their way to help with information, suggestions, leads, and favors were D. Frederick Baker, Judith A. Barter, Stephen Borkowski, P. J. Brownlee, Sarah Cash, Margaret C. Conrads, Robert Cozzolino, Maria DeAngelis, Katherine Degn, Linda S. Ferber, Mona Hadley, Valerie Ann Leeds, Barbara J. MacAdam, Joann Moser, Kathleen P. O'Malley, Michael Quick, William Keyse Rudolph, Carol Rusk, Alma Gilbert-Smith, Margaret Stenz, William Truettner, and Bruce Weber. I am grateful to Lenna Young Andrews, William

and Edith Glackens's great-niece, for sharing precious photographs and works of art belonging to her family.

Fundamental to this exhibition was the inclusion of rarely seen paintings and works on paper by Glackens in private hands, which would not have been possible without the cooperation of individual lenders. I benefited from the generosity of Barney A. Ebsworth, Gerald and Pearlann Horowitz, Elaine and Alan Kolodkin, Bob and Sandy London, Patricia O'Donnell, Ted Slavin, and several other collectors who prefer to remain anonymous. I am also privileged to thank the museum directors, curators, registrars, and other colleagues in public and private institutions across the country for their assistance with loans and research: Elizabeth Oustinoff, Adelson Galleries, Inc.; Douglas Dreishpoon and Laura J. Fleischmann, Albright-Knox Gallery; Philip Alexandre, Alexandre Gallery, New York; Liza Kirwin, Wendy Hurlock Baker, Marisa Bourgoin, Charles Duncan, Catherine Gaines, and Joy Goodwin, Archives of American Art, Smithsonian Institution; Joseph W. Lampo and Thom Hall, Arkansas Arts Center; Denise Mahoney and Anna Simonovic, Art Institute of Chicago; Stephanie Cassidy, Art Students League of New York; Steven A. Czarniecki, Bellport-Brookhaven Historical Society; James Berry Hill, Berry-Hill Galleries; Joachim Homann and Laura Latman, Bowdoin College Museum of Art; Virginia O'Hara and Bethany Engel, Brandywine River Museum; Teresa A. Carbone, Elizabeth Largi, and Elisa Flynn, Brooklyn Museum; Louis Zona and Rebecca Davis, Butler Institute of American Art; Lynn Zelevansky and Allison Revello, Carnegie Museum of Art; Martha E. Parker, Caxambas Foundation; Rusty Freeman and Tracy Shilling, Cedarhurst Center for the Arts; Maxine Croul and David Kahn, Central High School Archives, Philadelphia; Maria Saffiotti Dale, Chazen Museum of Art; Eric P. Widing and Catherine Foster, Christie's; William J. Hennessey, Jeff Harrison, and Molly Marder, Chrysler Museum of Art; David Franklin, Mark Cole, and Gretchen Shie Miller, Cleveland Museum of Art; Frederick D. Hill and Daisy Hill, Collisart, LLC; Philip Brookman and Anna Kuehl, Corcoran Gallery of Art; Jenny Sponberg and Taylor Acosta, Curtis Galleries, Inc.; Carl David, David David Gallery; Rachel DiEleuterio and Jennifer Holl, Delaware Art Museum; Timothy Anglin Burgard and Douglas DeFors, Fine Arts Museums of San Francisco; Cory Gooch and Jess Atkinson, Frye Museum of Art; William U. Eiland and Christy Sinksen, Georgia Museum of Art; Michael E. Shapiro, David Brenneman, Stephanie Heydt, Ronda Ensor, and Paula Haymon, High Museum of Art; John Murdoch, Jessica Todd Smith, and Jacqueline Dugas, Huntington Library, Art Collections, and Botanical Gardens; Katherine Degn and Carole Pesner, Kraushaar Galleries; Sara W. Duke and Tambra Johnson Reap, Library of Congress; Peter M. Kenny, Elaine Bradson, and Nesta Mayo, Metropolitan Museum of Art; Mary Weaver Chapin, Jane O'Meara, and Lydelle Abbott, Milwaukee Art Museum; Gail Stavitsky, Montclair Art Museum; Richard J. Berenson and Eric Fowler, Museum of American Illustration at the Society of Illustrators; Cornelia H. Butler and Karen Grimson, Museum of Modern Art; Charles Brock, Lisa M. MacDougall, and Judith Cline, National Gallery of Art; Helena Wright, National Museum of American History, Smithsonian Institution; Stephanie Knapp, Sarah Taggart, and Julie Mattsson, Nelson-Atkins Museum of Art; Douglas Hyland, Alexander J. Noelle, and John Urgo, New Britain Museum of American Art; Margaret O'Reilly and Jenny Martin-Wicoff, New Jersey State Museum; Mary-Kate O'Hare, Amber Woods Germano, and Millicent Matthews, Newark Museum; Jeff Richmond-Moll and Jennifer Johns, Pennsylvania Academy of the Fine Arts; Dorothy Kosinski, Eliza Rathbone, Susan Behrends Frank, Trish Waters, Liza Key, Karen Schneider, and Joseph Holbach, Phillips Collection; James Reinish, James Reinish & Associates, Inc.; Brandon Ruud and Stacey Walsh, Sheldon Museum of Art; Elizabeth Broun, Virginia Mecklenburg, and Alison H. Fenn, Smithsonian American Art Museum; Patricia Junker, Seattle Art Museum; Charles R. Loving, Robert Smogor, and Rebeka Ceravolo, Snite Museum of Art; John and Ann Surovek, John H. Surovek Gallery; Catherine Ricciardelli, Terra Foundation for American Art; Ross Mitchell, Violette de Mazia Foundation; Susan L. Talbott and Mary Busick, Wadsworth Atheneum; Adam D. Weinberg, Barbara Haskell, Jessica Pepe, and Anita Duquette, Whitney Museum of American Art; and Stephen Gleissner, Wichita Art Museum. In addition, I thank Paul Johansen, Karen Kirk, Terri MacKinnon, and Ruth Stephan for their help in securing loans from private collections.

Johanna Halford-MacLeod, director of publications at the Barnes Foundation, expertly guided every aspect of the publication of this catalogue. The book was edited with intelligence and flair by Ulrike Mills, who improved our prose and saved us from embarrassing errors. The beautiful and graphically innovative catalogue was designed by Joseph Cho and Stefanie Lew of Binocular, New York. The commitment and professionalism of Margaret Rennolds Chace, associate publisher at Skira Rizzoli, and her associates, Holly La Due and Loren Olson, were indispensable in the publishing and distribution of this volume. Claire Aelion-Moss, editor, and Deborah Lenert, visual resources manager at the Barnes Foundation, skillfully juggled words and pictures amid changing directives and tight deadlines.

I have reserved my heartiest thanks for Ira Glackens, whom I had the honor and great fun of knowing for a dozen years. He was a staunch friend, and I hope that this exhibition serves his memory well.

Avis Berman

WILLIAM GLACKENS

Introduction

AVIS BERMAN

"What I best remember about the pictures of Henri and Luks and Glackens," stated the critic Frank Jewett Mather, "is that they have always made me sit up. I get the feeling of seeing something for the first time and keenly—of a discovery."[1] Mather's praise has a distinctly valedictory tone, even though it was written a bare eight years after these three artists, along with five others, made a national splash when, exhibiting together as "The Eight" in February 1908, they secured a permanent place in the annals of American art. The artists in question were in early middle age—Robert Henri was fifty-one years old, George Luks forty-nine, and William Glackens just forty-six (fig. 1)—and years of productive work lay ahead of them. But Mather correctly discerned that their main contributions to realism—the topic of his article was American realists—were behind them. Mather described the realist as an artist who finds "his beauty ready made in the world and when he has ambushed it lets it alone, so far as a thing that is being put over into paint can be let alone."[2] Indeed, Glackens had diverged from Henri and Luks's path years before, hewing an autonomous trail. He had jettisoned dark, local color for a high-key palette, and though he remained a representational painter who created portraits, figural studies, nudes, interiors, landscapes, seascapes, and still lifes, his ambitions changed: the narrative observation that had served him so well in his early city scenes was redefined as optical empiricism. These stylistic transitions moved Glackens away from Henri's aesthetic precepts and aligned him more closely with such painters as Maurice Prendergast, Alfred Maurer, and Marsden Hartley, who had absorbed post-impressionism and fauvism and were exploring color relationships. Yet he remained pigeonholed as a Henri disciple. Glackens appreciated multiple currents of American and European modernism. He admired and emulated Édouard Manet and Pierre-Auguste Renoir, and his debt to these artists has been extensively documented. But his work is also steeped in knowledge of Edgar Degas, Théophile Steinlen, Jean-Louis Forain, Henri de Toulouse-Lautrec, Claude Monet, Camille Pissarro, Paul Cézanne, Henri Matisse, and Pierre Bonnard. His affinities with Matisse and Bonnard—Renoir's pictorial heirs—were significant, although they went unnoticed amid an overwhelming critical emphasis on labeling him as naively derivative of Renoir.

These contradictions and misapprehensions have colored critical and historical perspectives on the career of the American artist William Glackens (1870–1938; plate 1), who combined an extraordinary visual acuity with an equally strong need for independence. Not long after his arrival in New York City from his native Philadelphia at the end of 1896, Glackens had established himself as a leading illustrator of the day. His accurate and formally innovative drawings of soldiers at war, actors and their audiences, teeming streets, and urban recreations live on as both historical documents and works of art. Glackens created a diverse body of work in paintings, drawings, watercolors, etchings, and lithographs. His artistic career spanned five decades, from the 1890s to the 1930s. He studied at the Pennsylvania Academy of the Fine Arts, worked as an artist-reporter on several of the city's newspapers, and became friends with Henri, John Sloan, Everett Shinn, and Luks. Under Henri's influence, Glackens resolved to be a painter as well as an illustrator. From 1895 to 1896 the two journeyed to Paris, the Netherlands, and Belgium, where Glackens began to understand painting, learning what he needed from Diego Velázquez, Frans Hals, Manet, and James McNeill Whistler. In 1898, he was sent to Cuba to cover the Spanish-American War as an artist-reporter. He was present at the charge up San Juan Hill and witnessed and recorded several other important battles. Travel continued to stimulate his imagination, and later in life he visited and lived in Spain, France, and Italy, as well as Long Island, Cape Cod, Nova Scotia, Connecticut, and New Hampshire.

During the early years of the twentieth century Glackens, like Walt Whitman, became fascinated by the "hurrying human tides" of New York City. In interpreting the urban spectacle around him—the "visor'd, vast, unspeakable show and lesson!"[3]—Glackens addressed specific aspects of the metropolis in drawings and paintings that made him a pioneering figure in depicting the realities of public existence and amusements. With his finely honed memory and swift draftsmanship (plates 3–5), he was uniquely equipped to chronicle the exploding population of his city. In his portrayals of crowds, he expressed a detached yet democratic point of view echoing Whitman's own generous humanism. Through his assignments as an illustrator, Glackens also became professionally immersed in the visual world of theater, vaudeville, and burlesque, which offered another flood of tantalizing visual

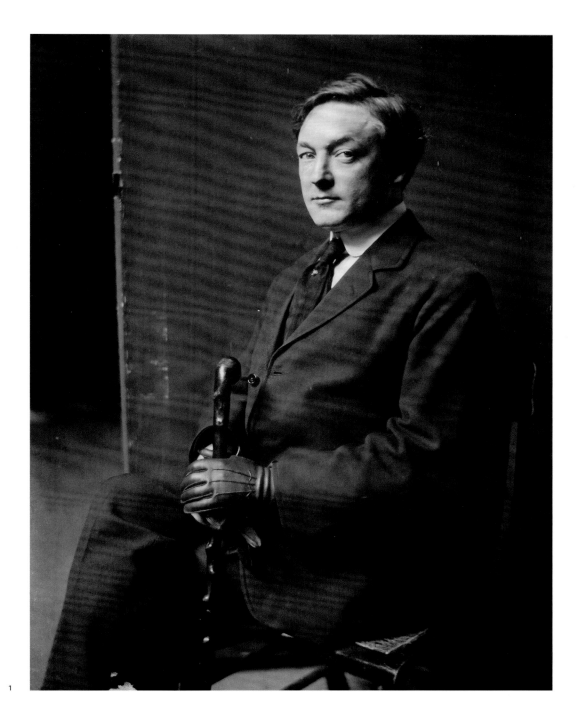

FIGURE 1
William Glackens, 1907.
Photograph by Gertrude
Käsebier, taken for the
exhibition of The Eight.
Delaware Art Museum,
Wilmington, Gift of Helen
Farr Sloan

1

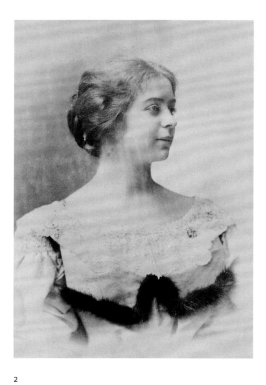

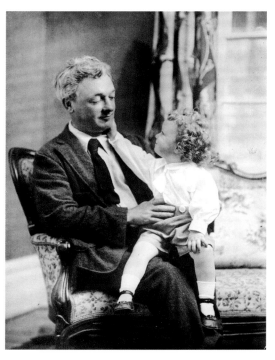

2

3

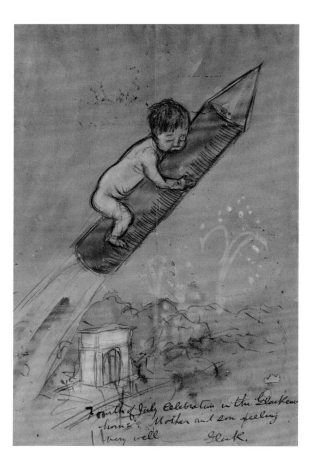

FIGURE 2
Edith Dimock, c. 1902.
Photograph. Museum of
Art, Fort Lauderdale, Nova
Southeastern University;
bequest of Ira Glackens,
photograph collection

FIGURE 3
William Glackens and
Lenna, c. 1916. Photograph.
Museum of Art, Fort
Lauderdale; bequest of
Ira Glackens, photograph
collection

FIGURE 4
Ira on a Rocket, 1907.
Watercolor and pencil on
board. Museum of Art,
Fort Lauderdale, Nova
Southeastern University

4

sensations that shaped his apprehension of the modern city as a nexus of commerce, congestion, festivity, and momentum. He captured the appearances and attitudes of the workers, shoppers, performers, and leisure classes with equal adeptness. Glackens also examined the ambiguous and evolving roles of women in a fast-changing society where rules were ignored and boundaries crossed. Women, he realized, were key to a genuine rendering of modern life, and they became essential to his project of painting the contemporary milieu. Because he understood that larger truths could be gleaned from the clues of seemingly minor details, clothing was not something Glackens left to chance. He seized on fashion as a conveyor of modernity: it encompassed commerce and manufacturing and it raised questions of social and sexual identity and the mutability of the urban world in which he lived. Glackens suggested the equation of status symbols and material possessions with human commodification. He recorded fashion's cultural importance as skillfully as the realistic and naturalistic literature of the period, from the hackneyed stories he was given to illustrate to the important contemporary novels published by Edith Wharton and Theodore Dreiser. Glackens shared with the French avant-garde whose work he knew so well the view that an accent on fashion was not frivolous, trivial, or easily dismissed.[4] Indeed, it was fresh subject matter in its time. When *The Shoppers* (see plate 75) appeared in the exhibition of The Eight, the critic James Gibbons Huneker pronounced it "contemporary with a vengeance."[5]

A number of Glackens's early major canvases depicted life's pleasures and diversions. Because he avoided insisting on a message via a "dire story unmitigated by attractive craft,"[6] he was criticized for neglecting the working-class themes that Sloan, Luks, and George Bellows frequently essayed. In other words, the most challenging realism revolved around brutal depictions of the urban poor, and as Glackens did not favor such subject matter in particular or strong commentary in general, he seemed less shaped by a confluence of social and cultural forces than some of his more politically radical friends and peers. Glackens's variety of realism had become increasingly focused on psychological expressiveness and shifting social standards. This was not a less authentic exploration of contemporary life, but it was a less obvious one. (Later on, Glackens took up still-life painting, another genre of minimal interest to Henri, Sloan, Luks, and Bellows. From his knowledge of Manet, Cézanne, and Matisse's work, Glackens, like Maurice Prendergast, recognized the "exalted status that still life assumes in the modernist era."[7])

Perhaps Glackens aroused envy because he was inordinately blessed. He was a gifted draftsman who was recognized as a top illustrator by 1899 and as a respected painter less than a decade later. Affable and handsome, he made a love match with an heiress (fig. 2); after their marriage in 1904, his financial situation went from parlous to secure. Glackens remained a prolific illustrator to earn a living, but since he was not pressured to sell his canvases, he was never forced to write articles, teach classes, issue manifestoes, or make pronouncements that artists more dependent on the marketplace often find necessary to do to receive attention and generate revenue. Yet whenever American artists needed help in broadening their exhibition opportunities and fighting against unjust systems perpetuated by art institutions, he joined in their defiance. Glackens was a reserved man who favored a regular life that became increasingly devoted to painting, travel, family (figs. 3, 4), and the epicurean joys of food and drink, and that existence was the world he painted. Because he was truthful to his own milieu, Glackens has been derogated as a painter of the bourgeois experience, but a similar accusation was leveled against Matisse by his detractors.

By 1907, Glackens had exhibited in many national and international venues and his work had been noticed by such important voices as Huneker and Dreiser.[8] In February 1908, as a member of The Eight, Glackens began participating in landmark exhibitions of American and European contemporary art. He was on the selection committee of the 1910 Independent Artists exhibition, the first large-scale invitational show of progressive artists in the United States, and two years later he chaired the American section for the epochal Armory Show, which introduced vanguard art to this country in 1913. Glackens was an early advisor and first president of the Society of Independent Artists, an artist-run exhibition cooperative free of selection committees that became a haven for painters too radical for establishment salons. Through his involvement in these important exhibitions and organizations, he was linked to other notable personalities in the burgeoning avant-garde, including Arthur B. Davies, Walt Kuhn, Maurer, Hartley, Maurice and Charles Prendergast, Alfred Stieglitz, John Quinn, and Albert E. Gallatin.

Glackens's best-known contribution to the development of modern art in America came about through his association with the brilliant collector Albert C. Barnes (plate 2). A Philadelphia chemist who became a self-made millionaire in the early twentieth century and wished to collect art, Barnes had attended high school with Glackens. When they renewed their friendship in 1911, Glackens guided him toward modern French painting. The artist traveled to Paris on a buying trip for Barnes in February 1912 and returned with works by, among others, Renoir, Pablo Picasso, Pissarro, Maurice Denis, Vincent van Gogh, Maurer, and Cézanne. These purchases formed the nucleus of Barnes's fabled collection. Glackens had no wish to play the art statesman nor continue with the darkly beautiful urban paintings that had established him. He chose a new and difficult path of mastering the use of high-key

color. As he wrote to Barnes, "I have found out that the pursuit of color is hard on drawing just as the pursuit of drawing is hard on color."[9] Glackens's investigation of chromatic relationships can be seen in the beach scenes he began to paint in 1908, which reached their zenith in the compositions created in Nova Scotia during the summer of 1910 and in Bellport, Long Island, during the summers of 1911 to 1916. His seascapes have been celebrated for their interplay between men, women, and children at leisure and the natural movements of clouds, sky, light, and water; the paintings are equally seductive for their clear, scintillating color and vibrant brushwork. In these idyllic glimpses of bathers, Glackens registered his own delight in the visible world, yet in his eyes this was hardly a defection from the accurate depiction of what was before him. When complimented on one of his early paintings, Glackens replied, "It's mud, life isn't like that!"[10] The larger intention of the beach scenes was to record myriad passing sensations — dissolving reflections, advancing and receding movements of the waves, subtle distinctions of a distant sky meeting the water, and the evanescence of ambient light. Barnes, who visited Glackens in Bellport, wrote in 1915, "One day this summer I was sitting with Glackens on the banks of Lake Ronkokoma [sic], when he pointed out to me in the surface of the water all the colors of the spectrum, and it rather aggravated me because I had been looking at the same water for ten minutes and saw in it only a suggestion of a bluish green color."[11]

Glackens had been a Francophile since his first visit to Paris in 1895. In New York, he was a regular visitor to exhibitions of French art in museums and galleries, and between 1925 and 1932, he and his family took up residence in France. They lived in Paris, in rural towns outside the capital, and in villages in the south of France, where he concentrated on landscapes and still lifes and occasionally returned to earlier themes of the beach and urban gathering spaces. As Glackens aged, floral still lifes became a dominant motif. Their preponderance among his late paintings suggests, in Barbara Novak's words, that "the artist immortalizing the flower engages in a complicated metaphor of his...own mortality."[12] Glackens's long stay in France, in concert with his reverence for Renoir, was regarded by xenophobic critics of the 1930s and early 1940s as traitorous. His artistic identity was deemed insufficiently American, and these simplistic opinions took decades to fade. Now, in a world of globe-trotting artists and universal familiarity with the notion that almost all art is based on other art, more expansive assessments have emerged. As Peter John Brownlee observed, "Glackens's continued exploration of color relationships and the gestural, painterly techniques...lend further nuance to our understanding of his goals as an assiduously practicing, resolutely modern artist....Glackens the artist was a fluid figure thoroughly versed in the artistic language of his transatlantic world, a modernist by practice, technique, and peripatetic personality."[13] In reconsidering the aims and breadth of Glackens's art, it is still possible to experience Mather's keen feeling of discovery.

For notes, see page 239.

PLATES 1—5

1

Self-Portrait, from *New York/Woman
with Apple* sketchbook, c. 1910
Charcoal, $7\frac{1}{2} \times 4\frac{1}{2}$ (19.1 × 11.4)

2

Albert C. Barnes, c. 1912
Black Conté crayon on tan-colored,
medium thick, machine-made,
wove paper, 8¾ × 5½ (22.2 × 14)

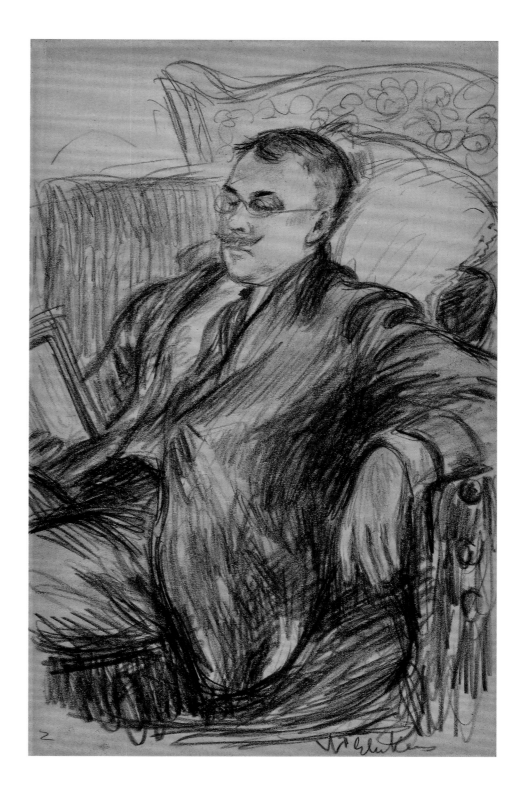

Curb Exchange No. 1, 1907 – 1910
Carbon pencil, watercolor, and Chinese white, 24⅝ × 19³⁄₁₆ (62.6 × 48.7)

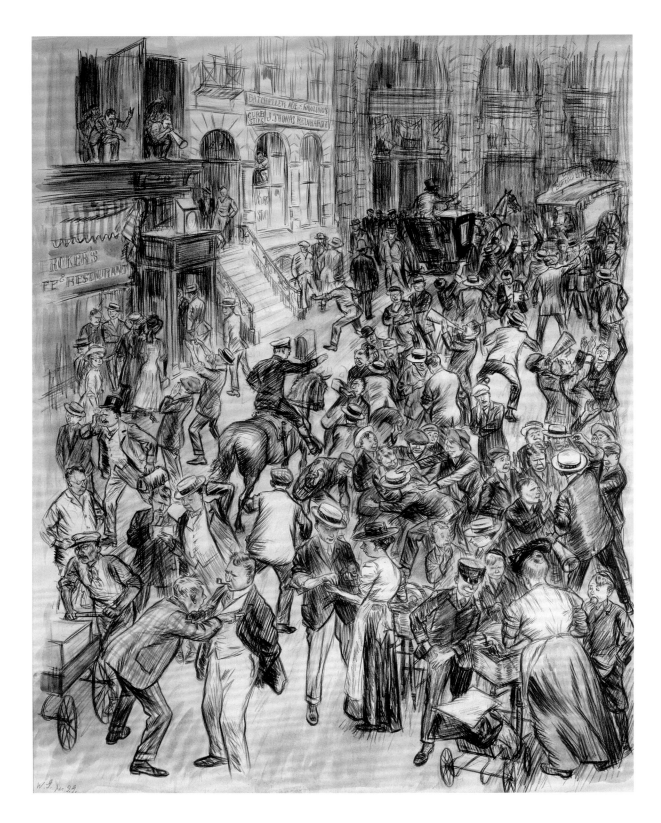

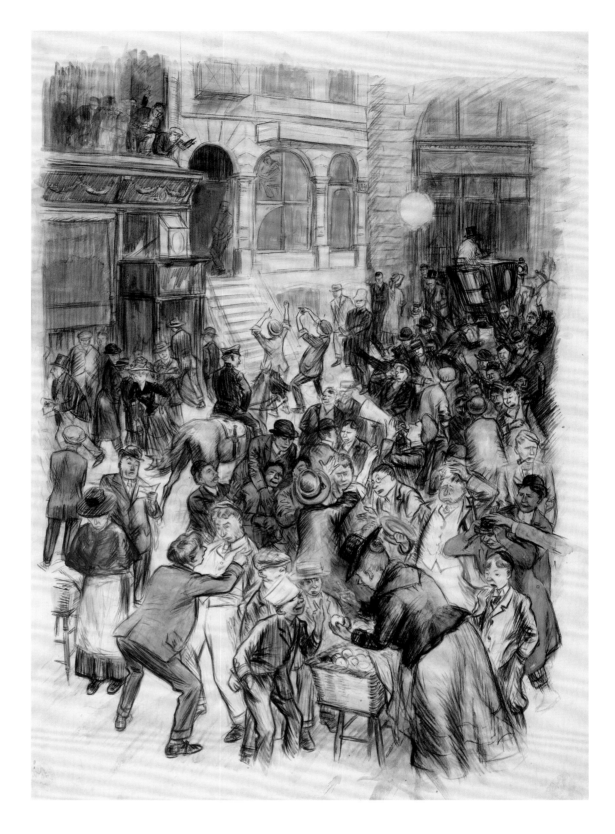

4

Curb Exchange No. 3, 1907 – 1910
Gouache and Conté crayon, 26½ × 18 (67.3 × 45.7)

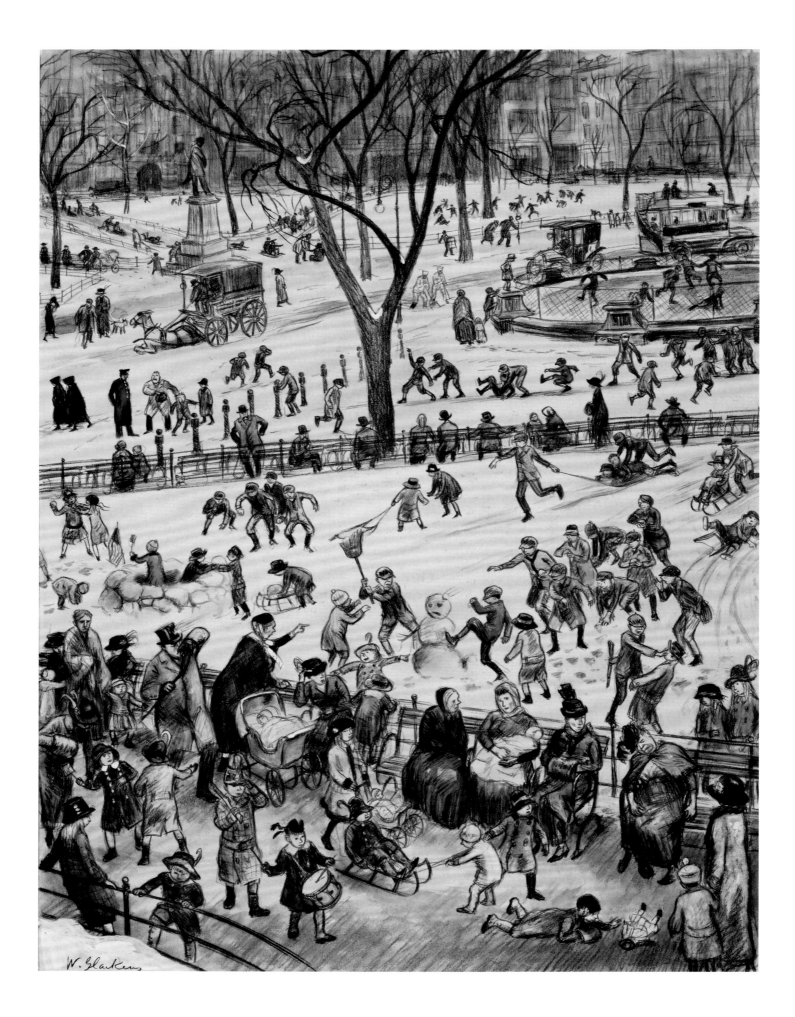

5

Washington Square, 1913
Charcoal, pencil, colored pencil, gouache,
and watercolor, 29⅛ × 22⅛ (74 × 56.2)

Philadelphia Landscape: William Glackens's Early Years

AVIS BERMAN

If, as Heraclitus proclaimed, geography is fate, then William Glackens's fate was a fortunate life. His natural talent was nourished in a fertile social and cultural environment that could only stimulate his innate gifts. To grow up, as Glackens did, in post–Civil War Philadelphia, meant that he would benefit from a panoply of urban and civic amenities: a rich visual tradition in art, craft, and architecture; a school system that provided its students with a rigorous grounding in the humanities and sciences; venerable art institutions offering excellent professional training; and a close coterie of progressive artists whose friendships never ceased to be important to him.

William James Glackens was the youngest of three children of Samuel (1843–1934) and Elizabeth Finn (1845–1924) Glackens, who were of English, Irish, and German ancestry. Samuel Glackens was a cashier and clerk for the Pennsylvania Railroad; he worked there fifty years and supported the family modestly but steadily. Their eldest child, Louis (1866–1933), drew from boyhood, and the second, Ada (1869–1931), had musical ability. William was born on March 13, 1870, at 3214 Sansom Street in West Philadelphia. In 1872 the University of Pennsylvania began buying up most of the property in the neighborhood for its campus, and three years later the Glackens family moved to a narrow brick row house at 2027 Cherry Street, close to the city center and its hub of schools, businesses, public buildings, and parks. William would live at this address for the next two decades. The district grew in importance architecturally and commercially, a consequence of the 1876 Centennial Exposition in Philadelphia. The fair, which commemorated the one-hundredth anniversary of the nation's independence, buoyed the city's reputation in arts and industry and pumped millions of dollars into the local economy.

Both William and Louis, who became a well-known illustrator for newspapers and humor magazines, drew with skill and ease, and entertained their classmates with sketches.[1] Like Louis before him, William was admitted to Central High School, one of the most prestigious public high schools in the country and the first one established in the state. When William entered secondary school in 1884, it was open only to boys, but the building on Broad and Green Streets was administered in conjunction with the nearby Philadelphia High School for Girls.

Central High School was more a preparatory school or junior college than a typical high school, and it had the authority to award A.B. degrees. Candidates passed tough entrance examinations, and the variety and difficulty of the ensuing courses ensured that only students of the highest caliber — roughly 25 percent — would stay the entire four years.[2] Of the 153 boys admitted to the ninetieth class with William Glackens, only forty graduated four years later, and Glackens did not graduate with his original class, but eighteen months later with the ninety-third class.[3]

Glackens took classes in English composition, algebra, geometry, calculus, history, German, Latin, geography, trigonometry, elocution, economic history, physics, chemistry, anatomy, physiology, astronomy — and four years of drawing.[4] Drawing, which included mechanical drawing, calligraphy, and perspective, was considered an essential part of the curriculum. Artistic prowess was encouraged, and Central High's history of it is impressive. Rembrandt Peale was the school's first professor of drawing and writing, shaping its art education program; among the notable students were William Trost Richards, Joseph Boggs Beale, and Thomas Eakins. With Glackens at Central High were John Sloan, James Preston, and Albert C. Barnes.

The Mirror, the school's literary and news magazine, often reported on Glackens, a popular boy who eagerly participated in student life. Known by his childhood nickname "Butts,"[5] he regaled the other students with caricatures of their instructors and, more formally, drew whole scenes on the blackboard with the faculty's approval. Sloan, who was acquainted with both Glackens brothers in high school, said that they "could draw in a way that amazed audiences of four or five hundred gathered in the school assembly hall. They could hold the attention of that gathering for hours at a time with a human résumé of everything that had happened that year."[6] William was also said to have illustrated a mathematics textbook for a teacher and to have done spot drawings for a dictionary.[7] He wrote "admirable articles" for *The Mirror*[8] and was a class officer and an outstanding athlete in track, football, and baseball. Barnes would later write, "During the four years there we became close friends, partly through my interest in his drawings of various scenes common to school-life, and partly

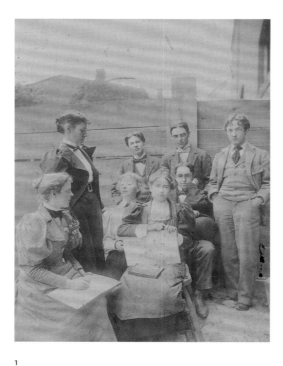

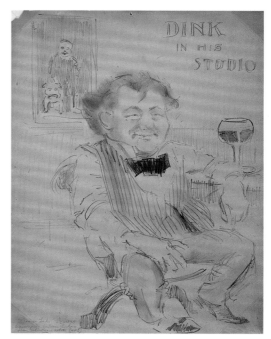

1

2

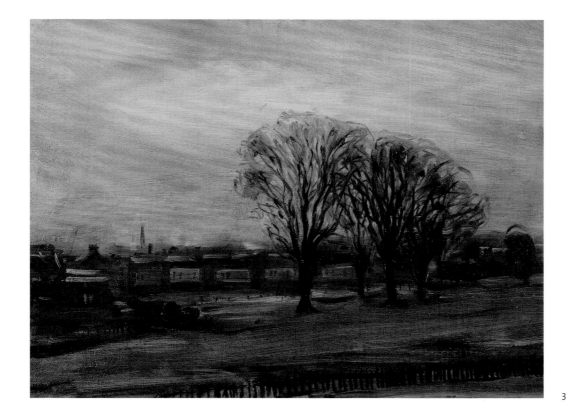

FIGURE 1
Students at the Pennsyl-
vania Academy of the
Fine Arts, 1894. William
Glackens is in the back row,
extreme right; Florence
Scovel is seen in profile,
standing. Photograph.
Everett Shinn Papers,
Archives of American Art

FIGURE 2
Dink in His Studio, c. 1895.
Graphite and charcoal
on Bristol board. This cari-
cature of George Luks by
Glackens was preserved by
John Sloan from the office
of the Philadelphia Press.
Delaware Art Museum,
Wilmington, Gift of Helen
Farr Sloan

FIGURE 3
Philadelphia Landscape,
1893. Oil on canvas.
Museum of Art, Fort
Lauderdale, Nova South-
eastern University; gift of
the Sansom Foundation

because we had the same interest in sports. We were members of the Central High School baseball team for several years."[9]

Shortly after Glackens graduated in February 1890, he departed for New York City, joining Louis to "make sketches for the popular magazines."[10] How long William remained in New York is unknown, but it may have been only a few weeks.[11] By March of 1891 he had returned to his parents' house in Philadelphia, and he began to work for the *Philadelphia Record* as an artist-reporter. In November of 1891, he enrolled in the antique (drawing from casts) class of the Pennsylvania Academy of the Fine Arts.[12]

Just as Central High School offered the best secondary education for any Philadelphia boy, the Academy was equally distinguished as an art school and museum. Founded in 1805, it is the oldest art institution in the United States, and it was no place for amateurs. Mary Cassatt, George Caleb Bingham, and William Harnett, among others, had studied there. The school's reputation rose and its curriculum strengthened when Eakins joined the faculty in 1876. Made director in 1882, Eakins insisted on instituting strict French academic training, with an emphasis on the primacy of observation, drawing, and painting of the living model. He was dismissed from the school in 1886, yet, wrote a historian of the school, "in varying degree, his ideas continued to be a factor in the training of the city's artists well into the new century."[13] By the time Glackens arrived, the teaching model was broadening. Harrison Morris, who was appointed the Academy's first managing director in 1892, instituted a more flexible program. The American impressionist landscape painter and portraitist Robert Vonnoh was hired as an instructor, and cast drawing was reinstated. Morris, who admired Eakins enormously, attempted to persuade him to teach at the Academy again, but in vain.[14] The Academy also held important loan and annual exhibitions that gave students an opportunity not only to show their own work, but also to see contemporary art from around the country.

Glackens began his studies at the Academy on November 12, 1891, and he attended steadily through October 1894. He enrolled in the antique class from November 1891 to April 1892, the evening life class in April 1892, the antique class again in October 1892, a life class from November 1892 to May 1893, the men's day life class from October 1893 to May 1894, and the life and head class from October to November 1894.[15] Taking so many classes naturally led to a widespread acquaintance with other students who later achieved professional renown. Along with Preston and Sloan, Glackens participated in courses at one time or another with Hugh Breckenridge, Edward W. Davis, Elizabeth Shippen Green, Frederic Gruger, Helen Henderson, Joe Laub, Alice Mumford, Maxfield Parrish, Florence Scovel (who later

married Shinn), and Everett Shinn (fig. 1). Shinn observed that the Academy "served as a kind of a club" for him and his friends, who went around the galleries together and studied the work of the English illustrators Charles Keene, John Leech, Phil May, and George du Maurier.[16]

Academy students first enrolled in the antique class and drew from plaster casts until they could "control a drawing, and had demonstrated some knowledge of anatomy."[17] Next they progressed to the life class, during which they drew from the nude model, and ultimately they moved on to the composition class, learning fundamental pictorial structure. The instructors for Glackens's classes listed in the Academy's catalogues were Henry Rankin Poore, Carl Newman, and Vonnoh,[18] but both Sloan and Gruger identified Glackens as a fellow student in classes taught by Thomas Anshutz, the Academy's principal instructor in the 1890s.[19] Anshutz had studied with Eakins at the Academy, and he was heavily influenced by his master's commitment to realism, but he, like Eakins, was not tied to literal naturalism. He acknowledged that the artist should "put such facts aside as interfere with the full rendering of the new truth, using only those which translate it."[20] Henry Thouron, a painter and muralist, was in charge of the composition segment of the life and head class Glackens took in 1894, and he was considered an enlightened and able educator.[21]

Glackens's job as a visual journalist at the *Record* also began to move his art in a distinctive direction. Before photo-engraving processes were sufficiently refined for the efficient and economical reproduction of photographs, cartoonists, illustrators, and engravers supplied images to the newspapers. Starting in the mid-1880s, artist-reporters were dispatched to the scene of breaking news, such as fires, accidents, sporting events, strikes, rallies, and parades. They took notes, made on-the-spot sketches, and brought their materials back to the newsroom to complete a full illustration, either alone or in concert with other artists working on different sections of the final product. A high level of draftsmanship, but also rapid execution, an eye for salient facts and details, and well-developed powers of memory were essential. In short, reporting provided invaluable training in plein-air sketching, the faithful representation of nature, and pictorial composition. Glackens's natural abilities in drawing were tested and improved — he had to learn to handle multiple figures in motion and to convey clothing, posture, attitude, facial expression, body language, emotion, and the overall situation in a few strokes. His line loosened and grew more animated. Shinn wrote that even early on Glackens was assigned to re-create crowd scenes because he was the most adept at them. Being dispatched to where the action was could not help but be an education in the grim and sensational aspects of city life.

In 1892 Glackens left the *Record* for a position with the *Philadelphia Press*, the city's leading newspaper. Sloan and Preston, who were taking courses at the Academy at the same time, were staff artists at the *Press*, as were two new acquaintances—Luks and Shinn. Davis, another occasional Academy attendee, was the art editor. Newspaper offices were a yeasty compound of stag humor, horseplay, and raffishness, and Sloan remembered the *Press*'s art department as

a dusty room with windows on Chestnut and Seventh Streets—walls plastered with caricatures [fig. 2] of our friends and ourselves, a worn board floor, old chairs and tables close together, "no smoking" signs and a heavy odor of tobacco, and Democrats (as the roaches were called in this Republican stronghold) crawling everywhere.... The fun we had there took the place of college for me.[22]

The artists thrived on the life, but none thought much of larger ambitions. That all changed for Sloan, Glackens, and the others when Robert Henri befriended them. Painter, teacher, and firebrand, Henri could make anyone want to be an artist.[23] Sloan, who credited Henri for his and his friends' aesthetic metamorphoses, said, "Henri could light the fire, and if there was a self-reliant, growing mind, the artist was started on his way for life."[24] Henri was only five years older than Glackens, but he was already a trained professional. He had toured Europe and lived in France, seeing the work of the old masters firsthand. Fresh from Paris, he was a charismatic personality burning with enthusiasm. Gruger recalled, "I heard him spoken of and I realized his return was somewhat eagerly anticipated. When he did come home, I, along with everyone else, fell under the spell of his winning personality."[25] In December 1892 the sculptor Charles Grafly had a party in his studio and invited about forty Academy alumni and students. Henri attended, as did Breckenridge, Davis, Glackens, Gruger, Preston, Edward Redfield, Elmer Schofield, and Sloan.[26] Glackens and Sloan met Henri at this party and a new coterie was formed.

Henri held a weekly open house at his studio at 806 Walnut Street. Artists would converge to talk, drink, and devise amateur plays and other amusements. These evenings were cherished as interludes of freedom and experiment. Henri educated his friends about his heroes, Diego Velázquez, Frans Hals, and Francisco de Goya, and two provocative contemporary exponents, Édouard Manet and James McNeill Whistler. Both Manet and Whistler were expert in the manipulation of black and white and of paint decisively applied, but they also appealed to an idealist such as Henri as examples of vanguard artists scorned during their lifetime but ultimately vindicated. Manet, Henri said, gave artists

license to take an "interest in the wrong side of things"; he "did not do the expected."[27]

Glackens was already a sought-after illustrator, and in 1893 he and Gruger were hired away from the *Press* by the *Philadelphia Public Ledger*. His first signed news illustrations—a distinction he had not been granted at the *Record* or the *Press*—ran on October 10, 1893.[28] The compositions are routine; the figures read as a mass of slightly differentiated shapes, and there are no personal characterizations or constructions of incident. Gruger and Glackens worked hard learning to draw—when the rest of the staff had gone home by 11:00 at night, they stayed to "get down to work" and "labor on pictorial problems."[29] Shinn also noted that Glackens made studies of the same subject again and again "to work out problems in line and form."[30] His easy line was laboriously achieved.

Glackens's first known painting—*Philadelphia Landscape* (fig. 3)—dates from 1893. It is a record not only of some nondescript buildings and the bare trees surrounding them on a late fall or winter day, but also of the atmosphere of a particular moment. Factual and purposely not picturesque, the canvas follows Henri's dictum of finding art in everyday life. Its tonalist palette also suggests the beginning of Glackens's decade-long preoccupation with Whistler, one of the artists he emulated in the process of finding his own means of expression and whose work, unlike Manet's, was frequently exhibited in Philadelphia. By the 1890s Whistler was a celebrity, known equally for the controversies he fanned as for the radical work he created. His artistic reputation was at its height in 1891, when the French nation bought the iconic *Arrangement in Grey and Black, No. 1: Portrait of the Painter's Mother*, 1871 (Musée d'Orsay, Paris).

Whistler was especially appreciated at the Academy. The portrait of his mother was exhibited there for the first time in the United States in 1881, and three years later the Academy hosted a traveling exhibition of fifty-two works.[31] After Morris took charge of the Academy's exhibitions, works by Whistler were included in every annual but one between 1893 and 1907,[32] and that of 1893 boasted a particularly strong showing. Whistler, along with Eakins, Vonnoh, Winslow Homer, George Inness, Eastman Johnson, John Singer Sargent, and William Merritt Chase, was among the select Americans invited to show more than the standard one to three works at the World's Columbian Exposition, the mammoth fair held in Chicago from May to October 1893.[33] Morris selected ninety-four paintings from the fair for the next Academy show, which ran from December 1893 to February 1894. Five of the oils were by Whistler: *La Princesse du pays de la porcelaine* (*The Princess from the Land of Porcelain*), *Nocturne in Blue and Gold: Valparaiso, Arrangement in Black: La Dame au brodequin jaune—Portrait of Lady Archibald Campbell*

FIGURE 4
William Glackens,
c. 1893–1894. Photograph.
The portrait on the easel
shows that Glackens had
studied Whistler's *The Fur
Jacket* and especially his
*Portrait of Lady Archibald
Campbell*. Museum of
Art, Fort Lauderdale, Nova
Southeastern University;
bequest of Ira Glackens,
photograph collection

FIGURE 5
Girl in White, 1894. Oil on
canvas. Private collection

FIGURE 6
William Glackens in the
studio he shared with
Robert Henri on Chestnut
Street, c. 1894. Photograph.
Girl in White is in the
background. Museum of
Art, Fort Lauderdale, Nova
Southeastern University;
bequest of Ira Glackens,
photograph collection

4

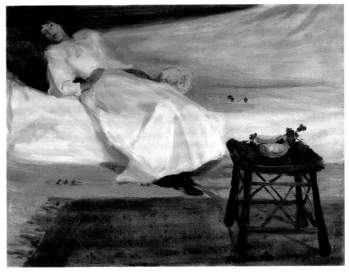

5

6

(*The Yellow Buskin*), *The Fur Jacket*, and *Chelsea Girl*. Whistler's paintings, along with Sargent's portrait of Ellen Terry as Lady Macbeth, attracted the greatest attention among the public and the students.[34] In 1894, the Academy students organized their first show of caricatures that parodied paintings in the concomitant annuals. Glackens received an honorable mention for *Jimmie*, his parody of *Chelsea Girl*.

Although the composition and loose, feathery brushstrokes of *Autumn Landscape* (plate 6) suggest that Glackens had seen reproductions of outdoor scenes by French rococo painters, the abstracted shapes, softened edges, and rapidly brushed figures in the service of a misty lyricism imply that he was aware of Whistler's evocations of London. At the Academy annuals, Glackens had examined Whistler's portraits and treatment of the figure (fig. 4), and he knew Whistler's images of women in white. The formal challenge of orchestrating various shades of white on white would have been discussed with Henri, and in painting a languid female figure clad in white (fig. 5), Glackens further introduces such Whistlerian touches as the fan and the spray of blossoms in a bowl, the latter the first known inclusion of a still-life element in his work.

Glackens and Henri traveled to New York on March 31, 1894, and Whistler was a topic of conversation. They visited the Metropolitan Museum of Art, the first one-person show of Arthur B. Davies, and the members' exhibitions of the National Academy of Design and the Society of American Artists. They were impressed by Davies, but the Society of American Artists' show was "light." Of the academicians, Henri said, "Oh so many miserable old fogys [*sic*]! Out with the Academy! Down with the school — they kill art.... Many painters, many pictures, few artists and few works of art. Vive the Japanese, Whistler, Chevannes [*sic*], Besnar [*sic*]." At the Metropolitan, Henri praised the Tanagra figurines, the works by Rembrandt, Hals, and Anthony van Dyck, as well as Manet's *Boy with a Sword*, 1861, and *Woman with a Parrot*, 1866. The Philadelphians also dropped in on Chase's studio at 51 West Tenth Street. Chase was not there, but an assistant let them in to see, as Henri put it, his "[w]onderful junk shop. Rich stuffs and admirably arranged. Grand tone to place given by fine copies of Velasquez [*sic*] et al."[35] Glackens returned to the museum in November 1894. He repeated his admiration of *Boy with a Sword*, linking it to Velázquez, and found that both works by Manet had a "family resemblance" to Whistler's *Symphony in White, No. 1: The White Girl*, 1861–1862 (National Gallery of Art, Washington), which was then on loan to the Metropolitan. "The intention of both men is identical, and their theory of drawing the same," he wrote to a friend. "We gloated over these three pictures all afternoon, and we came back the next day and gloated over them until it grew dark, and then we went back home to Philadelphia."[36]

In July of 1894 Glackens returned to the *Press*,[37] and in November he began sharing a studio with Henri at 1717 Chestnut Street (fig. 6).[38] Despite their bohemian camaraderie, they were living a weak imitation of a Parisian existence, and Henri must have instilled in Glackens the desire to experience the culture of a more cosmopolitan city in which artists were held in higher esteem. This desire could only have intensified in March 1895, when the New York branch of the Durand-Ruel Gallery exhibited fifteen works by Manet, including *A Bar at the Folies Bergère*, *Spanish Ballet*, *The Bullfight*, *A Matador (The Saluting Torero)*, *The Tragic Actor (Rouvière as Hamlet)*, *Faure in the Role of Hamlet*, *The Dead Christ with Angels*, *Music in the Tuileries*, *Masked Ball at the Opera*, and *The Luncheon*.

In June 1895, after a farewell party at Sloan's studio (fig. 7), Henri, Glackens, Schofield, Grafly, Augustus Koopman, and Colin Campbell Cooper sailed for France. They landed in Boulogne, and Henri, Glackens, and Schofield embarked for Paris. On June 11, Henri wrote to his parents, "We have nearly *killed* ourselves regularly every day in our efforts to see the Salons before they close. There are miles and miles of pictures.... There are many good things and hundreds and thousands of bad. There is lots of room at the top in art.... Glackens thinks Paris a wonderful place."[39] A few days later, the three left on a bicycle tour of Belgium and Holland via northern France, where they visited the great cathedral at Reims and Glackens extolled the countryside as more beautiful than any he had ever seen.[40] They pursued the masterpieces of the Dutch and Flemish schools, especially works by Rembrandt and Hals, in the principal cities of Belgium and Holland. "We saw everything to be seen in the north," Glackens wrote, "and gathered from it fresh convictions."[41] He then traveled to Italy, probably to Venice and Florence.[42] In October 1895 Glackens took a one-year lease on a studio at 6, rue de Boissonade in Montparnasse.

He immediately began to explore what was unique to Paris — its broad boulevards, its parks, and a freer life conducted in its great public spaces. Edward Hopper, who followed Glackens to Paris eleven years later, was surprised that Parisians were "in the streets and cafés" at all times.[43] He noted the welcome dissimilarity between the more business-oriented climate of New York and the joie de vivre he experienced in Paris, and he and Glackens expressed similar thoughts in letters home. Glackens haunted the Musée du Louvre — it was "a wonderful gallery," he wrote. "There is no need of any other school."[44] His stance combined what he had seen in the museums with the lessons of Manet, Whistler, and the impressionists: "the old masters were the only ones who really knew how to draw — and...they drew flat...high lights are vulgar, and...when one goes boldly and directly to express an idea he is at once assailed as clumsy."[45]

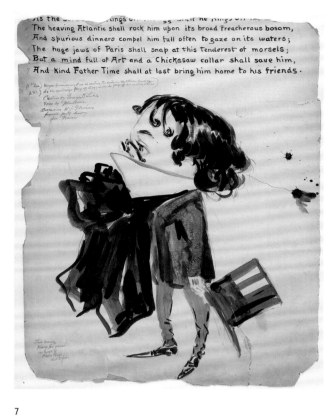

FIGURE 7
George Luks, *William Glackens*, June 1895. Ink on Bristol board. This caricature was made on the occasion of Glackens's departure for Paris—Luks drew the image and Sloan wrote the verse warning him of the dangers of going abroad. Delaware Art Museum, Wilmington

FIGURE 8
Science (formerly *Justice*), 1896–1897. Oil on canvas. Pennsylvania Academy of the Fine Arts, Philadelphia, Commissioned by the Pennsylvania Academy

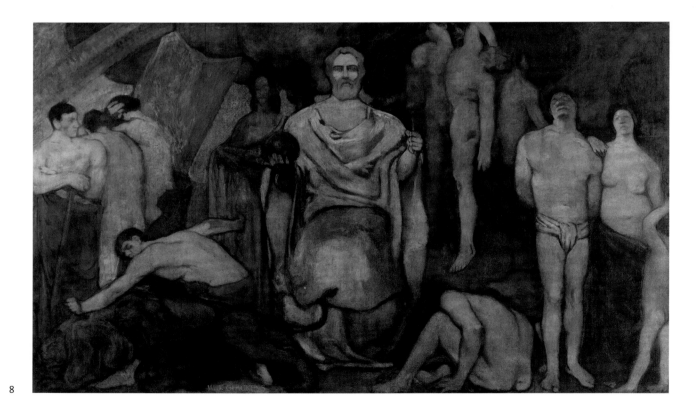

Yet Glackens was no stranger to street life, and the inspiration the cafés provided was part of a journey of self-discovery. Glackens and Henri spent evenings together at the Closerie des Lilas, a popular Montparnasse café, and nearby dance halls. The crowd for Glackens was no longer a collection of shapes to be gleaned from afar as part of a quick event, as it had been during his newspaper days. Now he examined the specific relationships of individuals to one another, their colors, movements, and emotions. The vivacious interaction of individuals was an index of personal liberty: Glackens's impression was similar to Hopper's. He was fascinated by the immediacy of café life, where men and women mixed as they pleased and couples flirted nonchalantly in public. In *Bal Bullier* (plate 7), one of two canvases he painted of encounters in the famous dance hall near his studio and the Closerie des Lilas, Glackens used Manet's restricted palette to advantage—whites, greens, and the occasional flashes of reds and yellows set off the dominant blacks and umbers. The nocturnal crowd scene with figures embedded in the background suggests that he had assimilated the nighttime paintings of Henri de Toulouse-Lautrec, whose posters were ubiquitous in the city. But above all, the vigorous brushstrokes—signals of artistic bravado and seductiveness—draw our eye to such erotic details as the dancing woman's petticoat and invite us to embrace the pleasure and variety of this world.

During this time Glackens met one of Henri's old Paris acquaintances, the Canadian artist James Wilson Morrice. A landscapist and incorrigible *boulevardier*, Morrice was an experienced guide to the Paris nightlife and a devotee of popular entertainment such as circuses and theaters. He also took the two Americans to Bois-le-Roi, on the outskirts of the Forest of Fontainebleau, in search of motifs.[46] Morrice likely would have mentioned the remarkable watercolors and monotypes of his friend and fellow Canadian, the Boston-based artist Maurice Prendergast, to Henri and Glackens. Both Morrice and Prendergast admired Whistler's intimate watercolors, and Morrice's fluid landscapes were also indebted to Whistler. The painting *La Villette* (plate 8) has a softly brushed quality that evokes a watercolor, and it shows that Glackens had not stopped experimenting with Whistler's methods. (In 1899, Glackens stated that Whistler and Manet were "the great artists of this century."[47]) Featuring a high-arched footbridge with a parade of dark, silhouetted figures below it, *La Villette* is highly reminiscent of Whistler's *Nocturne: Blue and Gold—Old Battersea Bridge*, 1872–1875 (Tate Britain), which was inspired by the woodcuts of Utagawa Hiroshige. Glackens also chose to portray the scene before him at twilight, Whistler's favorite time, when forms become indistinct. La Villette was an industrial neighborhood in northeastern Paris where the livestock markets and abattoirs

were located, and the water traffic was dense. Like Whistler, Glackens could tease out unexpected beauty in banal urban areas, especially when they were cloaked in fading light. Indeed, one of the most famous passages from Whistler's "Ten O'Clock" lecture could describe *La Villette*:

> And when the evening mist clothes the riverside with poetry, as with a veil, and the poor buildings lose themselves in the dim sky, and tall chimneys become campanili, and the warehouses are palaces in the night, and the whole city hangs in the heavens, and…the wayfarer hastens home.[48]

In the spring of 1896 Glackens gained recognition from the newer and livelier offshoot of the venerable Paris Salon, the apex of the official art world in France. The Société nationale des beaux-arts, founded (in its second incarnation) in 1890 and popularly known as the Champ-de-Mars for its location there, was not only open to younger and less established figures, but also more hospitable to foreign artists.[49] Yet because of the smaller number of artists admitted and its international character, it was more difficult to participate in the Champ-de-Mars than in the original Salon. Henri was accepted, as was Glackens. Glackens's painting *Au jardin du Luxembourg* (probably *In the Luxembourg*, plate 9), a contemporary scene of middle-class Parisians at leisure, was in the exhibition.[50] Neither the theme nor its energetic handling would have passed a traditional Salon jury, for Glackens's painterly vitality, which pervades the canvas and echoes its subject, is eminently modern. Rapid swoops, swirls, and blocks of pigment animate the sky, the jet of water erupting from the fountain, and even the folds and contours of the dress of the woman who lifts her skirts as she moves toward the viewer. The technique conveys spontaneity and confidence.

After returning to Philadelphia in October 1896 with "stacks of paintings,"[51] Glackens was one of thirteen Academy alumni engaged to execute mural-size paintings for the school's lecture room.[52] Henry Thouron, Glackens's former composition teacher, chose the artists, selecting, among others, Sloan, Parrish, Gruger, Mumford, and Henri (who refused the offer). Glackens completed two large canvases, titled *Science* and *Calliope*. *Calliope*, a single female figure representing the muse of epic poetry, has not survived. *Science* (fig. 8), which remains in the Academy's permanent collection, was executed in a manner and format not otherwise associated with Glackens. He had not worked on such a scale before, he probably had not attempted an allegorical rendering, and his own canvases had been limited to small portraits, landscapes, and urban vignettes. *Science* consists of several groups of foreshortened nudes and semi-draped figures,

a lion at the lower left, and a family unit on the lower right. They are arranged around an enthroned and robed male figure in the center of the composition, who perhaps symbolizes the authority of scientific reasoning and enlightenment.[53] Despite the compliment of having this enormous work on the Academy's walls, Glackens left Philadelphia before the end of 1896. Luks,

who had already departed to work as a cartoonist at the *New York World*, promised his friend a similar position if he relocated, and Glackens decided to take the chance. His years of apprenticeship were over — it was time to take on New York.

For notes, see page 239.

PLATES 6 – 9

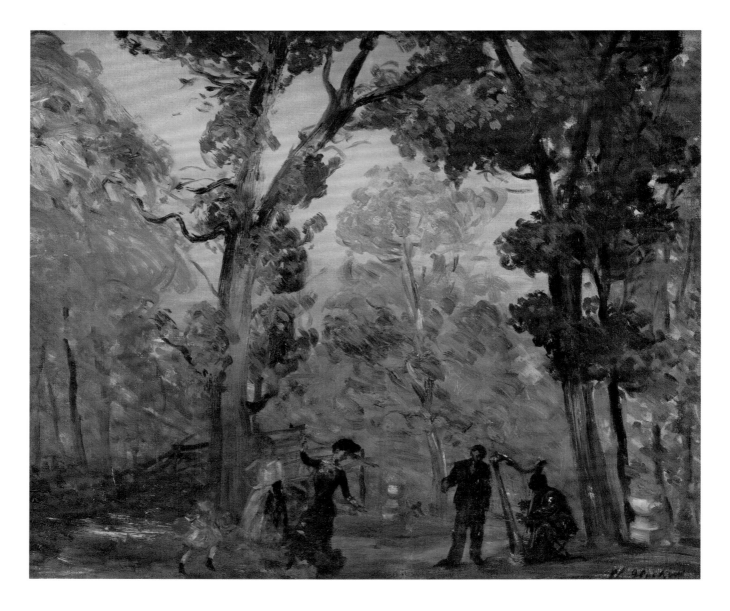

6

Autumn Landscape, 1893 – 1895
Oil on canvas, 25 × 30 (63.5 × 76.2)

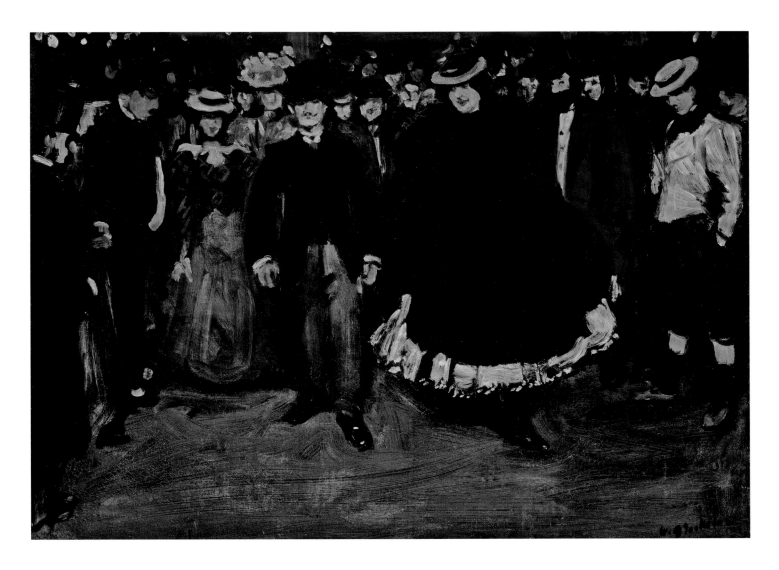

7

Bal Bullier, c. 1895
Oil on canvas, 23¹³⁄₁₆ × 32 (60.5 × 81.3)

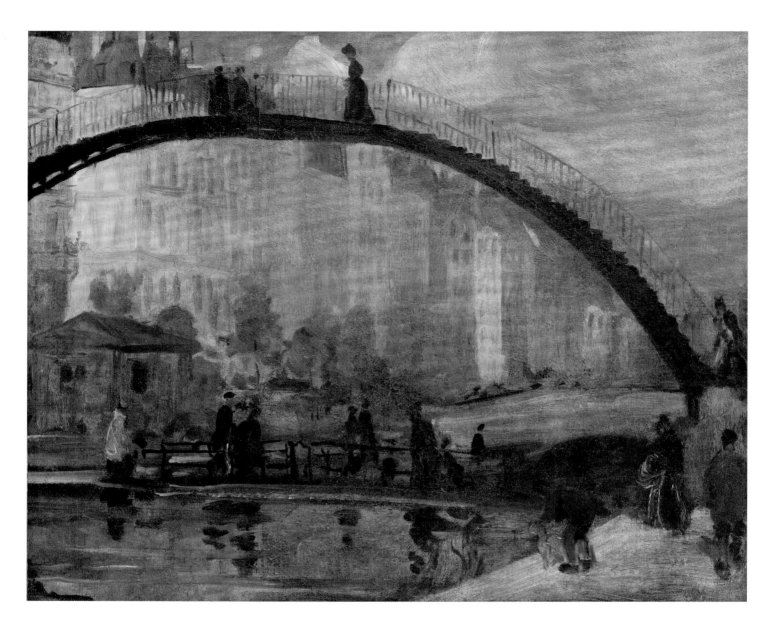

8

La Villette, c. 1895
Oil on canvas, 25 × 30 (63.5 × 76.2)

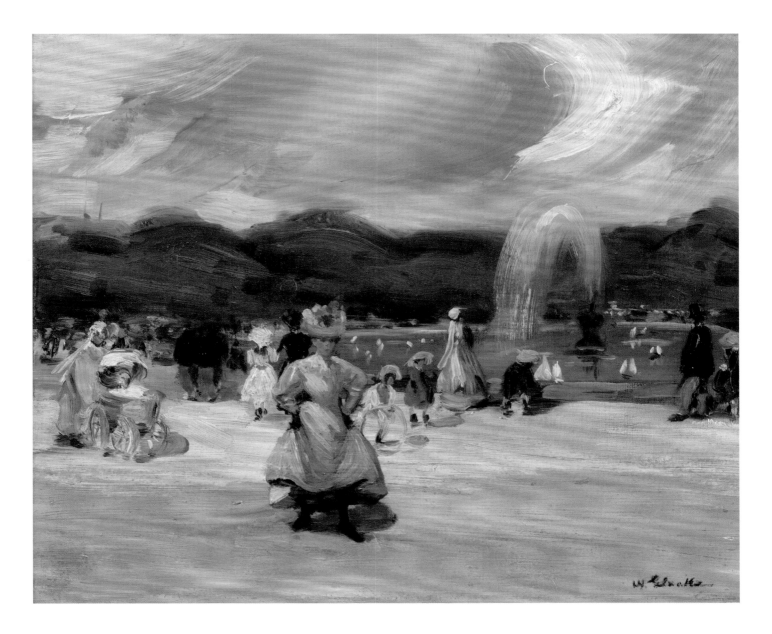

9

In the Luxembourg, c. 1896
Oil on canvas, 16 × 19 (40.6 × 48.3)

The Character and Rhythm of Modern Life: Glackens as an Illustrator

HEATHER CAMPBELL COYLE

His notations on the life around him, its character and rhythm, supplemented the writer's text in a way that few illustrations have ever done. They fulfilled characters and scenes but half drawn in the text, lent color, built form, where it was but faintly suggested.... He is, in any event, the father of the present school of illustrating.[1]
— Guy Pène du Bois, 1931

The City Seen: *A Spring Morning in Washington Square, New York*, 1910

A man in a top hat steadies a fashionable woman as she finds a seat on the upper level of a double-decker bus, while a child leans over the edge and drops his candy or treat on another man's hat. Below, a crowd in spring bonnets waits to enter the bus. A few steps away, a woman hurries her son and daughter toward the bus, as other children frolic on the grass under the watchful eyes of a patrolman. In the distance, cyclists share the road with horse-drawn carriages and an open motor car. Above them, the tall trees are green with leaves, though the lower ones remain dark and spindly. It is *A Spring Morning in Washington Square, New York*, as drawn by William Glackens for an April 1910 cover of *Collier's: The National Weekly* (plate 22).

One of Glackens's most expertly realized crowd scenes, this illustration encourages and rewards close examination. It depicts not so much a single story as a series of vignettes, and it delights in the profusion of details. A squirming baby pushes his mother's hat off her head. Dogs growl at each other. Two cyclists argue over a collision. The interactions and characters are conveyed through pose and gesture with minimal facial expression. Seen from the back, the arms of the women hauling themselves up the stairs vividly express the effort required to climb to the top of the bus, hampered by fitted jackets and long skirts. For Glackens, the

urban throng was not an indistinct mass, but a conglomeration of individual figures and stories.

In Glackens's drawing, the sidewalk and the bus stop are crowded, but the grass and the street are more sparsely populated, providing areas of nearly solid green and pale gray, echoed in slightly different tones in the façade of the bus that occupies the foreground. These areas of flat color, which recall Japanese prints, organize the composition. Much of the rest is rendered in monochrome. Only select elements stand out: patches of yellow and red-orange lead the viewer from the bus around the green, along the street, and toward Washington Arch. The meandering serpentine of the gray street, punctuated by spots of color, encourages the eye to wander from one set of figures to the next, replicating the rhythm of the strollers.

Glackens's compositional strategy is evident in a pencil study (plate 23) for the illustration. The crowd in the foreground is rendered in fast scribbles — no more than a few figures are fully worked out. Most of the incidents in the final work cannot be clearly discerned, but the layout and some of the key passages are present: the figures on the stairs, the pair of young men trailing the women in the center, the patrolman with his charge. Also apparent in the sketch are Glackens's characteristic quick, confident marks alternating with longer, sinuous lines. Glackens used short strokes — Richard J. Wattenmaker calls them "crisp, shorthand notations" — to define his small figures, and elegant, flowing lines for the trees, the bus, and Washington Arch.[2] In the pencil drawing, the figures in the foreground are represented by the tiny circles and ovals of their hats, and the various vehicles extend the motif into the middle ground. Large partial circles lie in the background, representing the fountain's pool and Washington Arch and complementing, in the published version, the rounded letters of the magazine title.

This pencil study was likely one of many. Glackens's friends and family recalled that he made dozens of drawings "to work out problems in line and form." He produced figure sketches constantly in his studio and as he moved through the city.[3] Around the time he was working on the *Collier's* illustration, Glackens filled a sketchbook and two large sheets with rapid sketches of men and women walking. The drawings in the sketchbook likely record on-the-spot impressions of New York sidewalk traffic (figs. 1, 2). In charcoal and chalk on stained paper, the large sheets also appear dashed off at the scene, though Shinn warns that Glackens made similar studies in his studio "with lightning speed, and repeated many times, until he had become so familiar with his subjects that he could place them in pictures without even referring to the sketches" (see plates 73, 74).[4] Seen from various angles, pedestrians hold bags and jackets as they walk, some with ease and others with great determination. Several

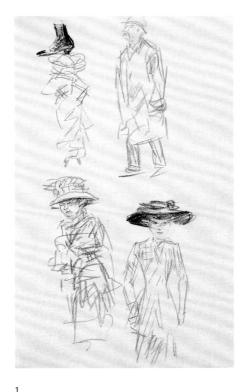

1

FIGURES 1, 2
Untitled sketches,
*New York/Woman
with Apple* sketchbook,
1910. Charcoal on
paper. Museum of
Art, Fort Lauderdale,
Nova Southeastern
University; gift of the
Sansom Foundation

FIGURE 3
By the River, 1895.
Etching. Museum of
Art, Fort Lauderdale,
Nova Southeastern
University; gift of the
Sansom Foundation

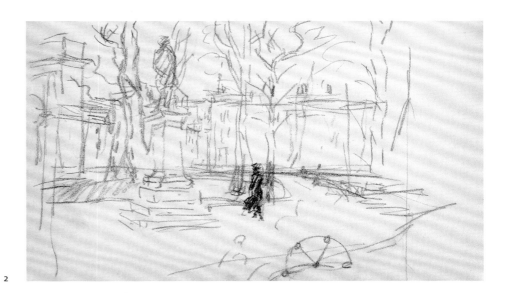

2

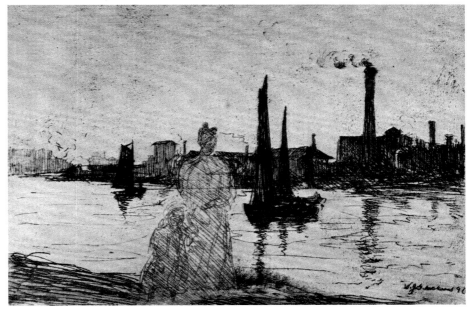

3

ladies wear the latest hats — with prominent feathers, bows, and flowers — and one girl balances a large load atop her head. None of these figures appears in this exact rendering in *A Spring Morning in Washington Square, New York*, but related characters populate this and other contemporary city scenes.

A Spring Morning in Washington Square, New York highlights Glackens's unique abilities as an illustrator and graphic artist. As his friend and colleague Everett Shinn observed, no one "could do a crowd quite like William Glackens."[5] A New Yorker for more than a decade and a resident of Washington Square when he designed this magazine cover, Glackens portrayed the character and rhythm of urban life for a national audience. New York City scenes were his specialty, appearing in *Collier's*, *Harper's Bazar*,[6] and the *Saturday Evening Post*. The self-assured strokes and myriad details of Glackens's urban crowds communicate the artist's joy in drawing. Immensely gifted as a draftsman, he drew constantly throughout his life. Drawing marked his youth, earned him success as an illustrator, and informed his paintings.

The Making of a Draftsman: Glackens in Philadelphia

Depicting city life had been Glackens's focus as an illustrator and a painter from the beginning of his career. He showed early promise as a draftsman, and his interest in art was established by the time he entered Central High School. There he met John Sloan, who noted: "I have known no one born with more natural ability to express himself graphically."[7] After graduating, Glackens found work as an artist-reporter for the *Philadelphia Record*. Dispatched to cover various newsworthy events — sometimes as they unfolded and sometimes well before or after the fact — he might make a few quick sketches on-site, but mostly relied on his memory. According to Shinn (who worked with Glackens later, in the 1890s), for his colleague, "one look on an assignment" was equivalent to studying an entire book on the subject.[8] When Glackens returned to the art department, he would begin drawing the event — be it a fire, a murder, or a meeting of dignitaries. Newspaper illustrators were encouraged to work in a standardized house style so that their work could be combined, using pen and ink, and their contributions were rendered more anonymous by being "pulled together" by another artist before being engraved.[9] Glackens befriended fellow newspaper illustrators Shinn, Sloan, and George Luks; all four moved between the city's newspapers, landing at one time or another at the *Press*.

In 1891, Glackens began to take classes at the Pennsylvania Academy of the Fine Arts. Later, he did not speak highly of art schools, but he must have appreciated the value of life drawing.[10] With Sloan and the painter Robert Henri, in the spring of 1893 Glackens helped form the Charcoal Club, a cooperative association founded to provide life classes at a lower fee than that charged by the Academy. The club met in the evenings to draw from nude and clothed models, and Henri provided criticism (fig. 4). The Charcoal Club attracted thirty-eight members and featured a relaxed bohemian atmosphere where "work went on late, and beer was required when the artists felt exhaustion creeping over them."[11] But when summer came, the number of students dwindled and the club was forced to disband.[12]

Around the same time, Glackens and Sloan traveled to the Schuylkill River and the countryside to draw and paint landscapes. On one such outing, in 1894, Sloan taught Glackens to etch. Glackens's first etchings were images of the Schuylkill, and one, *By the River*, was published in the short-lived journal *Moods* in 1895 (fig. 3).[13] The etching depicts boats on the river with industrial buildings behind them, and even in this very early work, the rendering is fluid and the composition picturesque. In subject and handling — especially in the frieze of boats and buildings and the reflections in the water — the print reveals the influence of James McNeill Whistler's well-known etchings of the Thames. On the shore, rendered sketchily, are a woman and child who appear to have been an afterthought, as elements of the building show through the woman's torso. Despite their ghostly state, the figures add narrative and pictorial interest, and they save the picture from being too obviously indebted to Whistler.

After the demise of the Charcoal Club, many of the city's young artists and illustrators gathered around Henri to discuss their favorite artists and writers. A charismatic leader, Henri encouraged the illustrators to become painters and to find subjects in the world around them. Glackens heeded his call and met with rapid success: in 1895 one of his paintings was selected for the annual exhibition of the Pennsylvania Academy of the Fine Arts. By 1895, he was ready for Europe. Accompanied by Henri and other friends from Philadelphia, he traveled abroad. When he returned to the United States and to illustration work, Glackens would make his home in New York.

Call of War: Glackens and the Spanish-American War, 1898

Late in 1896, Glackens took a job at the *New York Sunday World*, where he drew cartoons for six weeks before switching to the *Herald* as an artist-reporter for about a year. The perfection of the half-tone process, which allowed publishers to reproduce photographs in newspapers, meant fewer positions for artist-reporters, and Glackens began seeking commissions from magazines. In 1897, his illustrations for a Rudyard Kipling story appeared in *McClure's Magazine*, and the following year the editors made use of Glackens's newspaper experience, dispatching him, with writer Stephen Bonsal, to Cuba to cover the Spanish-American War.

As Frank Luther Mott has stated, the Spanish-American War was "almost ideal for newspaper treatment," being relatively

nearby, brief, and militarily successful.[14] It was also a war that the American press anticipated. As early as 1896, George Luks had been sent to cover the escalating tensions in Cuba, and the following year, the *New York Journal* dispatched Frederic Remington to the region.[15] When war was imminent in the spring of 1898, American newspapers and magazines shipped hundreds of writers, photographers, and artists to cover the unfolding events.

Glackens left New York in May and chronicled the troops embarking in Tampa, Florida. His drawing of American soldiers boarding in Tampa shows the men in orderly rows proceeding up the gangway (plate 10). Realism is conveyed via the figures in the foreground—each with an individualized face and their legs slightly out of step. Details of the ship, such as the "17" on the smokestack, enhance this sense of specificity. The awkward composition speaks to the factual nature of the document: Glackens's drawing is not a carefully arranged interpretation of the war, but a glimpse of the men heading off to fight it. This picture was reproduced in the *World*. Glackens's editor at *McClure's* had arranged for the illustrator to travel to Cuba on the *World*'s boat in exchange for his extra drawings, and he was instructed to send his "rough things done quickly" along for the newspaper.[16]

Glackens followed up this "rough thing" with an artfully composed water view of the fleet about to leave Tampa Bay (plate 11). Ships are massed neatly across the paper, with the huge transports at the center. His beautiful, summary treatment of smoke and reflections lends atmosphere to the picture, and a dinghy rowed by a solitary figure adds a sense of scale and poignancy—much like the figures on the shore in his early etching. Perhaps not surprisingly, this artistic picture was not used. Nor were his fine crowd drawings set in Santiago: *Santiago de Cuba* and *Starving refugees from Santiago congregating at El Caney* (plates 12, 14).

His published drawing, *El Pozo Centra, Santiago* (plate 13), brings the viewer to the charge up San Juan Hill, a battle Glackens witnessed. The image combines reportorial details with compositional devices that lend dynamism and historical weight to the scene, and it complements the liveliest section of Bonsal's narrative, when "discipline sprang from confusion, and the incredible never-to-be-forgotten charge occurred."[17] Glackens placed the viewer in the middle of the action by picturing the Rough Riders from behind, up the steep hill. The figures and the landscape create a stable pyramidal composition, and repeated diagonals, formed by the men's legs, lend movement to the figures. The fighters move in an orderly, yet not mechanical manner. For added naturalism, some soldiers hold on to their hats and reload their rifles. One looks out, connecting with the viewer,

and another winces in pain, providing human experience absent from the text.

In combining thoughtful composition, realistic detail, and eye contact with the viewer, Glackens's vision of San Juan Hill recalled recent illustrations of the Revolutionary War by Howard Pyle.[18] The composition of Glackens's unpublished *Surrender of the Spanish forces to General Shafter* (plate 15) specifically echoed Pyle's *The Battle of Bunker Hill* (fig. 5), which had appeared in *Scribner's* a few months before Glackens departed for Cuba.[19] Though generally associated with romantic images of swashbuckling pirates and heroic knights—the antithesis of Glackens's reportorial work—Pyle took a different approach in his images of American history. He studied costumes, terrain, and troop movements to create a convincing evocation of the past, and his history pictures were praised for their accuracy. Pyle was a highly successful illustrator, receiving a great deal of attention for his battle pictures in 1898, and he was a regular contributor to the magazines in which Glackens wanted to publish his work. As Glackens looked toward a future in magazine illustration, Pyle may have provided a sensible model for certain subjects, and replicating a successful composition hardly would have been shocking for an illustrator at the turn of the century. Pyle had borrowed the compositions for several of his war subjects from French academic painters.[20]

Glackens's years as an artist-reporter ended with his captivating illustrations of the Spanish-American War. But only a small selection of his drawings appeared in print. The war was short, and it was difficult getting the drawings to New York to accommodate the magazine's production schedule. In the end, *McClure's* published only two articles by Bonsal and one essay by Stephen Crane with Glackens's drawings, all well after Glackens returned in August, and in 1899 *Munsey's* published some of Glackens's pictures from Cuba.[21]

Making His Mark: Glackens in Magazines, c. 1900

Although many of his drawings remained unused (and his work therefore not compensated), Glackens gained valuable exposure with his dynamic war images. In a flourishing publication industry, his work was soon in demand by national magazines, and in the coming year he would find himself developing a new set of skills to illustrate popular fiction. In 1899, twenty-four articles and one book appeared with illustrations by Glackens, with a total of 121 published illustrations. He began to receive notice in the press.[22]

In 1899 and 1900, the writer Regina Armstrong featured Glackens in two articles about up-and-coming illustrators, categorizing him as a "typist." The typists, she explained, were radicals, more interested in individual expression than established

FIGURE 4
Charcoal Club with "Gypsy" Novello, 1893. Photograph. Glackens is in the back row, to the right of Henri, and Sloan is seated at lower left. John Sloan Manuscript Collection, Delaware Art Museum, Wilmington

FIGURE 5
Howard Pyle. *The Battle of Bunker Hill*, c. 1898. Oil on canvas. For Henry Cabot Lodge, "The Story of the Revolution," *Scribner's Magazine*, February 1898. Location unknown

FIGURE 6
Théophile Steinlen. Cover for *Gil Blas*, *"Frisson nouveau, par Guy de Téramond,"* 1900. Delaware Art Museum, Wilmington, Gift of Helen Farr Sloan, 1978

4

5
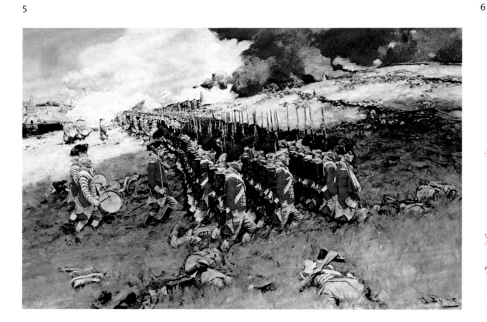

6

tradition, and she praised his "depiction of life in all its teeming naturalness," employing the words "truthfully," "transcribe," and "record" to describe his approach.[23] She characterized him as a radical realist who gave little thought to composition. His strength, she explained, was "in the expression of an idea." Armstrong positioned Glackens as "somewhat of a revolutionist" in the illustration world.

Glackens's style was a far cry from that of the established men — such as Pyle, Remington, and Charles Dana Gibson — yet he easily placed work in national magazines with wide circulation. Sloan recognized that his friend's immediate success with mainstream publications rested on subject matter. Glackens's work was accepted only for stories with a "vivid concept of human life."[24] In particular, he became known for scenes of contemporary life in New York. The city was a popular topic in national magazines at the turn of the century. Countless articles and stories provided voyeuristic descriptions of its sites, from the tables at Delmonico's to the markets of the Lower East Side. At the same time, progressive politics stirred interest in corruption and exploitation of the poor.[25] Around 1900, Glackens's reportorial style suited stories that promised readers access to the seedier quarters of the metropolis.

But tales of the city were told as human dramas, and to illustrate these subjects, Glackens needed to forsake the crowd for the intimacy of human interaction. He looked to new models, including the British comic illustrators Charles Keene and George du Maurier. Both specialized in scenes of contemporary life and excelled in the delineation of types, but, unlike Glackens, they were comfortable in the drawing room, depicting the small groups that fiction demanded.[26]

In Armstrong's profile, Glackens's recent work for *Scribner's* served as typical of his style. In August 1899, he had illustrated Albert White Vorse's romantic tale of an Italian immigrant and his beautiful daughter, Beatrice, who together run a marionette theater. The story took the reader into their world and was narrated by an upper-middle-class gentleman who enjoyed exploring the "nooks and corners" of New York.[27] Published in black and white with red areas, Glackens's illustrations captured the dusky interior of the theater. True to Armstrong's description, his characters were more types than individuals. His most successful illustration depicted Beatrice silencing the rowdy theater full of immigrant workers (plate 18). Her indignation is clear from her pose, with one fist raised and one hand on her hip. Her wide eyes and flushed cheeks reinforce this impression. Here, as in the text, Beatrice is both a type — a fiery Italian girl — and an individual with an inner life. For such a prominent figure, Glackens probably employed a model, which may account for her convincing individuality.[28] Glackens provided a solid representation of the text — even the stage set behind Beatrice is rendered

according to the author's description — and this ability soon attracted a major book commission.

Drawing on the Past: The Charles Paul de Kock Commission, 1902–1904

The atmospheric setting and apt evocation of the text Glackens showed in his magazine illustrations caught the attention of Frederick J. Quinby, an enterprising publisher who was planning a deluxe illustrated edition of the works of French author Charles Paul de Kock (1793–1871). A popular novelist who had penned an extensive series of novels about Parisian middle-class life, de Kock was "frankly devoted to the amusement of his public," and his light tales featured rich descriptions and slightly ribald humor.[29] His books were very popular in the United States. Quinby planned his series as an elaborate subscription publication in fourteen editions, several with original etchings and hand-colored plates.[30]

In 1902 the publisher approached Glackens to contribute to the first book, *Sister Anne I*, and Glackens supplied one drawing that was reproduced in a photogravure. Seven other artists participated in this volume, represented by etchings, line engravings, and hand-colored photogravures. Glackens's comic boudoir illustration caught the spirit of the text, and he became a regular contributor to the series. Realizing the scope of the project, he recommended Sloan, Shinn, and Luks to Quinby, and they joined the ranks.

For *Frère Jacques, Volume II*, Glackens took on another bedroom scene, but this time he followed the text a bit too closely. In the story a man discovers his wife in bed with another man. Glackens drew the scene as described, with the woman on the bed, her lover (in his nightshirt) on the floor, and her husband stomping around the room. The husband's pose is awkward, but this did not attract the editor's complaint. The problem was the lover in his nightshirt. His presence made the drawing too racy, and Glackens was forced to remove the figure and replace him with a chair (plates 16, 17). As Ira Glackens noted, in the published version, the husband and the crowd gathered at the door are "gaping and raving at having found the lady with a chair."[31] Other illustrators and artists faced similar indignities: in 1903, Pyle's editor at *Scribner's* asked him to "decurve" a female figure in one of his Arthurian stories, and in 1906, four of Sloan's New York City Life etchings were removed from the exhibition of the American Water Color Society for being "too vulgar."[32] One showed a woman in her nightgown.

After the first eight volumes were released, the de Kock books received a thorough review in the *Evening Sun*. Glackens was singled out for his ability to capture the writer's subject and tone: "This power of entering into the ideas of the authors whose work

he deals with is not the least notable of Mr. Glackens's gifts as an illustrator, and is worth remarking in a time when illustrations that illustrate are almost as rare as decorations that decorate."[33] The writer also recommended that entire volumes be given over to single illustrators, particularly Glackens and Sloan, and Glackens illustrated *Jean, Volume I* and *Edmond and His Cousin* on his own in 1903 and 1904.

Glackens's mature style as an illustrator emerged in these volumes, as he co-opted British and French sources to develop his graphic vocabulary. For these over-the-top comic stories set in mid-nineteenth-century Paris, Glackens could not rely on his reporter's eye, and he looked to other illustrators. *"Papa, carry me—take me up in your arms."* shows the influence of Théophile Steinlen in the strongly outlined masses and broad areas of diagonal shading (plates 19, 20; fig. 6). Steinlen's work, especially his illustrations for *Gil Blas*, had influenced Sloan and Shinn in the 1890s. While Glackens was in Paris, his friends briefly published their own Philadelphia-based *Gil Blas*, complete with Steinlen-inspired covers.[34] For these humorous stories, Glackens appropriately turned to French illustrators.

Experimenting with the ideas of others, Glackens perfected his own flat, monochrome style that reproduced beautifully and translated well into printmaking. *Who is this Columbine?* (plate 21) displays his increased skill in both composition and etching. The rich patterns and the details in the crowd do not detract from the key interaction between the gentleman in the top hat and the young woman costumed as Columbine. With her patterned dress, she stands out without being physically isolated, and his linear graphics read clearly. His etching technique is equally improved: areas in the foreground are etched deeply, with wider, darker lines, while the figures in the background are lightly inscribed.

Between 1902 and 1904, Glackens created fifty-four illustrations for the de Kock series, and this steady production allowed him to develop a distinctive graphic style. Unfortunately, Quinby's project proved overly ambitious and the company went bankrupt. Glackens and the other contributors struggled to collect fees for their work, and the venture was abandoned with only forty-two of fifty volumes of the Saint Gervais edition completed. Increasingly engaged with painting and magazine illustration, Glackens was able to fall back on other projects.

Crowd Sourcing: Glackens after 1907
After 1900, Glackens regularly published in *Collier's, McClure's, Scribner's,* and the *Saturday Evening Post.* In 1903, 158 illustrations by him appeared in forty-six magazine articles. His flat, linear style communicated distinctly in color or black-and-white. Art editors sought him out for urban subjects, and in 1907, he began to receive commissions for individual images of the bustling

streets of New York. In his illustrations, as well as his paintings, Glackens returned to the crowd as his favorite subject, and his sketchbooks provided the raw material for his increasingly complex compositions.

Throughout his career, Glackens drew constantly, filling dozens of sketchbooks with rapidly drawn figures and architectural details.[35] These sketchbooks record his immediate impressions, and they served to inject vitality and accuracy into his finished graphic works. For sketching, Glackens used waxy carbon pencil, charcoal, and chalk, which allowed him to capture mass and movement quickly.

His New York sketchbooks are filled with figure studies and architectural motifs. His figure sketches capture people on the move in the city, and although they cannot always be correlated to specific projects, these drawings allowed him to create convincing "types"—be they Fifth Avenue strollers or Lower East Side fruit vendors—in his finished works. Many of the architectural sketches are clearly related to specific illustrations. Glackens even sketched locales he knew well, such as Washington Square Park, to work out compositions for paintings and illustrations (see plate 5; fig. 6). In combination with his artist-reporter's memory, these sketches allowed him a convincing evocation of place. Sketches were particularly important for his full-page images of New York, which appeared with only a caption in *Collier's.* For armchair travelers across the country, these drawings presented a rich visual tour of New York, capturing the city through masterfully organized networks of vignettes.

Specific sketches can be identified for *Far from the Fresh Air Farm: The crowded city street, with its dangers and temptations, is a pitiful makeshift playground for the children* (plate 24). For Glackens, the Lower East Side was well outside his usual haunts, and it was not a location he painted, which may explain the large number of drawings. In his sketchbook, he delineated the matrons, in kerchiefs instead of hats, with sagging breasts and heavy loads. He sketched the fruit seller at her cart and the view up the street (figs. 7, 8). The details drawn from his sketches—the exchanges that take place, the establishments, the clothing of the characters, the way figures walk—contributed to his picture of poverty and temptation. This was not a site his middle-class readers were likely to visit, and Glackens transported them there via the pair of slender ladies (at lower left) situated to take in this overwhelming vista. While it is confirmed by the details in the scene, the moralizing caption is jarring compared to the visual pleasure of the drawing, and Glackens's picturesque approach seems ill-suited to the reformist agenda.[36]

With his sense of humor and zest for drawing, Glackens was most effective picturing the lighter side of city life, and some of his full-page drawings were published in celebration of

7

8

FIGURES 7, 8
Untitled sketches, *Paris and New York* sketchbook, undated. Museum of Art, Fort Lauderdale, Nova Southeastern University; gift of the Sansom Foundation

FIGURE 9
Tony Sarg. *The Shopping Hour on the Busy East Side—A Street Corner among the Tenements*, 1925. Published in *Tony Sarg's New York* (New York, 1926)

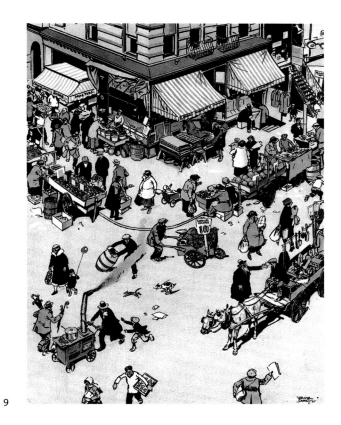

9

a holiday: *Patriots in the Making* was published on July 6, 1907, and *Christmas Shoppers, Madison Square* appeared as a double-page spread in December of 1912 (plates 25, 26). Crammed with detail, *Christmas Shoppers* captures the manic energy of the shopping district in December. The drawing does not have one focal point. Instead, it is masterfully organized into areas of varying density, conveying a particular urban reality. Cities are not uniformly crowded; pockets of activity and swaths of empty space vary throughout the day, reflecting patterns of movement. Here, as in other crowd drawings, the activity is concentrated around a busy intersection, where pedestrians and vehicles move in different directions. For this image of the business district rather than the Lower East Side, strong verticals and horizontals emphasize that there is order to this movement, though a disruption is apparent in the foreground where a strong diagonal marks the arm of a man in a tan jacket picking a woman's purse.

Taken in sum, Glackens's street views form an idiosyncratic guidebook to New York. Like many stories and essays of the period, his illustrations presented rich descriptions of famous and infamous places to a nation fascinated with New York City. His urban vistas included more detail, more crisply rendered, than a photograph could. Glackens gave viewers a magisterial view of a confusing landscape, while his figures—playing children, strolling women, and courting couples—encouraged *Collier's* readers to recognize the ordinary human element of city life in every neighborhood. In the 1920s, another generation of illustrators, including Reginald Marsh and Tony Sarg, would build on Glackens's interpretations of New York, with updated types overlaid on topography (fig. 9).[37]

A naturally gifted draftsman, Glackens developed a personal graphic style through constant drawing. With each of his major illustration projects, he refined his skills, culminating in the New York crowd pictures produced between 1907 and 1913. After 1913, Glackens made fewer illustrations and instead turned his attention to painting, a medium that benefited from his sketches and his experience as an illustrator.

For notes, see pages 239–240.

PLATES 10 — 26

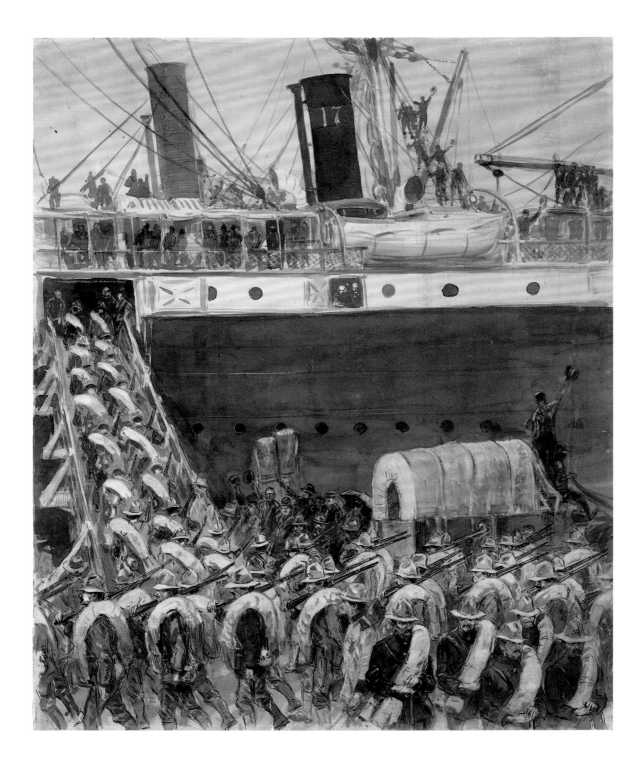

10

American troops boarding transport steamer,
Spanish-American War, 1898
Pen and ink, wash, Chinese white, and crayon, 23 × 18⅜ (58.4 × 46.6)

11

Fleet of transports just before the start, Tampa Bay, June 13, 1898
Wash and graphite, 12½ × 18 (31.8 × 45.7)

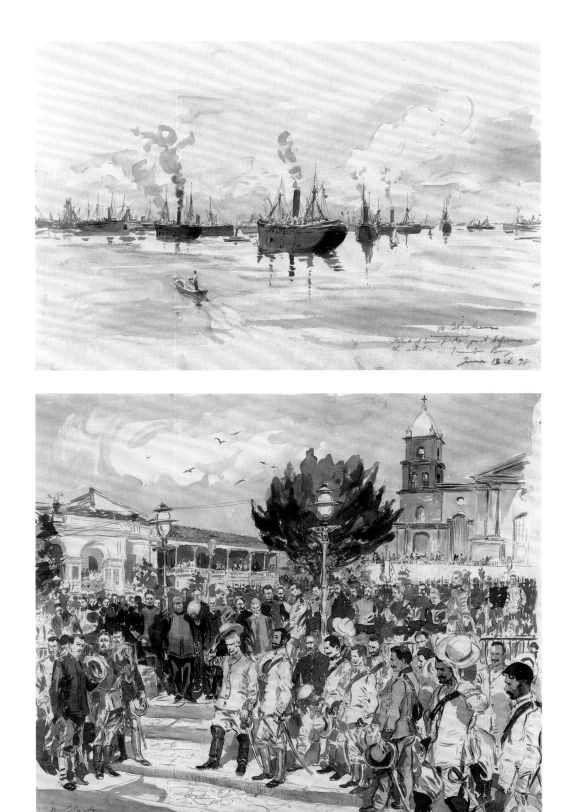

12

Santiago de Cuba, July 1898
Pen and ink, wash, Chinese white, and crayon, 18¼ × 21⅜ (46.4 × 54.3)

El Pozo Centra, Santiago, 1898
Pen and ink, wash, Chinese white, and crayon, 21 × 16⅛ (53.3 × 40.9)

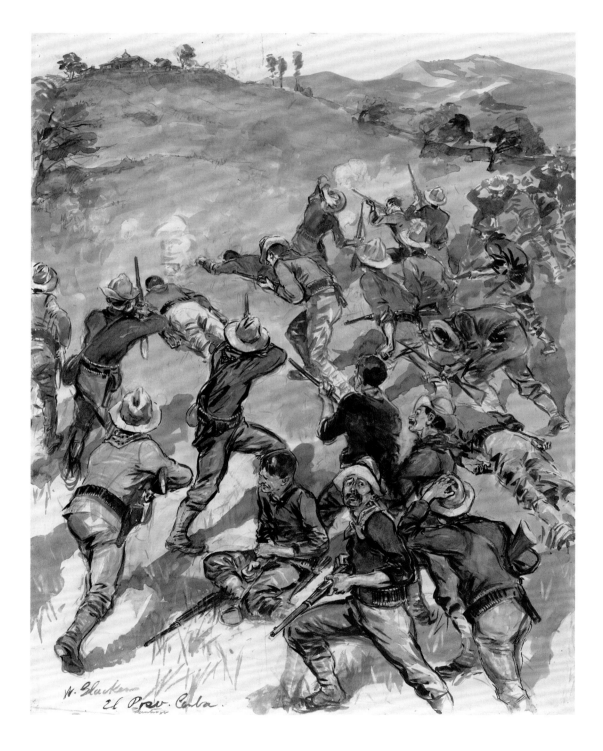

14

Starving refugees from Santiago congregating at El Caney, 1898

Pen and ink, wash, Chinese white, and crayon, 16⅛ × 21 (40.9 × 53.3)

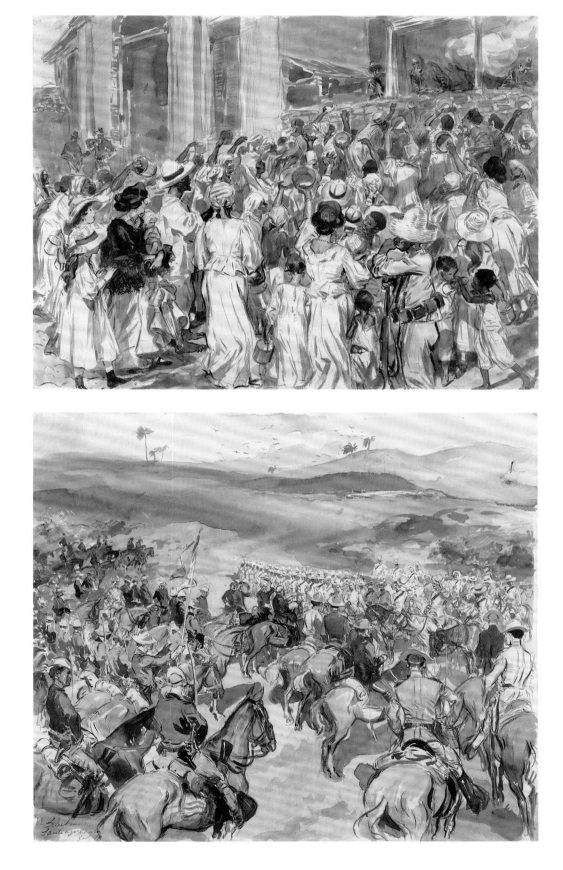

15

Surrender of the Spanish forces to General Shafter, July 1898

Pen and ink and wash, 18¼ × 21 (46.3 × 53.3)

16, 17

Edouard swore, and raved like a madman. (censored), 1903
Photogravure, 3½ × 5½ (8.9 × 14)

Edouard swore, and raved like a madman. (published), 1903
Photogravure, 3½ × 5½ (8.9 × 14)

18

She wheeled about and stamped her foot. "Silence, pigs!" she screamed., 1899
Charcoal, watercolor, and opaque gouache on board, 9 × 11 (22.9 × 27.9)

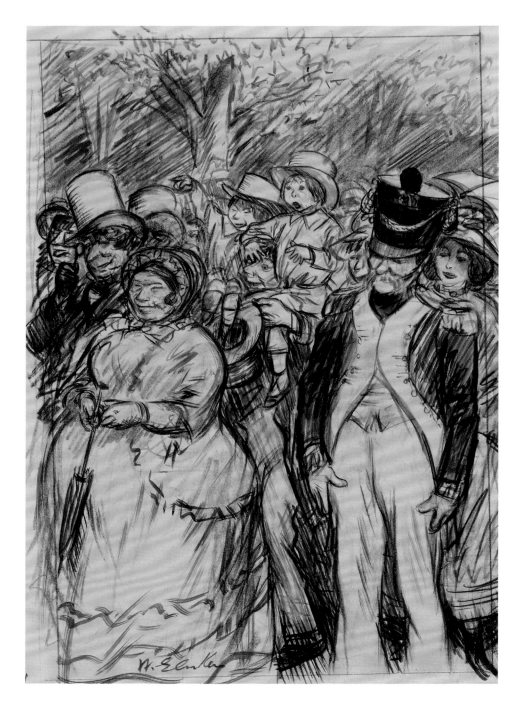

19

"Papa, carry me — take me up in your arms.," c. 1904
Pencil, black ink with brush, and charcoal on heavy cream paper,
$12^{11}/_{16} \times 10$ (30.2 × 25.4)

20

"Papa, carry me — take me up in your arms.," 1904
Photogravure, 5 × 3½ (12.7 × 8.9)

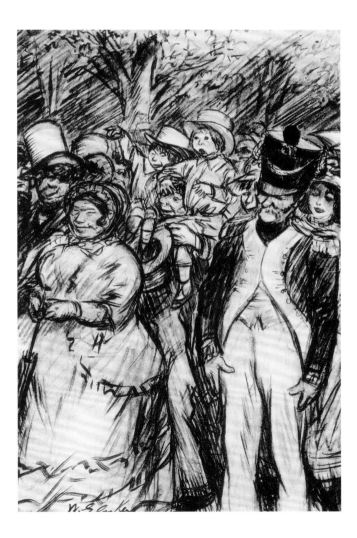

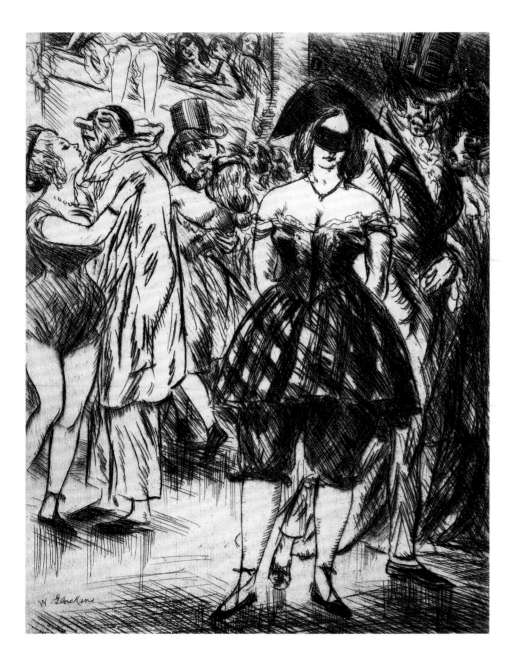

21

Who is this Columbine?, 1904
Etching, 9 × 5¾ (22.9 × 14.6)

22, 23

A Spring Morning in Washington Square, New York, 1910
Cover for *Collier's Weekly,* April 16, 1910, 15 × 10¾ (38.1 × 27.3)

Study for "A Spring Morning in Washington Square, New York," undated [1910]
Crayon, 23½ × 18 (59.7 × 45.7)

Far from the Fresh Air Farm: The crowded city street,
with its dangers and temptations, is a pitiful makeshift
playground for the children, 1911
Crayon heightened with watercolor, 24½ × 16½ (62.2 × 41.9)

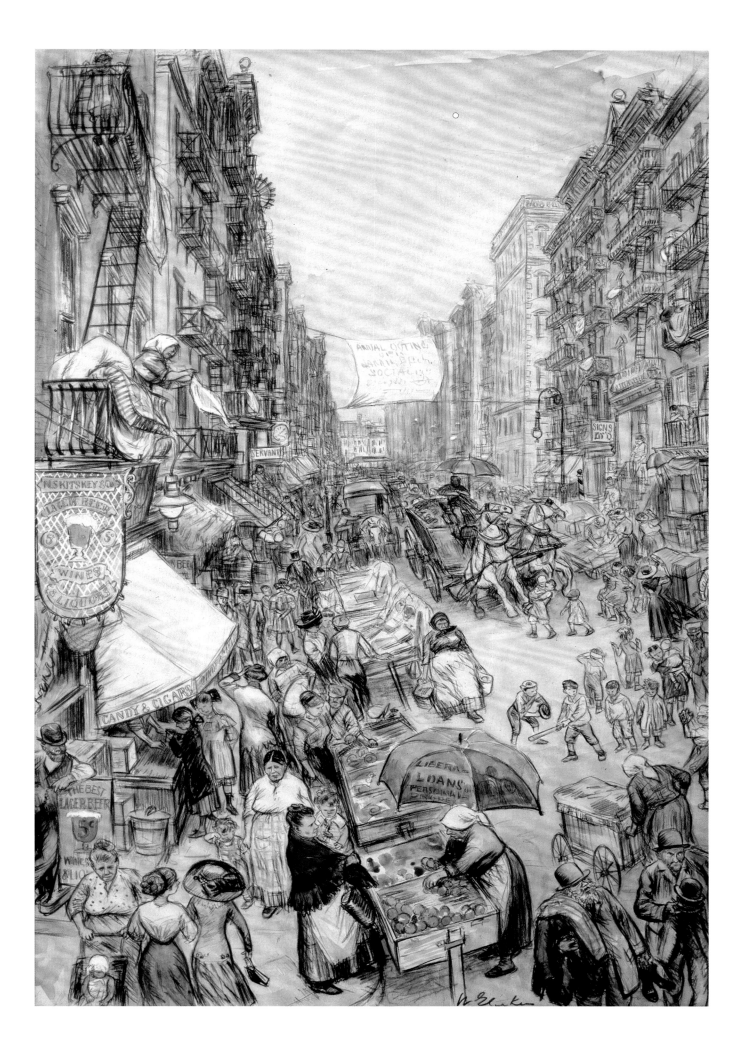

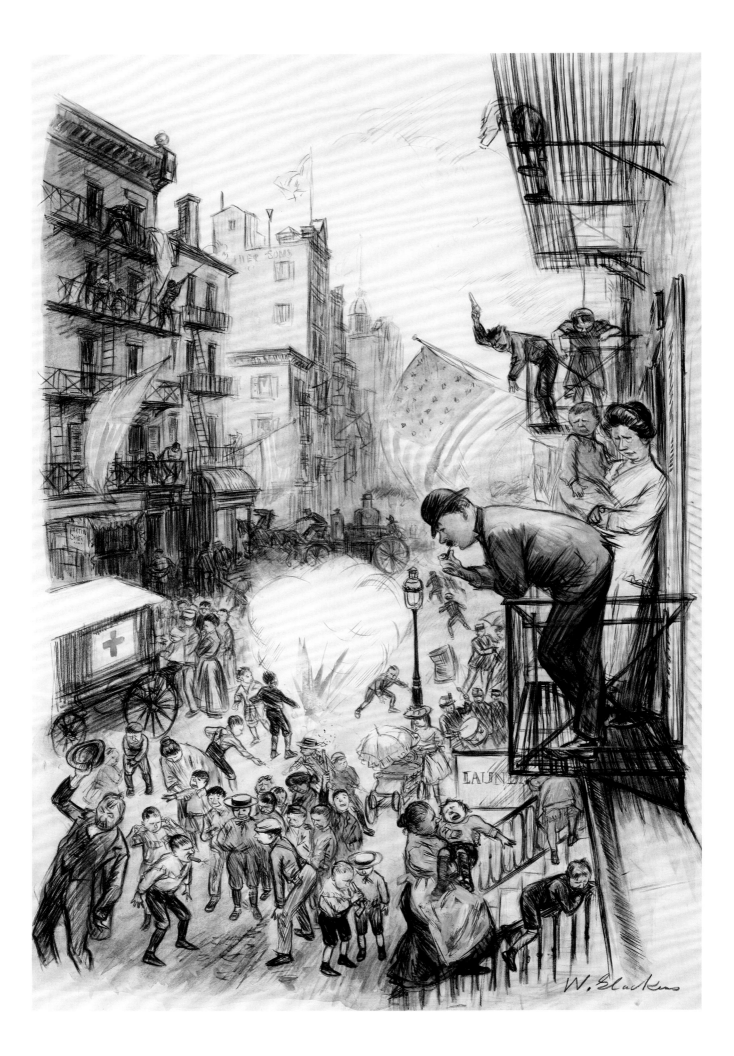

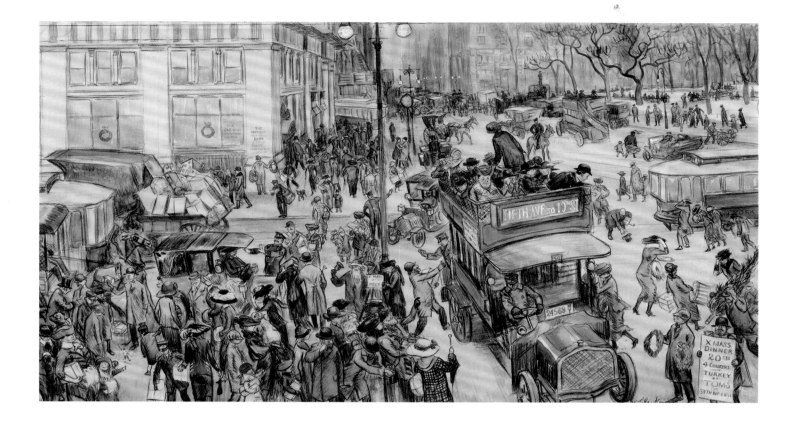

26

Christmas Shoppers, Madison Square, 1912
Crayon and watercolor, 17½ × 31 (44.5 × 78.7)

25

Patriots in the Making, 1907
Charcoal and watercolor, 20¼ × 13¾ (51.4 × 34.9)

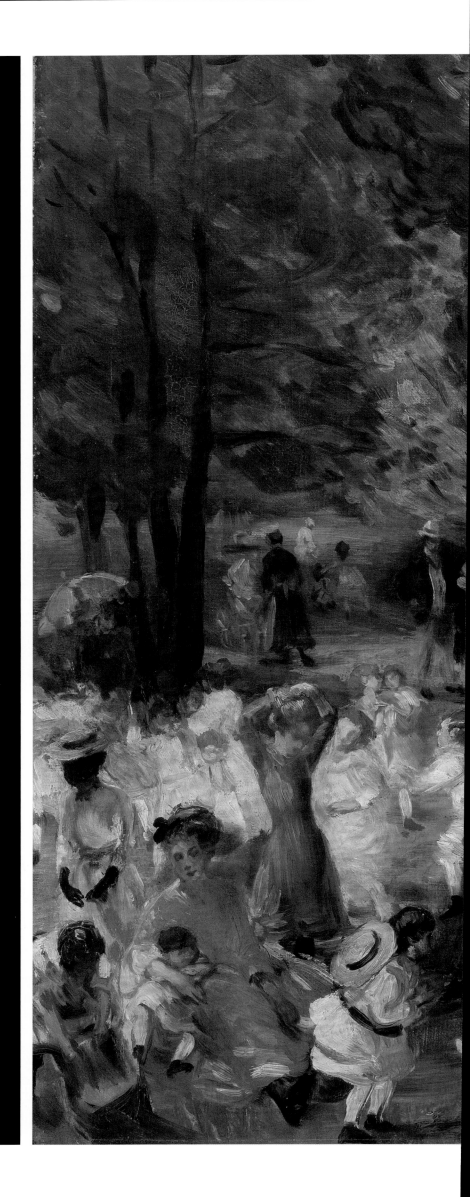

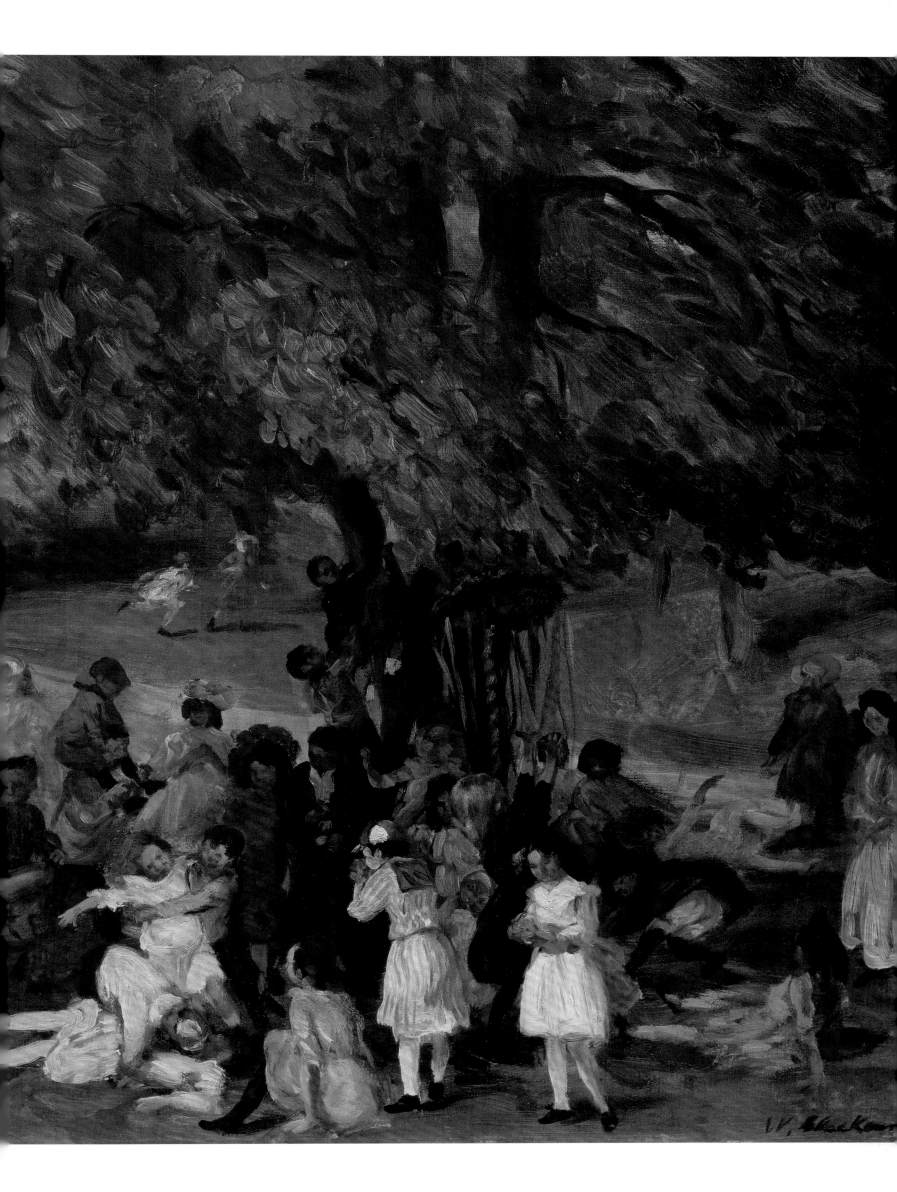

Urban Arcadia:
Glackens and the Metropolis

AVIS BERMAN

"Spectator and Sharer" (1897–1907)

After arriving in Manhattan at the end of 1896, William Glackens worked for a few weeks at the *New York World*, an often lurid paper that Joseph Pulitzer built up to record circulation. Glackens drew cartoons and feature illustrations before a "great advance"[1] in salary tempted him to jump to the *New York Herald*, a leader in broadening the range of subjects deemed suitable for coverage.[2] At the *Herald* he befriended the artist Ernest Fuhr, who became his frequent collaborator. By the summer of 1897 he had also begun to freelance for the monthly *McClure's Magazine*. Whether consciously or not, when Glackens opted for New York over Philadelphia for employment, he was acknowledging the inevitable end of his career as artist-reporter as much as the limitations of his birthplace for a progressive young painter. Photographs were beginning to replace drawings in news articles — they appeared in the *Herald* and the *New York Tribune* in 1897 — and the future for illustrators lay in the more lucrative realm of magazines and novels, which were published predominantly in New York. Furthermore, magazine work did not require a daily deadline and allowed artists more hours for their own pursuits. In the years immediately to come, Glackens determined which aspects of the city to paint and how to represent them technically, aesthetically, and psychologically.

Several genre paintings that survive from this period do not depict the bustling centers of the city. Instead, they are situated in isolated, rag-tag areas, on the edges of something else. Glackens seems to have avoided the metropolis almost deliberately, continuing with some of the pastimes and simple entertainments he had painted in France. Yet the New World could not help but intrude. For example, in *Outside the Guttenberg Race Track (New Jersey)* (plate 27), Glackens registers the present displacing the

past and the contrast between the advent of technology and a fragile human component being pushed to the margins of life. In its prime, from 1885 to 1893, the Guttenberg race track in what is now North Bergen, New Jersey, was known as the only track in the New York area that stayed open during the winter. It was a quick ferry ride across the Hudson for Manhattanites, who then took a horse-drawn car up the steep hill of the Palisades.[3] The grandstand at the track was glassed-in and heated, and countless bookmakers, stable boys, trainers, and concessionaires made a living there, with at least three thousand visitors arriving during the week, while on Saturdays, Sundays, and holidays, between ten and twelve thousand were admitted daily.[4] But in 1893 the state closed the track, and what remained open was neither the fancy seating area nor the extensive stables, but a cluster of outbuildings and rough structures that housed entertainment other than racing — a carousel, an open-air café, children's swings, and even a photography concession, all surviving on a fraction of the income they had enjoyed during the track's heyday. The gentle pathos of this shabby carnival is emphasized by Glackens's decision to portray the scene in winter: he reminds us that this was the season of the track's former glory, echoed in the subdued palette and soft light. Among these relics of the past rise telegraph poles and wires and a trolley car climbing up the hill. At the top is a group of men taking their leisure — unemployed or scratching out a living from the motley scene below.

Glackens may have felt the sting of outsider status himself. He was undecided as to whether he should enter the 1898 Pennsylvania Academy of the Fine Arts annual, telling his mentor Robert Henri in 1897 that his treatment the year before, when his two submissions were indifferently installed, still rankled. "I would like to be exhibiting myself there if I could expose half a dozen…at once, it strikes me as scarcely worth while [*sic*] to send two to have them balance the front windows like last year," he wrote.[5] Glackens did participate at the Academy in 1898 with five canvases, all Parisian subjects, but he was again unhappy with their installation — he complained to Henri in January 1898 that they were "skied" — hung too high to be seen properly.[6] Glackens was back at the *World*, along with George Luks and joined by Everett Shinn, working there until early May. He had talked to Henri about returning to Paris, because he was "not doing much,"[7] but history intervened. On February 15, 1898, the American battleship *Maine* was blown up in Havana harbor under mysterious circumstances. The explosion killed 266 American sailors onboard, and the United States called for the withdrawal of Spanish troops from Cuba. When this demand was ignored, the United States declared war against Spain on April 24, and the theater of action expanded to include the Philippines, Guam, and Puerto Rico.

The *World's* editors were among the loudest voices in inciting popular support for the war, and the paper dispatched correspondents on its own boat to report on the conflict in Cuba. Although Glackens was with the *World*, *McClure's* arranged to have him illustrate the dispatches of Stephen Bonsal, the veteran war correspondent whom the magazine had also engaged; in return, *McClure's* would pass on some of his extra drawings to the *World*.

Shipping out with the soldiers, he landed with them on the southern coast of Cuba. Unlike other illustrators who stayed close to their hotels in Havana, Glackens recorded the war in situ, after which he had to work up what he saw into elaborate scenes suitable for reproduction in pen, ink, pencil, and watercolor while suffering the same privations as the men he accompanied. One drawing, showing the surrender of the Spanish forces to the American army at Santiago de Cuba (see plate 15), reveals Glackens's continued explorations of unusual vantage points — or, rather, his astuteness about what the genuine one might be. Here, he positions the viewer where the common soldier would have stood: low, behind the masses of officers on horseback. Glackens presents a Breughel-like view of the panorama of events: in this case, the main action — the surrender — is a small part of a much greater tapestry. In this and other illustrations of the soldiers and their life, as well as in a haunting depiction of starving refugees in the aftermath of the fall of Santiago (see plate 14), the artist lets us know that the actions and experiences of individual human beings are more important than the pomp and ceremonies of the generals.

Another reason Glackens had so little patience with inauthentic heroic emotions was that he participated firsthand in the dangers and confusions of battle and the miserable conditions the troops endured — inept administrative decisions, lack of supplies, spoiled food and unclean water, relentless humidity, and exposure to disease and infection. He nearly starved, and all his belongings were stolen. After a cease-fire was signed on August 12, 1898, Glackens boarded a ship for New York. On the voyage home he contracted such a serious case of malaria that he thought he was going blind; he recovered, but recurrences of the disease plagued him for the rest of his life. On arrival in New York, he learned that *McClure's* would not use most of the drawings he had produced because the war had ended before they arrived, and the magazine paid only for what was published. Despite the documentary significance and aesthetic merit of the Spanish-American War illustrations, which Lincoln Kirstein praised as "perhaps the finest complete record of a war by an American painter,"[8] it is no wonder that Glackens never again worked as an artist-reporter.[9]

* * *

The character of Glackens's acquaintances and painting evolved quickly after his return to New York — no longer a newcomer,

he adjusted to the intoxicating lure of Manhattan. In 1899 he took a studio at 13 West 30th Street, in the heart of the Tenderloin, a wide-open zone running between West 14th and West 34th Streets. Beer gardens, gambling dens, dance halls, and brothels flourished there, along with cafés, restaurants, and both vaudeville and legitimate theater. The New York outside his door was lively, extravagant, flamboyant, rich in contrasts, and often sordid. It was a district made for bachelor nightlife, and Glackens and his compatriots, who had dropped newspaper work for magazines but still entertained the newsman's nocturnal habits, were habitués of Café Bordeaux, known as Mouquin's, a French restaurant where they would dine late and stay until closing time before repairing to an all-night bar.[10] Shinn ascended to the position of art editor at *Ainslee's Magazine* and hired Glackens (as well as John Sloan, Frederic Gruger, and James Preston) to illustrate for the periodical. Heavily engaged with the theater, Shinn hired his friend to execute vignettes of theater-going and other urban pastimes that showcased crowds for *Ainslee's*, as did *Harper's Bazar*, *Harper's Weekly*, and *Scribner's Magazine*. Through them, Glackens became professionally immersed in the visual world of theater, vaudeville, burlesque, and other varieties of live performance, and in the spectacle of throngs of people, sauntering or hurrying through the streets on their way to these entertainments.[11] This flood of tantalizing visual sensations shaped his apprehension of the modern city.

In the late 1890s and the early twentieth century, the notion of the crowd, whether a random aggregation of individuals or a group assembled to enjoy commercial mass entertainment such as the theater, sporting events, and amusement parks or even department stores, began to attract the notice of writers, historians, and sociologists. In 1899 Edwin Milton Royle published an article on vaudeville in *Scribner's*, calling it a uniquely American invention, a fundamental part of American culture, as indispensable as "the department store" to eager urban consumers.[12] Royle commented on vaudeville's extraordinary popularity as a mass democratic entertainment. In the words of the historian Gunther Barth, vaudeville "brought the momentum of the modern city from the sphere of work into that of amusement."[13] The illustrator of this article was Glackens.

At the same time that the phenomena of performance and display in popular theater and department stores were singled out for their cultural impact, so too were the related condition of urban congestion and the fact of the crowd itself. As Americans confronted the exploding population growth of their cities, their attitude toward the crowd evolved. In 1901 the *Atlantic Monthly* published an article in which the author mused on the "crowd civilization" that the American democracy produced, and defined the mission of modern art as expressing "the beautiful in endless

change, the movement of masses."[14] He called for a modern artist who could interpret the spirit of the crowd by being "a sharer and spectator at once" of its haunts and pastimes and who could live in both "the world the crowd has and the world it ought to have."[15] In popular treatises crowds were no longer uniformly portrayed as violent, undisciplined mobs. Instead, they were just as likely to be accepted as celebratory and festive, fashionable and modern.

Glackens, already recognized as an astute chronicler of the moods and expressions of crowds, as exemplified in the Spanish-American War illustrations, continued to explore them in paintings and drawings that demonstrated his capacity to adjust to new situations. In turn, the tempo and diversity of urban living imbued his work with vitality. He communicated a Whitmanesque sense of boundlessness, embracing the onrush of multitudes through painterly reportage and immediacy. In *Shop Girls* (see plate 43), which documents the new visibility of women comfortable on the town and in the workplace, Glackens plays on the barrage of moving images in a flowing populist embrace. The crowd was not a mob but an adaptable mix of personalities in motion, happy to associate with each other, confidently responding to whatever stimulus presented itself. No matter what their focus or gesture, the women never seem confused or break stride, even when a horse-drawn vehicle is driven into their midst, and it is clear that the artist admires their savoir-faire in navigating this fast-changing milieu.

Henri moved to New York in August 1900 and Glackens helped him find a place to live.[16] His presence may have prodded Glackens to concentrate again on painting. Henri introduced Glackens to the artist Van Dearing Perrine, who invited him to join the Country Sketch Club in Ridgefield, New Jersey, a getaway for artists. Perrine, who enjoyed rural life, had founded the club in 1899, and other early members were Maurice Sterne, George O. "Pop" Hart, and Charles W. Hawthorne.[17] The Country Sketch Club offered opportunities to exhibit, and a group show of its members was invited to the Art Institute of Chicago in March 1901. Indeed, Glackens had exhibited there in 1900, but he had shown his illustrations of the theater and vaudeville. He had sent these drawings to exhibitions in Philadelphia and Paris in 1900; that year too he first showed with the Society of American Artists, a New York organization established in 1877. But after he settled in Manhattan, Henri took the initiative in arranging exhibitions for his coterie, and the artists he chose had to produce.

Henri's first effort, a group show at the Allan Gallery in April 1901, announced "a few pictures" by seven painters: Henri, Glackens, Maurer, Fuhr, Perrine, Sloan, and Willard Bertram Price.[18] While lacking a checklist and with its contents unknown, this exhibition was the germ of the Henri group's shows that

became effective "instrument[s] for political and aesthetic change within the American arts community."[19] The show's one review was friendly, and its author was Charles FitzGerald, the new art critic for the New York *Evening Sun*, who was soon enlisted as a partisan of the Henri circle. FitzGerald and Glackens became friends, and FitzGerald introduced Glackens to Maurice Prendergast, who was visiting from Boston and working on scenes of Central Park and other public gathering places.[20] Writing in 1902 about a Society of American Artists exhibition that he otherwise derided for its insignificance, FitzGerald stated that although *Hammerstein's Roof Garden* (see plate 42), one of Glackens's first extant paintings to explore the theater as spectacle and stand-in for modern urbanity, was skied, "the wonder is not that it was badly hung but that it was hung at all. This is one of the most hopeful signs that almost persuades us the jury was wider awake than usual this year. Mr. Glackens's remarkable work in black and white has already won him a place in the forefront of living illustrators.... It is a pity that his paintings are not so well known as they deserve to be, but even this single contribution will help to show his worth."[21] In 1903 Glackens painted FitzGerald (plate 29; fig. 1), and the portrait constitutes one of artist's last major meditations on James McNeill Whistler.[22] The somber palette of blacks, whites, and grays, the fluid paint handling, and the elegant, elongated, introspective figure melded with its soft, dark background are all hallmarks of a classic Whistler portrait. Glackens diverged from Whistler primarily through his introduction of the vivid contrast between the whites of FitzGerald's brightly lit face and shirt collar and the blacks of his coat and vest. It is tempting to speculate that the *Portrait of Charles FitzGerald* was painted in late 1903, in memory of Whistler, who had died that July. His passing was commemorated in every leading newspaper and art journal, and FitzGerald wrote a brief tribute in the *Sun*.

Unlike the Allan Gallery venture, the next exhibition Henri organized caught most of the local critics' attention. It was held at the National Arts Club from January 19 to 31, 1904, and the participants were Henri, Arthur B. Davies (who had been close to Henri since the late 1890s), Glackens, Luks, Prendergast, and Sloan. By then these artists were familiar in the press, and their reputations guaranteed a response. Glackens was represented by eight paintings, most of which are lost. They included at least three canvases of female performers, a scene of a baseball game, and *East River Park*, c. 1902 (see page 143, fig. 1). The *New York Mail & Express* hailed the show:

Half a dozen of the most forceful and vigorous of this country's younger painters are showing some forty-five canvases, which will doubtless come as a surprise to the average frequenter of exhibitions and of dealers' galleries.

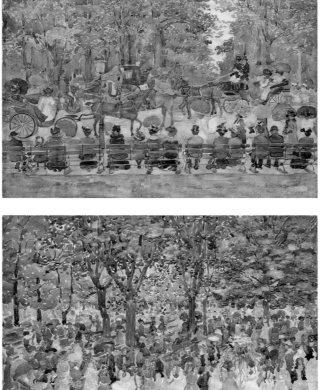

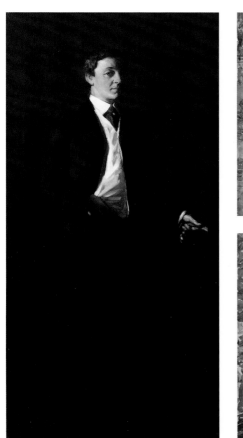

Here are men with various creeds, all of them robust and emphatic. They know what they want to do, they are not content to drift with the majority, and they are, every one, gifted in more than usual degree.[23]

Most of the other reviewers remarked on the exhibitors' originality and freshness of outlook, and even detractors admitted that the group was innovative. Arthur Hoeber of the *New York Globe & Commercial Advertiser* grumbled that the participants were "drawn together...by a unique way of presenting their notions in art....Decidedly they have a novel point of view, an outlook where nature is seen under her most lugubrious mood, where joyousness never enters...and where unhealthiness prevails to an alarming extent....Here are the dreary, the sad, and the bitter. The commonplace mortal will attribute these things to indigestion." One of Glackens's paintings of a ballet dancer he thought "sterling" yet "sad to a degree, suggesting nothing whatsoever of the brightness and frivolity of the theatre."[24] FitzGerald sprang to the artists' defense, writing, "There is nothing here of the vague compromise that we are accustomed to even in many of [our more famous painters], no fumbling of awkward facts, none of the usual bribes to taste." The group displayed the "frank decision and forthright power" that FitzGerald ascribed to Manet.[25] Perhaps the remark Glackens savored most came later in 1904, when he showed *East River Park* in the National Academy of Design's annual exhibition. The reviewer for *Brush and Pencil* observed, "Mr. Eakins, Mr. Glackens, and Jerome Myers would in their degree constitute a realist group of anarchical tendency."[26] The larger conclusion to be inferred from these criticisms — and the similar ones, both positive and negative, that The Eight would elicit over the next four years — is that of irrepressible parochialism. Considered in relation to the stylistic experiments brewing in Europe, the Henri group's realism was provincial and its anarchy temperate. As Sloan explained, "We found beauty in commonplace things and people. With a rather limited palette and through quick and direct work, we made pictures which have design and form because the intention was graphic and honest."[27] But in an atmosphere where Manet could be considered the acme of aesthetic radicalism and most artists avoided portraying seedy or unpleasant facets of urban life, any painter who tackled new subject matter and pursued the "swift simplifications, deformations and abbreviations"[28] that Glackens did, provided a brave, modern, and much-needed stance of independence.

* * *

In 1901 Glackens was introduced to Edith Dimock (1876–1955), his future wife. She was intelligent, outspoken, and of independent mind and means. Born in Hartford, Connecticut, to a father who was a wealthy textile manufacturer and a mother who espoused women's rights, Dimock defied even their expectations by moving to New York to become an artist. She was as well-trained professionally as her husband-to-be, having received a similar traditional and competent curriculum of instruction. She studied three full years at the Art Students League, from 1895 to 1898 and briefly in early 1899. She took a variety of courses, including painting, drawing from the antique, anatomy, perspective, life drawing, and composition.[29] After leaving the League, she enrolled in the New York School of Art at 57 West 57th Street, founded in 1896 by William Merritt Chase.[30] During this time Dimock, the illustrator May Wilson, and a Hartford friend named Louise Seyms were roommates in the Sherwood Studios, at 58 West 57th Street. The building was the first apartment house built specifically for artists, and with elevators, modern bathrooms, and one or two bedrooms per apartment, the accommodations were sybaritic compared to the lodgings most artists and art students occupied.

Dimock met Glackens because James Preston was courting Wilson in early 1901 and Glackens joined him one night at the women's apartment. Their relationship was probably given a boost in September 1901, when Henri and his wife moved into the Sherwood building[31] and Glackens had many more occasions to turn up there. Dimock formed her own friendship with Henri during the summer of 1902, when they were both in New London, Connecticut; she was staying in her parents' summer house nearby, and he was there for a portrait commission she had helped engineer.[32] In late November 1902 he commenced working on a full-length portrait of Dimock for a few days,[33] taking it up again in January 1903.[34] Other obligations intervened, and Henri did not complete the canvas (see page 105, fig. 3) until May 1904; by then it required a change of title, for the sitter had become Edith Dimock Glackens on February 16, 1904. Henri then painted a portrait of William Glackens in June 1904 (fig. 2),[35] and Glackens was similarly moved to paint his own portrait of Edith (see plate 40). Glackens's image of his wife is naturally less passive, more intimate — and more formidable and complex. He surpasses Henri's formula of a serene standing figure posing in the middle distance against a dark, empty background. In *Portrait of the Artist's Wife*, Edith Glackens is seated close to the foreground. She wears an elaborate and voluminous costume, redolent of wealth and status; as in a Dutch painting, her attire is restrained in color yet opulent in fabric combinations and textures. However, her amused expression as she eyes her new husband and watches him paint, affectionately taking his measure, suggests that she is not overwhelmed in the least and enjoying the occasion to be with him as he works, and her sense of will gives the portrait

its contemporary sensibility. Glackens also adds a realistic still life to the painting: the ripe fruit may symbolize the couple's abundant marital happiness, but the spots and discoloration that occurred during the days Glackens painted are a nod to his commitment to address the facts of visual appearance—which extended to his refraining from the convention of idealizing the image of his wife.

Glackens's marriage to Dimock permanently changed his financial circumstances. Although she did not yet have the great fortune that she would inherit when both parents died in 1917, she received regular payments from the Dimock family business, and her parents often gave her generous cash presents. Her independent income made it possible for the young couple to live far more lavishly than they would have on Glackens's earnings alone. He no longer experienced the financial pressures that dogged his peers and was free to devote more time to painting. Yet Glackens did not give up his career as an illustrator (plate 30), despite his hatred for its drudgery and his disgust at the treacly stories he was assigned. Nor did he seize the chance to exist solely on his wife's money; he was determined to contribute to the household, or at least pay for his professional expenses. In April 1907, when Sloan first approached Glackens about the $50 required for The Eight's exhibition, Glackens wondered if he could "afford it." Sloan marveled at that statement.[36] Edith's fortune was the source of the couple's domestic comfort, but Glackens was loath to tap it for subsidizing his exhibition career.

Marriage also expanded Glackens's outlook artistically, if for no other reason than that at first the newlyweds lived in the Sherwood Studios,[37] two blocks from Central Park. As his painting always reflected his environment, he began to observe the great green oasis that was the refuge of New Yorkers of all classes. His first attempt was *May Day, Central Park*, c. 1904 (plate 31). In the past, Glackens had made spot illustrations of people sitting and driving in the park, but in this painting he may have been inspired by the intricate, light-filled Central Park watercolors of children playing and adults promenading that Maurice Prendergast had created in 1900–1902 (figs. 3, 4), which Glackens would have known. (During the spring and summer of 1904, Prendergast was living in New York and staying at 115 West 56th Street,[38] also close to Central Park and the Sherwood Studios, and his influential presence could have spurred Glackens.) Like Prendergast, Glackens viewed Central Park as an urban arcadia, a harmonious universe uncorrupted by the growth around it. To him it was also a dynamic and spirited place. The previous generation of American artists, as exemplified by Chase and Childe Hassam, had depicted the city's parks, but their interpretations, preoccupied with landscape rather than influxes of people, tended to be more polite and static. In the words of William H.

Gerdts, "a pristine order" prevailed: adults, homogeneously upper-crust, aside from park employees or nursemaids, sat firmly or stood still, and even the children displayed unusual quiet.[39] Glackens's arcadia, in contrast, is a celebration of the here and now. A range of ages, types, and classes is represented in the meadow. Dozens of energetic boys and girls in their Sunday best chase one another, pushing and shoving after dancing around a maypole—the remnant of an annual festivity in the park[40]—propped against a tree trunk. The crowd is happy and liberated. The sense of movement is underscored by the artist's crisp, emphatic brushwork.

In the summer of 1904, the Glackenses moved to Greenwich Village, where they would reside for the rest of their lives. Their first home was at 3 Washington Square North, a Greek revival townhouse where Eakins and Augustus Saint-Gaudens had been tenants. Glackens elaborated on Central Park's arcadian qualities during the following year when he returned there to paint *The Drive, Central Park* and *Central Park, Winter* (plates 33, 34). Fewer visitors are in the park in winter; only children want to spend hours in the cold, and the adults in the scene are either parents or caretakers. In *Central Park, Winter*, the bare trees and most of the figures are silhouetted against a hilly background amid a deepening blue twilight, and Glackens suggests multiple spatial zones. Against the blue light, white snow, and gray shadows, the lively red accents of the children's hats, mittens, and sleds move in counterpoint to the rhythmic circle of the black and brown trees. Rapidly applied zig-zag brushstrokes of foliage and branches also animate the canvas and suggest the fugitive moment.

From 1902 to 1904, Glackens worked on a major commission illustrating the novels of Charles Paul de Kock, a nineteenth-century novelist popular for his risqué tales of Parisian life. Steeped in French drawing as well as Parisian subject matter, he then painted *At Mouquin's* (see plate 45), his most famous presentation of modern life. Moreover, Glackens sometimes took a backward glance—usually at an artist he admired, such as Whistler, Edgar Degas, or Manet—to move forward and shift into a more ambitious artistic statement.[41] With *At Mouquin's*, Glackens took up a motif he had treated at least three times before—in *Bal Bullier #2* (fig. 5), *Seated Actress with Mirror* (see plate 76), and *Who is this Columbine?* (see plate 21)—that of a couple locked in an ambiguous social and material encounter and the resulting dispassionate isolation of the woman from everyone else in the scene. *At Mouquin's* shows Glackens's clear-eyed commitment to psychological as well as visual realism; it is his own take on Édouard Manet's *A Bar at the Folies-Bergère* (fig. 6), both in its brilliant picturing of surfaces and in its examination of unromanticized sexual transactions.

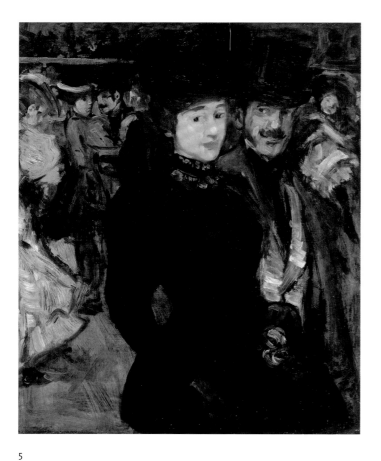

5

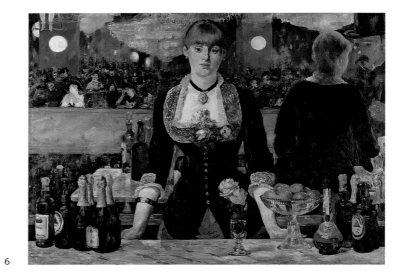

6

7

FIGURE 5
Bal Bullier #2, c. 1895–1896.
Oil on canvas. Private
collection

FIGURE 6
Édouard Manet. *A Bar
at the Folies-Bergère*,
1881–1882. Oil on canvas.
Courtauld Institute,
London

FIGURE 7
Mouquin's interior, 1909.
Photograph. Delaware Art
Museum, Wilmington

Glackens located this scene in an establishment with which he was intimately acquainted. Mouquin's, at 28th Street and Sixth Avenue, had opened in 1898, and Glackens had been one of its steadiest customers since roughly 1899, when he lived on West 30th Street.[42] A favorite haunt of artists and newspapermen, it was also considered the most authentic outpost of Parisian ambiance and cuisine in New York. The Mouquin family, who ran this restaurant and a downtown branch on Fulton Street, imported French wines and gastronomical delicacies.[43] A preserved menu from this period lists 175 wines in the cellar.[44] Mouquin's downstairs café, where Glackens set his canvas, was decorated in an expressly Parisian manner (fig. 7). It was furnished with shiny, marble-top tables, and its walls were lined with mirrors whose reflections added to the room's light and movement. Cushioned banquettes were placed against the mirrors where patrons could see and be seen. The multiple reflections of the café's lights and mirrors created an atmosphere of seduction. Mouquin's, like the bar at the Folies-Bergère, was not an exclusive Fifth Avenue restaurant. By its very location, it was one of "the gay, all-night restaurants patronized by the after-theater crowd, which lie in the 'Tenderloin.'"[45]

The actors in this drama were just as well known to the artist as the location. Glackens's stand-in for Manet's top-hatted man engaged with the barmaid was James B. Moore, who had been best man at his wedding. Owner of the Café Francis, a restaurant on West 35th Street that was a friendly and more bohemian rival of Mouquin's, Moore had a soft spot for artists, extending credit and bartering pictures for food and drink. A bluff man with a red face and coarse features who looked the part of the immemorial masher of the era, Moore was notorious among his set for the string of paramours he paraded around Manhattan as his "daughters." Because of his womanizing, it was assumed for years that the female figure in *At Mouquin's* was based on one of Moore's mistresses, but she was instead Jeanne Louise Mouquin, the wife of the restaurateur,[46] and a wedding ring is visible on her left hand. Even though she is the professional equal of Moore rather than an employee, Mme Mouquin, like Manet's barmaid, embodies the world-weary detachment of a modern woman regarded as a commodity. Her reverie isolates and protects her from her seducer, but not from the delectation of the audience. From their body language, the pair know that she is on display, and part of her companion's jovial avidity stems from his pride in showing off this gorgeous possession. Her silken dress shines and shimmers, her lustrous cloak pools over the chair into the foreground, and the audience is further enticed by the echo of the Manet-like still life of peonies and the sparkling array of bottles and glasses.

Ultimately, *At Mouquin's* was as much a staged event as the performance chronicled in *Hammerstein's Roof Garden*. Moore

and Mouquin likely came to Glackens's studio, separately or together, and he would have arranged their poses and chosen their costumes. Glackens knew that the painting was one of his best, and he entered it in the Carnegie Institute's tenth annual exhibition in November 1905. It received an honorable mention from the jury, whose members included Henri, Julian Alden Weir, John White Alexander, and, most important for Glackens, Eakins. With Eakins as one of the judges, the award was worth having.

* * *

The Glackenses did not take a honeymoon after they married in 1904, postponing it until May 1906 when they left for Spain and France. Edith's father paid their passage, and the couple journeyed to Gibraltar, Granada, Seville, and Madrid before sharing an apartment at 9, rue Falguière in Paris with James and May Wilson Preston. Alfred Maurer, who had moved to Paris in 1902, also lived in this building, and the Glackenses accompanied him to Chézy-sur-Marne and Château-Thierry, two river towns northeast of Paris where Maurer liked to paint landscapes.[47] The Glackenses also visited Dieppe and ultimately London before departing for the United States via Liverpool. Glackens commemorated the interlude with Maurer with his *Chateau Thierry* (see plate 88) and *Chezy-sur-Marne* (unlocated), and he would have witnessed the beginnings of a fundamental transformation in Maurer's own work. In New York, Maurer was rightly acclaimed as a superb painter of street scenes and figural studies in the dark and dramatic manner of Manet, Whistler, and Henri; like Glackens, he was interested in urban gathering places such as cafés and dance halls and women on the margins of society. But during that summer in the French countryside, Maurer was edging toward brilliant, saturated color; as the year wore on, he grew "thoroughly immersed in a dialogue with Fauvism," which had been introduced in Paris the year before.[48] Glackens was not ready to follow Maurer's bold, emotional use of color or his disregard of surface appearances, but he would have noted his friend's innovations and considered them for later use. Just as Prendergast was arguably the first American artist to embrace Paul Cézanne, Maurer was the first American to assimilate the discoveries of Henri Matisse. Glackens was exposed to artists who found a unique accommodation with the avant-garde; he was sympathetic rather than shocked or repulsed. Eventually, he moved toward their point of view as he was increasingly drawn to the primacy of color and light.

It was a productive summer—Glackens painted at least five canvases in Spain[49] and more than ten in France, "full of wonderful observation of life."[50] In Madrid, he visited the Prado, where he saw the great collections of works by Diego Velázquez

and Francisco de Goya for the first time. One of the finest canvases resulting from the time spent in Spain was *In the Buen Retiro* (plate 32), an evocation of an evening in Madrid's central public park and gardens located close to the Prado. Glackens created a monumental composition, framed by the dense rows of trees in the park. The crowd of nursemaids and their charges spill out of the grounds toward a lively pack of children in the foreground jumping rope and playing games. The palette emphasizes red, white, and black, the traditional colors of classic Spanish painting. Glackens prepared carefully, making individual sketches of single and multiple figures whose movements, gestures, and interactions reappear in an equally immediate manner in the finished painting (figs. 8, 9). Glackens himself suggested that the canvas was executed in Paris, a testament to his highly retentive memory.[51] The sketchy brushwork echoes the movement and vitality of the leisurely crowd, and it simplifies otherwise overwhelming representative detail. Each vignette of interrelated figures on one side of the composition is deftly balanced on the other by a similar group, but no juxtaposition or opposition is rigid or mechanical. The choreography of black stockings, ribbons, and hatbands leads the eye back and forth through this ritual event, the rhythm echoing the darting and skipping of the children.

In Paris, Glackens continued to create park scenes, making at least four different paintings of the Luxembourg Gardens.[52] In *Luxembourg Gardens* (see plate 89), his approach is more pared-down than in either *In the Buen Retiro* or his earlier Central Park scenes: the figures are disposed in a loose circle, and a lighter palette is introduced in the sandy foreground and soft contours of the distant Luxembourg Palace. The affect of the painting is less dramatic than that of *Buen Retiro* because the children, pictured in smart Parisian clothing, are on their best behavior. Mindful of staying tidy, they take their place in a proper, well-defined and refined world. The encircling trees, iron gates, and window sashes of the Luxembourg Palace give the painting structure and cradle the park's visitors in a protective shell as nurturing as the parents and caretakers guarding their children from harm. Glackens's interest in the gardens is artistic rather than documentary, and he paints what he wants us to see — the order and civilized ease so effortlessly found in the city he loved best.

When Glackens returned to New York, juries and exhibitions were still vexing Henri, Sloan, and Davies, as they had since the beginning of 1906.[53] Acceptance to important exhibitions in Manhattan was by no means assured. The Society of American Artists, which Glackens had joined in 1905, was founded in protest of the National Academy of Design's restrictive exhibition policies and as an outlet for less conservative artists. But by the turn of the century the memberships of the two organizations overlapped. In April 1906, the society merged with the Academy, and Glackens

became an associate academician by default. The Academy emerged as New York's reigning salon, with a near stranglehold on large-scale exhibition opportunities in the city,[54] and it effectively censored opposition through the selection process for its shows. The spring and fall annuals were nominally open to all, but nonmembers had to undergo selection by a jury of academicians. If their work veered outside certain norms and formulas, it was likely to be rejected, whereas members' submissions, no matter how feeble, were not subjected to competition. Moreover, an artist could not be elected an academician or an associate academician unless he or she had been approved for the spring or fall exhibition of that year.[55] This meant that innovative and adversarial artists were to be frozen out of Academy shows and their chances of gaining commissions and patrons reduced. Henri, already an associate, was elevated to full academician in 1906. Yet his sense of justice and belief in his friends' work mattered more than his own security, and he was prepared to alienate the establishment to rally others against it.

In March 1907 Henri attempted to have paintings by Glackens, Sloan, Luks, Shinn, and two of his students—Carl Sprinchorn and Rockwell Kent—enter the Academy's spring annual. When the jury and hanging committee rejected the lot, Henri withdrew two of his own submissions and aired his grievances to several newspaper reporters. (Henri and the former artist-reporters were experienced publicists, and, as the squabble wore on, every twist and turn of events was covered by the papers, much to the Academy's consternation.) On March 11, 1907, Sloan and Glackens talked over "the advisability of a split exhibition from the National Academy of Design since they seem to be more and more impossible,"[56] although Glackens ended up showing a painting in the Academy's spring annual. In April, Davies and Ernest Lawson (whom Glackens had introduced to the Henri coterie in 1905) were rejected for associate membership, Henri was removed from the Academy's jury,[57] and the lines were drawn. Henri selected the artists for the new splinter exhibition—himself, Sloan, Glackens, Luks, Shinn, Davies, Lawson, and Prendergast (fig. 10)—and on April 13, *Harper's Weekly* characterized Henri, Sloan, Jerome Myers, Luks, and Glackens as "revolutionary figures."[58] But they were hardly outsiders. When Davies secured the Macbeth Galleries at 450 Fifth Avenue as the site of the exhibition, it was a natural fit because everyone except Glackens had sold or shown works there. The group, which showed together only on this one occasion, was christened "The Eight" by the critic James Gibbons Huneker; their "outlaw salon," which opened on February 3, 1908, marked a significant gain for artistic independence in the United States—for the artists' right to show what they pleased.[59]

All the participants knew that the Macbeth show would be noticed, and the publicity from the cause célèbre of insurgency

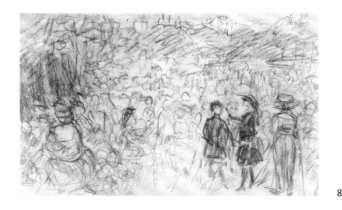

8

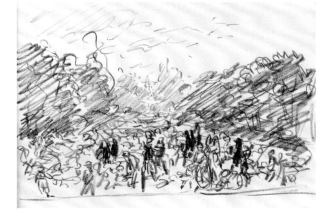

9

FIGURE 8
Study for *In the Buen Retiro, Paris* sketchbook, 1906/1922. Crayon on paper. Museum of Art, Fort Lauderdale, Nova Southeastern University; gift of the Sansom Foundation

FIGURE 9
Study for *In the Buen Retiro*, sketchbook, 1906/1908. Crayon on paper. Museum of Art, Fort Lauderdale, Nova Southeastern University; gift of the Sansom Foundation

FIGURE 10
George Luks, postcard to Robert Henri, *Henri and His 8*, 1908. Front row: Henri conducting, Sloan beating the drum; back row: Glackens, Davies, Prendergast, Lawson, Shinn, and Luks. Delaware Art Museum, Wilmington

FIGURE 11
In this detail of a letter to his wife, dated January 17, 1908, Glackens draws himself prostrate before the unfinished *Shoppers*. Photograph. Peter A. Juley Collection, Smithsonian American Art Museum

FIGURE 12
"*I was a* sopher. *I was poor, but I never went hungry,*" from Abraham Cahan, "Rabbi Eliezer's Christmas," *Scribner's Magazine* 26, no. 6 (December 1899), 662

12

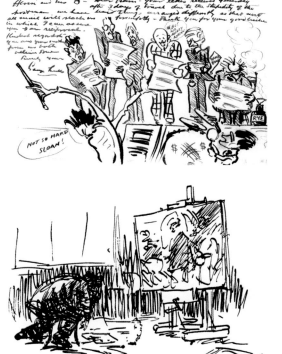

10

11

would be a bonanza to their reputations. Glackens was never vocal about these developments, but he knew about the exhibition from the beginning, attended the important meetings about it,[60] and selected the paintings he considered his best for inclusion. From paintings he completed before 1907, Glackens chose *At Mouquin's*, *May Day, Central Park* (reproduced in the catalogue as *Grey Day, Central Park*), *Coasting, Central Park*, c. 1905 (unlocated), and *In the Buen Retiro* (misspelled as *Bues Retiro, Madrid*). Another early picture—*The Battery*, c. 1902–1904 (private collection)—was reproduced in the catalogue, but it did not appear in the show; Glackens must have swapped it for a different canvas at the last minute. He also had three more recent paintings in preparation.

Probably begun in early 1907 because it was first exhibited in April of that year, *The Shoppers* (see plate 75) is the culmination of many themes Glackens had been pursuing for several years: the world of women and the central role his wife played in his life and work, the combination of urban spectacle and urban display, and the idea of performance and theater in life and art. The germ of the painting's compositional structure may be traced first to an illustration for a short story by Abraham Cahan, "Rabbi Eliezer's Christmas," published by *Scribner's Magazine* in 1899 (fig. 12).[61] In the illustration, two modern Gentile women visiting a Jewish neighborhood are purchasing cigarettes from an old man in front of a counter; both women are in profile and their faces are indistinct. The other customers are a man entering and a child departing the frame. A large open space in the foreground establishes distance between the image and the reader. Perhaps more saliently, in February 1907 Glackens was working on illustrations for a story that took place in a ladies' clothing store on Grand Street, also with a Jewish proprietor.[62] He made six illustrations depicting the shop's interior, each featuring female employees and shoppers.

In the painting, all aspects of ethnic particularity have been eliminated, and the spatial and psychodynamic aspects of the work have radically changed. The three women posing in the foreground are not anonymous models. Compared with the illustration, the space around them has contracted. The central figure is Edith Glackens; the seated figure at the lower left is Lillian Gelston Travis, her friend and fellow student at the Art Students League; and at right in the canvas is Florence Scovel Shinn. All three women had been or were artists, and the necessity of available models for posing was something they all understood. The other female figures, a salesperson and another customer, do not interest the artist as much. The saleswoman's face is generic, but the customer's head has a greenish cast worthy of a figure in a canvas by Henri de Toulouse-Lautrec. Travis is showing off her best feature, her thick golden-brown hair. Edith is dressed in a loose fur jacket and dark skirt, topped by a white-feathered hat that harmonizes with her long white gloves. The costume and the pose signal a personal event in the Glackenses' lives: she was pregnant when she posed for *The Shoppers* and would give birth to their first child, Ira Dimock Glackens, on July 4, 1907. The slightly flared coat hides her shape and she is standing in such a way that any swelling in her body would be ambiguous. The women may be in the lingerie department of a department store or perhaps a smaller shop devoted to linens, laces, and undergarments.[63] The hemmed-in view of the sales area, crowded even without crowds, suggests that only those with immediate business there are welcome. Edith's pregnancy is a more subtle communication of a female experience that men will never share. Indeed, with one or two significant exceptions, especially after Ira was born, men were almost never a part of Glackens's figural paintings or subjects of portraits. Florence Shinn stands apart from the other four women in *The Shoppers*—the only one not engrossed in the scene, she stares at the viewer and at Glackens himself. H. Barbara Weinberg has noted that Shinn "brings to mind several such figures—including Velázquez himself—in *Las Meninas*…which Glackens had admired in the Prado in 1906."[64] She underscores the theatrical nature of *The Shoppers*, because, as in *At Mouquin's*, this drama of consumption was staged in the artist's studio, and Shinn obliterates the distance between the audience and the action.

Glackens unerringly chronicled cultural changes through contemporary subjects not previously seen in American painting. In *The Shoppers*, for example, he pioneered the portrayal of the temptations of modern commerce and the desire for wanting things—much as Glackens's admirer Theodore Dreiser had done in *Sister Carrie* in 1900. In depicting women, he was not afraid of revealing the frank and sometimes sinister predicaments that came with new social and sexual freedoms. Similarly, he was "the first member of the [American] realist group to complete a major painting of a contemporary vaudeville subject."[65] Recently, however, his realism has been chided for being insufficiently bleak. Unlike Sloan, Luks, or Myers, Glackens failed to portray ghettos and tenements in his paintings.[66] In *The Shoppers* he neglected "the hardship that accompanied the manufacture of the luxury goods that his shoppers examine and wear."[67]

But it was precisely because Glackens ventured to those very precincts so regularly while on assignment as an illustrator that he chose not to address them as a painter. In fact, in February 1907, just about the time he had embarked on *The Shoppers*, Glackens was interviewed by the *New York Times* about his magazine work, and his answer merits quoting at length. The reporter, Otis Notman, stated that the "Russian Jew is [Glackens's] specialty. His work is confined wholly to character studies of a kindly yet

satirical nature." Glackens replied, "It is only stories that deal with the east side that I illustrate. I have always cared about that line of work. I like character studies.... I go over on the east side, and get my material there. Sometimes I make sketches, but then I come back and work out the picture from memory and imagination without a model. I don't care about the emotional side of art; for instance, I never paint or draw lovers."[68] Although Glackens drew many representations of city life located elsewhere in New York,[69] his renderings of the Lower East Side were numerous enough to be examined by critics. It is revealing that he spoke of his illustrations as character studies, because critics used that term to describe such paintings as At Mouquin's and The Shoppers. Yet Glackens did not necessarily separate "character studies" from "caricature," and just as he shunned hackneyed emotional clichés, he had no interest in introducing caricature into his paintings. However, ethnic identities, which had to be conveyed in a shorthand manner in his illustrations, sometimes slipped into expedient stereotypes. In 1907 to 1908 Glackens was in the process of defining the differences between what his illustrations were and what his paintings ought to be.[70] He wanted to remove his paintings from the realm of illustration. The miseries of the Lower East Side and other poorer neighborhoods were part of and reminded him of illustrating, which he undertook as employment, no matter how adroit the results. In his canvases, he wanted a break from illustration fare. Glackens's painting was truthful to his own comfortable life and milieu, and focusing on the slums would have struck him as inauthentic.[71] As his friend, the critic Mary Fanton Roberts, wrote, "Undoubtedly Glackens preferred painting the more sophisticated life at naïve moments rather than the primitive world making a brave effort at sophistication."[72] The Shoppers does have an illustrative base that draws on Glackens's mastery of character and drama, and it nearly concludes the dominance of a dark palette and line in his canvases. From then on, he longed for the freedom to move toward color and light.

"A Scream of Color" (1908–1913)

In preparing for The Eight's exhibition, Glackens worked on two other paintings: Race Track (see page 129, fig. 2) and View of West Hartford (plate 28). Just as The Shoppers was a summation of his previous work, these two disclosed his future direction. Race Track, probably painted in the summer and fall of 1907, picked up a motif he had essayed a decade before in Outside the Guttenberg Race Track (New Jersey). This time Glackens depicted a working track, dappled with spectators and flags flying. The spectator is positioned to watch the horses, jockeys, and handlers leave the paddock and ride toward the track. It is a searingly hot day and more than half the picture is filled with an overpowering, saturated sky and lightly impastoed cumulus clouds. The scene

is reminiscent of Degas, but the painting would undergo great changes between its inception in 1907 and its later reworking in 1908 and 1909. During Christmas of 1907, Glackens was in West Hartford with the Dimocks and painted View of West Hartford. The Dimock mansion overlooked the town center, with a distant view of Talcott Mountain (fig. 13). Glackens's use of imagery was thrifty: here too are elements first seen in Outside the Guttenberg Race Track (New Jersey). A red-and-white trolley car, telegraph poles, and a billboard quietly invade the bucolic scene, but there are no extraneous details, and every form, from the skaters gliding on the pond to the bare trees and damp pasture, is executed in quick, loose strokes. The color palette is noticeably warmer and lighter, with an emphasis on oranges, reds, yellows, golds, and browns against soft purples and blues. Glackens must have liked the outcome, in contrast to his misgivings about his other canvases. On January 17, 1908, he wrote to Edith about the picture and The Shoppers, which he was determined to revise (fig. 11), "Am already sick of the damn exhibition. There has been too much talk about it. I will probably fall very flat.... In my effort to fix my pictures up so far I have only succeeded in spoiling them. The Race Track has gone by the board. Shall substitute the one I painted in Hartford Christmas week. The Shoppers I can do nothing with. It is now minus Mrs. Shinn's and Mrs. Travis' heads. I can neither paint nor draw anymore."[73] But by the time the exhibition opened, the "spoiled" paintings were salvaged, and Glackens's final choices were The Shoppers, Race Track (titled Brighton Beach, Race Track in the catalogue), View of West Hartford (not listed in the catalogue, but part of the show and cited as New England Landscape in reviews), as well as the pre-1907 works listed above.

The exhibition of The Eight was wildly successful. Three hundred visitors per hour crowded in on opening day, and the gallery counted a total of seven thousand visitors coming through its doors. Seven paintings — none by Glackens — sold, four to the sculptor and art patron Gertrude Vanderbilt Whitney, cementing a growing relationship between her and the Henri circle in particular and American realism in general.[74] The reviews were evenly divided between praise and derision, but the exhibition pushed The Eight to the forefront of American art "and gained them widespread respect as painters, teachers, and spokesmen for progressive ideas."[75] After the show closed at Macbeth's, it traveled to the Pennsylvania Academy in March 1908, and, beginning in September 1908, to museums and public art associations in eight additional cities: Chicago, Toledo, Detroit, Indianapolis, Cincinnati, Pittsburgh, Bridgeport, Connecticut, and Newark.[76] Most of the museums had already invited these artists to exhibit, but the scope of the tour demonstrated that public institutions desired to showcase them and validate their legitimacy.

13

FIGURE 13
A view of West Hartford
similar to that seen in
Glackens's painting.
Undated. Photograph.
Connecticut State
Historical Society

FIGURE 14
The resemblance between
Glackens and the male
figure in *Vaudeville Team*
is discernible in this
photograph. Undated
[c. 1910]. Museum of Art,
Fort Lauderdale, Nova
Southeastern University;
bequest of Ira Glackens,
photograph collection

FIGURE 15
Vaudeville Team in the
dining room of Glackens's
apartment, c. 1938.
Photograph. Peter A. Juley
Collection, Smithsonian
American Art Museum,
Washington

14

Glackens withdrew *Race Track* from the exhibition tour and substituted *Sunday, Montmartre* (presumably *Flying Kites, Montmartre*, 1906; see page 200, fig. 3). By the time the exhibition reached its last stop in Newark in May 1909, Glackens also added one of his Luxembourg Gardens scenes from 1906.[77] Otherwise he was tired of the uproar. In May 1908, to drum up further publicity and sell a puzzle he created with an image of Theodore Roosevelt, Shinn confected a spurious association called the "Theodore III Club." Its alleged purpose was to support Theodore Roosevelt for a third term in office and its members were "eight artists and illustrators who created a stir in the art world" and "have decided to go into politics." A flowery oration on the subject attributed to the normally laconic Glackens was published.[78] He wrote to Edith, "Shinn's puzzle is out and the stories published in the papers about it make first class idiots of the whole lot of us. Everett has certainly taken advantage of his friends for advertising purposes."[79] Yet Glackens gave Shinn permission to use his name to help promote the puzzle, further adding, "If prestige is to be lost by advertising, even involuntarily, we, 'The Eight' haven't a single shred left. I am perfectly willing to let my name go on a breakfast food or a toilet soap."[80]

Glackens and his family went to Boston in June 1908, looking up Maurice Prendergast and meeting his brother, Charles. They went on to vacation in Dennis, Massachusetts, on Cape Cod, and Maurice Prendergast joined them in August. Working side by side with Prendergast no doubt persuaded Glackens to continue brightening his palette, as he had done in *View of West Hartford*. However, it posed an ongoing dilemma in *Race Track*, which, when completed, would blaze with azure blues set against hot oranges and reds. Albert C. Barnes, who bought *Race Track* in 1913, would comment, "the colors are glaring in both their intrinsic quality and their infusion with light…no grass was ever so green…no clay was ever so reddish-yellow, no sky was ever of that quality of blue, no roofs were ever so iridescent."[81] This dazzling palette can also be seen in *Cape Cod Pier* (see plate 60) and other canvases created during the summer of 1908, when Glackens jettisoned black as the basis of his palette and embraced nonlocal color.

Prendergast's influence in nudging Glackens to experiment with impressionist brushwork and more luscious color may have been given substantial reinforcement by a large exhibition of the work of Pierre-Auguste Renoir held at the Durand-Ruel Gallery's New York branch, from November 11 to December 8, 1908. It had been consistently possible to view some of Renoir's paintings in New York, including *Madame Georges Charpentier and Her Children*, 1878, purchased by the Metropolitan Museum of Art in 1907. Yet the 1908 survey, which consisted of forty-one paintings and works on paper ranging in date from 1873 to 1907, offered a

much more substantial view of the artist.[82] This exhibition was followed in March 1909 by a display of the semi-abstract fauve oils by Maurer at Alfred Stieglitz's gallery 291, which Glackens saw.[83] During that same time Marsden Hartley sought out the Prendergasts in Boston, and they gave him letters of introduction to Glackens and Henri. Hartley brought his neo-impressionist landscapes of Maine to Glackens, who kept them in his studio and showed them to other members of The Eight. Sloan's reaction was mixed and Shinn did not like the work at all, but Hartley later recalled that the Prendergasts, Davies, and Glackens gave their approval.[84] Hartley's canvases, like Lawson's, were tweedy in texture and thickly worked. The confluence of these events may have ratified Glackens's own growing interest in a more heightened and expressive palette and a preference for the abstract character of a scene — or, as Richard J. Wattenmaker put it, "the development of a forthright Impressionist technique."[85]

Vaudeville Team, c. 1908–1909 (plate 38),[86] shows a couple performing on stage. It is an ambitious painting and seemingly destined for an exhibition. It was one of several theater scenes he was working on, and it is related to *Pony Ballet*, 1910–1911 (see page 132, fig. 5), in size, theme, paint application, background patterns, and use of a similar stock theatrical backdrop. But unlike *Pony Ballet* and other large paintings created during this period, Glackens did not exhibit *Vaudeville Team*. He may have felt that it was unresolved, or the canvas had become too autobiographical for his taste. The face of the male figure in the painting resembles the artist so strongly that the likeness cannot be ignored (fig. 14). This reticent man may have been expressing how much he disliked his visibility on the stage of public life, which had drastically increased since The Eight exhibition and Shinn's publicity stunt. Here he steps into the role of a song-and-dance man, a cheap vaudevillian at the mercy of a crowd he is meant to entertain. He expresses these doubts and discomforts through the persona of the showman or actor, which allowed more openness than in real life. The female figure marks what is probably the first appearance of Kay Laurell, a vaudeville performer and showgirl who became one of Glackens's regular models (see plate 46).[87] The female figure — youthful, vivacious, and with a sensual, lupine grin, also takes on a larger symbolic role — that of the artist's inspiration. Here, the brilliant and translucent color of the model's hair, skin, and dress points to a new source of creative study — that of the chromatic radiance and textured brushwork of Renoir in particular and bolder and more complex color relationships in general. Every step of Glackens's development would be evaluated in the press; in the female figure, his evolving style is projected as a target of public scrutiny. Given the vortex of personal and artistic conflicts suggested by this canvas, it is understandable why Glackens decided to keep

it to himself. However, he did value the painting. In photographs taken of his house at 10 West Ninth Street, *Vaudeville Team* hangs in his dining room (fig. 15), where all his guests would see it.

* * *

Glackens always painted his world, and in the fall of 1908 its boundaries changed. The family moved to an apartment at 23 Fifth Avenue and Glackens took a studio on the second floor of 50 Washington Square South. The studio overlooked the square and provided a view of the park's arch, footpaths, trees, lawns, and roadways. (In those days, trolleys and buses traversed the park.) Although one of the Washington Square oils was first reproduced in 1907[88] and first exhibited throughout 1909, the bulk of the paintings, drawings, and pastels of the view from Glackens's window were created between 1910 and 1914.[89]

Washington Square, characterized by Henry James in 1904 as a "pleasant old punch-bowl" filled with "the wine of life,"[90] was a divided area only possible in a place such as New York, where rich and poor bump up against each other in jarring proximity and a few hundred yards could mean a major socioeconomic shift. The north side of the square, where the Glackenses had lived the first years of their married life, was the patrician part. Glackens's studio, on the south side, was close to the tenements of Sullivan, Thompson, and Laurens (now La Guardia Place) Streets, a solidly Italian-immigrant neighborhood by 1907.[91] Glackens's paintings and illustrations reflected the variegated nature of the square and his increasing distance from crowd scenes. Washington Square is recorded at different times of day, in different seasons, and under different weather conditions, but strollers, workers, and configurations of families are always included. However, his only massive crowd scenes of the square are found in his tour-de-force illustrations for *Collier's Magazine* in 1910 and 1913 (see plates 5, 22, 10), and in *Italian Parade*, 1910 (Whitney Museum of American Art, New York), and *Italo-American Celebration*, c. 1912 (Museum of Fine Arts, Boston). The drawings of the square reprise a Breughelian melange of figures, sharply observed and satirical, interacting in serpentine motion. They reflect many careful sketches of small stories and vignettes (see plate 23) showing that even in this people's paradise, where different classes and ethnic groups mingled without conflict, rowdy and noisy children were disciplined. Glackens considered Columbus Day celebrations enjoyable events.[92] Yet the paintings depict the crowds as alien, and the prevailing impression is of an impersonal pageantry seen from the safe and tranquil position of the studio.

The square seemed most appealing and arcadian to Glackens when it was relatively deserted. From his studio on the square, he could observe it any time he liked, which tended to be when leisure-seeking crowds were elsewhere. The emphasis of these oils was more on landscape than genre, focusing on color, light, and form rather than social comment. Glackens left New York from June through September, painting his Washington Square canvases during the other months of the year. Winter was especially fruitful — fewer people lingered outdoors in cold weather and the leafless trees revealed the arch, the green and brown lawns, the winding paths, the row of red-brick buildings to the north, and the scattered passersby Glackens could indicate with a few dots and dashes. Furthermore, the hazy skies and indistinct light were a change from the sparkling seas he painted during his summer sojourns in Wickford, Rhode Island, and Nova Scotia. *Street Cleaners, Washington Square* and *Washington Square* (plates 35, 36) combine Glackens's propensity to remain factual with his deepening desire for a more pictorial execution. In *Street Cleaners, Washington Square*, he exploits the unpredictable outside his window. He sees something not recorded by other artists — city workers in their white caps and uniforms hosing down the muddy path and melting the snow. With fewer main actors, Glackens could paint a scene that was "intimist," one of neighborhood. He uses thin, fluid brushstrokes to catch the spray of water, which is countered by the diagonally brushed, impastoed snow and multicolored streaks of reflecting water and ground. In the distance beyond the snow-covered lawn, he offers further displays of fluid, translucent color as well as visible, smooth brushwork. The painting is constructed of ever-widening concentric ovals that are suffused into a broader vision of urban life taking place on the borders of the square — the city laps at the edges of the canvas. *Washington Square*, also set during a winter thaw, is not as aestheticized in its treatment of mud and rapidly dirtying snow. Glackens examines an unvarnished fact of life in New York — mud and slippery streets, a real hazard in a city with so many pedestrians. The square's messy paths are even more sparsely populated, though a few brave souls find their way through. The staccato stabs and slabs of pigment are approximations of the heavy mud — the medium itself embodies the mundane, inconvenient weather conditions.

The bus moving out of *Washington Square* stars in the foreground and becomes a focal point of the composition in *The Green Car* (plate 37). Glackens revisits the same corner, dominated by the large tree, where a woman hails a trolley heading north. He captures a bright, warm day, expertly creating light reflecting from the snow and the melting puddles of water through bold combinations of intensely saturated colors. *The Green Car* looks as though it were painted outdoors, but it represents one of the artist's most effective syntheses of working directly from life while employing the observations and perceptions of the studio. The painting is so fresh that parts of it seem done at first stroke,

but its full, spacious composition and purposeful patterning, beginning with the car jutting into the open foreground, were worked up from preliminary drawings. Once more the trolley, the emblem of modernity, imports the realities of urban life into the square. Passengers arrive in front of Glackens's eyes and remind us of the contemporaneity and immediacy of the scene before him.

Glackens further explored his experiments with voluptuous color harmonies and optical effects in the monumental *Family Group* (plate 39). The canvas also memorialized the interior of his apartment at 23 Fifth Avenue, which was decorated with Oriental rugs and furniture upholstered in richly textured fabrics. Portrayed from left to right are Edith Glackens; her younger sister, Irene Dimock; Ira Glackens; and one of Edith's friends from Hartford, Grace Dwight Morgan. The patterning of colors on chairs, rugs, flowers, and cushions—a riot of furnishings that never seems cramped or congested—is made even more vibrant by the sun streaming in the window, rendering every surface radiant, as Glackens begins to blur the boundaries between background and foreground and shows his familiarity with the work of Matisse. *Family Group* was one of the three paintings Glackens chose for the epochal International Exhibition of Modern Art, known as the Armory Show, in 1913. One critic called *Family Group* "a scream of color,"[93] and the *New York Sun* went so far as to say that it "sets forth a power of organization, of sustained effort beyond the grasp of all but a few of the men most conspicuous to-day in American art…this gives you the sense of…a mind clearly made up as to design, color and the laying on of the paint itself. Glackens has not tried…to dodge any of the questions bound to arise in the realization of so considerable a project."[94]

Ira Glackens reported that when his father saw Grace Morgan in the colorful red-and-white attire she had just bought at Paul Poiret in Paris, he changed the entire composition and palette to include her. This addition to the canvas symbolizes the necessity for the modern American artist to recognize and embrace contemporary currents in French art. Glackens himself had already admired and assimilated the discoveries of the French impressionists, and in 1913, speaking about the advent of the Armory Show, he stated, "American art is like every other art—a matter of influence. Art, like humanity, every time, has an ancestry.… Everything worthwhile in our art is due to the influence of French art. We have not yet arrived at a national art. The old idea that American art…is to become a fact by the reproduction of local subjects…has long since been put to the discard."[95] In a sense, *Family Group* predicted these sentiments and made them sartorially concrete.

Glackens had his first solo exhibition in March 1912. The venue was the Madison Gallery, a progressive establishment devoted to American art founded in 1909 by Clara Potter Davidge, an interior designer who had a house and shop on Washington Square South.[96] Exactly what the artist showed in *Recent Works by William Glackens* is uncertain, but *The Green Car*, some New York street scenes that included other Washington Square canvases, two portraits, and a beach scene were mentioned in respectful reviews. Unfortunately, the gallery closed in April 1912, but exhibiting with Davidge allied Glackens with Allen Tucker, Samuel Halpert, D. Putnam Brinley, Walt Kuhn, Jonas Lie, Henry Fitch Taylor, Elmer MacRae, and other advanced artists in the Madison stable, and this in turn led to his becoming one of the original planners of the Armory Show. Glackens's receptivity to modern art attained historic status in February 1912: just before the Madison Gallery exhibition opened, he spent two weeks in Paris at the behest of Albert C. Barnes, his former high school friend who had become a wealthy businessman, purchasing modern paintings for him. Glackens, accompanied by Maurer, made the rounds of the dealers and bought thirty-three paintings and works on paper. Maurer also took Glackens to see the collection of Gertrude and Leo Stein.[97] No one with Glackens's visual acuity would have emerged unimpressed by these extraordinary aesthetic encounters. One of the first canvases he painted after returning from France was *March Day, Washington Square* (see plate 53). Even more emphatically than in *The Green Car*, Glackens made a virtue of emptiness, refraining from filling the canvas with surface incident. He planted abstract shapes in a figurative world and created breathing space through atmosphere, weather, and shimmering reflections. The last were obtained with fresh, limpid washes of arbitrary color. Short, wriggling brushstrokes activate the entire span of the picture as Glackens arrives at his own version of the optical restlessness of impressionism. By now, his urban arcadia is not so much crowds in perpetual flux, but the evanescence of subtle visual sensations. Inevitably, then, within another year or two, the metropolitan melee would cease to captivate him at all.

For notes, see pages 240–241.

PLATES 27 – 39

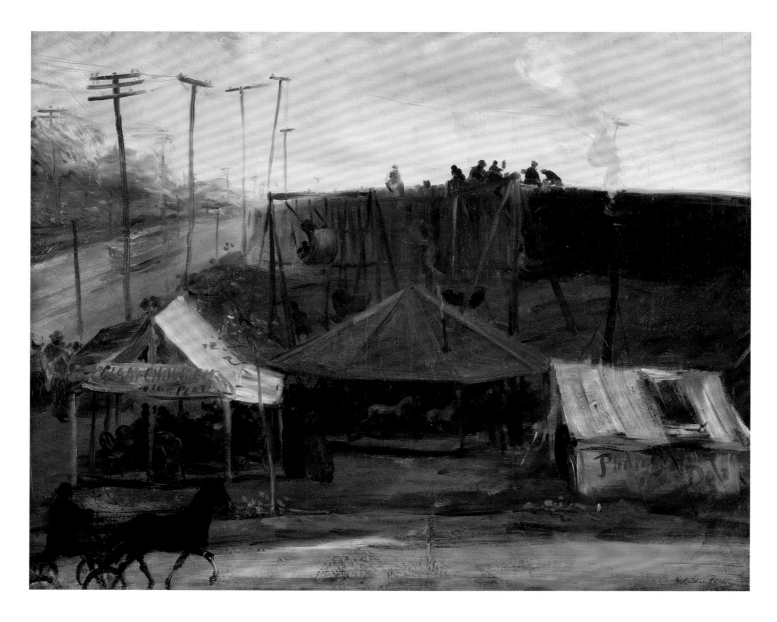

27

Outside the Guttenberg Race Track (New Jersey), 1897
Oil on canvas, 25½ × 32 (64.8 × 81.3)

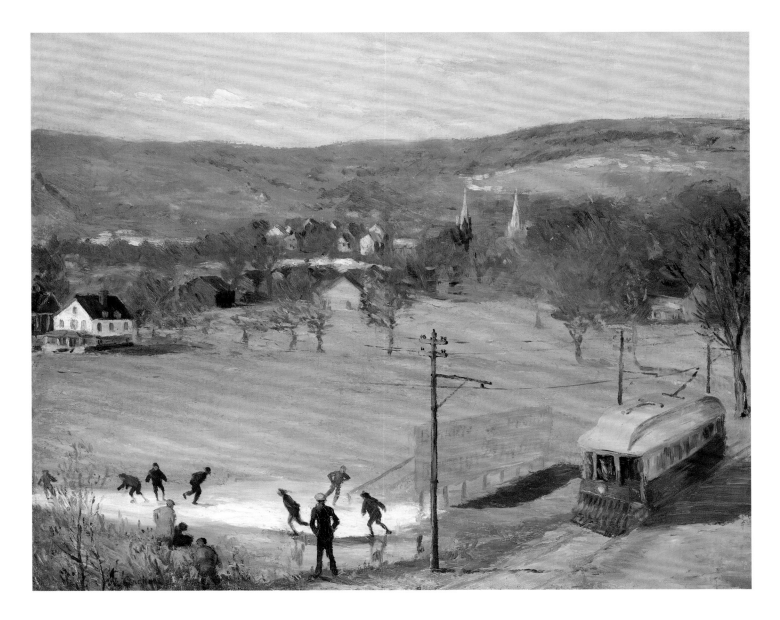

28

View of West Hartford, 1907
Oil on canvas, 26⅞ × 32¹⁄₁₆ (68.3 × 81.4)

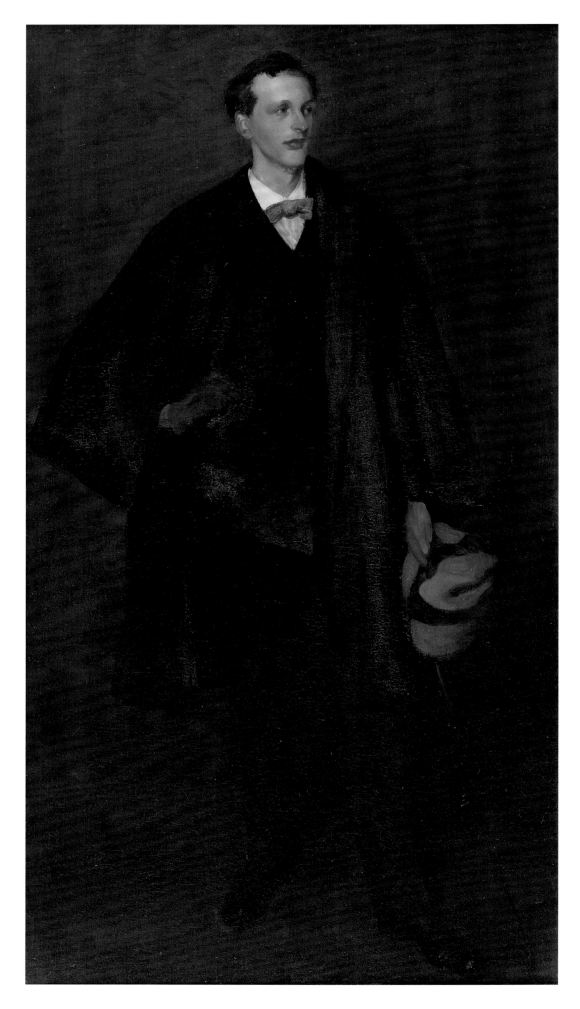

29

Portrait of Charles FitzGerald, 1903
Oil on canvas, 75 × 40
(190.5 × 101.6)

30

*Patrick Joseph went and bought himself
a grocery store on Monroe Street*, 1912
Ink and graphite on board, 22½ × 16¼ (57.2 × 41.3)

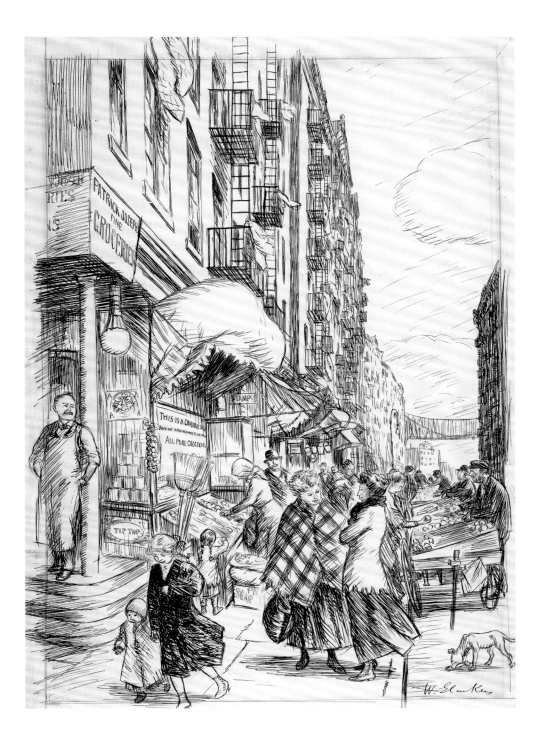

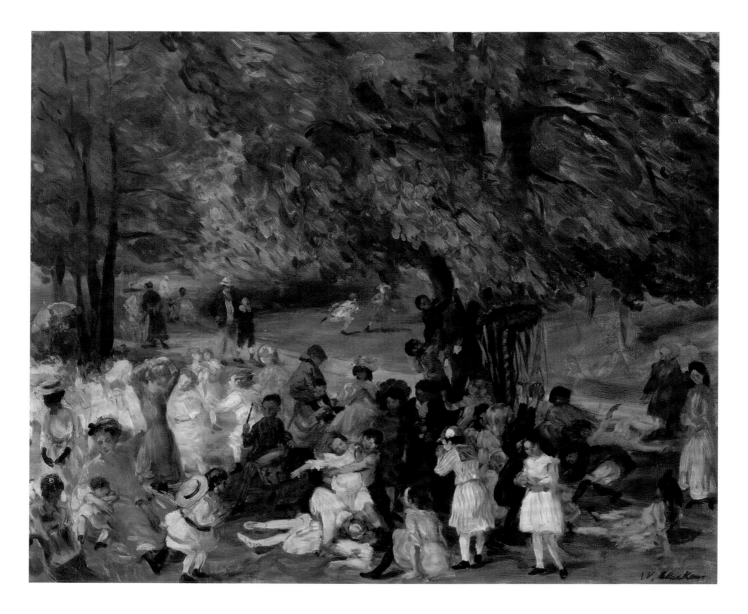

31

May Day, Central Park, c. 1904
Oil on canvas, 25⅛ × 34¼ (63.8 × 87)

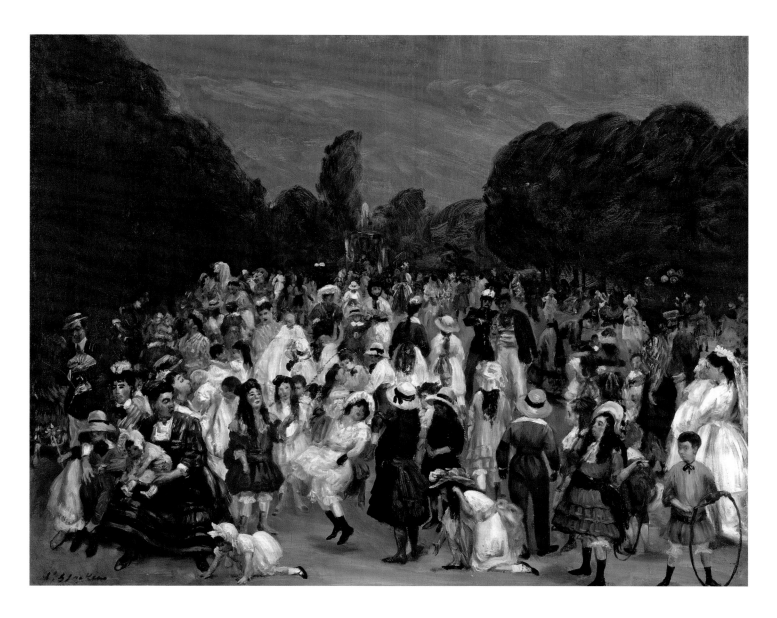

32

In the Buen Retiro, 1906
Oil on canvas, 25⅝ × 32¼ (65.1 × 81.9)

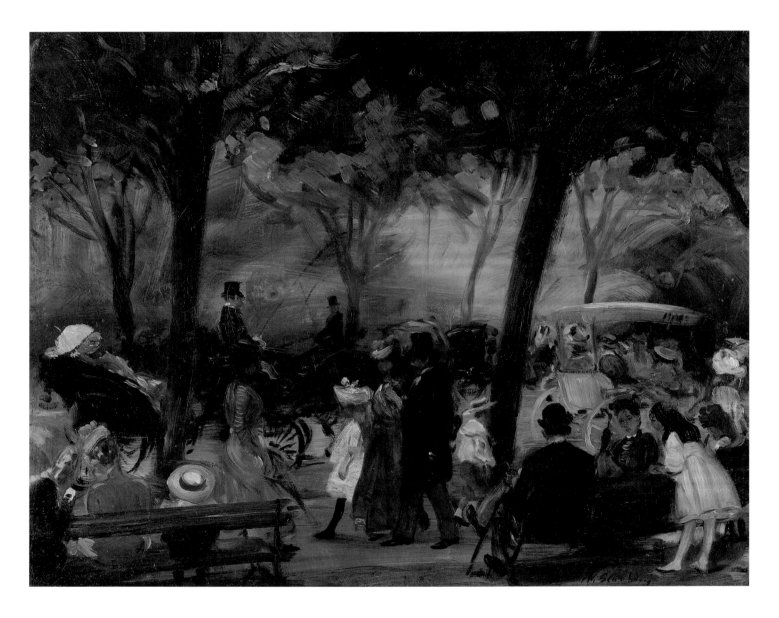

33

The Drive, Central Park, c. 1905
Oil on canvas, 25⅜ × 31⅞ (64.5 × 81)

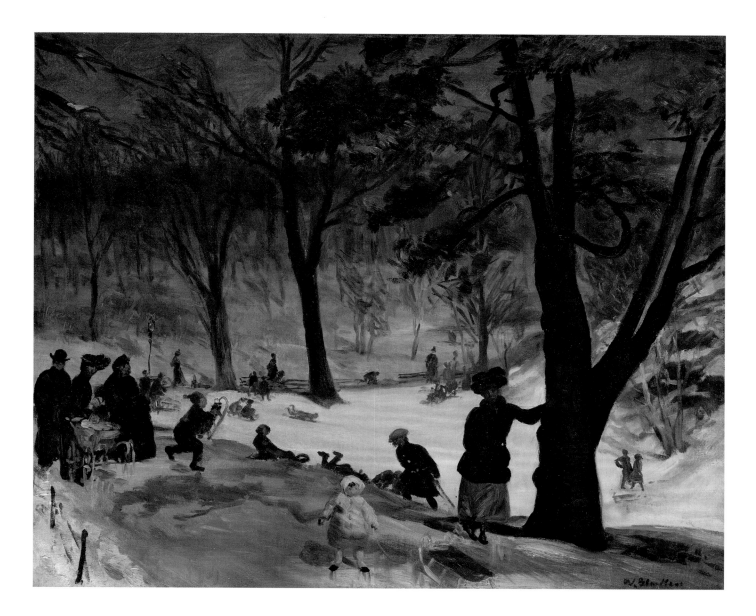

34

Central Park, Winter, c. 1905
Oil on canvas, 25 × 30 (63.5 × 76.2)

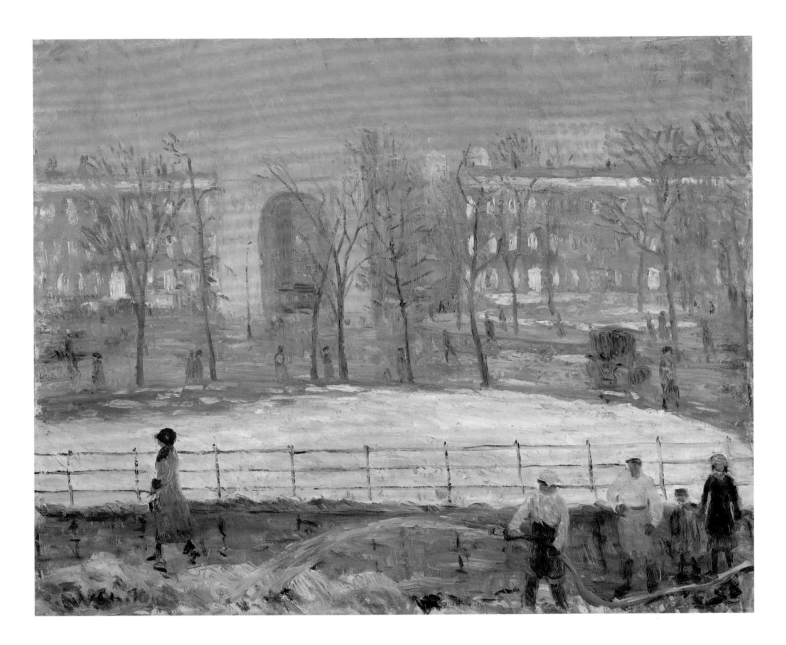

35

Street Cleaners, Washington Square, c. 1910
Oil on canvas, 25¼ × 30 (64.1 × 76.2)

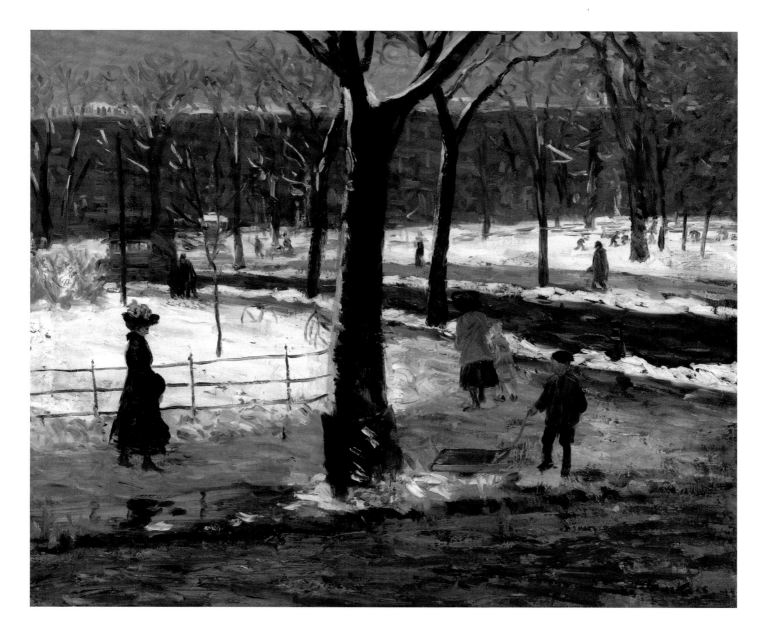

36

Washington Square, 1910
Oil on canvas, 25 × 30 (63.5 × 76.2)

37

The Green Car, 1910
Oil on canvas, 24 × 32 (61 × 81.3)

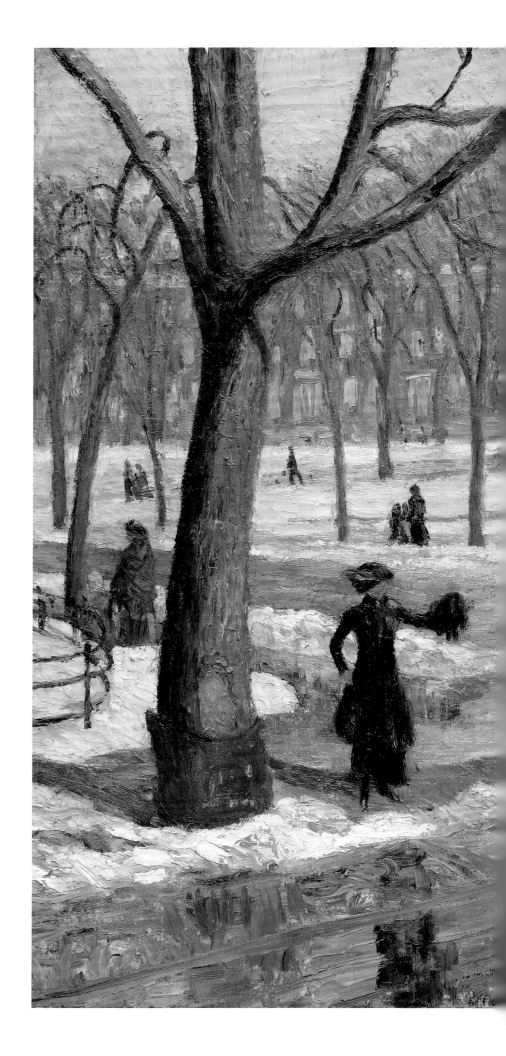

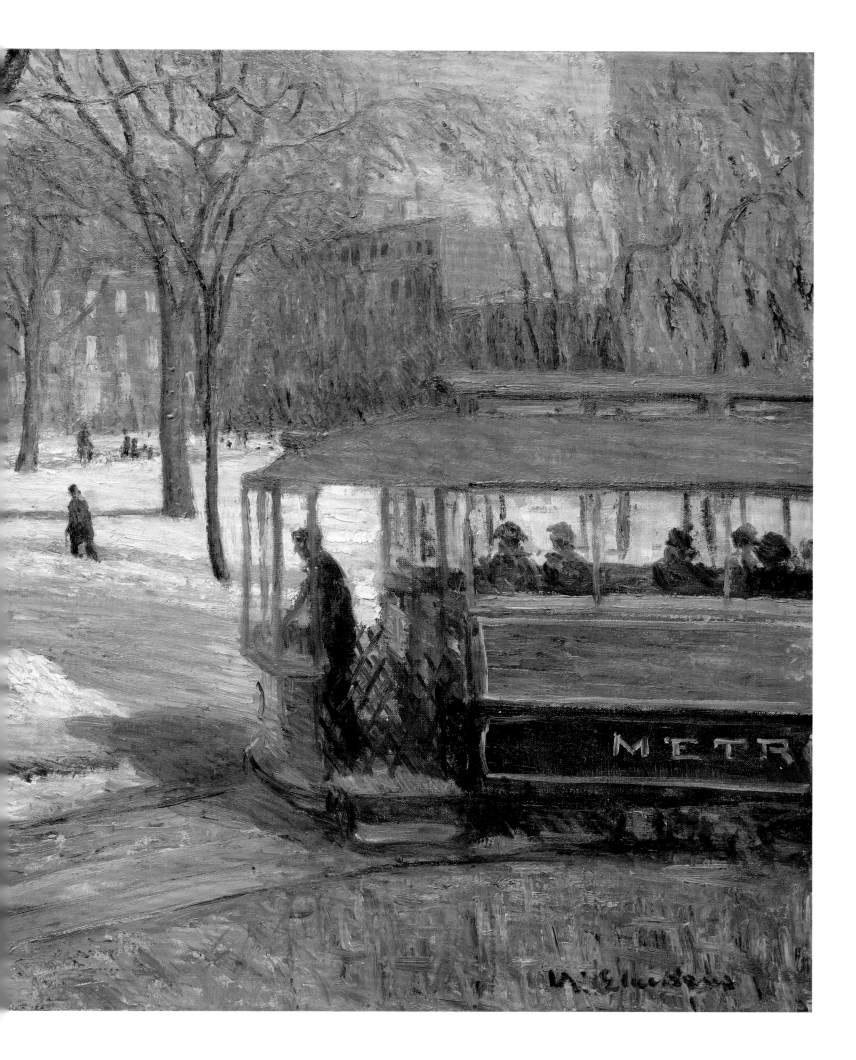

38

Vaudeville Team, c. 1908–1909
Oil on canvas, 48 × 36 (121.9 × 91.4)

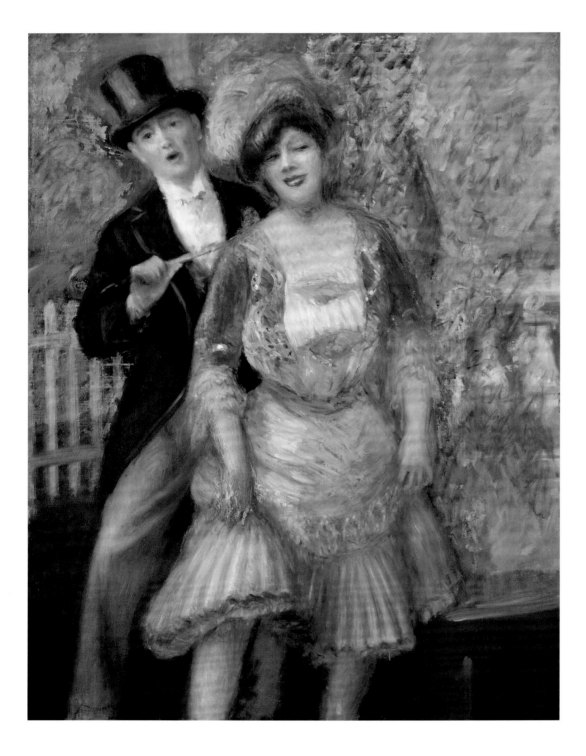

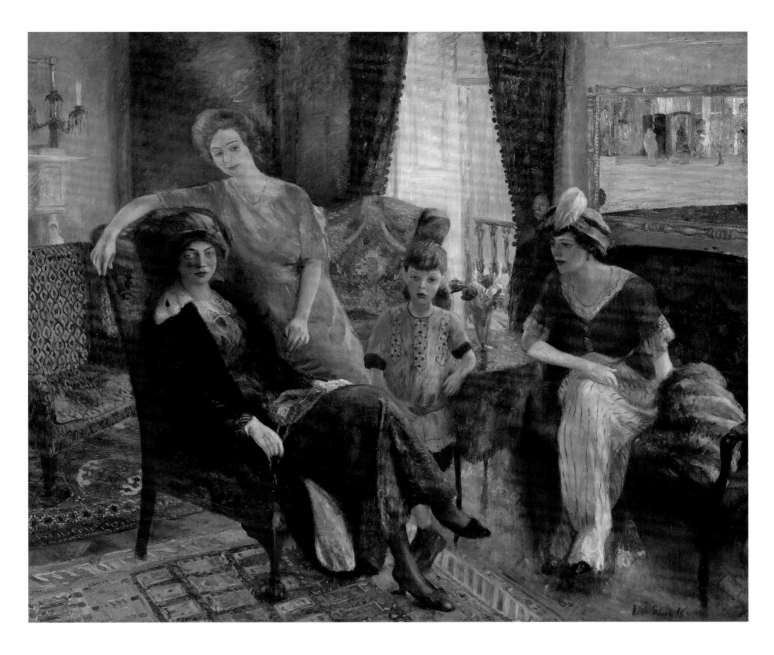

39

Family Group, 1910/1911
Oil on canvas, 71$\frac{15}{16}$ × 84 (182.8 × 213.3)

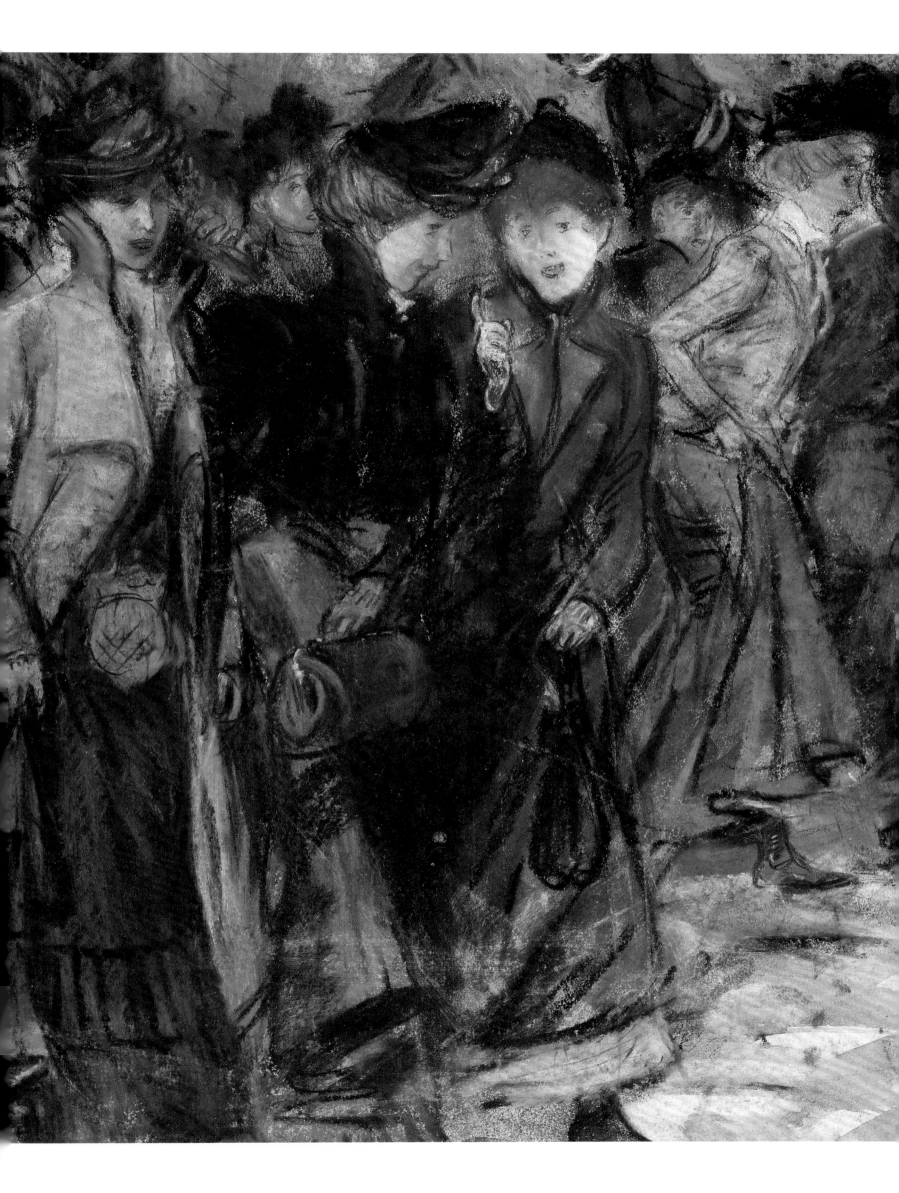

From the Stage to the Parlor: Glackens's Images of Women

CAROL TROYEN

"Started out for a walk and met Glackens," John Sloan wrote in his diary in July 1907. "He was going down to J. Moore's [James Moore, lawyer, restaurateur, and bon vivant], so at his invitation went down [and] met…three young ladies, perhaps, of the chorus girl type." On another occasion, Sloan described a dinner at the National Academy of Design that was attended by "many well dressed women, also many who looked like prosperous prostitutes, though I don't think that there were any of the actual demimonde there."[1] The intersection of bohemia and the demimonde, of artistic and polite society, to which Sloan alluded was increasingly apparent in New York at the turn of the twentieth century. Moral standards were in flux, and the role of women in particular—in the public sphere, the work force, and social encounters—was being redefined. As Sloan's professed inability to distinguish between women of the haute monde and well-dressed prostitutes attests, women's increasing independence and visibility often created social uncertainties.

Both William Glackens and Sloan supported voting rights for women. Unlike Sloan, however, Glackens was not socially committed, or at least he left no written evidence of active advocacy for women's causes.[2] But he was socially aware, and a number of his images reveal the complicated, often ambiguous, position of women in urban society. In 1904 he married the wealthy Edith Dimock and painted her frequently. Although in the paintings of Edith from this period Glackens did not refer to her career as an artist or her activity as a suffragist, he often alluded to the contradictions for women such as Edith—that is, independent-minded women of the upper middle class. By the 1910s and 1920s, however, a more hedonistic approach to picture-making supplanted the social awareness evident in Glackens's earlier work. These later pictures remained focused on women, especially Edith, but now women had become the vehicles through which he pursued his new interests in color, light, and intimate space. Both in his darker, more narrative works of contemporary life made after the turn of the century and in his later ones, dedicated to the exploration of formal issues, Glackens approached modernity through images of women.

As an illustrator for newspapers and popular magazines, Glackens was called upon to present a variety of female types. He drew pretty, idealized women, images that presented a cross between the "Gibson Girl" and the fresh-faced country lasses popular in art since Winslow Homer's day. He drew the New Woman, healthy, vivacious, and self-confident, engaging in newly popular and liberating sports (fig. 1). He illustrated courting couples and women wronged. He depicted spunky young women asserting their independence from both overprotective fathers and oversolicitous suitors.[3] In some of these pictures women are dependent; in others, they challenge Victorian mores. His illustrations were sometimes formulaic, as were the stories they accompanied. The images he produced for articles on city life provide a more nuanced view of the shifts in codes of public behavior.

A common topic at the turn of the century was the dramatic increase in new forms of popular entertainment. Various social and technological factors contributed to this development, for example increased leisure time and disposable income among the working and middle classes, and widespread electrification, which made city streets safe after dark. These changes affected women in particular. For the previous generation, it held true that "the unwritten constitution of the polite world…prescribes an early hour after which women shall not be seen unescorted on Broadway," but by the 1890s, well-lit streets and electrified trolleys made it possible for women to seek work beyond their own neighborhoods, to travel "alone…at night unmolested," and to enjoy the new pleasures of the city.[4]

Prime among those new pleasures was vaudeville, then in its heyday. By the 1890s, the proprietors of vaudeville had found a profitable niche between opera houses, catering to the wealthy, and concert saloons, appealing to rowdy lower-class men. Democratically priced and with both entertainers and audiences held to standards of propriety, vaudeville was pitched as family entertainment, appropriate for all. Women began to attend vaudeville performances unescorted, without fearing for their safety or their reputations.[5]

In illustrations for "The Vaudeville Theater" by Edwin Royle and "A Vaudeville Turn" by Cyrus Brady, Glackens demonstrates that by 1900 this new mobility was becoming the norm. His drawings of the audience show a number of women attending alone,[6] and his depictions of the performers—magicians, contortionists, singers, ethnic comedians—suggest little that might offend.

FIGURE 1
Bicycle Built for Two. From
*Lippincott's Monthly
Magazine,* August 1894

FIGURE 2
The Sherwood Sisters, 1901.
From *Scribner's Magazine*,
September 1901

FIGURE 3
Robert Henri. *Edith Dimock
Glackens*, 1902–1904.
Oil on canvas. Sheldon
Museum of Art, University
of Nebraska–Lincoln,
NAA–Gift of Miss Alice
Abel, Mr. and Mrs. Gene H.
Tallmann, The Abel
Foundation, and Mrs.
Olga N. Sheldon

1

3

2

Even the "Singing Soubrettes," saucy chorines in short skirts and low-cut bodices, appear perky, not salacious. In 1901, for another *Scribner's* article on vaudeville, Glackens reprised the "Singing Soubrettes" as *The Sherwood Sisters* (fig. 2). Showing three pretty dancers on stage, *The Sherwood Sisters* was a flirtatious allusion to three friends, aspiring artists who lived in the Sherwood Studios on West 57th Street: May Wilson, Louise Seyms, and Edith Dimock.[7] Presumably casting these women as cancan dancers was intended as a slightly naughty compliment and not a slur on their reputations, as it might have been a decade earlier.[8]

The year before he immortalized the "Sherwood Sisters," Glackens drew another vaudeville-themed picture, this time depicting patrons of one of the city's popular roof gardens. Roof gardens provided a breezy summer alternative to stifling hot theaters, a cooler and less formal setting for the variety acts normally staged indoors. In *A Summer-Night Relaxation*, accompanying the article "New York's Charm in Summer" (*Harper's Bazar*, August 18, 1900), Glackens focused on three members of the audience: two women and a man brought together for an evening's diversion. He then developed this vignette into *Hammerstein's Roof Garden* (plate 42), in which he expanded the view to take in more of the crowd, the stage, and, at the top of the image, the performer, a tightrope walker.

What began as a tightly composed illustration—the audience members and master of ceremonies arranged in a neat triangle—became an eccentric, disconcertingly scattered, tellingly modern painting. *Hammerstein's Roof Garden* is essentially monochromatic, punctuated by a few splashes of color. Glackens used staccato jabs of the brush to describe the lights surrounding the balcony, expressing both the excitement of the new electric city and the myriad sights and sounds raising the pulse of contemporary life. The space seems cavernous, unfocused, unmannered: the center is empty and Glackens has pushed the most interesting elements to the periphery. The performer, rendered with a few liquid strokes, both leads the viewer's eye out of the picture space and redirects attention downward, back to the group at the bottom of the composition. That group now consists of six people—five women and the same slightly bored, disgruntled man from the illustration. Their attitudes toward the performer and to one another appear odd, and the relationships among them are not clear.

Unlike indoor theaters, which had fixed seats, roof gardens were often furnished with café tables and moveable chairs. These allowed patrons to move closer together if they chose, or to shift their seats to better view the spectacle on stage or other audience members across the way. In *Hammerstein's Roof Garden*, neither the position of the chairs nor the body language of the patrons makes clear who came with whom, or who will leave unescorted.

The women may be entirely respectable, or they may be the "prosperous prostitutes" Sloan would write about: they wear form-fitting dresses that give no definite indication of social class. Some carry fans with which to cool themselves or to flirt. The woman at far right seems distracted; she sits stiffly erect, her hand resting nervously on the table. The casual, hand-on-hip pose of the central figure raises questions about her casualness in other things. As Glackens described it, the informality of a roof garden provided women new freedom to see and be seen and offered the exciting possibility of being seated next to anyone. But at the same time, he seems to be saying, a woman by herself in public is performing her own high-wire act, moving between independence and vulnerability, between propriety and risk.

While Glackens was painting *Hammerstein's Roof Garden*, he had begun to court Edith Dimock, who became his most frequent model. He was not the first to paint her—in 1902, his friend and mentor Robert Henri began a portrait of her. Over the next few years Henri would paint several other members of their social circle, including Glackens. Although the couple's portraits were the same size, they were different in expression: William's portrait is dramatic, the characterization forceful. The image of Edith, by contrast, reflects surprisingly patriarchal thinking.[9]

That portrait, completed in 1904 when Edith was about twenty-eight years old (fig. 3), shows Henri at his most Whistlerian. To emphasize her elegant, slender figure, she is posed in three-quarter view against a dark background. She wears a long, high-necked, off-white gown; her hands are clasped modestly before her. She seems younger and more vulnerable than her age, profession, and famously lively personality would suggest. The painting is not without its sensuous aspect—her innocence has its own allure—yet Edith is presented in the prevailing mode of depictions of young womanhood: graceful, demure, virginal, and removed from worldly concerns.

Shortly after their marriage, Glackens began his own portrait of his wife (plate 40), the same size as that by Henri and intended, perhaps, as the next chapter of her visual biography. By that time she had been living in New York for several years and was working as an artist; her family was broad-minded and supported her in a career choice unusual for a woman of her social class. Nonetheless, Glackens drew on portrait conventions designed to convey dignity, propriety, and prosperity, casting his wife in the role of a refined young matron. She is expensively dressed and is seated next to a mahogany tea table with a silver bowl of ripe fruit, items that are traditional emblems of a woman's wealth and fecundity[10] and that locate her firmly in a domestic sphere.

Edith is posed indoors, as though conversing with a friend over tea. Yet she is dressed to go out. She wears a traveling costume: an elaborate hat, kid gloves, and a jacket, possibly fur,

over a silk dress with full, pleated skirt. The outfit, bulky, fussy, and conservative, is not as flattering as the dress in Henri's portrait, and Edith does not seem entirely comfortable in it. Her expression, a half-smile, eyebrows arched, and head tilted, illustrates the sense of humor that had made her popular.[11] Her coy glance invites the viewer to share her enjoyment of the incongruities Glackens built into the portrait: she is shown "at home" yet dressed to go out; she is presented as a young matron despite living at a bohemian address and working as an artist.[12]

The portrait was not well received. According to Sloan, the first time Glackens tried to exhibit it, at the Society of American Artists' annual show in 1906, it "was rejected and [Henri, a member of the jury] made a big row in the jury room."[13] It was accepted at the annual exhibition of the Pennsylvania Academy of the Fine Arts the following year, though critics dismissed it as a joke, "an amusing caricature portrait…that cannot be taken seriously."[14] Compared to many of the portraits of women of Edith's social class in the Academy show, *Portrait of the Artist's Wife* must have appeared eccentric. One of those paintings, *Mrs. John Frederick Lewis* by Cecilia Beaux (fig. 4), also shows the sitter next to a mahogany table that displays luxurious domestic objects, but she exhibits a serious expression designed to underscore, not undermine, the painting's tokens of her pedigree. Glackens's portrait did find favor with one critic, the *New York Sun*'s James Huneker, who applauded it for being lifelike and lively:

> A living woman is built up before you, and the surfaces of her gown and coat are simply stunning in their actuality. The head is that of a quaint girl full of diabolic humor, kept well in hand but sizzling through the curiously shaped eye apertures.…His young lady is not pretty; he says so in his frankest brush terms. But she is better than pretty. She is full of character.[15]

Portrait of the Artist's Wife is at once true to life and a witty charade. Edith is shown both as the society matron she was meant to be and as playing the role of one while maintaining her distance. Her amused glance at the viewer acknowledges the contradictions between the behavior expected of her and her independent personality, between the strictures of her class and her identity as an artist and the wife of an artist.

In *The Shoppers* (see plate 75), another large-scale exhibition picture, Glackens again presented Edith playing the role of society matron. With her friends Florence Shinn (at far right) and Lillian Travis (seated at left) and an unidentified woman, she is shown in an upscale shop considering the purchase of a piece of lingerie. The painting was one of several of Glackens's depictions of shopping that reflected recent changes in New York's commercial

environment and their effect on women. Shopping had become a leisure-time activity, a way of socializing in public, and, for the moneyed classes, a way of displaying wealth. Fifth Avenue and especially Broadway between Astor Place and Madison Square (and later Herald Square) had become known as "Ladies' Mile,"[16] an area hosting an "endless procession of well-dressed handsome women."[17] Cars, buses, and trolleys made it easier for shoppers to travel to the new retail areas, as Glackens demonstrated in *Christmas Shoppers, Madison Square* (see plate 26). The growth of retail establishments created new jobs, many filled by young, ambitious, lower-middle and working-class women who for the first time found employment outside their own homes and neighborhoods. In the watercolor *Shop Girls* (plate 43), eager young women on their way to work fill the page, as Glackens must have imagined they filled the street, turning it into an all-female preserve. The only interloper is a man carrying a Christmas tree; he can barely shoulder his way through the bustling crowd. Glackens's shopgirls claim not only public space, but also new independence and a measure of economic self-sufficiency.[18]

For such young women, working in the shops also provided new possibilities for unchaperoned yet respectable engagements with men—engagements, as Glackens suggests in such illustrations as *With a brewery-driver's huge hand between her two slender ones*,[19] that could have romantic consequences. For wealthy women, by contrast, the proliferation of shops offered new diversions and new opportunities to be out in public, as well as new ways to demonstrate social superiority (as in Glackens's *At the Milliner's*, undated, The Metropolitan Museum of Art).

The Shoppers is Glackens's most ambitious exploration of this theme. He creates a complex tableau of well-dressed women entertaining themselves on a shopping expedition. He places his wife in the center of a shallow space and crowds the other figures around her.[20] It is a consumerist set piece: Edith and her friends act out the ritual of choosing intimate garments, a wholly feminine pursuit. Shopping together illustrates a new engagement with urban life,[21] yet the setting itself, an intimate, sheltering space dominated by women, parallels the genteel confinement of their own parlors.

Each woman has her role to play. The shopgirl hesitates respectfully as she proffers a garment. Edith's pose and especially her expression seem almost a caricature of patrician hauteur. The tilt of Lillian's head suggests her thoughtful consideration of the item being examined; the veiled figure remains in the wings. The women—all handsome and refined—attract the viewer's attention just as the lingerie attracts theirs. They are both looking and looked upon. Only Florence breaks character and glances out of the picture, her gaze almost a reprimand for the viewer's invasion of this "Adamless Eden."[22]

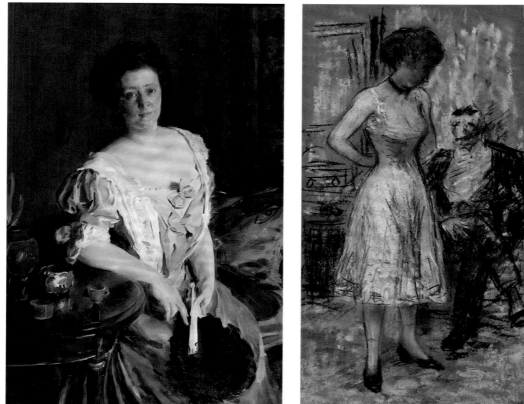

4 5

FIGURE 4
Cecilia Beaux. *Mrs. John Frederick Lewis*, 1906. Oil on canvas. Pennsylvania Academy of the Fine Arts, Philadelphia, Gift of Alfred Baker Lewis

FIGURE 5
Interior, 1899. Pastel. New Britain Museum of American Art, New Britain, Connecticut

FIGURE 6
George Luks. *Café Francis*, 1906. Oil on canvas. Collection of The Butler Institute of American Art, Youngstown, Ohio

6

When *The Shoppers* appeared in the exhibition of The Eight in 1908, Huneker applauded it as "contemporary with a vengeance,"[23] a phrase he could have applied equally to *At Mouquin's* (plate 45), another of Glackens's submissions to the show. In that painting, Glackens described an evening at the popular restaurant, posing members of his circle as the diners: James Moore, a notorious man-about-town; Jeanne Louise Mouquin (wife of the restaurant's proprietor) as his companion;[24] Edith Glackens, whose head appears between theirs in the mirror behind them; and, in conversation with Edith, Charles FitzGerald, a sympathetic critic and the Glackenses's future brother-in-law.

Mouquin's, at Sixth Avenue and 28th Street, had a varied clientele: writers, artists (a number of whom, such as Glackens, with studios in the neighborhood), middle-class theatergoers, and a smattering of society types. An evening there was compared to "taking a trip to Paris"[25] — presumably not only because of the food and decor, but also because of the thrill from exposure to the relaxed moral codes often associated with Paris. Moore was the focus of bohemian social life for Glackens, Sloan, and their circle, and was known for squiring around town attractive young women — "daughters" — to whom he was not related.[26] He was thus the ideal model for Glackens's rendering of what Huneker would call "the moment of liqueurs and soft asides."[27]

Glackens was fascinated by the transactions that took place under the guise of social encounters. In some cases, he portrays those transactions as explicit: in *Graft* (plate 44), for example, an imperious woman, presumably a madam, pays off a man — perhaps a backer or procurer — in the parlor of her establishment. In *Interior* (fig. 5), among the most disturbing of these images, a young woman is on private display, undressing before a ghoulish-looking man in formal attire. *Seated Actress with Mirror* (see plate 76) shows a woman, scantily clad, hearing the entreaties of an earnest young man. The connection between them is not clear — is he proposing a transaction or professing love?[28] — but either way, the woman appears to have the upper hand.

The aura of dissolution, the ambiguous exchange, and the frisson of crossing boundaries implied in these pictures are all found in *At Mouquin's*. Unlike his friend George Luks's portrait of Moore and a "daughter" (fig. 6), which has all the psychological subtlety of a leer, Glackens's painting implies a mere whiff of decadence in the contrast between the woman's bored expression and Moore's solicitous one, between his thick hand raising his drink while her pale slender fingers toy with her glass. The picture's message is further complicated by the "daughter's" uncertain identity and social position: as most of bohemia would have realized, a respectable woman was posing as something she was not. This play-acting, with its potential for miscues,

mirrored contemporary situations. "The way women dress today they all look like prostitutes,"[29] a waiter would testify in a vice investigation of a similar establishment. Some society women took pleasure in spending "reckless evenings in haunts where [they] thrilled with simple glee at the thought of what [they] must so obviously be 'taken for.'"[30] Glackens's painting alludes to the shifting standards of identity and propriety that made modern life both more complicated and more exciting.

Edith Glackens straddled the worlds of the upper middle class and the genteel bohemian. She frequently went to Mouquin's, fully aware of, and presumably more amused than offended by, Moore's peccadilloes. Glackens kept her apprised of the raffish goings-on at Moore's when she was out of town ("James Moore gave a party last night. There was quite a raft of men, no daughters"[31]). By juxtaposing her head with those of Moore and his companion, Glackens suggests the increasing fluidity in the social life of women of her class, who had begun to push against the boundaries of respectability by attending the theaters, cafés, and restaurants also frequented by more questionable company.

Nine years after *At Mouquin's*, Glackens produced another painting on the subject of café society, a remake of sorts, in which he focused even more intently on a young woman. In *Café Lafayette (Portrait of Kay Laurell)* (plate 46) he posed his sitter, a model, vaudevillian, and briefly the sensation of the Ziegfeld Follies, at a table in the café of the Hotel Lafayette.[32] As Mouquin's had been, the Café Lafayette was a popular hangout for artists and writers, many of whom, like Glackens, lived in the neighborhood. The ambience is familiar: small tables, sparkling drinks, lightweight chairs that can easily be shifted to accommodate new guests, and a mirror that reveals the bustling sociability of the scene.

Once again, Glackens's subject is a woman of indeterminate social position. She is informally dressed and her pale skin is dramatically set off by her makeup. Although wearing makeup in public, taboo in the Victorian era, had recently become more accepted, the brightness of Laurell's cheeks and lips is just beyond the limits of good taste.[33] She gazes out of the scene, seemingly not at the viewer but past him; a sense of dangerous possibility is in the air. As in *At Mouquin's*, there is no resolution, only ambivalence. The viewer regards the scene with a sense of social superiority mingled with fascination.

In 1910, Glackens helped organize the "Exhibition of Independent Artists," a huge unjuried show. He contributed eight works, including *Girl with Apple* (plate 50), a large painting of a reclining nude. In choosing to display a nude, Glackens deviated from the practice of many of his realist colleagues, who avoided the subject for major exhibition pictures because they

felt it smacked of academicism. At the same time, he was aware of the recent upheaval over Henri's painting *Salome*, 1909 (John and Mable Ringling Museum of Art, Sarasota, Florida), and the campaign to remove paintings of nudes and other "pernicious subjects" from art exhibitions.[34] Glackens's *Girl with Apple* was not seen as especially provocative, but it was a salvo against prudery and censorship nonetheless.

Glackens made several small preparatory sketches for *Girl with Apple* in pencil, pastel, and oil;[35] he also produced a large-scale alternate version of the subject the same year. In *Woman Sleeping* (fig. 7), he created a more naturalistic and voluptuous figure, one that displays a vivid sense of physical presence. That painting is more contemporary, yet thematically less complex, than *Girl with Apple*, in which Glackens claims a connection to both tradition and modernity, to old masters and recent French art. His template for *Girl with Apple*, as has often been noted, was Édouard Manet's *Olympia*, 1863 (Musée d'Orsay, Paris), which presented a contemporary prostitute in the guise of a reclining Venus that recalled paintings by Titian and other masters of the past. But even as Glackens drew on a prefabricated solution to the problem of refreshing an overdone subject, he made it his own by adding domestic touches. Along with details appropriated from Manet that locate the woman on the edge of polite society, he included homey props recognizable from his other paintings—the camelback sofa, the large, old-fashioned hat, one of his own seascapes hanging on the wall[36]—for a thoroughly middle-class setting. Glackens's studio model is presented as a modern-day Eve, apple in her hand and confident of her seductive powers. This intersection of the domestic and the erotic is a variation on Glackens's familiar theme, the interface of the bourgeois and the demimonde.

By the time he began working on *Girl with Apple*, Glackens's style had begun to change. His move to brighter, warmer colors, use of shallow space, and emphasis on pattern are all apparent here. Glackens was by nature a sensualist; the expression of this trait in paint would have found reinforcement in the modern and avant-garde work then beginning to be seen in New York. His interest in pursuing a brighter, less narrative, more modern style was given further impetus by a trip to France in 1912 and his immersion in the art of Pierre-Auguste Renoir. From this point, nudes became an increasingly significant part of his repertoire. At his solo exhibition at New York's Folsom Gallery in 1913, he showed eighteen pictures of which at least five were nudes. A critic recognized the new sensuality in his work: "There is something monumental in his nudes, a bigness, a solidity, a sound firmness of flesh.... No one gives us quite this sense of physical exhilaration and health."[37] Glackens's palette had become bolder and he was increasingly absorbed with painting light. His interest

in describing social and cultural situations had waned in favor of a more hedonistic approach.

Also by this time, adult men had ceased to play starring roles in his paintings. Even popular crowd scenes were dominated by women and children. He also painted many studies of individual women, both as portraits and as types.[38] Most are naturalistic, showing women in contemporary dress (see plate 78), but some of the pictures reflect a tradition of romantic fantasy with exotic costumes or surroundings (see plates 80, 81). As time went on, Glackens's figures, whether nude or clothed, became less and less specific, less rooted in the present. *Back of Nude* (plate 49), for example, has no setting, no studio props or furnishings, no drapery or discarded clothing, no facial features: it is simply a nude figure seen from the back against a generalized red ground. The silver bracelet on her arm is the only touch of contemporaneity, a personal note in a richly colored, sensuously painted, timeless image more evocative of Peter Paul Rubens and Titian (as well as Renoir) than of 1930s America. Glackens's earlier paintings were marked by a keen social awareness, and in particular by sensitivity to the complexities of changing roles and standards for women. By the early 1910s, this acuity gave way to the pursuit of visual pleasure.

Between about 1910 and 1925, Glackens painted a number of domestic genre scenes featuring his own family. His images of Edith in these pictures are strikingly different from his earlier representations of her (plate 75). He no longer showed her in public spaces. Instead, she is always at home: in their various Greenwich Village apartments, at her parents' home in Hartford, at their vacation houses.[39] She is always with her family—there is no successor to the 1904 portrait in which she is represented life-size and alone.

These scenes take place in cozy, warmly lit interiors; the space is compressed, and especially in paintings such as *The Conservatory*, c. 1917 (Museum of Art, Fort Lauderdale), and *The Artist's Wife Knitting* (fig. 8), Glackens's feathery brushwork contributes to the tapestry-like effect. The tonalities he uses for the figures correspond to those in the background, and the generalized atmosphere of peaceful domesticity becomes the subject of the painting.

In most of these works, Edith no longer exhibits her lively personality or seems to have much individuality at all: she is now part of the decorative intimacy of the space. Even in an image such as *Artist's Wife and Son* (see plate 77), which celebrates maternal solicitude, Edith's and Ira's identities are subsumed into the modern spirit of the picture. In her "zebra dress,"[40] whose white stripes are tinged with the red and blue tones of the surrounding furniture, Edith seems part of the relentless patterning and crowded space of the picture. Her arms around

9

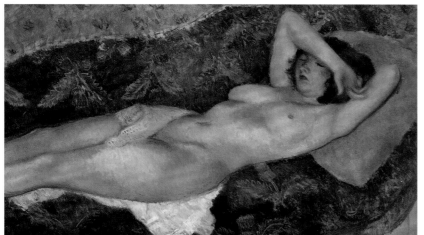

7

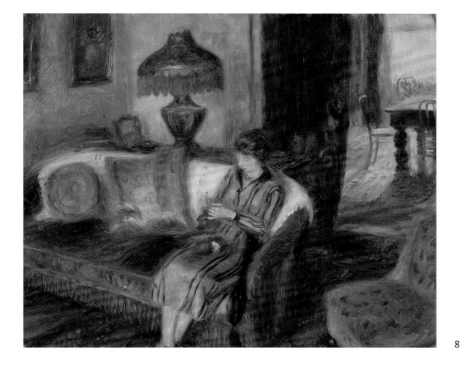

8

young Ira barely separate him from the pile of drapery and cushions behind. By blending figures and setting to create a flat, animated, even vaguely anxious surface, Glackens pushes his sentimental subject toward a modernist expression.

The most ambitious of Glackens's domestic genre scenes is the earliest, *Family Group* (see plate 39). A large, impressive painting, it provides a bridge between the pictures Glackens thought of as character studies and his developing, formally oriented, intimist style. *Family Group* shows Edith, four-year-old Ira, Edith's sister Irene Dimock at left, and Grace Morgan, a family friend, at right, in the Glackenses's apartment at 23 Fifth Avenue. Glackens may have been inspired to attempt an interior group portrait of this scale and complexity after seeing Renoir's *Madame Georges Charpentier and Her Children*, recently acquired by the Metropolitan Museum of Art. As Renoir had in that portrait, Glackens lavished attention on the wealth of accessories in the room: boldly colored, richly patterned rugs and furnishings, fringed drapes, a candelabrum on the mantel, a vase of flowers, and his own paintings and mirrors on the wall. Mirrors were among Glackens's favorite pictorial devices; he used them to reveal tête-à-têtes or reflect fashionable public bustle. Here they underscore the lush elegance of the interior. The women also appear as handsome appointments, wearing opulent clothes in the new, less restrictive styles that grew out of the feminist movement.[41]

The key figure in this painting is, surprisingly, not Edith but Irene. Her expression seems somewhat strained and her pose listless. The other women attend to her — Grace Morgan leans forward, attempting to engage her, while Edith places her arm on Irene's chair in a protective gesture (rather than around her son, who appears isolated in this sea of women). Irene at this time was deeply engaged with women's suffrage; John Sloan described her as "a very beautiful big healthy girl, very modern, a free woman in her ideas...."[42] Instead, Glackens presents her as a vulnerable personality; she adds a wistful note to an otherwise idyllic scene. *Family Group* showcases Glackens's love of sun, pattern, and bold color. It celebrates the material comforts of contemporary bourgeois life, while at the same time presenting an intriguing psychological study.

Family Group made its debut at the Armory Show, where Edith (exhibiting as Edith Dimock) was represented by eight watercolors. She had participated in the "Exhibition of Independent Artists" in 1910 and continued painting through the next two decades. She was a member of the Whitney Studio Club and had a solo show there in 1928. She and Glackens moved through the art world of the period as a couple,[43] yet none of his paintings of her alludes to her continuing career as an artist. This decision, in which Edith presumably was complicit, was not unusual among their circle: George Bellows, for example, painted his wife Emma many times, but always in a domestic setting, although she, too, had trained as an artist.[44]

It seems that Glackens's images of his wife became more conventional as his life became more conventionally, contentedly domestic. In the early years of their marriage, Glackens's portraits of Edith alluded to her "diabolical humor" or her patrician elegance and command, yet once the couple left their raffish artistic neighborhood and settled into increasingly luxurious apartments, her smiles become gentler and her sphere more unequivocally refined (see plates 41, 47). Once the focus of acute observations on the changing role of women in bourgeois society, Edith now becomes the center of a domestic idyll, filled with comfort and visual pleasure.

Much of Glackens's early work documents the roles of women in contemporary life and complements his friend Sloan's images of working-class women. His paintings from the 1910s and 1920s often pay homage to Renoir and parallel the experiments of Renoir's pictorial descendants such as Pierre Bonnard and Henri Matisse.[45] Glackens's images were not as radical, but they exhibit a similar love of light, color, and pattern, and a similarly intimate approach to painting women.

These concerns would come together in *The Soda Fountain* (see plate 82), Glackens's last great figure painting and one that combines the acute sensibility of his early café scenes and his continuing engagement with the sensuous painting of color and light. In *The Soda Fountain* Glackens revisits the dense, shallow spaces of *At Mouquin's* and *Café Lafayette*. Polished coffee urns have replaced mirrors, sundaes and sodas take the place of cocktails, actresses and "daughters" are now independent working girls. The picture space is crowded and flattened and is animated by repeating shapes (the bottles on the shelf, the rings of oranges and lemons, the buttons on the cash register). *The Soda Fountain* could be a scene from the movies: Glackens's warm, blended colors and loose brushwork suggest cinematic soft focus. At the same time, the subject parallels contemporary imagery by Edward Hopper (fig. 9), as well as by Reginald Marsh, Kenneth Hayes Miller, and others of the Fourteenth Street School. Although Glackens the epicure and cosmopolite may have privately mourned the demise of late night bird-and-bottle suppers in chic cafés and their replacement with chicken sandwiches from the counter, in *The Soda Fountain* he captured a truth of post-Prohibition America, one he portrayed perceptively and sympathetically. Here, too, Glackens approached modernity through his sensuous representation of women: they sit at the counter, one posed pertly on her stool, the other, with a sultry expression and dabbing at her lips with a napkin, just waiting to be discovered.

For notes, see pages 241–242.

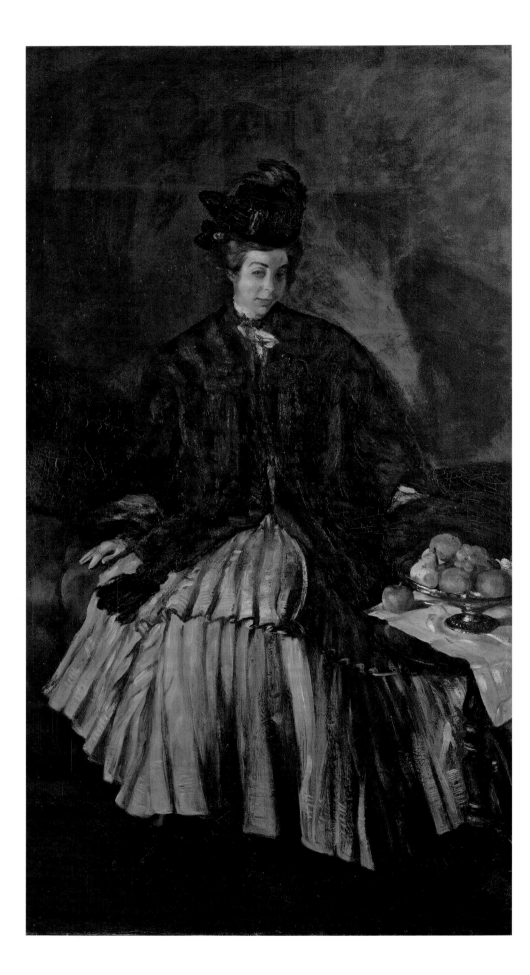

40

Portrait of the Artist's Wife, 1904
Oil on canvas, 73¾ × 40 (189.9 × 101.6)

41

Portrait of Edith, c. 1925
Pastel, 10 × 7¼ (25.4 × 18.4)

Hammerstein's Roof Garden, c. 1901
Oil on canvas, 30 × 25 (76.2 × 63.5)

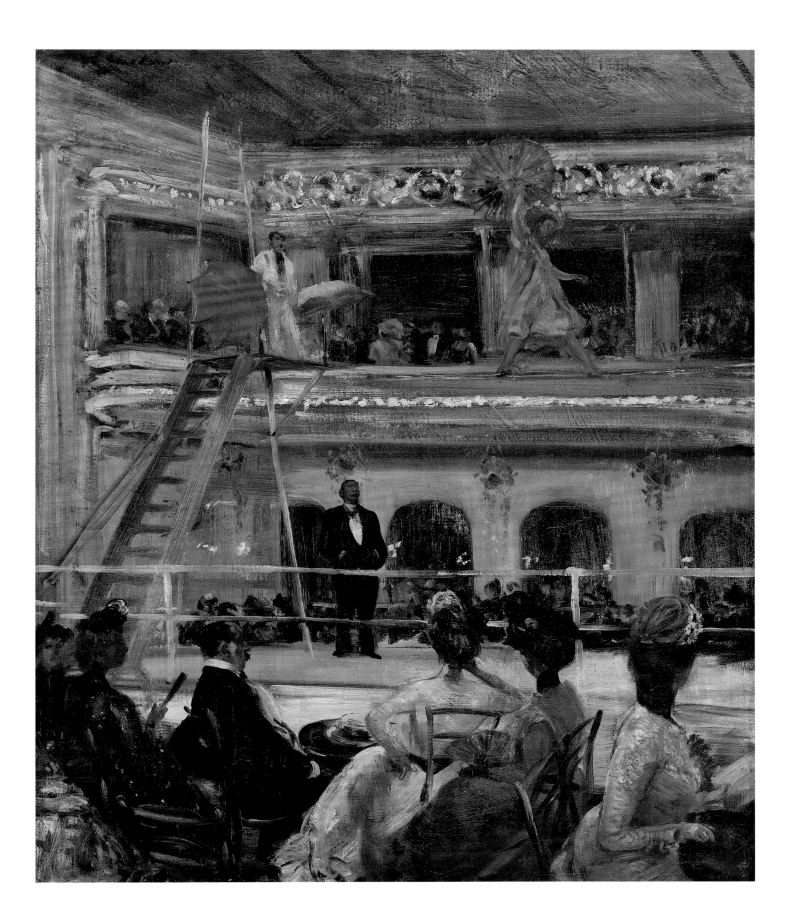

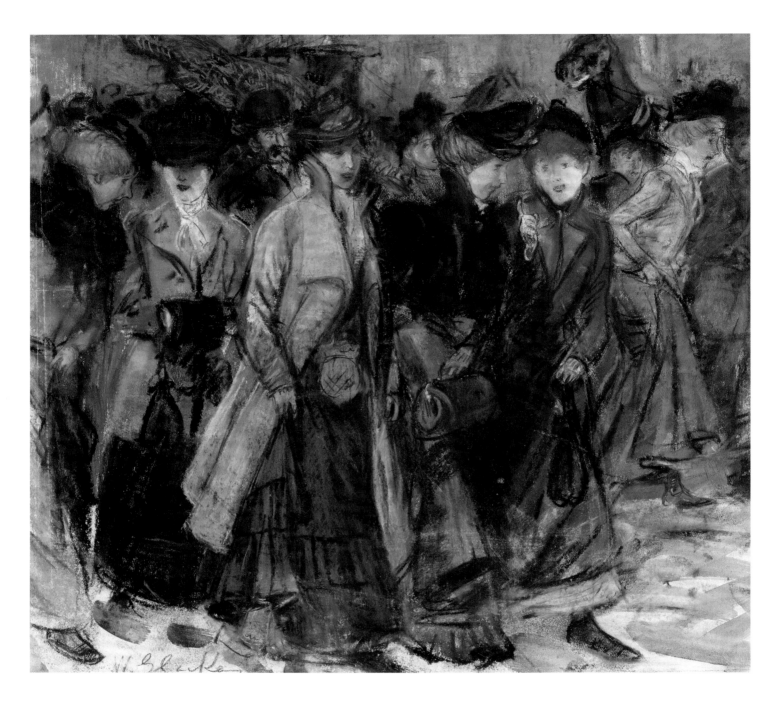

43

Shop Girls, c. 1900
Pastel and watercolor on illustration board, 13⅝ × 14⅜ (34.6 × 36.5)

44

Graft, 1903
Colored pastel, 10 × 8 (25.4 × 20.3)

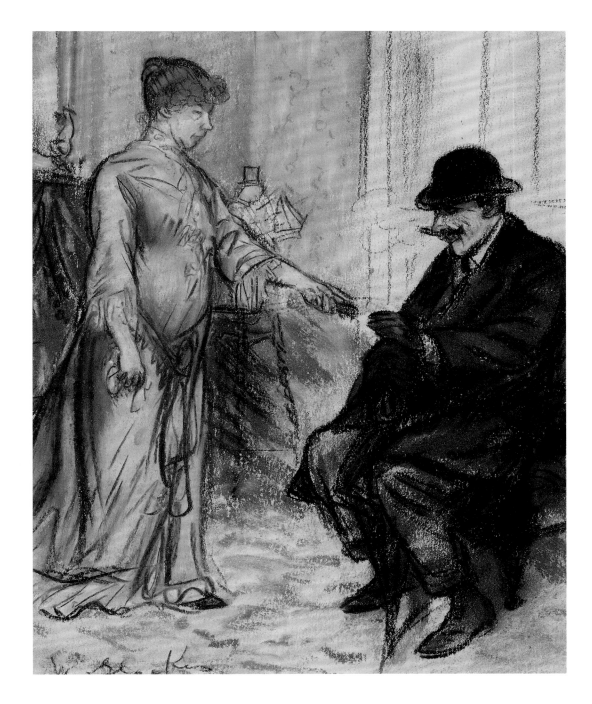

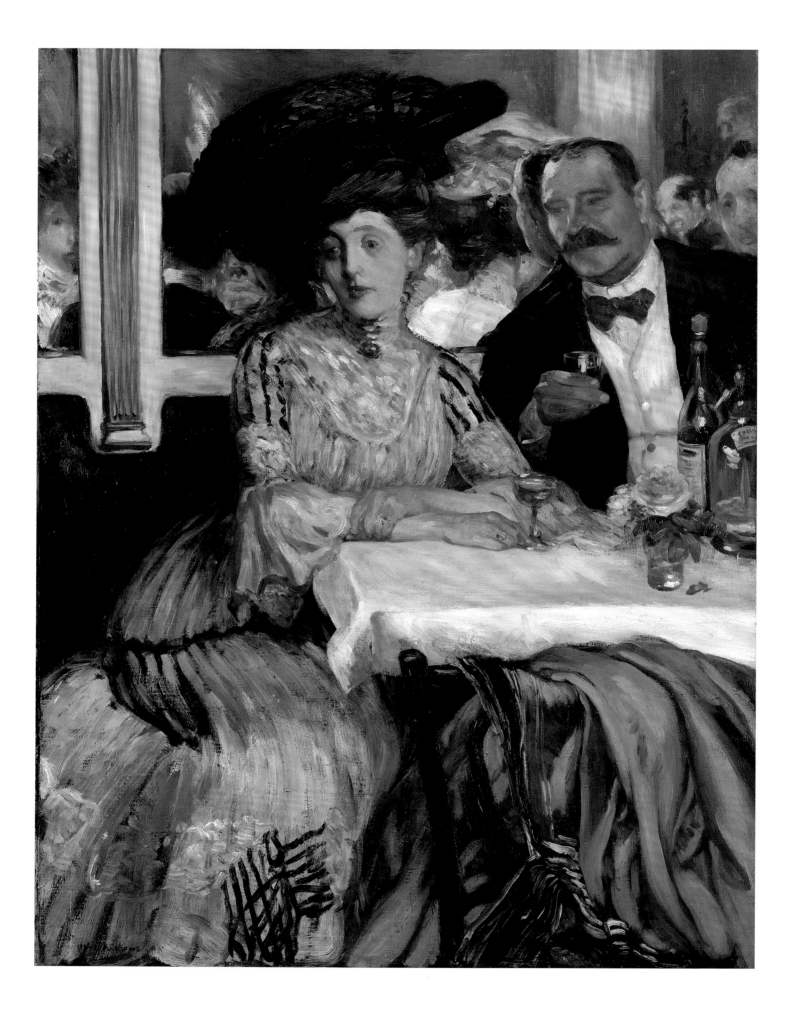

At Mouquin's, 1905
Oil on canvas, 48⅛ × 36¼ (122.4 × 92.1)

46

Café Lafayette (Portrait of Kay Laurell), 1914
Oil on canvas, 31¾ × 26 (80.7 × 66)

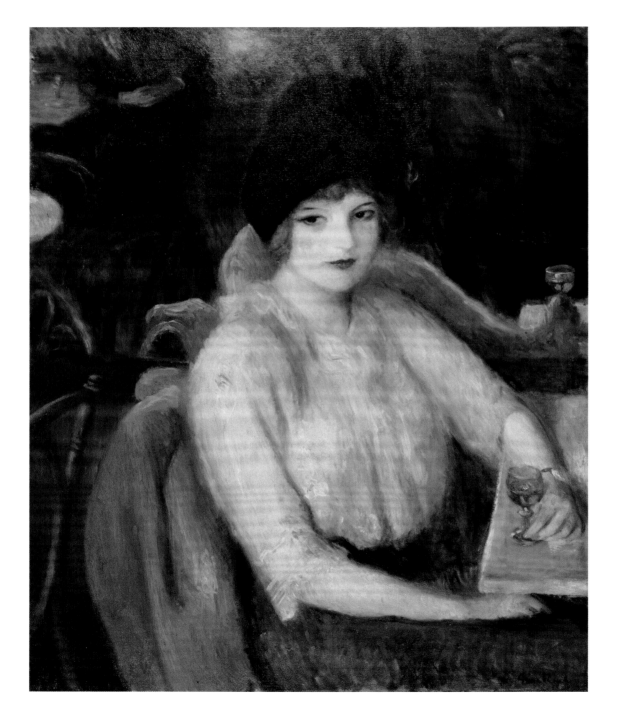

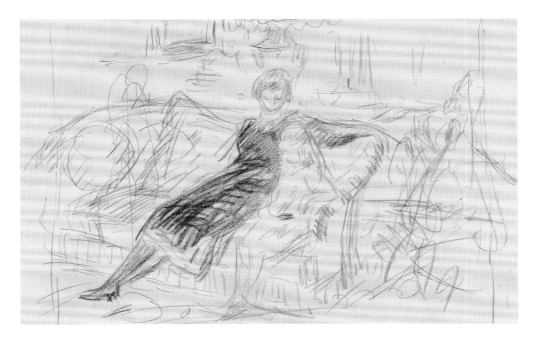

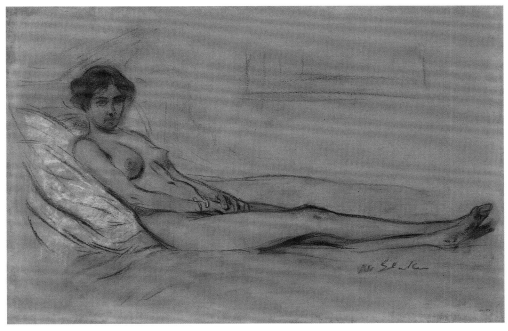

47, 48

Woman on a Sofa, c. 1920
Graphite and charcoal, 7⅞ × 4¾ (20 × 12.1)

Reclining Female Nude, c. 1910
Sanguine and blue pastels, chalk on gray paper, laid down, 10¹¹⁄₁₆ × 15¾ (27.2 × 40)

49

Back of Nude, c. 1930s
Oil on canvas, 30 × 25 (76.2 × 63.5)

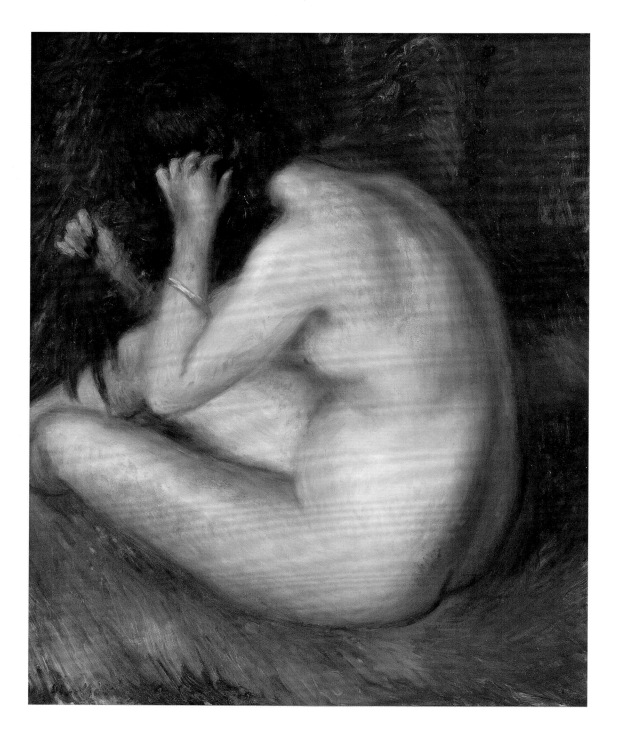

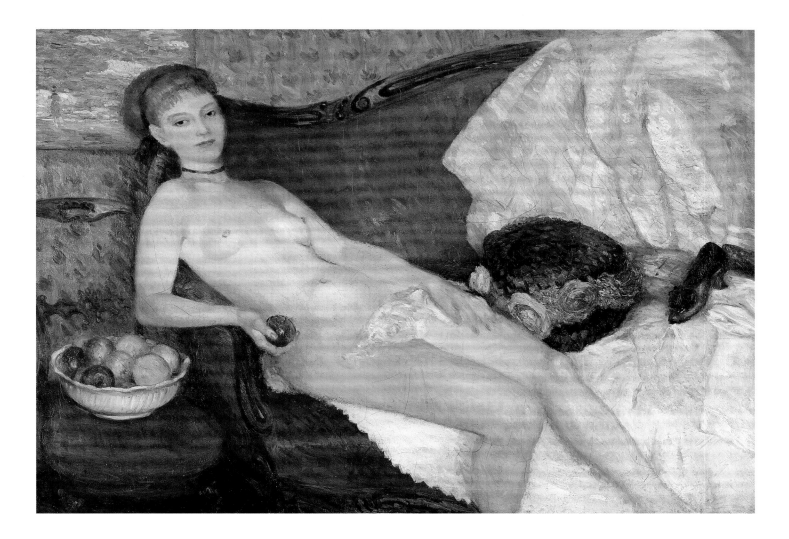

50

Girl with Apple, 1909 – 1910
Oil on canvas, 39⁷⁄₁₆ × 56³⁄₁₆ (100.2 × 142.7)

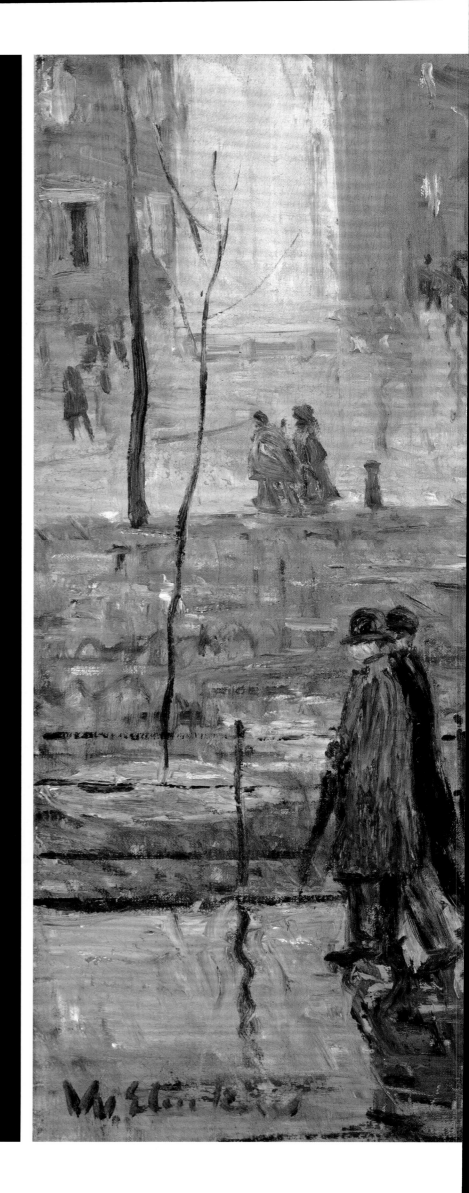

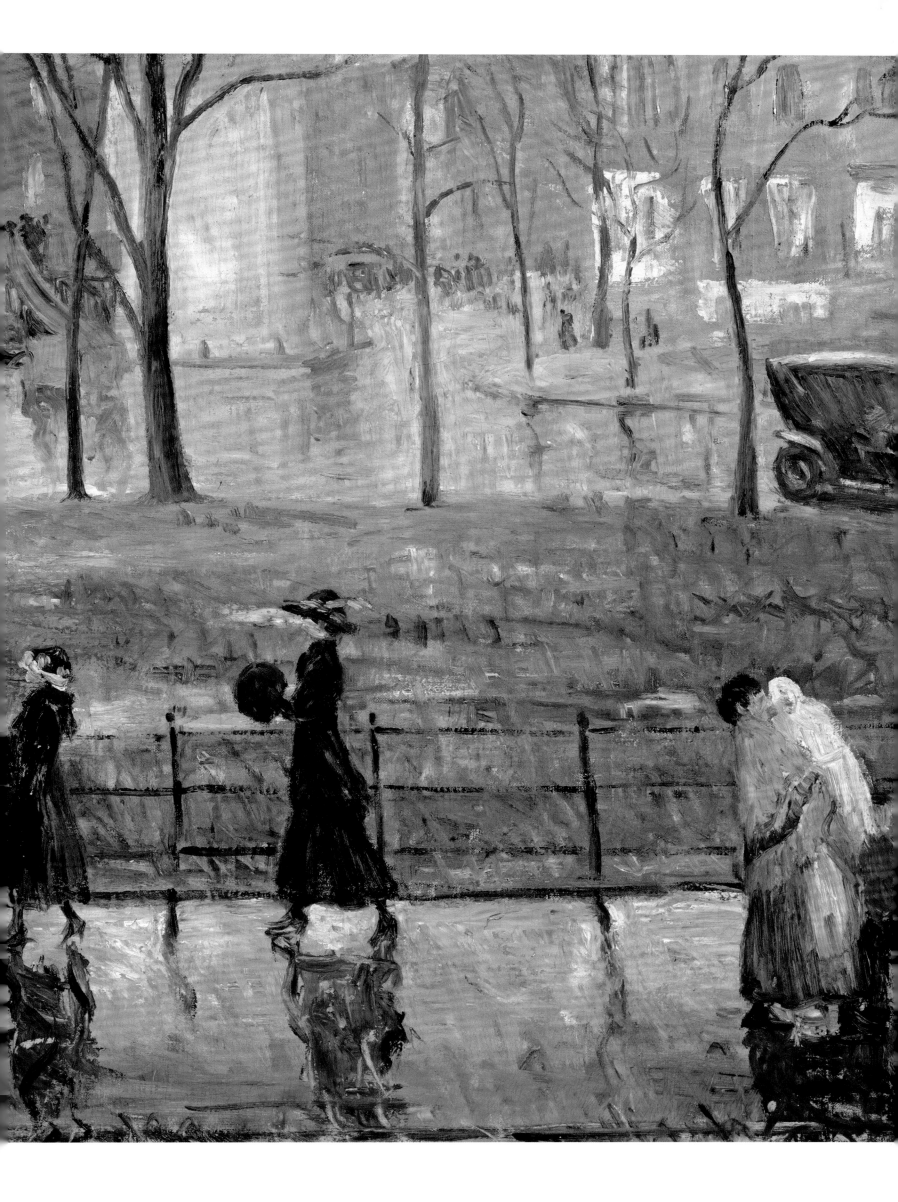

William Glackens: "Intensely Sincere and Intensely Brave"

JUDITH F. DOLKART

Recently reacquainted with his Central High School chum William J. Glackens (fig. 1), Philadelphia pharmaceuticals entrepreneur Albert C. Barnes wrote to the painter in January 1912, "Dear Butts: I want to buy some good modern paintings. Can I see you on Tuesday next in New York to talk to you about it?"[1] Perhaps Barnes was bored with buying horses for the hunt, a pastime of the Main Line town to which he had moved in 1905. Restless, intellectually curious, and flush with his Argyrol fortune, Barnes engaged Glackens in discussions of contemporary art and visited artists' studios with him.[2] His friend's exhibition history had by then established a reputation for independence and innovation, and the iconoclast Barnes reveled in the "pink cats, purple cows, cock-eyed houses, a few other manifestations of artistic genius" that distinguished the vision of a venturesome painter such as Glackens.[3] The artist's recently completed *Race Track*, 1908–1909 (fig. 2), proved the subject of intense conversation for the two men.[4] With a palette of vibrant red, green, blue, and orange, Glackens had used his illustrator's flair for anecdote to capture the jockeys in their colorful silks and their spirited mounts as they trot, caper, and bolt onto the course.[5] Barnes, intrigued, would devote the rest of his life to developing a method "to see as the artist sees."[6]

One month after their January meeting, Barnes sent Glackens to Paris on an art buying trip, specifically designating the work of Pierre-Auguste Renoir and Alfred Sisley as desirable for his collection.[7] With "spot cash"—$20,000—Glackens scoured Parisian galleries for two weeks.[8] At the end of his sojourn, he had acquired thirty-three oils, prints, and watercolors by Paul Cézanne, Maurice Denis, Vincent van Gogh, Berthe Morisot, Pablo Picasso, Camille Pissarro, Renoir, Sisley, and others—purchases that reflected even more avant-garde daring than the original request.[9]

These challenging works first adorned the walls of Lauraston, the Barnes home, and were later included in the ensembles at the Barnes Foundation in Merion, outside Philadelphia. Barnes bought the "brilliant and gaudy"[10] *Race Track* in March 1913, where it "has the unique distinction of being the only American canvas" in the country's "finest private collection," the *Craftsman* proudly announced. While the periodical's anonymous critic erroneously reported on the composition of the Barnes collection, the claim allied *Race Track* with the most advanced European painting.[11]

Throughout the 1910s, Glackens experimented with modernist idioms, transforming his work and defining an enduring, distinctive mature style. As the decade progressed, he assumed a role as a leader among his peers, championing European and American modernism through his active participation in the organization of the Armory Show and the Society of Independent Artists.

"Something Rare, Something New"

If *Race Track* was a "talisman" for Barnes's initiation into the aesthetics of modernism and the mysteries of artistic vision, as Richard J. Wattenmaker argues,[12] the work's consistent presentation in ambitious, well-publicized, and well-attended group and solo shows between 1908 and 1913 signaled Glackens's bold, new aesthetic stance—an embrace of and experimentation with impressionism and fauvism. Seemingly overlooked by the critics when it debuted in a realist palette at The Eight's showing at Macbeth's in February 1908, *Race Track*, completely repainted in high-keyed hues between 1908 and 1909, received more notice at the April 1910 nonjuried, prize-free Exhibition of the Independents—"an opportunity for individuality, an opportunity for experimenters," as organizer Robert Henri characterized the show's adversarial stance against the unadventurous presentations and exclusive selection process at the National Academy of Design.[13] Glackens supported Henri's effort by serving on the exhibition's selection committee, along with four other members of The Eight. Indeed, a critic's sneering association of the show's "vulgarity" with the "Luks-Glackens octette," established the avant-garde bona fides of the exhibition.[14] Yet, by 1910, Glackens had already stepped away from the realism of his mentor with *Race Track* and other entries such as *Girl with Apple*, 1909–1910 (see plate 50). In his overview of the show, Henri praised "something rare, something new in the thing he has to say"—indeed, "the manifestation of a temperament intensely sincere and intensely brave."[15]

Transfixed by *Race Track*'s "vivid reds and greens," the *Globe*'s Arthur Hoeber anticipated Barnes's wonder at Glackens's method of transferring what he saw to canvas: "If Mr. Glackens thus sees his nature, he must enjoy life far more than the ordinarily

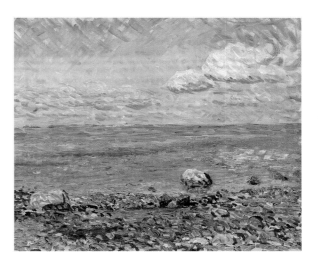

1

2

3

equipped human, for there is a riot of tone to his vision."[16] Many critics attributed Glackens's departure from the somber blacks and earth tones of the realists to the influence of impressionist and early modern French painting. In his first review of the Independents, James B. Townsend likened the "new art movement in America" to an erupting volcano, its first lava flow prompted by the "explosions of Matisse and his followers in France."[17] Just two months earlier, Glackens had found himself grouped with Marsden Hartley, Alfred H. Maurer, and Maurice B. Prendergast as "followers of the presumably crazy French painter Matisse"[18] in a review of an exhibition of landscape painting at the National Arts Club. The anonymous critic of the *World* also ascribed the palette to the influence of the fauve master: "Another picture by Glackens entitled 'The Race Track,' impresses one with the Matisse effect, and is rather over-accentuated in color."[19] Other critics focused on *Girl with Apple*, overlooking its allusions to Édouard Manet's provocative *Olympia* and describing it as "decidedly suggestive of Renoir"[20] and "surprisingly brilliant, though reminiscent of Renoir, particularly in its color scheme."[21] Impressed with the transitional, exploratory state of Glackens's work in 1910, fellow artist and influential collector Albert E. Gallatin noted: "He has gone far. He is going farther."[22]

While critics since the 1910s have underscored the artist's debt to Edgar Degas, Manet, Henri Matisse, and Renoir,[23] Glackens found his way to the palette and the visible, vigorous paint handling of *Race Track* by learning from fellow Americans Marsden Hartley, Ernest Lawson, Maurer, and Prendergast, as Wattenmaker has argued.[24] Artists whose works he could readily study and with whom he could paint, they were also important American exponents of the French styles with which Glackens increasingly experimented: impressionism (Lawson), post-impressionism (Hartley and Prendergast), and fauvism (Maurer). Important works by these Americans—so critical to Glackens's development as a modernist—also found their way to the walls of the Barnes Foundation, often as the painter introduced his colleagues and friends to the collector.[25] Welcomed by Barnes to visit his growing holdings, these artists became noted aesthetic interlocutors for him.

During a painting campaign in the summer of 1908 that anticipated regular seaside stints in Long Island, New England, and Nova Scotia, Glackens adopted brighter colors, working alongside Prendergast in Dennis, Massachusetts—for example, the hot orange and red dunes and cool mauve shadows of *Cape Cod Pier*, 1908 (see plate 60). When Glackens displayed another of these 1908 beach scenes at the National Academy of Design just months after The Eight showed at Macbeth's, Hoeber immediately saw that "the painter was striving to get away from the conventional rendering of his confreres"[26]: the Henri faction of

The Eight. Finding particular interest in the challenge of painting water, light, and the activities of holidaymakers, Glackens continued in this mode. A pure seascape, *Wickford, Low Tide*, 1909 (fig. 3)—perhaps more study than finished painting—blazes with vibrant oranges, yellows, pinks, and vermilions thickly applied with the palette knife along the rough, stony shoreline, while unpainted canvas shows through the loosely crosshatched blues of the sky. Alternating passages of aqua and orange define the calm shallows of the boulders, sea, and sandbars. A rare work without figures, *Wickford* lacks the markers of spatial depth—houses, piers, boats—that generally appear in Glackens's carefully composed works, rendering this painting unusually abstract.

With *Mahone Bay*, 1910 (plate 51), and *The Bathing Hour, Chester, Nova Scotia*, 1910 (fig. 4), Glackens returned to the leisure pursuits of summers on the coast, peppering his canvases with finely observed activities: boating, nannying, swimming, strolling, running, sunning. Before sending Glackens to Paris on the 1912 buying trip, Barnes had acquired *Mahone Bay*.[27] With these works, Glackens returns to more conventional spatial renderings with clearly defined fore-, middle-, and backgrounds. James Huneker found much to admire in *The Bathing Hour*—specifically, its dazzling realization of the sensation of the familiar: "[Glackens's] color grows more harmonious, though it often shocks by its brilliant dissonances. He is pulling up the key year after year, and his studies at Cape Cod the summer before last and at Nova Scotia last summer are of exceeding interest because, apart from their technical accomplishments, they begin to show, however dimly, the goal to which this ambitious and gifted young man is steering . . . these waters, skies, beaches . . . are nevertheless so real, or rather evoke the illusion of reality, that you experience in their presence what Henry James calls 'the emotion of recognition.'" The once mystifying directions of modernism were finding newly appreciative audiences.[28]

In *March Day, Washington Square*, 1912 (plate 53), painted just after Glackens returned from Paris in 1912, the artist conveys the slickness of a recent rain with the agile, liquid handling of the sidewalk reflections of elegantly attired and accessorized strollers with their muffs, umbrellas, and hats—perhaps residents of the glowing red townhouses that line the distant north side of the square. This fashionable group passes a working-class woman in a bright yellow shawl, her head uncovered, as she attends to an infant and a small child. With a fluid diagonal stroke of green, Glackens delineates the stairway of the distant streetcar. Employing similar attentiveness to snowfall and winter leisure pursuits, Glackens paints colorfully clothed children as they trudge up and slide down a snowy hill in cool blues, mauves, and white in *Sledding in Central Park*, 1912 (plate 52). Committed

to rendering spatial depth alongside the vigorous, visible paint handling of modernism, Glackens outlines the long tracks of the sledders in cool blues.

1913

On December 14, 1911, artists Walt Kuhn, Elmer MacRae, and Jerome Myers and Madison Art Gallery director Henry Fitch Taylor met to discuss the possibility of an exhibition of American and European contemporary art, most particularly "work usually neglected by current shows and especially interesting and instructive to the public."[29] Kuhn, MacRae, and Myers had participated in exhibitions of the Pastellists, an independent, artist-driven organization founded in 1910 that offered venues to show this medium without the "trammels imposed by commercial aspects."[30] An opportunity to present American painting in an international context, the exhibition promised greater ambition in scale than the Independents exhibition and a more adventurous spirit than the National Academy of Design's most recent showing, deemed "rotten" by Kuhn who had heard reports of its mediocrity.[31] Angling for a visible role as spokesman in the organization of the exhibition, Kuhn confided to his wife Vera his hope that Glackens would serve as president but reassured her: "Don't worry, I'll be the real boss."[32]

Glackens appeared a strategic choice for Kuhn, who also applauded his integrity and sense of self. "There is none of the low down jealousy in W. G.," Kuhn wrote to Vera on the occasion of his own successful show at the Madison Art Gallery.[33] Moreover, the "election," or selection, of Glackens was likely intended to represent a sea change in the leadership of American art—from Henri to the next generation—while maintaining an important and well-respected lineage. Not only had Glackens displayed his works in the exhibitions organized by Henri, but he also showed with the Pastellists and at international exhibitions, as well as in New York galleries and clubs hospitable to the most advanced American painting, including the Madison Art Gallery, the MacDowell Club, and the National Arts Club.[34]

Five days later, the Association of American Painters and Sculptors (AAPS) convened for the first time, again at the Madison Art Gallery—a venue owned by Clara Davidge that presented avant-garde American painting.[35] Praised as "non-commercial" by Kuhn,[36] the gallery offered many artists their first opportunities for one-artist shows, among them George Bellows (1911), Kuhn (1911), and Glackens (1912). In its review of Glackens's exhibition at Madison, *American Art News* wondered at the future of the intrepid gallery, which had not received promised financial patronage.[37] Invited along with fifteen others—a gathering that notably did not include Henri—Glackens attended and committed to the association's mission to "lead the public taste rather than

to follow it."[38] While Kuhn succeeded in his plan to become secretary and spokesman, impressionist painter J. Alden Weir was elected president but soon resigned because of the AAPS's well-publicized stance against the National Academy of Design, strange opposition given the number of participants who had exhibited there.[39] Arthur B. Davies assumed the presidency, with sculptor Gutzon Borglum taking the vice presidency. Among its first tasks, the AAPS arranged to lease the 69th Street Armory for its 1913 International Exhibition of Modern Art—a location that endowed the presentation with its enduring moniker: the Armory Show.

Intended to rival groundbreaking European exhibitions such as Roger Fry's post-impressionist shows at the Grafton Gallery in London in 1910 and 1912 and the Sonderbund in Cologne in 1912,[40] the Armory Show is best remembered for the debut of notable examples of European modernism—works by Constantin Brancusi, Marcel Duchamp, Vincent van Gogh, Paul Gauguin, Matisse, Picasso, Odilon Redon, and others. However, most of the 1,200 works of art in the Armory Show were by American artists. Although Glackens did not serve as president of the AAPS, he was named chair of the Domestic Art Committee in December 1912. Discussing the tasks of the committee—specifically, its circular, or call for entries—Davies wrote to Kuhn in October 1912: "I am inclined to work with Glackens on it. He has has [*sic*] more horse sense than any of the other fellows even with the shadow of the 'Blackest Henri' over him."[41] While Davies's letter underscores the esteem Glackens had garnered among his peers, his alignment of Glackens with Henri overlooked the independence Glackens had already shown as early as the summer of 1908 and publicly by 1910.

Excited by the works by Cézanne, Gauguin, and Van Gogh that he had secured for the show, Kuhn lamented to his wife: "The American Annex, of course, will be a sad affair."[42] Though the selection process remains somewhat mysterious—a ledger of names and object titles with "A" for accepted and "R" for rejected, as the sole evidence[43]—Kuhn remarked on Glackens's dedication to his role: "Glack has come out strong and determined to keep the standard of American stuff way up."[44] As he expressed hope for the future of American art, he unwittingly provided the show's evergreen emblem: "Davies agrees with me that America is the new soil and that the game is most interesting at home. Paris is a hot-house where they raise beautiful orchids and other wondrous plants but the rugged old pine grows best in arid climes."[45]

The invitational circular asked artists, both professionals and nonprofessionals, to submit works of all genres and media—"all art work that is produced for the pleasure that the producer finds in carrying it out…the result of any self-expression that may come most naturally to the individual."[46] Concerned with how

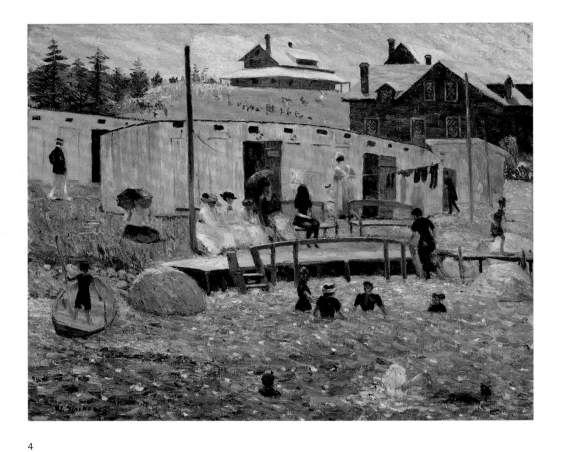

4

6

5

their fellow Americans might "compete" with the "individuality of expression and forceful manifestation of the creative power" in the European presentation, the AAPS sent a later memo to prospective exhibitors, urging that "our home exhibit be equally conspicuous in like feature."[47] In an interview with critic Guy Pène du Bois, rendered in prose by the latter and published on the eve of the Armory Show, Glackens found much to admire in the skill of his fellow co-presenters, but also concluded that the "arid and bloodless" art of the domestic exhibition would appear "tame" next to the works by European counterparts, noting that in American art, everything worthwhile was based on the influence of French art. Glackens urged American painters to "forget restraint," and he foresaw a renaissance for American painting.[48] As Gail Stavitsky has recently argued, American critics saluted the showing of their countrymen, noting the relative clarity and rationality of the display.[49]

With the three works Glackens exhibited in the Armory Show — Family Group, 1910/1911 (see plate 39), The Bathing Hour, Chester, Nova Scotia, and Sailboats and Sunlight (unlocated) — as well as the eighteen shown at the Folsom Gallery in the following month, he demonstrated his boldness, his own willingness to "forget restraint." While his showing at the Armory risked getting lost in the cacophony of the foreign exhibition, the exhibition at Folsom permitted a more sustained, stand-alone look at his oeuvre. In an unsigned notice in Craftsman, Mary Fanton Roberts declared Family Group "one of the most radiant, courageous color paintings America has produced."[50] Roberts further lauded Race Track, on view at Folsom, for its "fearlessness in the demarkation [sic] of color."[51] Sloan noted that "even Glackens is in the obvious color class just now,"[52] and Roberts further claimed that "a more complete realization of all that color can accomplish on canvas has never been presented…in one private exhibition in New York…."[53] Noting the very boldness Glackens urged, the New York Times applauded the painter as it faulted the rendering of the figures in the Degas-inspired Pony Ballet, 1910–early 1911 (fig. 5): "Perhaps there is no painter in the present generation who can succeed and fail so courageously in the same moment."[54]

A "Free Man"?
During the 1910s, Glackens showed regularly at a handful of New York venues devoted to the presentation of adventurous American painting, including the Bourgeois, Daniel, Macbeth, and Montross galleries.[55] Arguing that Glackens's work was too little recognized in America, Pène du Bois mentioned the artist alongside Cézanne and Renoir in a June 1914 article on Barnes and his nascent collection. Race Track appeared as the opening illustration.[56] A few months later, Pène du Bois touted Glackens as "the best eyes in American art,"[57] a distinction that Barnes quoted

in turn as he praised the singular talent of the artist to a skeptic.[58] The critic further described Glackens as a "normal man"—a seemingly unexceptional designation. But, to Pène du Bois, Glackens's "normality" stemmed from his ability to resist both the strict dictates of the Academy and the fiery rhetoric of the iconoclast: he was a "free man." Reviewing Glackens's work from The Eight to the Armory Show, Pène du Bois concluded that "this care free optimist is one of the most assiduous students and one of the bravest men in American painting."[59]

As Glackens presented his works in exhibitions throughout the 1910s, critics regularly noted his emulation of Renoir. In 1913, one critic celebrated Renoir's aesthetic as evidence of "artistic affinity" rather than "slavish imitation."[60] Soon, critics dubbed him "this Renoirino"[61] or routinely referred to his showings "in the Renoir vein"[62] or "in his best Renoir."[63] Pène du Bois, who once praised Glackens as a "free man," fretted: "he is fast turning the influence of the Frenchman's work upon his own into an expression, without a hint of the other, of himself."[64] However, Barnes paid his friend the greatest of compliments when he suggested that Glackens had outdone the master: "On Saturday I told [Leo] Stein why I considered your flower piece superior to Renoir's and he agreed with me in most respects."[65] By 1920, others seemed to have resigned themselves to the seeming constancy and quality of Glackens's adherence to the Renoir aesthetic: "William J. Glackens, who makes no attempt to conceal his admiration for Renoir nor the influence of the great Frenchman upon his work, nevertheless holds a personal view point in the presentation of his subjects…. the critic is compelled to say 'At any rate he does it well.'"[66] But Barnes later differentiated the work of Glackens from Renoir, noting that the American painter displayed his individuality and authenticity in his "very personal type of drawing" and his "use of all the plastic means."[67]

However, Glackens's willingness to experiment with new, even exotic, modes was also evident in that decade. For works such as Decoration, c. 1914 (fig. 6), Glackens looked to Indian art and Persian manuscripts, leading one critic to conclude: "They are a departure, for Glackens…. They are Glackens in another field but Glackens nevertheless."[68] Discussing the direction of Glackens's work in the teens, P. J. Brownlee insightfully notes that, in his move from multifigure works to portraiture, the artist animated his works with his nimble brushwork[69]—and further revealed his experimentation with other modes. Wattenmaker attributes the single figure compositions to Glackens's exposure to works by Cézanne in the Barnes collection.[70] With Armenian Girl, 1916 (see plate 80), Glackens exploited the elaborate costuming and an exoticism associated with Renoir's works of the 1910s and Matisse's first Nice period. In Glackens's work, the young woman sits in a shallow space with a fringed textile draped across the

corner of a patterned wall covering that evokes the harem, as does her colorfully embroidered, high-waisted garment.

While the critics debated developments in Glackens's works in this decade, the artist assumed the presidency of the Society of Independent Artists, a "no jury, no prizes" association incorporated in 1917 and modeled on a French counterpart, the Société des artistes indépendants. Charles Prendergast became vice-president, while foreign-born artists associated with the circle of collectors Walter and Louise Arensberg also joined the ranks, including Armory Show provocateur Marcel Duchamp. The exhibition was an all-inclusive affair. Prospective exhibitors paid six dollars for their six feet of wall on which to display two works at the Grand Central Palace. At the suggestion of Duchamp, head of the hanging committee, the Society displayed the works alphabetically to "relieve the hanging committee of the difficulties raised by their personal judgments as to the merits of the exhibits."[71] Henri, who embraced the "no jury, no prizes" ethos but did not display, described the presentation as a "disastrous hodge-podge" and argued for smaller shows of like material.[72] Glackens took on Henri's challenge and argued the case for the "big show," noting the lack of public interest for a presentation without "punch."[73] Writing two months in advance of the Society's exhibition — and on their paintings — Pène du Bois presciently captured the divergence of the original members of The Eight: "Men grow! Glackens and Henri started out together and now they are at nearly opposite ends of a straight line."[74]

Challenging the Society's dedication to its "no jury" commitment, Duchamp submitted his *Fountain*, a urinal emblazoned with the signature R. Mutt. Faced with this challenge, some directors of the Society of Independent Artists — a diverse assembly associated with The Eight and the Arensberg and Stieglitz circles — quickly gathered and voted to exclude the work from the exhibition, prompting Duchamp and Arensberg to resign immediately from the organization. However, an anecdote relayed by Charles Prendergast to Ira Glackens, son of the painter, prompted the canard that Glackens had dropped *Fountain*, irreparably damaging it and thereby solving the crisis of its submission.[75] Not merely misleading in the narrative of the "porcelain incident" — as Barnes daintily referred to the debate[76] — the story attributes to Glackens snobbery and a meanness of spirit incompatible with his demonstrated leadership. As a letter from Katherine Dreier to Glackens demonstrates, the Society's president had supported the notion that Duchamp should lecture on his readymades, with R. Mutt to bring the excluded *Fountain* to the lecture and explain the place of his entry in the exhibition — signs that the banished work had not been destroyed. Indeed, Alfred Stieglitz later photographed the work at Duchamp's request.[77] Although Glackens ceded the position of president of the Society of Independent Artists to John Sloan a year later, he continued to support the Society, displaying with it in almost every presentation from 1917 to 1929.

"A Big Man's Mind"

Without naming Glackens, Barnes commended the painter's importance to his collecting endeavor: "The most valuable single educational factor to me has been my frequent association with a life-long friend who combines greatness as an artist with a big man's mind."[78] Seemingly a valedictory statement, Barnes made his observation in his 1915 article "How to Judge a Painting," just four years after the two men had renewed their friendship. Although Barnes made all buying decisions following the foundational 1912 Paris trip, Glackens sometimes accompanied the collector to look at possible acquisitions from galleries. Knowing that the opinion of Glackens mattered to his client, French dealer Paul Guillaume inquired after the artist's opinion of the African sculpture Barnes had begun to buy in the early 1920s.[79] In his journal *Les Arts à Paris*, Guillaume published an article by Barnes on Glackens in 1924,[80] thereby further exposing the American to the avant-garde audience that frequented his gallery — a gesture of reciprocity that acknowledged the artist's role in bringing modernism, especially French modernism, to the United States. Following the death of his friend, Barnes promised the artist's widow that he "will live forever in the Foundation collection among the great painters of the past who, could they speak, would say he was of the elect."[81] Not only did Barnes install nearly fifty paintings and works on paper by Glackens in his Gallery, he installed *The Bathing Hour, Chester, Nova Scotia* and *The Raft* in the Main Room, his introduction to his aesthetic endeavor. After the painter's death in 1938, Barnes lent three works from the dynamic 1910s to the memorial exhibition at the Whitney Museum: *The Raft*, 1915 (page 151, fig. 12), *Armenian Girl*, and, of course, *Race Track*.

For notes, see pages 242–243.

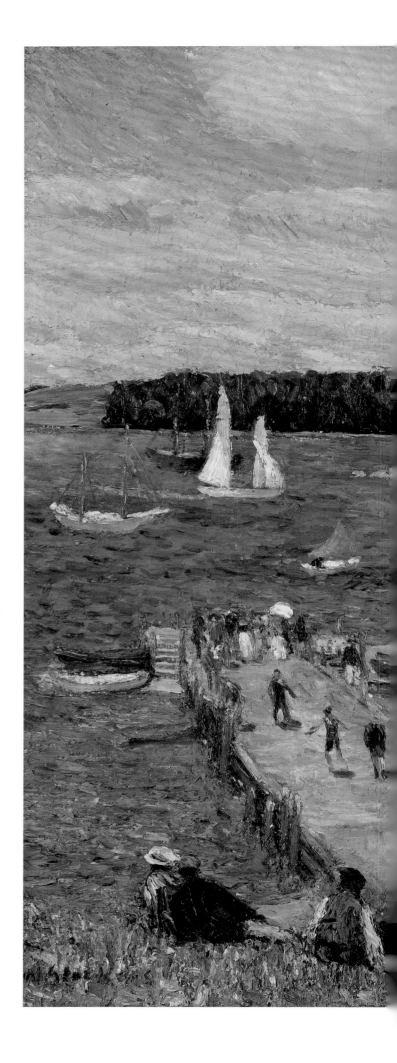

51

Mahone Bay, 1910
Oil on canvas, 26⅛ × 31⅞ (66.4 × 81)

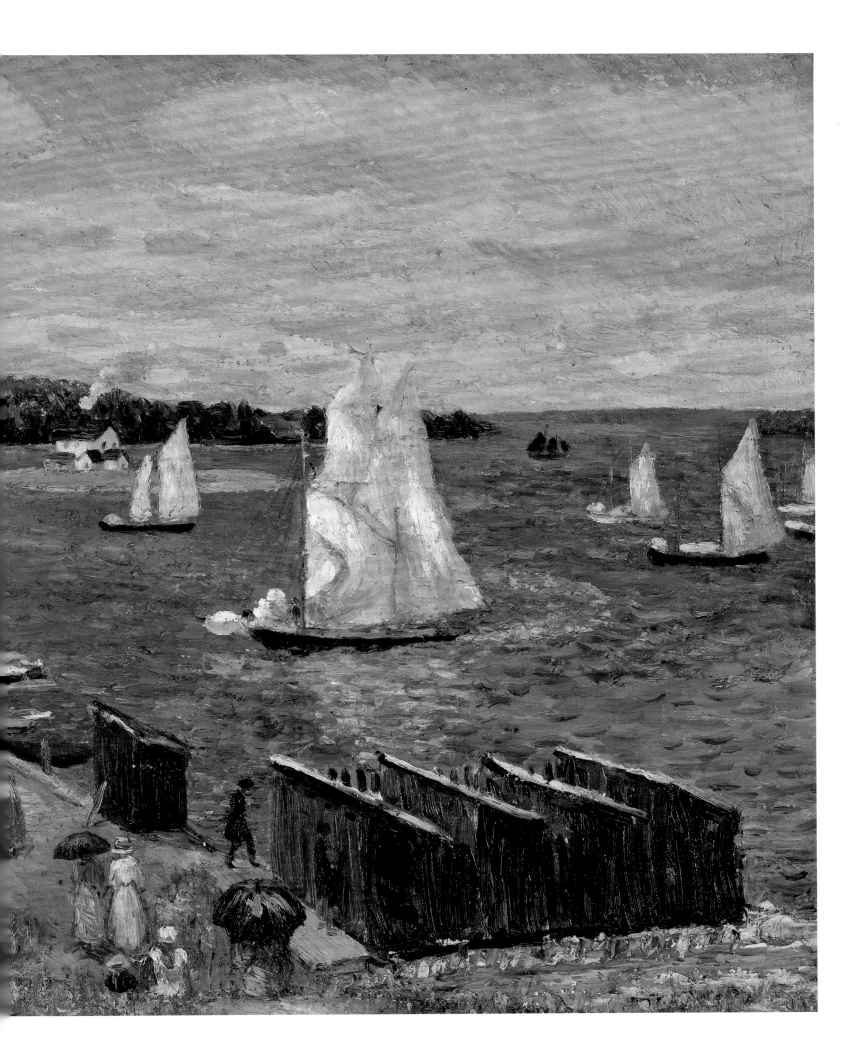

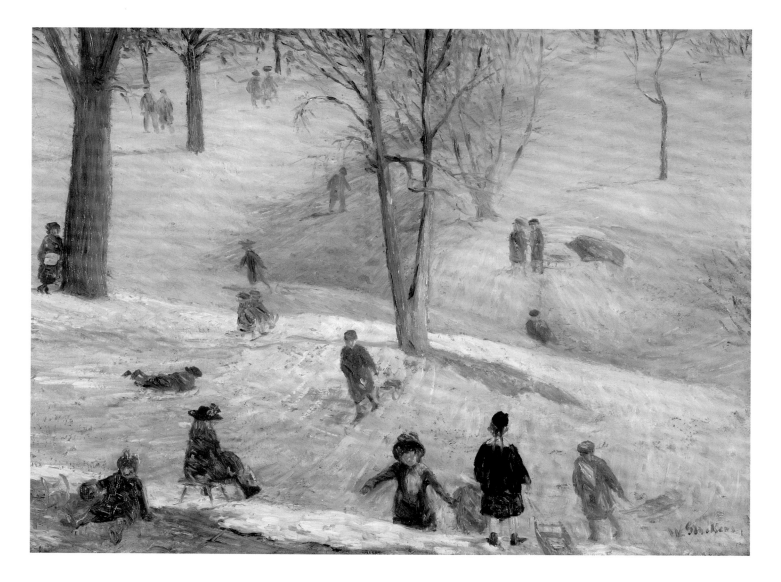

52

Sledding in Central Park, 1912
Oil on canvas, 23 × 31½ (58.4 × 31.5)

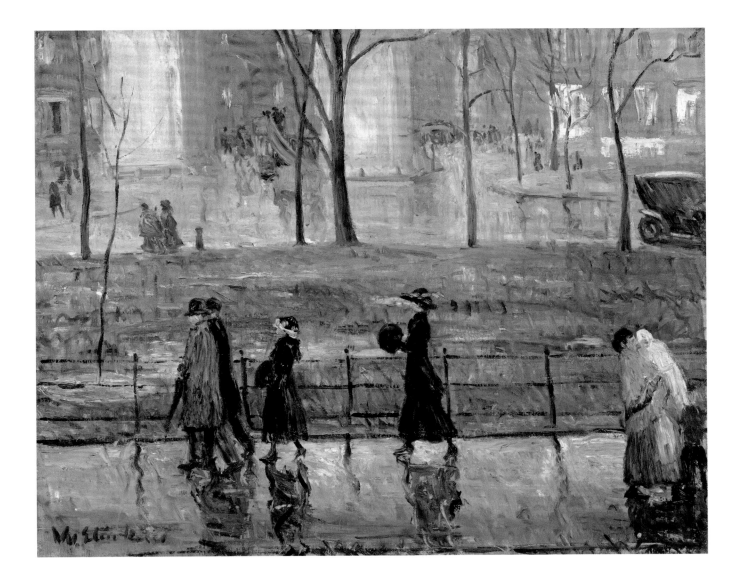

53

March Day, Washington Square, 1912
Oil on canvas, 25 × 30 (63.5 × 76.2)

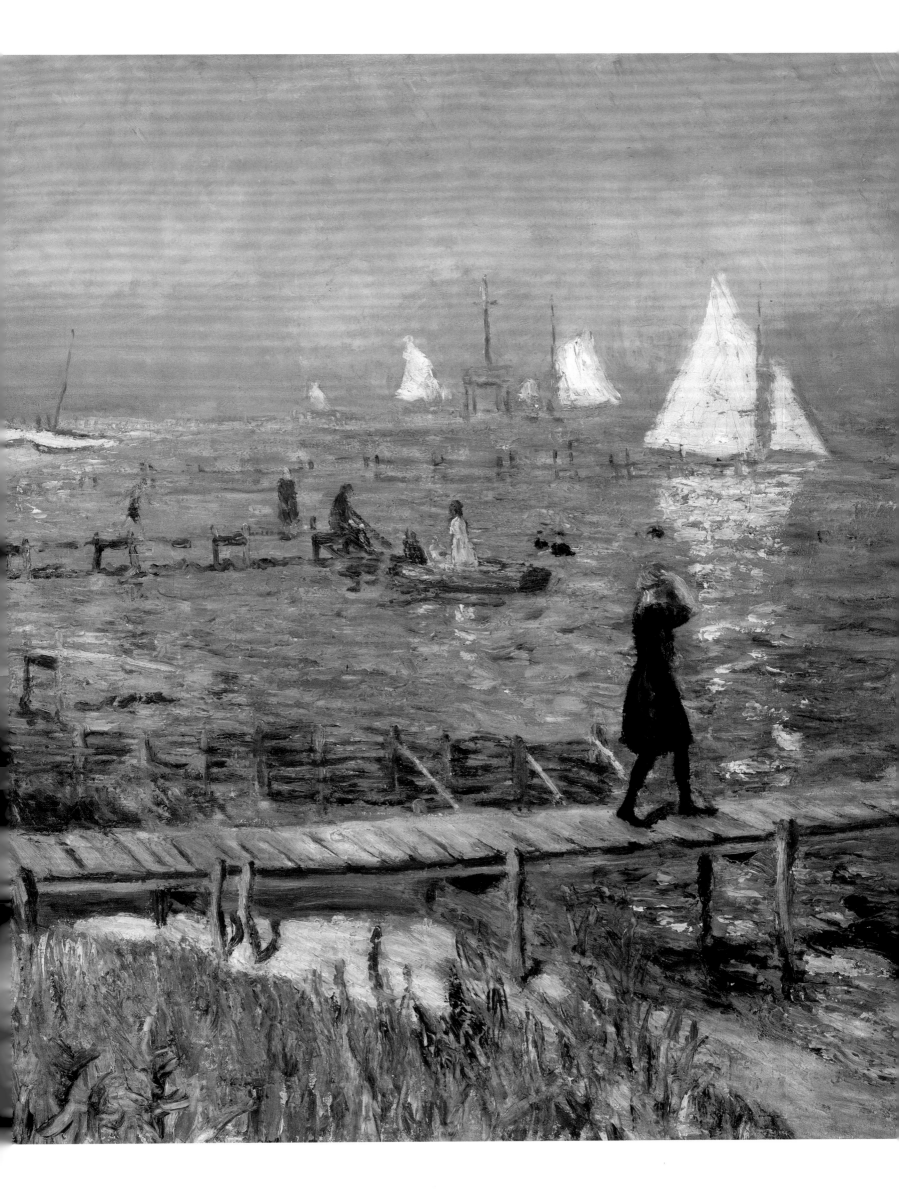

Scenes at the Shore: Glackens's Summers by the Sea

ALICIA G. LONGWELL

In William Glackens's *Girl with Apple*, 1909–1910 (see plate 50), a work rich in detail and abundant in texture, an element in the upper left-hand corner may at first go unnoticed. On the wall behind the nude figure the artist has included one of his own seashore paintings, so similar in complexion and hue to the patterned wallpaper that the framed piece is not readily discernible.[1] Yet the head of the nude enters insistently into this scene; clearly, Glackens does not want this detail to be overlooked or dismissed. In this ardent painting he aligns the genres of figure, still life, and landscape; acknowledges the lessons of past masters, from Édouard Manet to Pierre-Auguste Renoir to Paul Cézanne; and signals that the painting may be read as a summary statement of the artist's ambition. Scenes of daily life, the touchstone of the American artists known as The Eight, would enduringly occupy Glackens, and it was his aim to realize an art of distinction from this quotidian subject. It is to scenes by the shore that he will return again and again—liminal space at the juncture of land and water—where observation will ultimately give way to sensation. The economy of skills Glackens honed as a draftsman will serve him well in his quest for an art that encompasses both what can be seen and what can only be perceived. Scenes he painted at the shore, taken as a whole, advance the concept of impressionism, both in his own oeuvre and in American painting as a whole.[2] From 1907 to 1918 the artist painted by the shore annually, but an examination of his works from 1895 through 1929 further illuminates this theme.

1895–1902: City Shores
Two paintings from Glackens's first trip to Europe, *La Villette*, c. 1895 (see plate 8), and *In the Luxembourg*, c. 1896 (see plate 9), and three works subsequently painted in New York, *East River*

Park, c. 1902 (fig. 1), *The Battery*, 1902–1904 (private collection), and *Tugboat and Lighter*, 1904–1905 (plate 54), all situate groups of figures in urban surroundings at the water's edge. Both Paris pictures owe much to the work of the French impressionists, and the darker palette and tonal subtleties of *La Villette* are Whistlerian in concept. The city harbors that furnish the background for the three New York paintings are busy, bustling locales. The bright oval of the park in the foreground of *East River Park* contrasts sharply with the provisional and hazy depiction of the industrial Brooklyn waterfront it faces. City parks during the daytime were the province of women and children; the male figure at the extreme right is on the verge of exiting the frame—an incidental player at best. In *The Battery*, couples on a weekend excursion visit the site of Castle Clinton, an early nineteenth-century fortification and the port of immigration before Ellis Island. In the early 1900s, the building housed the New York City Aquarium and was a popular destination. Just as weekenders came to view the marine life captured and on display, Glackens had his own gambit of observation.

1906: European Honeymoon
In 1906, Glackens and his wife, the artist Edith Dimock Glackens, embarked on a belated honeymoon to Spain and France, and in two waterside paintings from this trip, the artist cast himself and Edith as members of the ensemble. In Paris, they took a studio apartment at 9, rue Falguière, in the same building as close friends and fellow artists James and May Wilson Preston. Glackens renewed a friendship with the artist Alfred Maurer, who had a studio in the building.[3] During his time in Paris, Maurer's work had taken a radical departure from the earlier paintings Glackens knew in New York. Maurer was deeply influenced by the saturated coloration in the work of the fauves, including Henri Matisse and André Derain, prompting one American in Paris to write home in 1905, "[Maurer is] a man who has 'arrived,' perhaps the best known American painter here."[4] Painter and photographer Edward Steichen, Alfred Stieglitz's advance man in Paris, was so enthused with Maurer's work that he persuaded Stieglitz to mount an exhibition at Stieglitz's New York gallery, 291, where they would prove to be "the most radically abstract color works seen in the gallery to date."[5]

Chateau Thierry, 1906 (see plate 88), is a detailed and accurate record of an excursion Maurer and the Glackenses took that summer to a popular bathing spot on the Marne River, some sixty miles east of Paris.[6] Maurer, who had served as Glackens's guide to the latest advances in Paris on this 1906 visit, is the figure in the red trunks, poised to dive into the river. Glackens gingerly leads his wife, in contemporary bathing costume, across the boardwalk. (Glackens himself is wearing the abbreviated

1

2

3

swim trunks fashionable in France but not yet commonly seen in America.) Will Glackens, too, "take the plunge" and enter the swift current — perhaps a symbol for the rapidly flowing course of modern art? His response will not come immediately, but it will be emphatically apparent in a painting begun two years later during a summer on Cape Cod.

On their return, Glackens chose the Dieppe – New Haven route to England as the most economical way for the couple to board their ship in Liverpool, but foul weather delayed them for several days. *Beach at Dieppe*, 1906 (The Barnes Foundation, Philadelphia and Merion, Pennsylvania), depicts the artist and his wife at far right[7] looking northwest to England, while children in the foreground dig in the sand. A sketchbook drawing (fig. 2) shows how fully realized Glackens's on-the-spot sketches were and how closely the final composition follows the sketch.[8] It is not unusual, certainly, for an artist to place himself in a painting, and Glackens had just been to the Prado, where he would have seen Francisco de Goya's *Family of Charles IV*, 1801, in which the artist stands at his easel behind the assembled royals, as does Diego Velázquez in *Las Meninas*, 1656. In Glackens's two paintings, however, we see him as the observer.

1907: Coney Island

By 1910 scenes by the water, whether near the city or at resort beaches, figured prominently in Glackens's oeuvre and provided a vehicle for artistic expression far beyond the simple continuation of the impressionists' depictions of halcyon days at the shore. Glackens's chosen scenes, whether earlier ones of Coney Island or the later beachside paintings, were clearly linked to his concept of modernity and his desire that his art be a reflection of modern life. From 1911 to 1916, during summers spent on Long Island's south shore, beach scenes would dominate his output, and the beach would be a destination to which he returned throughout his career. The rise of tourist resorts and the concept of leisure time were emerging topics in the public discourse. By 1888 the popular *Scribner's Magazine* queried, "Where Shall We Spend Our Summer?," noting that those seeking leisure included city workers able to afford just a day at Coney Island; middle-class vacationers looking forward to a week in the country; and the upper classes whose "cottages" at Newport and Saratoga Springs furnished seasonal respite.[9] The gated surroundings of resorts such as Newport held no interest for Glackens. He much preferred the lively scene at Coney Island and the coastal resorts of Long Island, Cape Cod, and Rhode Island. From sketching excursions in his bachelor days[10] to spending the summer in cottages with his wife and small children, the beach was the setting where Glackens could observe without being observed and navigate easily in a broad spectrum of society.

As early as the late 1890s (*Fruit Stand, Coney Island*, c. 1898; fig. 3), Glackens found ample pictorial rewards in excursions to Coney Island, and he would return nearly a decade later for a Fourth of July outing with his very pregnant wife. The Glackenses did not leave the New York area in the summer of 1907, presumably because of Edith's advanced condition; a holiday excursion or perhaps a magazine assignment prompted the trip. One contemporary observer found Coney Island an egalitarian utopia: "Old Ocean is a grand Old Democrat, and levels all petty distinctions. He buffets the rich and the poor alike, who, clad for bath, present very much the same appearance."[11] It was the leveling of the classes, this compression of the social order that above all captivated Glackens. He clearly relished the democratic spirit. In *Afternoon at Coney Island*, c. 1907 – 1909 (plate 57), Glackens demonstrates his "photographic eye" and is at his very best in observing and recording. The cast of characters is densely packed in the frame and the artist creates individual vignettes at every turn. In the background we see the New Iron Pier, built in 1878 by the Iron Steamboat Company, a facility with 1,200 bath lockers, restaurant saloons, an ice cream parlor, and a promenade deck. In the middle ground a stream of passengers has just left the pier and is pouring out onto the beach. In the far left foreground a roué steers two young women, one on each arm, briskly along the walk. Could they be newfound acquaintances made moments before on the ferry ride from Manhattan? Glackens presents numerous situations to pique our interest. The foreground is packed with figures. A woman bends to straighten the stocking of her bathing costume. A young woman sits on the beach, parting and separating her hair to dry it. A mother on the far right adjusts her young son's sun hat. A standing woman and a seated man exchange glances in the middle. A bucket and shovel rest in the sand next to a young girl and her mother. Glackens is here, and in *Morning at Coney Island*, c. 1907 – 1909, *Coney Island Beach Scene*, c. 1907 – 1909, and *Beach, Coney Island*, c. 1907 (plates 56, 58, 59), he is the consummate observer. Like a stage director, he assembles and reassembles his cast of characters. This is Glackens at his best, combining keen scrutiny with empathy and an understanding of his subjects. The pure sensuousness of a day at the beach, where propriety and custom are relaxed or suspended altogether, allowed for an easy mix of the classes with more than a touch of sexual license. In these illustrations Glackens is clearly delineating individual character, and he will begin to work toward an overall effect in his paintings.

1908: Cape Cod

Edith Dimock grew up in West Hartford, Connecticut, the daughter of prosperous textile manufacturer Ira Dimock, a self-made man whose business acumen enabled him to purchase the

imposing Cornelius J. Vanderbilt estate there. The Dimocks regularly summered at the Connecticut shore near New London, in Pequot. Edith was accustomed to this annual ritual and sought a way to continue it in her married life. She had gone to her parents' home in Hartford after the birth of her first child in July 1907 and decided in the spring of 1908 to travel to Cape Cod to secure a summer rental. The couple's extended separation that year no doubt reflected the tenuous living situation at 3 Washington Square North, at least by West Hartford standards. In marrying Glackens, Edith had eagerly embraced the bohemian lifestyle of the Greenwich Village artist, but she would retain a lifeline to the house on the hill in West Hartford.[12]

Preparations for an exhibition with seven of his confreres at the Macbeth Galleries in February 1908 occupied Glackens much of the winter, but he visited Hartford frequently and spent the 1907 Christmas holidays there. Although he did not sell any work from the exhibition, the reception was pandemonium and the eight artists were hailed as the new vanguard in American painting, despite Macbeth's protests to the contrary. Glackens's immediate concerns in the winter of 1908 were to find a new way forward in his art.

Writing from New York, Glackens is overjoyed by Edith's news that she found "a real storybook house, white, green shutters and chimney."[13] In the same letter he reveals to his wife more somber feelings about his art: "I wish all the damn pictures and paints would fly out the window or burn up. I loathe the sight of them."[14] The stalemate he acknowledges in this letter would be resolved that summer on Cape Cod. The precise location of the "storybook house" in Dennis, Massachusetts, is not known, but it was likely within walking distance of the Nobscussett Hotel, a grand hotel built in 1888 and later enhanced by a long pier extending out into Cape Cod Bay.[15] The Glackenses and their visitors may have arranged to make use of the hotel's facilities even though they were not resident guests.

Edith was happy that the summer of 1908 would afford a chance to enjoy the company of several fellow artists, including Everett Shinn and his wife, Florence ("Flossie") Scovel Shinn. Maurice Prendergast joined them in late August, taking the train to Yarmouth from his home in Boston. He wrote to Edith, "I hope all the people in the little white house have profited by the summer and are enjoying excellent health. I shall be interested to see what Glackens has done.... I am skeptical about doing any of my own work. If I don't I shall help you exterminate the mosquitoes."[16]

Edith's plan to reunite their circle of friends must have buoyed Glackens's spirits, for the summer was one of bold and daring transformation in his art. The addition of a child to the family would have motivated him to consider the future and the direction of his art. His work as an illustrator was lucrative and

still important for him, but he wanted to pursue a more serious art. It was widely understood that it was the Dimock money that brought stability to their lives. Glackens's friend John Sloan noted in a diary entry for July 20, 1907, shortly after the birth of Glackens's son: "A splendid dinner at Glackens', very good cooking and things so nice. He should be happy. A wife, a baby, money in the family, genius."[17]

There is no doubt that *Cape Cod Pier*, 1908 (plate 60), with its bold coloristic balance, marks a strong and indelible departure in the style of the artist's work. He has been compared more than once to Renoir, and similarities certainly exist in Glackens's later feathery brushwork. It is more difficult to correlate the lusciously statuesque forms of Renoir's female figures with the resolutely modern players in Glackens's tableaux.[18] By 1913 comparisons with Renoir were prevalent and generally favorable. One writer observed: "If one is at all reminded of Renoir...the thought of slavish imitation never arises, but rather the thought of artistic affinity."[19]

Although the high-keyed palette of *Cape Cod Pier* is new and adventuresome for Glackens, the work is based on the direct observation of nature. It is sunset and the beach and bluff are tinted with an igneous red-orange glow; the uprights of the pier cast lengthening shadows on the walkway. At right, female bathers swim or emerge from the water. A solitary male, fully dressed, is seated on a large rock. At left, a young girl calls her dog. A family sits near the water's edge. A couple rests on the sand under a striped beach umbrella. All these figures are provisional, limned with the smallest touch of brushstroke necessary to indicate form. Center stage is reserved for two young women striding purposefully on the pier back toward the hotel. Dressed in dazzling white and seen only from the back, they hold their parasols aloft like standards — as stalwart as any suffragette on the march.[20]

1909: Wickford

"This is an ideal spot,"[21] wrote Florence Shinn to Edith Glackens on a postcard dated July 1908, while vacationing with her husband at the Cold Spring House in Wickford, Rhode Island. This was most likely the reason the Glackenses chose the resort the following summer, joining the Shinns (a photograph attests to the convivial times; fig. 4). The Cold Spring House was the grande dame of local resorts, and Wickford's proximity to Newport and the Narragansett Pier with its casinos and nightlife would have offered more diversion than a quiet Cape Cod village.[22] This summer was an especially productive one for Glackens, less so for the mercurial Shinn. The prominent rock just offshore was a well-known landmark and became a focal point in several paintings. More than one observer has commented on the similarity in

style of Glackens's paintings that summer to Prendergast's, and given the two artists' propinquity the previous summer this is not surprising. The high-keyed palette of Cape Cod combined with the broken brushwork of Prendergast is readily apparent in *Wickford, Low Tide*, 1909 (see page 129, fig. 3), a beach scene uncharacteristically, at least for Glackens, devoid of human activity. At low tide, the water does not invite swimming—or at least the rocky shore is inhospitable to bathers. In *Rock in the Bay, Wickford*, 1909 (plate 61), the scene is magically repopulated and the rock becomes a friendly diving platform. The bustle and vitality of the beach are restored—Glackens favors an animated proscenium.

If Prendergast's influence was discernible, so, too, is the fact that Glackens knew of the work of another painter, Marsden Hartley. Hartley later recalled his first venture into the New York art world with a group of works he eventually brought to Stieglitz, but Glackens was among the first to see them. "I had come down from Maine with a set of paintings seen by no one outside of the brothers Prendergast, Glackens, and Davies, upon which these men had set some sort of artistic approval."[23] Glackens's vigorously impastoed *Breezy Day, Tugboats, New York Harbor*, c. 1910 (plate 55), may combine a response to both Hartley and Prendergast, though it was not a treatment Glackens would wholeheartedly embrace.

1910: Nova Scotia
In the summer of 1910 the Glackenses traveled to Nova Scotia, a holiday depicted in several paintings. *The Bathing Hour, Chester, Nova Scotia*, 1910 (page 132, fig. 4), and *Beach at Nova Scotia*, 1910 (The Arkell Museum, Canajoharie), suggest that fellow tourists were upper middle class.[24] Mahone Bay had become a fashionable resort in the late nineteenth century, with improved rail and steamship transport and accommodations built as a result of these enterprises, and it proved especially popular with Americans. Yachting was a prime pursuit in and around the many small islands dotting Mahone Bay, as seen in Glackens's *Mahone Bay*, 1910 (see plate 51). In this painting we begin to find the choreography of land, sea, and built environment Glackens would develop in the coming years. The thrusting diagonal of the pier, the stacked rooflines of the rustic bathhouses in the foreground, and the bird's-eye view of the animated bathers and strollers all figure prominently in his seaside compositions.

In *The Bathing Hour*, the sole adult male is on the periphery, walking behind the bathhouses at the extreme left of the compostion. He has no interaction with the group of women and children who populate the painting. Is the figure a surrogate for the painter himself, inserted into this feminine realm? The treatment of paint builds on that employed the previous summer in the paintings executed at Wickford, particularly *Rock in the*

Bay, Wickford, creating a transitional stylistic bridge between the Cape Cod and Nova Scotia paintings. (*The Bathing Hour* was subsequently included in the 1913 Armory Show, for which Glackens was an organizer, and Albert C. Barnes bought it for his collection the following year.) The critic James Huneker wrote a perceptive appraisal of the painting for the *New York Sun* in 1910, noting their "brilliant dissonances.... Beaches of inland seas, the waters of which are vivid blue; skies as hard blue as Italy's, white cloud boulders that roll lazily across the field of vision and shine on their edges with reflected light; grass so green that you ask yourself if Nova Scotia raises the crop from Celtic seed; nothing tempered as would a less sincere artist but set forth unmodulated and in audacious oppositions...."[25] Such a review would have lifted Glackens's spirits and sealed his resolve to ensure that summers could be spent exploring the possibilities of painting at the water's edge.

Bellport and Beyond
With the inclusion of *Girl with Apple* in the 1910 "Exhibition of Independent Artists," Glackens has announced that scenes at the water's edge are critical to his work. He will retreat from the city each summer, escaping the heat and the attendant health threats of hot weather. For the sake of the children (a daughter, Lenna, was born in 1913) and for the felicitous effect on Glackens's painting, securing a summer rental became a priority. The seasonal move to Bellport, New York, in 1911 proved to be a fortuitous one. The Glackenses would stay there the succeeding five summers, which introduced stability to his painting practice. His occupation would be less with the social commentary seen in the Coney Island work and more with the pragmatic investigations of composition and structure, the effects of light, and achieving an overall balance that would advance his art. Glackens still demonstrates affection for his subjects and intimacy in the beach pictures, but this becomes secondary to the creation of a harmonious whole. When several of the early Bellport paintings are included in an exhibition at the Folsom Gallery in March 1913, his second one-person show, a critic notes a distinct change in Glackens's renowned draftsmanship and that "figures are treated as spots of color rather than as forms."[26]

The first summer, Glackens rented a modest home known as the Petty cottage on what was then called Bellport Avenue. A pre-Revolutionary settlement, with many eighteenth-century homes still in use, the charming colonial village of Bellport on Long Island's South Shore was made even more accessible by the completion in 1910 of the East River railroad tunnels. (Previously train cars had to be transferred to barges and ferried across the river at Long Island City.) Summer inns and boarding houses flourished as early as the 1830s, and by the 1870s several hotels

4

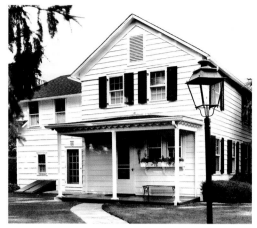

5

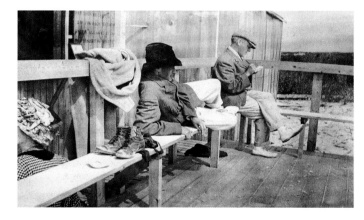

6

7

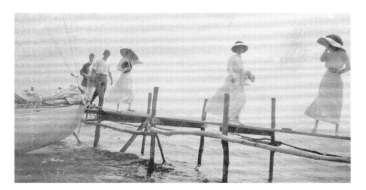

8

FIGURE 4
Edith Dimock Glackens,
William Glackens, and
Florence ("Flossie")
Scovel Shinn (from left)
at Wickford, Rhode Island,
summer 1909. Photograph.
Archives of American Art

FIGURE 5
Carmen Cottage,
now 28 Bellport Lane,
Bellport, New York,
2007. Photograph. The
Glackenses spent the
summers of 1912 to 1915
here. Photograph by
Cara Phillips, courtesy
Bellport-Brookhaven
Historical Society

FIGURE 6
William Glackens (right)
sketching, with Everett
Shinn and Flossie Shinn
(just visible on extreme
left) at the Old Inlet Club,
Fire Island, New York, 1911.
Photograph by Julia Edey
Paige. Courtesy Dr. Richard
Berman and the Bellport-
Brookhaven Historical
Society

FIGURE 7
Osborn's Bluff, c. 1900. The
high ground to the west
of Bellport Lane, with the
original golf clubhouse at
the far left. Hand-colored
photograph by Frances
Toms. Courtesy Bellport-
Brookhaven Historical
Society

FIGURE 8
The Yacht Club dock,
Bellport, 1913. Photograph.
Stick docks were quite
sturdy but were usually
removed from the water
for the winter and rebuilt
in the spring. Courtesy the
Paige Family and Bellport-
Brookhaven Historical
Society

could accommodate as many as one hundred guests each.[27] From 1912 to 1915, the Glackenses rented Carmen cottage (now 28 Bellport Lane; fig. 5). In 1916 the family moved from the cottage to a house in Brookhaven.

Bellport sits on the Great South Bay, protected from strong surf by the barrier of Fire Island. Enterprising sailboat "captains" operated ferry service to the ocean beaches on Fire Island, where a private club, Old Inlet Beach, was the most popular for Bellport residents. Facilities there were minimal but nonetheless required membership, and that membership was restricted. A 1911 photograph of Glackens and the Shinns (fig. 6)[28] suggests that Glackens was a member, although no major paintings of the ocean exist from the Bellport summers. He evidently preferred the activity and atmosphere of the bay beach. Bellport Bay has been described as the most picturesque portion of the Great South Bay because the land bordering its three sides is the highest along the entire bay front; it creates a scenic rise called Osborn's Bluff. Glackens frequently framed the scene in his paintings from this high vantage point (fig. 7). Adjacent to the beach was the first clubhouse for the golf club, built circa 1899, that stood just west of Academy Lane on the bluff overlooking the bay, with a long dock and steps leading down to the beach. The Bellport Yacht Club was formed in 1906 and the clubhouse was used exclusively by the Yacht Club when a new golf course was built in 1906. An important annual event was the Labor Day regatta, and Glackens painted *Bellport Regatta*, c. 1913 (Cheekwood Botanical Garden and Museum of Art).

Unquestionably, the Glackenses relished the convivial atmosphere in Bellport, where they were joined by many figures from the art, literary, and political worlds. Gertrude Foster Brown, president of the New York State Woman Suffrage Association in 1914, and her husband Raymond summered there. Barnes's mother had a home at nearby Blue Point, five miles west of Bellport, and Barnes and his wife visited regularly (plate 63). Frank Crowninshield ("Crownie" to his intimates), editor of *Vanity Fair*, was a Bellport personality, as were the mystery writer Mary Roberts Rinehart and the publisher Condé Nast. The Shinns were frequent visitors, and they reprised one of Shinn's Waverly Players presentations, *Hazel Weston or More Sinned against Than Usual*, written and directed by him, at Mrs. Edey's Nearthebay Playhouse.[29] Both the Glackenses had been recruited for the troupe several years earlier, staging performances in a theater built by Shinn himself in a small courtyard behind his studio at 112 Waverly Place.[30]

The novelist and humorist James L. Ford, author of the popular 1895 novel *Dolly Dillenbeck: A Portrayal of Certain Phases of Metropolitan Life and Character* and a close friend, looked back on the glittering times in a letter written to Edith in 1926.

"Bellport has changed a great deal, and not for the better, since you and I first knew it. I often think of the days when you and the Prestons [illustrators James M. Preston and his wife May Wilson Preston] and the Dwights [Hartford friends of Edith's] were there and I was stopping at that most admirable hotel, Hampton Hall.... Now the cottage colony is more given over to general noise and drink than it was then and nearly all the people I knew and like have either died or departed."[31]

In several early paintings from the Bellport years, *Vacation Home*, 1911, *Bathers at Bellport*, c. 1912, and *Jetties at Bellport*, c. 1916 (plates 64, 66, 68),[32] the stage is set and we see in place many of the elements that will cycle through the Bellport paintings. In *Bathers at Bellport*, the scene is from a westerly viewpoint, in fact the most extreme one Glackens will take. A figure emerges from the bathhouse and heads to the end of the pier, a structure that furnishes a strong horizontal element in the painting. Glackens's embrace of impressionistic effects is in abundant evidence here in the shimmering reflection of the sails of the boat in the middle ground and in the treatment of the beach grasses in the extreme foreground. *Jetties at Bellport* is remarkable for its energy, activity, and the youth of those depicted. One young swimmer climbs out of the water onto the pier, one runs on the pier toward the shore, and one races down the beach, as though these were three frames in a continuous moving image. Two bathers play on a floating pontoon anchored in deeper water. A small figure in the extreme foreground is leaning on a tall upended fishing net — it is, in fact, Glackens's young son Ira — perhaps contemplating a return to his pursuit. One placid figure is interested in nothing more than gazing out to sea: a young woman in a shimmering pink dress and white straw boater stands out in the middle ground. The fences and piers stack up horizontally as they recede into the distance, creating a visual balance.

In *Vacation Home*, Glackens has ventured a bit farther to the east where an imposing edifice, Bay House, built as a luxury hotel in 1874, fronts the beach, with a summerhouse (or gazebo) standing between the house and the water. The hotel was sold at the turn of the century to the Jewish Working Girls' Vacation Society of New York, a charitable organization founded in 1892 by Selina Ullmann Greenbaum (1866–1925). For a nominal fee, Jewish girls of working age could enjoy two weeks of vacation from the city.[33] Nearly forty girls are depicted in this painting, most frolicking in the water. Strong architectural elements include the hotel tower in the background, a row of bathhouses to the right, and the summerhouse and No. 2 Bellport Lane on the left. Forceful and vibrant color, as well as the feathery touch of the trees in the background and the grasses in the foreground, make for a lively and animated composition.

By the next summer, the number of figures has increased and a noticeable choreography emerges as they become those "spots of color" subsumed into the overall composition. Four paintings from the summer of 1913 demonstrate just how complex Glackens could be in his structure. *Beach Side*, 1912 – 1913 (plate 69), and *Summer Day, Bellport, Long Island*, 1913 (plate 67), taken together, form a 180-degree panorama of the shoreline — *Beach Side* looking west and *Summer Day* looking east. The building seen in both paintings is the first clubhouse for the golf club, built around 1898 and shared with the yacht club after 1906. Stick piers, whose elegant profile adds such visual interest, were often taken down in the winter to avoid the stormy weather (fig. 8). Steps built off the end of the pier made for easier entry into the water. *Beach Side* is perhaps a scene earlier in the season, as most of the group, which appears to be all women and young children, are clothed and observing from the shore; only three swimmers are in the water. The view to the southwest looks out to sea where two sailboats, one under full sail, occupy the center of the composition. Judging by the evenness of the light, the day is somewhat overcast. The pier, as in most of Glackens's beach paintings, functions as a strong horizontal and the building on the right as a framing architectural element. *Summer Day*, by contrast, is gloriously sunny, the blue of the water a dominant color, rich and saturated. We see the porch now from the opposite side and the view turns east. The club porch in the near left foreground again forms a strong element. The house visible just beyond No. 2 Bellport Lane reappears frequently in Bellport paintings. In the distance is the summerhouse or gazebo that figures prominently in the *Vacation Home* paintings. Again, the strong horizontals of the pier balance the picture. A 1912 Bellport sketchbook is a virtual storyboard for *Beach Side* and demonstrates how Glackens used his abiding techniques of instantaneous observation to vividly translate the spontaneity of the scene to the canvas (fig. 9).

One begins to sense the pull of this stretch of beach, not so much for its distinction but for the mutability of its components that, over the course of five years, will become so familiar to Glackens. *After Bathing, Vacation Home*, 1913 (plate 65), is painted from a vantage point just to the left of the one in *Vacation Home*. The scene depicts the moment after the girls emerge from the water, bend and arch their backs to dry their hair, and again gather in groups to sit on the beach. The close focus eliminates the sky. Glackens has introduced the effects of color and light into his paintings yet has not diminished his first love of conveying what he observes. The presence of the young women on this beach is as expected as the presence of Glackens's family just to the west. The women would not have seemed particularly remarkable or exotic to Glackens, who was familiar with most neighborhoods in New York, including the Lower East Side settlement houses. From

his studio on the second floor at 50 Washington Square South he continued to have a vantage point on the neighborhood. Twenty-eight fine homes had made up Washington Square North, but by the turn of the century, only four of the twenty-five remaining homes were still occupied by the original owners' children or grandchildren.[34] Yet Glackens relished the scene he observed from his house, his studio, and the street.[35] Bellport provided some of that same variety.

The centerfold for the Labor Day 1913 edition of *Harper's Weekly* was a reproduction of a Glackens illustration titled *Vacations* (fig. 10) — it demonstrates that the two facets of his career were still aligned. The scene no doubt would have surprised some readers as the locale did not look like a typical vacation spot, although it is the Bellport beach in front of the vacation home, where the young women in the water and on the shore are enjoying their two weeks at the beach. The two central figures, both drying their hair, one arching back, one bending forward, are identical to two central figures in *After Bathing, Vacation Home*. Glackens has shifted his viewpoint and, in a departure from most Bellport beach images, looks east in the direction of Osborne's dock, a decidedly less scenic prospect. None of the young women is attired in stylish swimwear as pictured on page ten of the magazine, accompanying an article entitled "Modesty in Women's Clothes." The author, Francis R. McCabe, quotes the noted British physician and psychologist Havelock Ellis: "There ought to be no questions regarding the fact that it is the adorned, the partially concealed body, and not the absolutely naked body, which acts as a sexual excitant."[36] The author goes on to recognize how quickly styles in women's fashions are spread. "In our aspiring democracy a distinctive working costume is unthinkable, but the working woman is very clever in adopting quickly any costume which the rich may wear, for whatever occasion it was originally designed. For instance, when certain summer girls took to wearing what is commonly known as the "middy blouse" for rougher forms of sport and tennis, the same costume suddenly bloomed out in great profusion in all the factory districts of all our towns."[37] The placement of this illustration situates Glackens's work firmly in the contemporary discourse.

By the summer of 1914, Glackens has begun to create more elaborate compositions (plate 62). *At the Beach*, c. 1914 – 1916 (plate 70),[38] was likely painted in the early part of the summer of 1916, the last one the Glackens family spent in Bellport. An outbreak of infantile paralysis (polio) created a great deal of panic — the "summer plague," as it was known, was widespread. By midsummer a *New York Times* headline read QUARANTINE GUARDS ON THE ROAD[39] and the Glackenses decided to leave the Bellport cottage and move several miles east to the neighboring

hamlet of Brookhaven, to a more isolated cottage with surrounding property. Glackens's later works include more figures and more activity, perhaps anticipating Bellport's growing popularity. In *At the Beach*, a roiling sea stirs bathers and promenaders on the covered pier alike. The foreground figures are solid and grounded. Those on the pier and under the portico are more elongated, anticipating Glackens's later attenuation of the figure. The female figure clutching her hat brim looks out to sea, perhaps searching for a child in the water. Two women in the left foreground are engrossed in conversation; a striped bathing costume becomes a prominent feature. A sketchbook study for the painting, made in 1916, reveals an amazing fidelity to the final work (fig. 11).

Captain's Pier, 1912–1914 (plate 71), one of the more complex of the Bellport paintings, may emphasize this growing division by contrasting the simple summer pleasure of the Village of Bellport, as seen in the rustic bath houses on the left and the elegantly clad crowds now frequently disembarking at the Captain's Pier. In *The Raft*, 1915 (fig. 12), and *The Water Slide*, c. 1915 (Willard Straight Hall Student Union Collection, Cornell University), Glackens moves the action offshore to show rollicking divers, bathers, and boaters. Purposeful dissonances are in place as well as the harmonious balance of color, form, and line.

Glackens's Bellport paintings are remarkable for their focus, over a five-year period, on a singularly confined strip of bay beach. Taken as a whole, they form a seamless record of experimentation and innovation. While it is not unusual for an artist to return to a locale year after year, Glackens's time in Bellport is distinguished for the straightforward transcription of the everyday that might otherwise go unrecorded. Ultimately, his preoccupation has become the play of form and light, the drama of color and balance.

Summer paintings that may date to 1917 include *North Beach Swimming Pool* (private collection). The Glackenses did not procure a seasonal rental that year because much of the summer was spent in West Hartford after the death of Edith's parents in May. Glackens may have remained in the city for extended periods. The pool was in North Beach, on the northern Queens shore of Flushing Bay (now East Elmhurst, the current site of La Guardia Airport), and easily accessible by ferry boat from East 92nd and 129th Streets and trolley service on the weekends. By the time Glackens visited, the beach had become polluted and most visitors came for the amusement park with the adjoining pool. In 1918 the Glackenses summered in Pequot near New London. In *At the Beach*, c. 1918 (plate 72), the bathers and beachgoers are the main attraction as they swim, sun, and converse at the water's edge facing the viewer. The figures are more modeled than in the Bellport paintings and Glackens concentrates to a greater degree on individualizing the participants, both in their facial features and their postures.

After the Beach

The Artist's Wife Knitting, c. 1920 (see page 111, fig. 8), is set in the sitting room of the Glackenses' new Village townhouse at 10 West 9th Street with a studio built on the top floor. Although now living only a few short blocks from Washington Square, the artist found himself less drawn to the life of the street. One of his still lifes hanging on the wall behind Edith may signal, as did the inclusion of a beachside painting in *Girl with Apple*, the artist's intentions and his thoughts of a future course. The last summer in Bellport, Glackens took advantage of the family's "fine garden" and primarily painted flowers, confiding in a letter to Robert Henri that he had thoroughly enjoyed this new pursuit.[40]

Glackens returned to the beach theme intermittently over the years. During the summers of 1920 to 1924, the family rented a house on a lake near Conway, New Hampshire. On a seven-year sojourn in Paris (a long-held dream of returning to live in France), he continued the practice of summers outside the city, and from 1926 to 1927, the family stayed at L'Isle-Adam, on the Oise River, just north of Paris, where the artist painted *The Beach, Isle-Adam*, 1926/1927 (see plate 94). A dozen young women in contemporary bathing attire swim, stand, and lounge by a wooden barricade in the foreground that secures a safe swimming area in the swiftly flowing current. In the middle ground vacationers sit under umbrellas, and in the distance an elegant clubhouse with red-tiled roof dominates the right side of the composition, balanced on the left by a stand of trees with emphatically delineated brushstrokes. The scene is at once more hedonistic and languorous than Glackens's American beach scenes, with a new attention to an overall orchestration of color.

In *Beach, St. Jean de Luz*, 1929 (see plate 96), we see that Glackens remains steadfast throughout his career in the ambition of these beach paintings and the significant place they retain in his oeuvre. One of the last French beach scenes, painted on the côte Basque, is as dense and vibrant as any depiction of a day at Coney Island. The Glackenses were seeking a change from the Mediterranean and set out for Hendaye, the most southerly resort on France's Atlantic coast, but the artist found that particular town "unpaintable."[41] He discovered that the nearby fishing village of Saint-Jean-de-Luz was much more to his liking and the intimate beach there perfect for his artistic purposes. Could the stylish couple in the center of the composition with arms intertwined, looking out to sea, be a stand-in for the artist and his wife? They add an elegiac note to this otherwise brilliantly sunny day at the beach, one of the last seaside paintings Glackens would complete.

Glackens's great friend Barnes wrote about him in *The Art in Painting* (1925): "He shows with detachment the essential picturesqueness and humanity of the events represented, and his

9

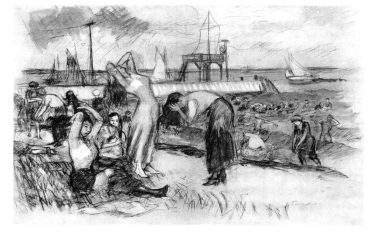

10

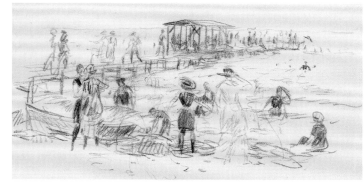

11

12

only comment upon life is that it is pleasant to live in a beautiful world."[42] Although written with much affection and admiration, Barnes's assessment, widely quoted over the years, may unwittingly diminish the scope of Glackens's contribution by implying that his art was one of ease. On the contrary, it is an art of ambition and aspiration, striving to produce the best possible painting.

In choosing to work at the juncture of land and sea, Glackens discovered a milieu perfectly suited to his enterprise, where he could ultimately transcribe to canvas with brush and paint the qualities of air and light.

For notes, see page 243.

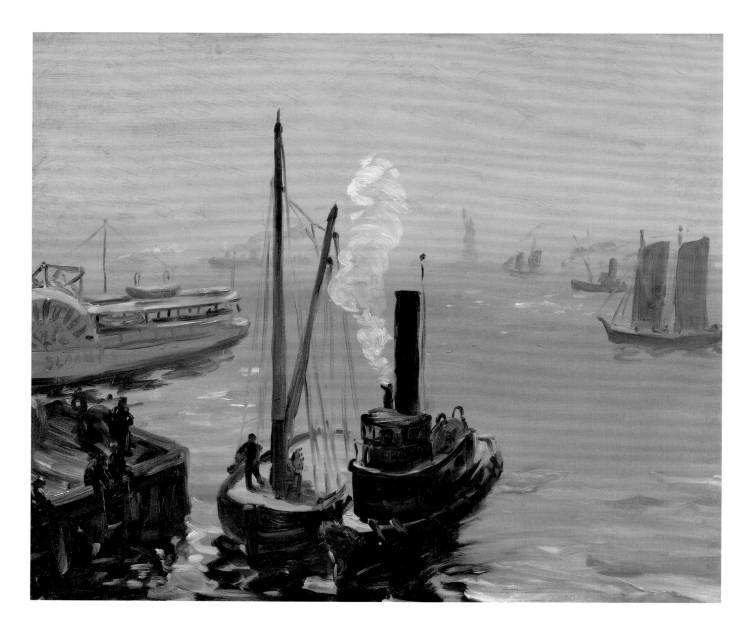

54

Tugboat and Lighter, 1904–1905
Oil on canvas, 25 × 30 (63.5 × 76.2)

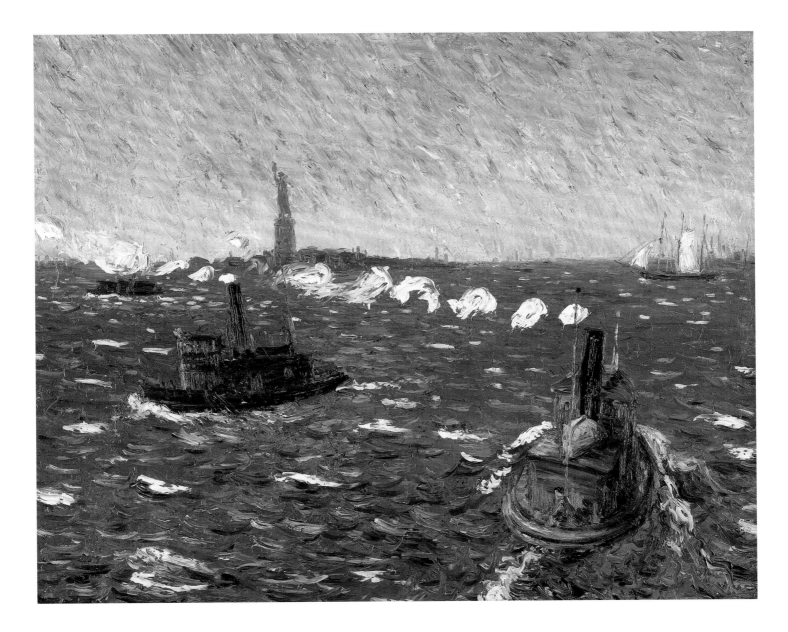

55

Breezy Day, Tugboats, New York Harbor, c. 1910
Oil on canvas, 26 × 31¾ (66 × 80.6)

56, 57

Morning at Coney Island, c. 1907 – 1909
Pencil, chalk, and wash, 8 × 11½ (20.3 × 29.2)

Afternoon at Coney Island, c. 1907 – 1909
Chalk, watercolor, and gouache, 14½ × 18⅝ (36.8 × 47.3)

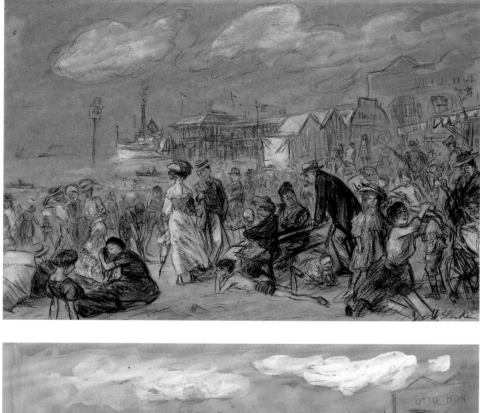

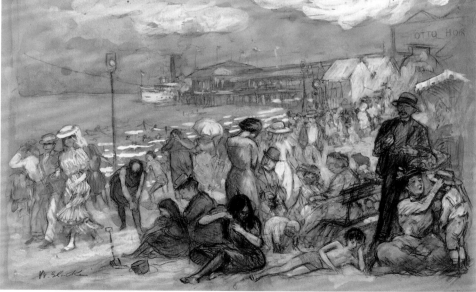

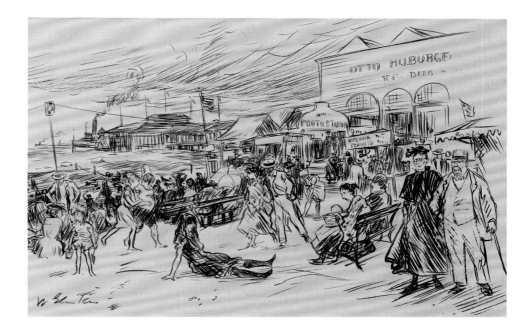

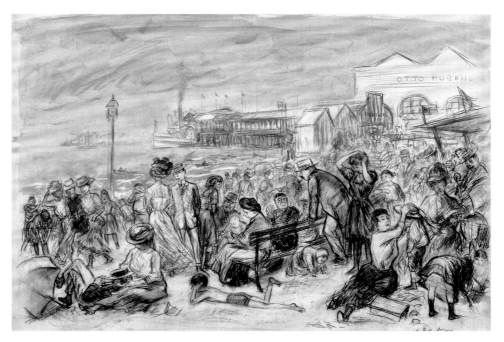

58, 59

Coney Island Beach Scene, c. 1907–1909
Ink and brush on machine-made wove paper, 8⅞ × 12¾ (21.8 × 32.4)

Beach, Coney Island, c. 1907
Illustration crayon, wash, and Chinese white, 22¼ × 29 (56.5 × 73.7)

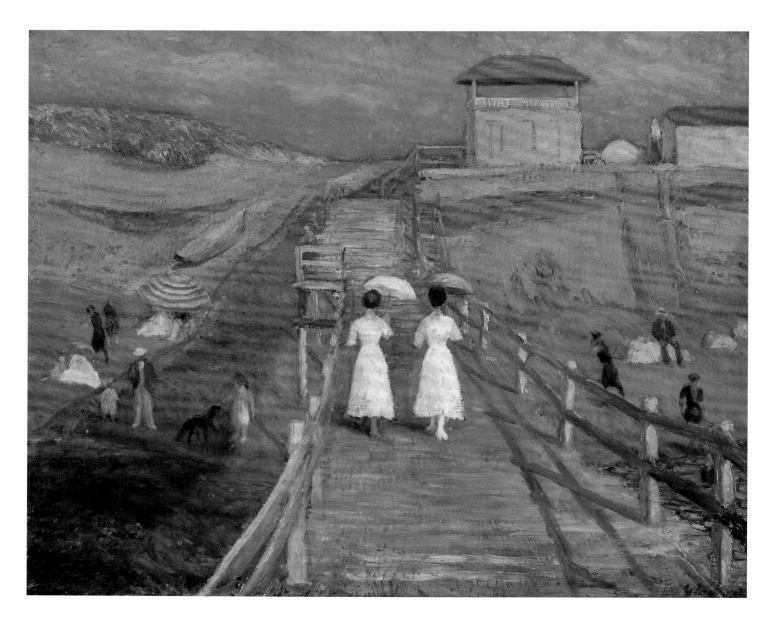

60

Cape Cod Pier, 1908
Oil on canvas, 26 × 32 (66 × 81.3)

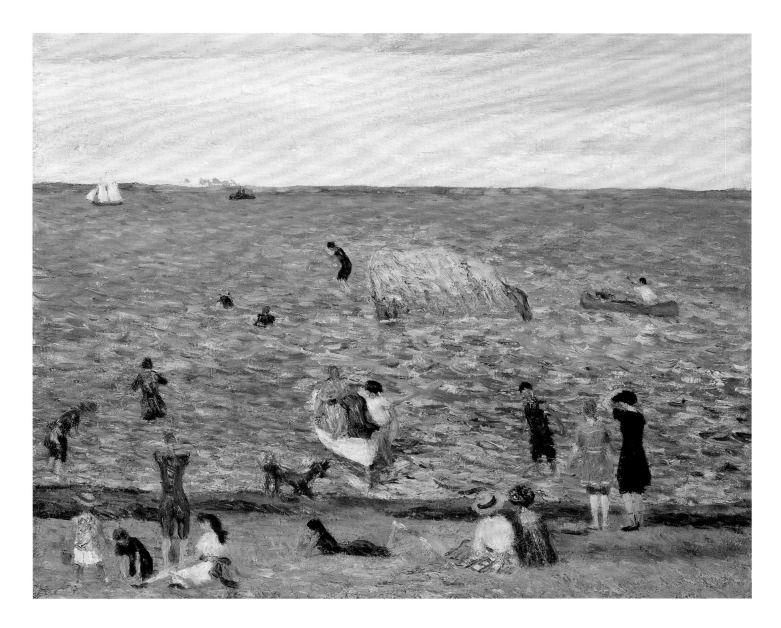

61

Rock in the Bay, Wickford, 1909
Oil on canvas, 26 × 32 (66 × 81.3)

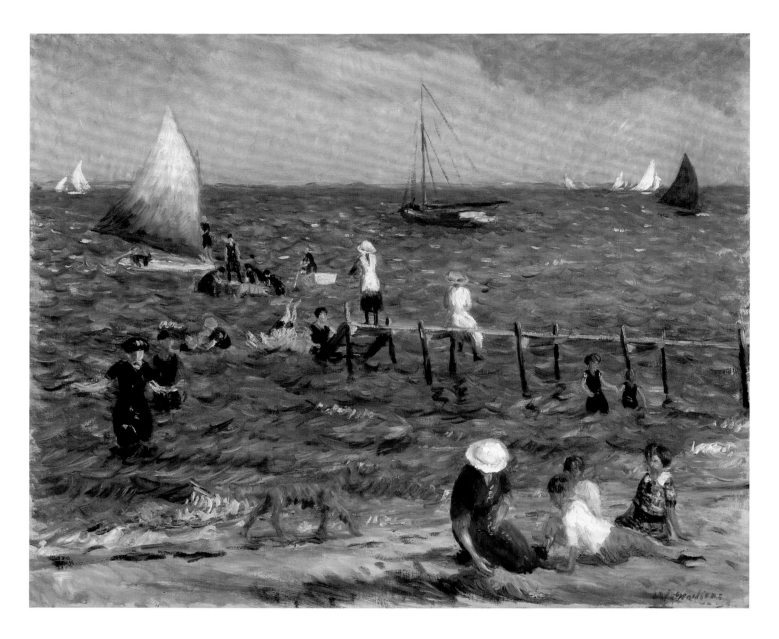

62

The Little Pier, 1914
Oil on canvas, 25 × 30 (63.5 × 76.2)

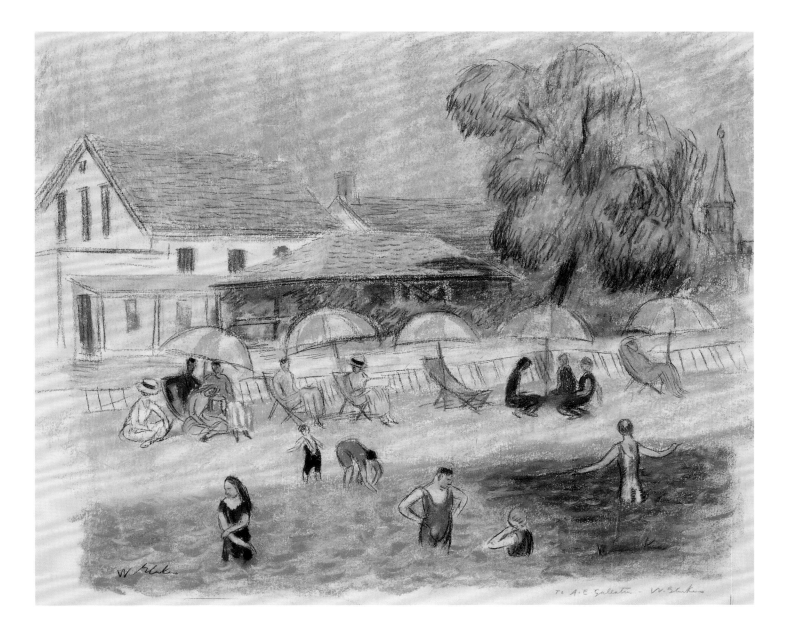

63

Beach Scene, c. 1914
Pastel and chalk, 17¼ × 22 (43.8 × 55.9)

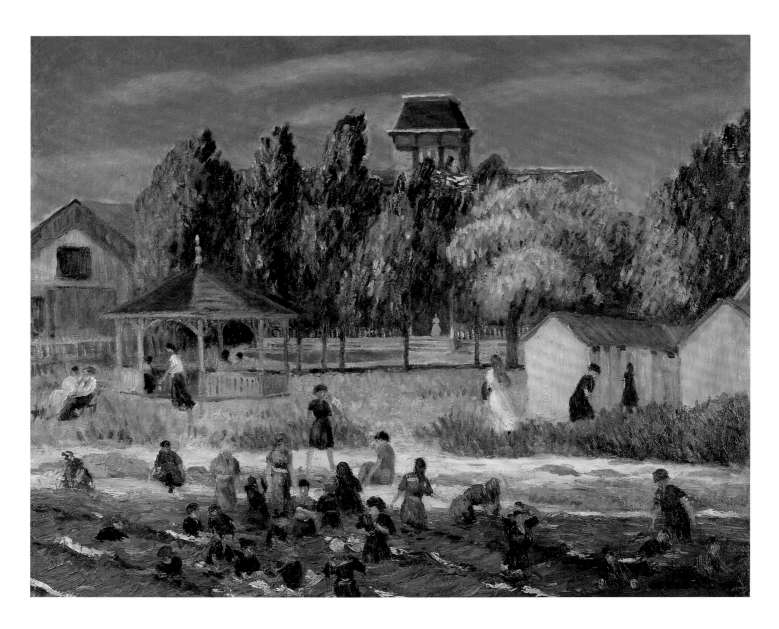

64

Vacation Home, 1911
Oil on canvas, 26 × 32 (66 × 81.3)

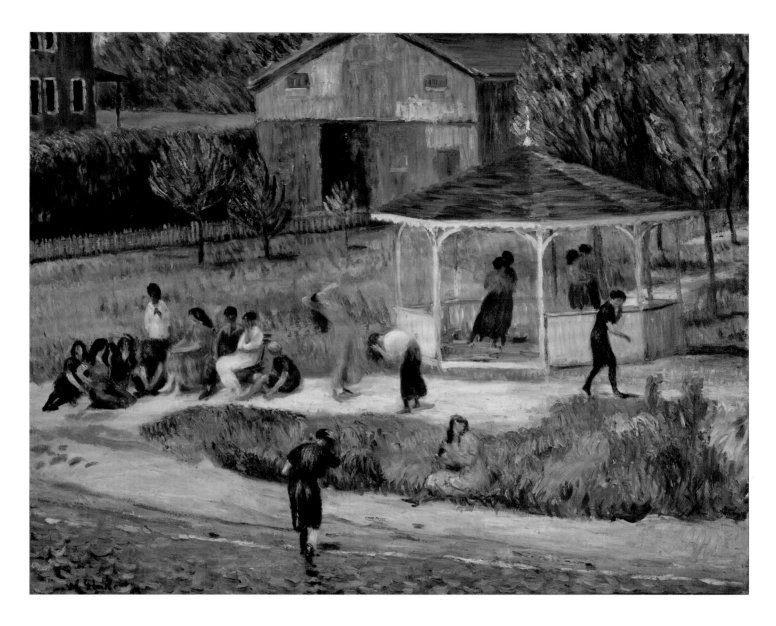

65

After Bathing, Vacation Home, 1913
Oil on canvas, 26 × 32 (66 × 81.3)

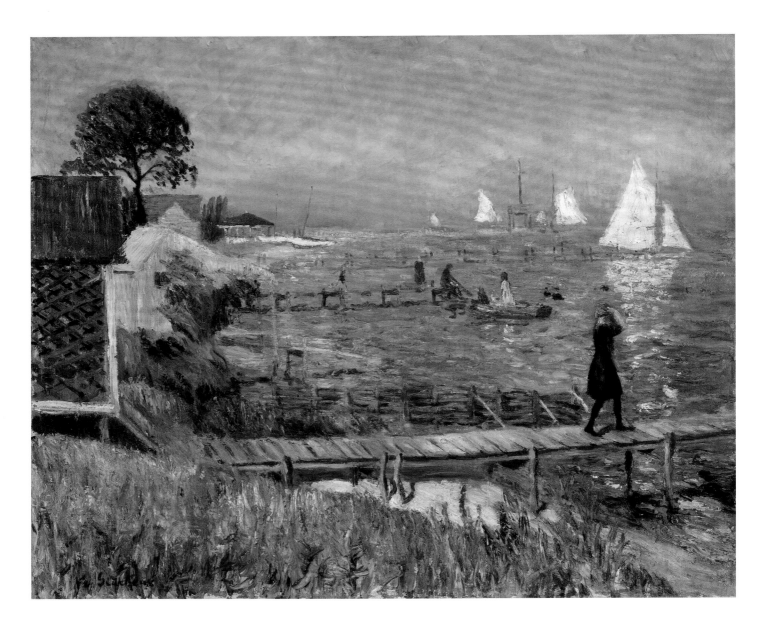

66

Bathers at Bellport, c. 1912
Oil on canvas, 25 × 30 (63.5 × 76.2)

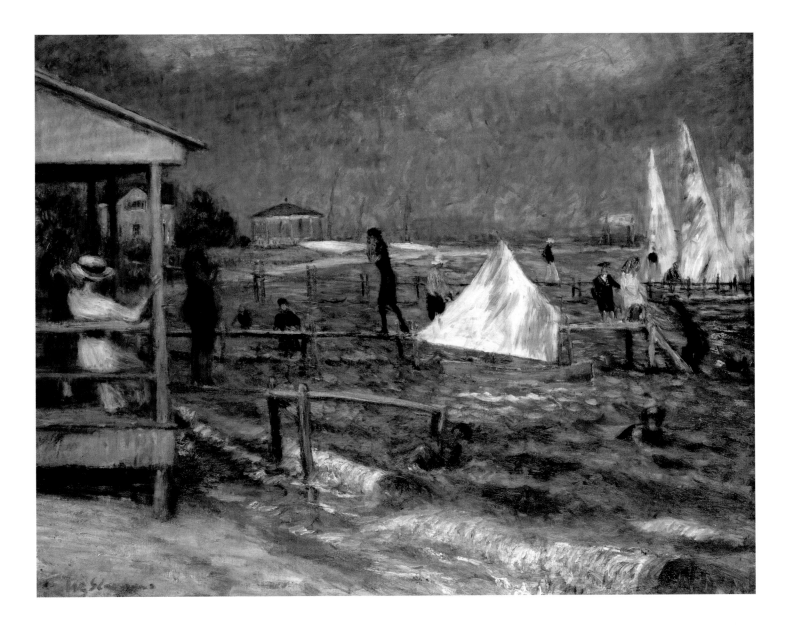

67

Summer Day, Bellport, Long Island, 1913
Oil on canvas, 26⅜ × 32⅛ (67 × 81.6)

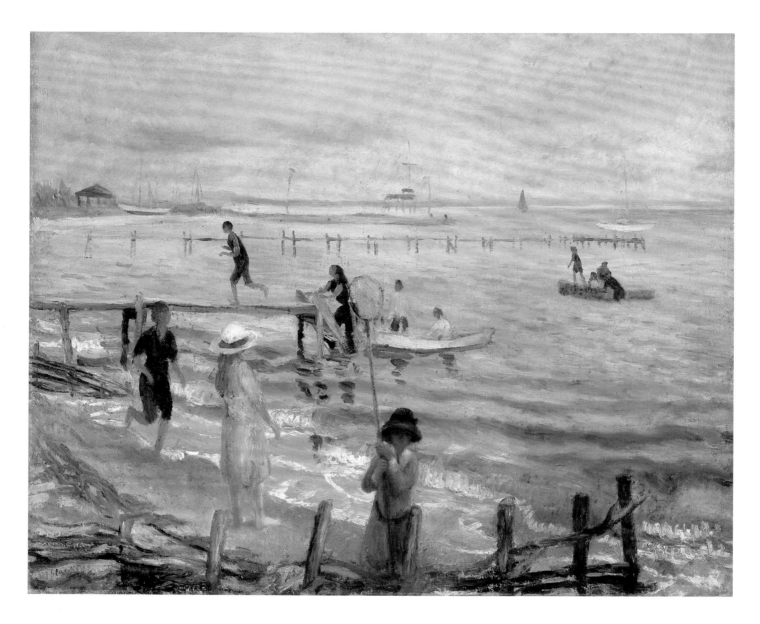

68

Jetties at Bellport, c. 1916
Oil on canvas, 25 × 30 (63.5 × 76.2)

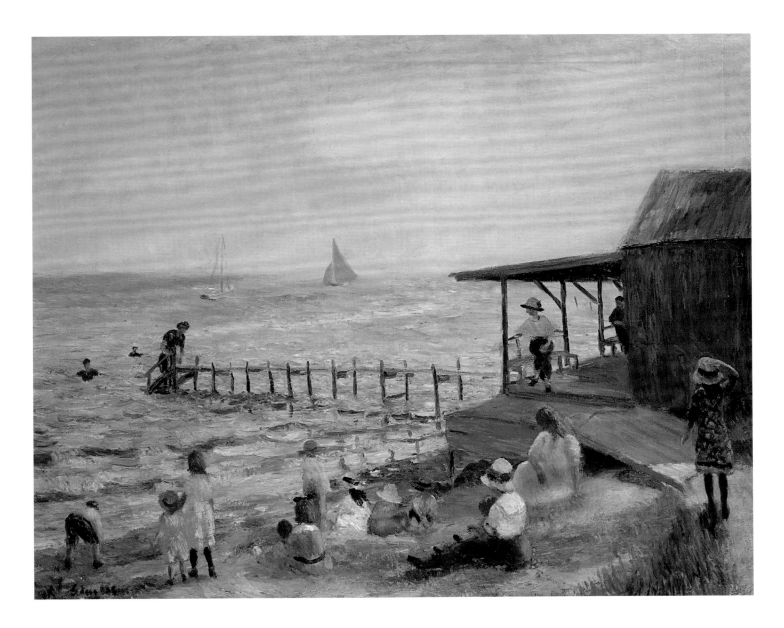

69

Beach Side, 1912–1913
Oil on canvas, 26⅛ × 32 (66.4 × 81.3)

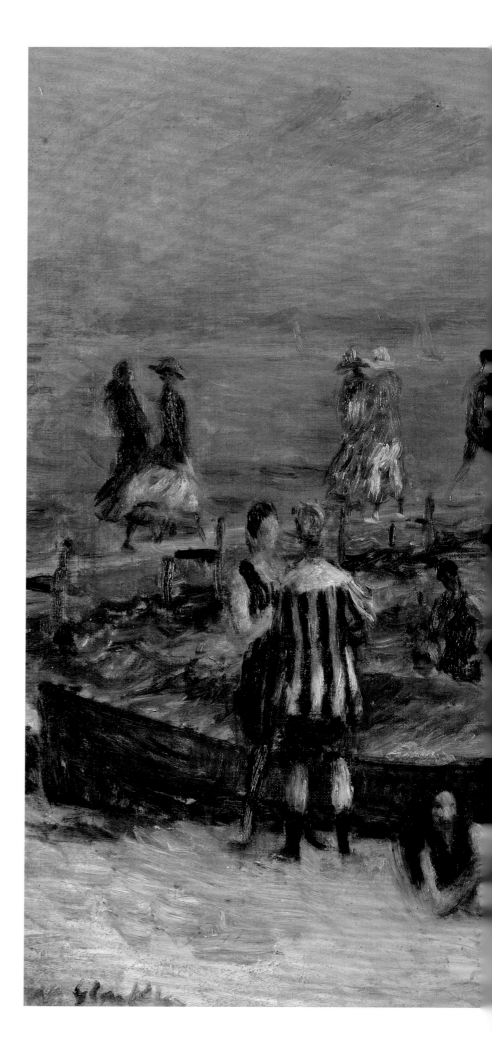

70

At the Beach, c. 1914 – 1916, signed 1917
Oil on canvas, 18⅛ × 24¹/₁₆ (46 × 61.1)

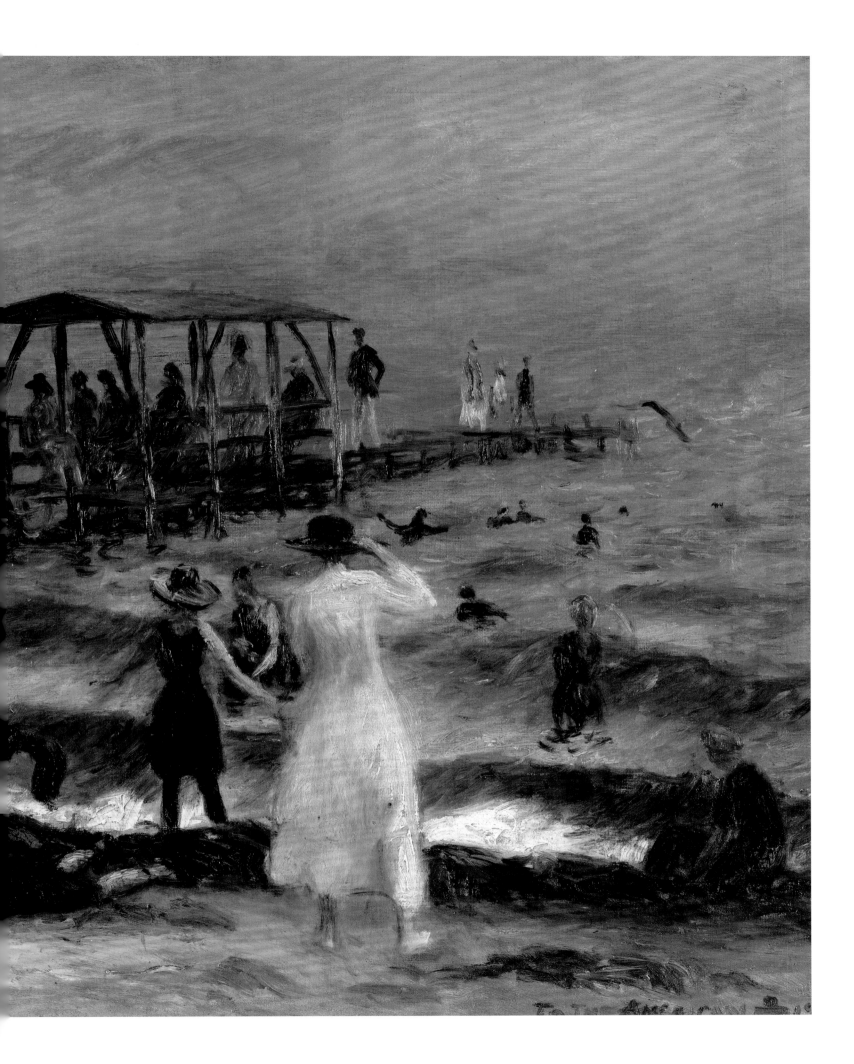

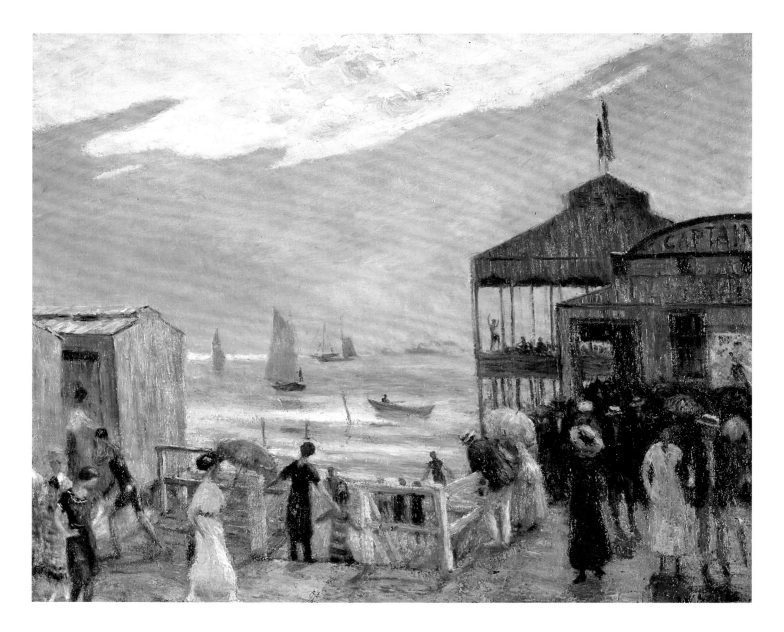

71

Captain's Pier, 1912–1914
Oil on canvas, 25⅛ × 30⅛ (63.8 × 76.5)

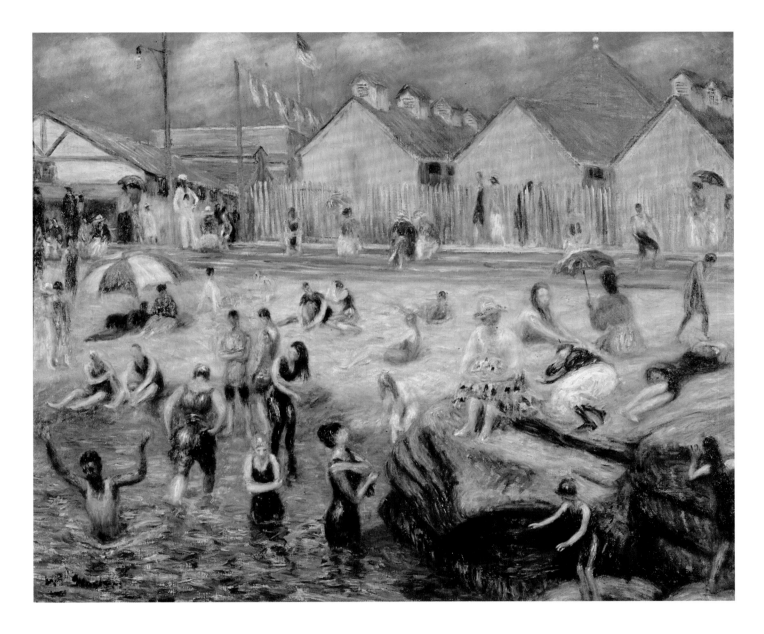

72

At the Beach, c. 1918
Oil on canvas, 25¼ × 30 (64.1 × 76.2)

The Ladies' Paradise: Glackens, Costume, and Fashion

PATRICIA MEARS

William Glackens had a much livelier interest in fashion than most of his peers in The Eight. The consistent and conspicuous use of fashion in his paintings throughout his career, often carefully selected and styled by the artist himself, aligned Glackens with leading French avant-garde painters of the previous century who used clothing as a metaphor for modernity. Two of his most famous paintings, for example, *At Mouquin's*, 1905 (see plate 45), and *The Shoppers*, 1907–1908 (plate 75), present high fashion as a visual centerpiece and employ it as a vehicle to convey the essence of the artist's sitters, as well as the immediacy of his urban world. For the leading French artists of the late nineteenth and early twentieth century, the connection between fashion and art was similarly compelling and has become an increasingly important area of study in recent decades.[1]

This essay examines a select group of paintings by Glackens. Comparisons between these works and earlier, nineteenth-century French avant-garde paintings illustrate that Glackens, as did the impressionists before him, understood fashion as a potent commodity that expressed the vibrancy of modern urban life. Clearly, Glackens appropriated elements from his predecessors and contemporaries, but far from being a mere copyist, his work indicates that he was aware of clothing depictions in popular media such as fashion plates (illustrations in magazines that could be removed). Although these images had been a source of inspiration for the impressionists and later French schools of art, their style changed dramatically in the early years of the twentieth century as they became densely colored, cleaner, linear, and more sophisticated in subject matter. These developments, as well as the advances in fashion photography, are reflected in the dramatic change in Glackens's paintings around the same time. For him, fashion was a splendid visual cipher that conveyed the social

standing and sexual identity of the wearer. Additionally, the artist valued fashion for its aesthetic enrichment of the urban arena and its association with commerce.

The connection between Glackens, his art, and fashion affirmed that he was an avid witness of women, children (plates 71, 79), and their costumes. In addition to paintings, he produced numerous drawings and sketches documenting women in all sorts of coats, dresses, blouses, skirts, shoes, stockings, and hats.[2] He almost always selected the clothing that female friends, family members, and models wore when they posed for him. The roles of the painter and his model mirrored the newly created relationship between the male couturier and his female client. Englishman Charles Fredrick Worth (1825–1895) supplanted the leading female dressmakers of the mid-nineteenth century in Paris when he began to market himself as far more than just a merchant or talented craftsperson. Worth did not have technical dressmaking or tailoring skills; dressed in a smock and cap, à la Rembrandt,[3] he dictated his groundbreaking designs to both client and atelier worker. He was an "artist of fashion" who set global fashion trends.

Works that most strongly feature fashion in the Glackens oeuvre were first produced in the later years of the nineteenth century and ranged from simple figure studies to formal portraits to intimate depictions of friends and family. The various painting genres not only reflected the presentation of fashion as executed by leading French artists, but they also revealed the tension between social standing and sexual identity in Glackens's female sitters. Three examples of this polarity between the respectable bourgeoise and her fashion rival, the woman of the demimonde, may be seen in *Girl in Black Cape*, 1897 (fig. 1), *Portrait of the Artist's Wife*, 1904 (see plate 40), and *Seated Actress with Mirror*, c. 1903 (plate 76). In depicting each female type, Glackens invoked the mantra of the avant-garde artists of the late nineteenth and early twentieth century as articulated by Baudelaire: paint the "heroism of modern life."[4]

In *Portrait of the Artist's Wife*, Edith Glackens, a trained artist, is not depicted in the more overtly feminine vein of painters such as Mary Cassatt, for example, who was noted for her ability as an artist to capture "Parisian elegance" and the charm of modern feminine beauty as well as for her personal interest in high fashion. Instead, Glackens channels the severity and monumentality of Diego Velázquez, as interpreted by Édouard Manet, and, later, by James McNeill Whistler and Robert Henri. Like the dark clothing worn by Whistler's monumental figures of the 1870s and 1880s, positioned in shadowed and hazy environments, Edith's costume is rendered in a style that more closely parallels Glackens's depictions of male sitters. Examples include his portraits of Charles FitzGerald, 1903 (see plate 29), and

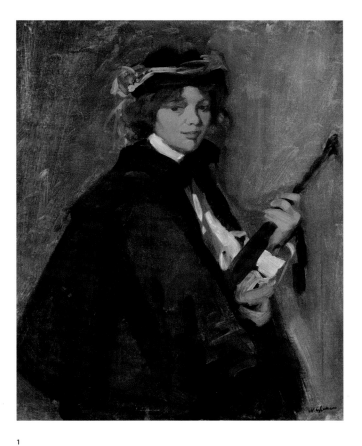

1

FIGURE 1
Girl in Black Cape, 1897.
Oil on canvas. Museum
of Art, Fort Lauderdale,
Nova Southeastern
University; gift of the
Sansom Foundation

FIGURE 2
*Late Day or Dinner Dresses
by Martial et Armand.*
Fashion plate illustration
by René, from *Femina*
(Paris, 1905), 486

FIGURE 3
The fur salon of Maison
Redfern. Photograph. From
Les Créateurs de la mode,
ed. Charles Eggimann
(Paris, 1910)

FIGURE 4
The main salon of Maison
Doucet. Photograph. From
Les Créateurs de la mode,
ed. Charles Eggimann
(Paris, 1910)

4

2

SALON DE FOURRURES
REDFERN

3

Ferdinand Sinzig, 1905 (Museum of Art, Fort Lauderdale)—both are elegant, commanding representations.

Glackens perhaps took a cue from Whistler in his canvas *Girl in Black Cape*, in which the rigid social markers evident in women's high fashion were likewise blurred. The broad expanse of the unknown sitter's dark cloak, white shirt, dark tie, tasseled umbrella (which can be read as a cane), and small, jaunty hat—all elements of the male wardrobe—erase obvious gender distinction. The same could be said of the grand ensemble worn by Edith Glackens in *Portrait of the Artist's Wife*. Here, Glackens chose a costume that bisects the body: the top is a dark cloak that obfuscates the female form, as do the coats and cloaks of Glackens's male subjects; the bottom is a sweeping, tiered and pleated skirt that also hides the body but unmistakably denotes the wearer's restrained femininity. Like the dark and moody rendering of her costume, Edith's identity glides between the masculine and the feminine—and also between the bourgeois and the bohemian, the professional artist and the dilettante.

While the portrait of Edith is a complex presentation of female fashion, a more explicit determination of the subject's social position and profession is evident in a painting executed by Glackens the year before, *Seated Actress with Mirror*. Here the clothing, or lack thereof, of the female sitter denotes an overt sexual intimacy that was rare in American paintings at that time. Despite the restricted color palette, Glackens's commanding skills as a draftsman are on view, obviously inspired and informed by his numerous theater illustrations. The subject and style of presentation are similar to Edgar Degas's images of informally seated ballerinas and bathing female nudes.

The back rooms of theaters were the realm of actresses and dancers. In the second half of the nineteenth century in Paris, the classrooms, wings, and stage of the magnificent Palais Garnier were home not only to the Paris Opera and its ballet, but also to some of the city's poorest girls who struggled to become fairies and nymphs on stage but frequently succumbed to prostitution. Access to these young dancers was a privilege paid for by wealthy male subscription holders, called *abonnés*, who often lurked in the foyers, flirted with the dancers in the wings, and then "laid siege to them in their dressing rooms."[5] Degas managed to gain entry to this private realm, and in *Seated Actress with Mirror*, Glackens clearly emulated the sense of intimacy that Degas's works conveyed.

It can be argued that Glackens's most celebrated work, *At Mouquin's*, is proof that fashion was a key element in conveying a vigorous slice of contemporary life in New York. This branch of Mouquin's celebrated restaurant—the second one—was founded in 1898 under the management of Swiss-born Henri Mouquin and his son, Louis. It was patronized by theatergoers

and members of The Eight, including Glackens. A little bit of Paris in New York, it served French wine and featured French music.

Within this Franco-American setting, Glackens positioned two central figures—James B. Moore (owner of Café Francis, Mouquin's competitor), seated on the right, and Jeanne Louise Mouquin, the wife of the owner and a true French model, on the left. Moore is clearly more animated than his companion, who faces away from him with a look of ennui. Yet his blocky frame, clad in black and white, occupies less than a quarter of the frame. She, by contrast, is the centerpiece and dominates the canvas, in a wide, sweeping hat and bright blue dress that is at once sinuous and frothy.

Madame Mouquin is depicted in a manner that seems at odds with her surroundings. The crowded and animated restaurant, as suggested by the numerous figures reflected in the mirror behind Mouquin and Moore, is a foil for her reserved manner. Some have proposed that Glackens may have found inspiration in Degas, specifically *The Absinthe Drinker*, 1875–1876 (Musée d'Orsay, Paris),[6] and the dour expression of its central female figure, but contemporary critics wrote that her expression conveys the unsavory relationship between Moore and Mouquin as one of a young woman trapped by a predatory older man. While this scenario is unlikely, the portrayal of Mme Mouquin reveals the complex signals communicated by women and the fashions they wore.

Mouquin's dress is either an afternoon or a dinner dress. It is decidedly "of the moment" with its high neckline, full and billowy bodice, fitted sleeves that flare out at the elbows into a trumpet-shaped ruffle, and bell-shaped skirt that caresses the wearer's form, very much in keeping with the overriding style of the era: the sinuous, organic art nouveau (fig. 2). The icy blue fabric is diaphanous, possibly silk chiffon, and ornamented with at least two types of lace—a finer and lighter version at the neck and a heavier type around the arms and on the skirt. The entire garment is boldly punctuated with horizontally applied bands of black ribbon that form stripes and lattice patterns on the sleeves and skirt. If *At Mouquin's* is Glackens's masterpiece, then this gorgeously rendered gown is the painting's crowning achievement. But it is also a potent symbol that displays Mouquin as a most enticing commodity, one whose role in the work and true identity are not easily reconciled.

If the morality of the women portrayed in Glackens's entertainment and café works was questionable, no such assessment may be made of those depicted in another of his most celebrated paintings, *The Shoppers*, executed primarily in 1907 and completed in early 1908. The theme of urban shoppers was addressed by Glackens as early as 1899, in a series of drawings

illustrating Abraham Cahan's story "Rabbi Eliezer's Christmas" for *Scribner's Monthly*.

While Glackens executed other such scenes, a large-scale work that focused on an intimate group of strictly upper-middle-class ladies shopping was new for the artist. Part group portrait, part snapshot of contemporary life, the work exhibits a connection to the seventeen pastels and four oil paintings executed by Degas between 1879 and 1886 — specifically depicting an interchange between customers and clients in a millinery shop — and a later series (1890s to about 1910) from which bourgeois clients were excluded. Like Degas, who showed the painter Mary Cassatt, a close friend, trying on hats, Glackens painted people he knew well. *The Shoppers* finds his wife, Edith, in the center; Lillian Gelston Travis, an artist colleague of Edith's, is seated with her back to the viewer; and Florence Scovel Shinn, his classmate at the Pennsylvania Academy of the Fine Arts and wife of painter Everett Shinn, stands to her right. In the darkened background, another unidentified shopper and a salesgirl can be seen.

Fashion and art in the late nineteenth century can hardly be contemplated without also considering commerce, the lifeblood of the modern world. Other artistic disciplines, such as literature, were engaged in conveying the connection between fashion and the worlds of manufacturing and retailing. One of the most celebrated literary publications on the subject is Émile Zola's novel *Au Bonheur des dames* (*The Ladies' Paradise*; 1883) — it remains the quintessential work on the department store and its female staff and patrons. If retail was so important to Parisian fashion, why was shopping not a more frequent subject for painters, just as it was for writers? It is ironic that for all their efforts to capture the modern world, few artists in France and the United States depicted the retail environment — be it a large department store, couture house, arcade, or small shop.[7] Glackens broke new ground with his splendidly but not idealistically rendered *The Shoppers*. (Two years later, a publication of Parisian haute couture was issued that featured photographs of its clients shopping, figs. 3, 4.)

The large scale of this painting is unique. So, too, is its highly finished quality (the furs, feathers, and cloth of selected garments can be easily read), and the individualized treatment of its multiple sitters, particularly the beautiful Florence Shinn and Edith, who was sometimes criticized for her homeliness. Even more striking is Glackens's staging of the dynamic interchange among the women positioned in the sensuous surrounding of a fashion store.

One of *The Shoppers*' most pronounced statements about women, fashion, and retail is the obvious distinction between clients and workers. Glackens, like Degas, relegated the shopgirl to the background, and both Edith Glackens and Lillian Travis look not at her but at the garment she holds for the shoppers'

inspection. The anonymity of such workers is reiterated in Glackens's *Shop Girls*, c. 1900 (see plate 43). There, a crush of young women in tailored coats, full skirts, and fashionable hats are bustling along the city streets as they appear to be leaving work. While they and their clothes are rendered respectfully and with care, there is little distinction between the women. Their individuality seems to be subsumed by the clothing and the frenzy of their movements.

By 1908, Glackens's work underwent a seismic shift. That year, The Eight held an exhibition at Macbeth Galleries in New York that attracted thousands of visitors before traveling to ten other venues. The show marked the end of predominantly dark colors for Glackens. Major changes were on the fashion horizon as well. Around 1908, women's high-style clothing was becoming more streamlined in silhouette, more vibrant in its color palette, and decidedly less nuanced in patterning and ornamentation. The revival of classicism, the influence of the Ballets Russes at its Paris debut in 1909, and the rise of a new group of young and experimental fashion designers in Paris — including Paul Poiret and prominent female couturiers, such as Madame Jeanne Paquin and Jeanne Lanvin — touched off a breathtaking change in the way fashion was depicted and disseminated. More avant-garde artists than ever before had begun to illustrate fashion plates, and in a manner that reflected the bolder new styles.

The work by Glackens that best illustrates the new trends in fashion is *Family Group*, 1910/1911 (see plate 39). It depicts four figures in an array of styles: Edith's simple, shift-style day dress is made from a vibrant *changement* (shot silk) in blue-green and pink-purple; her sister, Irene, wears a hat and fur-trimmed plush coat over a violet-blue dress; the Glackens's young son, Ira, age nine, is seen in an embroidered tunic; and Grace Dwight Morgan, a family friend from Hartford, Edith's hometown, wears a garment most in keeping with the new fashions that blended orientalism and fauvism. It is obvious that she has just returned from Paris — she wears a bright orange-red jacket and a hat with a large, centrally placed plume that echoes the headbands and turbans worn by the most avant-garde Parisiennes of the time, designed primarily by couturiers such as Poiret. Poiret was able to seamlessly blend a neoclassic silhouette (slim, columnar, and high-waisted) with oriental accessories (the turban) and a fauve color palette (fig. 5). Nicknamed the "wild beasts," the fauves and their brilliantly colored, exuberant, and decorative style, especially the work of Henri Matisse, inspired Poiret directly. The couturier wrote:

> Nuances of nymph's thighs, lilacs, swooning mauves, tender blue hortensias...all that was soft, washed out, and insipid, was held in honor. I threw into this

5

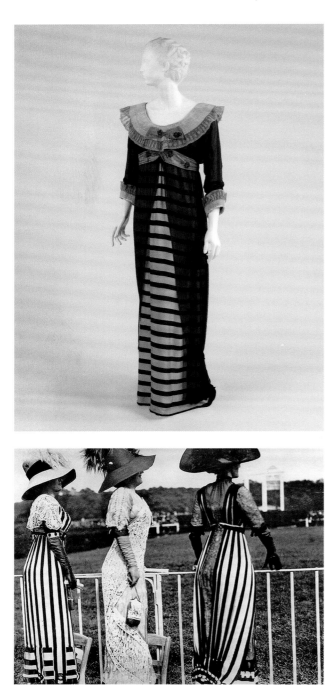

6

7

sheepcote a few rough wolves: reds, greens, violets, royal blues...oranges and lemons...the morbid mauves were hunted out of existence.[8]

This new fashion is also on display in a more intimate work by Glackens, *Artist's Wife and Son*, 1911 (plate 77). While the tender connection between mother and son is easily apparent, what stands out is the striped dress worn by Edith. Stripes, either woven or applied surface ornamentation, had been a standard in women's high fashion since the mid-nineteenth century. Images of striped dresses or striped parts of ensembles appeared in illustrations in the popular press and fine art alike. The use of this pattern was the central element in paintings such as Claude Monet's *Camille*, 1866 (Kunsthalle Bremen), Pierre-Auguste Renoir's *The Couple*, 1868 (Wallraf-Richartz Museum and Foundation Corboud, Cologne), and Édouard Vuillard's 1895 masterpiece, *Woman in a Striped Dress* (National Gallery of Art, Washington). In the first two works, long, undulating panels of striped silk pulse from the canvas like waterfalls. Vuillard, a member of the Nabis, a school that rejected naturalism in favor of pure design and color, presents this most basic of all patterned fabrics as the decorative centerpiece but in a more diffuse and painterly manner. Another important work, Renoir's *The Loge*, 1874 (Courtauld Gallery, London), focuses on the upper part of the sitter's boldly black-and-white-striped gown. Although the fabric is similar to that worn by Edith, the Renoir gown is cut curvaceously and has such densely ruched sleeves that the linear quality of the pattern is reduced.

Glackens's depiction of the boldly striped fabric of the dress worn by Edith is a departure from versions prior to circa 1910; it is rendered with greater clarity and linearity. Glackens called it her "Zebra Dress," and *Artist's Wife and Son* is one of three pictures painted between 1911 and 1914 in which a bold black-and-white-striped garment dominates the canvas.[9] One of those, *Pony Ballet*, 1910–1911 (see page 132, fig. 5), depicts two dancers from a popular performance number in corseted, leg-baring costumes, while another, *Girl in Black and White* (plate 78), shows a different version of the day dress worn by Edith.

This new style of gown, made from awning-width black-and-white fabrics, began to appear on the fashion stage at the onset of the second decade of the twentieth century. The neoclassical silhouette was inspired by the empire gowns of a century earlier, and its raised waistline and columnar shape were a perfect foil for the bold pattern (fig. 6).[10] Contemporaneous black-and-white photographic images, such as Jacques-Henri Lartigue's *The Day of the Drag Races at Auteuil*, 1911 (fig. 7), depict the striped dress in even greater sharpness. Whether Glackens ever saw such fashion images is not known, but the maker of Edith's dress certainly

would have, as it was au courant at the time this dual portrait was made.

Also important, but perhaps more subdued, is the outfit worn by Glackens's son. Like many young boys prior to World War I, four-year-old Ira is dressed in an ensemble consisting of a large collared top and shorts, and the top is trimmed with the most feminine of materials—lace. Ira's ensemble in this work, as well as in *Family Group*, strongly reflects high fashion. Mothers and children were always popular in fashion publications, but a new style was emerging. Part of the credit for this change may be attributed to Jeanne Lanvin.

One of the greatest couturiers of the twentieth century, Lanvin is not as well remembered as her contemporaries, Poiret and Gabrielle "Coco" Chanel, because she eschewed the more sexualized vision of the modern woman. By contrast to Poiret's odalisque and Chanel's dandy, Lanvin built an enormous fashion company by focusing, at least in part, on the role of motherhood and its idealized romantic symbolism. Along with haute couture, millinery, furs, and menswear, Lanvin made exquisite children's clothing; her daughter, Marie Blanche, was her petite mannequin. So important was the connection between the house of Lanvin and mother-and-child imagery that the latter became the leitmotif on all the house's *griffes*, or labels. Originally illustrated by noted illustrator Paul Iribe and updated by leading interior designer Albert Armand Rateau, many variations of the mother and child "logo" appeared in the Lanvin lexicon—on everything from perfume bottles to fashion show invitation cards—as well as in fashion publications such as *Gazette du bon ton* (fig. 9).[11]

As was typical of the era, young Ira was solely under the control of his mother. Very young boys were often dressed in fussy, somewhat effeminate styles. Edith, a particularly protective, oddly health-conscious mother, no doubt doted on her first-born. Both the lace-trimmed ensemble in *Artist's Wife and Son* and especially the somewhat exotic tunic worn in the *Family Group* are typical of Lanvin's high-style designs for children. But the unique element of Ira's ensemble in the portrait with his mother is the oversized brown belt that he holds in place around his hips. It most likely belonged to his father. If so, it is a touching detail that conveys the connection between a somewhat distant father and his young son.

In 1914, Glackens painted another portrait featuring a woman in a dress of contrasting black and white. Descriptively called *Girl in Black and White*, it presents an unidentified woman in a pose akin to the photographic portrait of couturier Lanvin, made by Nadar in 1900 (fig. 8). A comparison of the Glackens painting to an image of Lanvin might seem arbitrary, especially as they were created nearly fifteen years apart. However, they share a

8

10

FIGURE 8
Portrait of Jeanne Lanvin,
c. 1900. Photograph
by Nadar. Centre des
Monuments Nationaux,
Paris

FIGURE 9
Jeanne Lanvin *carte
d'invitation*, c. 1910.
Illustration by N. Vallée.
From Merceron 2007, 135

FIGURE 10
Lenna Glackens in Chinese
costume, 1918. Museum of
Art, Fort Lauderdale, Nova
Southeastern University;
bequest of Ira Glackens,
photograph collection

9

surprising number of similarities—the condensed background and similar position and cropping of both sitters; the single, prominently placed ornaments worn by each sitter and resting at the center front of their raised waistbands (Lanvin wears a large medallion suspended on a chain while Glackens's sitter has a red rose attached to her waistband); striped dresses (Lanvin wears a chiffon dress with a tone-on-tone overlay of wide lace bands, while the square white bodice of Glackens's sitter is edged in black and her skirt overlaid with three wide black ribbon bands); and decorative bouquets of flowers are placed near both women. The reason for drawing a comparison between this photograph of a specific couturier to the painting by Glackens is to demonstrate not only his awareness of the fashion trends of the time, but also to acknowledge that the artist may have been simultaneously attracted to both the avant-garde and the romantic factions of the high fashion world.

Like many of his contemporaries, Glackens depicted individuals from his private social circle in his paintings, occasionally dressing them in clothing from distant countries. Orientalism, prevalent in Europe for centuries, reached a new level of importance and influence on high fashion beginning in the late nineteenth century and culminating in the 1910s and 1920s. Artists also adopted the practice of painting sitters in Asian costume. Numerous works vividly presenting Japanese and Chinese dress and objects were rendered by Whistler, beginning as early as the 1860s, and by other Americans, such as Bernard Gutmann and Richard E. Miller, who painted at least nine works with Chinese robes from the 1900s through the 1920s.[12]

The most celebrated of Glackens's "exotic" costume pictures was the lovely portrait of his young daughter, Lenna. Entitled *Artist's Daughter in Chinese Costume*, 1918 (see plate 90 and fig. 10), it depicts the precocious strawberry blonde at the age of four. The Chinese costume in his depiction of Lenna is beautifully rendered in a glowing palette of orange and red counterbalanced with cool blues, and his use of the costume is unlike that in other orientalist paintings and fashionable images of the era. Rather than draping a Japanese kimono or Chinese dragon robe on a grown woman in a languid way, Glackens turned the notion of oriental sensuality on its head. Here, the exotic is de-sexualized.

The ensemble was typical of a large influx of Chinese goods that made their way into the American market in the early twentieth century, as Western interactions with China accelerated through military action, missionary activity, and tourism. Glackens may have procured the child's Chinese ensemble from Stewart Culin, a noted curator and ethnographer who had worked as an editor for the leading fashion trade newspaper *Women's Wear* (now known as *Women's Wear Daily*). Culin's tenures at the American Museum of Natural History and the Brooklyn Museum led to the creation of some of the greatest costume and textile collections in the world. He and his wife, Alice, were close friends of the Glackens family. In fact, Alice Mumford Roberts Culin was a classmate of Glackens at the Pennsylvania Academy of the Fine Arts. They met in 1891, years before she married Culin.

The portrait of Lenna is an anomaly not only in the depiction of exotic dress in art, but also in the Glackens oeuvre. His *Armenian Girl* and *Nude with Draperies* (plates 80, 81), both painted in 1916, were far more in step with the works of other artists such as Matisse. The almost violent clash of colors, particularly in *Armenian Girl*, echoes the dress from the *Family Group* of 1910/1911. Matisse's method of incorporating textile patterns into a single picture was adopted by Glackens in his exotic pictures as well as in *Family Group* and *Girl in Black and White*.

The colorful incorporation of fashion in the work of Glackens culminates in his last great figure painting, *The Soda Fountain* (plates 82–84). Begun in 1934 and completed the following year, it juxtaposes patrons and server and represents a return to depictions of the public world that had dominated the artist's early career. Three figures fill the canvas: the soda jerk (or server) who stands behind the counter is Ira Glackens, now a young man, dressed in a white coat; a female patron seated at the counter facing away from the viewer; and another young woman who dabs her red lips and appears ready to depart. Both women have been identified as working class, but dress as an indicator of class is now less distinct than in such works as *The Shoppers*.

American fashion had begun its great ascendency after World War I, both in terms of manufacturing (the United States far outpaced the world in ready-to-wear production) and design. While Paris was still the high-fashion capital and exuded tremendous influence on fashion around the world, the best American designers ignored far more haute couture than they incorporated. In the United States, many more options in clothing were available to consumers in large part because of social changes and the availability of ready-made clothes. While more and more women in America and Europe pursued an education, played sports, and entered the workforce, only American women had easy access to ready-to-wear clothing of good quality. Thus, the blurring of the lines between high- and low-end fashion parallels the construct of *The Soda Fountain*. Here, the demarcation between the social classes of worker and customer is less rigid than it was in *The Shoppers*.

The depiction of fashion by Glackens mirrored its social, cultural, economic, and aesthetic importance in America during the early years of the twentieth century. Its role as a marker of class and social standing parallels the close but sometimes contentious feelings Americans harbor about stylish dress. Fashion has frequently been decried as being merely ostentatious, frivolous,

and too often sexual. But clothing, especially high fashion, is inexorably tied to art because the human image, even when nude, is bound up with its fashionable portrayal. Furthermore, fashion connects the United States with France and with that nation's fine art, particularly throughout the late nineteenth and early twentieth centuries, as almost no other medium has. Susan Sontag wrote, "French culture…allows a link between ideas of vanguard art and fashion. The French have never shared the Anglo-American conviction that makes the fashionable the opposite of the serious."[13] Glackens clearly understood the power of fashion and used it exuberantly and consistently as a metaphor in creating his vision of the modern world.

For notes, see page 243.

73, 74

Figure Sketches No. 2, c. 1905 – 1910
Chalk, 15 × 22¾ (38.1 × 57.8)

Untitled (*Figure Sketches*), undated
Conté crayon, 16¼ × 20¼ (41.3 × 51.4)

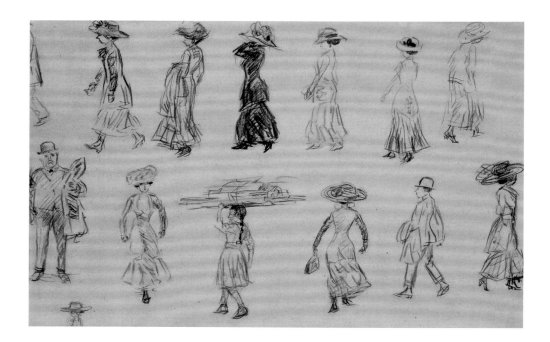

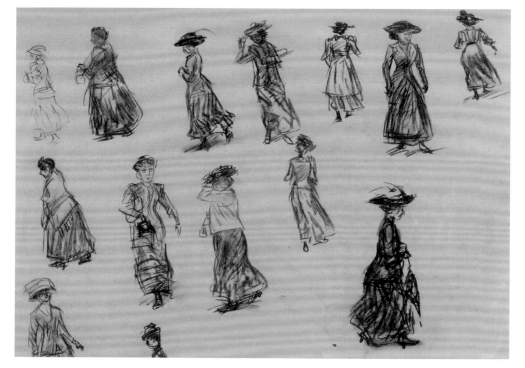

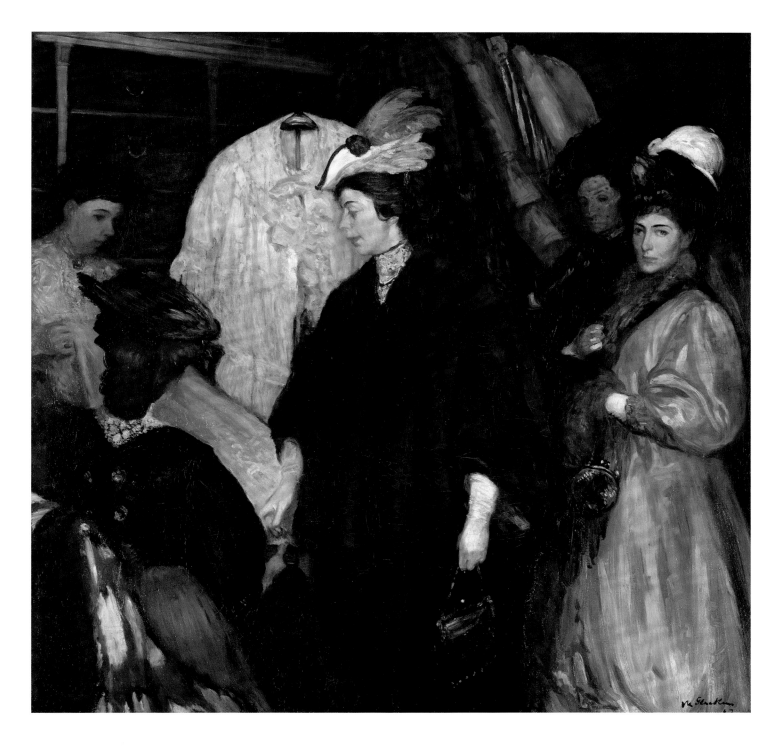

75

The Shoppers, 1907 – 1908
Oil on canvas, 60 × 60 (152.4 × 152.4)

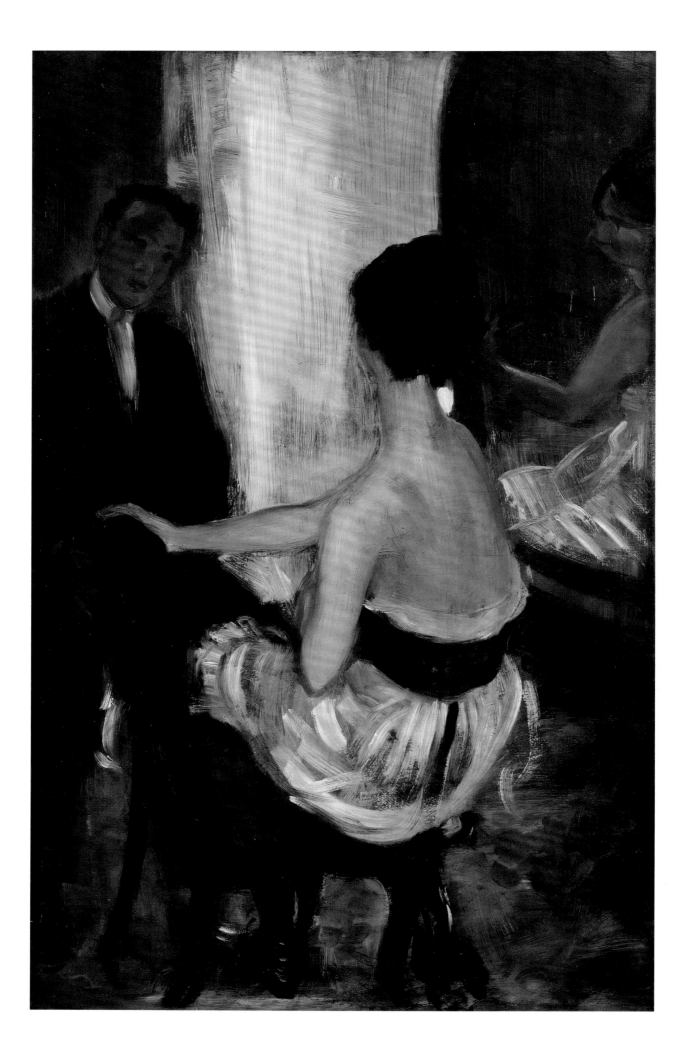

Seated Actress with Mirror, c. 1903
Oil on canvas, 48 × 30 (121.9 × 76.2)

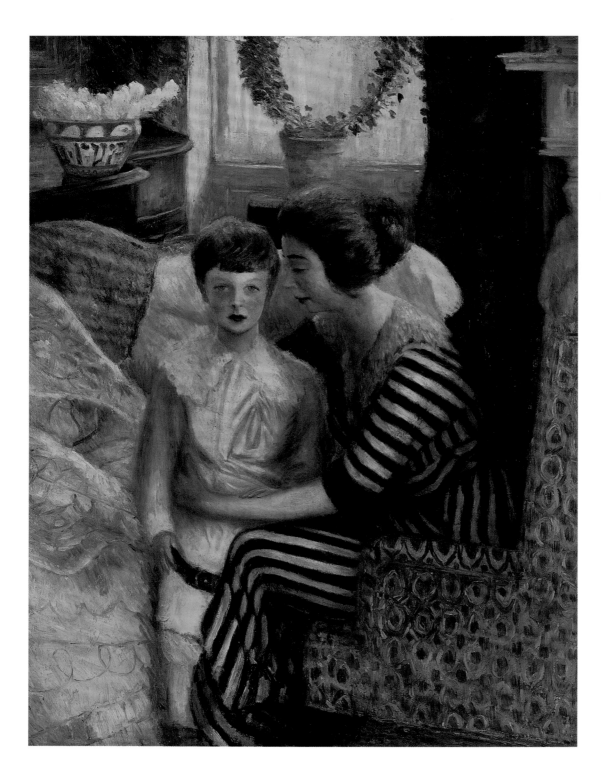

77

Artist's Wife and Son, 1911
Oil on canvas, 46 × 36 (116.8 × 91.4)

Girl in Black and White, 1914
Oil on canvas, 32 × 26 (83.1 × 66)

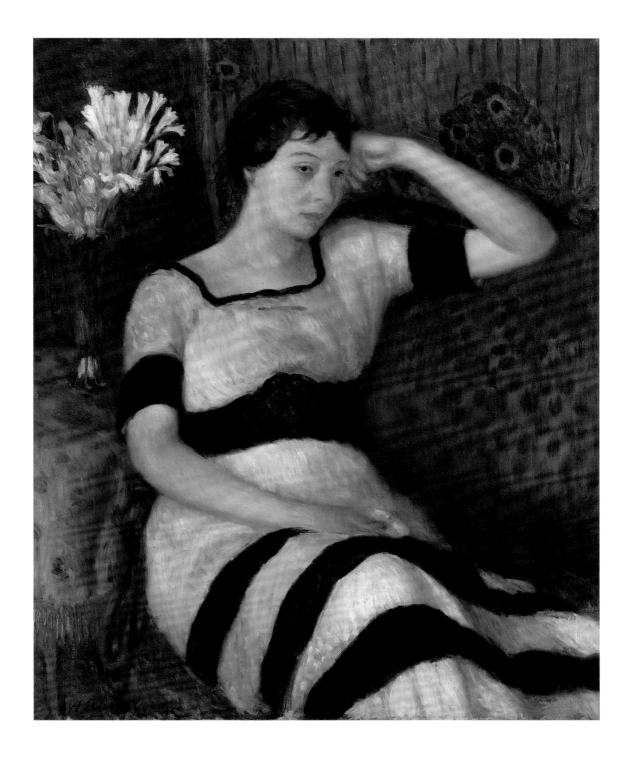

Children Rollerskating, c. 1912 – 1914
Oil on canvas, 23¾ × 17¹⁵⁄₁₆ (60.3 × 45.6)

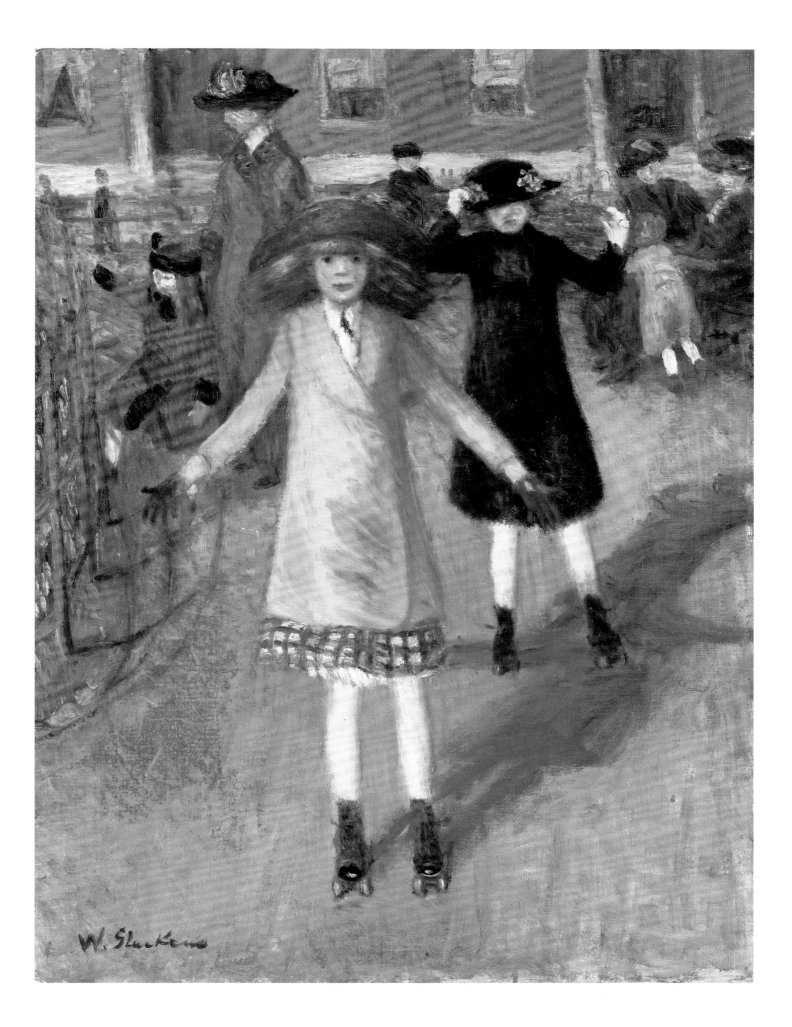

W. Glackens

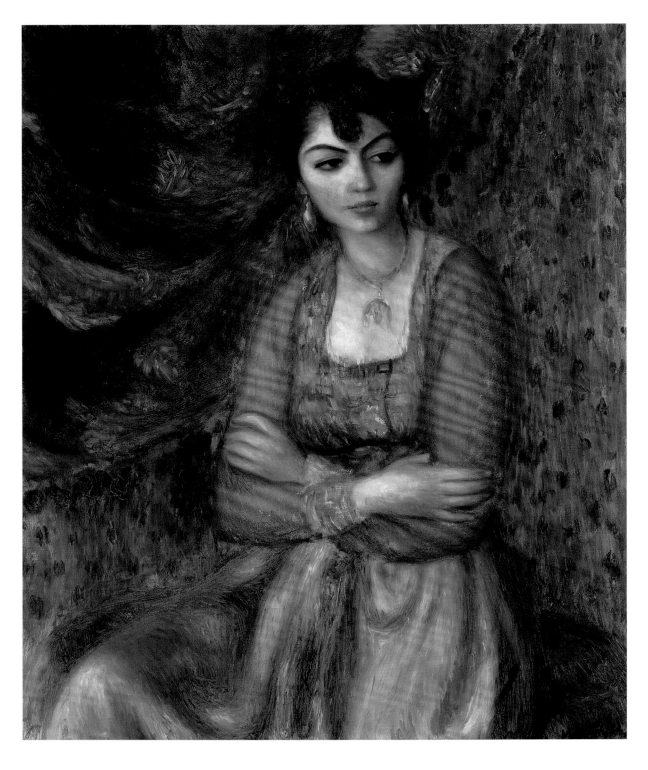

80

Armenian Girl, 1916
Oil on canvas, 32 × 26 (81.3 × 66)

81

Nude with Draperies, c. 1916
Oil on canvas, 30 × 25 (76.2 × 63.5)

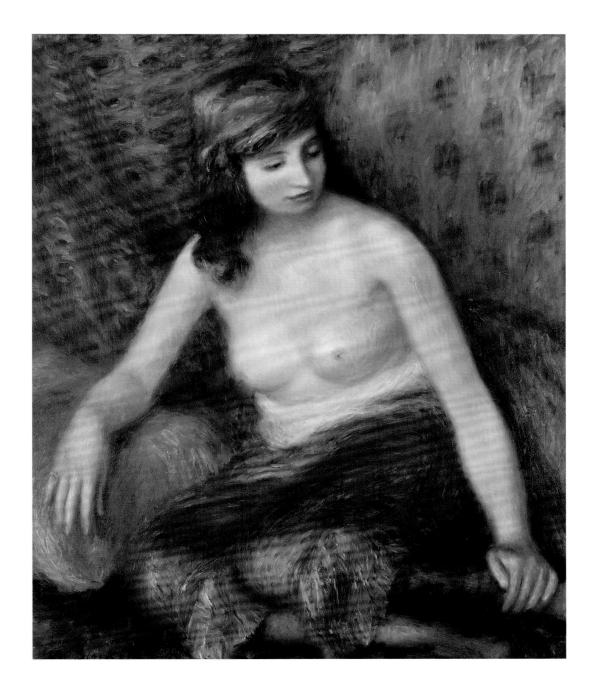

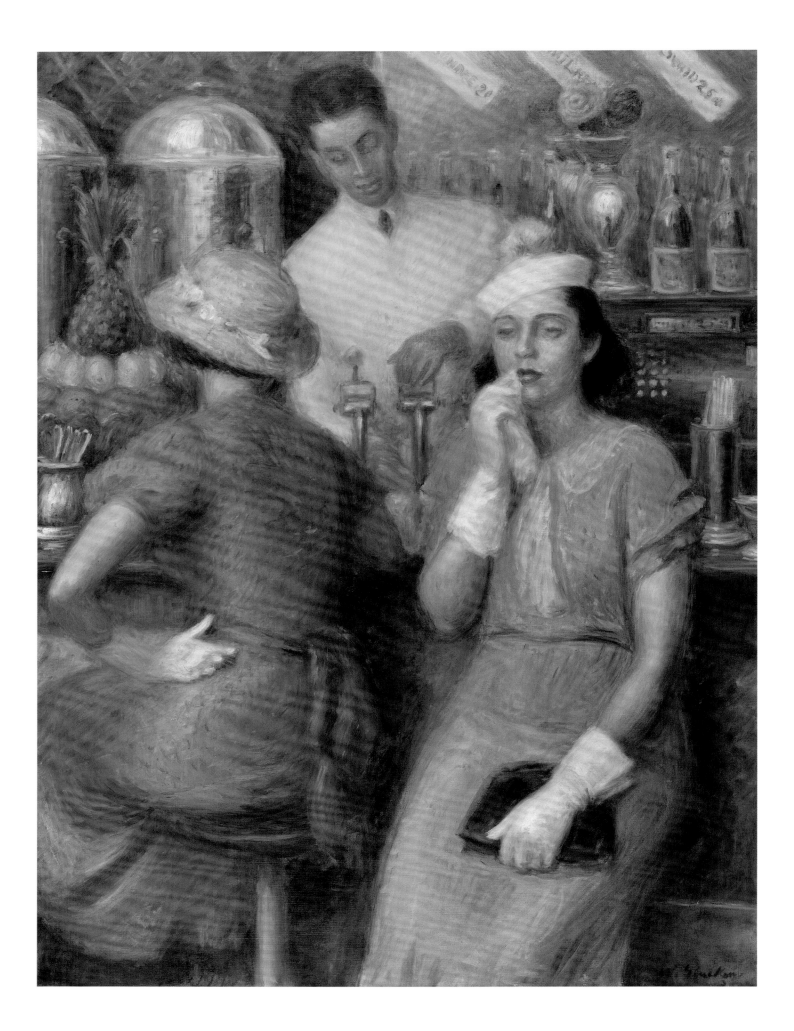

83, 84

Early Sketch for "The Soda Fountain," 1935
Graphite on lined paper, 5 × 3½ (12.7 × 8.9)

Study for "The Soda Fountain," 1935
Oil on board, 14 × 10 (35.6 × 25.4)

82

The Soda Fountain, 1935
Oil on canvas, 48 × 36 (121.9 × 91.4)

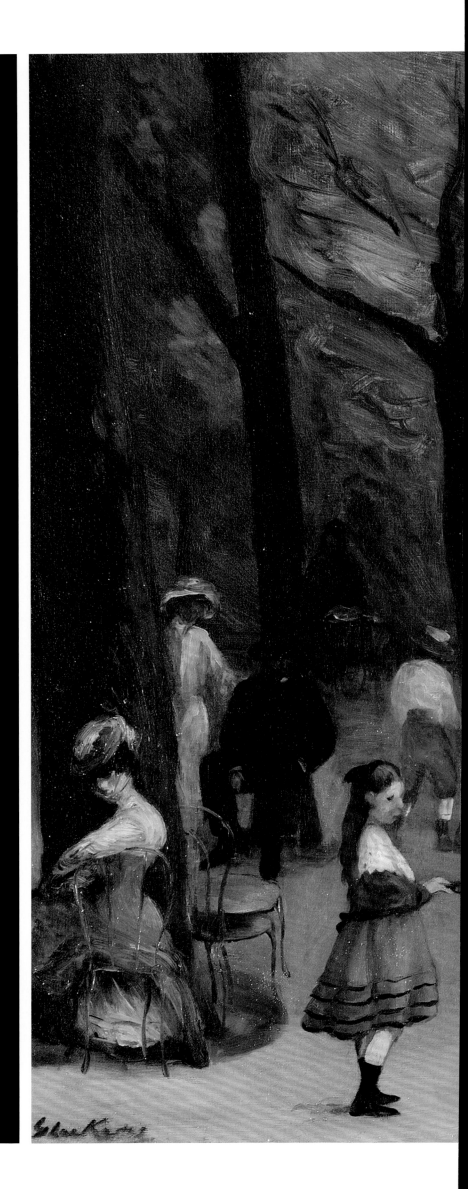

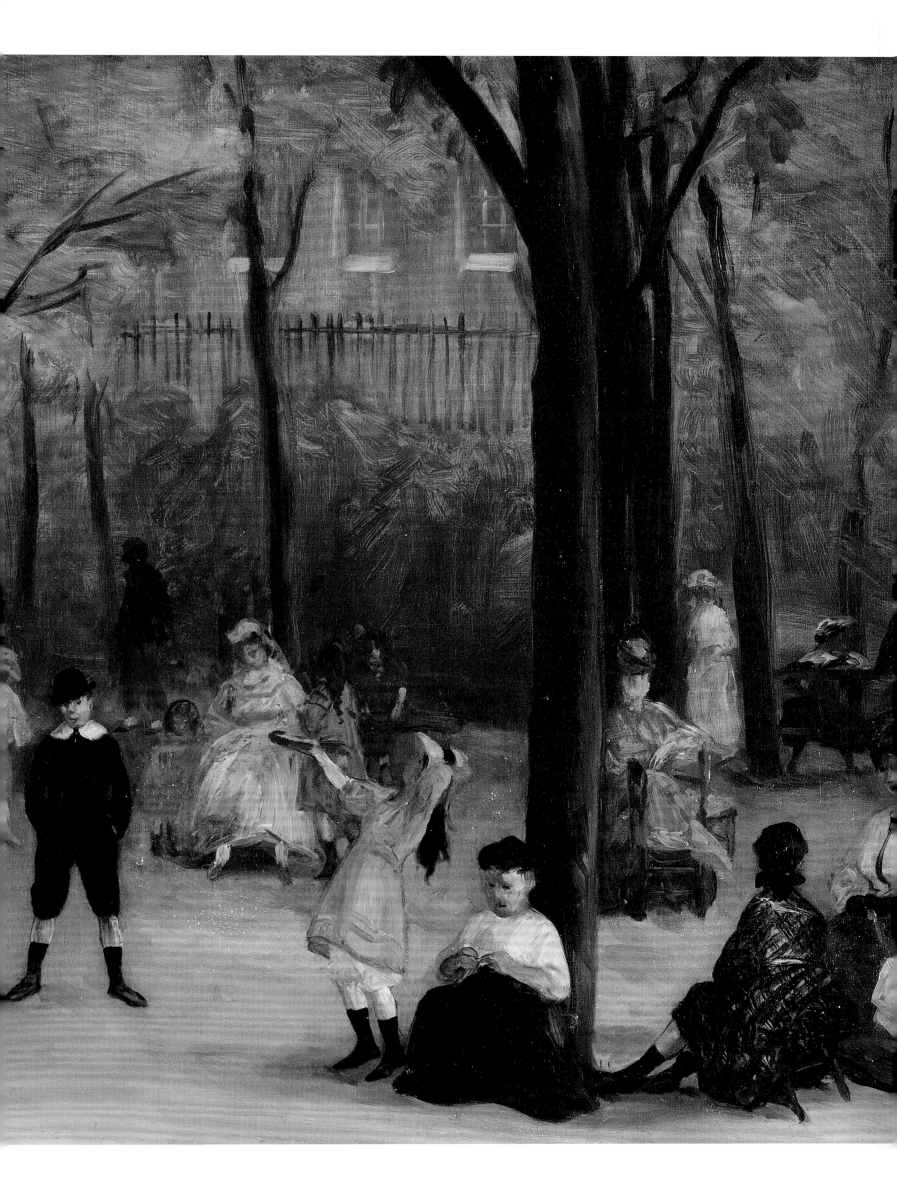

Glackens, French Art, and the Language of Modernism

MARTHA LUCY

"Everything worthwhile in our art is due to the influence of French art," William Glackens announced in 1913. "We have not yet arrived at a national art."[1] This pronouncement, made at the time of the Armory Show, was meant to galvanize fellow American painters toward innovation: though technically skilled, Glackens said, his colleagues were limited by "a lack of bravery," and a coherent brand of American modernism had yet to be defined. If Glackens's words hint at the sense of urgency confronting the young avant-garde in the early twentieth century, they also point to the paradox at the center of his own artistic project.

Glackens's debt to French art was enormous. So conversant was he in the vocabularies of the Parisian avant-garde — so wide-ranging were his sources and inspirations — that it is difficult to measure where this debt begins and ends. The Glackens scholarship can begin to sound like a sommelier picking out flavors in a glass of wine: this canvas has a touch of Degas, with strong hints of Matisse. Scholars have tried to impart some order to Glackens's absorption of French art across his career; the prevailing story is that after working as a "realist" in the early years and looking closely at Édouard Manet, he underwent a sudden transformation around 1907 and 1908, at which time he found color and became a full-fledged impressionist. At the time of Glackens's 1938 memorial retrospective, the critic Henry McBride described the artist's career trajectory: "The succession of pictures shows that he threw his pots of black paint out the window and became a violent impressionist almost overnight, trailing along abjectly in pursuit of the secrets of Renoir."[2]

Written almost seventy-five years ago, McBride's statement has come to delineate our understanding of Glackens's relationship to French art and his artistic evolution in general — that he was but a poor imitator of Pierre-Auguste Renoir, with a career that can be tidily divided into realist and impressionist phases. I propose that Glackens did not suddenly become "a violent impressionist almost overnight." French impressionism infused his work from the beginning, and his burst of color post-1908 resulted from another set of influences and, moreover, a wholly separate set of artistic goals. Also, Glackens's debt to Renoir needs to be better understood. Though McBride presents him as an insipid follower, Glackens saw his own relationship to Renoir — and to French art in general — in markedly different terms.

In assessing the role of French art in Glackens's oeuvre, one has to be cautious about constructing the artist as only derivative. In his important monograph, William H. Gerdts describes the canvases done between 1908 and 1911 as Glackens's "transitional period," a term that arises because the author cannot place him cleanly in a Manet or Renoir mode; when the artist strays too far from an inspiration he becomes uncategorizable. Yet it is admittedly difficult to avoid assigning specific influences to Glackens, as he continually absorbed French works and spoke candidly about his debts. If there is a productive aspect to studying influences — one that might allow us to see Glackens as a whole rather than as a sum of foreign parts — it is that his sources help us understand his shifting conception of what constituted modernity in painting.

* * *

Glackens's interest in French art stemmed, at least in part, from his love of the culture. "Paris was always my father's favorite city, and France his spiritual home," wrote Ira Glackens, the artist's son. "Everything suited him there, the food, the wine, the people in the streets and public gardens, whom he loved to sketch. . . . No other country seemed so to invite his pencil and his brush."[3] Glackens made the first of many trips to Paris in June of 1895 with Robert Henri and other artists; he stayed until October 1896, renting a studio in Montparnasse and traversing the city and its suburbs to observe the nuances of Parisian life, which he recorded in such lively works as *Bal Bullier* and *La Villette* (see plates 7, 8). Glackens returned to Montparnasse in the summer of 1906, this time with his wife, Edith, turning out several scenes of Montmartre, the Seine (*The Seine at Paris*, undated; plates 85, 86), *Luxembourg Gardens* (plate 89), and nearby Château-Thierry (plates 87, 88). After a brief buying trip to Paris for Albert C. Barnes in 1912, Glackens returned to his "spiritual home" in 1925 for an extended stay, renting a house with his family in Samois-sur-Seine outside Paris and traveling throughout the country for seven years.[4] *The Beach, Isle-Adam* (plate 94) is one of a series of paintings produced during sojourns in the Oise valley in 1926 and 1927;

Beach, St. Jean de Luz (plate 96) results from a summer spent in a fishing village on the Spanish border.

Glackens's "Frenchness" as an artist is not based on the depiction of French subjects. Rather, it is located in the continual deployment, throughout his career, of pictorial strategies borrowed from the French modernists. In early scenes of New York and Paris, it is the "realists"—Edgar Degas and especially Manet—who emerge as the most obvious sources, as has often been discussed. The vantage point in *Hammerstein's Roof Garden* (see plate 42), for example, issues directly from Degas's scenes of the ballet, where the viewer is immersed in the audience, witness to—and participant in—the spectacle of modern life. *Outdoor Theatre*, 1895 (private collection), painted during Glackens's 1895 trip to Paris, recalls Degas's *Café-Concert at Les Ambassadeurs*, 1876 (Musée des Beaux-Arts, Lyon), as the urban crowd swarms toward electric stage lights, hungry for the thrill of nighttime entertainment. The blunt sexuality of Glackens's *Seated Actress with Mirror* (see plate 76), with the hovering male visitor, seems impossible without Degas's brothel scenes. More generally, Glackens's attention to body language as a signifier of personality, as in the humorous *Café de la Paix*, 1906 (Museum of Art, Fort Lauderdale), seems also to owe something to Degas, who often translated the tools of the caricaturist into paint.[5]

Glackens's engagement with Manet was even more intense. He swooned over the French painter's works at the Metropolitan Museum of Art, at the Durand-Ruel gallery, and later in Barnes's collection, and he wrote movingly about these experiences. Manet is readily apparent in *Bal Bullier* and in the later scenes of the Luxembourg Gardens, particularly in the arrangement of figures and use of murky tones. While Manet's importance for Glackens's early production has been well explored, it never really disappears.[6] *Street Cleaners, Washington Square*, c. 1910 (see plate 35), for example, seems to be based compositionally and thematically on Manet's *View of the 1867 Exposition Universelle* (fig. 1), as both works present the intermingling of classes in the new modern city, with a gently curving fence demarcating the foreground; Glackens even borrows the worker with a water hose from Manet's picture. With its focus on commodities, *The Soda Fountain*, 1935 (see plate 82) might even be seen as an optimistic American twist on *A Bar at the Folies-Bergère* (page 76, fig. 6).

While Manet's work was central to Glackens's development, scholarship has tended to focus on this influence to the exclusion of all others, particularly in discussions of the early, darker canvases. This is perhaps linked to a broader trend in the field. As Barbara Weinberg has written, avant-garde artistic production around the turn of the century in America is often lumped into one of two categories: "*Impressionist* for the lightly brushed, high-key works that such artists as William Merritt Chase and Childe Hassam

executed in the late 1800s and *Realist* for the darker-toned urban scenes that Robert Henri…and [his] colleagues produced from about 1905."[7] Weinberg proposes that this dichotomy is deceptive—while the members of Henri's circle saw themselves as rejecting the American impressionist idiom, there were in fact many overlaps between the groups. Extending this argument, I propose that Glackens's association with Henri has shaped our understanding of his early influences—limiting them, in other words, to his realist counterparts in France. Indeed, there were hints in the criticism as early as 1910 that Glackens did not fit perfectly into the realist mold. The critic Albert E. Gallatin, for example, noted that despite Glackens's links to Degas, his work lacked the French painter's tendency "toward the ugly and repulsive."[8]

Glackens in his early years likely drew his inspiration from a broader range of French artists, especially given his immersion in the Parisian art scene from 1895 to 1896 and the increasing visibility of European modernism in New York around the turn of the century. In March of 1896, when Glackens was in Paris, Durand-Ruel exhibited an important selection of paintings by Berthe Morisot—a show Glackens presumably would not have missed as it also included a "portrait photogravé d'après Edouard Manet." Exhibitions of the work of Camille Pissarro and Renoir at the same gallery followed; works by Claude Monet had been on view just weeks before Glackens's arrival.[9] Although the impressionist palette had come to signal genteel conservatism in the decades after Chase, formal aspects of French impressionism still would have been appealing—indeed critical—to an up-and-coming American modernist.

While Glackens, in the early years, generally did avoid the bright colors of Monet's Argenteuil pictures, striking similarities are evident between his work and the more tonally subdued, urban canvases of the impressionists. *La Villette*, for example, painted in a working-class neighborhood on Paris's Right Bank, seems to borrow in both palette and composition from Monet's *Les Charbonniers* (fig. 2). Both scenes are composed of earthy tones—browns, blacks, and grays, with touches of white and swaths of golden light. In both canvases, silhouetted figures cut across the foreground, unceremoniously going about their business, and in both an arching bridge forms the dominant pictorial motif. We do not know if Glackens ever saw this particular canvas, but Glackens was clearly familiar with Monet's general idiom. An impressionist influence is evident as well in *Outside the Guttenberg Race Track (New Jersey)* (see plate 27), painted in 1897 just after Glackens's return to New York. With its open, airy composition, high vantage point, gridlike emphasis on verticals and horizontals, and broadly brushed patches of white, the picture recalls Morisot's *Hanging the Laundry Out to Dry*, 1875 (National Gallery of Art, Washington). The focus on figures at the

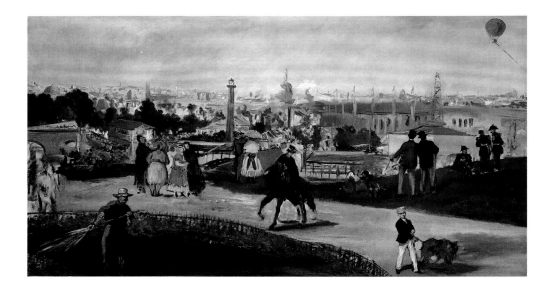

1

FIGURE 1
Édouard Manet.
*View of the 1867
Exposition Universelle*,
1867. Oil on canvas.
The National Museum
of Art, Architecture and
Design, Oslo

FIGURE 2
Claude Monet.
Les Charbonniers, c. 1875.
Oil on canvas. Musée
d'Orsay, Paris

FIGURE 3
Flying Kites, Montmartre,
1906. Oil on canvas.
Museum of Fine Arts,
Boston

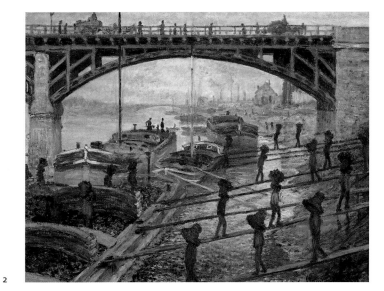

2

3

margins and the use of a compositional barrier to create a sense of visual withholding also evoke Morisot.

Glackens's absorption of impressionism, here and in other early canvases, is not simply equal to lively brushwork or the occasional lifting of a clever compositional device. It has more to do with his attitude—his optimistic presentation of the modern city as a place where classes mingle, where new and old technologies coexist, and where humans inhabit space with a sense of physical agency and ownership. In *Flying Kites, Montmartre* (fig. 3), painted on his second trip to Paris in 1906, children wander off and other figures send kites high into the sky. A man leans nonchalantly against a lamppost, a sign of comfort and confidence. In such scenes, Glackens emphasizes a physical relationship between people and their city. In the New York scenes, too, such as *Central Park, Winter* (see plate 34), figures move through the landscape, not just surveying their surroundings like detached Baudelairean flâneurs, but interacting with them bodily, as children throw themselves into the snowy hill with abandon. If the dark palette in such pictures is Manet's, then the lack of detachment, the sheer disordered physicality, is pure Renoir.

More than any of his impressionist colleagues, Renoir presented the modern urban experience as friendly rather than alienating, excising from his works any hint of the biting social commentary one finds in the work of Manet and Degas. To Renoir, humans are not anonymous flecks in Haussmann's spectacle-driven city but recognizable faces that interact and physically engage with their surroundings—as in *Moulin de la Galette*, 1876 (Musée d'Orsay, Paris). For Glackens, whose take on the modern city has been described as "euphemistic," Renoir's urban scenes would have been an obvious source, and he had ample opportunity to study them in Paris. Consider, for example, Glackens's *Luxembourg Gardens* (plate 89), a painting regularly compared to Manet's *Music in the Tuileries*, 1862 (Hugh Lane, Dublin), for its composition and use of blacks. Manet is unquestionably present. But the painting also reveals a certain Renoiresque physicality (and one might compare Glackens's piece to Renoir's own take on this subject), especially in the semicircle of figures in the foreground: a woman squats unselfconsciously while children play. Their effect is quite the opposite of Manet's self-aware figures, especially the pair of women who gaze out at the viewer, lending his picture its staged quality.

Glackens was likely thinking of Renoir as well when composing *At Mouquin's*, 1905 (see plate 45). The painting shows Glackens's good friend James Moore, a notorious bon vivant, with a fashionable female companion. Unsurprisingly, it is Manet and Degas who are regularly cited as inspirations for this picture: indeed, the latter's *Absinthe Drinker*, 1875–1876 (Musée d'Orsay,

Paris), seems a clear precedent, with its café mirror, across-the-table vantage point, and blankly staring figure; the broadly painted folds in the garments could have issued from Manet's brush. Yet James Huneker pointed to other influences in his 1908 analysis of the painting, noting that "Renoir is slightly evoked."[10] Possibly Renoir resides in the licks of white that conjure bottles, or in the way the woman's fingers rest absently on her glass, a gesture straight out of Renoir's *Luncheon* (fig. 4). Renoir is also evoked in the sense of warmth among Glackens's figures. While many scholars have read the woman's expression as a sign of weariness in the vein of Degas—she is "passive, somewhat bored, turning away from Moore," writes Gerdts—the scene suggests active gossiping rather than disaffected modern ennui, as Moore raises his glass and leans in with familiarity. Like Renoir, who so masterfully captured nuance—for example in the subtle flirtations in *Luncheon of the Boating Party*, 1880 (The Phillips Collection, Washington)—Glackens has captured the humanity amid the anonymous modern experience.

* * *

At Mouquin's was one of several works presented at the famous exhibition of The Eight at Macbeth Galleries in 1908. In a scathing review, W. B. McCormick called the event "the most foreign, the most Frenchified show of paintings that we had seen in New York in recent years."[11] The exhibition had been billed as marking a new departure in American art, McCormick complained, but Glackens and his colleagues "show nothing that is not thoroughly French in spirit." This was a common point of apprehension among critics: Catherine Beach Ely lamented that in looking to the French, Glackens had not "preserved his individuality."[12] But if critics worried about the possibility of a truly distinct American art buckling under the weight of a foreign paradigm, Glackens considered this paradigm absolutely essential. For him, new techniques and pictorial devices—the most innovative of which happened to be coming out of France—were building blocks from which a wholly individual structure could be created. To study French art did not make one a mere imitator, he insisted. Rather, absorbing influence was like absorbing a new language, and he reasoned that "art, like humanity, every time has an ancestry."[13]

On closer reading of McCormick's remarks, it seems what bothers him is not the Frenchness of the influences, but rather their outdatedness: "Surely it is not 'revolutionary' to follow in the footsteps of the men who were the rage in Paris twenty years ago," he writes, listing the outmoded Monet, Manet, and Degas. Glackens was one step ahead of McCormick and even before the 1908 show opened had already begun to show signs of a revised

artistic project. Another critic noticed the change and commented on Glackens's startling new palette: "It often shocks by its brilliant dissonances. He is pulling up the key year after year."[14] Arthur Hoeber described the new approach as "a riot of tone."[15] These critics are referring to works such as *View of West Hartford* (see plate 28), painted in 1907, where half the composition is given over to warm yellow; to *Race Track* (page 129, fig. 2), in which "one can fairly wallow in vivid reds and greens," as Hoeber remarked; and the 1908 *Cape Cod Pier* (see plate 60), in which a lavender walkway slices through an expanse of shocking bright orange. Such works signal a major shift in the artist's pictorial interests, as many have noted. Richard J. Wattenmaker, for example, observes that Glackens has "diminish[ed] the influence of Edouard Manet by virtually eliminating black as a pervasive tonality from his canvases."[16] Gerdts writes, "His artistic strategies had moved away from the dark Impressionism of Manet and Degas…toward a more orthodox Impressionism of light and color."[17]

The prevailing assumption is that this "pulling up" of the chromatic key around 1907 was a reflection of Glackens's new-found interest in French impressionism. "The bright colorism of such outdoor paintings as *View of West Hartford*…allies his work with the Impressionism of Monet," Gerdts continues. But as we have seen, French impressionism was not new to Glackens and a sudden interest in it makes little sense. More importantly, the color of the 1907/1908 pictures simply is not that of the French impressionists: the key is too intense, the values too saturated. The more likely influences were the newer directions in Euro-pean modernism—specifically the work of Henri Matisse and the fauves.[18] In *Cape Cod Pier*, for example, colliding zones of orange, lavender, green, and yellow recall the shocking color combinations that had made the fauves the scandal of Paris a few years earlier. Indeed, when *Race Track* was shown in the 1910 Exhibition of Independent Artists, one critic noted its "Matisse effect."[19]

Glackens's introduction to Matisse's work very likely occurred during his 1906 summer in Paris. Though he arrived too late to see the March-April Salon des Indépendants, at which Matisse's *Le Bonheur de vivre* (fig. 5) famously scandalized audiences, Matisse was the talk of the art world through the summer; the Druet gallery, too, had just closed a show. Moreover, Glackens's frequent contact with Alfred Maurer during those months seems to guarantee his exposure to the artist. Maurer, who lived in Paris, was a great admirer of the fauves, particularly of Matisse's bold experiments with color. Maurer and Glackens had neighboring studios in Montmartre and traveled together often; the *Chateau Thierry* picture documents their excursion to the Marne River. (It was Maurer who took Glackens years later, in 1912, to see Leo Stein's work by Matisse and Renoir.) Back in New York, Alfred

Stieglitz mounted America's first exhibition of work by Matisse in 1908, sending shock waves through the art community; he followed with another in 1910. Moreover, Glackens's fellow painters had begun to take an interest in the artist. George F. Of owned a small Matisse painting, and Maurice Prendergast, who was Glackens's painting companion in Cape Cod in 1908, was invigorated by the fauve compositions he had just seen in Paris. Barnes acquired the first of his many works by Matisse in 1912, and we can see Glackens experimenting with Matisse-derived patterns in the Barnes Foundation's *Girl in Green Turban*, c. 1913, as Wattenmaker has observed.[20]

What Glackens seems to have taken from the fauves in the 1907/1908 pictures was intense color arranged in broad, flat zones. Pictorial space in *Cape Cod Pier*, for example, is more compressed than in earlier pictures, as the walkway rises up toward the sky and the expanses of orange push toward the picture plane. *Race Track* seems to take a cue from André Derain's *Charing Cross Bridge* (fig. 6) of c. 1906: in both, a long curve pulls the eye over to the right, and both are constructed from blocks of green, blue, and orange-reds. Possibly Glackens knew this picture, as it was one of the stars of the 1906 Salon d'Automne. Even his later, more "impressionist" works demonstrate traces of fauve influence. The 1910 *Bathing Hour, Chester, Nova Scotia* (page 132, fig. 4), for example, one of his submissions to the Armory Show, is a light-filled scene with dabs of white paint giving sparkle to the water. Regardless of these impressionistic gestures, a certain fauvelike simplification turns the composition into chunks of shocking color, and space presses forward even as it recedes into the distance.

How should we understand this shift? Given his repeated calls for innovation, it is hardly surprising that Glackens would begin exploring a formal vocabulary that emblematized the most radical tendencies of the Parisian avant-garde; especially after the Armory Show, Matisse was "held up in the United States as an example of what should be admired or deplored in modern art."[21] But this transfer of alliances from realism and impressionism to fauvism also signaled a fundamental shift in Glackens's goals as a painter. If his 1913 Armory Show essay was a diagnosis of the state of American art at large, it was also subtly self-reflective: "The old idea that American art, that a national art, is to become a fact by the reproduction of local subjects…has long since been put to the discard."[22] In other words, artistic subversion through a devotion to gritty themes, as had been The Eight's practice, was no longer tenable as a modernist approach. Among the progressive critics and collectors in Glackens's circle—such as Barnes and Leo Stein—even impressionism had fallen in status, and for largely the same reason: with its concentration on surface appearances, it was considered a form of mere description, a slavish imitation of

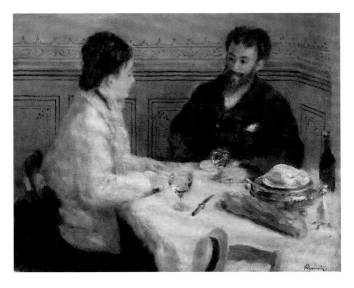

4

FIGURE 4
Pierre-Auguste Renoir.
Luncheon, 1875. Oil on
canvas. The Barnes
Foundation, Philadelphia
and Merion, Pennsylvania

FIGURE 5
Henri Matisse. *Le Bonheur
de vivre*, 1905–1906. Oil
on canvas. The Barnes
Foundation, Philadelphia
and Merion, Pennsylvania

FIGURE 6
André Derain. *Charing
Cross Bridge*, c. 1906.
Oil on canvas. Musée
d'Orsay, Paris

5

6

nature. Glackens began to shift the terms of his modernism from a concern with truth-telling to a concern with formalism—especially the notion of pure color. "The early Americans were illustrative," he said in 1913. "It was France that showed them the error of their project."[23]

* * *

If the fauves helped push Glackens toward a more autonomous use of color, it was ultimately Renoir—especially the artist's later works—that offered the best model for his new formalist goals. Glackens's devotion to Renoir during the 1910s and 1920s is regularly discussed in the literature, and the topic consumed critics during his own time.[24] By 1915 nearly every piece on Glackens mentions his infatuation with Renoir—most often in a disparaging way—drawing parallels between the vibrant palettes and the tendency of both artists toward cheery subject matter.[25] Yet never is there any analysis of what, technically, Glackens took from Renoir, as Wattenmaker has pointed out, nor is there any consideration of which works Glackens actually saw during these later decades.[26] The assumption is that for both artists, color was merely an outward expression of an inner happy spirit, and that Glackens naturally gravitated toward Renoir because of a shared artistic temperament: "Renoir's style was well suited to Glackens's own warm, pleasant nature," John Gordon asserts.[27] Unsurprisingly, the critical language used to assess these two artists is nearly identical: for every pronouncement that Glackens's paintings reflect "a world without care, without drabness, without malice, without profundity, and without irritation," as one critic wrote in 1937, a matching statement exists to sum up Renoir's artistic goals.[28] In such interpretations, the work of these two painters is nothing but sweetness and light, utterly lacking in formal rigor. If Renoir's modernism has been misunderstood by later generations of Greenbergian modernists looking for flatness and abstraction as the correct pictorial values, Glackens's own work is woefully entangled in that reception history.[29]

There is no doubt that Glackens admired Renoir's "absolute devotion to the 'joie de vivre,'" as he called it.[30] It was the human, anecdotal nature of Renoir's impressionism that filtered into his own earlier scenes of Paris and New York. But as Glackens's artistic goals shifted, Renoir eventually came to stand for something else in his practice—for pure form, sensuousness, and color that was bold and experimental without being arbitrary. Perhaps inspired by the 1908 exhibition of forty-one paintings by Renoir at the Durand-Ruel New York gallery, Glackens in 1910 produced his most Renoiresque work to date: *Girl with Apple* (see plate 50), showing a beautiful model reclining, her bare skin surrounded by a deep red sofa.[31] The canvas is like no other in Glackens's oeuvre.

With no pretense for her nudity, the model reads as a classical muse rather than as an actor in a narrative (as in the earlier *Seated Actress*); this is a painting about painting, a self-enclosed world devoted to art, and the canvas framing her head seems to reinforce this notion. While the steady gaze and upright torso recall Manet's *Olympia*, 1863 (Musée d'Orsay, Paris), the timelessness of the subject, the sensuality of the palette, and the tactile flesh rendered in short, delicate strokes all evoke Renoir—specifically Renoir's later canvases.

In Renoir's late paintings, phenomenological naturalism is jettisoned for the pursuit of solidity and essential form, and impressionist contemporaneity is exchanged for more timeless subjects. The role of color changes, too: no longer deployed as a record of visual phenomena, color suffuses Renoir's canvases with sensuality and becomes a structural element employed in the building of solid sculptural volumes. In *Reclining Nude* (fig. 7), for example—the kind of canvas on display at the 1908 Durand-Ruel show—a bare back is a study in color relationships, as the figure's physicality emerges out of subtle shifts in tone. These are the paintings that made Renoir the favorite of formalist critics such as Barnes, Stein, Roger Fry, and Willard Huntington Wright. Glackens also threw himself into a study of these color relationships: note the use of lavender on his model's thigh.

If *Girl with Apple* reveals Glackens awakening to Renoir's later production, by the mid-1910s he was fully immersed in the study of these canvases. Many were displayed at Durand-Ruel's 1912 *Exhibition of Paintings by Renoir*, composed mostly of works from the 1880s and 1890s—a show Glackens certainly would have seen. (Barnes, with whom he was in close contact, bought several works there.) But it was in Merion, on his regular visits to Barnes's collection, that Glackens would have found himself utterly surrounded by Renoir; the collector had already amassed sixty canvases by the end of 1916. Glackens's *Lenna Painting* (Museum of Art, Fort Lauderdale) of around 1918 seems a direct homage to the small *La Lecture* Glackens bought for Barnes in 1912. When he painted *Artist's Daughter in Chinese Costume* (plate 90) in 1918, Glackens was certainly looking at the Renoir *Writing Lesson* Barnes had acquired three years earlier, though in terms of theme, format, and the dominance of red-orange, the picture also evokes Renoir's *Claude in Clown Costume*, 1909 (Musée de l'Orangerie, Paris).

In works such as *Back of Nude* (see plate 49), painted probably in the 1930s, Glackens engages most directly with the type of works by Renoir in Barnes's collection.[32] Like *Bather in Three-Quarter View* (fig. 8), for example, the figure sits in a self-enclosed position, oblivious to the viewer's presence. Soft, palpable flesh takes up the majority of the canvas, composed of swirling color patterns, as reds and lavenders collect at the body's edges and green articulates the spine. Glackens has clearly studied the

7 8

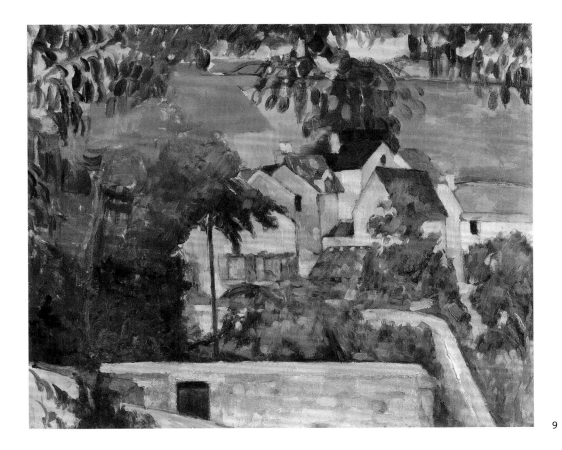

9

contours of Renoir's bodies, which refuse a solid boundary in a deliberate blurring between figure and ground; note the flesh tones carried over into the background, much as in Renoir's *Bather in Three-Quarter View*. Like Renoir's nudes, Glackens's nude is meant to have weight and structure—the task of color here—and the background, a field of abstract strokes, seems to push the figure forward.

Applying Renoir's lessons was not without frustrations. "I have found out that the pursuit of color is hard on drawing just as the pursuit of drawing is hard on color," he wrote to Barnes. "Renoir survived but who else?"[33] In a rigorous analysis of Glackens's paintings, Violette de Mazia explained how, despite his obsessive study, the American painter's use of color is ultimately different from Renoir's. She writes, "Glackens's color lacks the degree and kind of solidity, of depth, which in Renoir makes the color so much an integral part of the texture and structure of the fully three-dimensional volumes."[34] Indeed, looking back at *Girl with Apple*, the lavender paint describes the body's surface rather than serving to sculpt volume.

It was probably this dilemma of color and structure that brought Glackens to grapple somewhat curiously with the work of Paul Cézanne in 1930. Glackens was well aware of Cézanne much earlier; Stieglitz had mounted two important Cézanne exhibitions in 1910 and 1911, and Glackens had secured an important landscape for Barnes during his 1912 trip. By 1916 Barnes had acquired fourteen works by the artist; "I am naturally keyed up to see your Cézannes," Glackens wrote to his friend a few years later.[35] The artist was never far from his mind. At least one critic in 1910 compared Glackens to Cézanne in terms of his tendency to fixate on a singular motif: the Washington Square pictures were his Mont Sainte-Victoire.[36] One can sometimes detect a Cézannean touch in his application of paint, as in the loosely brushed passages in *Armenian Girl* (see plate 80).[37] In *Hillside near La Ciotat* (plate 97), however, painted during a summer stay near Marseilles, the focus is on structure. In the vein of Cézanne's landscapes at Auvers, where clusters of houses poke through the trees (fig. 9), Glackens emphasizes the geometry in nature and brings out hard edges—roofs, eaves, walls—to create an overall

scaffolding for the picture. Yet color is more impressionistic than structural, as lively purple shadows splash against buildings and hug the contours of long horizontal walls.

In the canvases from Glackens's extended French sojourn, glimpses of daily life occasionally return, as in the crowded beach scenes at L'Isle-Adam and Saint-Jean-de-Luz, and in the raucous *Bal Martinique* (plate 95). But the larger resistance to anecdote still prevails. Canvases from the mid-1920s are generally free of figures and narratives; objects begin to play starring roles, giving themselves over to pure formal exploration, as in *Still Life with Three Glasses* (see plate 101), where fruit and dishes are immersed in a world of hot color and vibrating patterns. For some critics, Glackens's still-life compositions were an achievement in pure painting. Responding to a 1937 exhibition of flower pieces, Margaret Breuning wrote, "There is the utmost subtlety in the patterns of color, in the relations of form and contour.... What lusciousness of pigment, what purity of color."[38]

Bonnard is a clear inspiration for such works. Glackens had purchased a portrait by the artist in 1912, and in *Still Life with Three Glasses* and *Breakfast Porch* (plates 91–93) his influence reveals itself in the choice of subjects and in the sheer embrace of the decorative,[39] and in the way such canvases read as self-enclosed universes of color in which objects and figures appear suspended in time. In *Breakfast Porch* we are far from the anecdotal mode of *At Mouquin's*. The volume of the earlier picture has been turned down. The vantage point is high, detached, as in so many of Bonnard's table pictures, and humans do not interact but stare absently into their spoons and cups. Glackens here is utterly unconcerned with the momentary, the expressive gesture, the fleeting nuances of social interaction. He is after something more eternal. In its quiet stillness, the feeling is one of domestic ritual endlessly repeated, a collection of a thousand moments, and the breakfast table becomes a subject as timeless as the classical nude. If, by Glackens's own appraisal in 1913, his early work was too "illustrative," the French modernists supplied him with an alternate language for expression.

For notes, see pages 243–244.

85, 86

The Seine at Paris, undated
Drypoint, 3 × 5½ (7.6 × 14)

The Seine at Paris, undated
Charcoal, 4¾ × 7 (12.1 × 17.8)

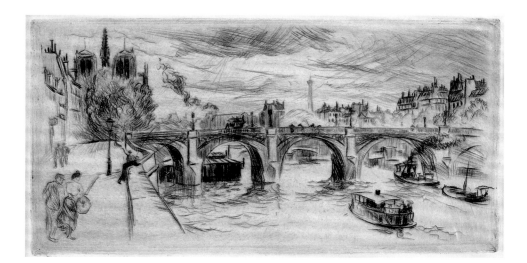

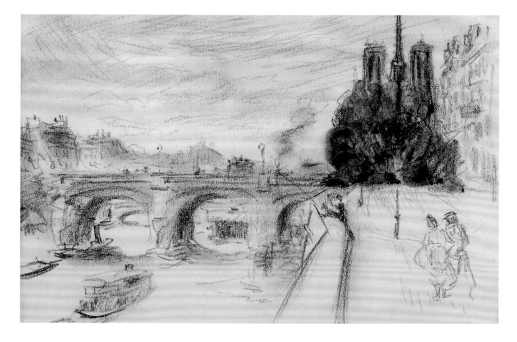

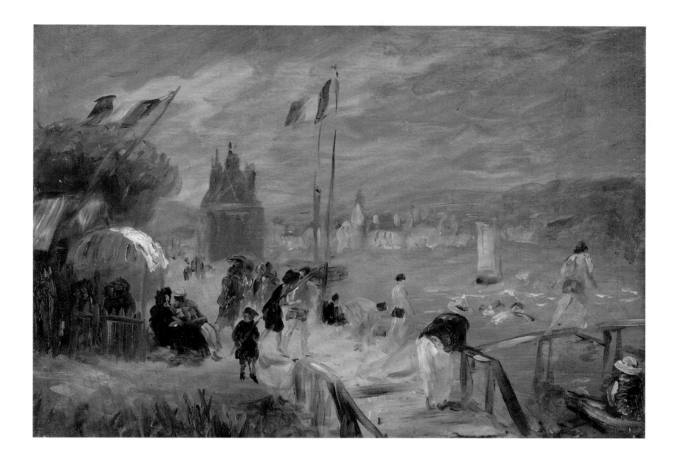

87

Study for "Chateau Thierry," 1906
Oil on panel, 6¼ × 8¾ (15.9 × 22.2)

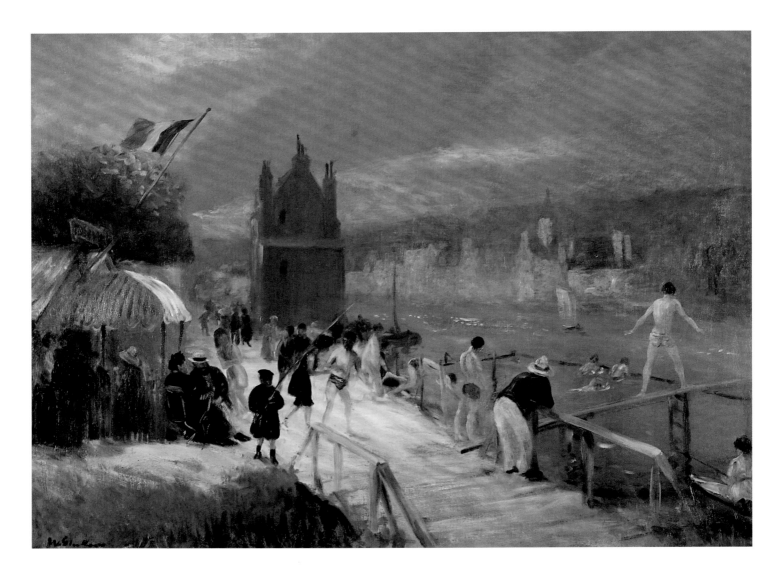

88

Chateau Thierry, 1906
Oil on canvas, 24 × 32 (61 × 81.3)

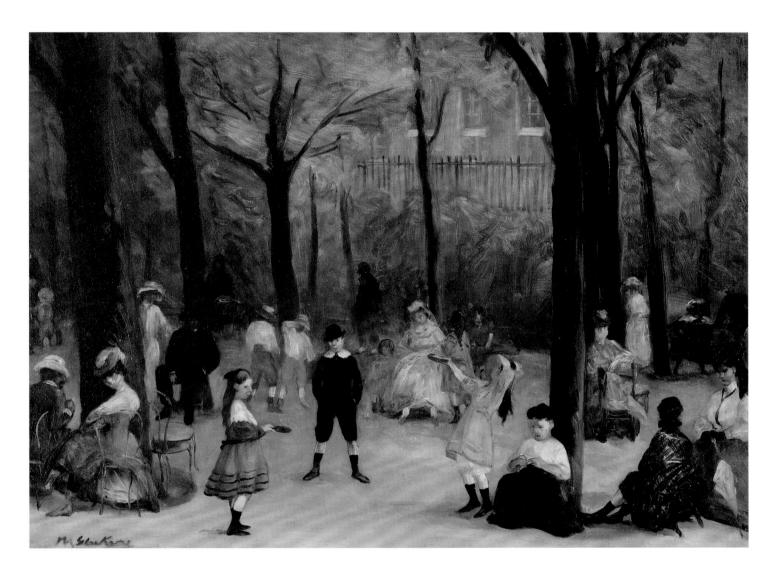

89

Luxembourg Gardens, 1906
Oil on canvas, 23⅞ × 32⅛ (60.6 × 81.6)

Artist's Daughter in Chinese Costume, 1918
Oil on canvas, 48 × 30 (121.9 × 76.2)

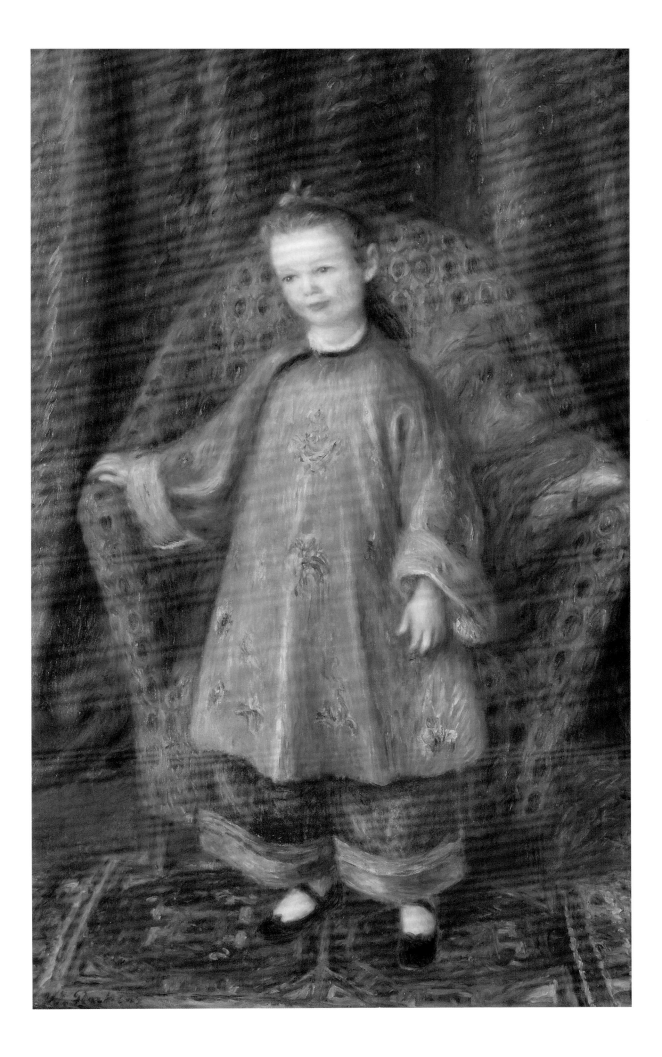

91, 92

Study for "Breakfast Porch," undated
Oil on canvas, 16 × 12 (40.6 × 30.5)

Study for "Breakfast Porch," undated
Oil on canvas board, 15 × 11⅜ (38.1 × 28.9)

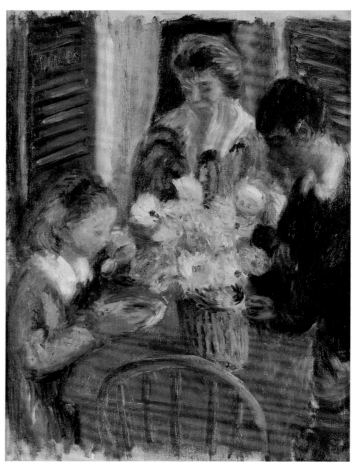

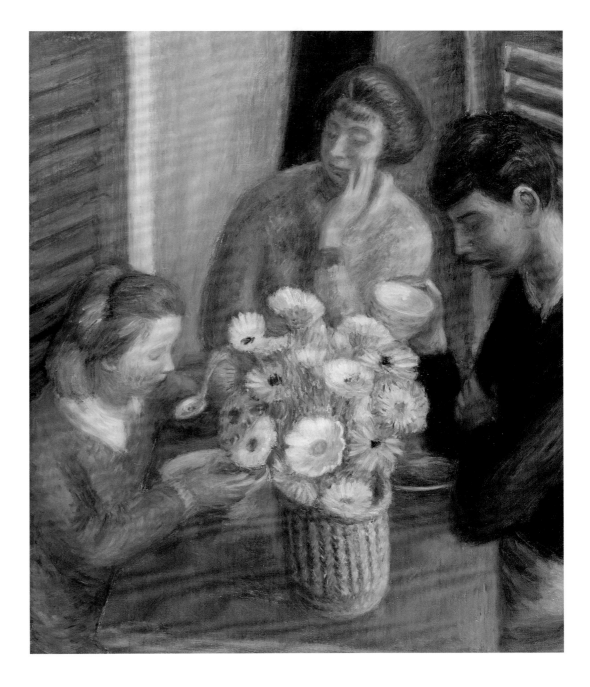

93

Breakfast Porch, 1925
Oil on canvas, 30 × 25 (76.2 × 63.5)

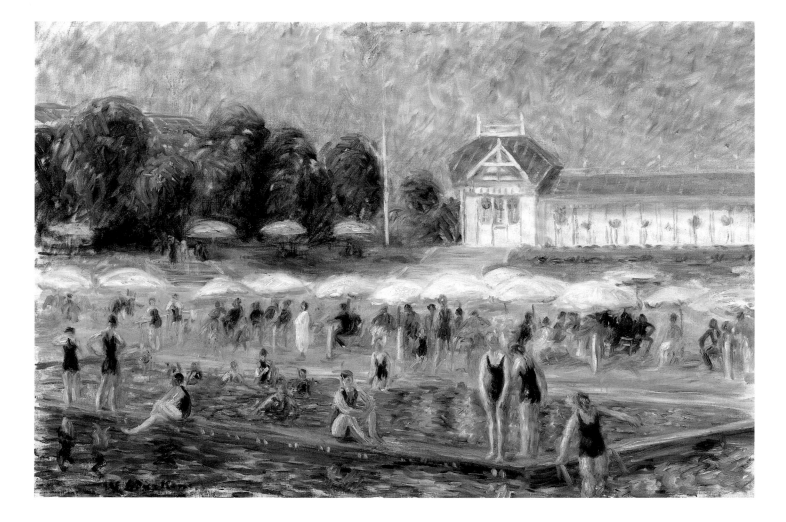

94

The Beach, Isle-Adam, 1926/1927
Oil on canvas, 20 × 32 (50.8 × 81.3)

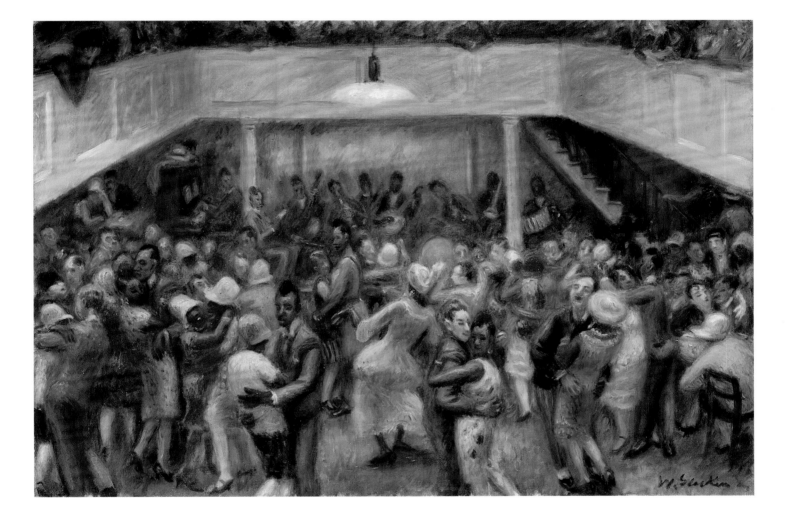

95

Bal Martinique, 1928
Oil on canvas, 22 × 32 (55.9 × 81.3)

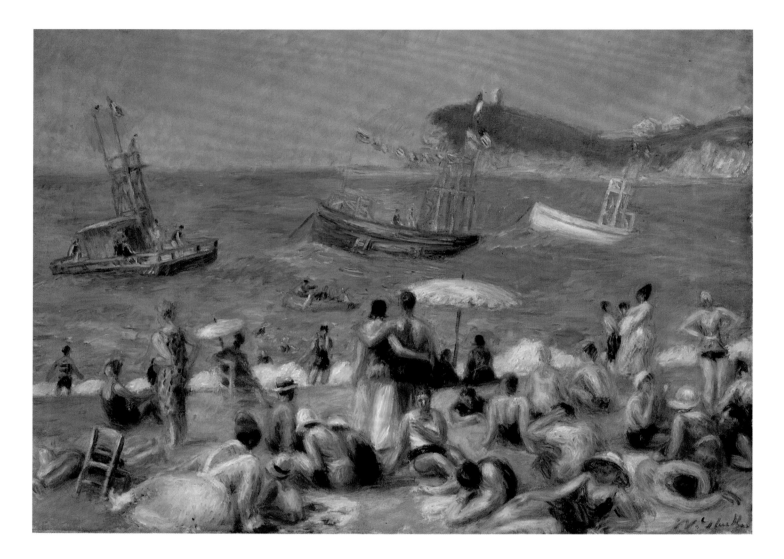

96

Beach, St. Jean de Luz, 1929
Oil on canvas, 23¾ × 32 (60.3 × 81.3)

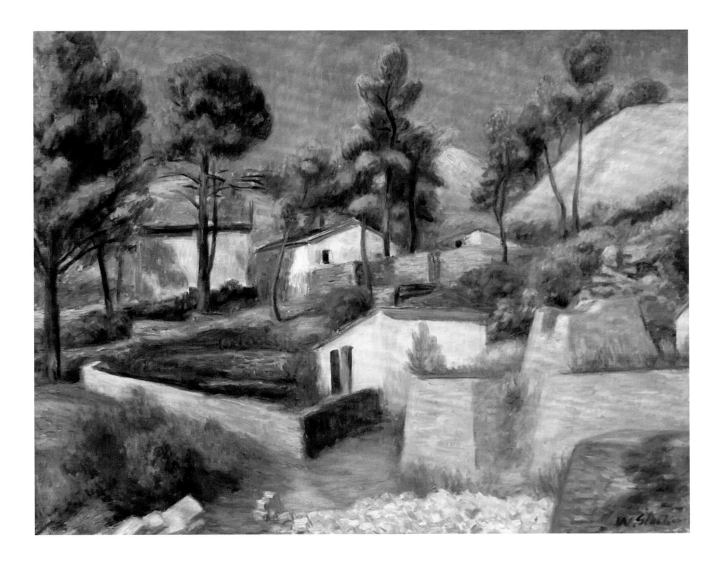

97

Hillside near La Ciotat, 1930
Oil on canvas, 26 × 32 (66 × 81.3)

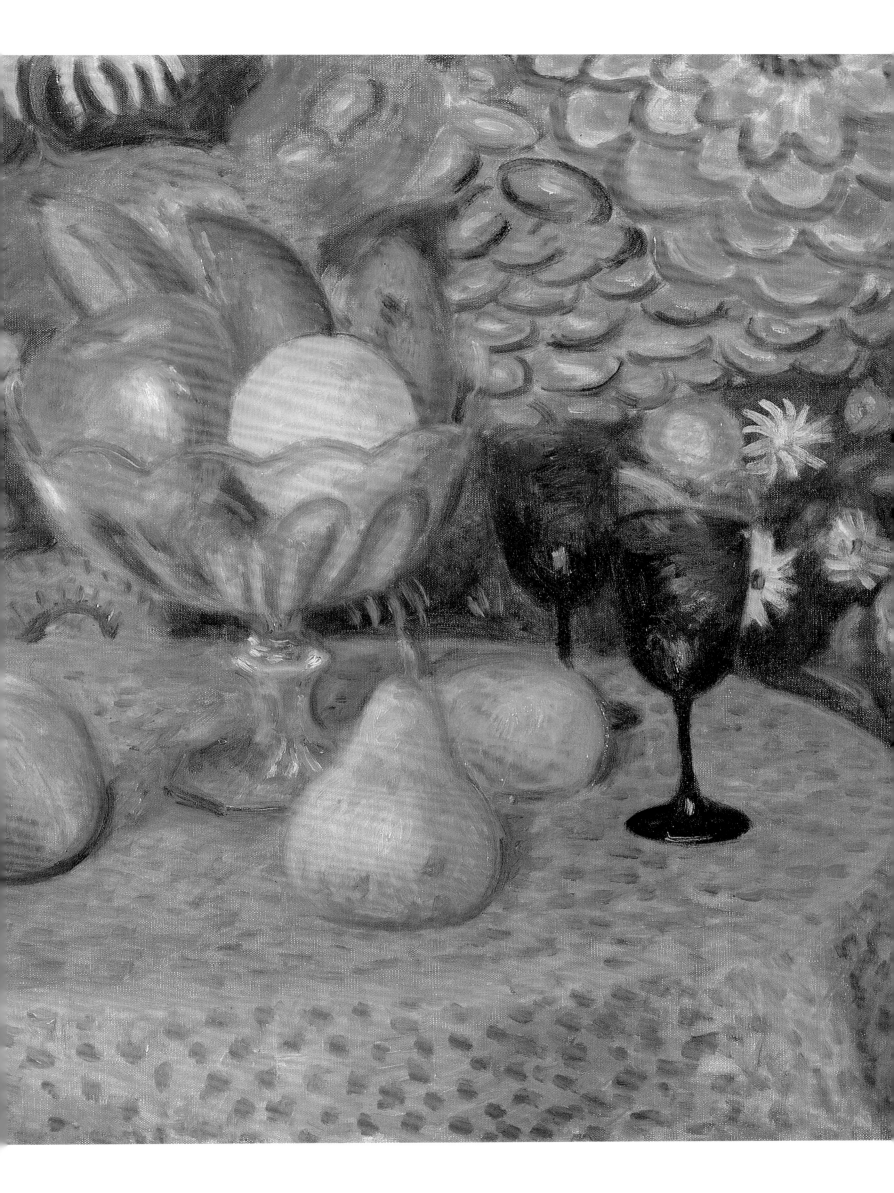

Revelations in Pure Painting: William Glackens's Still Lifes

ELIZABETH THOMPSON COLLEARY

William Glackens's enthusiasm for recording bustling urban scenes, idyllic landscapes, and handsome figurative subjects also extended to artfully placed still lifes. The arrangements of flowers and fruit in decorative containers that appear in Glackens's early work, initially playing seemingly secondary roles in larger figurative compositions, soon came to the fore. While the still-life elements in figurative paintings throughout his career have been described as "decorative adjuncts,"[1] in many of these works they are in fact integral to the conception of the painting. They add bright notes of color to otherwise subdued settings, elevate a gloomy mood, or perhaps contribute to a narrative.

Glackens first exhibited still lifes in 1915 and produced a total of more than 150 "floral portraits" or "flower pieces," as they were often called, more than in any other genre.[2] When he was interviewed in 1936 after receiving the Allegheny Garden Club prize at the Carnegie International exhibition for a flower piece, he said, "flowers have absolute purity, and their extraordinary variety of colors makes them irresistible" (fig. 1).[3]

Glackens's passion for flowers ran deep, as evidenced by the fact that in the descriptive titles for his floral portraits he named at least twenty-eight different varieties.[4] He rarely dated his still-life paintings and he often used multiple titles for the same works—a single painting might have been titled differently each time it was exhibited. It is therefore difficult to determine precisely how his style and choice of subjects evolved over time. Based on the few works that were dated, as well as exhibition and photographic records, they may be grouped roughly by decade.

In the same way the people, locales, and interior settings in Glackens's larger, more complex works held personal meaning, so too did his still-life subjects. They often included fruits the family enjoyed eating and flowers grown in the gardens near houses they occupied. In 1916, when the family was spending its last summer at Bellport, Long Island, Glackens wrote to Robert Henri, "I have been painting flowers chiefly this summer as we had a fine garden. I got a lot of fun out of it."[5] The containers that held the colorful fruits and varied blooms were chosen either because they were favored objects the family owned or simply bowls, vases, or pitchers the artist found inherently beautiful. They range from plain, cylindrical glass vases for the most elaborate floral arrangements and hand-painted Quimper pitchers to silver, porcelain, and glass bowls and compotes filled with sumptuous arrays of fruit. At least one of the smaller containers, a fluted green glass vase, is included in numerous large figurative compositions and smaller still lifes.[6]

When planning his flower-piece compositions, Glackens preferred the casual placement of flowers in a vase or pitcher; he did not arrange them, choosing instead to let them fall naturally. Emma Bellows, the wife of his friend George Bellows, remembered Glackens saying that he believed "the day after a bouquet of flowers was put in a vase, the flowers essentially arranged themselves, and, therefore, there was no need for the artist to adjust his still-life arrangement in any formal order."[7] The artist's son Ira Glackens echoed this observation: "I had never seen him put any flowers in a vase or arrange them. Usually, he would see a bunch of flowers in the living room, put there by my mother, and pick them up and carry them to his studio...sometimes my mother would 'plant' a vase of flowers and say nothing. Soon...it would be up in his studio being painted."[8]

Throughout his career, as Glackens worked on larger, more complex compositions, the same bold stylistic ventures that characterized his figurative, landscape, and interior subjects appeared in his still lifes as well. While staying true to the appearance of the natural forms of the objects portrayed, the still-life paintings display the same daring chromatic arrangements and lively brushwork found in his larger pictures. As he explored impressionist technique, the "influence of [Pierre-Auguste] Renoir had delightful results in the small, sparkling flower pieces through which the purification and intensification of the artist's color may be traced."[9]

Figure Paintings with Still Lifes

Two early examples of prominent still lifes within larger figure compositions are seen in *Portrait of the Artist's Wife* (see plate 40), painted in 1904, the year of Glackens's marriage to Edith Dimock, and *Girl with Apple*, 1909–1910 (see plate 50). Glackens clearly considered the still life an essential component of the painting now known as *Portrait of the Artist's Wife*—when it was exhibited at the National Arts Club in 1908, he called it "Lady with Fruit."[10] Given the frontal placement of the fruit and the fact that it provides the primary bright notes of color in an otherwise

1

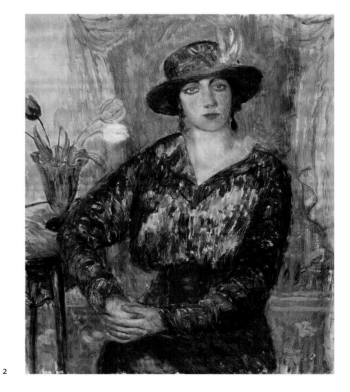

2

FIGURE 1
William Glackens
painting *Tulips*, 1935.
Photograph. Museum
of Art, Fort Lauderdale,
Nova Southeastern
University; bequest of
Ira Glackens, photograph
collection

FIGURE 2
*Woman in Red Blouse
with Tulips*, c. 1913–1914.
Oil on canvas. The Barnes
Foundation, Philadelphia
and Merion, Pennsylvania

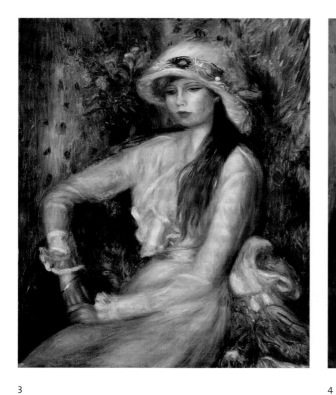

3

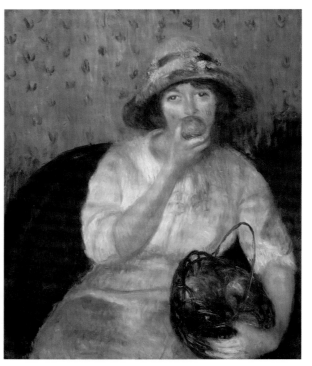

4

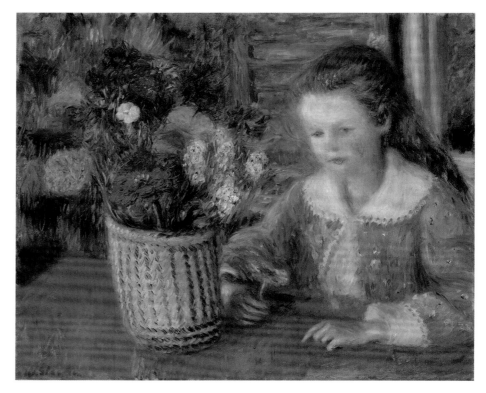

5

earth-toned canvas, the title "Lady with Fruit" was accurate. Beyond formal concerns, the shiny silver compote, piled high with red and yellow fruit, is also important to the mood of the picture as its much-needed spark of color echoes Edith Glackens's feisty, spirited temperament. When judging the extent to which still-life features can be considered integral to figurative compositions, one need only consider the painting without them.

In *Girl with Apple*, a fruit bowl is placed in the left foreground, its presence emphasized not only because the young woman has casually plucked an apple from the bowl, but also because of the chromatic range evident in the fruits. The red apples are set against the warm yellow fruits and, directly in the center of the bowl, a bright green apple heightens the contrast and draws attention to the still life. The bowl of fruit is painted with more precise detail than the rest of the painting, with the exception of the model's face. The fruit is not only positioned in the foreground, but the apple has also always been identified in the title, acknowledging its essential role. *Girl with Apple* is an early example of a painting in which a figure overtly interacts with a still-life element—as other figures will do in future compositions.[11] In naming the picture *Girl with Apple*, Glackens ensures that the woman's handling of the apple becomes the subject of the painting.

After Glackens had married and began to include family members in his figure compositions, objects found in his home often appeared in his paintings. Set in the parlor of the artist's home, in *Family Group*, 1910/1911 (see plate 39), the small green glass vase on the table at the center, filled with a few tulips and illuminated by sunlight pouring through the open door to the balcony, is not essential to the composition. It is, however, noteworthy as the first appearance of a vase Glackens clearly favored; it appeared numerous times in the decades that followed in figurative paintings such as *Woman in Red Blouse with Tulips* (fig. 2) and in several independent still lifes.

Two decorative still-life features are included in *Artist's Wife and Son*, 1911 (see plate 77), which, like *Family Group*, is set in Glackens's home. Although these features are situated in the background plane of this crowded picture, Glackens brightly illuminated them with warm light coming in through the window to ensure they would be visible in the tightly compressed space. The large ivy topiary in a clay pot rises behind Edith's head like a halo—its circular structure echoes her gesture as she lovingly wraps her arms around her son, emphatically embracing him. On the table to the left, Glackens placed a colorful decorative bowl filled with white tulips. Once again the still-life elements lighten the mood of the picture with fresh greenery and flowers in a sunny space, diminishing the cramped feeling of an otherwise claustrophobic composition.

Although the floral still life is not acknowledged in the title, it is perhaps even more integral to the emotional tone of *Girl in Black and White*, 1914 (see plate 78), in which the figure resting her head on her hand appears glum as she stares into the distance. She wears an elegant dress with a festive red flower fastened to the bodice, which softens the stark black-and-white tailored design in the same way the large floral bouquet close to the figure softens and brightens the mood of the picture. With the flowers' pale hues matching the color of the sitter's skin, the bouquet fills what would have been an empty space beside her. Once again, were the still life to be removed, the picture would more decisively portray a forlorn woman.

Around the same time Glackens painted *Girl in Black and White*, he depicted another woman who glances away from the viewer; in this case her eyes are cast downward and her mouth suggests a pouting mood. Nonetheless, in *Julia's Sister*, dated c. 1915 (fig. 3), the lush, resplendent surroundings create a lyrical atmosphere. Glackens's vivid, feathered brushstrokes virtually dance on the surface of the canvas as they describe the pink ruffles on the model's sheer dress, the lively flowers and ribbon that adorn her hat, the patterned fabrics and wall coverings beside and behind her, and the tall bouquet of live flowers next to her.

The interaction between figure and fruit in *Girl with Apple* is taken a step further in *Girl with Green Apple*, c. 1911 (fig. 4). In the earlier painting, the nude simply held an apple, a static still-life element plucked from a bowl. Here, a few years later, Glackens depicts a comfortably seated young woman who has begun to eat one, taken from the colorful basket that she cradles in her arm. His innate love of decorative floral patterns is evident in the wallpaper behind the figure and the lush pink flowers that adorn her blue hat. The artist's mastery of lighting effects can be seen in the soft illumination of the model's eyes, which draws our attention to her wistful expression as she looks up from her apple just long enough to catch the viewer's gaze.

Glackens produced many drawn and painted studies for *Breakfast Porch*, 1925 (see plates 91–93), exhibiting two final versions of the painting. One is a three-figure group that includes the artist's wife, son, and daughter seated at the breakfast table (see plate 93), and another shows his daughter seated at the table alone (fig. 5). Both paintings are examples of figurative compositions with integral still lifes that have become almost as large as the figures beside or behind them, so much so that the still life virtually crowds the figures out of the picture. Indeed, the basket of flowers on the edge of the table in the three-figure version of *Breakfast Porch* measures 16 by 9½ inches, making that single feature larger than some of Glackens's individual still-life compositions. The entire canvas measures 25 by 30 inches. In the paintings, more attention is lavished on the flowers than on the

figures, and again, the space they occupy appears cramped, as if the vase or basket of flowers came first and the figures were then fitted around them.[12]

In the mid-1930s Glackens, although weakened by failing health, still managed to complete *The Soda Fountain* (see plate 82), his last monumental figurative painting in which a still life is a key focal point—here it repeats the colors of the patrons' dresses. This is a late example in which a large, essential still-life element extends beyond the space seemingly allotted for it. Situated in the middle ground, the elaborate citrus tower, topped by a pineapple and rising from a large glass compote, appears to be too wide or too large to fit on the shallow counter in front of Ira, the model for the young man serving soda. The arrangement of fruit is wedged into the space between the nearby figure's shoulder and neck. Moreover, a shapely vase with red and yellow roses is also forced into a tight space between the green bottles lined up on the shelf above the cash register. Despite the tight arrangement, the painting is an exemplary work.

Still-Life Paintings

Glackens's individual still-life paintings, most of them flower pieces, may be divided loosely by decade, with the work of each period displaying distinctive traits. The earliest still lifes dating from 1913 to 1920 are small and feature frontal, vertical compositions and simple settings; the works from the 1920s are larger and more complex, some with horizontal formats, and display bold decorative patterns inspired by Henri Matisse; the flower pieces from the 1930s are once again simpler in composition but larger in scale and feature more imposing containers or bouquets.

From the outset Glackens's still-life paintings met with critical acclaim. When first shown at the Daniel Gallery in 1916, his flower pieces were praised in several publications. One writer noted that Daniel had "the most astonishing exhibition of the season" and that "in the first room one enters there is...a rich still life by Glackens."[13] A. E. Gallatin stated, "The flower pieces are most fresh and engaging, in which he shows his love of glorious and radiant color."[14] The following year a critic described an exhibition of new work as "extremely refreshing," and of the three flower pieces included he declared "Flowers Against Blue is especially a gem."[15]

Glackens was thought to have first exhibited his still-life paintings at the Daniel Gallery in 1916.[16] Yet a letter to the artist dated December 15, 1915, from Albert C. Barnes,[17] who was collecting Glackens's flower pieces at the time,[18] discusses a work that Barnes and Leo Stein had recently seen at the Daniel Gallery, confirming that Glackens showed a flower piece in the *Gift Paintings Exhibition* held at Daniel in December of 1915. The letter is noteworthy because, while inquiring about Glackens's still-life painting technique, Barnes mentions that he had seen one of his "flower pieces" at Daniel a few days earlier with Leo Stein. He then noted Stein's criticism of Glackens's occasionally "indeterminate" backgrounds that seem to "envelope [sic] the flowers...." Barnes went on to report that "Stein was very fair, and was frank in saying that he considers your work the best of any painter in America." The earliest of the eight flower pieces in the Barnes Foundation collection are small, the two largest just over 12 by 15 inches. They are characterized by compositions that feature plain tabletops or cloths and, with the exception of one later work, plain backgrounds; in each one a container of flowers fills the center of the painting. These simple arrangements offer great variety in the flowers depicted and the containers that hold them. They range from simple cylinders (*Flowers in a Blue Vase*, c. 1915) filled with loose clusters of flowers to more elaborately decorated vases filled with fuller bouquets (*Zinnias in Striped Blue Vase*, c. 1915).

In February of 1912 Glackens had traveled to Paris to purchase modern French paintings for Barnes. During that sojourn, accompanied by his friend Alfred Maurer, he visited the home of Leo and Gertrude Stein, where he would have seen still lifes by Matisse and Paul Cézanne.[19] Later that year, when Barnes traveled to Paris to buy more pictures, he purchased Cézanne and Matisse still lifes, including one from Leo Stein.[20] Glackens had ample opportunity to see Barnes's new purchases as, according to Ira Glackens, after his father had renewed his friendship with Barnes, "so began...frequent weekends when the G.'s were absent visiting the Barneses at their place at Overbrook, near Philadelphia."[21]

Perhaps a more direct impetus for Glackens to start painting independent still-life compositions arose in the summer of 1912 when Maurice Prendergast came to visit. In his memoir, Glackens's son Ira recounted:

> Maurice came to visit the G.'s when we were spending the summer at Bellport, Long Island, in 1912. He brought his sketch box of course, and when everyone was sitting on the lawn under the trees one hot day he noticed a small bowl of fruit on the grass, got out his paints, and painted it. He left the picture behind him, and we have always treasured it. In later years W. more than once spoke of the difficulty of painting those green apples against the green grass, and much admired the little painting.[22]

The brushwork in the Prendergast piece, now known as *Apples and Pears on the Grass* (Museum of Art, Fort Lauderdale), displays the vigorous movement Glackens employed in many of his still-life paintings. Their palettes were similar, with both artists using bold juxtapositions of vivid complementary colors to enliven the surfaces of their pictures.

Glackens surely observed Prendergast's efforts to resolve formal challenges, as both artists forged ahead to define their respective new styles, inspired by Cézanne's spatial explorations and Matisse's passion for decorative, rhythmic detail. After 1914, when Prendergast and his brother moved to New York and rented a studio at 50 Washington Square South, in the same building where Glackens worked, he would have seen Prendergast's still lifes. As Eleanor Green noted, although "Prendergast is not known to have mentioned or exhibited his still life paintings…he certainly considered this small body of paintings an important part of his oeuvre and well may have had one or more on his easel at any time during his life."[23]

In addition to becoming familiar with Prendergast's pictorial experiments with still life, works said to "fully justify Prendergast's categorization as a modernist,"[24] in 1912 Glackens began serving as chairman of the Committee of Domestic Exhibits for the Armory Show, which opened in February 1913. Charged with choosing the American works, he viewed and studied numerous still lifes submitted by vanguard painters who were investigating the genre, among them Marsden Hartley, Maurer, Charles Sheeler, and Joseph Stella. Moreover, from 1913 to 1923 Glackens exhibited alongside these artists at Daniel, Montross, and Bourgeois galleries, and the People's Art Guild, all known for showing daring contemporary art. Glackens may have arrived at still-life painting through his individual creative pursuits, but in doing so he aligned himself with the next generation of the American avant-garde.

A shared interest in pursuing modernist still life was especially critical for Glackens's relationship with Maurer. The artists had been friends for many years, dating back to a group exhibition at the Allan Gallery in New York in 1901. When Glackens visited Maurer in France in 1912, he saw firsthand the bold, fauve-inflected still lifes Maurer was beginning to produce, and he was so impressed that he purchased one for Barnes while he was there.[25] Indeed, Maurer and Glackens were on parallel paths in working out how to paint still lifes, because both were moving away from the dark tonalities and urban subjects of the Ashcan painters. "Between 1904 and 1907 Glackens and Maurer separately broke from the somber palette and traditional sense of composition.… Glackens found stimulation in the brushwork and tonality of the Impressionists and the rich colors of Renoir while Maurer was inspired by the Fauves.… A synthesis of the primary lessons of Cézanne and Matisse provides the pictorial vocabulary for the floral works of both Glackens and Maurer. The flattening of space which Cézanne explored…and the color and pattern which intrigued Matisse, gave inspiration and liberation" to both artists.[26]

In the use of bright, contrasting colors and bold, decorative patterns, Glackens's still-life paintings of the 1920s were clearly inspired by Matisse. The spatial structure in these pictures also changed, evolving from earlier simple frontal views to incorporating multiple shifting perspectives, comparable to Cézanne's experiments. In *Flowers against a Palm Leaf Pattern*, c. 1920–1930 (fig. 6), the title acknowledges the setting rather than describing the flowers or their container. Indeed, the palm-leaf pattern is the most conspicuous element in the composition, filling the background with stylized swirling shapes in dashing strokes of red, orange, yellow, and green. Compared to earlier works, Glackens has scaled down the size of the still life—although centrally located, it no longer fills the picture plane, so that more space can be given to the pattern on the wall and the colorful rippling surface on which the vase sits.

The viewpoint in *Flowers against a Palm Leaf Pattern* is still frontal, but in two sumptuous tabletop arrangements of fruit and flowers dating from the mid-1920s, viewpoints are combined, tilted, and skewed. The dominant feature in *Still Life with Three Glasses* (plate 101) is again the bold decorative design on the wall. Glackens's love for rhythmic pattern is jubilantly in evidence here, accentuated by the presence of simple objects—the plain pitcher, goblets, and fruit—that do not compete with the busy design behind them. He unified his composition, a riot of warm colors and cool accents, by repeating the reds and yellows in the lively spotted cloth, the simple forms of the fruits on the table, and the compote; the same warm hues appear in the intricately stylized flowers on the wall. The glass compote is another container that Glackens used in more than one painting; a larger version of the compote holds the tower of fruit that crowds the counter in *The Soda Fountain*.

In *Still Life with Roses and Fruit*, c. 1924 (plate 98), the decorative fringed cloth on the table is tilted upward so that the basket, bowl, and vase on it are more visible. As in the other works from the 1920s, the background wallpaper pattern is a key element in the composition: its vertical design leads the viewer's eye downward to enjoy the lavish display below. The numerous disparate still-life elements—decorative footed bowl with fruit, basket with patterned napkin and bread, and vase spilling over with flowers—are unified through Glackens's ingenious repetition of shape and color to create a handsome work. The artist combined Renoir's feathered brushstrokes with Cézanne's shifting perspective and Matisse's love of decorative ornament to create a work that is wholly his own.

In two other flower pieces from the mid-1920's, *Tulips and Freesia*, c. 1925 (private collection), and *Flowers on a Garden Chair*, 1925 (plate 103), Glackens replaced tabletop settings with decorative chair seats, viewed from above, one with a crisscross pattern on a metal garden chair and the other with a geometric patchwork pattern.[27] The colors of the distinctive Quimper pitcher in *Flowers*

on a Garden Chair are repeated in the lush bouquet above. The painting also displays spatial incongruities, with a viewpoint and delineation of space that are oddly skewed. Glackens shows simultaneously a profile view of the pitcher that holds the bouquet *and* an aerial view of the chair seat, a spatial anomaly first used by Cézanne in his still-life paintings. Glackens may have intentionally distorted the perspective to display the woven pattern of the chair seat more accurately — an appealing geometric design that is set off by the curvilinear lines of the chair back. His love for decorative detail extends to the rendering of the design on the distinctive pitcher, with a man in profile dressed in a red shirt and blue trousers; the colors of his garments are repeated in the bouquet above. The palette features Glackens's favored emerald green on the metal chair and in the shiny foliage in the bouquet, set off against the cool blue pitcher and bachelor buttons, the assorted deep red and vermilion blooms, and the white daisies, added for contrast. This is an overtly cheerful picture, an example of what a critic had in mind when she wrote, "what joy in pure painting these flower pieces afford!"[28]

In 1939, when Glackens's memorial exhibition was traveling to numerous venues, the assistant director of the Carnegie Institute reflected on Glackens's legacy and recalled the award given for one of his last floral portraits. Commenting on the Allegheny Garden Club Prize won by Glackens in 1936 at the Carnegie International exhibition, John O'Connor Jr. wrote: "this honor was appropriate for his particular gift; no artist ever more deserved this recognition of his flower paintings. Forbes Watson has well noted that few artists of any period painted flowers more in the spirit in which the earth made them. He captured the essential qualities of the flowers and made them live perpetually enveloped in his luminous colors."[29]

Flowers in a Quimper Pitcher, dated 1913 – 1915 (fig. 7), the earliest flower piece in the Barnes Foundation collection, introduces distinctive French pottery, produced in the Breton town of Quimper since the early eighteenth century. Often decorated with figures and stylized floral motifs, these pitchers became a favored container for Glackens; the variety of hand-painted motifs that cover their lustrous surfaces surely appealed to him.[30] In the 1930s Glackens painted flower pieces that once again featured his beloved Quimper pitchers. Like the Barnes Foundation's small *Flowers in Quimper Pitcher*, with its stylized floral designs on the pitcher that lead the eye to the brilliant bouquet above, the designs in the larger, later version of *Flowers in a Quimper Pitcher* (plate 102) trail up the front of the pitcher. Thin, quick strokes of vermillion and orange lead the eye up to the larger, more lavish bouquet, where rich red, cream, and rose pink hues are set off

against emerald green foliage. When Ira Glackens described his father's last summer of painting, he singled out another Quimper pitcher still life as one of his best. He wrote that "the summer of 1937 was spent in…a beautiful place, surrounded with peach orchards, lawns and flower beds…life there was very pleasant." He then explained that, despite the bucolic setting, his father "painted little that year," but that *Bouquet in a Quimper Pitcher* (see plate 100) was produced, the best-known and perhaps most gay and brilliant of all his many flower pieces."[31]

The late Quimper pitcher painting, praised by Ira Glackens, was also described by John O'Connor in discussing Glackens's transition from his early dark paintings to a brighter palette: "from then on he was committed to his glowing, vibrant, luminous study of form in color which he brought to a culmination in…*Bouquet in a Quimper Pitcher*."[32] The pitcher in this highly regarded painting includes its own sweeping floral motif that leads the eye upward. In comparison with *Flowers in a Quimper Pitcher*, the pitcher in the later composition is more detailed and the large, lush, asymmetrical bouquet of flowers is filled with a greater variety of blooms and greenery, creating a more elegant and sophisticated display. The dense assortment appears to include tiger lilies, poppies, cosmos, freesia, chrysanthemums, zinnias, and trumpet vines — an exquisite mass of blossoms and leaves, with a variety of colors, textures, and brushstrokes used to describe them. Exuberant and beautifully crafted still-life paintings such as this one may have been what the artist and critic Guy Pène du Bois had in mind when he wrote that Glackens painted "some of the most vibrant flower pieces known to our painting."[33]

The inherent quality and lasting appeal of Glackens's flower pieces may perhaps be gauged by the fact that decades after he first exhibited them they were still thought to be "irresistible," as the artist himself had described the appeal he found in flowers. On the occasion of a 1995 exhibition of Glackens's flower pieces, critic Hilton Kramer described the paintings as "fodder for a new canon" and stated that they were a "real revelation. I was a little shocked to find these paintings such a rich pictorial experience. Glackens' command of color and the sheer sensuousness of the oil medium, and the way he imparts to the entire surface of his paintings a high lyric glow, have an irresistible authority."[34] Accompanying the review was a reproduction of *Flowers against Yellow Wallpaper* (fig. 8), a work in which Glackens's flowers were "made to live perpetually in his luminous color," as per Forbes Watson's dictum. Painted eighty years ago, the flower pieces stand as a radiant testimony to Glackens's artistic legacy.

For notes, see page 244.

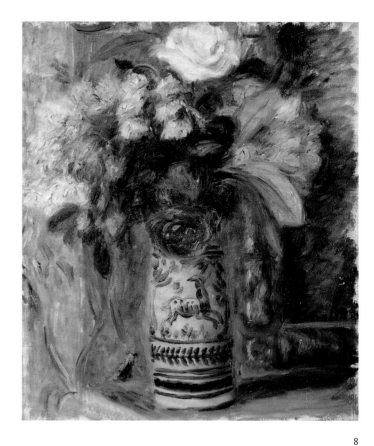

8

6

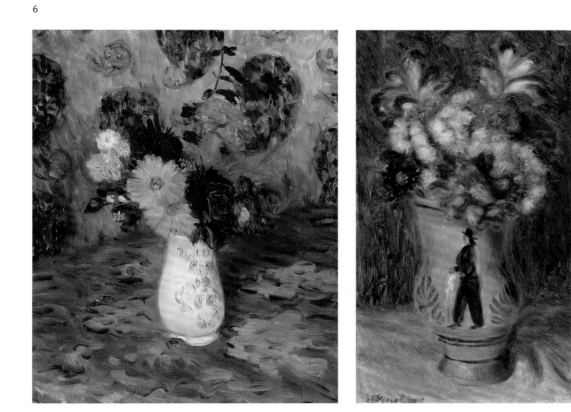

7

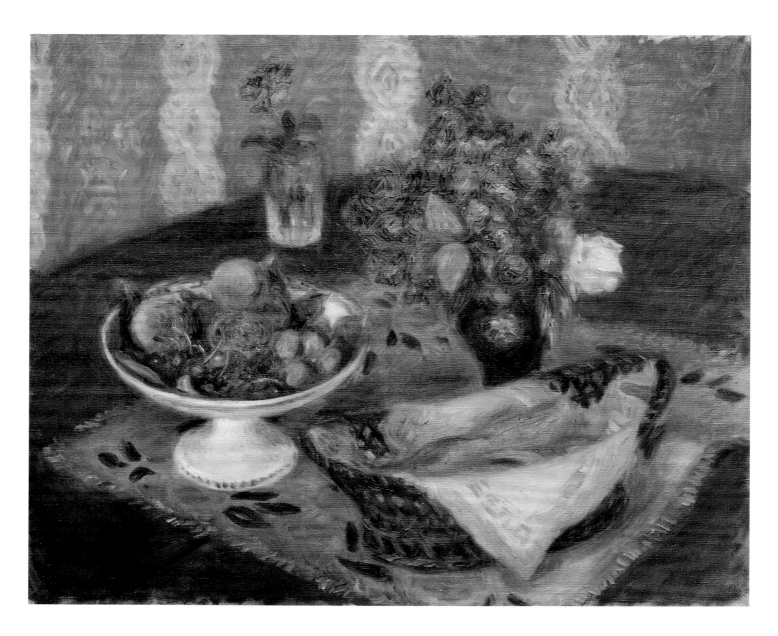

98

Still Life with Roses and Fruit, c. 1924
Oil on canvas, 19⅝ × 23 1/16 (49.9 × 58.6)

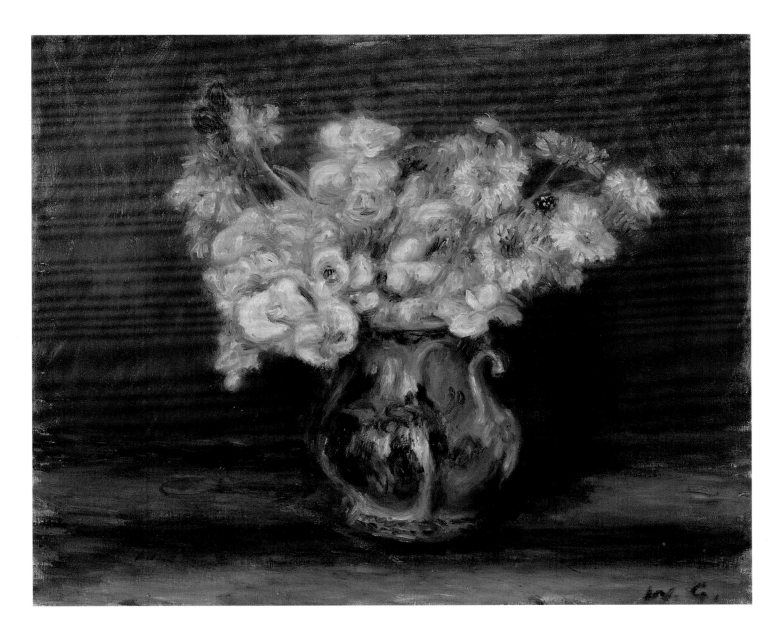

99

Flowers in a Sugar Bowl, c. 1935
Oil on canvas, 15 × 18⅛ (38.1 × 46)

Bouquet in a Quimper Pitcher, 1937
Oil on canvas, 24 × 18 (61 × 45.7)

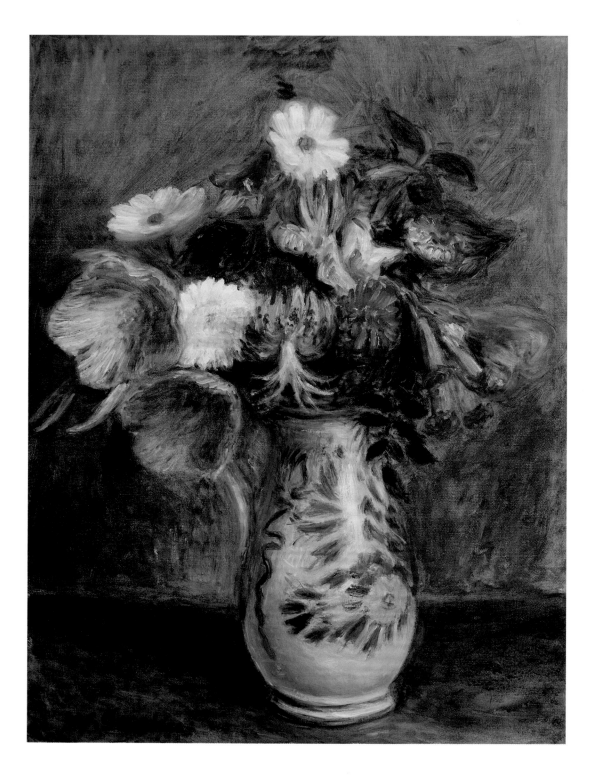

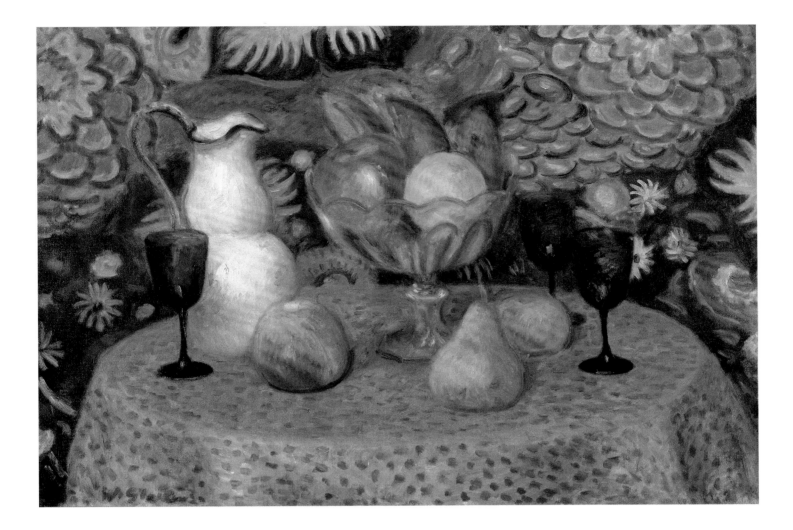

101

Still Life with Three Glasses, mid-1920s
Oil on canvas, 20 × 29 (50.8 × 73.7)

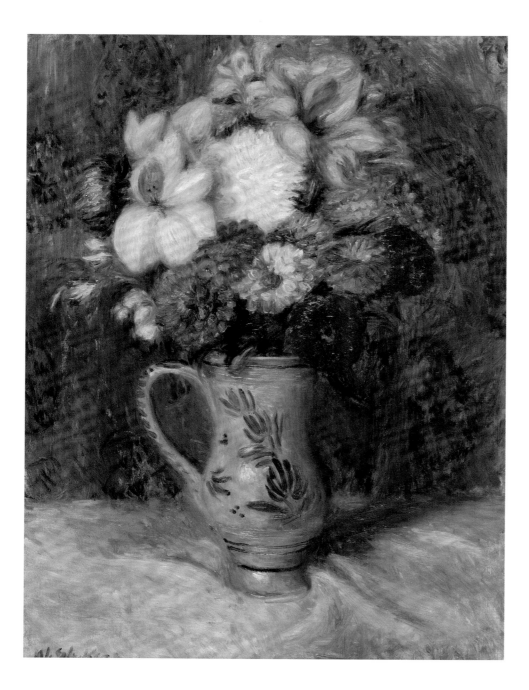

102

Flowers in a Quimper Pitcher, c. 1937
Oil on canvas, 24 × 18 (61 × 45.7)

103

Flowers on a Garden Chair, 1925
Oil on canvas, 20 × 15 (50.8 × 38.1)

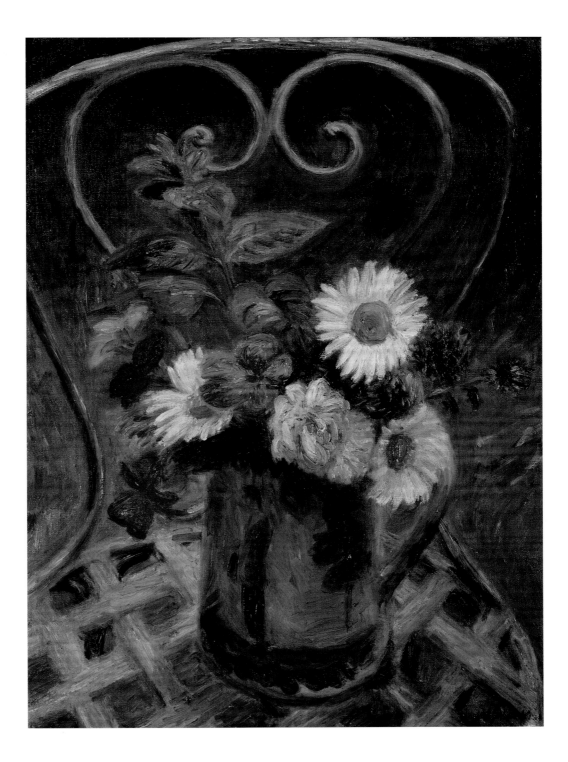

Notes

Introduction
pages 14–18

1 Mather 1916, 13.
2 Mather 1916, 13.
3 Both quotations are from Walt Whitman's *Broadway*, which was first published in the *New York Herald* on April 10, 1888.
4 See, for example, Gloria Groom et al. 2012 for a thorough exposition of this thesis.
5 [Huneker] 1908b, 6.
6 Watson 1939, 7.
7 Barbara Novak, "Introduction," in Foshay 1984, xv.
8 Huneker reviewed Glackens's work in 1908 and 1910 and Dreiser commented it on in 1907. See Huneker 1908a, [Huneker] 1908b, Huneker 1910, and Milroy 1991, 36.
9 William Glackens, letter to Albert C. Barnes, undated [September–October 1924], BFA, quoted in Wattenmaker 2010, 69.
10 Salpeter 1937, 88.
11 Albert C. Barnes, letter to Edgar A. Singer Jr., November 16, 1915, BFA, quoted in Wattenmaker 2010, 65.
12 Novak, "Introduction," in Foshay 1984, xvi.
13 Peter John Brownlee, "On a Perpetual Holiday: The Art of William Glackens after The Eight," in Kennedy et al. 2009, 45, 50.

Early Years
pages 28–36

1 Ira Glackens, letter to William Schack, January 17, 1957, William Schack Papers, AAA, reel 2917.
2 Elmer Field, letters to William Schack, April 18, 1955, and April 18, 1958,

William Schack Papers, AAA, reel 2917.
3 At that time, graduations took place twice a year, in February and in June.
4 Edmonds 1902, 367; *The Semi-Centennial Celebration of the Central High School of Philadelphia Proceedings of the Public Meeting at the Academy of Music*, program published by the Semi-Centennial Committee, 1888, Central High School Archives, Philadelphia. I thank David Kahn and Maxine Croul, Central High School Archives, for access to the school's manuscript collections.
5 As a child William had a new coat with brass buttons; when he bragged, "See my buttons" to his classmates, they started calling him "Butts," and the name stuck. Albert C. Barnes, for example, consistently referred to him as "Butts," and John Sloan called him "Butts" and later "Glack." See Glackens 1990, 10.
6 John Sloan, unpublished speech for William Glackens Memorial, 1939, JSA, box 44, page 1.
7 Quoted in Salpeter 1937, 190–191.
8 "Class A's Entertainment," 8.
9 Quoted in Salpeter 1937, 190.
10 "Sporting Dotlets," 19.
11 A 1923 article on Glackens reported that after graduation from high school, he was employed by an advertising agency for three weeks. See Watson 1923, 250.
12 Louis Glackens, student registration card, January 20, 1890, Art Students League of New York Archives, New York City; William Glackens, student registers, PAFA records, AAA, reel P62. I thank Stephanie Cassidy for access to the League's records.

13 Sewell 1976, xviii.
14 Louise Lippincott, "Thomas Eakins and the Academy," in Philadelphia 1976, 181.
15 Student registers, PAFA records, AAA, reel P62. I thank Jeff Richmond-Moll, PAFA Archives, for consulting the school's records for me.
16 Shinn 1945, 22.
17 Perlman 1978, 19.
18 Jeff Richmond-Moll, e-mail to author, October 5, 2012.
19 Perlman 1978, 19, reported that Gruger met Sloan, Glackens, James Preston, and Joe Laub in Anshutz's class. Sloan also stated that Glackens took the class.
20 Thomas P. Anshutz, letter to Edward H. Coates, May 15, 1893, PAFA Archives, quoted in Frank H. Goodyear Jr., "The Eight," in Philadelphia 1976, 189.
21 Information on Thouron's career at the school was provided by Jeff Richmond-Moll, e-mail to the author, October 22, 2012. Thouron was not named in Academy catalogues as the instructor for any classes for which Glackens registered, but Maxfield Parrish and Elizabeth Shippen Green, who were in the same classes as Glackens, listed Anshutz and Thouron as their instructors in their résumés.
22 Philadelphia 1945, 7.
23 Sloan 1977, 6.
24 Berman 1988, 77.
25 Quoted in Perlman 1978, 19.
26 Perlman 1978, 20.
27 Henri 1960, 200.
28 Bullard 1968, 15–16.
29 Quoted in Perlman 1978, 30.
30 Shinn 1945, 22.
31 See Sylvia Yount, "Whistler and Philadelphia: A Question of Character," in Merrill et al. 2003, 50–63, for a full account of Whistler's relationship with the city's artists and art institutions.
32 Yount in Merrill et al. 2003, 57.
33 See Washington 1993 for a history of the mammoth art exhibition.
34 Yount in Merrill et al. 2003, 56.
35 Robert Henri journal, April 4, 1894, YCAL, box 20, folder 471.
36 William Glackens, letter to Miss Smith, November 25 [1894], Kraushaar Galleries Archives, New York.
37 Perlman 1978, 28.

38 Robert Henri journal, November 1894, YCAL, box 20, folder 471; Robert Henri, "Outline for Projected Autobiography, 1888–1901," YCAL, box 23, folder 540.
39 Robert Henri, letter to Theresa Gatewood and Richard H. Lee, July 11, 1895, YCAL, box 14, folder 347.
40 William Glackens, letter to Miss Smith, September 7, 1895, Kraushaar Galleries Archives; Robert Henri, letter to Theresa Gatewood and Richard H. Lee, July 5, 1895, YCAL, box 14, folder 348.
41 William Glackens, letter to Miss Smith, September 7, 1895, Kraushaar Galleries Archives.
42 An unidentified clipping in the *Philadelphia Times* for May 1895 announced that Henri, Glackens, and Grafly were going to France on the same steamer and that Henri and Glackens would "travel to Venice during the latter part of July, spending the winter in Florence." See Robert Henri scrapbooks, AAA, reel 886.
43 Edward Hopper, letter to Elizabeth Hopper, November 23, 1906, Whitney Museum of American Art Archives, Edward and Josephine Hopper Research Collection, Box A-5(a), quoted in Berman 2005, 31.
44 William Glackens, letter to Miss Smith, September 7, 1895, Kraushaar Galleries Archives.
45 Armstrong 1899, 109.
46 Nicole Cloutier, "The Gentleman Painter" and "Chronology," in Cloutier et al. 1985, 21, 45.
47 Armstrong 1900, 247. See also Armstrong 1899, 109.
48 Whistler 1967, 144.
49 Fink 1990, 122–123, 347.
50 Fink 1990, 124.
51 William Glackens, letter to Miss Smith [December 1895], Kraushaar Galleries Archives. Among the paintings were *Outdoor Theatre, Paris, Circus Parade, Bal Bullier #2, On the Quai, Sailboats, Luxembourg Gardens, Figures in a Park, Paris, Café Scene, Charenton, The Wine Shop*, and *Bridge over the Seine*.
52 It is unknown whether Glackens was asked to participate in the project before he returned home. The commissions had certainly been initiated before then, because the proposal was first made to the Academy's board of directors on April 13, 1896.

See "Board Minutes, April 13, 1896," JSA, box 24. Sloan was working on his murals during the summer of 1896.
53 Wattenmaker 1975, 183–186. See also Gerdts 1996, 24–25.

Draftsman
pages 44–52

1 Epigraph from Pène du Bois 1931, 12.
2 Wattenmaker 2004, 9.
3 Shinn 1945, 22.
4 Shinn 1945, 22.
5 Shinn 1945, 23.
6 The name of the magazine was spelled with one "a" in *Bazar* until 1928.
7 John Sloan, Typescript of an Address to the Art Students League at the time of the Memorial Exhibition for Glackens, JSA, Delaware Art Museum, box 130.
8 Shinn 1945a, 9.
9 John Sloan, quoted in Farr Sloan 1967, n.p. For the practical aspects of newspaper illustration, see also Perlman 1988, 115–120.
10 Armstrong 1900, 247.
11 The ledger for the Charcoal Club is in the John Sloan Archives at the Museum of Modern Art, New York. A copy is in the JSA at the Delaware Art Museum, box 48. Glackens 1957, 8.
12 John Sloan diary, January 15, 1908, in St. John 1965, 184.
13 Glackens's etching appeared in *Moods: A Journal Intime* 2 (1895), n.p. *Moods* was a "little magazine" published in Philadelphia.
14 Mott 1962, 533.
15 On Luks in Cuba, see Gambone 2009, 88–100.
16 Glackens 1957, 23.
17 Bonsal 1898a, 510. Unfortunately, Glackens's illustration appears on page 507.
18 See, for example, Pyle's *Washington and Steuben at Valley Forge*, Wilson 1896, 172; and *The Retreat through the Jerseys*, Cabot Lodge 1898, 395.
19 Cabot Lodge 1898, 130.
20 On Pyle's borrowing, see Heather Campbell Coyle, "Composing American History: Howard Pyle's Illustrations for Henry Cabot Lodge's 'The Story of the Revolution,'" in Coyle 2011, 73–85.
21 Bonsal 1898a, 499–518, and Bonsal 1898b, 118–128. Crane

1899, 332–336. Titherington 1899a, 895–916; Titherington 1899b, 40–59; and Titherington 1899c, 258–278.

22 Even for an established illustrator, 121 published illustrations would constitute a good year. Pyle published only 29 illustrations in 1899, and in his most productive year, he published 227 illustrations. For a complete listing of Glackens's illustrations in books and magazines, see Allyn and Hawkes 1987.

23 Armstrong 1900, 244, 247.

24 Sloan, Typescript of an Address to the Art Students League at the time of the Memorial Exhibition for Glackens.

25 Hills 1977, 91.

26 Armstrong 1899, 109.

27 Vorse 1899, 168.

28 Armstrong 1899, 109. Barbara J. MacAdam identified a beautiful 1906 model study for an illustration. See MacAdam 2011, 52–53.

29 [FitzGerald] 1903.

30 This discussion of the de Kock books relies on the Saint Gervais edition housed at the Delaware Art Museum. For a promotional description of the project, see "The Costliest Set of Books in the World," *The Booklover* 3 (September/October 1902): 358–360.

31 Glackens 1983, 40.

32 On Pyle, see May and May 2011, 120. John Sloan diary, May 2, 1906, in St. John 1965, 33.

33 [FitzGerald] 1903.

34 Copies of the Philadelphia *Gil Blas* are in the Helen Farr Sloan Library and Archives, Delaware Art Museum.

35 Ira Glackens noted that his father "never went out without a sketchbook." Glackens 1972, n.p.

36 For a reading of this picture in terms of reform efforts targeting the Lower East Side, see Rebecca Zurier and Robert W. Snyder, "Introduction," in Zurier et al. 1995, 22–25.

37 See also Marsh 1922, 82–83.

Urban Arcadia
pages 70–86

1 Robert Henri diary, February 4, 1897, Robert Henri papers, AAA, reel 885.

2 Brown 1967, 16.

3 This Palisades location may also have been the backdrop of a related painting, *Boys Sliding*, c. 1897 (Delaware Art Museum, Wilmington). *Boys Sliding* further establishes a winter date for *Outside the Guttenberg Race Track (New Jersey)*.

4 Babcock 1892, 6. See also colinsghost.org/2010/01/winter-racing-at-new-jerseys-guttenberg-race-track-1885-1893.html for the history of the Guttenberg Race Track.

5 William Glackens, letter to Robert Henri, n.d. [1897], YCAL, box 4, folder 91. See also Robert Henri diary, February 4, 1897, AAA, reel 885, in which Henri states that Glackens "will soon come back" to Paris.

6 William Glackens, letter to Robert Henri, January 22, 1898, YCAL, box 4, folder 91.

7 Robert Henri, letter to Theresa Gatewood and Richard H. Lee, November 15, 1897, YCAL, box 14, folder 350.

8 Kirstein 1944, 104, quoted in de Gregorio 1955, 99.

9 Always ready to help a friend, Glackens did report one more time. He filled in for F. R. Gruger, who was unavailable to cover the arrival in New York of Admiral George Dewey in September 1899 for the *Philadelphia Public Ledger*. On October 2, 1899, the *Ledger* ran Glackens's drawing of a Pennsylvania regiment passing in review before Dewey. See Perlman 1978, 36.

10 Glackens 1990, 31.

11 Patricia McDonnell, "American Early Modern Artists, Vaudeville, and Film," in McDonnell et al. 2002, 31. Between 1899 and 1901, Glackens made more than two dozen illustrations of vaudeville and popular-theater scenes for periodicals.

12 Royle 1899, 485–495.

13 Barth 1980, 207, quoted in McDonnell et al. 2002, 6.

14 Lee 1901, 240, 246. Lee, an American clergyman, wrote about the crowd and modern culture for many years, and published his essays in a book titled *Crowds: A Moving-Picture of Democracy* (1913). I am grateful to Martha Lucy for calling this reference to my attention.

15 Lee 1901, 248–249.

16 Homer 1969, 99.

17 Arleen Pancza, "Van Dearing Perrine and The Country Sketch Club," in Graham Gallery 1986, 13.

18 Quoted in Perlman 1991, 47.

19 Milroy 1991, 15.

20 Perlman 1991, 48; see also Wattenmaker 1994, 67.

21 [FitzGerald] 1902.

22 See also Lacey Taylor Jordan, catalogue entry for *Portrait of Charles FitzGerald* in Merrill et al. 2003, 186.

23 "Six Painters" 1904.

24 Hoeber 1904.

25 [FitzGerald] 1904, quoted in Milroy 1991, 37.

26 "The Eightieth Exhibition" 1905, 79–80.

27 John Sloan, verbatim notes, 1944–1951, 104, JSA.

28 Huneker 1908a.

29 Art Students League of New York registration cards, Art Students League of New York Archives. I thank Stephanie Cassidy for making this material available to me.

30 After studying at the League and before enrolling at the Chase school in New York, Dimock temporarily returned home to Hartford and took classes with Chase when Chase taught there once a week. This instruction was insufficient, and she went back to Manhattan. I thank D. Frederick Baker for information on Chase in Hartford; see also Ira Glackens, "A Garden of Cucumbers," unpublished manuscript, Sansom Foundation Archives.

31 Robert Henri diary, September 28, 1901, AAA, reel 885.

32 Robert Henri diary, July 14 and July 15, 1902, AAA, reel 885.

33 Robert Henri diary, November 2–21, 1902, AAA, reel 885.

34 Robert Henri diary, January 24–25, 1903, AAA, reel 885.

35 Perlman 1984, 81. In 1905, Glackens was painting a portrait of Henri, but it is not known if he completed it.

36 John Sloan diary, April 15, 1907, in St. John 1965, 122.

37 Glackens 1990, 57.

38 Mathews 1990, 177.

39 Gerdts 1994, 8. See also pages 46, 129, and 134 for analyses of the American impressionists' preference for painting Central Park's scenery rather than the many city dwellers in it.

40 See Gerdts 1994, 137, for information on May Day in Central Park. Maurice Prendergast depicted May Day festivities in several watercolors in 1901–1902, and George Bellows portrayed the children in a processional manner in his *May Day in Central Park*, 1905 (private collection).

41 I thank Richard J. Wattenmaker for suggesting this idea to me. A similar motivation may lie behind the Manet-influenced *Girl with Apple*.

42 Henri's diaries frequently mention evenings with Glackens and others at Mouquin's.

43 The Mouquin family's background and ancestry are detailed on the family's website, http://history.mouquin.com/mouquin.shtml. The Mouquins also report that the 28th Street restaurant's real name was the Café Bordeaux, but everyone called it Mouquin's.

44 DeCasseres 1932, 366.

45 Phillips et al. 1909, 22.

46 See the Mouquin family's website, http://history.mouquin.com/mouquin.shtml.

47 Epstein 1999, 18–19, 31–32.

48 Epstein 1999, 28.

49 John Sloan diary, October 13, 1906, in St. John 1965, 69.

50 John Sloan diary, November 18, 1906, in St. John 1965, 80.

51 Glackens 1990, 71. Glackens wrote to Henri from Paris that he had not yet started painting from his "Spanish impressions" and, while in Spain, he had had a serious attack of malaria.

52 Three paintings are in museums: the Corcoran Gallery of Art, the Munson-Williams-Proctor Institute, and the Wichita Art Museum; a fourth is recorded in a photograph in the Peter A. Juley Collection, Smithsonian American Art Museum.

53 John Sloan diary, January 8, 1906, in St. John 1965, 4.

54 The Eight and their peers had many invitations to show outside of New York. Glackens, for example, had shown in Philadelphia, Boston, Buffalo, Pittsburgh, Chicago, Paris, London, Cincinnati, and St. Louis since 1900. See Milroy 1991, 32–33, for details of this disparity.

55 Clark 1954, 1961. See also Avis Berman, "'As National as the National Biscuit Company': The Academy, the Critics, and the Armory Show," in Dearinger 2000, 132.

56 John Sloan diary, March 11, 1907, in St. John 1965, 112.

57 "Academy Bars Noted Artists," *New York Mail*, April 11, 1907.

58 Samuel Swift, "Revolutionary Figures in American Art," *Harper's Weekly* 51 (April 13, 1907): 534–536, quoted in Milroy 1991, 24.

59 The Eight's genesis and reception have been extremely well documented. See, for example, Perlman 1979 and Milroy 1991. For cultural and social histories of The Eight and their peers, see Weinberg et al. 1994, Zurier et al. 1995, and Zurier 2006.

60 Both Sloan's and Henri's diaries record Glackens's attendance at various meetings from March and April 1907 through early 1908.

61 The illustration is "I was a *sopher*. I was poor, but I never went hungry," in Cahan 1899, 663.

62 "The Wiles of the Wooer," by Myra Kelly, was published in the September 1907 issue of *McClure's Magazine*. In an interview in February 1907, Glackens stated that he was working on the illustrations for this story.

63 In "Social Discourse in William Glackens' *The Shoppers*," an unpublished paper for the City University Graduate School, fall 1991, Cynthia Roznoy speculated that *The Shoppers* was inspired by the 1907 opening of the New York branch of Wanamaker's department store in Astor Place, just blocks from his studio, and that the action is situated there. Several other authors took up her idea. However, *The Shoppers* was first exhibited at the Carnegie Institute in April 1907, and Wanamaker's opened in New York in September 1907. I thank William H. Gerdts for a copy of Roznoy's paper.

64 H. Barbara Weinberg, "Cosmopolitan and Candid Stories, 1877–1915," in Weinberg and Barratt 2009, 171.

65 Weintraub 1999, 343.

66 See Rebecca Zurier, "The Making of Six New York Artists," in Zurier et al. 1995, 74–75.

67 Weinberg and Barratt 2009, 171.

68 Notman 1907.

69 See, for example, his contemporaneous illustrations of Coney Island beach scenes.

70 See also, "Should Museums Form Collections of Illustrations?," *New York Herald*, December 1, 1907, in which Glackens, when interviewed, wished to categorize his illustrations as discrete from his paintings.

71 See Glackens's interview in Baury 1911, 410, in which he states that he was not brought up in the slums and thus did not feel at home there.

72 Roberts 1939, 10.

73 William Glackens, letter to Edith Glackens, January 17, 1908, quoted in Glackens 1990, 84.

74 Berman 1990, 83–84, 91–93.

75 Milroy 1991, 15.

76 Zilcer 1984, 44.

77 Zilcer 1984, 44–45.

78 "Artists Drop Work to Boom Roosevelt," *New York Times*, May 11, 1908.

79 William Glackens, letter to Edith Glackens, May 14, 1908, quoted in Glackens 1990, 107.

80 William Glackens, letter to Everett Shinn, n.d. [May 1908], Everett Shinn Papers, ᴧᴧᴧ, reel 952.

81 Barnes 2000, 471. See also Wattenmaker 2010, 66, 75–78, who cites Ernest Lawson's influence as well.

82 I thank Martha Lucy for the date and contents of the Renoir show at Durand-Ruel.

83 Quoted in Epstein 1999, 34.

84 Haskell 1980, 17, 186; Marsden Hartley, "291—and the Brass Bowl," in Frank et al. 1979, 120; Sloan diaries, March 20 and March 23, 1909, in St. John 1965, 301–302. After getting help from Glackens, Hartley brought his work to Alfred Stieglitz, who liked the paintings. Hartley's first show at 291 took place in May 1909.

85 Wattenmaker 2004, 8.

86 I thank Richard J. Wattenmaker for determining the date of *Vaudeville Team*.

87 I am grateful to Bob A. London for proposing the identities of both figures. Photographs of Kay Laurell match this image of her.

88 "A March Day on Washington Square," presumably from at least March 1907, if the title is accurate, was reproduced in a February 1908 article in *Craftsman*. The painting's compositional format is similar to that of the Luxembourg Gardens paintings of 1906.

89 According to Weber 2001, 54, Glackens created more

than twenty paintings, plus pastels and charcoal and pencil drawings, of the square between 1906 and 1919.

90 James 1968, 88.

91 Harris 2003, 132–133.

92 See Stenz 1999 and Stenz 1996 for two meticulous interpretations of these paintings. I thank William H. Gerdts for a copy of the latter paper.

93 Joseph Edgar Chamberlain, "More of International Exhibition," *New York Evening Mail*, February 1913, quoted in Gail Stavitsky, "Americans and the Armory Show: An Introduction," in Stavitsky et al. 2013, 35.

94 "Glackens Art Seen in His Recent Work," *New York Sun*, March 5, 1913.

95 Glackens 1913, 159.

96 Oaklander 1996, 20, 23. Unless otherwise stated, all information on the gallery is derived from this article.

97 Wattenmaker et al. 1993, 6–7. See also Judith F. Dolkart's essay in this volume.

Women

pages 104–112

1 John Sloan diary, July 19, 1907, and March 10, 1912, in St. John 1965, 143, 608.

2 Edith Glackens was a committed suffragist and Glackens supported her efforts, marching with her in the suffragist parade in New York in 1913, for example. Neither left written evidence of their political commitment; however, Sloan provides a record: "At dinner we had Mr. Quinn, Glackens and Mrs. Glackens. Glack is not very well.... After dinner...we had a loud pow wow argument on Suffrage for Women and Socialism. Mrs. Glack shows that he is thinking right on these matters." John Sloan diary, June 9, 1910, in St. John 1965, 432.

3 See, for example, *Ye Summer Girl*, 1895, *Philadelphia Record*, May 22, 1891: 5; *Bicycle Built for Two*, a poster illustrating the August 1894 issue of *Lippincott's Magazine*; *Setting at the Plain Deal Table, Her Head Fallen Upon Her Arm*, c. 1900, gouache on paper, Museum of Art, Fort Lauderdale; an illustration for "The Hermit of Rue Madame" by William le Queux, *Ainslee's Magazine* 3 (April 1899): 269;

"Oh," he would gasp, "to have a daughter!," illustration for "Between Two Fools," by R. V. Risley, *Ainslee's Magazine* 4 (November 1899): 483.

4 "Life on Broadway," *Harper's New Monthly Magazine* (1878), and Richard Harding Davis, "Broadway," in *The Great Streets of the World* (New York: Scribner's, 1892), 26, both cited in David Nasaw, "It Begins with the Lights: Electrification and the Rise of Public Entertainment," in McDonnell et al. 2002, 46, 50.

5 Robert C. Allen, "'A Decided Sensation': Cinema, Vaudeville, and Burlesque," in McDonnell et al. 2002, 73–75.

6 See, for example, the headpiece, and *"Persons who secrete campaign rations about them....,"* in Royle 1899, 485, 486; and *"I'm so glad you found me. Oh, take me away"* in Brady 1901, 352. See also Fairman 1993, 211.

7 Glackens 1990, 36–37.

8 This was not the only illustration in which Glackens hid a sly tribute to his social circle. The headpiece of the Royle article, showing a magician and his assistant, includes a placard announcing the act as "Davis and Sloan," presumably a reference to Edward Wyatt Davis and John Sloan, friends since his Philadelphia days.

9 Both portraits are now at the Sheldon Museum of Art, Lincoln, Nebraska. Henri's conservative attitude in his portrait of Edith is especially apparent when compared to his *The Art Student: Portrait of Miss Josephine Nivison*, 1906 (Milwaukee Art Museum), also an image of a young woman artist. Nivison, however, is depicted in a painter's smock and with brushes in her hand and displays both determination and charm.

10 One of the best-known examples of the use of such attributes in American art is John Singleton Copley's *Mrs. Ezekiel Goldthwait*, 1771 (Museum of Fine Arts, Boston).

11 Sloan frequently comments admiringly about her "wit of expression" and her "unique, clever wits [used] to good purpose." John Sloan diary, October 12, 1904, and November 30, 1908, in St. John 1965, 69, 267.

12 Immediately after their marriage in April, the Glackenses lived in the Sherwood Studios on West 57th Street. They moved to 3 Washington Square North over the summer. At that time, Edith was pursuing a career as an illustrator and watercolor painter. She exhibited in the American Watercolor Society's show in 1904 and provided illustrations for Grace Van Rensselaer Dwight, *The Yellow Cat and Her Friends* (New York: D. Appleton, 1905), on which she was presumably working the year of her marriage. See Wattenmaker 2010, 332.

13 John Sloan diary, March 4, 1906, in St. John 1965, 19.

14 "102nd Annual Exhibition" 1907, III: 1.

15 Huneker 1908a.

16 Stern et al. 1983, 191. Among the popular stops along "Ladies Mile" were such department stores as B. Altman, Lord & Taylor, and Macy's.

17 "New York That Never Sleeps," *New York Times*, January 8, 1905, magazine section, 2, quoted in Montgomery 1998, 92.

18 Glackens was aware of hazards to women moving unaccompanied through public spaces. In *Christmas Shoppers, Madison Square*, he shows a man rifling through the purse of a woman waiting for a bus, and in *Curb Exchange No. 3* (see plate 4), he depicts women being ogled and harrassed by men as they make their way down a crowded street.

19 Accompanying the story "The Wiles of the Wooer," Kelly 1907, 541.

20 An irony here is that it was Edith's own money, not her husband's, that paid for the fur coat and fancy hat. Glackens casts his wife and her friends as shoppers, as members of the upper middle class for whom shopping for luxury goods is an afternoon's diversion. This did not require much playacting as several of the women were from that class, although they were artists and had chosen to ally themselves with bohemian circles — a fact that goes unacknowledged in the painting.

21 See Montgomery 1998, 90–93.

22 This phrase appears in "Picturing the City," in Zurier et al. 1995, 150.

23 [Huneker] 1908b, 6.

24 See Valerie Ann Leeds, "Pictorial Pleasures: Leisure Themes and the Henri Circle," in Tottis et al. 2007, 27.

25 Stern et al. 1983, 225.

26 Glackens 1990, 73.

27 [Huneker] 1908b, 6.

28 See again the illustration referred to in note 6, *"I'm so glad you found me...."* In it, Glackens created a variation on this theme. A young man who has fallen in love with an actress interrupts her performance to plead for her attention, alarming the rest of the audience.

29 The rest of his comment makes clear the confusion sometimes resulting from these situations: "the waiter can some times get in bad by going over and trying to put some one next to them, they may be respectable women." Investigator's Report, February 1917, quoted in Peiss 1986, 98.

30 These were the thoughts of Undine Spragg, the protagonist of Edith Wharton's novel, *The Custom of the Country* (Wharton 1913, 167–168). Spragg was a fictional version of the society women who enjoyed flirting with the edges of bourgeois respectability in this way. See Montgomery 1998, 34.

31 William Glackens, letter to Edith Glackens, September 1904, quoted in Glackens 1990, 62.

32 For an excellent discussion of this picture and for additional information about Kay Laurell, see Franklin Kelly, "William Glackens, Café Lafayette," in Robertson et al. 2000, 105–107.

33 "The Art of Making Up" 1912, 15.

34 See "Introduction" and "Picturing the City" in Zurier et al. 1995, 19, 173.

35 These are discussed in "Nude with Apple," in Carbone 2006, 1: 558–560.

36 Carbone points to the ribbon around the model's neck and the blue shoes as details drawn from *Olympia* to heighten the erotic effect of the image. See Carbone 2006, 1: 559.

37 "News and Notes" 1913, 67.

38 See, among many examples, *Julia's Sister*, c. 1915 (see page 224, fig. 3); *Portrait of a Young Girl*, c. 1915 (New Britain

Museum of American Art, New Britain, Connecticut); and *Pink Silk Trousers*, c. 1916–1918 (Museum of Art, Fort Lauderdale).

39 Of Glackens's numerous paintings of Edith and their children, *Family Group* (see plate 39) is set in their apartment at 23 Fifth Avenue; *Artist's Wife and Son* (see plate 77) may take place there or in the apartment at 29 Washington Square West, to which they moved in 1911. *Picnic Island*, c. 1915 (Museum of Art, Fort Lauderdale), depicts Edith and a child on vacation in Bellport. *The Conservatory*, c. 1917 (Museum of Art, Fort Lauderdale), shows the family at Edith's parents' home in West Hartford. *Home in New Hampshire*, c. 1920 (Museum of Art, Fort Lauderdale), represents them in Conway, New Hampshire. Both *The Artist's Wife Knitting* and *Edith, Ira, and Lenna in the Living Room*, c. 1920 (Museum of Art, Fort Lauderdale), are set in their new house at 10 West 9th Street. *Breakfast Porch* and the preparatory sketches for it (see plates 91–93) take place at Samois-sur-Seine, France, where the Glackenses spent the summer of 1925.

40 According to Ira, this was Glackens's name for the dress. Transcript, talk by Ira Glackens at the opening of the Glackens exhibition at the Saint Louis Art Museum in 1969; Glackens archive, Museum of Art, Fort Lauderdale.

41 Stansell 2010, 153. Their attire was absolutely au courant. In a letter to the art dealer Antoinette Kraushaar, Ira Glackens commented: "An old family friend, Mrs. Daniel H. Morgan, who lived on the floor above us, returned from Paris with a magnificent creation of the famous couturier P Poiret, which had a vermilion blouse and white satin skirt. Father got her to pose in this costume." Ira Glackens to Antoinette Kraushaar, June 5, 1966; Glackens archive, Museum of Art, Fort Lauderdale.

42 John Sloan diary, November 27, 1911, in St. John 1965, 582. Ira Glackens notes that Irene Dimock served as secretary to Carrie Chapman Catt for a time. Glackens 1990, 185.

43 Berman 1990, 131.

44 To cite another example, Henri often painted his wife Marjorie, who was a successful cartoonist, but he never alluded to her profession in these pictures.

45 For a fuller discussion of the parallels between Glackens and such intimist painters as Bonnard, see Martha Lucy's essay on Glackens and French art in this volume.

Advocate
pages 128–134

1 Albert C. Barnes, letter to William Glackens, January 19, 1912, London Collection, cited in Wattenmaker 2010, 18.

2 Archival evidence such as canceled checks indicates that Barnes purchased paintings as early as 1904, but the extent of these holdings is not known. Wattenmaker 2010, 17, 53 n. 33.

3 Albert C. Barnes, letter to Edgar A. Singer Jr., November 16, 1915, BFA. Barnes and Glackens also had much in common as Philadelphia boys from modest beginnings who found financial independence — Barnes through his business affairs, Glackens through his marriage to Edith Dimock.

4 Wattenmaker 2010, 66.

5 Judith F. Dolkart, "Race Track," in Dolkart and Lucy 2012, 210.

6 Barnes 1937, 7; see Dolkart and Lucy 2012, 10.

7 Albert C. Barnes, letter to William Glackens, January 30, 1912, London Collection, cited in Wattenmaker 2010, 18.

8 Albert C. Barnes, letter to William Glackens, January 30, 1912, London Collection, cited in Wattenmaker 2010, 18.

9 For a complete list of works acquired by Glackens for Barnes, see Wattenmaker 2010, 19–20. Wattenmaker attributes these more daring purchases to the influence of Paris-based American painter Alfred H. Maurer, whose friendship with Gertrude and Leo Stein exposed Glackens more fully to the work of Paul Cézanne, Maurice Denis, Henri Matisse, Pablo Picasso, and Félix Vallotton. See Wattenmaker 2010, 128. While Barnes's interest in collecting was perhaps spurred by the example of John G. Johnson, the latter may have owed his interest in avant-garde French painting to

Barnes. Walter Pach noted Glackens's role as an advisor to Johnson. See Pach 1912, 92.

10 L. M. 1913, 7.

11 [Roberts] 1913, 135. Barnes had already acquired *Mahone Bay*, 1910, by Glackens in January 1912 (now Sheldon Museum of Art, University of Nebraska), but he exchanged the work for the painter's *Beach at Dieppe*, 1906 (BF562) in October 1912. He had also acquired *Self-Portrait*, 1908 (BF105), and *Pony Ballet*, 1910–early 1911 (BF340). Acquisitions by Americans Arthur B. Davies, Henry Fromuth, Ernest Lawson, Alfred H. Maurer, and Maurice Prendergast preceded *Race Track* as well. See Wattenmaker 2010, 53 n. 35.

12 Wattenmaker 2010, 66.

13 Henri 1910, 160.

14 The Gilder 1910, 16.

15 Henri 1910, 162.

16 Hoeber 1910.

17 Townsend 1910, 2.

18 "Landscapes" 1910, 6.

19 *New York World*, section II, April 3, 1910, cited in Wattenmaker 2010, 75.

20 Townsend 1910, 2.

21 "Around the Galleries" 1910.

22 Gallatin 1910, 68.

23 Alfred Stieglitz presented two exhibitions of Matisse's drawings at 291 in 1908 and 1910, to which all artists interested in European modernism surely flocked. While the 1908 show also included the first painting by Matisse in America — *Nude in a Wood*, 1906, recently purchased by Michael and Sarah Stein for painter and framer George F. Of — these presentations did not provide significant examples of the artist's coloristic derring-do (except through black-and-white photographs), turning Maurer's March–April 1909 exhibition at 291 into an important opportunity to see fauve painting. In 1912, Stieglitz organized a third Matisse exhibition that presented the artist's sculpture.

24 Wattenmaker 2010, 66.

25 For a complete catalogue of the American holdings at the Barnes Foundation, see Wattenmaker 2010.

26 Hoeber 1909, cxxxvi.

27 Wattenmaker 2010, 53 n.35.

28 "Seen in the World of Art: William Glackens Shows His Versatility," *New York Sun*,

December 18, 1910, cited in Wattenmaker 1988, 77.

29 Association of American Painters and Sculptors Records, 1911–1914: Minutes, December 14, 1911, AAA, Box 3, Folder 5.

30 "Notes" 1911, 639.

31 Walt Kuhn, letter to Vera Kuhn, December 9, 1911, AAA, Kuhn Family Correspondence, Box 3, Folder 46.

32 Walt Kuhn, letter to Vera Kuhn, December 15, 1911, AAA, Kuhn Family Correspondence, Box 3, Folder 46.

33 Walt Kuhn to Vera Kuhn, December 7, 1911, AAA, Kuhn Family Correspondence, Box 3, Folder 46.

34 Glackens had presented his work internationally at the Salon of the Société Nationale des Beaux-Arts, Paris (1896); American Pavilion at the Exposition Universelle, Paris (1900); Modern Society of Portrait Painters, Institute in Piccadilly, London (1907); Kunst Akademie, Berlin (1910); United States Pavilion, Buenos Aires and Santiago (1910); and the American Pavilion, Rome (1911).

35 For more on Clara Davidge, Henry Fitch Taylor, and the Madison Gallery, see Oaklander 1996, 20–37.

36 Walt Kuhn, letter to Vera Kuhn, December 7, 1911.

37 "Glackens's Recent Work" 1912, 2.

38 Association of American Painters and Sculptors Records, 1911–1914: Minutes, December 19, 1911, AAA, Box 3, Folder 5.

39 J. Alden Weir, letter to Henry Fitch Taylor, January 3, 1912, AAA, Armory Show Records, Box 3, Folder 3; McCarthy 2013, 68–69.

40 Arthur B. Davies to Walt Kuhn, September 2, 1912, AAA, Armory Show Records, Box 1, Folder 1.

41 Arthur B. Davies, letter to Walt Kuhn, October 10, 1912, AAA, Armory Show Records, Box 1, Folder 1.

42 Walt Kuhn to Vera Kuhn, November 11, 1912, AAA, Armory Show Records, Box 1, Folder 4.

43 Domestic Art Committee: Record Book, 1913, AAA, Armory Show Records, Box 1, Folder 75.

44 Walt Kuhn to Vera Kuhn, December 20, 1912, AAA,

Armory Show Records, Box 1, Folder 4.

45 Walt Kuhn to Vera Kuhn, November 11, 1912.

46 "Circular Invitation." Artist and Lenders Correspondence: Domestic, A–D, 1912–1913. AAA, Armory Show, Box 1, Folder 9.

47 Note to prospective exhibitors from the Domestic Exhibition Committee, January 4, 1913. Artists and Lenders Correspondence: Domestic, A–D. AAA, Armory Show Records, Box 1, Folder 9.

48 Glackens 1913, 159–164.

49 For more on the response to the American presentation, see Stavitsky et al. 2013, 30–37.

50 [Roberts] 1913, 136.

51 [Roberts] 1913, 135.

52 John Sloan diary, April 15, 1911, in St. John 1965, 526.

53 [Roberts] 1913, 135.

54 "News and Notes" 1913.

55 For more on these galleries and their part in advancing vanguard American paintings, see Zilczer 1974, 2–7.

56 Pène du Bois 1914a, 304–306, 325–326.

57 Pène du Bois 1914b, 404.

58 Albert C. Barnes, letter to Singer, November 16, 1915, BFA.

59 Pène du Bois 1914b, 406.

60 "Art Notes" 1913.

61 "Chicago" 1917, 6.

62 "The High Jinks" 1916, 3; "At the Daniel" 1916, 2.

63 "Montross Gallery" 1918, 2.

64 Pène du Bois 1915, 339.

65 Barnes to William J. Glackens, December 15, 1915, BFA.

66 "Four Painters" 1920, 3.

67 Barnes and de Mazia 1939, cited in Wattenmaker 2010, 70.

68 "Moderns" 1915, 286.

69 Brownlee in Kennedy et al. 2009, 47–48.

70 Wattenmaker 2010, 68. Barnes acquired *Madame Cézanne* (BF710) in 1912 and *Madame Cézanne with Green Hat* (BF141) in 1915. A third portrait of Madame Cézanne, now in the collection of the Detroit Institute of Arts, was published in Pène du Bois's 1914 article on the Barnes collection.

71 "Foreword," in *Catalogue of the First Annual* 1917.

72 Henri 1917, 175–177, 216.

73 "The Biggest Exhibition" 1917, 165.

74 "Notes of the Studios" 1917, 200.

75 Glackens 1984, 187–188.

76 See correspondence

between Barnes and William Carlos Williams, September–November 1920, BFA.

77 For a thorough discussion of the debates over *Fountain*, see Camfield 1987, 64–94.

78 Barnes 1915, 248.

79 Paul Guillaume, letter to Albert C. Barnes, November 21, 1922, BFA.

80 Barnes 1925, 2–3.

81 Albert C. Barnes, letter to Edith Glackens, June 3, 1938, quoted in Glackens 1984, 259–260.

Shore Scenes
pages 142–152

1 Carbone 2006, 560. The author notes that the "patterned backdrop of the wallpaper and a seascape probably representing one of Glackens's shore pictures…are rendered in blue and lavender tones that neutralize the contrast to some degree," and further points out the similarity to Glackens's *Wickford, Low Tide*, 1909 (Museum of Art, Fort Lauderdale).

2 For the definitive and comprehensive study of Glackens's beach scenes as a contribution to the international tradition of impressionism, see Wattenmaker 1988, 74–94.

3 Maurer, who exhibited with Glackens in New York in 1901 at the Allan Gallery, had been living in Paris since 1902.

4 As quoted in Greenough et al. 2000, 62.

5 Greenough et al. 2000, 62. *Exhibition of Sketches in Oil by Alfred Maurer, of Paris and New York*; fifteen works were on view from March 30 to April 19, 2009.

6 See also *Study for "Chateau Thierry,"* 1906 (see plate 87), a small oil on panel sketch for the painting that Glackens likely executed on the spot or on his return to Paris.

7 Glackens 1957, 72.

8 Fellow illustrators often remarked on Glackens's "photographic eye."

9 Greely 1888, 481–488.

10 He and his friend the illustrator Ernest Fuhr traveled to Nova Scotia in the summer of 1903. Only one painting is known from that period, *Cap Noir—Saint Pierre*, 1903 (Curtis Galleries).

11 As quoted in Sterngass 2001, 104.

12 In Edith's art student days she shared an apartment with May Wilson and Louise Seyms, a Hartford friend, in the 57th Street Sherwood Studios, where each week, as her son later noted, "a capon, already roasted, was sent down from Hartford." Glackens 1957, 36.

13 Glackens 1957, 103.

14 Glackens 1957, 103.

15 I am deeply grateful to Elizabeth Thompson Colleary for making available to me her extensive research on the site of *Cape Cod Pier.*

16 Glackens 1957, 114. The Glackenses became even closer to Prendergast and his brother Charles, who was renowned for his elaborately carved panels and picture frames, when the brothers moved to New York in 1914, using a studio on the top floor of the building at 50 Washington Square South where Glackens also had a studio.

17 John Sloan diary, July 20, 1907, in St. John 1965, 143.

18 Some works by Glackens, such as *Temple Gold Medal Nude*, c. 1918 (private collection), even the most astute viewer might mistake for a work by Renoir. By the time of this painting, critics had become less charitable on the topic of Glackens's debt to Renoir.

19 As quoted in Gerdts 1996, 97.

20 Glackens would in fact join Edith and her fellow artists in the great 1913 suffragette march down Fifth Avenue, when women paraded with their professions. Prieto 2001, 170.

21 Flossie (Florence Scovel) Shinn, letter to Edith Glackens, July 27, 1908. AAA, William and Ira Glackens Papers, reel 4709.

22 "When one tired of the quiet charms of Cold Spring or the nearby village, one could walk but a few hundred yards and hop aboard 'The General' for an exciting steam over to busy Newport.…Another option, a short walk away, was to jump aboard the Sea View Electric Trolley at the Station just across from the North Kingstown Town Hall and motor down to Narragansett Pier [with its] many casinos. Each evening one could always safely return to the tranquil peace of the Cold Spring House.…" Other guests were Alexander Stirling Calder, Glackens's fellow

student in Philadelphia, and his eleven-year-old son Sandy Calder, as well as the women's rights advocate Margaret Sanger and her husband. http://nklibrary.org/sites/default/files/pdf/nklibrary/swamptown/Swamptown%205-8. I am grateful to William H. Gerdts for pointing out this reference.

23 Frank et al. 1934, 237.

24 Present in both paintings is a uniformed nursemaid, who in the Arkell painting appears to be African American. She bends down to fasten the jacket of her young charge, identified as Glackens's three-year-old son Ira, who is making his first known appearance in his father's paintings.

25 Huneker 1910. As quoted in Wattenmaker 2010, 81.

26 [Watson] 1913, 1: 9.

27 Bigelow 1985, 42.

28 Shinn and Glackens remained lifelong friends. After Shinn's divorce from Flossie, the relationship between the couples cooled as Edith was not fond of his second wife, Corinne, but she did like his two subsequent spouses. DeShazo 1974, 176.

29 Principe 2008, 42.

30 There was a stage, red velvet curtains, campstool seating for fifty, and inventive stagecraft (the effects of snow were achieved by shredded newspaper scattered from on high) at the Greenwich Village theater, which was no doubt replicated at Bellport. Shinn's satires of popular melodramas were enormously popular with audiences, and one of Shinn's plays was later bought and produced on the vaudeville circuit. DeShazo 1974, 74, 80.

31 James L. Ford, letter to Edith Glackens, August 23, 1926. AAA, William and Ira Glackens Papers, reel 4709.

32 The standard date given for *Jetties at Bellport* is c. 1916, but the composition and stylistic elements argue for 1912. See Wattenmaker 1988, 83.

33 By 1917, the society was housing more than eight hundred girls annually at Bellport and at another facility in the Adirondacks; http://jwa.org/encyclopedia/article/greenbaum-selina. New York's Triangle Shirtwaist Factory Fire in 1911, in which 147 young female factory workers perished, many of them recent

Jewish immigrants, brought to national attention the plight of these young women.

34 McFarland 2005, 79.

35 McFarland 2005, 179.

36 McCabe 1913, 10–12.

37 McCabe 1913, 12.

38 The date of 1917 assigned to this painting comes most likely from a date added by Glackens when he donated it to a Red Cross WWI fund drive in Spring 1917.

39 Gould 1995, 7.

40 See Wattenmaker 1988, 89.

41 Glackens 1957, 240.

42 Barnes 1925, 297.

Fashion
pages 174–182

1 Two exhibitions that focus on the strong connection between fashion and art are *Matisse: The Fabric of Dreams, His Art and His Textiles*, 2005, Musée Matisse, Le Cateau-Cambrésis; Royal Academy of Arts, London; and the Metropolitan Museum of Art, New York; and *Impressionism, Fashion and Modernity*, Art Institute of Chicago; Musée d'Orsay, Paris; and the Metropolitan Museum of Art, New York, 2012. Many other such exhibitions and publications have been created over the past three decades.

2 Examples of clothing studies may be seen in *Figure Sketches No. 2* and *Figure Sketches* (plates 73, 74).

3 Coleman 1989, 9.

4 Charles Baudelaire, "The Heroism of Modern Life," in Baudelaire 1981, 104.

5 Trachtman 2003, online.

6 Gerdts 1996, 54–55.

7 Aruna D'Souza, "Why the Impressionists Never Painted the Department Store," in D'Souza and McDonough 2006, 129–147.

8 Poiret 1931, 93.

9 A fourth work by Glackens depicting a striped woman's garment is *At the Beach*, c. 1914–1916, signed 1917 (see plate 70). One of the Bellport pictures, it is primarily a landscape featuring numerous small-scale human figures, one wearing a boldly striped bathing costume that is unique.

10 Paul Poiret was among the first couturiers to create such gowns; he was also a pioneer in disseminating images of it in his privately commissioned

albums filled with fashion pochoirs, or stenciled prints. The pochoir process, characterized by its crisp lines and brilliant colors, replaced machine printing and ended an era of poor-quality color reproductions in fashion publishing. Magazines such as *Le Jardin des dames et des modes* and the *Gazette du bon ton: Arts, modes & frivolités* were filled with pochoir images by well-known artists such as George Barbier and Paul Iribe.

11 A similar image by Georges Barbier appeared in *Gazette du bon ton*, 1913; see Black and Garland 1975, 309.

12 Sarah Cheng, "Chinese Robes in Western Interiors: Transitionality and Transformation," in Myzelev and Potvin 2010, 132.

13 Sontag 1982, xxvi.

French Art
pages 198–206

I am grateful to Avis Berman and Richard J. Wattenmaker, who generously shared their thoughts on Glackens and their Glackens materials with me.

1 "The American Section" 1913, 159–162.

2 McBride 1938, 8.

3 Glackens 1983, 69–70.

4 The artist's travels in France between 1925 and 1932 are detailed in Glackens 1983.

5 Glackens later downplayed the influence of Degas and even Daumier as caricaturists, citing instead his interest in certain English cartoonists. "I feel a bit out of place…connected up with Goya, Daumier and Degas," Glackens wrote to Albert Barnes in 1924. BFA.

6 On Manet's influence on Glackens see, for example, Wattenmaker 2004, 2–47.

7 Weinberg et al. 1994, 3.

8 Gallatin 1910, lxviii–lxxi.

9 These shows at the Durand-Ruel gallery in Paris were *Berthe Morisot: Exposition de son oeuvre avec portrait photogravé d'après Edouard Manet*, March 5–23, 1896; *Exposition Renoir*, May 28–June 6, 1896; and *Exposition d'oeuvre récentes de Camille Pissarro*, April 15–May 9, 1896. The works of the impressionist painter Armand Guillaumin had also been on view at Durand-Ruel sometime in 1896:

Exposition de tableaux et pastels de Armand Guillaumin, n.d.
10 [Huneker] 1908b, 6.
11 McCormick 1908.
12 Ely 1921, 1332–1343.
13 "The American Section" 1913, 159.
14 Huneker 1910.
15 Hoeber 1908.
16 Wattenmaker 2010, 66.
17 Gerdts 1996, 89.
18 To be fair, Gerdts does consider the possibility of a fauve influence, though he does not explore it.
19 Cited in Wattenmaker 2010, 75.
20 See Wattenmaker 2010, 68.
21 O'Brian 1999, 1.
22 "The American Section" 1913, 159.
23 "The American Section" 1913, 160.
24 On the critical reaction to Glackens's fixation on Renoir, see Gerdts 1996 and also Dawson 2002.
25 While many critics accused Glackens of being derivative, the artist had his defenders, among them Forbes Watson, Robert Henri, and Barnes. After overhearing someone calling Glackens's pictures "imitation Renoirs," Barnes said, "I did not have an opportunity to tell the bastard what I thought of his appearance, his profession, and his opinions." Albert C. Barnes, letter to William Glackens, January 17, 1917. BFA.
26 Wattenmaker 2010, 67.
27 Gordon 1958, 6–9.
28 Salpeter 1937, 87–88.
29 On Renoir's modernism see Martha Lucy, "Grappling with Renoir's Modernism in the Collection of Dr. Barnes," in Lucy and House 2012, 21–45.
30 Glackens to Barnes, September 27, 1924. BFA.
31 The show was *Exhibition of Paintings by Pierre-Auguste Renoir*, November 14–December 5, 1908.
32 *Back of Nude* is especially close to Renoir's *Nude from the Back* (BF976); however, Barnes did not acquire that painting until 1939.
33 William Glackens, letter to Albert C. Barnes, n.d. [1924]. BFA.
34 de Mazia 1971, 7.
35 William Glackens, letter to Albert C. Barnes, n.d. [1921]. BFA. Glackens also would have seen canvases by Paul Cézanne at the Metropolitan Museum of Art's enormously popular showing of post-impressionism

that summer. *A Loan Exhibition of Impressionist and Post-Impressionist Art*, May 3–September 15, 1921.
36 Huneker 1910.
37 See Wattenmaker 2010, 68. Wattenmaker compares *Armenian Girl* to Cézanne's *Portrait of Madame Cézanne*, which Barnes had acquired in 1922.
38 Breuning 1937, 117.
39 Glackens bought Pierre Bonnard's *Portrait of Madame Franc-Nohain* from Bernheim-Jeune in 1912. It is now in the collection of the Philadelphia Museum of Art. He may well have seen Bonnard's work as early as 1896, when the artist had an exhibition in Paris; the specific dates of the show are unknown. *Exposition P. Bonnard*, Galerie Durand-Ruel, Paris, 1896.

Still Life
pages 222–228

This essay is dedicated to Steven P. Hollman.
1 Gerdts 1996, 146.
2 De Gregorio 1955, 555–575, includes a catalogue of all 157 still-life works the author located.
3 Audio recording of 1936 radio interview, WNBC radio, New York. Transcript in the Glackens archive, Museum of Art, Fort Lauderdale.
4 According to De Gregorio's catalogue of Glackens's still-life paintings, the flower-piece titles included tulips, zinnias, amaryllis, anemones, asters, black-eyed Susans, California poppies, foxgloves, gladioli, pansies, daisies, calendula, freesias, roses, chrysanthemums, dahlias, daylilies, delphiniums, fuchsias, stock, jonquils, lilacs, lilies, mimosas, narcissus, nasturtiums, verbenas, and petunias, among others.
5 William Glackens, letter to Robert Henri, October 5, 1916, quoted in Wattenmaker 1988, 89.
6 Glackens's favored green glass vase, first seen in *Family Group*, appeared again in numerous still-life composi-tions, among them *Freesia and Tulips*, c. 1915 (Butler Institute of American Art); *Zinnias and Fruit*, c. 1930 (Kalamazoo Institute of Arts); *Red and White Tulips*, undated (private collection); and *Floral Still Life*,

undated (Sansom Foundation). The vase is also part of several figurative compositions, including *Sleeping Girl*, c. 1912 (The Barnes Foundation, Phila-delphia), and *Julia* (private collection).
7 De Gregorio 1955, 231, includes the recollection of Emma Bellows, recorded during the author's interview with her in New York City, November 8, 1954.
8 Ira Glackens, letter to Vincent J. de Gregorio, August 24, 1954, quoted in de Gregorio 1955, 231–232.
9 Davidson 1938, 22. Regarding the influence of modern French painters on the flower pieces, Glackens had encountered their works in France in 1906 and 1912, and those on display at the Armory Show from December 20, 1913, through January 8, 1914. Also, the Durand-Ruel Gallery in New York held an *Exhibition of Paintings Representing Still Life and Flowers by Manet, Monet, Pissarro, Renoir, Sisley, Andre d'Espagnat* that Glackens surely would have seen.
10 The early version of the title, "Lady with a Basket of Fruit," which also acknowledged the significance of the fruit to the composition, may help to explain why, according to Ira Glackens, the work was rejected from a portrait exhibition. He recalled that in 1906 *Portrait of the Artist's Wife*, originally called *Lady with a Basket of Fruit*, had been rejected by the Society of American Artists for a portrait show, and the reason given was that the basket of fruit standing on a small table beside the full-length seated figure somehow took the painting out of the realm of portraiture. It was evidently a still life!" Glackens 1983, 77.
11 In *Girl in White* (see page 32, fig. 5), 1894, Glackens first showed a figure interacting with a still-life element, but the small bowl with a loose spray of red flowers in the middle ground of the picture is not prominent, nor is it in close proximity to the girl. There are, however, two blossoms next to her on the couch, which suggests that she removed them from the bowl before setting them down. I thank Avis Berman for pointing out the still-life feature.

12 In the earlier version of *Breakfast Porch* (see page 224, fig. 5), Lenna is shown alone at the table with the same large flower basket in front of her although it is filled with a different bouquet. She is not eating breakfast and the table is not set for a meal; instead, she has plucked a single flower from the basket and now she, too, interacts with a still-life element, either examining the bloom or perhaps simply appreciating its beauty.
13 "Art Notes" 1916, 201.
14 Gallatin 1916, 262.
15 Partial clipping, *New York Evening Post*, January 20, 1917. Metropolitan Museum of Art Thomas J. Watson Library vertical files.
16 Gerdts 1996, 147–149.
17 Albert C. Barnes, letter to William Glackens, December 15, 1915. Presidents' Files, Albert C. Barnes Correspondence, BFA, Merion, Pennsylvania.
18 The number of still-life paintings in the Barnes Foundation is second only to that of the Museum of Art, Fort Lauderdale, which owns seventeen. The Barnes works are all early, dating from 1913 to 1916; the Fort Lauderdale works are primarily late, dating from the 1930s. All the Barnes paintings were acquired from the artist, presumably during studio visits as it appears that none of them was exhibited before Barnes bought them; the Fort Lauderdale still lifes were part of Ira Glackens's bequest and were owned by the family.
19 Colin B. Bailey, "The Origins of the Barnes Collection," in Bailey et al. 2011, 46. Leo and Gertrude Stein had bought both Matisse's *Dishes and Melon*, 1906–1907, and Cézanne's *Five Apples*, 1877–1878, in 1907. See also Bishop, Debray, and Rabinow 2011, 96, 106.
20 In December of 1912 Barnes bought his first two paintings by Matisse from Leo and Gertrude Stein, one of them *Still-Life with Melon* (*Collioure*), 1905; two days later he bought Cézanne's *Still Life* from art dealer Ambroise Vollard. See Wattenmaker 1993, 8, 30.
21 Glackens 1990, 155.
22 Glackens 1990, 120.
23 Green 1976, 142.
24 Sims 1980, 25.

25 See Wattenmaker 2010, 53, n. 44, 133. Glackens purchased five paintings by Maurer for Barnes — four landscapes and one still life.
26 Kaplan 1995, n.p.
27 In *Tulips and Freesia*, a plain, tapered, cylindrical vase sits on what appears to be a crocheted afghan; the vase is comparable to others Glackens used, often with large, full, dense bouquets that feature the greatest variety of blooms. Other examples include *Bouquet of Flowers and Vase*, 1915 (Wichita Art Museum), and *Still Life: Flowers in a Vase*, undated (private collection).
28 Breuning 1937, 117. The 1937 Kraushaar exhibition included a room devoted exclusively to Glackens's floral still lifes.
29 O'Connor 1939, 275.
30 In addition to *Bouquet in a Quimper Pitcher*, 1937 (private collection), *Flowers in a Quimper Pitcher*, c. 1937 (Museum of Art, Fort Lauder-dale), and the Quimper pitcher that appears in *Flowers on a Garden Chair*, all included in this catalogue and exhibition, *Zinnias in a Quimper Pitcher* (private collection) was shown in the 1966–1967 Glackens retrospective, and in 1995 Kraushaar Galleries showed *Anemones and Tulips in a Quimper Pitcher*, undated.
31 Glackens 1990, 258.
32 O'Connor 1939, 277.
33 Pène du Bois 1940, 83–84.
34 Kramer 1995, 23.

Exhibition History

EMILY C. WOOD

*indicates one-artist exhibition

1892

Unity Art Club, Philadelphia. *Exhibition.* May 1892.

"The Unity Art Club." *Philadelphia Inquirer,* May 22, 1892: 2.

1893

Pennsylvania Academy of the Fine Arts, Philadelphia. *Exhibition of Students' Work.* November 1893.

"Local Art Notes." *Philadelphia Inquirer,* November 5, 1893: 9.

1894

Pennsylvania Academy of the Fine Arts, Philadelphia. *Student Caricatures of Works in the 63rd Annual Exhibition.* March 6 – 20, 1894.

"Art Caricatures by Academy Pupils." *Philadelphia Press,* February 28, 1894.

"Great Paintings Caricatured: A Unique Exhibit by the Students at the Academy of the Fine Arts." *Philadelphia Inquirer,* March 4, 1894: 9.

"A Caricature Exhibition." *Philadelphia Times,* March 4, 1894.

"Art Notes." *Philadelphia Inquirer,* March 11, 1894: 8.

Pen and Pencil Club, Philadelphia. *Exhibition of Newspaper Art.* Opened March 15, 1894.

Pennsylvania Academy of the Fine Arts, Philadelphia. *Sixty-Fourth Annual Exhibition.* December 17, 1894 – February 23, 1895 (catalogue).

1896

Salon of the Société Nationale des Beaux-Arts, Paris. *Exposé au Salon de Champ-de-Mars.* Opened April 23, 1896.

"Among the Artists." *Philadelphia Inquirer,* April 26, 1896: 24.

The Art Institute of Chicago. *Ninth Annual Exhibition of Oil Painting and Sculpture by American Artists.* October 20 – December 6, 1896 (catalogue).

Pennsylvania Academy of the Fine Arts, Philadelphia. *Sixty-Sixth Annual Exhibition.* December 21, 1896 – February 22, 1897 (catalogue).

"The Academy's Yearly Show." *Philadelphia Inquirer,* December 20, 1896: 18.

1898

Pennsylvania Academy of the Fine Arts, Philadelphia. *Sixty-Seventh Annual Exhibition.* January 10 – February 22, 1898 (catalogue).

1900

The Plastic Club, Philadelphia. *Special Exhibition of Works by Three Philadelphia Illustrators: Henry McCarter, Maxfield Parrish [and] William Glackens.* January 22 – February 10, 1900 (catalogue).

"In Art Circles." *Philadelphia Inquirer,* January 21, 1900: 8.

Society of American Artists, Fine Arts Building, New York. *Twenty-Second Annual Exhibition.* March 24 – April 28, 1900 (catalogue).

American Pavilion, Exposition Universelle, Paris. *Fine Arts American Section: Illustrations and Drawings.* April 15 – November 12, 1900.

Boston Art Students' Association, Copley Hall. *First Annual New Gallery Exhibition of Contemporary American Art.* November 21 – December 18, 1900 (catalogue).

The Art Institute of Chicago. *Exhibition of Original Drawings Loaned by Charles Scribner's Sons.* December 13 – 30, 1900 (catalogue).

1901

Pennsylvania Academy of the Fine Arts, Philadelphia. *Seventieth Annual Exhibition of American Paintings, Watercolors and Sculpture.* January 14 – February 23, 1901.

Pennsylvania Academy of the Fine Arts, Philadelphia. *American Pictures from the Paris Exposition.* February 7 – 24, 1901 (checklist).

The Art Institute of Chicago. *Exhibition of the Country Sketch Club of New York.* March 1 – 24, 1901 (catalogue).

Water Color Club, Boston Art Club Galleries. *Fourteenth Annual Exhibition.* March 1 – 16, 1901 (catalogue).

Allan Gallery, New York. *Glackens, Henri, Maurer, Fuhr, Sloan, Perrine, and Price.* April 4 – 27, 1901.

Pan-American Exposition, Buffalo. *Exposition of Fine Arts.* May 1 – November 1, 1901 (catalogue).

1902

Pennsylvania Academy of the Fine Arts, Philadelphia. *Seventy-First Annual Exhibition.* January 20 – March 1, 1902.

Society of Illustrators, Taft and Belknap Company Gallery, New York. *First Annual Exhibition.* Opened March 3, 1902. Traveled to Scranton Club, Scranton, Pennsylvania, March 20 – 27, 1902; Cincinnati Art Museum.

FitzGerald, Charles. "At the American Art Galleries and Elsewhere." *New York Evening Sun,* March 4, 1902.

Society of American Artists, New York. *Twenty Fourth Annual Exhibition.* March 28 – May 4, 1902 (catalogue).

"Society of American Artists Exhibition: Third Notice." *New York Sun,* April 14, 1902: 6.

FitzGerald, Charles. "The Society and the Ten Deserters." *New York Evening Sun,* April 3, 1902: 4.

Pennsylvania Academy of the Fine Arts, Philadelphia. *Third Annual Sketch Exhibition of the Fellowship of the Academy.* March 31 – April 19, 1902.

"My Note Book." *Art Amateur* 46, no. 6 (May 1902): 148.

Cincinnati Art Museum. *Ninth Annual Exhibition of American Artists.* May 17 – July 7, 1902.

1903

Library Gallery, Pratt Institute, New York. *Original Drawings and Paintings for Illustration by Well-known Artists.* January 30 – February 26, 1903.

Society of Illustrators, Taft and Belknap Galleries, New York. *Second Annual Exhibition.* January 31 – February 13, 1903.

"Artists in Black and White." *New York Times,* February 7, 1903: Editorial.

FitzGerald, Charles. "Exhibitions of Illustrations." *New York Evening Sun,* February 11, 1903.

Society of American Artists, Fine Arts Building, New York. *Twenty-Fifth Annual Exhibition.* March – April 1903.

FitzGerald, Charles. "The Society of American Artists." *New York Evening Sun,* April 3, 1903: 6.

Colonial Club, New York. *Exhibition of Paintings Mainly by New Men.* Closed April 3, 1903.

Moravian Seminary, Bethlehem, Pennsylvania. *Exhibition for Bach Festival.* May 9 – 16, 1903.

The Art Institute of Chicago. *Sixteenth Annual Exhibition of Oil Painting and Sculpture by American Artists.* October 20 – November 25, 1903 (catalogue).

1904

Picture Gallery, Wanamaker Department Store, New York. *Exhibition of Drawings.* January 1904.

National Arts Club, New York. *Loan Exhibition of Pictures by Robert Henri, George Luks, W. Glackens, Arthur B. Davies, and Maurice Prendergast.* January 5 – 31, 1904.

"Six Impressionists." *New York Times,* January 20, 1904.

FitzGerald, Charles. "A Significant Group of Paintings." *New York Evening Sun,* January 23, 1904: 4.

De Kay, Charles. "French and American Impressionists." *New York Times,* January 31, 1904.

Society of Illustrators, Taft and Belknap Galleries, New York. *Third Annual Exhibition.* February 15 – 27, 1904.

FitzGerald, Charles. "The Gibbs Collection and the Illustrators." *New York Evening Sun,* February 20, 1904.

Society of American Artists, Fine Arts Building, New York. *Twenty-Sixth Annual Exhibition.* March 26 – May 1, 1904.

"American Artists Exhibit." *New York Sun,* March 27, 1904: 6.

FitzGerald, Charles. "The Society of American Artists III." *New York Evening Sun,* April 2, 1904.

Louisiana Purchase Exposition, Department of Fine Art, Saint Louis, Missouri. April 30 – December 1, 1904 (guide).

The Art Institute of Chicago. *Seventeenth Annual Exhibition of Oil Painting and Sculpture by American Artists.* October 20 – November 27, 1904.

Carnegie Institute, Pittsburgh. *Ninth Annual Exhibition of Paintings.* November 3 – January 4, 1905 (catalogue).

Society of Illustrators, Strollers Club, New York. *Fourth Annual Exhibition.* November 14 – 27, 1904.

FitzGerald, Charles. "Local Exhibitions." *New York Evening Sun*, November 26, 1904.

National Arts Club, New York. *Group Exhibition of Paintings*. December 1905 – January 1906.

National Academy of Design, New York. *The Eightieth Annual Exhibition*. December 31, 1904 – January 28, 1905 (catalogue).

FitzGerald, Charles. "The National Academy of Design." *New York Evening Sun*, December 31, 1904.

Landers, W. T. "The Eightieth Exhibition of the National Academy of Design." *Brush and Pencil* 15, no. 2 (February 1905): 73 – 83.

1905

Pennsylvania Academy of the Fine Arts, Philadelphia. *One Hundredth Annual Exhibition*. January 21 – March 4, 1905.

Trenton, New Jersey. *Collier Collection of Works by Distinguished American Painters and Illustrators*. Opened February 4.

"Art School Sketches." *Trenton Sunday Advertiser*, February 5, 1905: 15.

Society of American Artists, Fine Arts Building, New York. *Twenty-Seventh Annual Exhibition*. March 25 – April 30, 1905.

"American Paintings Shown." *New York Sun*, March 26, 1905: 3.

"News of a Week in the World of Art." *Philadelphia Inquirer*, March 26, 1905: 1.

"Society of American Artists." *New York Evening Post*, March 27, 1905: 4.

FitzGerald, Charles. "Certain Painters at the Society." *New York Evening Sun*, April 1, 1905.

"Annual Society Display." *American Art News* 3, no. 74 (April 8, 1905): 1.

"American Art at Society's Show." *New York World*, April 16, 1905: 4.

Cincinnati Art Museum. *Twelfth Annual Exhibition of American Artists*. May 20 – July 10, 1905.

Fine Arts Pavilion, Portland, Oregon. *Lewis and Clark Centennial Exposition*. June 1 – October 15, 1905.

Carnegie Institute, Pittsburgh. *The Tenth Annual Exhibition*. November 2, 1905 – January 1, 1906 (catalogue).

"Carnegie Institute Exhibition." *American Art News* 4, no. 5 (November 11, 1905): 2.

Townsend, M. E. "Pittsburgh's Annual Art Exhibition." *Brush and Pencil* 16, no. 6 (December 1905): 199 – 205.

Pennsylvania Academy of the Fine Arts, Philadelphia. *Fellowship Exhibition*. Opened November 16, 1905.

National Academy of Design, New York. *The Eighty-First Annual Exhibition*. December 31, 1905 – January 28, 1906 (catalogue).

1906

Pennsylvania Academy of the Fine Arts, Philadelphia. *One Hundred and First Annual Exhibition*. January 22 – March 3, 1906.

"101st Annual Show Represents the Very Best American and European Work." *Philadelphia Inquirer*, January 21, 1906: 2.

"The Exhibition of the Pennsylvania Academy of the Fine Arts." *Collector and Art Critic* 4, no. 4 (February 1906): 105 – 109.

Modern Gallery, New York. *Inaugural Exhibition*. February 24 – March 7, 1906.

Society of American Artists, Fine Arts Building, West 57th Street, New York. *Twenty-Eighth Annual Exhibition*. March 17 – April 22, 1906 (catalogue).

"Pictures at the Society." *New York Times*, April 1, 1906.

Modern Gallery, New York. *Exhibition of Pictures*. Spring 1906.

American Art Galleries, New York. *San Francisco Relief Exhibition and Sale*. May 6 – 8, 1906.

Albright Art Gallery, Buffalo. *First Annual Exhibition of Selected Paintings by American Artists*. May 31 – September 2, 1906.

Worcester Art Museum, Massachusetts. *Ninth Annual Exhibition of Oil Paintings*. May 31 – September 23, 1906 (catalogue).

Pennsylvania Academy of the Fine Arts, Philadelphia. *Seventh Annual Fellowship of the Academy Exhibition*. November 6 – 24, 1906.

"Season of Art Exhibitions Open at the Academy Tomorrow." *Philadelphia Inquirer*, November 4, 1906: 3.

1907

Modern Society of Portrait Painters, Royal Institute Galleries, London. *First Exhibition*. January 1907.

"The Arts." *Speaker*, January 19, 1907: 481.

"London Letter." *American Art News* 5, no. 15 (January 26, 1907): 5.

Pennsylvania Academy of the Fine Arts, Philadelphia. *One Hundred and Second Annual Exhibition*. January 21 – February 24, 1907.

"Art in Philadelphia." *New York Sun*, February 4, 1907: 6.

Caffin, Charles H. "Current Pennsylvania Academy Exhibition: News Report." *Brush and Pencil* 19, no. 1 (January 1907): 11 – 12.

National Academy of Design, Fine Arts Building, New York. *Eighty-Second Annual Exhibition*. March 16 – April 20, 1907.

"The Academy, Its Pride and Glory." *New York Times*, March 17, 1907.

Carnegie Institute, Pittsburgh. *The Eleventh Annual Exhibition*. April 11 – June 13, 1907 (catalogue).

Cincinnati Art Museum. *Fourteenth Annual Exhibition of American Art*. May 18 – July 17, 1907.

Pennsylvania Academy of the Fine Arts, Philadelphia. *Eighth Annual Exhibition of the Fellowship of the Pennsylvania Academy*. October 28 – November 17, 1907.

1908

National Arts Club, Gramercy Park, New York. *Special Exhibition of Contemporary Art*. January 4 – 25, 1908.

"Contemporary Art at National Club." *New York Times*, January 5, 1908.

Macbeth Galleries, New York. *Exhibition of Paintings*. February 3 – 15, 1908 (catalogue). Parts of exhibition traveled to Pennsylvania Academy of the Fine Arts, Philadelphia, March 7 – 19, 1908 (catalogue); The Art Institute of Chicago, *Paintings by Eight American Artists Resident in New York and Boston*. September 8 – October 7, 1908; Toledo Museum of Art, October 15 – November, 1908; Detroit Museum of Art, November 28 – December 1908; John Herron Art Institute, Art Association of Indianapolis, January 6 – 31, 1909; Cincinnati Art Museum, February 6 – 28, 1909; Carnegie Institute, Pittsburgh, March 5 – 31, 1909; Bridgeport Art Association, Bridgeport Public Library, Connecticut, April 10 – 24, 1909; Newark Museum Association, Newark Public Library, New Jersey, May 5 – 23, 1909.

"New York's Art War and the Eight 'Rebels.'" *World Magazine* (NY), February 2, 1908.

"Art in Varied Forms." *Brooklyn Daily Eagle*, February 4, 1908: 4.

Chamberlin, Joseph Edgar. "Two Significant Exhibitions." *New York Evening Mail*, February 4, 1908: 6.

"'The Eight' Exhibit New Art Realism." *New York American*, February 4, 1908: 10.

"Art and Artists." *Philadelphia Inquirer*, March 8, 1908: 12A.

"Widely Shown Exhibition of 'The Eight' American Artists at the Public Library." *Newark Evening News*, May 1, 1909: 2: 3.

Meadville Art Association, Public Library, Pennsylvania. *Second Annual Exhibition of Paintings by American Artists*. April 1908.

Carnegie Institute, Pittsburgh. *Twelfth Annual International Exhibition of Painting*. April 30 – June 30, 1908.

Pennsylvania Academy of the Fine Arts, Philadelphia. *Ninth Annual Exhibition of the Fellowship of the Pennsylvania Academy*. Opened October 19, 1908.

National Academy of Design, New York. *Winter Exhibition*. December 12, 1908 – January 9, 1909 (catalogue).

1909

National Academy of Design, New York. *Eighty-Fourth Annual Exhibition*. March 13 – April 17, 1909 (catalogue).

MacDowell Club, New York. *Exhibition of Paintings*. April 1909.

American Water Color Society, Central Gallery, New York. *Forty-Second Annual Exhibition*. April 29 – May 23, 1909.

"American Water-Color Exhibit. (Second Notice.)" *American Art News* 7, no. 30 (May 8, 1909): 6.

"Much Individuality Seen This Year in the Central Gallery at the Water Color Exhibition." *New York Times*, May 9, 1909.

Carnegie Institute, Pittsburgh. *Thirteenth Annual Exhibition of Paintings*. April 29 – June 30, 1909.

Rand School of Social Science, New York. *First Annual Exhibition of Paintings, Sculptures, Etchings and Drawings*. May – June 1, 1909.

Albright Art Gallery, Buffalo. *Fourth Annual Exhibition of Selected Paintings by American*

Artists. May 10 – August 30, 1909 (catalogue).

"Art Notes Here and There." *New York Times,* May 23, 1909: X6.

City Art Museum, Saint Louis, Missouri. *Fourth Annual Exhibition of Selected Paintings by American Artists.* Opened September 12, 1909.

National Academy of Design, New York. *Winter Exhibition.* December 11, 1909 – January 9, 1910 (catalogue).

1910

City Club, New York. *Exhibition of Landscapes by American Artists.* January – February 1, 1910.

"Art at the City Club." *American Art News* 8, no. 16 (January 29, 1910): 6.

"Notes: Reviews." *Craftsman* 17, no. 6 (March 1910): 717.

Pennsylvania Academy of the Fine Arts, Philadelphia. *One Hundred and Fifth Annual Exhibition.* January 23 – March 20, 1910.

National Arts Club, New York. *Exhibition of American Landscape Painting.* February 3 – 20, 1910.

Hoeber, Arthur. "Art and Artists." *Globe and Commercial Adviser,* February 7, 1910.

"Work of Contemporary American Landscape Painters Shown at National Arts Club." *New York Times,* February 6, 1910.

National Academy of Design, New York. *Eighty-Fifth Annual Exhibition.* March 12 – April 17, 1910 (catalogue).

The Independents, West 35th St., New York. *Exhibition of Independent Artists.* April 2 – 27, 1910.

"Police Called at Opening of Art Show. 'Salon of Protest' Visited by 2,500 Persons and Great Gallery Is Overcrowded." *New York Herald,* April 2, 1910: 12.

Mather, Frank Jewett. "The Independent Artists." *New York Evening Post,* April 2, 1910: 7.

"Independents Hold an Art Exhibit." *World* (NY), April 3, 1910: 11, 7.

"With the Independent Artists." *New York Evening Mail,* April 4, 1910: 6.

Hoeber, Arthur. "Art and Artists." *New York Globe and Commercial Advertiser,* April 5, 1910: 10.

Huneker, James. "Around the Galleries." *New York Sun,* April 7, 1910: 6.

Townsend, James B. "The Independent Artists." *American Art News* 8, no. 26 (April 9, 1910): 2.

"Many and Varied Talents Displayed...." *New York Times,* April 17, 1910.

Henri, Robert. "The Exhibition of Independent Artists." *Craftsman* 18, no. 2 (May 1910): 161 – 173.

American Water Color Society, New York. *Forty-Third Annual Exhibition.* April 24 – May 22, 1910 (catalogue).

Königliche Akademie der Künste, Berlin, Germany. *Ausstellung Amerikanischer Kunst* (Exhibition of American Art). March – April 1910. Traveled to Munich, Germany, May 1910.

"Notes: Reviews." *Craftsman* 17, no. 5 (February 1910): 597.

Brinton, Christian. "American Art in Germany." *Craftsman* 18, no. 3 (June 1910): 310 – 321.

Albright Art Gallery, Buffalo. *Fifth Annual Exhibition of Selected Paintings by American Artists.* May 11 – September 1, 1910 (catalogue).

Worcester Art Museum, Massachusetts. *Thirteenth Annual Exhibition of Oil Paintings.* June 3 – September 19, 1910.

United States Pavilion, Buenos Aires, Argentina. *Exposición Internacional de Arte del Centenario.* July 12 – September 1, 1910. Traveled to Santiago, Chile, *International Fine Arts Exposition.* Opened September 17, 1910.

City Art Museum, Saint Louis, Missouri. *Fifth Annual Exhibition of Selected Paintings by American Artists.* September 15 – November 15, 1910.

National Academy of Design, New York. *Annual Winter Exhibition.* December 10, 1910 – January 8, 1911 (catalogue).

1911

The Pastellists, Folsom Galleries, New York. *Initial Exhibition.* January 10 – 25, 1911.

"Pastellists at Folsom's." *American Art News* 9, no. 14 (January 14, 1911): 6.

"First Exhibition of 'The Pastellists' Suggests the Revival of a Charming Form of Eighteenth-Century Art." *New York Times,* January 15, 1911: 5: 5.

Pène du Bois, Guy. "Pastellists Hold Their First Exhibition. Grace and Charm Mark Delightful Show." *New York American,* January 16, 1911: 9.

"Notes: Reviews." *Craftsman* 19, no. 6 (March 1911): 639.

Art Association of Columbus, Ohio. *Scaled Down Exhibition of Original Independents Show of 1910.* January – February 1911.

Newark Museum Association, Art Gallery, New Jersey. *Exhibition of City Landscapes.* February 1911.

Museum of Fine Arts, Houston. *Exhibition of Selected Paintings by American Artists* [1st Annual]. February 1 – March 2, 1911 (catalogue).

Art Association of New Orleans, Louisiana. *Eighth Annual Exhibition.* March 18 – April 1, 1911.

American Pavilion, Rome. *International Art Exhibition of Pictures and Sculpture.* March 27 – November 1, 1911.

Richmond Hill House, New York. *Exhibition for Settlement House Boys.* Closed April 12, 1911.

Union League Club, New York. *Exhibition of Modern American Painters.* April 14 – 19, 1911.

"Art Exhibition at Union League." *New York Times,* April 14, 1911.

"Exhibitions Now On: Insurgents Capture League." *American Art News* 9, no. 28 (April 22, 1911): 6.

American Watercolor Society, Galleries of the Fine Arts Building, New York. *Forty Fourth Annual Exhibition.* April 27 – May 21, 1911. Selections traveled to Detroit Museum of Art as *Seventh Annual Exhibition of Selected Watercolors by American Artists* or *The Rotary Exhibition.* January 25 – February 10, 1912; The Art Institute of Chicago, May 7 – June 5, 1912.

"Water Color Exhibit by American Society." *Brooklyn Daily Eagle,* May 1, 1911: 9.

"An Exhibition of Watercolors." *Lotus Magazine* 2, no. 5 (May 1911): 133 – 139.

Carnegie Institute, Pittsburgh. *Fifteenth Annual Exhibition of Paintings.* April 27 – June 30, 1911 (catalogue).

"The Value of Water Color Painting, and the Spring Exhibition in New York." *Craftsman* 20, no. 4 (July 1911): 350 – 357.

Cincinnati Art Museum. *Eighteenth Annual Exhibition of Works of American Artists.* May 20 – July 22, 1911 (catalogue).

John Herron Art Institute, Indianapolis. *Third Annual Exhibition on the Indiana Circuit of Oils, Watercolors, Pastels and Prints.* August 1 – September 22, 1911.

Albright Art Gallery, Buffalo. *Annual Watercolor Exhibition by American Artists.* September 16 – October, 1911.

Art Association of Richmond, Virginia. *Fifteenth Annual Exhibition.* October 10 – 29, 1911.

Madison Art Gallery, New York. *Exhibition.* November 3 – 26, 1911.

Pennsylvania Academy of the Fine Arts, Philadelphia. *Ninth Annual Philadelphia Watercolor Exhibition.* November 13 – December 17, 1911.

Society of Illustrators, American Federation of Arts (organizer). *Exhibition of the Work of American Illustrators.* 1911 – 1912. Traveled to John Herron Art Institute, Indianapolis, January 1 – 15, 1911; The Art Institute of Chicago, April 4 – 30, 1911; Public Library, New York, as *Second Special Exhibition,* November 15 – December 2, 1911; Worcester Art Museum, Massachusetts, December 14, 1911 – January 8, 1912; Milwaukee Galleries; Toledo Museum of Art; Cincinnati Art Museum.

The Pastellists, Folsom Galleries, New York. *Second Annual Exhibition.* December 9 – 20, 1911.

National Academy of Design, New York. *Winter Exhibition.* December 9, 1911 – January 7, 1912.

"Matters of Art." *New York Tribune,* December 17, 1911: 7.

1912

Syracuse Museum of Fine Arts. *Illustrations by John W. Alexander and William J. Glackens.* January 1912.

Boston Art Club. *Modern Pictures by American Artists.* January 20 – February 10, 1912.

MacDowell Club, New York. *Seventh Group Exhibition. Modern Paintings by Americans.* January 25 – February 6, 1912.

"Seventh MacDowell Group." *American Art News* 10, no. 16 (January 27, 1912): 6.

*Madison Art Gallery, New York. *Recent Works by William Glackens.* Closed March 25, 1912.

"Glackens' Recent Work." *American Art News* 10, no. 23 (March 16, 1912): 2.

The Art Institute of Chicago. *Rotary Exhibition: Seventh Annual Exhibition of Water Colors by American Artists.* May 7 – June 5, 1912 (catalogue).

City Club, New York. *Eighth Exhibition of City Pictures.* June 1912.

"Exhibition of City Pictures at the City Club." *New York Times*, June 2, 1912.

Society of Illustrators, National Arts Club, New York. *Third Annual Exhibition*. Opened October 21, 1912.

Folsom Galleries, New York. *Exhibition by Six Painters of New York Life*. October 17–30, 1912.

"Art Notes: American Life by American Painters." *Craftsman* 23, no. 3 (December 1912): 371–372.

1913

Pennsylvania Academy of the Fine Arts, Philadelphia. *One Hundred and Eighth Annual Exhibition*. February 9–March 30, 1913 (catalogue).

Association of American Painters and Sculptors, 69th Regiment Armory, New York. *International Exhibition of Modern Art [The Armory Show]*. February 15–March 15, 1913 (catalogue). Traveled to The Art Institute of Chicago, March 24–April 17, 1913; Copley Hall, Copley Society of Boston, April 28–May 18, 1913.

"Painters' Exhibit Approaches Salon." *Philadelphia Inquirer*, February 23, 1913: 6.

"Art at Home and Abroad." *New York Times*, March 2, 1913.

*Folsom Gallery, New York. *Exhibition of Paintings by William J. Glackens*. March 1–17, 1913.

"W. J. Glackens' Pictures." *Brooklyn Daily Eagle*, March 5, 1913: 8.

"Paintings by William Glackens." *Evening Post* (NY), March 8, 1913: Art Notes.

L. M. "Glackens at Folsom's." *American Art News* 11, no. 22 (March 8, 1913): 7.

"Beginning the Art Pilgrimage." *New York Sun*, March 9, 1913: 15.

"News and Notes of the Art World." *New York Times*, March 9, 1913.

"Mr. Glackens, Mr. Frieseke, and Some Others." *New York Tribune*, March 9, 1913: 6.

"Notes of General Interest." *Craftsman* 24, no. 1 (April 1913): 135–136.

"Exhibitions at the Galleries." *Arts and Decoration* 3, no. 6 (April 1913): 210–211.

"Glackens Art Seen in His Recent Works." *New York Sun*, March 5, 1913.

MacDowell Club, New York. *Special Exhibition of Water-colors, Pastels and Drawings by Four Groups of Artists*. Closed May 20, 1913.

Gargoyle Club, Wilkes-Barre, Pennsylvania. *Annual Exhibition*. Opened November 16, 1913.

"Gargoyle Club Will Hold Art Exhibit Sunday." *Wilkes-Barre Times*, November 15, 1913: 5.

The Art Society of Pittsburgh, Carnegie Institute. *Impressionist and Cubist Exhibition*. December 1–31, 1913.

Daniel Gallery, New York. *Modern American Art*. December 16, 1913–January 3, 1914 (catalogue).

1914

The Pastellists, National Arts Club, New York. *Annual Exhibition*. February 5–21, 1914.

Montross Gallery, New York. *Exhibition of Paintings and Drawings*. Version of 1913 Carnegie Institute exhibition. February 2–23, 1914 (catalogue). Traveled to Detroit Museum of Art as *Exhibition of Modern Art*, March 1–15, 1914 (brochure); Cincinnati Art Museum, as *Special Exhibition, Modern Departures in Painting: "Cubism," "Futurism," Etc.*, March 19–April 5, 1914 (brochure); Gallery of Art, Peabody Institute, Baltimore, April 15–May 15, 1914 (brochure).

Pennsylvania Academy of the Fine Arts, Philadelphia. *One Hundred and Ninth Annual Exhibition*. February 8–March 29, 1914 (catalogue).

MacDowell Club, New York. *Thirteenth Group Exhibition of Paintings by Henri, Glackens, Lawson, Preston, Reuterdahl, Sloan, Mager, and Lund*. February 19–March 2, 1914.

"Henri and Fellows at MacDowell Club." *American Art News* 12, no. 20 (February 21, 1914): 6.

Reinhardt Galleries, New York. *Exhibition of American Paintings*. Spring 1914.

Buffalo Fine Arts Academy, Albright Art Gallery. *Ninth Annual Exhibition of Selected Paintings by American Artists*. May 16–August 31, 1914 (catalogue).

Corcoran Gallery of Art, Washington. *Fifth Biennial Exhibition of Contemporary American Oil Paintings*. December 17, 1914–January 24, 1915 (catalogue).

"Corcoran Gallery Exhibit Brilliant." *Philadelphia Inquirer*, December 20, 1914: 2.

Whitney Studio, New York. *Fifty-Fifty Sale and Exhibition for the American Ambulance Hospital*. Opened December 17, 1914.

1915

Daniel Gallery, New York. *A Representative Exhibition of American Art of Today*. January 2–26, 1915 (catalogue).

"At the Daniel Gallery." *American Art News* 13, no. 14 (January 1915): 4.

Whitney Studio, New York. *Loan Exhibition by A. E. Gallatin for Artists' Relief in France*. February 2–16, 1915.

Pennsylvania Academy of the Fine Arts, Philadelphia. *One Hundred and Tenth Annual Exhibition*. February 7–March 28, 1915 (catalogue).

"Technique Absorbs Modern Painters." *Philadelphia Inquirer*, February 14, 1915: 2.

Memorial Art Gallery, Rochester. *Exhibition of Paintings by W. Elmer Schofield and a Collection of Paintings Representative of the Modern Movement in American Art*. February 16–March 7, 1915.

Palace of Fine Arts, San Francisco. *Panama-Pacific International Exposition*. February 20–December 4, 1915 (catalogue).

California Gallery of Fine Arts, San Diego. *Panama-California Exposition*. March 9–December 31, 1915.

Montross Gallery, New York. *Exhibition of Paintings, Drawings and Sculpture*. March 23–April 24, 1915.

"The 'Very Latest' at Montross Gallery." *American Art News* 13, no. 25 (March 27, 1915): 2.

"Moderns at the Montross Gallery." *Arts and Decoration* 5, no. 7 (May 1915): 285–286.

Brooklyn Museum. *Contemporary American Painting*. April 4–May 3, 1915.

Pène du Bois, Guy. "The Apron Strings of Academic Art: As Exemplified at the Recent Brooklyn Exhibition." *Arts and Decoration* 5, no. 8 (June 1915): 319, 329, 338–339.

American Salon of Humorists, Folsom Galleries, New York. *Initial Exhibition of the American Salon of Humorists*. April 17–May 1, 1915.

"Humor Has Its First Salon." *Washington Herald*, June 6, 1915: Feature.

"Sad and Serious Reflections on the First Salon of American Humorists." *Current Opinion* 58, no. 6 (June 1915): 429.

Montross Gallery, New York. *Special Exhibition of Modern Art Applied to Decoration by Leading American Artists*. April 28–May 22, 1915 (catalogue).

"More of the Latest." *American Art News* 13, no. 30 (May 1, 1915): 2.

Britton, James. "More 'Modernism.' (By the Second Viewer)." *American Art News* 13, no. 31 (May 8, 1915): 2.

Montross Gallery, New York. *Summer Exhibition of Pictures and Sculpture*. Summer (June) 1915.

People's Art Guild, University Settlement, New York. *Exhibition of Pictures*. November 1915.

Hackley Art Gallery, Muskegon, Michigan. *Exhibition of Paintings by Twelve American Artists*. December 1915.

Daniel Gallery, New York. *Gift Paintings Exhibition*. December 8–24, 1915.

National Academy of Design, New York. *Winter Exhibition*. December 18, 1915–January 16, 1916 (catalogue).

1916

Daniel Gallery, New York. *Special Exhibition: American Art of Today*. January 1–18, 1916 (catalogue).

Department of Fine Arts, San Francisco. *Post Panama-Pacific Exposition Exhibition*. January 1–May 1, 1916 (catalogue).

Whitney Studio, New York. *Exhibition of Modern Paintings by American and Foreign Artists*. January 5–18, 1916 (catalogue).

Art Association of Indianapolis, John Herron Art Institute. *Thirty First Annual Exhibition of Paintings*. January 11–February 13, 1916 (catalogue).

American Art Galleries, New York. *Exhibition of the Hugo Reisinger Collection for Auction*. January 13–18, 1916.

People's Art Guild, New York. *Exhibition*. February 1916.

Montross Gallery, New York. *50 Pictures by 50 American Artists*. February–March 4, 1916.

Seligmann Galleries, New York. *Exhibition for the Benefit of La Fraternité des Artistes from the Collection of A. E. Gallatin*. February 2–12, 1916.

Pennsylvania Academy of the Fine Arts, Philadelphia. *One Hundred and Eleventh Annual Exhibition*. February 6–March 26, 1916.

The Thumb Box Gallery, New York. *Exhibition of Drawings, Water Colors and Pastels.* February 21–March 11, 1916.

Seattle Fine Arts Society. *Exhibition of Oils from the San Diego Exposition.* March 1916.

Pratt Institute, Brooklyn. *American Illustration from the Collection of Mr. George Whittle.* March 10–April 8, 1916.

Detroit Museum of Art. *Group of Paintings by Beal, Bellows, Chase, Dougherty, Glackens, Henri, Hayley Lever, Schofield and Weir* or *Group of Paintings by Twelve Contemporary American Artists.* April–May 1, 1916. Traveled to Toledo Museum of Art, March 1916; Memorial Art Gallery, Rochester, May 1916.

Daniel Gallery, New York. *Summer Exhibition of Works by American Artists.* May 20–September 1916.

Daniel Gallery, New York. *1916–1917 Opening Exhibition of Paintings and Drawings at the Enlarged Daniel Gallery.* September–October 1916 (catalogue).

Rhode Island School of Design, Providence. *Annual Fall Exhibition of American Paintings.* October 4–26, 1916.

Daniel Gallery, New York. *Mr. A. E. Gallatin's Collection of French Graphic Art.* November 1–14, 1916.

National Association of Portrait Painters, Fine Arts Building, New York. *Sixth Annual Circuit Exhibition.* November 2–26, 1916. Traveled to Memorial Art Gallery, Rochester, December 3–26, 1916; Boston Art Club, January 1–27, 1917; Carnegie Institute, Pittsburgh, February 3–28, 1917; Corcoran Gallery of Art, Washington, March 7–30, 1917.

St. Botolph Club, Boston. *Paintings by William Glackens, Maurice B. Prendergast, William E. Schumacher.* November 1916.

Knoedler Galleries, New York. *Exhibition of Foreign and American Painters.* November 27–December 16, 1916 (catalogue).

Ardsley School of Modern Art, New York. *Impressionism, Post Impressionism and Cubism.* Winter 1916.

Corcoran Gallery of Art, Washington. *Sixth Biennial Exhibition of Oils by Contemporary American Artists.* December 16, 1916–January 21, 1917.

"Arts and Artists Pass in Review." *Philadelphia Inquirer,* December 17, 1916: 5.

"Sixth Corcoran Exhibit." *American Art News* 15, no. 11 (December 23, 1916): 2.

Daniel Gallery, New York. *Gift Paintings.* Closed December 31, 1916.

1917

Knoedler Galleries, New York. *Exhibition of Paintings.* January 1917.

*Daniel Gallery, New York. *Recent Paintings by W. J. Glackens.* January 17–30, 1917 (catalogue).

"Pictures and Sculptures." *American Art News* 15, no. 15 (January 20, 1917): 3.

"What Is Stirring in the Realm of Art." *Brooklyn Eagle,* January 28, 1917: 10.

"Art and Arts Pass on Review." *Philadelphia Inquirer,* January 28, 1917: 5.

*The Arts Club of Chicago, Illinois. *Paintings by William J. Glackens.* February 5–23, 1917.

Bargelt, Louise James. "Art." *Chicago Daily Tribune,* January 28, 1917: 11.

Bourgeois Galleries, New York. *Exhibition of 71 Paintings by Foreign and American Modernist Artists.* February–March 10, 1917.

Knoedler Galleries, New York. *Exhibition of American Painters.* February 15–March 3, 1917 (catalogue).

"'Modernists' at the Bourgeois' Galleries." *American Art News* 15, no. 19 (February 17, 1917): 3.

Touchstone Galleries, New York. *Exhibition of Drawings.* April 1917.

Detroit Museum of Art. *Third Annual Exhibition of Selected Paintings by American Artists.* April 9–May 30, 1917. Traveled to Toledo Museum of Art, Summer 1917.

Society of Independent Artists, Grand Central Palace, New York. *First Annual Exhibition.* April 10–May 6, 1917 (catalogue).

"Art at Home and Abroad." *New York Times,* April 8, 1917.

"A Mile of Pictures." *New York Times,* April 11, 1917.

Daniel Gallery, New York. *Recent Watercolors by American Artists.* Closed April 24, 1917.

"Watercolors at Daniels." *American Art News* 15, no. 26 (April 7, 1917): 2.

People's Art Guild, Jacob A. Riis House, New York. *Exhibition of Paintings.* Spring 1917.

Collectors' Club, New York. *Exhibition and Sale of Drawings by Howard Pyle and Other Artists.* May 9–11, 1917.

Mahoning Institute of Art, Public Library, Youngstown, Ohio. *A Loan Exhibition of Paintings.* May 11–June 1, 1917 (catalogue).

People's Art Guild, Unity House of the Ladies' Waistmakers' Union, Bear Mountain, New York. *Summer Exhibition.* July 1917.

Jesup Memorial Library, Bar Harbor, Maine. *Exhibition of Etchings and Lithographs from A. E. Gallatin's Collection.* August 13–25, 1917.

"Bar Harbor." *American Art News* 15, no. 37 (September 15, 1917): 6.

Art Association of Newport, Rhode Island. *Exhibition of Paintings by George Bellows, Arthur B. Davies and W. Glackens.* September 4–18, 1917 (catalogue).

"Newport." *American Art News* 16, no. 1 (October 13, 1917): 7.

*Art Students League, Fine Arts Building, New York City. *Exhibition of Paintings by William J. Glackens.* November 1917.

Penguin Club, New York. *Exhibition of Paintings and Sculptures to Be Sold.* Closed November 10, 1917.

Macbeth Galleries, New York. *Exhibition of Paintings and Sculptures, Views of New York.* November 22–December 5, 1917 (catalogue).

Sculptors' Gallery, New York. *Exhibition of Sculptures and Paintings by Prominent Artists.* Winter 1917 (catalogue).

1918

Knoedler Galleries, New York. *Exhibition of One Hundred Distinctive Drawings by Masters Both American and European.* January 2–19, 1918 (catalogue).

Bourgeois Galleries, New York, from the Private Collection of A. E. Gallatin. *Exhibition of Paintings and Graphic Art.* January 3–February 2, 1918.

"Modern Artists at Bourgeois Galleries." *American Art News* 16, no. 13 (January 5, 1918): 3.

Carson Pirie Scott and Co. Galleries, Chicago. *Exhibition of Important Paintings by Henri, Bellows, Glackens and Sloan.* Through January 1918.

Stuart, Evelyn Marie. "Exhibitions at the Chicago Galleries." *Fine Arts Journal* 36, no. 1 (January 1918): 43–47.

Whitney Studio, New York. *Indigenous Art Show.* Opened February 4, 1918.

Art Students League, New York. *Exhibition of Sketches and Drawings.* March 18–22, 1918.

Montross Galleries, New York. *Exhibition of Paintings by American Artists.* Closed March 30, 1918.

"Art Notes." *New York Times,* March 11, 1918.

"American Artists Show New Styles." *New York Sun,* March 18, 1918: 7.

"Americans at Montross Gallery." *American Art Notes* 16, no. 24 (March 23, 1918): 3.

Bourgeois Galleries, New York. *Exhibition of Modern Art Arranged by a Group of European and American Artists in New York.* March 25–April 20, 1918 (catalogue, with text by Oscar Bluemner).

"Art at Home and Abroad." *New York Times,* March 31, 1918.

Penguin Club Galleries, New York. *Exhibition of Contemporary Art.* March 16–April 6, 1918.

Society of Independent Artists, Moorish Gardens, New York. *Second Annual Exhibition.* April 20–May 12, 1918 (catalogue).

Knoedler Galleries, New York. *Exhibition of American Paintings and Sculptures Pertaining to the War.* April 29–May 15, 1918 (catalogue).

Anderson Galleries, New York. *Exhibition and Sale of Works of Art Donated to the American-British-French-Belgian Permanent Blind War Relief Fund.* May 11–25, 1918.

Los Angeles Modern Art Society, Brack Shops. *Annual Exhibition.* Spring 1918.

New York Public Library, "Avenue of the Allies." *Outdoor Exhibition for the Fourth Liberty Loan Drive.* October 1918.

Pennsylvania Academy of the Fine Arts, Philadelphia. *Sixteenth Annual Watercolor Exhibition and Seventeenth Annual Exhibition of Miniatures.* November 10–December 15, 1918 (catalogue).

Manhattan Painter-Gravers Club, Mussman Gallery, New York. *First Exhibition of Prints.* November 12–26, 1918.

American Art Galleries, New York. *Allied War Salon.* December 9–24, 1918 (catalogue).

Art Salon of the Hotel Majestic, New York. *First Annual Independent Exhibition of the Work of American Painters.* Closed December 30, 1918.

Whitney Studio Club, New York. *Paintings and Sculpture by Members of the Whitney Studio Club.* December 1918 (catalogue).

1919

Montross Gallery, New York. *Exhibition of American Painters.* Closed January 25, 1919.

"Americans at Montross's." *American Art News* 17, no. 14 (January 11, 1919): 2.

Pennsylvania Academy of the Fine Arts, Philadelphia. *One Hundred and Fourteenth Annual Exhibition.* February 9 – March 30, 1919 (catalogue).

Society of Independent Artists, Roof Garden of Waldorf-Astoria, New York. *Third Annual Exhibition.* March 23 – April 15, 1919 (catalogue).

Knoedler Galleries, New York. *Exhibition of Paintings Donated to the American Red Cross.* April 28 – May 10, 1919 (catalogue).

Montross Gallery, New York. *Paintings and Drawings by American Artists.* May 1919.

"Special Exhibition at Montross." *American Art News* 17, no. 31 (May 10, 1919): 2.

Franco-American Committee (organizer), Musée Nationale de Luxembourg, Paris. *Exposition d'artistes de l'école Américaine.* May – November 1919.

Art Association of Newport, Rhode Island. *Eighth Annual Exhibition of Pictures by American Painters.* July 12 – 29, 1919 (catalogue).

Atwood Gallery, Gloucester, Massachusetts. *Exhibition of Works by Hassam, Lie, Glackens, Lever, Sloan, Hopkinson, Kronberg and Prendergast.* July 24 – August 11, 1919.

Gallery-on-the-Moors, Gloucester, Massachusetts. *Hassam, Lie, Glackens, Haley-Lever, Sloan, Hopkinson, Kronberg and Prendergast.* July 24 – August 11, 1919.

Gallery-on-the-Moors, Gloucester, Massachusetts. *Fourth Annual Exhibition.* August – September 8, 1919.

Daniel Gallery, New York. *Exhibition of Modern Paintings.* Fall 1919.

Townsend, James B. "Artists' Summer Colonies: Gloucester, Mass." *American Art News* 17, no. 38 (September 13, 1919): 6.

City Art Museum, Saint Louis, Missouri. *Fourteenth Annual Exhibition of Selected Paintings by American Artists.* September 14 – October 28, 1919.

E. Gimpel and Wildenstein Galleries, New York. *First Annual Exhibition of the American Painters, Sculptors, and Gravers.* November 3 – 22, 1919 (catalogue). Traveled to Rochester; Buffalo Fine Arts Academy, Albright Art Gallery, December 6, 1919 – January 5, 1920; Detroit Institute of Arts, January 15 – 25, 1920 (checklist); The Art Institute of Chicago, March 9 – April 1, 1920; City Art Museum, Saint Louis, Missouri, as *Works by the Society of American Painters, Sculptors, and Gravers,* April 15 – May 31, 1920; Denver; Minneapolis; Cleveland.

McBride, Henry. "News and Comment in the World of Art." *New York Sun,* October 26, 1919.

Pennsylvania Academy of the Fine Arts, Philadelphia. *Seventeenth Annual Watercolor Exhibition and Eighteenth Annual Exhibition of Miniatures.* November 9 – December 14, 1919.

Knoedler Gallery, New York. *Exhibition of Watercolors and Pastels.* Closed November 29, 1919.

Adolphus Hotel, Dallas Art Association, Texas. *First Annual Exhibition of Contemporary International Art.* November 18 – 27, 1919 (catalogue).

Touchstone Galleries, New York. *Exhibition of the Work of Six Modern Painters.* Closed December 14, 1919.

"Random Impressions in Current Exhibitions." *New York Tribune,* December 7, 1919: 13.

Corcoran Gallery of Art, Washington. *Seventh Biennial Exhibition of Oil Paintings by Contemporary American Artists.* December 21, 1919 – January 25, 1920.

1920

Daniel Gallery, New York. *Exhibition of Paintings by Glackens, Henri, Lawson and Prendergast.* Closed January 31, 1920.

"Notes on Current Art." *New York Times,* January 11, 1920.

"Four Painters at Daniel Galleries." *American Art News* 18, no. 13 (January 17, 1920): 3.

Pennsylvania Academy of the Fine Arts, Philadelphia. *One Hundred and Fifteenth Annual Exhibition.* February 8 – March 28, 1920 (catalogue).

Art Department, Randolph-Macon Women's College, Ashland, Virginia. *Ninth Annual Exhibition: Paintings and Sculpture of Contemporary Artists.* March 6 – 31, 1920 (catalogue).

Montross Gallery, New York. *Exhibition of Group of American Painters.* March 7 – 20, 1920.

Society of Independent Artists, Waldorf-Astoria, New York. *Fourth Annual Exhibition.* March 12 – April 1, 1920 (catalogue).

Whitney Studio Club, New York. *Exhibition of the Work of the Members.* March 30 – April 30, 1920 (catalogue).

Madison Hall, University of Virginia, Charlottesville. *Display of Paintings and Bronzes by Contemporary American Artists.* April 1920.

Arts Club of Chicago. *Exhibition of a Group of Paintings by William J. Glackens, Robert Henri, Ernest Lawson, and Maurice Prendergast.* April 5 – 19, 1920.

Montross Gallery, New York. *Exhibition of Early Works of Davies, Glackens, Henri and Prendergast.* Closed May 8, 1920.

"Notes on Current Art." *New York Times,* April 18, 1920.

Field, Hamilton Easter. "At the Montross Gallery." *Brooklyn Daily Eagle,* April 11, 1920: 8.

"Random Impressions in Current Exhibits." *New York Tribune,* April 11, 1920: 6.

Daniel Gallery, New York. *A Review of the Season of 1920.* April – May 15, 1920.

"Random Impressions in Current Exhibits." *New York Tribune,* April 25, 1920: 7.

Colony Club, New York. *Exhibition of Modern French and American Pictures.* Spring 1920.

Mrs. Harry Payne Whitney (organizer). *Overseas Exhibition of American Paintings.* Traveled to International Art Exhibition, Venice, May 1 – November 1920; Grafton Galleries, London, March 12 – April 1921; Sheffield, England; Galerie Georges Petit, Paris, as *Exposition d'un groupe de peintres Americains,* July 4 – 30, 1921 (catalogue); Whitney Studio, New York, November 2 – 15, 1921.

Montross Gallery, New York. *Special Exhibition of Eighteen American Painters.* May 11 – June 5, 1920.

City Art Museum, Saint Louis, Missouri. *Fifteenth Annual Exhibition of Paintings by American Artists.* September 15 – October 31, 1920 (catalogue).

Daniel Gallery, New York. *Exhibition of Modern Painters.* Fall 1920.

New Society of Artists, E. Gimpel and Wildenstein Gallery, New York. *Second Annual Exhibition.* November 8 – 27, 1920 (catalogue).

McBride, Henry. "Modern Art." *Dial* 70 (January 1921): 111 – 114.

Anderson Galleries, New York. *Exhibition and Sale of the Collection of Paintings from the Estate of Walter Kerr.* November 22 – 26, 1920.

Mattatuck Historical Society, Waterbury, Connecticut. *Exhibition of Oils by Leading American Artists.* December 1920.

1921

Daniel Gallery, New York. *Paintings by Glackens, Henri, Lawson and Prendergast.* January 8 – February 8, 1921.

"Four Artists at Daniel's." *American Art News* 19, no. 15 (January 22, 1921): 5.

"Art: Exhibition of Paintings." *New York Times,* February 6, 1921.

Pennsylvania Academy of the Fine Arts, Philadelphia. *One Hundred and Sixteenth Annual Exhibition.* February 6 – March 27, 1921 (catalogue).

"The World of Art: Pennsylvania Academy Exhibition — First Notice." *New York Times,* February 13, 1921.

Cleveland Museum of Art. *Exhibition of American Paintings by Contemporary Artists.* February 15 – March 27, 1921.

University Art Department, The Ohio State University, Columbus. *Loan Exhibition.* March 1921.

Montross Gallery, New York. *Spring Exhibition of American Paintings.* Spring 1921.

Society of Independent Artists, Waldorf-Astoria, New York. *Fifth Annual Exhibition.* March 11 – April 2, 1921 (catalogue).

Whitney Studio Club, New York. *Annual Exhibition of Paintings and Sculpture by Members.* March 20 – April 20, 1921 (catalogue).

Newman's Art Gallery, Philadelphia. *Fourth Spring Exhibition.* Closed March 30, 1921.

Adolphus Hotel, Dallas Art Association. *Second Annual Exhibition of American and European Art.* April 7 – 21, 1921 (catalogue).

Carnegie Institute, Pittsburgh. *Twentieth Annual International Exhibition of Paintings.* April 28 – June 30, 1921 (catalogue).

The Metropolitan Museum of Art, New York. *Impressionist and Post Impressionist Paintings.* May 3 – September 15, 1921.

Junior Art Patrons of America, Fine Arts Building, New York. *Retrospective Exhibition of American Art.* May 6 – 21, 1921.

The Metropolitan Museum of Art, New York. *Exhibition of Watercolors.* Summer 1921.

New Society of Artists, Wildenstein Galleries, New York. *Third Annual Exhibition.* November 15 – December 15, 1921.

"Art: Societies and Individuals." *New York Times*, November 20, 1921.

Art Society of Hartford, Art School, Connecticut. *Exhibition of Paintings and Lithographs.* December 1921 – January, 1922.

Corcoran Gallery of Art, Washington. *Eighth Biennial Exhibition of Oil Paintings by Contemporary American Artists.* December 18, 1921 – January 22, 1922.

1922

Whitney Studio Club, New York. *Exhibition of Paintings by Max Kuehne and Wm. J. Glackens.* January 10 – 29, 1922 (extended to March 5).

"Two-Man Show at Whitney Studio Club." *American Art News* 20, no. 15 (January 21, 1922): 10, 12.

"At the Whitney Studio Club." *Brooklyn Daily Eagle*, January 22, 1922: C.

"Random Impressions in Current Exhibits." *New York Tribune*, January 22, 1922: 6.

Pennsylvania Academy of the Fine Arts, Philadelphia. *One Hundred and Seventeenth Annual Exhibition.* February 5 – March 26, 1922 (catalogue).

Society of Independent Artists, Waldorf-Astoria, New York. *Sixth Annual Exhibition.* March 11 – April 2, 1920 (catalogue).

Montross Gallery, New York. *Special Exhibition of Contemporary Art.* Through April 1922.

Colony Club, New York. *Modern Sculpture, Water Colors and Drawings.* April 2 – 13, 1922 (catalogue).

Buffalo Fine Arts Academy, Albright Art Gallery. *Sixteenth Annual Exhibition of Selected Paintings by American Artists.* April 9 – June 12, 1922 (catalogue).

Carnegie Institute, Pittsburgh. *Twenty First Annual International Exhibition of Paintings.* April 27 – June 15, 1922 (catalogue).

Montross Gallery, New York. *Exhibition of Paintings by American Artists.* May 1922.

Brooklyn Society of Artists, Brooklyn Museum. *Sixth Annual Exhibition.* May 3 – June 1, 1922.

"Americans of Varied Tendencies." *American Art News* 20, no. 31 (May 13, 1922): 1.

Lloyd, David. "Some Interesting American Object Lessons in Change of Fashions in Painting." *New York Evening Post*, May 20, 1922.

"The World of Art: Exhibitions of Lithography and Painting." *New York Times*, May 21, 1922.

Daniel Gallery, New York. *Exhibition of Group of Artists.* Summer 1922.

"Modern Painters at Daniel Galleries." *American Art News* 20, no. 35 (June 10, 1922): 2.

Daniel Gallery, New York. *Opening Exhibition of Paintings by Modern American Artists.* Fall (November) 1922.

Garden Club of America, Ferargil Galleries, New York. *Paintings and Outdoor Sculpture by the Garden Club of America.* November – December 2, 1922.

"Individualists Among Moderns." *American Art News* 21, no. 7 (November 25, 1922): 2.

Belmaison Gallery, Wanamaker's Department Store, New York. *Exhibition of Paintings, Drawings and Water Colors of Interiors.* Closed December 30, 1922.

1923

Montross Gallery, New York. *Special Exhibition of Contemporary Art.* January – February 10, 1923.

"Seven Artists at the Montross." *American Art News* 21, no. 16 (January 27, 1923): 2.

Belmaison Gallery, New York. *Annual Exhibition of Modern American Art.* January – February 17, 1923.

New Society of Artists, Anderson Galleries, New York. *Fourth Annual Exhibition.* January 2 – 27, 1923.

"New Society's Show Sets a High Mark." *American Art News* 21, no. 13 (January 6, 1923): 1 – 2

Toronto Museum of Art, Canada. *Exhibition of Contemporary American Art.* January 26 – March 4, 1923.

Pennsylvania Academy of the Fine Arts, Philadelphia. *One Hundred and Eighteenth Annual Exhibition.* February 4 – March 25, 1923 (catalogue).

Baltimore Museum of Art. *Inaugural Exhibition.* February 21 – April 1, 1923 (catalogue).

Society of Independent Artists, Waldorf-Astoria, New York. *Seventh Annual Exhibition.* February 24 – March 18, 1923 (catalogue).

Montross Gallery, New York. *Exhibition of Paintings by Contemporary American Artists.* Spring 1923.

Whitney Studio Club, Whitney Galleries, New York. *Annual Exhibition of Paintings and Sculpture by the Members.* April 2 – 30, 1923 (catalogue).

Albright Art Gallery, Buffalo. *Seventeenth Annual Exhibition of Selected Paintings by American Artists.* April 8 – June 18, 1923

"Contemporary Americans." *Art News* 21, no. 27 (April 14, 1923): 1.

Anderson Galleries, New York. *Interiors Assembled by Karl Freund Furnished with Objects of Art Old and New.* April 22 – May 14, 1923.

Carnegie Institute, Pittsburgh. *Twenty Second Annual International Exhibition of Paintings.* April 26 – June 17, 1923.

Belmaison Gallery, Wanamaker's Gallery of Modern Decorative Art, New York. *Exhibition of Paintings, Watercolors, Drawings, Etchings, Lithographs, Photographs and Old Prints of New York City.* May 19 – June 15, 1923.

Marie Sterner Gallery, New York. *Exhibition of American Paintings.* May 1923.

Montross Gallery, New York. *Summer Exhibition.* June – August 1923.

"Montross Exhibits American Pictures." *Art News* 21, no. 34 (June 2, 1923): 1.

Memorial Art Gallery, Rochester. *Annual Summer Exhibition of Contemporary American Paintings.* July – September 1923.

Rhode Island School of Design, Providence. *Annual Autumn Exhibition of Paintings by Leading American Artists.* Opened October 16, 1923.

Morgan Memorial Museum, Hartford, Connecticut. *Exhibition of Water Colors, Pastels and Drawings.* November – Winter 1923.

Daniel Gallery, New York. *Exhibition of Art.* November – Winter 1923.

Artists Club of Hartford, State Armory, Hartford, Connecticut. *Greenwich Village Fair Exhibition.* December 1923.

Corcoran Gallery of Art, Washington. *Ninth Biennial Exhibition of Oil Paintings by Contemporary American Artists.* December 16, 1923 – January 20, 1924.

1924

American Section, Rome. *International Biennial Art Exhibition.* Opened January 1924.

New Society of Artists, Anderson Galleries, New York. *Fifth Annual Exhibition.* January 2 – 31, 1924.

"New Society Exhibit Has a Wide Range." *American Art News* 22, no. 13 (January 5, 1924): 2.

C. W. Kraushaar Galleries, New York. *An Important Collection of Paintings, Sculptures and Bronzes by Celebrated American Artists.* January 15 – February 16, 1924 (catalogue).

Pennsylvania Academy of the Fine Arts, Philadelphia. *One Hundred and Nineteenth Annual Exhibition.* February 3 – March 23, 1924 (catalogue).

Omaha Society of Fine Arts, Nebraska. *Exhibition of American Paintings from the Milch Galleries.* February 17 – March 8, 1924.

Art Patrons of America, Jacques Seligmann Galleries, New York. *Inaugural Exhibition of Paintings.* March 1924.

Society of Independent Artists, Waldorf-Astoria, New York. *Eighth Annual Exhibition.* March 7 – 30, 1924 (catalogue).

Mulvane Museum, Topeka, Kansas. *Exhibition of Paintings and Etchings.* April 3 – 4, 1924.

Buffalo Fine Arts Academy, Albright Art Gallery. *18th Annual Exhibition of Selected Paintings and Small Bronzes by American Artists.* April 20 – June 30, 1924.

Carnegie Institute, Pittsburgh. *The Twenty-Third Annual International Exhibition.* April 24 – June 15, 1924.

Newark Museum of Art, New Jersey. *Paintings and Sculpture from the Recent Exhibition of Independent Artists.* Spring 1924.

Brooklyn Museum. *Exhibition of Modern Paintings, Pastels and Water Colors from the Collection of A.E. Gallatin.* Spring 1924.

Corcoran Gallery of Art, Washington. *Special Exhibition of Oil Paintings by Fourteen Modern American Painters.* May 4 – 18, 1924.

Art Patrons of America and Mrs. Albert Sterner (organizer). *Exhibition of Contemporary American Art.* Traveled to Chambre syndicale de la

curiosité et des beaux-arts, Paris, June 7–July 5, 1924; London.

Memorial Art Gallery, Rochester. *Annual Summer Exhibition of Contemporary American Paintings.* July 17–September 28, 1924.

The Metropolitan Museum of Art, New York. *Exhibition of Drawings.* December 1924–January 1925.

1925

New Society of Artists, New York. *Sixth Annual Exhibition.* January 5–31, 1925.

Art Students League, New York. *Fiftieth Birthday Jubilee Exhibition.* January 24–February 5, 1925.

Pennsylvania Academy of the Fine Arts, Philadelphia. *One Hundred and Twentieth Annual Exhibition.* February 8–March 29, 1925 (catalogue).

Society of Independent Artists, Waldorf-Astoria, New York. *Ninth Annual Exhibition.* March 6–30, 1925 (catalogue).

*Kraushaar Galleries, New York. *Exhibition of Paintings by William J. Glackens.* April 1–22, 1925 (catalogue).

"Art: Exhibitions of the Week." *New York Times,* April 5, 1925: 12.

Detroit Institute of Arts. *Eleventh Annual Exhibition of Paintings by American Artists.* April 21–May 31, 1925.

Whitney Studio Club, Anderson Galleries, New York. *Tenth Annual Exhibition of Paintings and Sculpture by Members.* May 18–30, 1925 (catalogue).

Durand-Ruel Gallery, Paris. *Exposition Trinational.* June 5–28, 1925 (catalogue). Traveled to London, October 1925.

Cleveland Art Museum. *Fifth Annual Exhibition of Contemporary American Paintings.* June 12–July 12, 1925 (catalogue).

Carnegie Institute, Pittsburgh. *Twenty-Fourth Annual International Exhibition of Paintings.* October 15–December 6, 1925.

The Art Institute of Chicago. *Thirty-Eighth Annual Exhibition of American Paintings and Sculpture.* October 29–December 13, 1925.

Los Angeles Museum of Art. *First Pan-American Exhibition of Oil Paintings.* November 27, 1925–February 28, 1926.

National Academy of Design, New York. *Commemorative Exhibition 1825–1925.* December 1, 1925–January 3, 1926 (catalogue).

1926

The New Society of Artists, Anderson Galleries, New York. *Seventh Annual Exhibition.* January 6–30, 1926 (catalogue).

Wildenstein Galleries, New York. *Tri-National Exhibition of Contemporary Art— French, British and American.* January 26–February 15, 1926.

Rehn Gallery, New York. *Today in American Art.* February–March 16, 1926.

"Many Types of Art Are Now on Exhibition." *New York Times,* February 28, 1926: 12.

Society of Independent Artists, Waldorf-Astoria, New York. *Tenth Annual Exhibition.* March 6–30, 1926 (catalogue).

Corcoran Gallery of Art, Washington. *Tenth Biennial Exhibition of Oil Paintings by Contemporary American Artists.* April 4–May 16, 1926.

Buffalo Fine Arts Academy, Albright Art Gallery. *Twentieth Annual Exhibition of Selected Paintings by American Artists.* April 25–June 21, 1926 (catalogue).

Kraushaar Galleries, New York. *Summer Exhibition.* May–Summer 1926.

The Art Institute of Chicago. *Sixth International Watercolor Exhibition.* May 3–30, 1926 (catalogue).

Whitney Studio Club, Anderson Galleries, New York. *Eleventh Annual Exhibition of Paintings and Sculpture by Members.* May 8–20, 1926 (catalogue).

Pennsylvania Academy of the Fine Arts, Philadelphia. *Sesqui-Centennial Exposition.* June 1–December 1, 1926.

Cleveland Museum of Art. *Sixth Exhibition of Contemporary American Paintings.* June 11–July 11, 1926.

Musée Galliera, Paris. *L'Art français au service du franc.* Fall 1926.

Carnegie Institute, Pittsburgh. *Twenty Fifth Annual International Exposition of Paintings.* October 14–December 5, 1926.

The Art Institute of Chicago. *Thirty-Ninth Annual Exhibition of American Paintings and Sculpture.* October 28–December 12, 1926 (catalogue).

Durand-Ruel Gallery, Paris. *Peintres et sculpteurs américains de Paris.* October 30–November 15, 1926 (catalogue).

California Palace of the Legion of Honor, Lincoln Park, San Francisco. *First Exhibition of Selected Paintings by American Artists.* November 15, 1926–January 30, 1927.

New Society of Artists, Grand Central Galleries, New York. *Eighth Annual Exhibition.* November 15–December 4, 1926.

1927

Whitney Studio Club, Whitney Galleries, New York. *Twelfth Annual Exhibition of Paintings and Sculpture by Members.* February 16–March 5, 1927 (catalogue).

Kalonyme, Louis. "Whitney Studio Club Members Exhibit Their Work." *New York Times,* February 27, 1927: 12.

Brooklyn Museum. *Paintings in Oil by the Group of American Painters of Paris.* April 22–September 1, 1927.

Detroit Institute of Arts. *Thirteenth Annual Exhibition of American Art.* April 26–May 31, 1927.

Los Angeles Museum of Art. *Eighth Annual Exhibition of Paintings and Sculpture.* May 1927.

Cleveland Museum of Art. *Seventh Annual Exhibition of Contemporary American Paintings.* June 10–July 10, 1927.

*Daniel Gallery, New York. *Recent Paintings by William J. Glackens.* December 17, 1927–January 29, 1928.

1928

Whitney Studio Club, Whitney Galleries, New York. *Exhibition of Contemporary Portraits.* January 24–February 14, 1928 (brochure).

Society of Independent Artists, Waldorf-Astoria, New York. *Twelfth Annual Exhibition.* March 9–30, 1928 (catalogue).

*Kraushaar Galleries, New York. *Exhibition of Paintings by William Glackens.* March 28–April 12, 1928 (catalogue).

"William Glackens." *Arts* 13 (May 1928): 317.

Whitney Studio Club, Whitney Galleries, New York. *Thirteenth Annual Exhibition of Paintings by Members.* April 29–May 26, 1928 (catalogue).

Cleveland Museum of Art. *Eighth Annual Exhibition of Contemporary American Paintings.* June 8–July 8, 1928.

Corcoran Gallery of Art, Washington. *Eleventh Biennial Exhibition of Contemporary American Oil Paintings.* October 28–December 9, 1928.

Rainey, Ada. "Corcoran American Exhibition." *Washington Post,* October 28, 1928: S10.

Brooklyn Museum. *The Ninth Annual Exhibition of Paintings and Sculpture by the New Society of Artists.* November 19, 1928–January 1, 1929 (catalogue).

1929

Memorial Art Gallery, Rochester. *Paintings and Sculpture by 33 Contemporary American Artists.* January 10–February 12, 1929.

Pennsylvania Academy of the Fine Arts, Philadelphia. *One Hundred and Twenty Fourth Annual Exhibition.* January 27–March 17, 1929 (catalogue).

American Art Dealers Association, Anderson Galleries, New York. *Third Annual Exhibition.* March–April 13, 1929.

Society of Independent Artists, Waldorf-Astoria, New York. *Thirteenth Annual Exhibition.* March 9–31, 1929.

Whitney Studio Galleries, New York. *The Circus in Paint.* April 1929 (brochure).

Jewell, Edward Alden. "Sawdust and Peanuts." *New York Times,* April 7, 1929: X12.

Arts Council of the City of New York, Architectural and Allied Arts Exposition, Grand Central Palace. *One Hundred Important Paintings by Living American Artists.* April 15–27, 1929 (catalogue).

Cincinnati Museum of Art. *Thirty-Sixth Annual Exhibition of American Art.* May 31–July 31, 1929.

Cleveland Museum of Art. *Ninth Exhibition of Contemporary American Paintings.* June 7–July 7, 1929.

Harvard Society for Contemporary Art, Cambridge. *Exhibition of Paintings and Sculpture.* October–November 1, 1929.

Phillips Memorial Gallery, Washington. *Modern French and American Paintings.* October 1929–February 9, 1930.

Dalzell Hatfield Galleries, Los Angeles. *One Hundred and Twenty Five Years of American Landscape Painting.* October 1929.

Carnegie Institute, Pittsburgh. *Twenty-Eighth International Exhibition of Painting.* October 17–December 1929.

"Carena's Painting Takes First Prize." *New York Times,* October 18, 1929.

Jewell, Edward Alden. "New Carnegie International Open at Pittsburgh." *New York Times,* October 20, 1929: 12x.

"Art: Pittsburgh's 28th."
Time, October 28, 1929.

Philpott, Anthony J.
"Harvard Society's
Exhibition of Paintings and
Sculpture." *Daily Boston
Globe*, October 29, 1929: 8.

The Art Institute of Chicago.
*Forty Second Annual Exhibition
of American Paintings and
Sculpture*. October 24 –
December 8, 1929 (catalogue).

1930

New Society of Artists, The Art
Centre, New York. *Eleventh
Annual Exhibition*. Closed
January 18, 1930.

Harris, Ruth Green.
"A Round of Galleries."
New York Times, January 12,
1930: 12x.

Pennsylvania Academy of
the Fine Arts, Philadelphia.
*One Hundred and Twenty Fifth
Annual Exhibition*. January 26 –
March 16, 1930 (catalogue).

Whitney Studio Galleries, New
York. *Spring/Flower Exhibition*.
March 17 – 29, 1930 (catalogue,
with foreword by Lloyd
Goodrich).

Detroit Institute of Arts.
*Sixteenth Annual Exhibition
of American Art*. April 4 – 28,
1930.

Albright Art Gallery, Buffalo.
*Twenty Fourth Annual
Exhibition of Selected Paintings
by American Artists*. April 27 –
June 16, 1930.

Kraushaar Galleries, New York.
Exhibition of Paintings. May –
Summer 1930.

Cincinnati Museum of Art.
*Thirty-Seventh Annual
Exhibition of American Art*.
June 1 – 29, 1930.

Cleveland Museum of Art.
*Tenth Annual Exhibition of
Contemporary American
Paintings*. June 6 – July 6, 1930.

Carnegie Institute, Pittsburgh.
*Twenty-Ninth International
Exhibition of Painting*.
October 16 – December 7, 1930.

The Art Institute of Chicago.
*Forty-Third Annual Exhibition
of American Paintings and
Sculpture*. October 30 –
December 14, 1930 (catalogue).

National Academy of Design,
New York. *Special Exhibition of
Members' Work*. November 25 –
December 31, 1930 (catalogue).

Corcoran Gallery of Art,
Washington. *Twelfth Annual
Exhibition of Contemporary
American Paintings in Oil*.
November 30, 1930 – January 11,
1931.

Museum of Modern Art,
New York. *Painting and
Sculpture by Living Americans*.
December 3, 1930 – January 20,
1931 (catalogue).

1931

Baltimore Museum of Art.
*First Baltimore Pan American
Exhibition of Contemporary
Paintings*. January 15 –
February 28, 1931 (catalogue).

American Art Association,
Anderson Galleries, New York.
For the Benefit of the
Emergency Unemployment
Committee. *Exhibition of
Old and Modern Masters*.
March 15 – April 4, 1931.

Detroit Institute of Arts.
*Seventeenth Annual Exhibition
of American Art*. April 14 –
May 24, 1931.

*Kraushaar Galleries, New
York. *Paintings by William
Glackens*. April 15 – 30, 1931.

Jewell, Edward Alden.
"Glackens Seen at His Best."
New York Times, April 17,
1931: 26.

"William Glackens:
Kraushaar Galleries."
ArtNews 29 (April 18,
1931): 10.

Schnakenberg, Henry
Ernest. "Exhibitions:
William Glackens." *Arts* 17
(April 1931): 579 – 581.

Albright Art Gallery, Buffalo.
*Twenty-Fifth Annual Exhibition
of Selected Paintings by
American Artists*. April 26 –
June 22, 1931.

Albright Art Gallery, Buffalo.
*Exhibition of Master Prints
and Small Sculpture Owned
by Buffalo Residents*. May 6 –
June 1, 1931 (catalogue).

Cleveland Museum of Art.
*Eleventh Annual Exhibition of
Contemporary American Oil
Painting*. June 12 – July 12, 1931.

Carnegie Institute,
Pittsburgh. *30th Annual
International Exhibition of
Paintings*. October 15 –
December 6, 1931.

The Art Institute of Chicago.
*Forty-Fourth Annual Exhibition
of American Paintings and
Sculpture*. October 29 –
December 13, 1931 (catalogue).

Whitney Museum of American
Art, New York. *Opening
Exhibition—Part 1 of the
Permanent Collection: Painting
and Sculpture*. November 18,
1931 – January 2, 1932.

Pennsylvania Museum of Art,
Philadelphia. *Living Artists*.
November 20, 1931 – January 1,
1932 (catalogue).

1932

Ainslie Galleries, Waldorf-
Astoria, New York. *Exhibition
of Paintings*. January 1932.

Whitney Museum of American
Art, New York. *Watercolors,
Drawings, Prints from the
Permanent Collection*.
January 5 – February 4, 1932.

Rochester Memorial Art
Gallery, New York. *Forty
Modern Americans*.
January 7 – 28, 1932.

K. G. S. "Art: Paintings by a
Russian." *New York Times*,
January 3, 1932: 31.

Pennsylvania Academy of
the Fine Arts, Philadelphia.
*One Hundred and Twenty
Seventh Annual Exhibition*.
January 24 – March 13, 1932
(catalogue).

Whitney Museum of American
Art, New York. *Exhibition of
American Society of Painters,
Sculptors and Gravers*.
February 6 – 28, 1932.

Art Department, Randolph-
Macon Women's College,
Ashland, Virginia. *Twenty-first
Annual Exhibition of Paintings*.
March 18 – April 16, 1932.

Society of Independent Artists,
Grand Central Palace, New
York. *Sixteenth Annual
Exhibition*. April 2 – 24, 1932
(catalogue).

Whitney Museum of American
Art, New York. *The Summer
Exhibition*. May 3 – October 12,
1932 (catalogue).

Cleveland Museum of Art.
*Twelfth Annual Exhibition of
Contemporary American Oil
Painting*. June 10 – July 10, 1932.

Kraushaar Galleries, New York.
Summer Exhibition. June 21 –
August 1932.

Jewell, Edward Alden. "Art:
Kraushaar's Opens Show."
New York Times, June 22,
1932: 25.

City Art Museum, Saint
Louis, Missouri. *Twenty
Seventh Annual Exhibition of
Paintings by American Artists*.
September 3 – October 16, 1932
(catalogue).

Jersey City Museum
Association, Bergen Branch
Library, Jersey City. *Exhibition
of Paintings and Sculpture*.
Opened September 19, 1932.

The Art Institute of Chicago.
*Forty Fifth Annual Exhibition
of American Paintings and
Sculpture*. October 27, 1932 –
January 2, 1933 (catalogue).

Museum of Modern Art,
New York. *American Painting
and Sculpture, 1862 – 1932*.
October 31, 1932 – February 11,
1933 (catalogue).

Whitney Museum of American
Art, New York. *First Biennial
Exhibition of Contemporary
American Painting*. November
22, 1932 – January 5, 1933
(catalogue).

Jewell, Edward Alden. "In
the Realm of Art: Opening
Week of the New Year."
New York Times, January 8,
1933: 12X.

Phillips Memorial Gallery,
Washington, with the
American Federation of
Arts (organizer). *School of
Impressionism*. November 1932 –
March 1933. Traveled.

Corcoran Gallery of Art,
Washington. *Thirteenth
Exhibition of Contemporary
American Oil Paintings*.
December 4, 1932 – January 11,
1933 (catalogue).

1933

Fair Park Gallery, State Fair,
Dallas. *Art Department State
Fair of Texas 1933 Exhibition:
Showing the Changes in
Painting for the Last Hundred
Years in Europe and America*.
1933 (catalogue).

Montclair Art Museum,
New Jersey (assembled by
Macbeth Galleries). *Forty
Years of American Painting*.
January 1 – 29, 1933 (catalogue).

Whitney Museum of American
Art, New York. *Exhibition of
1932 Acquisitions*. January 10 –
February 16, 1933.

Pennsylvania Academy of
the Fine Arts, Philadelphia.
*One Hundred and Twenty-
Eighth Annual Exhibition*.
January 30 – March 19, 1933
(catalogue).

"S. W. Norris Chief Art Show
Winner." *New York Times*,
January 29, 1933: N2.

College Art Association,
Rockefeller Center, New York.
*1933 International Exhibition
of Contemporary Paintings*.
February 5 – 27, 1933 (cata-
logue). Traveled to Worcester
Art Museum, Massachusetts,
January 6 – 31, 1933; Cleveland
Museum of Art, March 8 –
April 8, 1933.

Kraushaar Galleries, New York.
*Fourteen Paintings by Fourteen
American Artists*. February 16 –
March 30, 1933.

Jewell, Edward Alden. "Art
in Review." *New York Times*,
February 17, 1933: D17.

College Art Association,
Howard Young Galleries, New
York. *Entering the Twentieth
Century*. Opened March 2,
1933.

Carey, Elizabeth Luther.
"In Our Century's Riotous
Youth." *New York Times*,
March 12, 1933: 8X.

Philadelphia Museum of Art,
Pennsylvania. *Flowers in Art*.
April 1 – May 1, 1933.

Society of Illustrators, New
York. *Thirty First Annual
Exhibition*. April 5 – 22, 1933.

Cheshire Gallery, Chrysler
Building, New York. *Exhibition
of Drinking Scenes*. Spring
1933.

The Art Institute of Chicago. *A
Century of Progress Exhibition
of Painting and Sculpture. Lent
from American Collections*.
June 1 – November 1, 1933
(catalogue).

Cleveland Museum of Art. *Thirteenth Exhibition of Contemporary American Oil Painting.* June 16 – July 16, 1933.

Art Association of Newport, Rhode Island, with Whitney Museum of American Art, New York. *Exhibition of Painting and Prints from the Whitney Museum of American Art and Work by Members of the Art Association of Newport.* August 5 – September 5, 1933 (catalogue).

Marie Sterner Gallery, New York. *Exhibition of Watercolors.* Fall 1933.

Museum of Fine Arts, Springfield, Massachusetts. *Opening Exhibition.* October 7 – November 2, 1933 (catalogue).

Carnegie Institute, Pittsburgh. *Thirty First Annual International Exhibition of Paintings.* October 19 – December 10, 1933.

Whitney Museum of American Art, New York. *Twentieth Century New York in Paintings and Prints.* November 9 – 30, 1933.

Whitney Museum of American Art, New York. *First Biennial Exhibition of American Contemporary Sculpture, Watercolor and Prints.* December 5, 1933 – January 11, 1934 (catalogue).

William Rockhill Nelson Gallery of Art, Kansas City, Missouri. *Inaugural Exhibition: Loan Exhibition of American Paintings since 1900.* December 10, 1933 – February 1, 1934 (catalogue).

1934

Denver Art Museum. *Exhibition.* 1934.

Jersey City Museum Association, New Jersey. *Exhibition.* 1934.

College Art Association of America (organizer). *American Painters Memorial Exhibition since 1900* (catalogue). Traveled to Louisville Art Association, Louisville, Kentucky, January 1 – 31, 1934; Guild Hall Museum, East Hampton, New York, September 1 – 30, 1934; Toledo Museum of Art, October 7 – 28,

1934; Museum of Fine Arts, Springfield, Massachusetts, November 1 – 30, 1934; unknown venue, New York, December 1 – 31, 1934; Currier Gallery of Art, Manchester, New Hampshire, March 1 – 31, 1935; Buffalo Fine Arts Academy, April 1 – 30, 1935; Memorial Art Gallery, Rochester, May 1 – June 30, 1935.

Cronyn and Lowndes, Rockefeller Plaza, New York. *Exhibition of American Oil Paintings.* January 1934.

Baltimore Museum of Art. *Survey of American Painting.* January 10 – February 28, 1934 (catalogue).

Pennsylvania Academy of the Fine Arts, Philadelphia. *One Hundred and Twenty Ninth Annual Exhibition.* January 28 – February 25, 1934 (catalogue).

Rockefeller Center, R. C. A. Building, New York, sponsored by Mayor LaGuardia. *Municipal Art Exhibition.* February 28 – March 31, 1934.

Lyman Allyn Museum, New London, Connecticut. *Second Anniversary Exhibition: American Painting of the Last Fifty Years.* March 2 – April 15, 1934 (catalogue).

Art Department, Randolph-Macon Women's College, Ashland, Virginia. *Twenty-third Annual Exhibition of Paintings.* March 5 – 29, 1934.

The Art Institute of Chicago. *Thirteenth Annual International Exhibition of Water Colors.* March 29 – April 29, 1934 (catalogue).

Philadelphia Museum of Art, Pennsylvania. *Contemporary American Painting.* March 31 – April 30, 1934.

Kraushaar Galleries, New York. *Summer Exhibition.* May – Summer 1934.

Grand Central Art Galleries, American Pavilion, Venice. *Nineteenth International Biennial Art Exhibition.* May 12 – October 5, 1934 (catalogue).

The Art Institute of Chicago. *Century of Progress Exposition of Paintings and Sculpture.*

June 1 – November 1, 1934 (catalogue).

Jewell, Edward Alden. "Chicago Exhibits Treasures of Art." *New York Times,* May 30, 1934: 15.

Jewell, Edward Alden. "In the Realm of Art: Glances Backward and About." *New York Times,* June 10, 1934: X9.

Carson Pirie Scott Galleries, Chicago. *Exhibition of American Paintings.* Opened June 4, 1934.

City Art Museum, Saint Louis, Missouri. *Twenty-Ninth Annual Exhibition of Paintings by American Artists.* September 15 – October 30, 1934.

Whitney Museum of American Art, New York. *Fall Exhibition of Paintings, Prints, Sculpture from the Permanent Collection.* October 2 – 18, 1934.

Wanamaker Store Galleries, New York. *Wanamaker Regional Art Exhibition.* October 15 – November 3, 1934 (catalogue).

Carnegie Institute, Pittsburgh. *The Thirty-Third International Exhibition of Paintings.* October 18 – December 9, 1934 (catalogue).

National Gallery of Canada, Ottawa. *Exhibition of Contemporary Paintings by Artists of the U.S.* November 6 – 30, 1934. Traveled throughout Canada in 1935.

Whitney Museum of American Art, New York. *Second Biennial Exhibition of American Contemporary Painting.* November 27, 1934 – January 10, 1935 (catalogue).

1935

Cincinnati Art Museum. *Paintings from the Howald Collection Lent by the Columbus Gallery of Fine Arts.* January 6 – February 3, 1935.

Pennsylvania Academy of the Fine Arts, Philadelphia. *One Hundred and Thirtieth Annual Exhibition.* January 27 – March 3, 1935 (catalogue).

Wadsworth Atheneum, Hartford, Connecticut. *American Painting and Sculpture of the Eighteenth, Nineteenth, and Twentieth Centuries.* January 29 – February 19, 1935.

*Kraushaar Galleries, New York. *Exhibition of Paintings by William Glackens Retrospective.* February 11 – March 8 (extended from March 2), 1935 (catalogue).

Jewell, Edward Alden. "William Glackens Has One-Man Show." *New York Times,* February 15, 1935: 22.

"Glackens's Art Over the Years." *Sun* (NY), February 15, 1935.

"Retrospective Exhibit by William Glackens." *New York Post,* February 23, 1935: Week's Calendar.

Watson, Forbes. "The Innocent Bystander: William Glackens." *Magazine of Art* 28 (March 1935): 166 – 168.

Art Students League, New York. *Exhibition of Illustration and Painting.* Closed March 9, 1935.

Marie Sterner Gallery, New York. *Flower Exhibition.* Spring 1935.

Jewell, Edward Alden. "Flower Paintings Offered in Shows." *New York Times,* March 21, 1935: 26.

National Academy of Design, New York. *One Hundred and Tenth Annual Exhibition.* March 13 – April 9, 1935 (catalogue).

The Art Institute of Chicago. *The Fourteenth International Exhibition, Water Colors, Pastels, Drawings, Monotypes.* March 21 – June 9, 1935 (catalogue).

Corcoran Gallery of Art, Washington. *Fourteenth Exhibition of Contemporary American Oil Paintings.* March 24 – May 5, 1935.

"Theater: Corcoran Biennial." *Time,* April 1, 1935.

Whitney Museum of American Art, New York. *The Social Scene in Paintings and Prints.*

March 26 – April 29, 1935 (catalogue).

Junior League of New York City, League Clubhouse, New York. *Exhibition of English, French and American Humorous and Satirical Drawings and Prints of the 18th, 19th, and 20th Centuries.* April 3 – 27, 1935.

Art Department, Randolph-Macon Women's College, Ashland, Virginia. *Twenty-fourth Annual Exhibition: Modern American Paintings.* April 4 – May 5, 1935.

Kraushaar Galleries, New York. *Exhibition of Water-Colors and Pastels.* May – June 1, 1935.

Marie Sterner Gallery, New York, in conjunction with Municipal Art Committee's "First Annual Summer Festival." *Summer Exhibition.* Opened June 1935.

Toledo Museum of Art. *Twenty-Second Annual Exhibition of Selected Paintings by Contemporary Artists.* June 2 – August 25, 1935.

Cleveland Museum of Art. *The Fifteenth Exhibition of Contemporary American Oils.* June 7 – July 7, 1935.

M. H. de Young Memorial Museum, San Francisco, with California Palace of the Legion of Honor. *Exhibition of American Paintings from the Beginning to the Present Day.* June 7 – July 7, 1935 (catalogue).

The Berkshire Museum, Pittsfield, Massachusetts. *Whitney Museum of American Art.* August 1 – September 1, 1935 (catalogue).

Phillips Memorial Gallery, Washington, with American Federation of Arts (organizer). *Contemporary American and European Paintings from the Phillips Memorial Gallery Selected by Mr. Phillips to Show the "Center" of the Recent Art Movement Rather than Extreme "Right" or "Left"* (checklist). Traveled to Art Department, Sweet Briar College, Virginia, October 6 – 27, 1935; Art Department, College of Wooster, Ohio, November 4 – 18, 1935; Montana State College, Bozeman, November 24 – December 1, 1935; Seattle

Art Museum, Washington, December 11, 1935 – January 5, 1936; Witte Memorial Museum, San Antonio, January 12 – 26, 1936; Delgado Museum, New Orleans, February 1 – 26, 1936; Art Association of Chattanooga, Tennessee, March 4 – 25, 1936; Dayton Art Institute, Ohio, May 1936; Everhart Museum, Syracuse, Summer 1936; San Francisco Museum of Art, October 1936; Faulkner Memorial Art Gallery, Santa Barbara, November 8 – 29, 1936; Fort Worth Art Museum, Texas, January 5 – February 2, 1937.

Carnegie Institute, Pittsburgh. *Thirty-Fourth International Exhibition of Paintings.* October 17 – December 8, 1935 (catalogue).

The Art Institute of Chicago. *Forty Sixth Annual Exhibition of American Paintings and Sculpture.* October 24 – December 8, 1935 (catalogue).

Museum of the City of New York. *Parades and Processions in New York.* December 4, 1935 – May 1, 1936.

1936

Pennsylvania Academy of the Fine Arts, Philadelphia. *131st Annual Exhibition.* January 26 – March 1, 1936.

"New Yorkers Win 5 of 6 Art Prizes." *New York Times,* January 26, 1936: 21.

*Addison Gallery of American Art, Phillips Academy, Andover, Massachusetts. *Paintings by William J. Glackens.* February 1 – March 1, 1936 (catalogue).

Art Department, Randolph-Macon Women's College, Ashland, Virginia. *Twenty-fifth Annual Exhibition: American and European Paintings.* March 2 – 23, 1936.

Columbus Gallery of Fine Arts, Ohio. *Glackens Exhibition.* Spring 1936.

Raleigh Art Center, North Carolina. *Exhibition.* April 1936.

Pennsylvania Academy of the Fine Arts, Philadelphia. *Illustration Exhibit by Former Students.* March 13 – April 12, 1936.

Society of Independent Artists, Grand Central Palace, New York. *Twentieth Anniversary Exhibition.* April 25 – May 17, 1936.

Museum of Modern Art, New York. *Modern Painters and Sculptors as Illustrators.* April 29 – September 2, 1936.

New School for Social Research, New York, for the benefit of the Little Red School House. *Exhibition of Contemporary Art.* May 9 – 29, 1936.

Municipal Art Committee and the City of New York, International Building, Rockefeller Center, New York. *First National Exhibition of American Art.* Opened May 18, 1936.

Addison Gallery of American Art, Phillips Academy, Andover, Massachusetts. *Small Paintings Small Sculpture by Contemporary Americans.* May 23 – June 21, 1936.

Kraushaar Galleries, New York. *Summer Group Exhibition.* June – Summer 1936.

International Art Center, New York. *Third Annual Washington Square Open-Air Art Exhibition.* June 4 – 13, 1936.

Dallas Museum of Fine Arts. *The Centennial Exposition: Exhibition of Paintings, Sculptures and Graphic Arts.* June 6 – November 29, 1936 (catalogue).

Art Association of Newport, Rhode Island. *Exhibition of Contemporary Paintings and Sculpture.* June 29 – July 19, 1936 (catalogue).

Carnegie Institute, Pittsburgh. *Thirty-Fourth International Exhibition of Modern Paintings.* October 15 – December 6, 1936.

"Leon Kroll Wins 1936 Carnegie Art Award." *Rochester Democrat and Chronicle,* October 16, 1936.

Jewell, Edward Alden. "Leon Kroll Wins Carnegie Prize; Repeats American Art Triumph." *New York Times,* October 16, 1936: 27.

Jewell, Edward Alden. "Six Nations' Paintings." *New York Times,* October 18, 1936: X9.

Breuning, Margaret. "Carnegie International, 1936." *Parnassus* 8, no. 6 (November 1936): 4 – 8.

The Art Institute of Chicago. *American Paintings and Sculpture: Forty-seventh Annual Exhibition.* October 22 – December 6, 1936 (catalogue).

"Art: Sedate & Sweet." *Time,* November 2, 1936.

Whitney Museum of American Art, New York. *Third Biennial Exhibition of Contemporary American Painting.* November 10 – December 10, 1936 (catalogue).

Carnegie Institute, Pittsburgh. *Paintings from the Collection of Albert C. Lehman.* December 17, 1936 – February 2, 1937 (catalogue).

1937

City Art Museum, Saint Louis, Missouri. *Thirty-First Annual Exhibition of Selected Paintings by American Artists.* January 3 – February 2, 1937 (catalogue).

Addison Gallery of American Art, Phillips Academy, Andover, Massachusetts. *Materials and Methods in Painting and Print Making.* January 5 – February 5, 1937.

*Kraushaar Galleries, New York. *Flower Paintings by William Glackens.* January 5 – 31, 1937.

Devree, Howard. "A Reviewer's Notebook." *New York Times,* January 10, 1937: X10.

Whitney Museum of American Art, New York. *Exhibition of Recent Acquisitions.* January 19 – February 5, 1937.

Pennsylvania Academy of the Fine Arts, Philadelphia. *One Hundred and Thirty-Second Annual Exhibition.* January 24 – February 28, 1937 (catalogue).

Whitney Museum of American Art, New York. *New York Realists, 1900 – 1914: Robert Henri, George Luks, John Sloan, William Glackens, Ernest Lawson, George Bellows, Everett*

Shinn, Glenn O. Coleman and Guy Pène du Bois. February 9 – March 12, 1937 (catalogue).

"Art: New York Realists." *Time,* February 22, 1937: Arts.

Jewell, Edward Alden. "Art by 'Realists' Put on Exhibition." *New York Times,* February 10, 1937: 20.

Jewell, Edward Alden. "The New York Realists." *New York Times,* February 14, 1937: X9.

Kraushaar Galleries, New York. *Group Exhibition.* February 1937.

"In the Realm of Art: Midwinter Round Up." *New York Times,* February 14, 1937: X9.

Wilkes-Barre Art Gallery, Pennsylvania. *Fifty Years of American Art.* February 1937.

Marie Sterner Gallery, New York. *Exhibition of Nineteenth Century American Art.* March – April 10, 1937 (catalogue, with foreword by Barnard Lintott).

Slattery Gallery, Boston. *Exhibition of Paintings by Contemporary American Artists.* March 8 – 20, 1937.

Chapin, James, and Anthony J. Philpott. "Paintings by Contemporary American Artists Exhibited." *Daily Boston Globe,* March 10, 1937: 3.

Corcoran Gallery of Art, Washington. *Fifteenth Biennial Exhibition.* March 28 – May 9, 1937.

Jewell, Edward Alden. "A Nation-Wide Survey." *New York Times,* April 4, 1937: 9X.

Detroit Institute of Arts. *Annual Exhibition of American Art.* April 2 – 31, 1937.

American Pavilion, Paris. *Universal Exposition on Art and Technique in Modern Life.* May 25 – November 25, 1937.

The Metropolitan Museum of Art, New York. *Recent Acquisitions of Contemporary American Paintings.* Opened May 29, 1937.

Jewell, Edward Alden. "Metropolitan Purchases." *New York Times,* May 30, 1937: X7.

Whitney Museum of American Art, New York. *Exhibition from Permanent Collection.* June 1 – July 15 and September 9 – 30, 1937.

Toledo Museum of Art. *Twenty-Fourth Annual Exhibition of Selected Paintings by Contemporary American Artists.* June 6 – August 29, 1937 (catalogue).

Greater Texas and Pan American Exposition, Dallas Museum of Fine Arts. *Art of the Americas: Pre-Columbian and Contemporary.* June 12 – October 31, 1937 (catalogue).

Cleveland Museum of Art. *American Painting from 1860 Until Today.* June 23 – October 4, 1937 (catalogue).

Kraushaar Galleries, New York. *Small Paintings by American Artists.* July 1937.

Art Association of Newport, Rhode Island. *Exhibition of Contemporary Paintings and Sculpture.* July 10 – 31, 1937 (catalogue).

Cincinnati Art Museum. *Forty-Fourth Annual Exhibition of American Art.* October 1 – November 14, 1937 (catalogue).

Art Gallery, State University of Missoula, Montana. *Inaugural Exhibition.* Opened October 5, 1937.

Kraushaar Galleries, New York. *Group Exhibition of Paintings.* October 23 – November 1, 1937.

Carnegie Institute, Pittsburgh. *International Exhibition of Paintings.* October 14 – December 5, 1937 (catalogue).

Whitney Museum of American Art, New York. *Sixth Annual Exhibition of Contemporary American Painting.* November 10 – December 12, 1937 (catalogue).

International Art Center, New York. *Exhibition of Scenes in New York's Parks and Playgrounds Since 1903.* December 1937 – January 2, 1938.

1938

Macbeth Galleries, New York. *"The Eight" (of 1908) Thirty Years After.* January 4–17, 1938 (catalogue).

Jewell, Edward Alden. "First U.S. Realists Seen in Art Show." *New York Times,* January 5, 1938: L 19.

Davidson, Martha. "'The Eight,' Timely Show of a Once Revolutionary Group." *Art News* 36, no. 16 (January 1938): 18–19.

McCausland, Elizabeth. "Gallery Notes." *Parnassus* 10, no. 1 (January 1938): 44.

Bruening, Margaret. "Art in New York." *Parnassus* 10, no. 2 (February 1938): 24.

Baltimore Museum of Art. *Two Hundred Years of American Painting.* January 15–February 29, 1938.

Pennsylvania Academy of the Fine Arts, Philadelphia. *One Hundred and Thirty-Third Annual Exhibition.* January 30–March 6, 1938.

Kraushaar Galleries, New York. *Drawings by Glackens, Du Bois, Sloan, and Wortman.* February 15–March 5, 1938.

*Corcoran Gallery of Art, Washington. *Drawings for Illustrations by William J. Glackens.* March 22–April 10, 1938.

"New Exhibit of Drawings at Corcoran." *Washington Post,* March 20, 1938: TS5.

Whitney Museum of American Art, New York. *Exhibition of Still-Lifes and Flowers from the Permanent Collection.* Spring 1938.

Nebraska Art Association, University of Nebraska at Lincoln. *Forty-Eighth Annual Exhibition of Paintings.* Spring 1938.

"American Art Bought by Nebraska Gallery." *New York Times,* April 22, 1938: 17.

Wildenstein Galleries, London. *Exhibition of Contemporary American Paintings.* May 25–June 25, 1938.

Print Rooms, Hollywood, organized by Walker Galleries,

New York. *Exhibition of Paintings.* June 6–July 2, 1938.

Colorado Springs Fine Arts Center, Colorado. *Fourth Annual Exhibition of Paintings by Artists West of the Mississippi.* Summer 1938.

Carnegie Institute, Pittsburgh. *Thirty-Sixth International Exhibition of Paintings.* October 13–December 4, 1938 (catalogue).

*Whitney Museum of American Art, New York. *William Glackens Memorial Exhibition.* December 14, 1938–January 15, 1939 (catalogue). Traveled to Carnegie Institute, Pittsburgh, February 1–March 15, 1939.

"Museum to Hold Glackens Show." *New York Times,* December 10, 1938: 15.

Jewell, Edward Alden. "Art of Glackens Put on Exhibition." *New York Times,* December 14, 1938: L29.

Klein, Jerome. "Whitney Museum Opens a Memorial Glackens Exhibit." *New York Post,* December 17, 1938: 14.

Davidson, Martha. "The Gay Glackens: In Memoriam." *Art News* 30 (December 17, 1938): 9.

Genauer, Emily. "Memorial Show of Glackens' Art." *New York World-Telegram,* December 17, 1938:.12.

"Painting and Pleasure." *Time,* December 26, 1928: Arts.

Jewell, Edward Alden. "Glackens Memorial at the Whitney." *New York Times,* December 18, 1938: X11.

Cobb, Jane. "Living and Leisure." *New York Times,* January 1, 1939: D7.

McCausland, Elizabeth. "Gallery Index." *Parnassus* 11, no. 1 (January 1939): 51.

1939

Sweet Briar College, Virginia. *French and American Paintings: Eugène Delacroix, Gustave Courbet, Dunoyer de Segonzac, André Derain, Gifford Beal, Louis Bouche, Russell Cowles, William Glackens, Henry G.

Keller, John Koch, Richard Lahey, Henry Schnakenberg, John Sloan, Edmund Yaghjian.* 1939.

*Department of Fine Arts, Carnegie Institute, Pittsburgh. *Memorial Exhibition of Works by William J. Glackens.* February 1–March 15, 1939.

O'Connor, John Jr. "The Glackens Exhibition." *Carnegie Magazine* 12 (February 1939): 273–277.

*Glackens Residence, New York. *Loan Exhibition of Paintings by William Glackens.* February 17–March 3, 1939 (catalogue).

Department of Fine Arts, Golden Gate International Exhibition, San Francisco. *Contemporary Art.* February 18–October 29, 1939.

Art Students League, Fine Arts Building, New York. *Annual Exhibition of Members.* March 10–30, 1939 (catalogue).

Society of Independent Artists, Grand Central Palace, New York. *Twenty-Third Annual Exhibition and Memorial.* March 30–April 19, 1939.

National Academy of Design, American Fine Arts Building, New York. *Special Exhibition: A Century of Art.* May 9–July 25, 1939 (catalogue).

*American Federation of Arts (sponsor). *William Glackens Memorial Exhibition* (catalogue). Traveled to Arts Club of Chicago, May 19–June 12, 1939; Los Angeles County Museum of Art, July 5–August 10, 1939; City Art Museum, Saint Louis, Missouri, October 1–20, 1939; Speed Memorial Museum, Louisville, Kentucky, November 2–18, 1939; Cleveland Museum of Art, December 1–31, 1939; Corcoran Gallery of Art, Washington, January 21–February 18, 1940; Norfolk Museum of Arts and Sciences, Virginia, March 3–24, 1940.

Jewett, Eleanor. "Open Glackens Memorial Show at Arts Club." *Chicago Daily Tribune,* May 30, 1939: 13.

Poe, Elizabeth E. "City Fortunate to View Glackens Art Exhibition." *Washington

Times-Herald,* January 28, 1940: C8.

Watson, Jane. "Work of Glackens on View at Corcoran." *Washington Post,* January 28, 1940: 6.

Walker Galleries, New York. *Views of New York.* Summer 1939.

Kraushaar Galleries, New York. *Summer Show.* June–August 1939.

Whitney Museum of American Art, New York. *Twentieth Century Artists.* Opened September 13, 1939.

*University Club, New York. *Exhibition of Original Drawings by William Glackens.* Opened September 18, 1939.

*Kraushaar Galleries, New York. *Drawing by William Glackens of Spanish-American War Scenes.* October 16–November 4, 1939.

Jewell, Edward Alden. "New York: Two Marin Shows—Glackens, Schary." *New York Times,* October 22, 1939: X9.

McCausland, Elizabeth. "Glackens Drawings." *Parnassus* 11, no. 7 (November 1939): 20.

The Art Institute of Chicago. *Half a Century of American Art.* November 16, 1939–January 7, 1940.

James St. L. O'Toole Gallery, New York. *Exhibition of American Art.* December 1939.

Cortissoz, Royal. "More Americans." *New York Herald Tribune,* December 17, 1939: 6: 8.

1940

*Edith Glackens Residence, New York. *Loan Exhibition of Paintings by William Glackens.* February–March 8, 1940.

National Academy of Design, New York. *One Hundred and Fourteenth Annual Exhibition.* March 14–April 11, 1940 (catalogue).

World's Fair, Flushing Meadows, New York. *Masterpieces of Art: European and American Paintings.* May–October 27, 1940.

Philadelphia Museum of Art. *Life in Philadelphia.* May 1–September 22, 1940 (catalogue).

Bennington College Gallery, Vermont. *Portraits by Contemporary American Artists.* June 3–15, 1940.

Smith College Museum of Art, Northampton, Massachusetts. *"Aspects of American Painting 1900–1940."* June 12–22, 1940.

Fine Arts Festival, University of Iowa, Iowa City. *Exhibition of American Paintings and Etchings.* July 14–29, 1940 (catalogue).

Washington County Museum of Fine Arts, Hagerstown, Maryland. *Exhibition.* September–November 1940. Traveled to Minneapolis Institute of Arts, Minnesota, January–June 1941.

Kraushaar Galleries, New York. *Drawings by American Artists.* October 7–26, 1940.

Carnegie Institute, Pittsburgh. *Survey of American Painting.* October 24–December 1, 1940 (catalogue).

*Glackens Residence, New York. *Second Annual Loan Exhibition of Paintings by William Glackens.* October 29–November 26, 1940.

Whitney Museum of American Art, New York (organizer). *Sixty Paintings from the Whitney Museum.* Traveled to Albright Knox Art Gallery, Buffalo, November 1–December 6, 1940; Toledo Museum of Art, January 5–February 9, 1941; Detroit Institute of Arts, February 21–March 23, 1941.

1941

Weyhe Gallery, New York. *American Humor in Black and White.* January 1941.

SW Branch, Central Public Library, Washington. *Paintings Lent by the Phillips Memorial Gallery.* February 11–March 23, 1941 (checklist).

Johnson-Humrickhouse Memorial Museum, Coshocton, Ohio. *Exhibition of American Painting.* February 27–March 20, 1941.

Whitney Museum of American Art, New York. *This Is Our City.* March 11 – April 13, 1941 (catalogue).

Society of Independent Artists, American Fine Arts Building, New York. *Twenty-Fifth Anniversary and Retrospective Exhibition.* April 17 – May 7, 1941 (catalogue).

The Metropolitan Museum of Art, New York. *A Special Exhibition of Contemporary Painting in the United States (La Pintura Contemporanea Norteamericana).* April 19 – 27, 1941 (catalogue). Traveled to South America.

Amherst College, Amherst, Massachusetts. *American Paintings from the Whitney.* May 1 – 13, 1941.

Fogg Art Museum, Harvard University, Cambridge. *American Landscape Painting: George Inness to George Bellows.* May 5 – 31, 1941 (catalogue).

Mount Holyoke Friends of Art, Mount Holyoke College, South Hadley, Massachusetts. *Fifty Paintings from the Collection of the Whitney.* May 20 – June 15, 1941.

Santa Barbara Museum of Art. *Painting Today and Yesterday in the United States. Opening Exhibition.* June 5 – September 1, 1941 (catalogue).

Kraushaar Galleries, New York. *Summer Group Exhibition.* August – September 12, 1941.

Devree, Howard. "A Reviewer's Notebook: The Show at Kraushaar's." *New York Times,* August 3, 1941: X7.

Kraushaar Galleries, New York. *Americans 1900 – 1920.* September 1 – 15, 1941.

Brooklyn Museum. *Recent Accessions.* October 23 – December 7, 1941.

*Edith Glackens Residence, New York. *Third Exhibition of Paintings.* November 13 – December 14, 1941.

Art Center, Parkersburg, West Virginia. *Fourth Annual Exhibition of Oils and Watercolors.* November 23 – December 10, 1941.

1942

National Academy of Design, New York. *Exhibition of Academy's Permanent Collection.* Opened January 8, 1942.

Brooklyn Museum. *Drawings by 19th-Century & Contemporary Artists.* January 29 – March 16, 1942.

Museum of Modern Art, New York. *New Acquisitions: American Drawings.* February 18 – March 15, 1942 (checklist).

Whitney Museum of American Art, New York. *One Hundred Important Paintings from the Museum's Permanent Collection.* April 1 – May 29, 1942.

Parke-Bernet Galleries, New York. *Happier Days in the United Nations: Loan Exhibition of Paintings for the Benefit of the American Red Cross.* June 16 – July 3, 1942.

Whitney Museum of American Art, New York. *Exhibition of Work from the Permanent Collection.* September 15 – October 25, 1942.

American British Art Center, New York. *An Exhibition of Paintings of the 19th and 20th Centuries of the City of New York.* October 20 – November 7, 1942.

Munson-Williams-Proctor Art Institute, Utica, New York, for the benefit of the American Red Cross. *Exhibition of 20th Century Drawings from the Museum of Modern Art.* November 4 – 25, 1942.

*Edith Glackens Residence, New York. *Fourth Annual Memorial Exhibition of the Paintings of William Glackens.* November 6 – December 6, 1942 (brochure).

Jewell, Edward Alden. "From the Academic to the Ultra-Modern. Glackens's Annual." *New York Times,* November 8, 1942: X9.

"Annual Tribute Paid to William Glackens." *Art Digest* 17 (November 15, 1942): 11.

Kraushaar Galleries, New York. *Paintings, 1915 – 1920.* November 30, 1942 – January 9, 1943.

Museum of Modern Art, New York. *20th Century Portraits.* December 9, 1942 – January 24, 1943 (catalogue).

1943

The American Fine Arts Society, New York, with the Art Students League of New York. *The 50th Year Exhibition of Distinguished Artists.* February 7 – 28, 1943 (catalogue).

Milwaukee Art Institute, Wisconsin. *Masters of Modern American Painting.* March 5 – 28, 1943.

*Corcoran Gallery of Art, Washington. *William Glackens — Memorial Exhibition of Oil Sketches.* March 21 – May 2, 1943.

Addison Gallery of American Art, Phillips Academy, Andover, Massachusetts. *Art Begins at Home: The Addison Gallery Gift Plan.* September 17 – October 11, 1943.

Babcock Galleries, New York. *American Tonalists and Impressionists.* September 20 – October 16, 1943 (brochure).

*Edith Glackens Residence, New York. *Fifth Annual Memorial Exhibition of the Paintings, Sketches, and Drawings of William Glackens.* November 6 – December 5, 1943 (catalogue).

"Briefer Mention." *New York Times,* November 14, 1943: X6.

Brooklyn Museum. *The Eight: Robert Henri, John Sloan, William J. Glackens, Ernest Lawson, Maurice Prendergast, George B. Luks, Everett Shinn [and] Arthur B. Davies.* November 24, 1943 – January 16, 1944 (catalogue).

Jewell, Edward Alden. "'Eight' and Their Successors: The Brooklyn Museum Recalls Work by a Group of Pioneering Americans...." *New York Times,* November 28, 1943: X7.

Vaughan, Malcolm. "Eight Who Made History in Art." *New York Times,* November 28, 1943.

1944

American British Art Center, New York. *Exhibition of Drawings of the 19th and 20th Centuries.* January 5 – 22, 1943 (checklist).

Whitney Museum of American Art, New York. *Exhibition of Oils, Water-colors, Drawings and Sculpture from the Permanent Collection.* February 1 – March 14, 1944.

Museum of Modern Art, New York. *Modern Drawings.* February 16 – May 10, 1944.

Wildenstein Gallery, New York, for the benefit of the American Red Cross. *Stars of Yesterday and Today.* March 8 – April 4, 1944.

Museum of Modern Art, New York. *Look at Your Neighborhood.* March 29 – June 25, 1944.

National Gallery of Art, Washington. *American Battle Painting: 1776 – 1918.* July 4 – September 4, 1944 (catalogue). Traveled to Museum of Modern Art, New York, September 27 – November 12, 1944.

Museum of Fine Arts, Boston. *Sport in American Art.* October 11 – December 10, 1944.

*Edith Glackens Residence, New York. *Seventh Annual Memorial Exhibition of the Paintings and Drawings of William Glackens.* November 4 – December 2, 1944.

School Art League, New York (organizer). *Thirty-Fifth Anniversary Loan Exhibition: Portraits of Children by American Artists.* Traveled to Portraits, Inc. Gallery, New York, November 8 – 25, 1944.

1945

National Association of Portrait Painters, New-York Historical Society, New York. *Portraits of Americans by Americans.* April 1 – May 5, 1945 (catalogue).

Heckscher Museum of Art, Huntington, New York. *Thirteen Drawings from the Collection of the Whitney Museum of American Art.* May 5 – 20, 1945.

Kraushaar Galleries, New York. *New York Scenes.* September – October 7, 1945.

*The Art Institute of Chicago. *Masterpiece of the Month: Chez Mouquin, Painting by William Glackens (American, 1870 – 1938).* September 1 – 29, 1945.

French and Company Gallery, New York. *Exhibition of American Paintings.* October 1945.

Philadelphia Museum of Art, Pennsylvania. *Artists of the Philadelphia Press.* October 14 – November 18, 1945 (catalogue, with essays by John Sloan and Everett Shinn).

Breuning, Margaret. "Whistler's 'Gold Scarab' in Marie Sterner Show." *Art Digest* (October 13, 1945): 12.

Baum, Walter E. "Newspaper Artists of Old Honored as Pioneers." *Evening Bulletin* (Philadelphia), October 13, 1945: Art, 10G.

"Philadelphia Story — Told by Four Artists." *Art Digest,* October 15, 1945: 14.

"The Press: Reporters of the Brush." *Time,* October 29, 1945.

*Edith Glackens Residence, New York. *Around New York: Seventh Annual Memorial Exhibition of the Paintings and Drawings of William Glackens.* Opened November 2, 1945.

Rypins, Evelyn. "Seventh Exhibit of Glackens Art." *Villager* (NY), November 1, 1945.

Brooklyn Museum. *Landscape: An Exhibition of Paintings.* November 9, 1945 – January 1, 1946 (checklist).

1946

*Corcoran Gallery of Art, Washington. *Water Colors and Pastels (Original Illustrations) by William J. Glackens.* May 8 – 26, 1946.

French and Company Gallery, New York. *Exhibition of American Paintings Arranged by Marie Sterner.* Closed June 8, 1946.

Reed, Judith Kay. "Taste and Quiet Beauty in American Art." *Art Digest* 20 (May 15, 1946).

National Gallery of Art, Washington, and State Department (organizers). *American Painting from the Eighteenth Century to the Present.* Traveled to Tate Gallery, London, June–July 1946.

 Wilenski, Reginald Howard. "A London Look at U.S. Painting in the Tate Gallery Show." *Art News* (August 1946): 27.

Kraushaar Galleries, New York. *Group Exhibition.* June 1946.

Akron Art Institute, Ohio. *America Paints Outdoors.* July 1946–September 1947.

*Edith Glackens Residence, New York. *Ninth Annual Memorial Exhibition (Featuring Portraits).* November 7–December 1, 1946.

 "Annual Show Held at Artist's Home." *Villager* (NY), November 7, 1946.

 Jewell, Edward Alden. "Disparate Events." *New York Times*, November 17, 1946.

Grand Central Art Galleries, New York, from the IBM Collection. *60 Americans since 1800.* November 19–December 5, 1946 (catalogue).

1947

Yale Gallery of the Fine Arts, New Haven, Connecticut. *Loan Exhibition from the Whitney Museum of American Art.* March 1–31, 1947.

Milwaukee Art Institute, Wisconsin. *Sports and Adventure in American Art.* February 15–March 30, 1947.

John Levy Gallery, New York. *Retrospective Exhibition of Twenty-Five American Artists.* Spring 1947.

French and Company Gallery, New York. *Group Show.* July 1947.

Kraushaar Galleries, New York. *Summer Group Show.* July 1947.

Utah Centennial Commission, Salt Lake City. *Utah Centennial Exhibition: 100 Years of American Painting.* July 1–29, 1947.

Kansas City Art Institute and School of Design, Missouri. *30 Drawings from the Whitney Museum of American Art.* September 29–October 28, 1947.

*Edith Glackens Residence, New York. *Tenth Memorial Exhibition of Paintings by William Glackens.* November 2–30, 1947.

 "Glackens Memorial Exhibit to Open." *Villager* (NY), October 1947.

Brooklyn Museum. *American Printmaking, 1913–1947: A Retrospective Exhibition.* November 18–December 16, 1947 (catalogue).

Kraushaar Galleries, New York. *Holiday Show.* December 1947.

1948

Saginaw Museum, Michigan. *American Painting from Colonial Times Until Today.* January 9–February 15, 1948 (catalogue).

Wichita Art Museum, Kansas. *12 Paintings from the Whitney Museum of American Art.* January 30–February 29, 1948.

Binghamton Museum of Fine Arts, Public Library, New York, IBM (organizer). *Exhibition of 19th and 20th Century American Paintings.* March 31–April 30, 1948.

Randolph-Macon Women's College Art Gallery, Ashland, Virginia. *The Thirty-seventh Annual Exhibition: American Painting.* May 7–June 7, 1948.

Kraushaar Galleries, New York. *50 Years of New York.* Summer 1948.

Brooklyn Museum. *Coast and the Sea: A Survey of American Marine Painting.* November 19, 1948–January 16, 1949.

1949

Des Moines Art Center, Iowa. *Turn of the Century: American Artists, 1890 to 1920.* 1949.

Saginaw Museum, Michigan. *20th Century American Painting.* 1949.

*Kraushaar Galleries, New York. *Paintings and Drawings by William Glackens.* January 3–29, 1949 (catalogue).

 "Works of Famous Artist on View." *Villager* (NY), January 6, 1949.

 Carlson, Helen. "A Portrait of New York." *New York Sun*, January 7, 1949.

 Devree, Howard. "Diverse Americans." *New York Times*, January 9, 1949: X8.n.

Corcoran Gallery of Art, Washington. *De Gustibus.* January 9–February 20, 1949.

 "Art: The Kunastrokicm Point." *Time*, February 28, 1949.

Museum of the City of New York. *Three Rivers Around the Rim of Manhattan.* May 5–September 18, 1949.

Greenwich Village Fresh Air Fund Festival, New York. *20 Paintings from the Collection of the Whitney Museum of American Art.* May 7–16, 1949.

The Metropolitan Museum of Art, New York. *Comparisons in American Art and Literature.* May 7–31, 1949.

Whitney Museum of American Art, New York. *Juliana Force and American Art.* September 24–October 30, 1949 (catalogue).

1950

The Society of the Four Arts, Palm Beach, Florida. *From Plymouth Rock to the Armory.* February 9–March 5, 1950.

The Century Association, New York. *Aspects of New York City Life.* March 1–May 8, 1950.

French and Company Gallery, New York. *Flower Paintings from 1600 to the Present.* Spring 1950.

Art Gallery, Munson-Williams-Proctor Art Institute, Utica. *Selected American Paintings, 1900–1950.* April 30–May 21, 1950.

Randolph-Macon Woman's College Art Gallery, Ashland, Virginia. *The Thirty-ninth Annual Exhibition: Contemporary American Painting and Sculpture.* May 7–June 4, 1950.

Milch Gallery, New York. *Summer Exhibition of American Painters from the 19th Century and Contemporaries.* Summer 1950.

The Metropolitan Museum of Art, New York. *Twentieth-Century Painters, U.S.A., and Twentieth-Century Prints, U.S.A.* June 16–October 29, 1950.

 "Art: The 200." *Times*, July 3, 1950.

Corcoran Gallery of Art, Washington. *American Procession: 1492–1900.* July 8–December 17, 1950.

 "Art: Cavalcade." *Time*, July 17, 1950.

1951

Columbus Gallery of Fine Arts, Ohio. *Inaugural Exhibition.* January–February 1951.

Milwaukee Art Institute, Wisconsin. *Loan from the Whitney Museum of American Art.* January 4–February 15, 1951.

The Metropolitan Museum of Art, New York. *75th Anniversary Exhibition of Painting and Sculpture by 75 Artists Associated with the Art Students League of New York.* March 16–April 29, 1951 (catalogue).

The Dayton Art Institute, Ohio. *The City by the River and the Sea: Five Centuries of Skylines.* April 18–June 3, 1951 (catalogue).

Home Show, Pan-Pacific Auditorium, Los Angeles Municipal Department of Art. *Exhibition of Paintings from the Collection of the Metropolitan Museum of Art.* June 13–24, 1951.

Department of Fine Arts, University of Iowa, Iowa City. *Thirteenth Annual Fine Arts Festival. Six Centuries of Master Drawings.* Summer 1951 (catalogue).

The Metropolitan Museum of Art, New York. *The Lewisohn Collection.* November 2–December 2, 1951 (catalogue).

The Dayton Art Institute, Ohio. *America and Impressionism.* October 19–November 11, 1951. Traveled to Columbus Gallery of Fine Arts, Ohio, November 18–December 19, 1951.

Brooklyn Museum. *Revolution and Tradition: An Exhibition of the Chief Movements in American Painting from 1900 to the Present.* November 15, 1951–January 6, 1952 (catalogue).

Grand Central Art Galleries, New York. *Painters of the United States, 1720–1920, from the Permanent Collection of the Fine Arts Department of IBM.* November 15–December 8, 1951 (catalogue).

National Academy of Design, New York. *The American Tradition, 1800–1900.* December 3–16, 1951 (catalogue). American Federation of Arts (organizer). Traveled to The Wilmington Society of Fine Arts, Wilmington, March 3–30, 1952; Fort Dodge Federation of Arts, Iowa, April 17–May 8, 1952; University of Arkansas, Fayetteville, May 10–June 10, 1952; Roanoke Fine Art Center, Virginia, July 7–August 17, 1952; Saginaw Museum, Michigan, August 11–September 25, 1952; J. B. Speed Art Museum, Louisville, October 5–26, 1952; University of Miami, Coral Gables, November 9–30, 1952; Nashville Committee for the Coordination of the Arts, Tennessee, December 14, 1952–January 4, 1953; Columbia Museum of Art, South Carolina, January 15–February 5, 1953; Milwaukee Art Institute, Wisconsin, February 16–March 29, 1953; Huntington Arts Society, West Virginia, April 12–May 3, 1953.

1952

Dallas Museum of Fine Arts. *Some Businessmen Collect Contemporary Art.* April 6–27, 1952 (catalogue).

Randolph-Macon Woman's College Art Gallery, Ashland, Virginia. *The Forty-first Annual Exhibition: American Paintings.* May 11 – June 9, 1952.

Museum of Modern Art, New York (organizer). *Thirty-Four Paintings from the Whitney Museum of American Art.* Traveled to Abilene Museum of Fine Arts, Texas, October 6 – 27, 1952; Hackley Art Gallery, Muskegon, Michigan, November 5 – 26, 1952; Art Institute of Zanesville, Ohio, December 10 – 31, 1952; Tucson Fine Arts Association, Arizona, January 14 – February 4, 1953; Lauren Rogers Library and Art Museum, Laurel, Mississippi, February 18 – March 11, 1953; Louisiana State Exhibit Museum, Shreveport, March 25 – April 15, 1953; J. B. Speed Art Museum, Louisville, April 29 – May 19, 1953; Miami Beach Public Library and Art Center, Florida, June 8 – 29, 1953.

Milch Gallery, New York. *Exhibition of Landscape Paintings.* June 1952.

Carnegie Institute, Pittsburgh. *The Pittsburgh International Exhibition of Contemporary Painting.* 1952.

1953

Wildenstein and Company, New York. *Landmarks of American Art 1670 – 1950.* February 26 – March 28, 1953 (catalogue).

Louchheim, Aline B. "Landmarks in American Painting." *New York Times,* February 22, 1953.

Kraushaar Galleries, New York. *Exhibition of 20th Century Drawings.* Spring 1953.

Des Moines Art Center, Iowa. *Fifth Anniversary Exhibition: Realism in Painting and Sculpture.* June 5 – July 12, 1953.

B. Altman and Company, New York. *12 Paintings from the Permanent Collection of the Whitney Museum of American Art: Paintings of New York by New Yorkers.* June 8 – 13, 1953.

Fine Arts Gallery, University of Colorado, Boulder. *Exhibition of Paintings.* June 21 – August 16, 1953.

Syracuse Museum of Fine Arts, New York. *125 Years of American Art.* September 16 – October 11, 1953 (catalogue).

Fine Arts Building, Los Angeles County Fair, Pomona. *Painting in the U.S.A., 1721 to 1953.* September 18 – October 4, 1953.

Kraushaar Galleries, New York. *Paintings by Glackens, Lawson, Prendergast, Sloan.* September 28 – October 17, 1953 (catalogue).

Devree, Howard. "In Diverse Veins." *New York Times,* October 4, 1953: X10.

Addison Gallery of American Art, Phillips Academy, Andover, Massachusetts (organizer). *Exhibition of Paintings from The Phillips Academy, Andover, Mass.* Western Canada Art Circuit, November 15, 1953 – June 3, 1954.

1954

Martha Jackson Gallery, New York. *Exhibition and Sale of American Paintings.* February 3 – 28, 1954.

The Century Association, New York. *Exhibition.* March 31 – May 30, 1954.

Knoedler Galleries, New York. *American Panorama: American Painting in the Brooklyn Museum Collection.* April 8 – 30, 1954.

"The Middle Years." *Time,* May 3, 1954: Art.

Santa Barbara Museum of Art. *Impressionism and Its Influence in American Art.* May 3 – 30, 1954 (catalogue). Traveled to Toledo Museum of Art, January 3 – 31, 1954; Seattle Art Museum, February 10 – March 7, 1954; Dallas Museum of Fine Arts, March 21 – April 18, 1954; M. H. de Young Memorial Museum, San Francisco, June 8 – July 5, 1954.

West Side Jewish Community Center, Los Angeles. *Exhibition of Small American Paintings from the IBM Collection.* Closed August 9, 1954.

Governor Dummer Academy, Byfield, Massachusetts. *Loan Exhibition of Paintings.* December 10, 1954 – November 8, 1955.

1955

Philadelphia Museum of Art. *American Painting.* 1955.

Pennsylvania Academy of the Fine Arts, Philadelphia. *One Hundred Fiftieth Anniversary Exhibition.* January 15 – March 13, 1955 (catalogue). Traveled to Museo de Arte Moderno, Madrid, April 15 – May, 1955; Strozzi Palace, Florence, June 1955; Ferdinandeum Museum, Innsbruck, Austria, July 15 – August, 20, 1955; City Hall, Copenhagen, September 1955; Musées royaux des Beaux-Arts de Belgique, Brussels, October 16 – November 15, 1955.

"Art: Who's Who in Philadelphia." *Time,* February 7, 1955.

Vancouver Art Gallery, Canada. *Two Hundred Years of American Painting.* March 8 – April 3, 1955 (catalogue).

Picture Galleries, Marshall Field and Company, Chicago. *Exhibition of Still Life Paintings by American Artists.* April 12 – May 5, 1955.

Albright-Knox Art Gallery, Buffalo. *Fifty Paintings: 1905 – 1913.* May 14 – June 12, 1955.

Kraushaar Galleries, New York. *Exhibition of Contemporary Americans.* Summer 1955.

Mineral Industries Gallery, Pennsylvania State University, University Park. *Pennsylvania Painters: Centennial Exhibition.* October 7 – November 6, 1955 (catalogue).

Renaissance Society, Goodspeed Hall, University of Chicago. *11 American Pioneers of the 20th Century.* October 13 – November 8, 1955.

Museum of the City of New York. *Four Centuries of Italian Influence in New York.* October 18, 1955 – March 15, 1956.

American Academy of Arts and Letters, New York. *Exhibition of Works by the Participants of the First Armory Show of 1913 or/and the First Annual Exhibition of the Society of Independent Artists, 1917.* December 2 – 30, 1955 (catalogue).

Heckscher Museum of Art, Huntington, New York, with Huntington Art League, New York (organizer). *30 Paintings from the Collection of the Whitney Museum of American Art.* December 7 – January 6, 1956.

1956

National Arts Club, New York. *Exhibition of Paintings from the IBM Permanent Collection.* April 1956.

Fine Arts Department, Marquette University, Milwaukee. *Festival of the American Arts.* April 20 – May 20, 1956.

Wadsworth Atheneum, Hartford, Connecticut. *In Memoriam: Paintings by William J. Glackens and Edith Dimock Glackens.* June 18 – July 15, 1956.

Minard, Ralph. "Art Show Recalls Historic Home." *Hartford Times,* June 16, 1956.

Chautauqua Art Association, Chautauqua Women's Club, New York. *One Hundred Years of American Painting.* July 1 – 22, 1956 (catalogue).

Mount Holyoke College Museum of Art, South Hadley, Massachusetts. *French and American Impressionism: An Exhibition Celebrating the Twenty-fifth Anniversary of the Mount Holyoke Friends of Art.* October 5 – November 4, 1956 (catalogue).

Kraushaar Galleries, New York. *"The Eight": Work by Davies, Glackens, Henri, Lawson, Luks, Prendergast, Shinn and Sloan.* Opened October 8, 1956.

Roberson Memorial Center, Binghamton, New York. *Impressionist Painting.* October 15 – November 15, 1956.

Jacksonville Art Museum, Florida. *American Painting: Second Quarter of the 20th Century.* 1956.

1957

Corcoran Gallery of Art, Washington. *Twenty-Fifth Biennial Exhibition of Contemporary American Oil Paintings.* January 13 – March 10, 1957 (catalogue). Traveled to Toledo Museum of Art, April 1 – 30, 1957.

Brooklyn Museum. *Golden Years of American Drawings, 1905 – 1956.* January 22 – March 17, 1957 (catalogue).

Montclair Art Museum, New Jersey. *The Eight.* April 7 – 28, 1957.

Davis Gallery, New York. *An Intimate Collection.* April 22 – May 30, 1957 (catalogue).

Stanford University, California. *Exhibition of the Works from the Whitney Museum of American Art.* May – June 1957.

Zabriskie Gallery, New York. *The City 1900 – 1930.* June 16 – July 31, 1957 (catalogue).

University of Colorado, Boulder. *Exhibition.* June 17 – August 24, 1957.

Contemporary Arts Center, Cincinnati Art Museum. *An American Viewpoint: Realism in the Twentieth Century.* October 12 – November 17, 1957. Traveled to Dayton Art Institute, Ohio, November 27 – January 15, 1957 (catalogue).

Kraushaar Galleries, New York. *William Glackens and His Friends.* November 5 – 30, 1957.

Preston, Stuart. "An American Period and Other Shows." *New York Times,* November 10, 1957: 11, 13.

Brooklyn Museum, New York. *Face of America: The History of Portraiture in the United States.* November 13, 1957 – January 26, 1958.

1958

Walt Whitman Hall, Hofstra College, Hempstead, New York. *Art and the Theatre.* January 6 – 27, 1958.

Addison Gallery of American Art, Phillips Academy, Andover, Massachusetts. *Artistic Highlights of American History.* January 10 – March 23, 1958.

Whitney Museum of American Art, New York (organizer). *30 Paintings from the Collection of the Whitney Museum of American Art.* Traveled to Art League of Manatee County, The Art Center, Bradenton, Florida, January 12 – 24, 1958; Gulf Coast Art Center, Clearwater, Florida, February 13 – March 1, 1958; Florida Southern College, Lakeland, March 4 – 22, 1958; Rollins College, Winter Park, March 24 – April 10, 1958; Jacksonville Art Museum, Florida, April 20 – May 12, 1958.

Westmoreland County Museum of Art, Greensburg, Pennsylvania. *Exhibition.* January 15, 1958 – July 31, 1959.

Georgia Museum of Art, University of Georgia, Athens. *Georgia Museum of Art: Dedication Exhibition.* January 28 – February 22, 1958 (catalogue).

Davis Galleries, New York. *American Working Drawings Prior to 1925.* January 31 – February 22, 1958 (catalogue).

 Dore Ashton. "Americans before 1925 in Casual Mood." *New York Times,* February 7, 1958: 15.

Slater Memorial Museum, Norwich, Connecticut. *Bellows and the Eight.* February 1 – 28, 1958.

Syracuse Museum of Art, New York. *Arthur B. Davies, William Glackens, Robert Henri, Ernest Lawson, George Luks, Maurice Prendergast, Everett Shinn, John Sloan: An Exhibition.* February 3 – 24, 1958 (catalogue).

Zabriskie Gallery, New York. *The "Eight."* February 3 – March 1, 1958 (catalogue).

American Academy of Arts and Letters, New York. *Exhibition.* February 1958.

Kraushaar Galleries, New York. *Still Life Exhibition with Works by William J. Glackens and Maurice Prendergast.* February – March 1958 (catalogue).

Mead Art Museum, Amherst College, Massachusetts. *The 1913 Armory Show in Retrospect.* February 17 – March 17, 1958 (catalogue).

The Society of the Four Arts, Palm Beach, Florida. *American Paintings and Sculpture Lent by the Whitney Museum of American Art.* March 2 – April 14, 1958.

Butler Institute of American Art, Youngstown, Ohio. *Special Exhibit of Accessions During the Last Two Years.* April 1 – 30, 1958.

Des Moines Art Center. *Tenth Anniversary Show.* June 1 – July 20, 1958 (catalogue).

Kraushaar Galleries, New York. *Still Life Paintings and Watercolors by American Artists.* July 1958 (catalogue).

La Napoule Art Foundation, Mandelieu-la-Napoule, France. *Exhibition.* August 1 – September 20, 1958.

Fort Worth Art Center, Texas, from collection of IBM public service program. *Small Paintings by Americans.* August 9 – 31, 1958. Traveled to Albany Institute of History and Art, New York, opened December 14, 1960.

William Hayes Ackland Memorial Art Center, University of North Carolina, Chapel Hill. *Paintings, Drawings, Prints and Sculpture from American College and University Collections: Inaugural Exhibition.* September 20 – October 20, 1958.

Cincinnati Art Museum. *Two Centuries of American Painting.* October 4 – November 4, 1958.

Miller Library, Colby College, Waterville, Maine. *Twentieth Century American Paintings.* October 6 – 25, 1958. Traveled to Bowdoin College Museum of Fine Arts, Brunswick, Maine, November 3 – 22, 1958; The New Britain Art Institute Art Museum, Connecticut, December 13, 1958 – January 4, 1959.

Huntington Art Galleries, West Virginia. *150 Paintings from the Whitney Museum of American Art.* October 19 – November 16, 1958.

Carnegie Institute, Pittsburgh. *Retrospective Exhibition of Paintings from Previous Internationals, 1896 – 1955.* December 5, 1958 – February 8, 1959 (catalogue).

1959

Museum of Art, Carnegie Institute, Pittsburgh. *Retrospective of Carnegie International Exhibitions.* 1959.

Currier Gallery of Art, Manchester, New Hampshire. *Exhibition.* 1959.

North Shore Art Center, Great Neck, New York. *Exhibition of the Eight.* January 2 – 31, 1959.

Dallas Museum for Contemporary Arts, Texas. *Fort Worth Collects.* January 6 – 22, 1959 (catalogue).

Delaware Art Museum, Wilmington. *American Paintings.* January 9 – 25, 1959.

Addison Gallery of American Art, Phillips Academy, Andover, Massachusetts. *The American Line.* January 10 – February 15, 1959.

Wildenstein Gallery, New York. *Masterpieces of the Corcoran Gallery of Art, A Benefit Exhibition in Honor of the Gallery's Centenary.* January 28 – March 7, 1959 (catalogue).

 Devree, Howard. "Corcoran Centenary." *New York Times,* February 1, 1959: X19.

Coe College, Cedar Rapids, Iowa. *1959 Arts Festival.* March 3 – April 26, 1959.

Davis Galleries, New York. *The Beach Scene – an American Tradition.* March 10 – April 4, 1959 (catalogue).

George Walter Vincent Smith Art Museum, Springfield, Massachusetts. *James D. Gill Retrospective Exhibition.* April 5 – May 3, 1959.

Kraushaar Galleries, New York. *Exhibition of Landscapes.* May 1959.

Miami University Art Museum, Oxford, Ohio. *Miami University Sesquicentennial.* May 1 – June 30, 1959.

Devree, Howard. "Annual Awards. Stress on Landscape." *New York Times,* May 24, 1959: X17.

Westmoreland County Museum of Art, Greensburg, Pennsylvania. *Two-Hundred and Fifty Years of Art in Pennsylvania.* Opened May 29, 1959.

Brooklyn Museum. *Salute to the Hudson-Champlain Celebration.* June 23 – September 13, 1959.

Parrish Art Museum, Southampton, Long Island. *Impressionist Paintings by American Artists.* June 27 – July 19, 1959.

American National Exposition, Sokolniki Park, Moscow, Russia. *American Painting and Sculpture 1930 – 1959.* July 25 – September 4, 1959 (catalogue, with text by Lloyd Goodrich). Reshown at the Whitney Museum of American Art, New York. *Paintings and Sculpture from the American National Exhibition in Moscow.* October 28 – November 15, 1959 (brochure, with checklist). Traveled to San Francisco Museum of Art, California, December 8, 1959 – January 1, 1960.

Chautauqua Institution, New York. *Selections from the Butler Institute of Art.* August 2 – 14, 1959.

Hirschl and Adler Galleries, New York. *Exhibition of the Collection.* Fall 1959.

Addison Gallery of American Art, Phillips Academy, Andover, Massachusetts. *Living with Design.* October 22 – November 23, 1959.

Little Red Schoolhouse, Bleecker Street, New York. *Fifteenth Art Show and Sale: All-American.* November 13 – 15, 1959.

1960

Delaware Art Center, Wilmington. *The Fiftieth Anniversary of Independent Artists in 1910.* January 9 – February 21, 1960 (catalogue).

American Academy of Arts and Letters, Art Gallery, New York. *A Change of Sky: Paintings by Americans Who Worked Abroad.* March 4 – April 3, 1960 (catalogue).

Osterhout Library, The Wyoming Valley Art League, Wilkes-Barre, Pennsylvania. *The Eight.* (Loan exhibition from The Metropolitan Museum of Art and WMAA). April 8 – 30, 1960 (brochure).

*Carpenter Art Galleries, Dartmouth College, Hanover, New Hampshire. *William Glackens Retrospective.* May 5 – June 30, 1960 (brochure).

Bowdoin College Museum of Art, Brunswick, Maine. *Americans Abroad.* August 7 – September 15, 1960.

Blair County Arts Foundation, Altoona, Pennsylvania. *Ashcan School.* October – November 1960.

Museum of Modern Art, New York. *100 Drawings from the Museum Collection.* October 12, 1960 – January 2, 1961 (checklist).

The Isaac Delgado Museum of Art, New Orleans. *The World of Art in 1910.* November 15 – December 31, 1960 (catalogue).

1961

Hayden Gallery, Massachusetts Institute of Technology, Cambridge. *American Paintings, 1900 – 1957 from the Whitney Museum of Art.* Closed February 28, 1961.

Davis Galleries, New York. *19th and 20th Century American Landscapes.* March 6 – 25, 1961.

Castellane Gallery and Heller Gallery, New York. *The Eight.* Spring 1961.

Randolph-Macon Women's College Art Gallery, Ashland, Virginia. *The Fiftieth Annual Exhibition: Artists on Our Want List.* April 30 – May/ June 5, 1961.

Delaware Art Museum, Wilmington. *The Life and Times of John Sloan.* September 22 – October 29, 1961 (catalogue).

Brooklyn Museum. *The Nude in American Painting.* October 6 – December 10, 1961.

 "Art: Shy About the Nude." *Time,* October 13, 1961.

Philbrook Art Center, Tulsa, Oklahoma. *The Eight.* October 1961.

Whitney Museum of American Art, New York. *American Art of Our Century.* November 15 – December 10, 1961 (catalogue). Traveled to The Society of the Four Arts, Palm Beach, March 3 – April 1, 1962.

American Federation of Arts, New York (organizer). *Major Paintings from the Whitney Museum of American Art: 1950 – 1957.* Traveled to Memorial Art Gallery, University of Rochester, New York, December 1 – 22, 1960; Akron Art Institute, Ohio, January 5 – 25, 1961; Massachusetts Institute of Technology Museum, Cambridge, February 6 – 28, 1961; Art Gallery, University of Minnesota, Minneapolis, March 15 – April 5, 1961; Art Gallery, University of California, Berkeley, April 19 – May 10, 1961; Museum of Art, University of Oregon, Eugene, May 24 – June 15, 1961; Museum of Fine Arts, Montreal, September 7 – 30, 1961.

1962

*Library of Congress, Washington. *Exhibition of Drawings by William Glackens.* March 10 – May 15, 1962.

Ahlander, Leslie Judd. "Ashcan Art at Library of Congress." *Washington Post,* March 11, 1962.

Getlein, Frank. "Glackens Prints Fine Example of Artist-Reporter's Talent." *Washington Sunday Star,* March 11, 1962.

Fort Wayne Art School and Museum, Indiana. *Selections from the Butler Institute of American Art.* May 21 – May 31, 1962.

Currier Gallery of Art, Manchester, New Hampshire. *One Hundred American Drawings from the Collection of Paul Magriel.* July 11 – September 7, 1962 (catalogue). Traveled to Phoenix Art Museum, February – March 1963; Portland Art Museum, Oregon, April 15 – May 19,

1963; University Art Museum, University of Texas at Austin, November 8 – December 6, 1964.

National Gallery of Canada, Ottawa, from the collection of Mr. Walter P. Chrysler Jr. *The Controversial Century 1850 – 1950.* September 28 – November 4, 1962 (catalogue).

Alfredo Valente Gallery, New York. *The Ash Can School Exhibition of Oils, Watercolors, Drawings and Pastels.* November – December 7, 1962.

Dwight Art Memorial, Mount Holyoke College, South Hadley, Massachusetts. *A Special Exhibition of Works of Art From the Mount Holyoke College Collection.* November 8, 1962 – January 27, 1963.

1963

Sheldon Museum of Art, University of Nebraska, Lincoln. *A Selection of Works from the Art Collections at the University of Nebraska.* 1963.

Columbus Gallery of Fine Arts, Ohio. *American Traditionalists of the 20th Century.* February 15 – March 17, 1963 (catalogue).

Museum of Art, Munson-Williams-Proctor Art Institute, Utica, New York. *1913 Armory Show: 50th Anniversary Exhibition.* February 17 – March 31, 1963. Traveled to Armory of the Sixty-Ninth Regiment, New York, April 6 – 28, 1963.

"Armory Show Exhibit Opens Today in Art Museum." *Utica Observer Dispatch,* February 17, 1963: C.

Dallas Museum of Fine Arts, Texas. *Gallery Gardens.* February 23 – March 24, 1963 (catalogue).

School of Visual Arts, New York. *A Whitney Loan Show of 26 Works from the Permanent Collection.* March 29 – April 19, 1963.

Kraushaar Galleries, New York. *American Artists 1900 – 1950.* Closed April 27, 1963.

YMCA, Glen Cove, New York. *Art Show and Sale: From*

the Armory through Today. May 25 – 27, 1963.

Art Dealers Association of America, Parke-Bernet Galleries, New York. *Review of the Season, 1962 – 63.* June 18 – July 27, 1963.

Southern Vermont Art Center, Manchester. *The Eight: Fifty-five Years Later.* June 22 – July 21, 1963.

Spindletop Research Center, Lexington, Kentucky. *A Whitney Museum Sampler.* October – November 1963. Traveled to Huntington Galleries, Huntington, West Virginia, December 8, 1963 – January 5, 1964.

American Federation of Arts, New York (organizer). *American Impressionists, Two Generations.* October 1963 – May 1965. Traveled to Fort Lauderdale Art Center, Florida; Brooks Memorial Art Gallery, Memphis; Cummer Gallery of Art, Jacksonville, Florida; Delaware Art Museum, Wilmington, January 15 – February 2, 1964; Michigan State University, East Lansing; Evansville Public Museum, Illinois; Roanoke Fine Arts Center. Circulated in Canada by the National Gallery of Canada, September 3, 1964 – May 2, 1965. Vancouver Art Gallery, Canada; Beaverbrook Art Gallery, Fredericton, Canada; Queen's University, Kingston, Canada; Norman Mackenzie Art Gallery, Regina, Canada; St. John's, University of Newfoundland; London Public Library and Art Museum; Art Gallery of Greater Victoria, Victoria, Canada.

Minneapolis Museum of Art, Minnesota. *Four Centuries of American Art.* November 27, 1963 – January 19, 1964.

1964

Butler Institute of American Art, Youngstown, Ohio. *Exhibition.* 1964.

Davis Gallery, New York. *American Painting around 1900.* January 1964.

Junior League of Albuquerque with the University of New Mexico (co-organizers). Art Gallery, University of New

Mexico, Albuquerque. *Impressionism in America.* February 9 – March 14, 1965. Traveled to M. H. de Young Memorial Museum, San Francisco, March 30 – May 5, 1965 (catalogue).

Museum of Modern Art, New York (organizer). *The Eight* (checklist). Traveled to Quincy Art Center, Quincy, Illinois, February 23 – March 25, 1964; Columbia Museum of Art, South Carolina, April 2 – April 23, 1964; Mercer University, Macon, Georgia, May 8 – 29, 1964; Tennessee Fine Arts Center, Nashville, June 15 – July 27, 1964; E. B. Crocker Art Gallery, Sacramento, California, September 6 – 27, 1964; Charles and Emma Frye Art Museum, Seattle, Washington, October 18 – November 8, 1964; Weisman Art Museum, University of Minnesota, Minneapolis, November 23 – December 20, 1964; Centennial Art Museum, Corpus Christi, Texas, January 6 – 27, 1965; Theodore Lyman Wright Art Center, Beloit College, Wisconsin, February 11 – March 3, 1965; State University College, Oswego, New York, April 7 – 28, 1965; Roberson Memorial Center, Binghamton, New York, May 9 – 30, 1965.

City Art Museum, Saint Louis, Missouri. *200 Years of American Painting.* April 1 – May 31, 1964 (catalogue).

Flint Institute of Arts, Michigan. *The Coming of Color.* April 2 – 30, 1964.

The Adult Education Center, Temple B'nai Shalom, Rockville Center, New York. *From the Collection of Whitney Museum of American Art — 5th Annual Art Exhibit.* April 26 – 29, 1964.

Zabriskie Gallery, New York. *New York, New York.* June 2 – 26, 1964.

Brooklyn Museum. *American Painting: Selections from the Collection of Daniel and Rita Fraad.* June 9 – September 25, 1964 (catalogue). Traveled to Addison Gallery of American Art, Phillips Academy, Andover, Massachusetts, October 10 – November 8, 1964.

Long Island Arts Center, Festival of the Arts, Adelphi University, Garden City. *Century of American Art: 1864 – 1964.* July 10 – 26, 1964.

Baltimore Museum of Art. *1914.* October 6 – November 15, 1964 (catalogue).

The American Academy of Arts and Letters, New York. *Robert Henri and His Circle: George Bellows, Arthur B. Davies, William J. Glackens, Ernest Lawson, George Luks, Maurice Prendergast, Everett Shinn, John Sloan, Eugene Speicher.* December 11, 1964 – January 10, 1965. Traveled to Chapellier Galleries, New York, March 12 – April 15, 1965.

1965

University of New Mexico Art Gallery, Albuquerque. *Impressionism in America.* February 9 – March 14, 1965 (catalogue). Traveled to M. H. de Young Memorial Museum, San Francisco, March 30 – May 5, 1965.

Lakeview Center for the Arts and Sciences, Peoria, Illinois. *Two Hundred Years of American Painting.* March 27 – April 28, 1965 (catalogue).

New York State Council on the Arts, New York. *Exhibition at New York State Pavilion at New York World's Fair.* April 1 – October 1965.

Brooklyn Museum. *Herbert A. Goldstone Collection of American Art.* May 15, 1965 – September 12, 1965.

James Prendergast Library, Jamestown, New York. *Exhibition.* October 3 – 10, 1965.

1966

Alfredo Valente Gallery, New York. *Ashcan School.* January 17 – February 17, 1966.

Palm Beach Gallery, Florida. *Exhibition of Paintings from the Whitney's Permanent Collection.* February 1 – 17, 1966.

*City Art Museum, Saint Louis, Missouri. *William Glackens in Retrospect.* November 18 – December 31, 1966 (catalogue, with text by Leslie Katz). Traveled to National Collection

of Fine Arts (now SAAM), Smithsonian Institution, Washington, February 10–April 2, 1967; Whitney Museum of American Art, New York, April 25–June 11, 1967.

McCue, George. "In Retrospect." *St. Louis Post-Dispatch*, November 20, 1966: 24–27.

"Current Exhibitions." *Bulletin of the City Art Museum of St. Louis* 2, no. 4 (November–December 1966): 8–10.

"Painting: A Reporter of Innocence." *Time*, December 2, 1966: Arts.

Young, Mahonri Sharp. "Letter from U.S.A.: William Glackens and Some Other Painters." *Apollo* 85 (1966): 73–74.

Howard, Pamela. "Will Pedantry Spoil Bill Glackens?" *Washington Daily News*, February 10, 1967: 27.

Hudson, Andrew. "The 'Ashcan' Didn't Distract Glackens." *Washington Post*, February 12, 1967: G9.

Getlein, Frank. "Art: Fine Glackens Show at National Collection." *Sunday Star* (DC), February 12, 1967: D3.

"William Glackens' Art at Smithsonian." *Georgetowner*, February 16, 1967: 9.

Ken, Diana. "Glackens in Retrospect." *Villager*, April 27, 1967: 6.

Kramer, Hilton. "Illuminating a Period." *New York Times*, April 30, 1967: D23.

Butler, T. Joseph. "William Glackens Exhibition." *Connoisseur* (October 1967): 133–135.

Root Art Center, Hamilton College, Clinton, New York. New York State Council on the Arts (organizer) and American Federation of Arts (circulation). *Exhibition of American Impressionism.* Opened February 20, 1966.

Finch College Museum of Art, New York. "Galaxy of Ladies." Spring 1966 (catalogue, with text by Barbara Novak).

Corcoran Gallery of Art, Washington. *Past and Present: 250 Years of American Art.* April 15–September 30, 1966 (checklist).

American Federation of the Arts (organizer). *A Century of American Still-Life Painting, 1813–1913.* Traveled from June 1, 1966–November 30, 1967 (catalogue). Traveled to Pomona College Museum of Art, Montgomery Art Center, California, April 30–May 21, 1967.

Whitney Museum of American Art, New York. *Art of the United States.* September 27–November 27, 1966.

Alfredo Valente Gallery, New York. *20th Century American Masters.* October–November 23, 1966.

American Federation of the Arts (organizer). *The Ash Can School.* Traveled to State University College Art Department, Oswego, New York, November 10–December 1, 1966; University of Rochester, New York, January 19–February 9, 1967; Everson Museum of Art, Syracuse, February 23–March 16, 1967; Guild Hall, East Hampton, March 30–April 20, 1967; Staten Island Institute of Arts and Science, New York, May 4–25, 1967; Andrew Dickson White Museum of Art, Cornell University, Ithaca, July 13–August 3, 1967; Hamilton College, Clinton, New York, September 21–October 12, 1967.

Schweitzer Gallery, New York. *All American.* December 1966.

1967

Addison Gallery of American Art, Phillips Academy, Andover, Massachusetts. *Roots and Promise of American Art.* January 10–March 13, 1967.

*Rutgers University Art Gallery, New Brunswick, New Jersey. *The Art of William Glackens.* January 10–February 10, 1967 (catalogue with text by Richard J. Wattenmaker).

National Gallery of Canada, Ottawa. *Ernest Lawson 1873–1939.* January 13–February 5, 1967 (catalogue). Traveled.

Wildenstein Galleries, New York. *Masterpieces of the Corcoran Gallery of Art.* January 28–March 7, 1967.

Alfredo Valente Gallery, New York. *Ashcan School.* Closed February 17, 1967.

Grand Rapids Art Museum, Michigan. *Twentieth Century American Paintings.* April 1–30, 1967.

*Kraushaar Galleries, New York. *William Glackens.* May 16–June 3, 1967 (catalogue).

Whitney Museum of American Art, New York. *American Art of the Twentieth Century, Selections from the Permanent Collection.* June 30–September 24, 1967.

Brooklyn Museum, New York. *Summer Exhibition: The Mrs. Albert C. Barnes Bequest.* July 10–August 27, 1967.

Whitney Museum of American Art, New York, organized with New York Cultural Foundation. *The Artist's New York: Special Exhibition—New York Cultural Showcase Festival Fortnight.* October 1–November 5, 1967.

Art Students League, New York (organizer with AFA). *American Masters: Art Students League.* Traveled to Quincy Art Center, Illinois, October 8–29, 1967; Art Students League of New York, November 12–December 3, 1967; School of Fine Arts, Arkansas State College, January 21, 1967–February 12, 1968; Norton Gallery, School of Art, West Palm Beach, Florida, February 25–March 17, 1968; Abilene Fine Arts Museum, Texas, March 31–April 21, 1967; Montgomery Museum of Fine Arts, Alabama, May 5–26, 1968; Laguna Gloria Art Museum, Austin, Texas, June 9–30, 1968; Cummer Gallery of Art, Jacksonville, Florida, August 18–October 13, 1968.

North Carolina Museum of Art, Raleigh. *North Carolina Collects.* October 10–29, 1967 (catalogue).

Brooklyn Museum. *Triumph of Realism.* October 3–November 19, 1967 (catalogue).

1968

Telfair Academy, Savannah. *American Painting.* January 9–February 20, 1968. Traveled to The Society of the Four Arts, Palm Beach, March 1–31, 1968.

Whitney Museum of American Art, New York. *Twenty-Four 20th Century Americans, Selections from the Permanent Collection.* July 2–August 11, 1968.

Saint-Gaudens Memorial, Cornish, New Hampshire. *American Drawing: A Collection from the Addison Gallery.* July 5–August 5, 1968.

Heckscher Museum of Art, Huntington, New York. *The Image in 20th-Century America.* September 13–October 27, 1968.

Perret, George Albert. "Heckscher Exhibit Magnificent." *Suffolk Sun*, September 20, 1968.

Swain School of Design, William W. Crapo Gallery, New Bedford, Massachusetts. *Artist in the City.* October 17–November 22, 1968 (catalogue).

Hirschl and Adler Galleries, New York. *The American Impressionists.* November 12–30, 1968 (catalogue).

Museum of Fine Arts, St. Petersburg, Florida. *Exhibition.* 1968.

1969

Chapellier Galleries, New York. *American Art Selections.* 1969 (catalogue).

*Fort Wayne Art Institute, Fort Wayne, Indiana. *The Art of William Glackens.* March 16–April 13, 1969 (catalogue).

Whitney Museum of American Art, New York. *Selections from the Permanent Collection.* April 17–May 18, 1969.

Museum of Art, Fine Arts Festival, University of Iowa, Iowa City. *Inaugural Exhibition.* May 5–July 15, 1969 (catalogue).

Whitney Museum of American Art, New York. *Seventy Years of American Art, Permanent Collection: Section 1, 1900–1949.* July 3–September 28, 1969.

Lakeview Center for the Arts and Sciences, Peoria, Illinois. *The Eight.* September 12–November 9, 1969.

Whitney Museum of American Art, New York. *American Art: 1900–1949.* September 29–November 4, 1969.

Georgia Museum of Art, University of Georgia, Athens, and The American Federation of Arts (organizers). *A University Collects: Georgia Museum of Art.* Traveled September 1969–October 1970.

City Art Museum of Saint Louis, Missouri. *American Art in St. Louis: Paintings, Watercolors, and Drawings Privately Owned.* October 24–November 30, 1969.

American Bank and Trust Company, New York. *Exhibition.* November 19–December 19, 1969.

1970

Heckscher Museum of Art, Huntington, New York. *Artists of Suffolk County—Part III: The Figurative Tradition.* 1970.

Albany Institute of History and Art, New York. *Paintings by Various Artists.* January–March 1970.

Dallas Museum of Fine Arts, Texas. *The M. P. Potamkin Collection.* January 28–March 8, 1970 (catalogue).

Whitney Museum of American Art, New York. *Selections from the Permanent Collection.* July 10–November 25, 1970.

American Federation of the Arts, New York (organizer). *Selections from the Ferdinand Howald Collection: The Columbus Gallery of Fine Arts* (catalogue). Traveled to the Columbus Gallery of Fine Arts, Ohio, September 1970–June 1971.

1971

Lowe Art Museum, University of Miami, Florida. *French Impressionists Influence American Artists.* March 19–April 25, 1971 (catalogue).

Meredith Long Gallery, Houston, Texas. *Americans at Home and Abroad, 1870–1920.* March 26–April 9, 1971 (catalogue).

Whitney Museum of American Art, New York. *Permanent Collection: 1900–1945.* June 19–October 3, 1971.

National Portrait Gallery, Washington. *Portraits of the American Stage, 1771–1971.* September 10–October 31, 1971 (catalogue).

1972

Delaware Art Museum, Wilmington. *American Painting: 1840–1940.* January 7–February 6, 1972 (catalogue).

Delaware Art Museum, Wilmington. *The "Eight."* February 11–27, 1972.

*National Collection of Fine Arts, Smithsonian Institution, Washington. *Drawings by William Glackens, 1870–1938.* February 25–April 30, 1972 (catalogue).

Forgey, Benjamin. "Drawings in a Show That Defines a Key Historical Moment." *Sunday Star* (DC), February 27, 1972.

Baro, Gene. "Glackens Exhibit." *Washington Post*, February 25, 1972: B13.

Adams Davidson Galleries, Washington. *One Hundred Years of American Painting, 1840–1940.* March 19–April 22, 1972 (catalogue).

Brooklyn Museum. *Century of American Illustration.* March 22–May 14, 1972.

Corcoran Gallery of Art, Washington. *Summer's Lease.* June 13–August 31, 1972.

Georgia Museum of Art, University of Georgia, Athens (organizer). *Selections from the Collection of the Georgia Museum of Art.* Traveled to Charles H. MacNider Museum, Mason City, Iowa, June 29–August 13, 1972; Canton Art Institute, Ohio, August 29–September 24, 1972.

Whitney Museum of American Art, New York. *Selections from the Permanent Collection.* July 30–September, 1972.

Brooklyn Museum. *American Drawings from the Brooklyn Museum Collection.* August 23–November 5, 1972.

Delaware Art Museum, Wilmington. *The Golden Age of American Illustration, 1880–1914.* September 14–October 15, 1972.

Corcoran Gallery of Art, Washington. *Conservation in the Museum.* September 15–October 22, 1972 (checklist, unpublished).

Pennsylvania Academy of the Fine Arts, Philadelphia. *John Sloan.* September 16–October 22, 1972 (catalogue).

Whitney Museum of American Art, New York. *The City as a Source.* November 22, 1972–January 1, 1973.

1973

Allentown Art Museum, Pennsylvania. *The City in American Painting.* January 20–March 4, 1973.

The Metropolitan Museum of Art, New York. *American Impressionist and Realist Paintings & Drawings from the Collection of Mr. and Mrs. Raymond J. Horowitz.* April 19–June 3, 1973 (catalogue).

Canajoharie Library and Art Gallery, New York. *Exhibition of 19th and 20th Century American Art.* June–August 1, 1973.

Museum of Fine Arts, Boston. *Impressionism: French and American.* June 15–October 14, 1973 (catalogue).

National Gallery of Art, Washington. *American Impressionist Painting.* July 1–August 26, 1973 (catalogue). Traveled to Whitney Museum of American Art, New York, September 18–November 2, 1973; Cincinnati Art Museum, December 15, 1973–January 31, 1974; North Carolina Museum of Art, Raleigh, March 8–April 29, 1974.

American Masters Gallery, Los Angeles. *Exhibition of Paintings, Drawings, and Graphics by 20th-century American Realists.* August 1973.

Whitney Museum of American Art, New York. *Selections from the Permanent Collection.* September 14–November 12, 1973.

Community Gallery, Brooklyn Museum. *Children's Christmas Boutique.* November 14, 1973–January 2, 1974.

Tyler Art Gallery, State University of New York, Oswego, New York. *Exhibition.* 1973.

1974

William Rockhill Nelson Gallery of Art and Mary Atkins Museum of Fine Arts, Kansas City, Missouri. *Nineteenth-Century American Painting.* February 17–March 31, 1974.

Virginia Museum of Fine Arts, Richmond (on Artmobile). *The Eight.* June–December 12, 1974.

Parrish Art Museum, Southampton, New York. *The Eight.* August–September 1974.

Adams Davidson Galleries Inc., Washington. *100 Years of American Drawings and Watercolors, 1870–1970.* September–October 1974.

Whitney Museum of American Art, New York. *100 Years of American Genre Painting.* September 18–November 10, 1974 (catalogue). Traveled to Museum of Fine Arts, Houston, as *The Painter's America, Rural and Urban Life, 1810–1910,* December 6, 1974–January 19, 1975; Oakland Museum of California, February 10–March 30, 1975.

Kraushaar Galleries, New York. *People 1920–1940.* September 1974.

1975

Office of the Mayor, City Hall, New York. *The Ash Can School.* April 21–July 7, 1975.

Kraushaar Galleries, New York. *American Water Colors and Drawings.* September 23–October 18, 1975.

Brown, Gordon. "American Water Colors and Drawings." *Arts Magazine* 50 (October 1975): 19.

National Academy of Design, New York. *A Century and a Half of American Art.* October 10–November 30, 1975 (catalogue).

Art Gallery of Ontario, Canada. *Puvis de Chavannes and the Modern Tradition.* October 24–November 30, 1975 (catalogue).

Katonah Gallery, New York. *American Painting 1900–1976: The Beginning of Modernism 1900–1934.* November 1, 1975–January 4, 1976.

The Art Students League, New York. *New York by Artists of the Art Students League of New York in Celebration of the Centennial Year.* November 3, 1975–January 4, 1976 (catalogue).

Weatherspoon Art Gallery, The University of North Carolina at Greensboro. *The Eleventh Annual Art on Paper Exhibition.* November 16–December 14, 1975 (catalogue).

Neuberger Museum of Art, College at Purchase, State University of New York. *American Drawings & Watercolors from the Collection of Susan and Herbert Adler.* November 22, 1975–January 8, 1976 (catalogue).

Pennsylvania Academy of the Fine Arts, Philadelphia (organizer). *Portrait of Young America: A Selection of Paintings in the Collection of the Pennsylvania Academy of the Arts* (catalogue). Traveled to Whitney Museum of American Art, New York, December 11, 1975–February 22, 1976.

1976

Corcoran Gallery of Art, Washington. *Corcoran [The American Genius].* January 24–April 4, 1976.

Utah Museum of Fine Arts, University of Utah, Salt Lake City. *Graphic Styles of the American Eight.* February 29–April 11, 1976 (catalogue).

Chrysler Museum of Art, Norfolk. *Three Hundred Years of American Art in the Chrysler Museum.* March 1–July 4, 1976 (catalogue).

Philadelphia Museum of Art, Pennsylvania. Bicentennial Exhibition, *Philadelphia: Three Centuries of American Art.* April 11–October 10, 1976, (catalogue).

Pennsylvania Academy of the Fine Arts, Philadelphia. *In This Academy: The Pennsylvania Academy of the Fine Arts, 1805–1976.* April 22–December 31, 1976 (catalogue).

Brooklyn Museum (organizer). *Masterpieces of American Painting from the Brooklyn Museum* (catalogue). Traveled to Davis and Long Galleries, New York, April 30–May 29, 1976; Saint Louis Art Museum, Missouri, October 8–November 28, 1976.

Heckscher Museum of Art, Huntington, New York. *Artists of Suffolk County Part X: Recorders of History.* May 9–June 20, 1976.

Allentown Art Museum, Pennsylvania. *The American Flag in the Art of Our Country.* June 14–November 14, 1976 (catalogue).

Montgomery Museum of Fine Arts, Alabama. *American Painting 1900–1939: Selections from the Whitney Museum of American Art.* June 29–August 8, 1976 (catalogue).

Brooklyn Museum. *American Watercolors & Pastels from the Brooklyn Museum Collection.* July 3–September 19, 1976.

Dixon Gallery and Gardens, Memphis, Tennessee. *Mary Cassatt and the American Impressionists.* July 4–August 8, 1976 (catalogue).

Frederick S. Wight Art Gallery, University of California, Los Angeles. *The American Personality, The Artist-Illustrator of Life in the United States, 1860–1930.* October 12–December 12, 1976. Traveled to Amon Carter Museum of Art, Fort Worth, Texas, July 8–August 22, 1976.

The Phillips Collection, Washington. *American Art from the Phillips Collection, Part 2.* September 4–October 24, 1976.

Metropolitan Museum of Manila, Philippines. *American Painting from the Brooklyn Museum.* October 4–31, 1976 (checklist).

Charleston Art Gallery of Sunrise, Charleston, West Virginia. *Bicentennial Exhibition, West Virginia's Artistic Heritage: A Collector's Exhibition.* October 10 – November 30, 1976 (catalogue).

Hirschl and Adler Galleries, Inc., New York. *The American Experience.* October 27 – November 27, 1976.

ACA Galleries, New York. *Ernest Lawson Retrospective.* November 27 – December 24, 1976 (catalogue).

Whitney Museum of American Art, New York. *On Canvas: Selections from the Permanent Collection.* December 7, 1976 – January 8, 1977.

Hammer Galleries, New York. *Impressions of New York City, 1900 – 1976.* 1976 (catalogue).

1977

Brockton Art Center, Massachusetts. *American Pastimes.* January 27 – April 17, 1977 (catalogue).

*Kraushaar Galleries, New York. *Drawings by William Glackens.* February 8 – 26, 1977 (catalogue).

Brown, Gordon. "William Glackens." *Arts Magazine* 51 (April 1977): 42.

Whitney Museum of American Art, New York. *Turn-of-the-Century America: Paintings, Graphics, Photographs, 1890 – 1910.* June 30 – October 2, 1977 (catalogue). Traveled to Saint Louis Art Museum, December 1, 1977 – January 21, 1978; Seattle Art Museum, February 2 – March 12, 1978; Oakland Museum of California, April 4 – May 28, 1978.

Whitney Museum of American Art, New York. *Friends' Collections.* July 27 – October 9, 1977.

Arts Council of Great Britain, London (organizer). *The Modern Spirit: American Painting 1908 – 1935.* Traveled to Royal Scottish Academy, Edinburgh, August 20 – September 11, 1977; Hayward Gallery, London, September 28 – November 20, 1977.

1978

Hood Museum of Art, Dartmouth College, Hanover, New Hampshire. *Portraits at Dartmouth.* March 10 – April 16, 1978 (catalogue, with text by Arthur R. Blumenthal).

Wildenstein & Co. Gallery, New York. *Veronese to Franz Kline: Masterworks from the Chrysler Museum at Norfolk.* April 13 – May 13, 1978 (catalogue).

Corcoran Gallery of Art, Washington. *The William A. Clark Collection.* April 26 – July 16, 1978.

Gibbes Art Gallery, Carolina Art Association, Charleston. *Tradition and Modernism in American Art: 1900 – 1925.* May 25 – June 25, 1978 (catalogue).

ACA Gallery, New York, for the benefit of the Chemotherapy Foundation. *19th and 20th Century Masterpieces in New York Private Collections.* September 26 – October 11, 1978 (catalogue, with text by Dennis Anderson).

Beals, Kathie. "Impressive Art Show Tribute to Collectors." *Herald Statesman, Yonkers,* September 26, 1978: Lifestyles, B1.

Whitney Museum of American Art, New York. *Introduction to 20th Century American Art: Selections from the Permanent Collection.* October 10, 1978 – September 16, 1979.

Corcoran Gallery of Art, Washington. *The Object as Subject.* December 10, 1978 – February 4, 1979.

1979

Sordoni Art Gallery, Wilkes College, Wilkes-Barre, Pennsylvania. *An Exhibition of Paintings by the Eight: Robert Henri, Arthur B. Davies, William Glackens, Ernest Lawson, George Luks, Maurice Prendergast, Everett Shinn, John Sloan.* March 9 – April 1, 1979 (catalogue).

Queens Museum of Art, Flushing, New York. *By the Sea: 20th Century Americans at the Shore.* June 16 – September 9, 1979 (catalogue).

Everson Museum of Art, Syracuse, New York. *Flowers, Gardens, Bouquets in Art.* September – October 1979.

Whitney Museum of American Art, New York. *Tradition and Modernism in American Art, 1900 – 1930.* September 11 – November 11, 1979.

Tacoma Art Museum, Washington. *The American Eight.* November 14 – December 30, 1979 (catalogue).

1980

Henry Art Gallery, University of Washington, Seattle. *American Impressionism.* January 3 – March 2, 1980 (catalogue, with text by William H. Gerdts). Traveled to Frederick S. Wight Gallery, University of California at Los Angeles, March 9 – May 4, 1980; The Terra Museum of American Art, Evanston, Illinois, May 16 – June 22, 1980; The Institute of Contemporary Art, Boston, November 27 – December 4, 1980.

Hughes, Robert. "Art: Charm, Yes; Inspiration, No." *Time,* August 18, 1980: 64.

Heritage Plantation of Sandwich, Massachusetts. *An American Flower Show.* May 9 – October 13, 1980 (catalogue).

Corcoran Gallery of Art, Washington. *That's Entertainment.* June 12 – August 24, 1980.

Whitney Museum of American Art, New York. *The Figurative Tradition and the Whitney Museum of American Art: Paintings and Sculpture from the Permanent Collection.* June 25 – September 28, 1980 (catalogue).

Museum of Fine Arts, Boston. *Americans Outdoors: Painters of Light from Homer to Hassam.* August 12, 1980 – January 1981 (catalogue).

Delaware Museum of Art, Wilmington. *City Life Illustrated, 1890 – 1940: Sloan, Glackens, Luks, Shinn; Their Friends and Followers.* September 7 – November 23, 1980 (catalogue).

Corcoran Gallery of Art, Washington. *Guy Pène du Bois: Artist About Town.* October 10 – November 30, 1980 (catalogue). Traveled to Joslyn Art Museum, Omaha, January 10 – March 1, 1981; Mary and Leigh Block Gallery, Northwestern University, Evanston, Illinois, March 20 – May 10, 1981.

Corcoran Gallery of Art, Washington. *The Common Touch.* October 10, 1980 – January 18, 1981.

New Britain Museum of American Art, Connecticut. *American Drawings: Benjamin West to Ben Shahn: Selections from the Paul Magriel Collection.* November 16, 1980 – January 4, 1981 (catalogue).

1981

Tokyo Metropolitan Art Museum, Japan. *Visions of New York City — American Paintings, Drawings and Prints of the 20th Century.* March 20 – May 24, 1981.

Corcoran Gallery of Art, Washington. *The Artist as Illustrator.* March 31 – June 14, 1981 (checklist).

Grand Central Art Galleries, New York. *New York, New York: Familiar Places/ Old and New.* April 14 – May 8, 1981 (catalogue).

Addison Gallery of American Art, Phillips Academy, Andover, Massachusetts. *Masterworks from the Collection: 50th Anniversary Exhibition.* May 9 – June 14, 1981.

Museum of Fine Arts, Houston, Texas. *Sunlight on Leaves: The Impressionist Tradition.* June 12 – August 16, 1981 (catalogue).

Whitney Museum of American Art at Fairfield County, Stamford, Connecticut. *Pioneering the Century: 1900 – 1940, Selections from the Permanent Collection of the Whitney Museum of American Art. Inaugural Exhibition of Fairfield County Branch.* July 14 – August 26, 1981.

Parrish Art Museum, Southampton, New York. *The Long Island Landscape, 1865 – 1914: The Halcyon Years.* July 26 – September 20, 1981 (catalogue).

The Phillips Collection, Washington. *Appreciations: American Impressionist Paintings and Related Works from The Phillips Collection.* September 12 – November 29, 1981 (catalogue).

Corcoran Gallery of Art, Washington, with SITES. *Of Time and Place: American Figurative Art from the Corcoran Gallery.* September 23 – November 15, 1981 (catalogue). Traveled to Cincinnati Art Museum December 6, 1981 – January 23, 1982; San Diego Museum of Art, February 14 – April 3, 1982; University of Kentucky, Lexington, April 25 – June 12, 1982; Hunter Museum of Art, Chattanooga, July 4 – August 21, 1982; Philbrook Art Center, Tulsa, Oklahoma, September 12 – October 30, 1982; Portland Art Museum, Oregon, November 21, 1982 – January 2, 1983; Des Moines Art Center, January 23 – March 12, 1983; Museum of Fine Arts, St. Petersburg, Florida, April 3 – May 21, 1983.

Santa Barbara Museum of Art. *A Selection of 19th and 20th Century American Drawings from the Collection of Hirschl & Adler Galleries.* October 3 – November 29, 1981 (catalogue).

Minnesota Museum of Art, St. Paul. *American Style: Early Modernist Works in Minnesota Collections.* October 24 – December 27, 1981 (catalogue).

1982

C. W. Post Art Gallery, Long Island University, Greenvale. *A Century of American Impressionism.* January 30 – February 28, 1982 (catalogue).

Whitney Museum of American Art, Downtown Branch, New York. *Lower Manhattan from Street to Sky.* February 23 – April 30, 1982 (catalogue).

Saint Louis Art Museum, Missouri. *Impressionism Reflected: American Art, 1890 – 1920.* May 7 – June 27, 1982.

Parrish Art Museum, Southampton, New York. *The Long Island Landscape, 1914–1946.* June 13–August 1, 1982 (catalogue).

Heckscher Museum of Art, Huntington, New York. *Seven/Eight: Paintings by the Canadian "Group of Seven" and the Americans "The Eight."* June 20–August 1, 1982 (catalogue).

The National Museum of Modern Art, Tokyo. *Japanese Artists Who Studied in the U.S.A. and the American Scene.* July 24–September 5, 1982 (catalogue). Traveled to The National Museum of Modern Art, Kyoto, September 14–October 11, 1982.

*Kraushaar Galleries, New York. *William Glackens: Illustrator.* August–September 17, 1982.

> Russell, John. "Art: When Glackens Illustrated for a Living." *New York Times,* August 13, 1982: Arts.

The Taft Museum, Cincinnati. *The 30's Remembered Part III: Painting and Sculpture.* September 23–December 4, 1982 (catalogue).

Joseph Faulkner Main Street Gallery, Chicago. *Drawings and Watercolors. Degas to Klee.* 1982.

1983

Art Students League, New York. *The Immortal Eight and Its Influence.* January 9–29, 1983 (catalogue).

Whitney Museum of American Art, New York. *The Eight.* January 13–March 20, 1983.

Hirshhorn Museum and Sculpture Garden, Washington. *"The Eight" and the Independent Tradition in American Art.* January 13–March 15, 1983. Traveled to Terra Museum of American Art, Evanston, Illinois, April 1–May 8, 1983.

Canton Art Institute, Ohio (co-organizer). *Impressionism, an American View.* February 20–April 3, 1983. Traveled to The Westmoreland County Museum of Art, Greensburg, Pennsylvania, April 9–May 22, 1983; The Butler Institute of American Art, Youngstown, Ohio, June 5–July 17, 1983.

Delaware Art Museum, Wilmington. *The "Eight."* February 23–March 23, 1983.

Nelson-Atkins Museum of Art, Kansas City, Missouri. *Genre.* April 5–May 15, 1983 (catalogue).

Albany Museum of Art, Georgia. *American Impressionist Paintings from The Phillips Collection.* September 9–October 25, 1983 (checklist).

National Academy of Design, New York. *Artists by Themselves.* November 3, 1983–January 1, 1984 (catalogue). Traveled to National Portrait Gallery, Washington, February 10–March 25, 1984; Everson Museum of Art, Syracuse, May 4–June 17, 1984; Joslyn Art Museum, Omaha, July 7–August 19, 1984; The Ackland Art Museum, University of North Carolina, Chapel Hill, September 1–October 25, 1984; Norton Gallery and School of Art, West Palm Beach, November 1, 1984–January 6, 1985; Los Angeles County Museum of Art, February 7–March 15, 1985; Pinacoteca Ambrosiana, Milan, October 16–December 18, 1987, as *Da Pittore, a pittore*; Galleria degli Uffizi, Florence, April 15, 1988–June 15, 1988.

Hirschl and Adler Galleries, New York. *Realism and Abstraction. Counterpoints in American Drawing 1900–1940.* November 12–December 30, 1983 (catalogue).

1984

Neuberger Museum, City University of New York. *The Artist as Reporter, 1897–1915.* April 8–July, 1984 (catalogue).

International Exhibitions Foundation, Washington (organizer). *Twentieth Century American Drawings: The Figure in Context.* 1984. Traveled to Terra Museum of American Art, Evanston, Illinois, April 29–June 17, 1984; Arkansas Art Center, Little Rock; Oklahoma Museum of Art, Oklahoma City; Toledo Museum of Art; Elvehjem Museum of Art, Madison, Wisconsin; National Academy of Design, New York, March–May 5, 1985 (catalogue, text by Paul Cummings).

Nassau County Museum of Art, Roslyn Harbor, New York. *The Shock of Modernism in America: The Eight and Artists of the Armory Show.* April 29–July 29, 1984 (catalogue).

Westmoreland County Museum of Art, Greensburg, Pennsylvania. *Twenty-Fifth Anniversary Exhibition: Selected American Paintings 1750–1950.* May 18–July 22, 1984 (catalogue).

Cummer Gallery of Art, Jacksonville, Florida. *American Favorites from the Warner Collection of Gulf States Paper Corporation and the David Warner Foundation.* September 16–November 11, 1984.

Phillip Morris Company, New York. *Art of 42d Street.* September 26–November 29, 1984.

Mitchell Museum, Mt. Vernon, Illinois. *Masterworks from the Midwest Museums.* September 29–November 25, 1984 (catalogue).

Art Museum Association of America (organizer). *American Reflections: Paintings 1830–1940: From the Collections of Pomona College and Scripps College.* 1984–1987 (catalogue). Traveled to Tucson Museum of Art, Arizona, December 15, 1984–February 13, 1985.

1985

Nabisco Brands Gallery, East Hanover, New Jersey. *Exhibition.* 1985.

Delaware Art Museum, Wilmington. *William Glackens and His Friends.* January 18–April 21, 1985.

Museum of Art, Carnegie Institute, Pittsburgh. MOA *Masterpieces.* January 29–April 3, 1985.

*Delaware Art Museum, Wilmington. *William Glackens: Painter in New York, 1897–1919.* March 15–April 28, 1985.

*Delaware Art Museum, Wilmington. *William Glackens: Illustrator in New York, 1897–1919.* March 15–April 28, 1985. Traveled to Museum of Art, Pennsylvania State University, College Park, June 30–

September 8, 1985; Hudson River Museum, Yonkers, September 15–November 24, 1985 (catalogue).

> Donohoe, Victoria. "Glackens' Days as Illustrator Are Spotlighted in Delaware." *Philadelphia Inquirer,* March 23, 1985.

> Cope, Penelope Bass. "Capturing Scenes from City Life." *Sunday News Journal* (Wilmington), March 31, 1985: G6.

> Perlman, Bennard. "William Glackens, Illustrator, in Wilmington Exhibit." *Daily Record* (Baltimore), March 1985: 12.

> "Forum: Highlights from Glackens Exhibition and Crafts Anniversary." *Delaware Art Museum Quarterly* 1, no. 2 (Winter 1985).

Museum of Art, Carnegie Institute, Pittsburgh. *American Drawings and Watercolors in the Museum of Art, Carnegie Institute.* Opened Spring 1985. Traveled to Edinburgh, Scotland, August 3–September 21, 1985; Amon Carter Museum, Fort Worth, April 18–June 1, 1986; Huntington Library and Art Gallery, San Marino, California, June 21–August 3, 1986.

Corcoran Gallery of Art, Washington. *Henri's Circle.* April 20–June 16, 1985 (checklist).

Amon Carter Museum, Fort Worth, Texas. American Paintings, Watercolors, and Drawings from the Collection of Rita and Daniel Fraad. May 24–July 14, 1985 (catalogue).

New Britain Museum of American Art, Connecticut. *The Eight: Arthur B. Davies, William Glackens, Robert Henri, Ernest Lawson, George Luks, Maurice Prendergast, Everett Shinn, John Sloan.* September 15–October 27, 1985 (catalogue).

Museums at Stony Brook, New York. *The Long Island Landscape, 1820–1920.* October 10, 1985–April 6, 1986.

*Kraushaar Galleries, New York. *William Glackens (1870–1938).* October 30–November 23, 1985 (brochure).

1986

Delaware Museum of Art, Wilmington (organizer). *The Best of American Illustrations: Selections from the Delaware Art Museum.* Traveled to Terra Museum of American Art, Chicago, January 10–March 2, 1986 (catalogue).

Museum of Art, Rhode Island School of Design, Providence. *The Eden of America: Rhode Island Landscapes, 1820–1920.* January 24–April 27, 1986 (catalogue).

Whitney Museum of American Art at Philip Morris, New York. *Urban Pleasures: New York 1900–1940.* February 7–April 3, 1986.

> Shepard, Richard F. "Art of Living." *New York Times,* February 10, 1986: C17.

Equitable Center, New York, organized by Whitney Museum of American Art. *Twentieth-Century American Art: Highlights of the Permanent Collection.* February 13, 1986–April 15, 1987.

Flint Institute of Arts, Michigan. *Representing America, 1900–1940: Paintings from the Permanent Collection of the Whitney Museum of American Art.* April 27–June 15, 1986 (catalogue).

Brooklyn Museum. *Curator's Choice: Plein-Air Pleasures.* July 9–September 8, 1986 (checklist).

Georgia Museum of Art, University of Georgia, Athens (organizer). *Forty Years of Collecting: American Paintings, Watercolors, and Drawings from the Georgia Museum of Art.* Traveled to Gallery of the Federal Reserve Building, Washington, September 16–November 14, 1986.

Museums at Stony Brook, New York. *The Long Island Landscape: 1820–1920.* October 10–April 6, 1986 (catalogue).

Cummer Gallery of Art, Jacksonville, Florida. *Artistic Transitions: From the Academy*

to Impressionism in American Art: Twenty-Fifth Anniversary Exhibition. October 24, 1986 – January 11, 1987 (catalogue).

1987

Louis Newman Gallery, Beverly Hills, California. *In Black and White: Selected American Drawings and Prints.* 1987.

Addison Gallery of American Art, Phillips Academy, Andover, Massachusetts. *At Work and Play: Selections from the Permanent Collection.* May 15 – July 31, 1987.

Guild Hall Museum, East Hampton, New York. *American Masters: Landscape Paintings from The Phillips Collection.* May 25 – June 28, 1987 (catalogue).

Whitney Museum of American Art at Philip Morris, New York. *The Social Graces, 1905 – 1944.* July 16 – September 24, 1987 (brochure).

Columbus Museum of Art, Ohio (organizer). *A Select View: Paintings from the Columbus Museum.* Traveled to Knoxville Museum of Art, Knoxville, Tennessee, opened September 1987; Madison-Morgan Cultural Center, Madison, Georgia; Museum of the Southwest, Midland, Texas; Paine Art Center and Arboretum, Oshkosh, Wisconsin; The R. W. Morton Art Gallery, Shreveport, Louisiana; Louisiana Arts and Science Center, Baton Rouge, Louisiana; and Brevard Art Center and Museum, Melbourne, Florida, December 17 – January 29, 1989.

Museum of Art, Rhode Island School of Design, Providence. *Whistler to Weidenaar: American Prints, 1870 – 1950: Gifts from the Fazzano Brothers and Other Donors.* September 18 – November 8, 1987 (catalogue).

Lancaster, Mary Jo. "American Painting Evolves In 'A Select View.'" *Orlando Sentinel*, January 1, 1989: Lifestyle.

1988

Sarah Lawrence College Art Gallery, Bronxville, New York. *Personal Places: American Landscapes, 1905 – 1930.* February 16 – April 24, 1988 (catalogue).

Whitney Museum of American Art, New York (organizer). *Twentieth Century American Art.* Traveled to Robert Hull Fleming Museum, University of Vermont, Burlington, March 25 – May 22, 1988; Hunter Museum of Art, Chattanooga, June 12 – August 7, 1988; Phoenix Art Museum, Arizona, August 26 – October 2, 1988.

Dixon Gallery, Memphis. *Exhibition.* April 1988 – February 1989.

Westmoreland Museum of Art, Greensburg, Pennsylvania. *Penn's Promise: Still Life Painting in Pennsylvania, 1798 – 1930.* May 28 – July 31, 1988.

M. H. de Young Memorial Museum, San Francisco. *Viewpoints — The Studied Figure: Tradition and Innovation in American Art Academies, 1865 – 1915.* October 19, 1988 – January 7, 1989.

*Kraushaar Galleries, New York. *Drawings by William Glackens.* December 1, 1988 – January 7, 1989 (catalogue).

"Drawings by William Glackens." *New York Times*, December 9, 1988: C27.

1989

National Gallery of Art, Washington. *American Paintings from the Manoogian Collection.* June 4 – September 4, 1989 (catalogue). Traveled to M. H. de Young Memorial Museum, San Francisco, September 23 – November 26, 1989; The Metropolitan Museum of Art, New York, December 19, 1989 – February 25, 1990; Detroit Institute of Arts, March 27 – May 27, 1990.

Terra Museum of American Art, Chicago. *American Painters in France, 1830 – 1930.* June 14 – September 3, 1989 (catalogue).

Telfair Academy of Arts and Sciences, Savannah, Georgia. *Robert Henri and the Ashcan School.* June 28 – August 13, 1989 (catalogue).

Tampa Museum of Art, Florida. *At the Water's Edge: 19th and 20th Century American Beach Scenes.* December 9, 1989 – March 4, 1990. Traveled to Center for the Arts, Vero Beach, Florida, May 4 – June 17, 1990; Virginia Beach Center for the Arts, Virginia, July 8 – September 2, 1990.

South Bend Art Center, Indiana. *American Master-pieces from the Warner Collection.* December 9, 1989 – February 4, 1990.

1990

Addison Gallery of American Art, Phillips Academy, Andover, Massachusetts. *Boys and Girls, Men and Women.* April 12 – June 10, 1990.

Parrish Art Museum, Southampton, New York. *A Celebration of American Ideals: Paintings from the Brooklyn Museum.* May 27 – July 22, 1990. Traveled to Albright-Knox Gallery, Buffalo, November 16, 1991 – January 5, 1992.

The Phillips Collection, Washington. *Men of the Rebellion: The Eight and Their Associates.* September 22 – November 4, 1990 (catalogue). Traveled to The Society of the Four Arts, Palm Beach, Florida, January 8 – February 7, 1993; Orlando Museum of Art, Florida, March 13 – May 23, 1993; Palmer Museum of Art, Pennsylvania State University, University Park, September 4 – November 7, 1993; Lakeview Museum, Peoria, Illinois, November 27, 1993 – January 30, 1994.

Brooklyn Museum, New York. *The Brooklyn Museum Collection: The Play of the Unmentionable.* An installation by Joseph Kosuth, September 27 – December 31, 1990.

Contemporary Art Society of Milwaukee, Milwaukee Art Museum, Wisconsin. *Third Benefit Art Auction and Exhibition.* October 11 – 27, 1990.

1991

Museum of Art, Fort Lauderdale. *Paintings, Sculpture, and Prints from the Permanent Collection.* Closed January 9, 1991.

*Kraushaar Galleries, New York. *William Glackens: The Formative Years.* May 8 – June 8, 1991 (brochure).

Pennsylvania Academy of the Fine Arts, Philadelphia, with the American Federation of Arts. *Light, Air and Color: American Impressionist Paintings from the Collection of the Pennsylvania Academy of the Fine Arts.* June 8 – April 14, 1991 (catalogue). Traveled to Greenville County Museum of Art, South Carolina, March 24 – May 31, 1992; Orlando Museum of Art, Florida, June 28 – August 23, 1992; Akron Art Museum, Ohio, September 12 – November 8, 1992; Memorial Art Gallery of the University of Rochester, New York, December 13 – February 7, 1993; The Beaverbrook Art Gallery, Fredericton, New Brunswick, March 7 – May 2, 1993; Museum of Art, Huntsville, Alabama, May 30 – July 18, 1993.

Montgomery Museum of Fine Arts, Alabama. *Impressions of America: The Warner Collection of Gulf States Paper Corporation.* June 18 – July 28, 1991.

Milwaukee Art Museum, Wisconsin. *Painters of a New Century: The Eight & American Art.* September 6 – November 3, 1991 (catalogue, with text by Elizabeth Milroy). Traveled to Denver Art Museum, December 7, 1991 – February 16, 1992; National Gallery of Canada, Ottawa, April 16 – June 7, 1992; Brooklyn Museum, New York, June 26 – September 21, 1992.

"Painters of a New Century: The Eight." *On & Off The Wall* (Denver Art Museum), November/December 1991: 4.

Kimmelman, Michael. "A Magnificent Eight, Reveling in Rebellion." *New York Times*, June 26, 1992: Arts.

*Museum of Art, Fort Lauderdale. *Selections from the Glackens Collection.* December 19, 1991 – August 21, 1992 (brochure).

1992

Southern Vermont Arts Center, Manchester Center. *Exhibition.* 1992.

Spanierman Gallery, New York. *The Eight and Their Circle.* January 7 – March 28, 1992.

Museum of Fine Arts, Boston. *European and American Impressionism: Crosscurrents.* February 19 – May 17, 1992 (catalogue).

*Delaware Art Museum, Wilmington. *Focus on William Glackens.* February 24 – May 17, 1992.

Art Services International, Alexandria, Virginia (organizer). *Masterworks of American Impressionism from the Pfeil Collection* (catalogue, with essay by William H. Gerdts). Traveled to The Columbus Museum, Georgia, opened February 1992; The Walters Art Gallery, Baltimore, May – June 14, 1992; National Academy of Design, New York, July 9 – August 30, 1992; The Philbrook Museum of Art, Tulsa, September 20 – November 29, 1992; Phoenix Art Museum, Arizona, December 19 – February 14, 1992; Center for the Fine Arts, Miami, March 6 – May 9 1992; Dixon Gallery and Gardens, Memphis, June 6 – August 8, 1992; Honolulu Academy of Arts, Hawaii, September 2 – October 17, 1993; Birmingham Museum of Art, Alabama, November 6, 1993 – January 2, 1994; Portland Art Museum, Oregon, January 22 – March 20, 1994; Milwaukee Art Museum, Wisconsin, April 9 – June 5, 1994.

Smith, Roberta. "French Impressionism's American Cousins." *New York Times*, August 14, 1992: Arts.

Museum of Art, Fort Lauderdale. *American Paintings: A Promised Gift.* March 6 – August 1992.

Louis Newman Galleries, Beverly Hills, California. *Four American Masters: John Sloan, William Glackens, Gifford Beal, John Koch.* April 2–16, 1992 (catalogue).

Delaware Art Museum, Wilmington. *The Better Half of "The Eight."* May 1– September 13, 1992.

Nassau County Museum of Art, Roslyn Harbor, New York. *An Ode to Gardens and Flowers.* May 10–August 9, 1992.

Brooklyn Museum. *The Eight and Their Circle: Works on Paper.* June 26–September 21, 1992 (brochure).

*Museum of Art, Fort Lauderdale. *Touch of Glackens.* August 28, 1992–January 12, 1993.

Whitney Museum of American Art, New York. *Highlights of the Permanent Collection.* September 9–November 29, 1992.

Addison Gallery of American Art, Phillips Academy, Andover, Massachusetts. *Point of View: Landscapes from the Addison Collection.* October 16– December 20, 1992.

Dixon Gallery and Gardens, Memphis. *Impressions of America.* November 15, 1992–January 24, 1993.

Huntington Museum of Art, West Virginia. *Selected American Paintings from The Daywood Collection.* November 15, 1992–May 8, 1993 (brochure). Traveled to Fleischer Museum, Scottsdale, Arizona, January 5–March 15, 1992; Museum of Art, Fort Lauderdale, April 9–June 7, 1992; Greenville County Museum of Art, South Carolina, July 5–August 16, 1992; Albany Museum of Art, Georgia, September 13– October 25, 1992; Oklahoma City Museum of Art, Oklahoma, June 20–August 1, 1993; Telfair Academy of Arts and Sciences, Savannah, August 24–October 3, 1993; Leigh Yawkey Woodson Art Museum, Wausau, Wisconsin, November 6, 1993–January 2, 1994; Owensboro Museum of Fine Art, Kentucky, January 16–

March 6, 1994; Federal Reserve Bank, Kansas City, Missouri, March 25–May 6, 1994.

*John H. Surovek Gallery, Palm Beach. Special Exhibition of Paintings by William Glackens. December 15, 1992–January 10, 1993 (brochure).

1993

*Delaware Art Museum, Wilmington. *Focus on William Glackens.* January 15–April 25, 1993.

*Museum of Art, Fort Lauderdale. *The Magic of Line: Graphics from the Glackens Collection.* February 12– August 15, 1993.

Nassau County Museum of Art, Roslyn Harbor, New York. *Intimates and Confidants in Art: Husbands, Wives, Lovers and Friends.* February 28–May 23, 1993 (catalogue).

Yale University Art Gallery, New Haven, Connecticut. *A Private View: American Paintings from the Manoogian Collection.* April 3–July 31, 1993 (catalogue). Traveled to Detroit Institute of Arts, September 11–November 14, 1993; High Museum of Art, Atlanta, December 19, 1993– March 6, 1994.

National Museum of American Art, Washington. *American Impressions: Masterworks From American Art Forum Collections, 1875–1935.* March 26–July 5, 1993.

> Berry, Heidi L. "The Successful Collector's Path; From That First Awkward Purchase to a Lifelong Obsession." *Washington Post,* July 1, 1993: Home, T12.

Corcoran Gallery of Art, Washington. *The Century Club Collection.* July 21– September 13, 1993 (checklist).

Georgia Museum of Art, University of Georgia, Athens. *American Impressionism in Georgia Collections.* September 11–November 14, 1993. Traveled to Museum of Fine Arts, St. Petersburg, Florida, December 5, 1993– March 6, 1994; Mint Museum of Art, Charlotte, North

Carolina, April 16–June 19, 1994.

Montclair Museum of Art, Montclair, New Jersey. *300 Years of Art in America: Masterworks from the Montclair Art Museum.* September 1993– July 1994.

Whitney Museum of American Art, New York. *In a Classical Vein: Works from the Permanent Collection.* October 18, 1993–April 3, 1994.

Owen Gallery, New York. *The Eight.* November 1– December 10, 1993 (catalogue).

Zabriskie Gallery, New York. *Charles Daniel and the Daniel Gallery.* December 22, 1993– February 12, 1994 (catalogue).

1994

*Museum of Art, Fort Lauderdale. *William Glackens: Portrait and Figure Painter.* February 10–July 17, 1994 (checklist).

Museum of Art, Fort Lauderdale. *A Century Ago: Artists Capture the Spanish-American War.* February 10– July 17, 1994 (brochure).

Parrish Art Museum, Southampton, New York. *Modern Meets the Masses.* February 20–April 10, 1994 (catalogue).

Brooklyn Museum (organizer). *New York: A Magnet for Artists.* Traveled to Tokyo Metropolitan Art Museum, Japan, April 15– June 12, 1994 (checklist).

San Jose Museum of Art. *American Art 1900–1940, A History Reconsidered: Selections from the Permanent Collection of the Whitney Museum of American Art.* May 7, 1994–October 29, 1995 (catalogue).

The Metropolitan Museum of Art, New York. *American Impressionism and Realism: The Painting of Modern Life, 1885–1915.* May 10–July 24, 1994 (catalogue). Traveled to Amon Carter Museum, Fort Worth, Texas, August 21– October 30, 1994; Denver Art Museum, December 3, 1994– February 5, 1995; Los Angeles

County Museum of Art, March 12–May 14, 1995.

> Weinberg, H. Barbara. "Impressionists, Realists and the American City." *Antiques Magazine* 145, no. 4 (April 1994): 542–551.

Canton Museum of Art, Ohio. *George Luks: Expressionist Master of Color.* November 25, 1994– January 29, 1995 (catalogue).

1995

*Owen Gallery, New York. *William Glackens: Member of The Eight and American Impressionist.* February 1– March 31, 1995.

Museum of Art, Fort Lauderdale. *Henri's Disciples: William Glackens and John Sloan.* February 10–April 2, 1995 (brochure, with text by Jorge H. Santis).

Musée d'Art Américain, Giverny, France. *Lasting Impressions: American Painters in France, 1865–1915.* April 1–October 31, 1995 (catalogue).

Kraushaar Galleries, New York. *Flower Paintings by William Glackens & Alfred H. Maurer.* May 12–June 16, 1995 (catalogue).

Virginia Museum of Fine Arts, Richmond. *America Around 1900: Impressionism, Realism and Modern Life.* June 12– September 17, 1995. Traveled to Museum of Art, Fort Lauderdale, October 27, 1995– January 14, 1996.

Whitney Museum of American Art, New York. *Views from Abroad: European Perspectives on American Art, Part 1.* June 28– October 18, 1995 (catalogue). Traveled to Stedelijk Museum, Amsterdam, November 17, 1995–January 28, 1996.

> Kimmelman, Michael. "Rethinking Postwar Pigeonholes for Art." *New York Times,* July 7, 1995: Arts.

Whitney Museum of American Art, New York. *America Around 1900.* July 1–September 1, 1995.

National Museum of American Art, Smithsonian Institution, Washington. *Metropolitan Lives: The Ashcan Artists and Their New York, 1897–1917.* November 17, 1995–March 17, 1996 (catalogue, with texts by Rebecca Zurier, Robert W. Snyder, and Virginia M. Mecklenburg). Traveled to The New-York Historical Society, New York, May 1–August 4, 1996.

> Shaw-Eagle, Joanna. "Works of 'Ashcan Artists' Vibrate with Life, Color Despite the Years." *Washington Times,* November 19, 1995.

> Richard, Paul. "'Guts! Guts! Life! Life!' The Brash Ashcan Artists." *Washington Post,* November 24, 1995: D7.

> Bailey, Janet. "The Ashcan School's New York." *Diversion* (December 1995): 147–153.

> Burchard, Frank. "Beauty Out of the Ashes." *Washington Post Weekend,* December 15, 1995.

> Shaw-Eagle, Joanna. "Ashcan Painters Made the Ordinary into Art." *Insight,* January 1–8, 1996.

> "New York Pictures: The Ashcan Artists." *Antiques and Auction News,* February 2, 1996: 24.

> Pomeranz, Judy. "Ashcan Artists Bring Old New York to Life." *Journal,* March 6, 1996.

> Naves, Mario. "Glackens, Sloan & Friends: The Ashcan Artists' New York." *New Criterion* 14, no. 10 (June 1996): 48–50.

> May, Stephen. "Metropolitan Lives: The Ashcan Artists and Their New York." *Antiques and the Arts Weekly,* July 12, 1996: 1, 68–70A.

Brown, Joshua. "A Spectator of Life—A Reverential, Enthusiastic, Emotional Spectator." *American Quarterly* 49, no. 2 (June 1997): 356–384.

Yount, Sylvia. Review of "Metropolitan Lives: The Ashcan Artists and Their New York." *Journal of American History* 84, no. 1 (June 1997): 176–180.

Canton Museum of Art, Ohio. *The Legacy of Cape Ann*. September 9–October 30, 1995 (brochure).

Anne Gary Pannell Center Art Gallery, Sweet Briar College, Virginia. *From the Golden Valley to the Silver Screen: American People and Places, 1820–1945. Selections from the Sweet Briar College Collection*. September 12–November 5, 1995 (catalogue).

*Museum of Art, Fort Lauderdale. *Traces of a Life: The William Glackens Sketchbooks*. October 27, 1995–January 14, 1996 (brochure).

Museum of Art, Fort Lauderdale. *America Around 1900: Impressionism, Realism and Modern Life*. October 27, 1995–January 14, 1996.

Museum of Art, Fort Lauderdale. *Glackens' Circle*. December 8, 1995–May 5, 1996.

1996

Cornell Fine Arts Museum, Rollins College, Winter Park, Florida. *The Independents: The Ashcan School and Their Circle from Florida Collections*. March 9–May 5, 1996 (catalogue, with text by Valerie Ann Leeds).

 Leeds, Valerie Ann. "The Independents: The Ashcan School and Their Circle from Florida Collections." *American Art Review* 8, no. 2 (May 1996): 96–107, 159–160.

Nassau County Museum of Art, Roslyn Harbor, New York. *Town and Country: In Pursuit of Life's Pleasures*. May 12–August 11, 1996.

Pennsylvania Academy of the Fine Arts, Philadelphia. *To Be Modern: American Encounters with Cézanne and Company*. June 14–September 29, 1996 (catalogue).

Whitney Museum of American Art, New York. *NY, NY: City of Ambition. Artists & New York, 1900–1960*. July 3–October 27, 1996.

Jordan-Volpe Gallery, New York. *Masterpieces of American Painting from the Brooklyn Museum*. October 17–December 7, 1996.

1997

Bruce Museum, Greenwich, Connecticut. *Reflections of Taste: American Art from Greenwich Collections*. January–March 30, 1997.

Whitney Museum of American Art, New York. *Works from the Charles Carpenter and Charles Simon Collections*. January 16–March 9, 1997.

 Zimmer, William. "Known Artists, Fresh Work from Private Collections." *New York Times*, March 9, 1997: NY and Region.

Terra Museum of American Art, Chicago. *American Artists and the French Experience*. April 12–August 27, 1997.

Owen Gallery, New York. *The Eight*. April 15–June 14, 1997 (catalogue).

Seattle Art Museum, Washington. *Seattle Collects Paintings: Works in Private Collections*. May 22–September 7, 1997.

Pennsylvania Academy of the Fine Arts, Philadelphia (organizer). *Light, Air and Colour: American Impressionist Paintings from the Collection of the Pennsylvania Academy of the Fine Arts* (catalogue). Traveled to Bermuda National Gallery, Bahamas, September 27, 1997–January 9, 1998.

Terra Museum of American Art, Chicago. *American Artists and the Paris Experience, 1880–1910*. November 22, 1997–March 8, 1998.

*Museum of Art, Fort Lauderdale. *A Gift of Glackens*. December 1996–September 1997.

*Kraushaar Galleries, New York. *At Home Abroad: William Glackens in France (1925–1932)*. November 6–December 6, 1997 (brochure).

1998

Munson-Williams-Proctor Art Institute, Utica, New York (organizer). *Masterworks of American Art from the Munson-Williams-Proctor Institute*. Traveled to Knoxville Museum of Art, Tennessee, February 27–August 23, 1998 (catalogue).

 Schweizer, Paul D. "Masterworks from the Munson-Williams-Proctor." *American Art Review* 10, no. 3 (June 1998): 180.

Museum of Art, Fort Lauderdale. *Glackens: The Story Teller*. May 16–November 25, 1998 (brochure).

Milwaukee Art Museum, Wisconsin. *Making Marks: Drawing in the 20th Century from Picasso to Kiefer*. June 12–August 23, 1998 (catalogue).

Portland Museum of Art, Maine. *Impressions of the Riviera: Monet, Renoir, Matisse and Their Contemporaries*. June 25–October 18, 1998 (catalogue).

Whitney Museum of American Art, New York (organizer). *In the City: Urban Views 1900–1940*. Traveled to Asheville Art Museum, North Carolina, June 26–November 1, 1998; New York State Museum, Albany, May 21–July 11, 1999; Orange County Museum of Art, Newport Beach, October 16, 1999–January 23, 2000; Georgia Museum of Art, Athens, November 11, 2000–January 14, 2001.

Corcoran Gallery of Art, Washington. *The Forty-fifth Biennial: The Corcoran Collects 1907–1998*. July 17–September 29, 1998 (catalogue).

Berry-Hill Galleries, New York. *Ashcan Kids: Children in the Art of Henri, Luks, Glackens, Bellows and Sloan*. December 2, 1998–January 16, 1999 (catalogue, with text by Bruce Weber).

 Glueck, Grace. "Ashcan Kids: Children in the Art of Henri, Luks, Glackens, Bellows and Sloan." *New York Times*, January 8, 1999: Arts.

1999

National Gallery of Art, Washington. *American Impressionism and Realism: The Margaret and Raymond Horowitz Collection*. January 24–May 9, 1999 (catalogue).

Butler Institute of American Art, Youngstown, Ohio (organizer). *From Ship to Shore: Marine Paintings from the Butler Institute of American Art*. Traveled to Sunrise Museums, Charleston, West Virginia, February 7–April 18, 1999; Kalamazoo Institute of Arts, Michigan, May 9–July 4, 1999; Mint Museum, Charlotte, North Carolina, July 25–December 5, 1999; Montgomery Museum of Fine Art, Alabama, January 2–February 27, 2000; Mobile Museum of Art, Alabama, March 12–May 7, 2000; Museums at Stony Brook, New York, May 28–August 6, 2000; Mitchell Art Gallery, Annapolis, Maryland, August 20–October 15, 2000; Muskegon Museum of Art, Michigan, November 5–December 31, 2000; Gibbes Museum of Art, Charleston, South Carolina, January 21–March 18, 2001.

Museum of Fine Arts, St. Petersburg, Florida. *In the American Spirit: Realism and Impressionism from the Lawrence Collection* (catalogue). March 21–June 13, 1999.

Musée d'Art Américain, Giverny, France (organizer). *The City and the Country: American Perspectives, 1870–1920*. April 1–July 15, 1999 (catalogue). Traveled to Terra Museum of American Art, Chicago, December 10, 1999–May 7, 2000 (in modified form).

Whitney Museum of American Art. *The American Century Part I, 1900 to 1950*. April 25–September 20, 1999 (catalogue).

Horsley, Carter B. "The American Century Part I, 1900 to 1950." *City Review*, July 31, 1999: Art/Museums; http://www.thecityreview .com/whitac.html.

Owen Gallery, New York. *American Impressionism: Exhibition of Paintings*. October 20–December 15, 1999 (catalogue).

Des Moines Art Center, Iowa. *A Century of Art on Paper*. December 11, 1999–February 13, 2000 (catalogue).

2000

*Lebanon Valley College, Annville, Pennsylvania. *William Glackens: Works and Progress*. January 13–February 20, 2000 (catalogue).

Albany Museum of Art, Georgia. *Pride in Place: Landscapes by the Eight in Southern Collections* (catalogue, with essay by William H. Gerdts). January 14–March 12, 2000. Traveled to Montgomery Museum of Art, Alabama, April 1–May 13, 2000; Lauren Rogers Museum of Art, Laurel, Mississippi, June 15–August 13, 2000; Cheekwood Museum of Art, Nashville, August 31–October 15, 2000.

 Gerdts, William H. "The Eight in Southern Collections." *American Art Review* 12, no. 4 (August 2000): 162–173.

*Queens Museum of Art, Flushing Meadows, New York. *William Glackens: A Journey from Realism to Impressionism*. February 23–April 30, 2000 (brochure).

 Glueck, Grace. "An Ashcan Rebel Who Turned Back to Renoir." *New York Times*, April 7, 2000: Art Review.

Art Dealers Association of America (organizer), Seventh Regiment Armory, New York. *Twelfth Annual Art Show*. February 24–28, 2000.

 Adams, Rebecca Knapp. "The Art Show: A Preview Look at What Some Top Dealers Are Bringing to the Armory." *Art & Auction* (February 2000): 48–53.

Whitney Museum of American Art, New York. *Highlights from the Permanent Collection: From Hopper to Mid-Century.* February 26, 2000–May 21, 2006.

National Gallery of Art, Washington. *Twentieth-Century Art: The Ebsworth Collection.* March 5–June 11, 2000 (catalogue).

Musée d'Art Américain, Giverny, France. *Waves and Waterways: American Perspectives, 1850–1900.* April 1–October 31, 2000 (catalogue).

Smithsonian American Art Museum, Washington (organizer). *Scenes of American Life: Treasures from the Smithsonian American Art Museum.* Traveled to The Bruce Museum of Arts and Science, Greenwich, Connecticut, April 1–May 28, 2000; Tennessee State Museum, Nashville, June 20–August13, 2000; Frye Art Museum, Seattle, June 16–September 9, 2001; Institute of History and Art, Albany, October 13–December 9, 2001; Dayton Art Institute, Ohio, January 12–March 24, 2002; Westmoreland Museum of American Art, Greensburg, Pennsylvania, August 4–October 13, 2002.

Brooklyn Museum and Masahiko Shibata and Braintrust, Inc. (organizers). *French and American Impressionist Works from the Collection of the Brooklyn Museum of Art.* Traveled to the Koriyama City Museum of Art, April 29–June 4, 2000; Hokkaido Asahikawa Museum of Art, June 10–July 16, 2000; Museum of Contemporary Art, Sapporo, July 22–August 27, 2000; Isetan Museum of Art, Tokyo, September 14–October 22, 2000; Matsuza-kaya Art Museum, Nagoya, November 2–26, 2000; Kumamoto Prefectural Museum of Art, December 1–January 21, 2001; Utsonomiya Museum of Art, January 27–March 11, 2001; Daimaru Museum, Umeda-Osaka, March 14–April 8, 2001; Takamatsu City Museum of Art, April 20–May 20, 2001.

Nassau County Museum of Art, Roslyn Harbor, New York. *Dance, Dance, Dance.* June 11–September 17, 2000.

Delatiner, Barbara. "The Guide: Best Bet." *New York Times,* June 11, 2000: NY and Region.

The Metropolitan Museum of Art, New York. *City Life Around the Eight.* August 22, 2000–January14, 2001.

Museum of Art, St. Petersburg, Florida. *An American Palette: Works from the Collection of John and Dolores Beck.* November 12, 2000–January 14, 2001 (catalogue, with text by Valerie Ann Leeds). Traveled to Orlando Museum of Art, Florida, March 16–May 26, 2002.

2001

University of Virginia Art Museum, Charlottesville. *Poetry of the Prosaic: Early 20th Century American Painting.* January 13–March 11, 2001.

Musée d'Art Américain, Giverny, France (organizer). *The Extraordinary and the Everyday: American Perspectives 1820–1920.* April 1–November 30, 2001 (catalogue).

Berry-Hill Galleries, New York. *Homage to the Square: Picturing Washington Square, 1890–1965.* May 23–July 13, 2001 (catalogue).

Snite Museum of Art, University of Notre Dame, Indiana. *William J. Glackens, Painter: A Tribute to C. Richard Hilker, Patron.* June 10–August 5, 2001 (catalogue).

Porter, Dean A. "William Glackens." *American Art Review* 13, no. 4 (August 2001): 158–163.

Fred R. Kline Gallery, Santa Fe, New Mexico. *Selected Master Drawings.* July–September 2001.

Nassau County Museum of Art, Roslyn Harbor, New York. *Old New York and Artists of the Period: 1900–1941.* August 19–November 4, 2001 (catalogue).

Van Gelder, Lawrence. "Footlights: City Scenes." *New York Times,* August 15, 2001: Arts.

Wright State University Art Galleries, Dayton, Ohio, in cooperation with Georgia Museum of Art. *Tracing Vision: Modern Drawings from the Ceseri Collection and the Georgia Museum of Art.* September 12–October 14, 2001. Traveled to Samuel P. Harn Museum of Art, University of Florida, Gainesville, December 17, 2002–February 2, 2003; Jule Collins Smith Museum of Fine Art, Auburn University, Alabama, as *Modern Drawings from the Ceseri Collection,* March 24–May 28, 2006.

Samuel P. Harn Museum of Art, University of Florida, Gaines-ville. *The Swamp: On the Edge of Eden.* September 29, 2000–January 7, 2001 (catalogue). Traveled to Cummer Museum of Art, Jacksonville, February 7–April 15, 2001.

Gomez, Edward M. "Where Exuberant Dreams Often Sink Out of Sight." *New York Times,* April 8, 2001: Arts.

French Regional and American Museums Exchange (organizer). *Made in U.S.A.: American Art 1908–1947, between Nationalism and Internationalism.* Traveled to Musée des Beaux-Arts de Bordeaux, October 1, 2001–December 31, 2001; Musée des Beaux-Arts de Rennes, January 18–March 31, 2002; Musée Fabre, Montpellier, April 12–June 23, 2002.

Owen Gallery, New York. *American Paintings from Private Collections.* October 23–December 15, 2001 (catalogue).

2002

Addison Gallery of American Art, Phillips Academy, Andover, Massachusetts. *Place and Perceptions.* April 16–July 31, 2002.

Woodmere Art Museum, Philadelphia, and Krasdale Galleries, Bronx. *Central High School Alumni Exhibition.* April 14–July 7, 2002 (catalogue).

Emerson Gallery, Hamilton College, Clinton, New York. *Hamilton Collects American Art.* April 19–June 9, 2002 (catalogue).

Frederick R. Weisman Art Museum, Minneapolis. *On the Edge of Your Seat: Popular Theatre and Film in Early 20th-Century American Art.* April 20–August 4, 2002 (catalogue).

Whitney Museum of American Art, New York (organizer). *In the City: Edward Hopper and Urban Realism.* Traveled to Santa Barbara Museum of Art, May 13–September 22, 2002; Samuel P. Harn Museum of Art, Gainesville, Florida, October 15, 2002–January 5, 2003; Fresno Metropolitan Museum of Art, History and Science, California, January 18–March 30, 2003; Utah Museum of Fine Arts, University of Utah, Salt Lake City, May 16–August 24, 2003; Columbia Museum of Art, New York, October 4, 2003–January 18, 2004; Cummer Museum of Art, Jacksonville, February 4, 2004–May 23, 2004.

San Diego Museum of Art, California. *Idol of the Moderns: Pierre-Auguste Renoir and American Painting.* June 29–September 15, 2002. Traveled to El Paso Museum of Art, Texas, November 3, 2002–February 16, 2003 (catalogue).

California Palace of the Legion of Honor and M. H. de Young Memorial Museum, San Francisco (organizers). *American Accents: Visual Culture as History.* Traveled to Mobile Tri-Centennial, Alabama, July 1, 2002–January 5, 2003; Winterthur Museum Garden and Library, Delaware, October 11, 2003–February 1, 2004; Charles M. Avampato Museum, Charleston, West Virginia, February 28–May 30, 2004.

Krasdale Gallery, Bronx, New York. *Eakins to Schamberg; Glackens to Kahn—A Common Bond.* August–September 15, 2002.

Musée d'Art Américain, Giverny, France (organizer). *Paris-New York, Roundtrip. American Modernism in the Making, 1875–1940. Works from the Terra Foundation for the Arts and the Huntington Library, Art Collections and Botanical Gardens.* September 15–November 30, 2002 (catalogue).

Owen Gallery, New York. *The Eight: Arthur B. Davies, William Glackens, Robert Henri, Ernest Lawson, George Luks, Maurice Prendergast, Everett Shinn, John Sloan.* October 23–December 14, 2002 (catalogue).

Bank of Austria Kunstforum, Vienna. *Impressionism: America France Russia.* October 25, 2002–February 23, 2003 (catalogue).

Debra Force Fine Art Gallery, New York. *Images de la France: American Artists in Paris, 1880–1925.* November 1–December 21, 2002 (catalogue).

Palmer Museum of Art, Pennsylvania State University, University Park. *An Endless Panorama of Beauty: Selections from the Jean and Alvin Snowiss Collection of American Art.* November 12, 2002–May 16, 2003 (catalogue).

2003

Adelson Galleries, New York. *Beyond Native Shores: A Widening View of American Art, 1850 to 1975.* April 1–May 10, 2003 (catalogue, with text by Jay Cantor).

Owen Gallery, New York. *American Paintings, Drawings and Sculpture.* April 25–June 21, 2003 (catalogue).

Terra Museum of American Art, Chicago. *American Classics from the Collection.* May 14–June 15, 2003.

The Iris & B. Gerald Cantor Center for Visual Arts, Stanford University, California. *The Changing Garden: Four Centuries of European and American Art.* June 11–September 7, 2003 (catalogue). Traveled to Dixon Art Gallery and Gardens, Memphis, October 19, 2003–January 11, 2004; University of Michigan Museum of Art, Ann Arbor, March 13–May 23, 2004.

The Long Island Museum of American Art, History and Carriages, New York. *Face to*

Face: 200 Years of Figurative Arts on Long Island. June 7 – September 7, 2003.

Corcoran Gallery of Art, Washington. The Impressionist Tradition in America. July 19, 2003 – October 18, 2004 (checklist).

Smith, Roberta. "Washington's Museums Traverse Miles and Eras." New York Times, August 22, 2003: Art Review.

Owen Gallery, New York. The Eight: Robert Henri, Arthur B. Davies, William Glackens, Ernest Lawson, George Luks, Maurice Prendergast, Everett Shinn, John Sloan. October 23 – December 14, 2003 (catalogue).

*Gerald Peters Gallery, New York. William Glackens: American Impressionist. November 20, 2003 – January 3, 2004 (catalogue).

Eckardt, Allison. "William Glackens." Magazine Antiques 164, no. 6 (December 2003): 22.

High Museum of Art, Atlanta. After Whistler: The Artist and His Influence on American Painting. November 22, 2003 – February 8, 2004 (catalogue). Traveled to Detroit Institute of Arts, as American Attitude: Whistler & His Followers, March 14 – June 6, 2004.

*Kraushaar Galleries, New York. William Glackens as Illustrator. December 2 – 31, 2003 (brochure).

Butler Institute of American Art, Youngstown, Ohio (organizer). Treasures from the Butler Institute of American Art. Traveled to Saginaw Art Museum, Michigan, December 11, 2003 – February 29, 2004; Midwest Museum of American Art, Elkhart, Indiana, April 2 – May 30, 2004.

2004

The Columbus Museum, Georgia. Tales from the Easel: American Narrative Paintings from Southeastern Museums, c. 1800 – 1950. February 8 – April 11, 2004. Traveled to Tampa Museum of Art, Florida, April 25 – July 11, 2004; Speed Art Museum, Louisville, September 14 – December 12, 2004; El Paso Museum of Art, Texas, January 16 – April 10, 2005.

Berry-Hill Galleries, New York. French Impressions. May – June 2004 (catalogue).

Portland Museum of Art, Maine. Monet to Matisse, Homer to Hartley: American Masters and Their European Muses. June 24 – October 17, 2004 (catalogue).

Kraushaar Galleries, New York. American Watercolors, 1910 – 1920: Including Oscar Bluemner, Charles Burchfield, Charles Demuth, William Glackens, Maurice Prendergast, Marguerite Zorach, William Zorach and Others. October 1 – October 30, 2004.

Princeton University Art Museum, New Jersey. West to Wesselmann: American Drawings and Watercolors in the Princeton University Art Museum. October 16, 2004 – January 9, 2005 (catalogue, with text by John Wilmerding). Traveled to Musée d'Art Américain, Giverny, France, April 1 – July 3, 2005; High Museum of Art, Atlanta, April 1 – June 25, 2006.

Owen Gallery, New York. American Paintings. October 27 – December 18, 2004 (catalogue).

Corcoran Gallery of Art, Washington. Figuratively Speaking: The Human Form in American Art 1770 – 1950. November 20, 2004 – August 7, 2005 (checklist).

2005

Musée d'Art Américain, Giverny, France (organizer). Passing through Paris: American Artists in France, 1860 – 1930. April 1 – October 31, 2005 (brochure).

The Philadelphia Museum of Art. The Academy Goes Modern. April 30 – October 16, 2005.

Bernard Goldberg Fine Arts, International Fine Art Fair, New York. New York, as They Saw It. May 13 – 18, 2005 (brochure, with text by Avis Berman).

Grand Hotel Gallery, Mackinac Island, Michigan. Summer Leisure in the Gilded Age. May 30 – October 2005.

Spanierman Gallery LLC, New York. Art for the New Collector IV. Online, July 12 – September 10, 2005 (catalogue).

Williams College Museum of Art, Williamstown, Massachusetts. Moving Pictures: American Art and Early Film, 1890 – 1910 (catalogue). July 16 – December 11, 2005. Traveled to Reynolda House Museum of American Art, Winston-Salem, North Carolina, March 24 – July 16, 2006; Grey Art Gallery, New York University, September 13 – December 9, 2006; The Phillips Collection, Washington, February 17 – May 20, 2007.

Corcoran Gallery of Art, Washington. Encouraging American Genius: Master Paintings from the Corcoran Gallery of Art. August 27, 2005 – January 2, 2006 (checklist). Traveled to Museum of Fine Arts, Houston, February 12 – May 7, 2006; Parrish Art Museum, Southampton, New York, June 3 – September 12, 2006; Mint Museum of Art, Charlotte, North Carolina, October 7 – December 31, 2006; John and Mable Ringling Museum of Art, Sarasota, Florida, February 3 – April 29, 2007.

Luce Visible Storage/Study Center, Brooklyn Museum, New York. Crayon Painting: American Pastels, 1890 – 1935. September 21, 2005 – January 8, 2006.

Owen Gallery, Manhattan, New York. The Eight. October 27 – December 18, 2005 (catalogue).

Ayers, Robert. "Reviews: New York 'The Eight' Owen Gallery." ArtNews 105, no. 4 (April 2006): 148.

Berry-Hill Galleries, New York. Paintings of New York: 1800 to 1950. November 15, 2005 – January 28, 2006.

Arkell Museum of Art, Canajoharie, New York (organizer). Selections from the Arkell Museum. Traveled to Hyde Museum of Art, Glens Falls, New York, November 20, 2005 – July 17, 2006.

2006

Brooklyn Museum. Urban Views: Realist Prints and Drawings by Robert Henri and His Circle. January 11 – May 14, 2006.

Vero Beach Museum of Art, Florida. Masters of Light: Selections of American Impressionism from the Manoogian Collection. January 30 – April 23, 2006 (catalogue).

Columbus Museum of Art, Ohio. American Impressionism: Variations on a Theme. February 3 – June 4, 2006 (catalogue).

Brooklyn Museum. Landscapes from the Age of Impressionism. February 3 – May 13, 2007. Traveled to Hangaram Art Museum, Seoul Arts Center, June 2 – September 3, 2006; Busan Museum, Korea, September 9, 2006 – January 7, 2007; John and Mable Ringling Museum of Art, Sarasota, Florida, June 15 – September 16, 2007; North Carolina Museum of Art, Raleigh, October 21, 2007 – January 13, 2008; Virginia Museum of Fine Arts, Richmond, February 15 – May 11, 2008; Denver Art Museum, June 13 – September 7, 2008; Portland Museum of Art, Maine, September 25, 2008 – January 4, 2009; Joslyn Art Museum, Omaha, June 5 – September 12, 2010; The McNay, San Antonio, Texas, October 6, 2010 – January 16, 2011; Crocker Art Museum, Sacramento, June 11 – September 18, 2011.

MacMillan, Kyle. "An Impressionism Show Where the Americans Are the Stars." Denver Post, June 13, 2008: Arts and Entertainment.

Mitchell Museum, Cedarhurst Center for the Arts, Mt. Vernon, Illinois (organizer). Cassatt to Wyeth: American Masterworks from the Cedarhurst Center for the Arts. Traveled to Southern Vermont Art Center, Manchester, July – September 1, 2006; Blanden Memorial Art Museum, Fort Dodge, Iowa, April 7 – July 6, 2007; Mennello Museum of American Art, Orlando, Florida, Spring 2007; Dixon Gallery and Gardens, Memphis, Tennessee, February 3 – April 13, 2008.

Senesac, Joel. "Summer Residency: Vermonters Graced with Exhibits of Well-known Artists." Vermont Guardian, August 11, 2006: Local.

Luce Visible Storage/Study Center Alcove, Brooklyn Museum. First in Line: Preparatory Drawing for Paintings in the Collection. October 18, 2006 – March 25, 2007.

Delaware Art Museum, Wilmington. Nostalgic Journey: American Illustration from the Collection of the Delaware Art Museum. October 28 – December 31, 2006 (catalogue).

Spanierman Gallery LLC, New York. American Paintings, 1850 – 1965. Online, November 16, 2006 (checklist).

2007

Solomon R. Guggenheim Museum, New York (organizer). Art in America: Three Hundred Years of Innovation. Traveled to National Art Museum of China, Beijing, February 10 – April 5, 2007; Shanghai Museum, with the Museum of Contemporary Art, Shanghai, China, April 30 – June 30, 2007; Museo Guggenheim, Bilbao, Spain, October 10, 2007 – April 27, 2008.

Detroit Institute of Arts (organizer). Life's Pleasures: The Ashcan Artists' Brush with Leisure, 1895 – 1925. March 2 – May 25, 2008 (catalogue). Traveled to Frist Center for the Visual Arts, Nashville, August 2 – October 28, 2007; New-York Historical Society, November 18, 2007 – February 10, 2008.

Smithsonian American Art Museum, Smithsonian Institution, Washington. Variations on America: Masterworks from American Art Forum Collections. April 13 – July 29, 2007 (checklist).

Carnegie Museum of Art, Pittsburgh. *Masters of American Drawings and Watercolors: Foundations of the Collection, 1904–1922.* June 16–October 7, 2007 (catalogue).

Musée d'Art Américain, Giverny, France (organizer). *At Leisure: American Paintings.* July 15–October 31, 2007.

The Phillips Collection, Washington. *American Impressionism: Paintings from The Phillips Collection* (catalogue). June 16–September 16, 2007. Traveled to Dixon Gallery and Gardens, Memphis, October 28, 2007–January 6, 2008; Memorial Art Gallery, University of Rochester, New York, April 12–June 15, 2008; Montgomery Museum of Fine Arts, Alabama, July 1–October 15, 2008; Oklahoma City Museum of Art, November 6, 2008–January 18, 2009; The Society of the Four Arts, Palm Beach, Florida, March 13–April 26, 2009; Museum of Fine Arts, Santa Fe, New Mexico, June–early September 2009.

O'Sullivan, Michael. "'Impressionism': The Spirit of America." *Washington Post*, June 29, 2007: WE20.

Owen Gallery, New York. *American Paintings: With a Selection of Works by William Glackens.* Fall 2007 (catalogue).

2008

Vero Beach Museum, Florida. *Face Forward: American Portraits from Sargent to the Present.* February 2–May 25, 2008 (catalogue).

Corcoran Gallery of Art, Washington. *The American Evolution: A History through Art.* March 1–July 27, 2008 (checklist).

Cheekwood Museum of Art, Nashville, Tennessee. *Painters of American Life: The Eight.* March 7–June 15 2008.

Musée d'Art Américain, Giverny, France (organizer). *At Leisure: American Paintings.* April 1–October 31, 2008.

New-York Historical Society, New York. *Drawn by New York: Six Centuries of Watercolors and Drawings at the New-York Historical Society.* September 19, 2008–January 19, 2009.

Moonan, Wendy. "Painting the Town's Vanished Vistas." *New York Times*, November 7, 2008: C35.

Arkell Museum of Art, Canajoharie, New York. *Sleigh Bells, Green Fields, and Falling Leaves: Four Seasons of American Art.* November 1, 2008–February 7, 2009.

Spanierman Gallery, New York. *Works on Paper 2008.* November 20, 2008–January 3, 2009 (catalogue).

ACA Galleries, New York. *Small and Everlasting (1897–2008): Paintings, Drawings, Sculpture.* December 4, 2008–March 31, 2009.

2009

Butler Institute of American Art, Trumbull Branch, Ohio. *Small Masterworks: Butler Collection.* January 25–February 22, 2009.

Davis Gallery, New Britain Museum of American Art, Connecticut. *The Eight and Their Circle: Watercolors, Lithographs, Engravings and Drawings.* March 6–May 24, 2009.

New Britain Museum of American Art, New Britain, Connecticut. *The Eight and American Modernisms.* March 6–May 24, 2009 (catalogue). Traveled to Milwaukee Museum of Art, Wisconsin, June 6–August 23, 2009.

Genocchio, Benjamin. "The Eight, Divided by 8." *New York Times*, March 29, 2009: Arts Review.

University of Virginia Art Museum, Charlottesville. *American Impressionism and Urban Realism.* March 21–April 24, 2009.

Hollis Taggart Galleries, New York. *Gallery Selections.* April 29–May 29, 2009.

Whitney Museum of American Art, New York. *Modern Life: Edward Hopper and His Time.* October 27, 2010–April 10, 2011 (catalogue). Traveled to Bucerius Kunst Forum, Hamburg, Germany, May 9, 2009–August 30, 2009; Kunsthal Rotterdam, The Netherlands, September 26, 2009–January 17, 2010.

The Metropolitan Museum of Art, New York (organizer). *American Impressionism and Realism: A Landmark Exhibition from the Met.* Traveled to The Queensland Art Gallery, Brisbane, Australia, May 30–September 20, 2009 (catalogue).

Cheekwood Museum of Art, Nashville, Tennessee. *From Washington to Warhol: Americana Redefined.* July 11, 2009–January 3, 2010.

Spanierman Gallery LLC, New York. *Ashcan School Paintings and Drawings.* Online September 2009 (checklist).

The Metropolitan Museum of Art, New York. *American Stories: Paintings of Everyday Life, 1765–1915.* October 12, 2009–January 24, 2010. Traveled to Los Angeles County Museum of Art, California, February 28–May 23, 2010 (catalogue).

2010

Spanierman Gallery LLC, New York. *American Still-Life Paintings (1829–2009).* January 19–February 20, 2010 (brochure, with text by William H. Gerdts).

Galerie Werner, Pittsburgh. Spanierman Gallery LLC, New York (organizer). *Gilded Age to Modern Era Paintings.* February 5–27, 2010.

Cheekwood Museum of Art, Nashville, Tennessee. *The American Impressionists in the Garden.* March 13–Sep. 6, 2010.

Kalamazoo Institute of Arts, Michigan. *Flowers in Art: Selections from the Collection.* May 29–September 12, 2010.

Nassau County Museum of Art, Roslyn Harbor, New York.

The Sea around Us. June 5–September 12, 2010 (catalogue).

Vero Beach Museum of Art, Florida. Connections: *Selections from the Permanent Collection.* June 19–September 26, 2010.

Clay Center for the Arts and Sciences, Spanierman Gallery LLC, New York. *Art, Nature, and the American City, 1840–1955.* July 10–October 10, 2010 (checklist).

Spanierman Gallery LLC, New York. *Summer Selections–2010.* July 22–September 11, 2010 (checklist).

Wadsworth Atheneum Museum of Art, Hartford, Connecticut. *American Moderns on Paper: Masterworks from the Wadsworth Atheneum Museum of Art.* October 2–January 17, 2011 (catalogue). Traveled to Amon Carter Museum, Fort Worth, Texas, February 27–May 30, 2010; Portland Museum of Art, Maine, June 24–September 12, 2010.

Gold, Sylviane. "From Avant-Garde to Resurgent Realism." *New York Times*, October 31, 2010: CT9.

Parrish Art Museum, Southampton, New York. *American Still Life: Treasures from the Parrish Art Museum.* October 10–November 28, 2010.

Earl, Brenda, and Allison Morrow. "Fall Exhibition Features Still Life Treasures From Parrish Collection." *Hamptons Online*, September 29, 2010.

Schwendener, Martha. "Still Life Americana: Beyond Fruit." *New York Times*, November 7, 2010: LI12.

Spanierman Gallery LLC, New York. *In Praise of Women.* October 21–November 20, 2010 (checklist).

San Diego Museum of Art, California (organizer). *Visions of the United States: Selected Paintings from the San Diego Museum of Art.* Traveled to Suzhou Museum, Jiangsu, China. Opened November 2010.

2011

Chrysler Museum of Art, Norfolk, Virginia. *American Masterpieces from the Batten Collection.* January 26–August 31, 2011.

National Gallery, London. *An American Experiment: George Bellows and the Ashcan Painters.* March 3–May 30, 2011 (catalogue, with text by David Peters Corbett).

Whitney Museum of American Art, New York. *Breaking Ground: The Whitney's Founding Collection.* April 28–September 18, 2011 (catalogue).

Brooks Museum of Art, Memphis. *Monet to Cézanne/ Cassatt to Sargent: The Impressionist Revolution.* July 16–October 9, 2011.

2012

Dixon Residence, Dixon Gallery and Gardens, Memphis. *Selections from the Kattner Collection of American Painting.* January 22–May 13, 2012.

Pennsylvania Academy of the Fine Arts, Philadelphia. *PAFA and Dr. Barnes.* April 7–July 8, 2012 (brochure).

Sozanski, Ed. "Barnes at the Pennsylvania Academy: A Scandal in 1923." *Philadelphia Inquirer*, April 15, 2012.

Chronology

EMILY C. WOOD

1870

March 13. William James Glackens is born at 3214 Sansom Street, Philadelphia, to Samuel Glackens, a clerk for the terminal division of the Pennsylvania Railroad, and Elizabeth Cartwright Finn Glackens. William is the youngest of three children. His brother, Louis Maurice Glackens, becomes a well-known illustrator for *Puck*, the *New York World*, and other publications; his sister, Ada, lives at home.

1884

June. Admitted to Central High School, Philadelphia; begins attending in September. John Sloan and Albert C. Barnes are fellow students.

1889

Summer. First trip to Canada.

1890

February. Graduates from Central High School with a Bachelor of Arts degree; presents an address at his commencement. Continues to live with his parents at 2027 Cherry Street through 1893.

1891

March. Works as an artist-reporter for the *Philadelphia Record*. His first published illustration appears March 15. Other illustrations are published elsewhere.

November. Registers as a student at the Pennsylvania Academy of the Fine Arts,

Philadelphia, and attends until November 1894. His instructors are Thomas Anshutz, Carl Newman, Henry Rankin Poore, Henry Thouron, and Robert Vonnoh. Sloan is a classmate, and Glackens also makes friends with fellow students Frederic Gruger, Alice Mumford, Maxfield Parrish, James Preston, Florence Scovel, and May Wilson.

1892

Leaves the *Record* and joins the staff of the *Philadelphia Press*, where Sloan is also working. Meets Edward Davis, George Luks, and Everett Shinn.

May. Participates in his first exhibition, held at the Unity Club in Philadelphia. Goes on sketching expeditions with Sloan and other friends.

December. Sloan introduces him to Robert Henri.

1893

March. With Sloan and others, participates in the Charcoal Club, an informal student group that meets in the evenings to draw from the nude model—a less expensive alternative to the Academy's life class; the club disbands by September.

Fall. Hired away from the *Press* by the *Philadelphia Public Ledger*.

December. Visits Florida with Edward Redfield, returns in January 1894. His first extant paintings, *Philadelphia Landscape* and *Autumn Landscape*, are indicative of his early style.

1894

Occupies a studio at 1717 Chestnut Street, Philadelphia.

March 6. Enters the Academy's student exhibition, which showcases caricatures of works in the *63rd Annual*. Glackens's *Jimmie*, 1894—a parody of James McNeill Whistler's *Chelsea Girl*—receives honorable mention and is auctioned for $2.

March 15. Showcases his newspaper illustrations at the Pen and Pencil Club, Philadelphia.

May. Receives an Academy scholarship for the excellence of his work.

July. Returns to the *Press* to work.

November. Shares his studio with Henri.

December. Participates in his first major exhibition, the *64th Annual* at the Pennsylvania Academy of the Fine Arts; wins an award for his painting *The Brooklyn Bridge*.

1895

Glackens and Henri move to a studio at 1919 Chestnut Street, Philadelphia. First major book illustration published in *Through the Great Campaign with Hastings and His Spellbinders*, by George Nox McCain.

June 8. Sails to France with Henri and other Philadelphia artists on a cattle boat.

July. Cycles through northern France, Belgium, and Holland with Henri and Elmer Schofield to study the Dutch masters.

October. Rents a studio at 6, rue Boissonade, in Montparnasse. Makes sketching trips in Paris, outside the city, and in the forest of Fontainebleau, with Henri and Canadian painter James Wilson Morrice.

1896

April. Exhibits one painting in Paris at the Salon du Champ-de-Mars, organized by the Société nationale des beaux-arts.

October. Returns to Philadelphia and lives at 2027 Cherry Street. Begins

work on *Science* and *Calliope*, two murals for the Pennsylvania Academy's lecture room; they are unveiled in April 1897.

December. Moves permanently to New York City and rents studio once occupied by George Inness in the Holbein Studio Building complex at 139 W. 55th Street. Works as a cartoonist on the New York *Sunday World*; his first comic, *Christmas for the Rich*, appears December 13.

1897

Briefly rents a studio at 26 W. 24th Street, which he shares with George Luks, before returning to 139 W. 55th Street in 1898.

January. Leaves the *World* to become an artist-reporter at the *New York Herald*.

August. His first magazine illustrations, for "Slaves of the Lamp" by Rudyard Kipling, appear in *McClure's Magazine*. Magazine illustrations make up the bulk of Glackens's livelihood for the next fifteen years.

1898

May. Hired by *McClure's Magazine* to report on the American forces fighting the Spanish-American War; embarks with the troops in Tampa, Florida, and follows them into Cuba.

August. Returns to New York after the cease-fire. On the boat home contracts malaria, from which he is never completely cured. Twenty-two of his forty-three drawings are eventually published after the war in *McClure's* and *Munsey's Magazine*. After this assignment, he does not work as an artist-reporter again.

1899

Establishes a career as a magazine illustrator, receiving assignments from *Ainslee's*, *Century*, *Collier's Weekly*, *Harper's Bazar*, *Harper's Weekly*, *McClure's Magazine*, *Munsey's*, and *Scribner's*. Receives his first assignment to illustrate a popular novel, *Santa Claus's Partner*, by Thomas Nelson

Page. Rents a studio at 13 W. 30th Street.

1900

April 15. Exhibits recent drawings published in *Scribner's* at the American Pavilion in the Universal Exposition in Paris. Art critic of the New York *Evening Sun*, Charles FitzGerald, introduces Glackens to Maurice Prendergast.

Summer. Henri introduces Glackens to Van Dearing Perrine. Glackens visits Perrine and joins his Country Sketch Club in Ridgefield, New Jersey; shares a cabin with George O. "Pop" Hart and Maurice Sterne.

1901

Meets fellow artist Edith Dimock through James Preston.

March. Sends painting of Luxembourg Garden to the Country Sketch Club's exhibit at the Art Institute of Chicago.

April. Participates in a group exhibition with Henri, Ernest Fuhr, Alfred Maurer, Sloan, Perrine, and Willard Bertram Price at the Allan Gallery, New York.

May. Receives a gold medal for his drawing *In Town It's Different* at the Pan-American Exposition in Buffalo.

October. Introduces Henri to Maurice Prendergast.

1902

Receives commissions from the *Saturday Evening Post*.

March. Joins the new Society of Associated Illustrators and exhibits in its first annual. Receives a major commission to contribute illustrations to a complete edition of the collected stories of the nineteenth-century French writer Charles Paul de Kock. Fifty-four illustrations in thirteen volumes are published through 1904; at Glackens's invitation, Sloan, Luks, and Preston also participate.

1903

Paints portrait of Charles FitzGerald.

August. Travels with Fuhr to Saint Pierre, off the coast of Newfoundland, to paint and fish.

1904

January 5. Group show organized by Henri at the National Arts Club in New York opens, with Arthur B. Davies, Glackens, Henri, Luks, Maurice Prendergast, and Sloan.

February 16. Marries Edith Dimock at her family's home in West Hartford, Connecticut.

April. Wins a silver medal for *Ballet Girl in Pink* and a bronze medal for illustration at the Louisiana Purchase Exposition in St. Louis.

June. Poses for Henri for a full-length portrait (*Portrait of William J. Glackens*, Sheldon Museum of Art, Lincoln, Nebraska).

Summer. Moves to 3 Washington Square North. Meets Ernest Lawson.

1905

April. Elected as a new member of the Society of American Artists.

November. Receives honorable mention in the *10th Annual Exhibition* at the Carnegie Institute for *At Mouquin's*. The jury includes Thomas Eakins, Robert Henri, and J. Alden Weir.

1906

Carnegie Institute acquires three of Glackens's original illustrations from *Scribner's Magazine*.

April. Becomes an associate member of the National Academy of Design when it merges with the Society of American Artists.

May. The Glackenses travel to Spain and France, visiting Gibraltar, Granada, Seville, and Madrid. They then take a studio apartment at 9, rue Falguière, Paris, with James and May Wilson Preston, and visit Chézy-sur-Marne and Château-Thierry with Alfred Maurer. They travel to London and return to New York from Liverpool at the beginning of October.

1907

Submits two paintings to the spring exhibition of the National Academy, of which Henri was a part of the selection jury; one, *The Sixth Bull*, is accepted.

July 4. Glackens's son, Ira, is born.

1908

February. Davies, Glackens, Henri, Lawson, Luks, Prendergast, Shinn, and Sloan, subsequently known as "The Eight," hold an exhibition at the Macbeth Galleries, New York. More than seven thousand visitors attend; the show travels to Philadelphia, Chicago, Toledo, Detroit, Indianapolis, Cincinnati, Pittsburgh, Bridgeport, Connecticut, and Newark. Glackens summers in Dennis, Massachusetts, on Cape Cod, and shares plein-air painting trips with Prendergast.

Fall. The Glackens family moves to the second floor of 23 Fifth Avenue. William acquires a studio at 50 Washington Square South.

1909

June. The Glackenses travel to New London and then on to Wickford, Rhode Island, near Narragansett Bay, with Everett and Florence Scovel Shinn.

1910

March. Helps organize the first exhibition of the Independents with Henri, Sloan, Davies, Walt Kuhn, and others. Glackens shows *Girl with Apple*. Paints a portrait of Ernest Lawson for the latter's acceptance as an associate member of the National Academy of Design. Summers near Chester, Nova Scotia, on Mahone Bay; he frequently sees Walt and Vera Kuhn, who are vacationing nearby.

1911

Summer. Rents a cottage at Bellport, Long Island, on Great South Bay, and spends the following five summers there. Moves to 29 Washington Square West.

December 19. Association of American Painters and Sculptors holds its first meeting, with Glackens as a charter member; the group's purpose is to organize the Armory Show (formally, the International Exhibition of Modern Art) in 1913.

1912

February. Travels to Paris to buy paintings for Albert Barnes, who has become a successful inventor and wealthy businessman. Reunites with Maurer, who introduces him to Gertrude and Leo Stein.

March. Returns to New York with canvases and works on paper for Barnes by Edgar Degas, Pierre-Auguste Renoir, Paul Cézanne, Vincent van Gogh, Maurer, Pierre Bonnard, Pablo Picasso, Alfred Sisley, and others. His first one-artist show opens at the Madison Art Gallery, New York.

April. Glackens is appointed as chairman of the Committee on Domestic Exhibits for the upcoming Armory Show by its committee president, Arthur B. Davies. Glackens is also consulted by Barnes's lawyer, John G. Johnson, for help in supplementing Johnson's collection with works by French modernists.

1913

February 17. The Armory Show opens in New York.

March. Second one-artist show at the Folsom Gallery, New York. Barnes buys *Race Track* directly from the show. Glackens draws *On Broadway, Near Eighth*, his only contribution to the socialist magazine *The Masses*, for which Sloan was art editor. Illustrates three short stories by Theodore Dreiser for *The Century*, which are later published in the book *A Traveler at Forty*.

December 6. Daughter, Lenna, is born.

December 16. Participates in *Modern American Art*, his first group exhibition at the new Daniel Gallery.

1914

Significantly reduces illustration assignments to devote more time to painting. Old friends Maurice and Charles Prendergast move from Boston to occupy a studio above Glackens's at 50 Washington Square South.

October. Undergoes surgery at Thomas Jefferson Hospital, Philadelphia; Albert and Laura Barnes are in constant attendance and he recuperates at their house.

1915

February. Wins a bronze medal for *At Mouquin's* at the Panama-Pacific International Exposition.

April. Exhibits in the first American Salon of Humorists, patterned after the French precursor, at the Folsom Galleries, New York. Summers at Bellport with Albert and Laura Barnes and Maurice Prendergast.

August 28. Irene Dimock marries Charles FitzGerald at City Hall in Manhattan; Edith and William Glackens are witnesses at the ceremony.

December. The Metropolitan Museum of Art acquires its first works by Glackens, donated by Albert E. Gallatin.

1916

Summer. The Glackenses leave their house at Bellport, Long Island, for a house in Brookhaven to escape a local epidemic of infantile paralysis.

December 5. Society of Independent Artists is founded.

1917

January. First one-artist show at the Daniel Gallery.

February. One-artist show at the Arts Club of Chicago.

April. Elected as the first president of the Society of Independent Artists, modeled after its French counterpart, holding "no jury, no prizes" exhibitions. He exhibits with them from 1917 to 1929 and in 1932, 1939, and 1941.

May. Both of Edith Glackens's parents die, and the Glackens family spends most of the remainder of the year in West Hartford.

November. One-artist show at the Art Students League of New York.

1918

April. Joins a group that forms at the Whitney Studio to create the American Artists' Mutual Aid Society, to help artists affected by WWI. Summers in Pequot, near New London, Connecticut.

October. Appointed to the Committee on Arts and Decoration of the mayor's committee on National Defense to promote allied arts in connection with the war; for this, he paints a mural celebrating Russia at the *Avenue of the Allies*, an outdoor exhibition stationed near the New York Public Library.

1919

February. Illustrates his last story, "On the Beach," by Roy Norton, for *Collier's Weekly*. Buys a house at 10 W. 9th Street. Summers in Gloucester, Massachusetts.

November. Becomes a member of the committee for the Society of American Painters, Sculptors and Gravers: the first exhibition is held at Wildenstein Galleries, New York, and travels to Albright Art Gallery, Buffalo, Detroit Institute of Arts, The Art Institute of Chicago, Saint Louis Art Museum, Denver, Minneapolis, and Cleveland (through 1920).

1920

May. Is included in Gertrude Vanderbilt Whitney's overseas exhibition of American painting, which travels to the Venice Biennial; Grafton Galleries, London; Georges Petit Galleries, Paris; and the Whitney Studio Club, New York (through 1921). Buys a farm in Conway, New Hampshire, and spends summers there through 1924.

1921

January. Included in a group exhibition at the Daniel Gallery with Henri, Lawson, and Prendergast. Throughout the year, exhibits at the Whitney Studio Club, Cleveland Museum of Art, Dallas Art Association, Carnegie Museum of Art, and the Metropolitan Museum of Art, among other venues. Metropolitan Museum of Art purchases *Central Park, Winter*.

1922

January. Exhibits with Max Kuehne in a two-artist show at the Whitney Studio Club.

1923

January. Included in the Toronto Museum of Art's *Exhibition of Contemporary American Art*.

1924

January. Exhibits at the American section of the International Biennial in Rome.

February 1. Maurice Prendergast dies. Glackens receives the Temple Gold Medal at the 119th Annual of the Pennsylvania Academy of the Fine Arts for the painting subsequently known as the *Temple Gold Medal Nude*. Begins the protracted struggle of painting *Breakfast Porch*, 1925; three paintings with this title and numerous studies and sketches exist.

1925

January 10. Serves as one of twenty-four honorary pall-bearers at the funeral of George Bellows, who died January 8.

April. First one-artist show at C. W. Kraushaar Galleries, New York, his primary dealers for seven decades.

May. The Art Institute of Chicago acquires *At Mouquin's*.

June. Work shown at Durand-Ruel Gallery in Paris during the Trinational Exposition, which also travels to London. The Glackens family leaves the United Sates to live in France for an extended period.

Summers first in Paris and then in Samois-sur-Seine; Charles Prendergast stays with them and neighbors are Viette and Leon Kroll. Spends the winter at Les Pivoines, a villa in Vence. The next seven years, the Glackenses spend most of their time abroad, particularly in Paris and its suburbs and in the south of France. Glackens's health begins to deteriorate.

1926

May. Tours Italy: Naples, Pompeii, Sorrento, Rome, Orvieto, Perugia, Siena, Assisi, Florence, and Venice. Spends the summer at L'Isle-Adam, a small town on an island in the Oise River, and the winter at 51, rue de Varenne, Paris.

October. Exhibits in Paris at the Durand-Ruel Gallery and later at the Musée Galliera.

1927

Summers in L'Isle-Adam.

August. Travels to Dublin with his family to visit the FitzGeralds, who have moved to Ireland.

October. Arrives in New York.

December. One-artist show at the Daniel Galleries.

1928

March. Returns to Paris, before his one-artist show opens at Kraushaar Galleries that month. Summers in Vence.

September. Departs from France and arrives in New York in October.

October 24. Davies dies.

1929

January. The Phillips Memorial Gallery in Washington, acquires *Bathers at Bellport*.

May. Returns to Paris; takes house at 110, rue du Bac. Summers at the fishing village Saint-Jean-de-Luz, on the Spanish frontier.

July 12. Henri dies.

October. Wins second prize at the twenty-eighth Carnegie International for *Bathers, Isle Adam*.

November. Returns to Les Pivoines; remains through the winter.

1930

April. Shows *The Promenade* at the Detroit Institute of Art's *Sixteenth Annual Exhibition of American Art*, which the museum purchases.

May. Travels to Paris from Vence via Arles, Nîmes, Orange, Avignon, Aix-en-Provence, and Beaune.

July – August. Summers at Villa des Cytharis in La Ciotat, near Marseille.

August. Sails from Marseilles via Naples, Palermo, Lisbon, and the Azores for New York.

1931

April. One-artist show at Kraushaar Galleries.

Spring. Returns to Paris; summers at Villa des Orangers in Le Suquet, near Cannes.

October. Returns to New York.

November. Whitney Museum of American Art opens to the public; the permanent collection includes *Parade, Washington Square*.

1932

June. Leaves New York for England to visit Irene and Charles FitzGerald, who have moved to Sidmouth, in Devon; spends August and September in Cannes.

November. Returns to New York from Marseilles.

Winter. Visits Lawson in Coral Gables, Florida. Occupies a studio at 62 Washington Square, New York.

1933

January. Wins the Carol H. Beck Gold Medal at the Pennsylvania Academy of the Fine Arts' *128th Annual Exhibition* for *Girl in Black and White*. The Whitney Museum of American Art purchases *Fête du Suquet* from its *First Biennial Exhibition of Contemporary American Paintings*.

February. Exhibits in the College Art Association's *International Exhibition of Contemporary Paintings*, which travels to the Worcester Art Museum and the Cleveland Museum of Art. Elected as a full member of the National Academy of Design.

October 28. Luks dies.

1934

May. Exhibits *Parade, Washington Square* and *Fête du Suquet* in the *Nineteenth International Biennial Art Exhibition* in Venice.

June. Participates in the Art Institute of Chicago's *Century of Progress Exposition* for the 1933 World's Fair held in Chicago.

Summer. Visits Vermont and Baie-Saint-Paul, Canada, near Quebec.

1935

February. Retrospective exhibition held at Kraushaar Galleries. Paints *The Soda Fountain*; Ira Glackens poses for the figure of the soda jerk.

1936

January. Wins the Jennie Sesnan Gold Medal at the Pennsylvania Academy of the Fine Arts for best landscape with *Beach, St. Jean de Luz*.

February. Addison Gallery of American Art in Andover, Massachusetts, organizes a retrospective of his paintings.

May. Visits the FitzGeralds in Sidmouth. Travels to France.

July. Returns to New York from Le Havre; spends rest of summer in Rockport, Maine.

October. Exhibits at the Art Institute of Chicago's *Forty-seventh Annual Exhibition*, and *The Soda Fountain* receives the Norman Wait Harris Bronze Medal. At the Carnegie International's *Thirty-fourth Annual Exhibition*, *Tulips* wins the Allegheny Garden Club prize.

1937

February. Travels to Key Largo, Florida, and visits Lawson.

April. Corcoran Gallery of Art purchases *Luxembourg Gardens* from its *Fifteenth Biennial Exhibition of Contemporary American Artists*.

May. Receives the Grand Prix at the Paris Exposition for *Central Park, Winter*. Summers near Stratford, Connecticut. The Metropolitan Museum of Art purchases *The Green Car*.

1938

January 28. Receives the J. Henry Scheidt Memorial Prize for *Bal Martinique*, exhibited at the *133rd Annual Exhibition* of the Pennsylvania Academy of the Fine Arts.

May 22. Dies suddenly of a cerebral hemorrhage while visiting Charles and Eugenie Prendergast in Westport, Connecticut.

June. Museum of Fine Arts, Boston, acquires *Flying Kites, Montmartre*.

December 14. Memorial exhibition opens at the Whitney Museum of American Art, New York, and travels to the Carnegie Institute, Pittsburgh, in February 1939. A smaller version of the show is circulated by the American Federation of Arts and travels to Chicago, Los Angeles, San Francisco, Saint Louis, Louisville, Kentucky, Cleveland, Washington, DC, and Norfolk, Virginia (until March 1940).

This chronology was adapted and expanded from the chronology by Holly J. Hudson in Gerdts 1996, 264 – 267.

Exhibition Checklist

Dimensions are given in inches followed by centimeters. Height precedes width.

Works of art shown only at specific venues are noted as follows:

MOAFL Museum of Art, Fort Lauderdale
PAM Parrish Art Museum
BF The Barnes Foundation

PAINTINGS

Autumn Landscape, 1893–1895
Oil on canvas
25 × 30 (63.5 × 76.2)
Museum of Art, Fort Lauderdale,
Nova Southeastern University;
Gift of the Sansom Foundation,
94.68
PLATE 6

Bal Bullier, c. 1895
Oil on canvas
23¹³⁄₁₆ × 32 (60.5 × 81.3)
Terra Foundation for American
Art, Chicago, Daniel J. Terra
Collection, 1999.59
PLATE 7

La Villette, c. 1895
Oil on canvas
25 × 30 (63.5 × 76.2)
Carnegie Museum of Art,
Pittsburgh; Patrons Art
Fund, 56.13
PLATE 8

In the Luxembourg, c. 1896
Oil on canvas
16 × 19 (40.6 × 48.3)
Museum of Art, Fort Lauderdale,
Nova Southeastern University;
Bequest of Ira Glackens, 91.40.66
PLATE 9

Outside the Guttenberg Race
Track (New Jersey), 1897
Oil on canvas
25½ × 32 (64.8 × 81.3)
Museum of Art, Fort Lauderdale,
Nova Southeastern University;
Gift of the Sansom Foundation,
94.4
PLATE 27

Hammerstein's Roof Garden,
c. 1901
Oil on canvas
30 × 25 (76.2 × 63.5)
Whitney Museum of American
Art, New York; Purchase, 53.46
PLATE 42
(MOAFL)

Seated Actress with Mirror,
c. 1903
Oil on canvas
48 × 30 (121.9 × 76.2)
Museum of Art, Fort Lauderdale,
Nova Southeastern University;
Gift of the Sansom Foundation,
2013.T3.
PLATE 76

Portrait of Charles FitzGerald,
1903
Oil on canvas
75 × 40 (190.5 × 101.6)
Museum of Art, Fort Lauderdale,
Nova Southeastern University;
Gift of the Sansom Foundation,
92.45
PLATE 29

May Day, Central Park, c. 1904
Oil on canvas
25⅛ × 34¼ (63.8 × 87)
Fine Arts Museums of
San Francisco, Museum
purchase, gift of the Charles E.
Merrill Trust with matching
funds from the M. H. de Young
Museum Society, 70.11
PLATE 31

Portrait of the Artist's Wife, 1904
Oil on canvas
74¾ × 40 (189.9 × 101.6)
Wadsworth Atheneum Museum
of Art, Hartford, CT. Gift of
Ira Glackens in memory of
his mother, the former Edith
Dimock of Hartford, 1876–1955
PLATE 40

Tugboat and Lighter, 1904–1905
Oil on canvas
25 × 30 (63.5 × 76.2)
Museum of Art, Fort Lauderdale,
Nova Southeastern University;
Bequest of Ira Glackens,
91.40.154
PLATE 54

Central Park, Winter, c. 1905
Oil on canvas
25 × 30 (63.5 × 76.2)
Lent by The Metropolitan
Museum of Art, George A.
Hearn Fund, 1921 (21.164)
PLATE 34

The Drive, Central Park, c. 1905
Oil on canvas
25⅜ × 31⅞ (64.5 × 81)
The Cleveland Museum of Art;
Purchase from the J. H. Wade
Fund, 1939.524
PLATE 33

At Mouquin's, 1905
Oil on canvas
48⅛ × 36¼ (122.4 × 92.1)
The Art Institute of Chicago,
Friends of American Art
Collection 1925.295
PLATE 45
(BF)

Chateau Thierry, 1906
Oil on canvas
24 × 32 (61 × 81.3)
The Huntington Library,
Art Collections, and Botanical
Gardens, San Marino, CA,
Gift of the Virginia Steele
Scott Foundation 83.8.19
PLATE 88
(BF)

In the Buen Retiro, 1906
Oil on canvas
25⅝ × 32¼ (65.1 × 81.9)
Ted Slavin Collection
PLATE 32
(BF)

Luxembourg Gardens, 1906
Oil on canvas
23⅞ × 32⅛ (60.6 × 81.6)
Corcoran Gallery of Art,
Washington, Museum
purchase, William A. Clark
Fund 37.1
PLATE 89

Study for "Chateau Thierry," 1906
Oil on panel
6¼ × 8¾ (15.9 × 22.2)
The Huntington Library,
Art Collections, and Botanical
Gardens, San Marino, CA,
Gift of the Virginia Steele
Scott Foundation 83.8.20
PLATE 87
(BF)

View of West Hartford, 1907
Oil on canvas
26⅞ × 32¹⁄₁₆ (68.3 × 81.4)
Wadsworth Atheneum Museum
of Art, Hartford, CT. The Ella
Gallup Sumner and Mary Catlin
Sumner Collection Fund,
1957.243
PLATE 28

The Shoppers, 1907–1908
Oil on canvas
60 × 60 (152.4 × 152.4)
Chrysler Museum of Art,
Norfolk, VA, Gift of Walter P.
Chrysler, Jr., 71.651
PLATE 75
(BF)

Cape Cod Pier, 1908
Oil on canvas
26 × 32 (66 × 81.3)
Museum of Art, Fort Lauderdale,
Nova Southeastern University;
Gift of an Anonymous Donor,
85.74
PLATE 60

Vaudeville Team, c. 1908–1909
Oil on canvas
48 × 36 (121.9 × 91.4)
London Family Collection
PLATE 38

Rock in the Bay, Wickford, 1909
Oil on canvas
26 × 32 (66 × 81.3)
Collection of the New Jersey
State Museum, Trenton;
Museum Purchase, FA1985.34
PLATE 61

Girl with Apple, 1909–1910
Oil on canvas
39⁷⁄₁₆ × 56³⁄₁₆ (100.2 × 142.7)
Brooklyn Museum, Dick S.
Ramsay Fund 56.70
PLATE 50

Breezy Day, Tugboats,
New York Harbor, c. 1910
Oil on canvas
26 × 31¾ (66 × 80.6)
Milwaukee Art Museum,
Gift of Mr. and Mrs. Donald B.
Abert and Mrs. Barbara Abert
Tooman M1974.230
PLATE 55

Street Cleaners, Washington
Square, c. 1910
Oil on canvas
25¼ × 30 (64.1 × 76.2)
The Barnes Foundation,
Philadelphia and Merion, PA,
BF2035
PLATE 35

The Green Car, 1910
Oil on canvas
24 × 32 (61 × 81.3)
Lent by The Metropolitan
Museum of Art, Arthur
Hoppock Hearn Fund, 1937
(37.73)
PLATE 37

Mahone Bay, 1910
Oil on canvas
26⅛ × 31⅞ (66.4 × 81)
Sheldon Museum of Art,
University of Nebraska-Lincoln,
UNL–Anna R. and Frank M.
Hall Charitable Trust H-193
PLATE 51

Washington Square, 1910
Oil on canvas
25 × 30 (63.5 × 76.2)
New Britain Museum of
American Art, New Britain, CT,
Charles F. Smith Fund, 1944.3
PLATE 36

Family Group, 1910/1911
Oil on canvas
71¹⁵⁄₁₆ × 84 (182.8 × 213.3)
National Gallery of Art,
Washington, Gift of Mr. and
Mrs. Ira Glackens 1971.12.1
PLATE 39

Artist's Wife and Son, 1911
Oil on canvas
46 × 36 (116.8 × 91.4)
Permanent Collection, Snite
Museum of Art, University of
Notre Dame, IN: Gift of the
Sansom Foundation 1995.045
PLATE 77

Vacation Home, 1911
Oil on canvas
26 × 32 (66 × 81.3)
Curtis Galleries,
Minneapolis, MN
PLATE 64

Bathers at Bellport, c. 1912
Oil on canvas
25 × 30 (63.5 × 76.2)
The Phillips Collection,
Washington, DC
PLATE 66
(BF)

March Day, Washington
Square, 1912
Oil on canvas
25 × 30 (63.5 × 76.2)
Private collection,
Washington, DC
PLATE 53

Sledding in Central Park, 1912
Oil on canvas
23 × 31½ (58.4 × 31.5)
Museum of Art, Fort Lauderdale,
Nova Southeastern University;
Bequest of Ira Glackens,
91.40.150
PLATE 52

Beach Side, 1912–1913
Oil on canvas
26⅛ × 32 (66.4 × 81.3)
The Nelson-Atkins Museum of
Art, Kansas City, MO (Bequest
of Frances M. Logan) 47-109
PLATE 69

Captain's Pier, 1912–1914
Oil on canvas
25⅛ × 30⅛ (63.8 × 76.5)
Bowdoin College Museum of
Art, Brunswick, ME, Gift of
Stephen M. Etnier, Honorary
Degree, 1969; 1957.127
PLATE 71

Children Rollerskating,
c. 1912–1914
Oil on canvas
23¾ × 17¹⁵⁄₁₆ (60.3 × 45.6)
Brooklyn Museum, Bequest
of Laura L. Barnes 67.24.1
PLATE 79

After Bathing, Vacation Home,
1913
Oil on canvas
26 × 32 (66 × 81.3)
London Family Collection
PLATE 65

Summer Day, Bellport,
Long Island, 1913
Oil on canvas
26⅜ × 32⅛ (67 × 81.6)
Collection of Cedarhurst Center
for the Arts, Mount Vernon, IL,
Gift of John R. and Eleanor R.
Mitchell, 1973.1.21
PLATE 67

Café Lafayette (Portrait of
Kay Laurell), 1914
Oil on canvas
31¾ × 26 (80.7 × 66)
Collection of Barney A.
Ebsworth
PLATE 46

Girl in Black and White, 1914
Oil on canvas
32 × 26 (83.1 × 66)
Whitney Museum of American
Art, New York; Gift of the
Glackens Family, 38.53
PLATE 78
(MOAFL)

The Little Pier, 1914
Oil on canvas
25 × 30 (63.5 × 76.2)
The Barnes Foundation,
Philadelphia and Merion, PA,
BF497
PLATE 62

At the Beach, c. 1914–1916,
signed 1917
Oil on canvas
18⅛ × 24¹⁄₁₆ (46 × 61.1)
Pennsylvania Academy of the
Fine Arts, Philadelphia,
Edward H. Coates Fund, 1952.6.1
PLATE 70

Jetties at Bellport, c. 1916
Oil on canvas
25 × 30 (63.5 × 76.2)
Collection Albright-Knox Art
Gallery, Buffalo, New York;
Evelyn Rumsey Cary Fund,
1935; 1935:5
PLATE 68

Nude with Draperies, c. 1916
Oil on canvas
30 × 25 (76.2 × 63.5)
Collection of Elaine and Alan
Kolodkin
PLATE 81

Armenian Girl, 1916
Oil on canvas
32 × 26 (81.3 × 66)
The Barnes Foundation,
Philadelphia and Merion, PA,
BF176
PLATE 80

At the Beach, c. 1918
Oil on canvas
25¼ × 30 (64.1 × 76.2)
Collection of The Newark
Museum, Gift of Mrs. Felix
Fuld, 1925; 25.1167
PLATE 72

Artist's Daughter in Chinese
Costume, 1918
Oil on canvas
48 × 30 (121.9 × 76.2)
Museum of Art, Fort Lauderdale,
Nova Southeastern University;
Gift of the Sansom Foundation,
92.28
PLATE 90

Still Life with Roses and Fruit,
c. 1924
Oil on canvas
19⅝ × 23¹⁄₁₆ (49.9 × 58.6)
High Museum of Art, Atlanta,
Purchase with Henry B. Scott
Fund, 57.1
PLATE 98

Flowers on a Garden Chair,
1925
Oil on canvas
20 × 15 (50.8 × 38.1)
Museum of Art, Fort Lauderdale,
Nova Southeastern University;
Bequest of Ira Glackens,
91.40.112
PLATE 103

Study for "Breakfast Porch,"
undated
Oil on canvas
16 × 12 (40.6 × 30.5)
Collection of the Sansom
Foundation, G-072
PLATE 91

Study for "Breakfast Porch,"
undated
Oil on canvas board
15 × 11⅜ (38.1 × 28.9)
Collection of the Sansom
Foundation, G-071
PLATE 92

Breakfast Porch, 1925
Oil on canvas
30 × 25 (76.2 × 63.5)
Museum of Art, Fort Lauderdale,
Nova Southeastern University;
Gift of the Sansom Foundation,
92.30
PLATE 93

Still Life with Three Glasses,
mid-1920s
Oil on canvas
20 × 29 (50.8 × 73.7)
Collection of The Butler
Institute of American Art,
Youngstown, OH. Museum
Purchase 1957; 957-O-111
PLATE 101

The Beach, Isle-Adam,
1926/1927
Oil on canvas
20 × 32 (50.8 × 81.3)
Private collection, Philadelphia
PLATE 94

Bal Martinique, 1928
Oil on canvas
22 × 32 (55.9 × 81.3)
Kraushaar Galleries,
New York
PLATE 95

Beach, St. Jean de Luz, 1929
Oil on canvas
23¾ × 32 (60.3 × 81.3)
Terra Foundation for American
Art, Chicago, Daniel J. Terra
Collection, 1988.8
PLATE 96
(PAM)

Back of Nude, c. 1930s
Oil on canvas
30 × 25 (76.2 × 63.5)
Museum of Art, Fort Lauderdale,
Nova Southeastern University;
Gift of the Sansom Foundation,
92.34
PLATE 49

Hillside near La Ciotat, 1930
Oil on canvas
26 × 32 (66 × 81.3)
John H. Surovek Gallery,
Palm Beach, FL
PLATE 97

Flowers in a Sugar Bowl,
c. 1935
Oil on canvas
15 × 18⅛ (38.1 × 46)
Parrish Art Museum, Water Mill,
New York, Gift of Mr. and Mrs.
Alfred Corning Clark, Clark
Collection, 1958.4.11
PLATE 99

Study for "The Soda Fountain,"
1935
Oil on board
14 × 10 (35.6 × 25.4)
Pennsylvania Academy
of the Fine Arts, Philadelphia,
Gift of the Reverend
Edward M. DePaoli, Priest
of the Archdiocese of
Philadelphia, on behalf
of the Sansom Foundation,
1994.7
PLATE 84

The Soda Fountain, 1935
Oil on canvas
48 × 36 (121.9 × 91.4)
Pennsylvania Academy
of the Fine Arts, Philadelphia,
Joseph E. Temple and
Henry D. Gilpin Funds,
1955.3
PLATE 82

Flowers in a Quimper Pitcher,
c. 1937
Oil on canvas
24 × 18 (61 × 45.7)
Museum of Art, Fort Lauderdale,
Nova Southeastern University;
Bequest of Ira Glackens,
91.40.144
PLATE 102

Bouquet in a Quimper
Pitcher, 1937
Oil on canvas
24 × 18 (61 × 45.7)
London Family Collection
PLATE 100

WORKS ON PAPER

American troops boarding
transport steamer, Spanish-
American War, 1898
Pen and ink, wash, Chinese
white, and crayon
23 × 18⅜ (58.4 × 46.6)
Prints and Photographs
Division, Library of Congress,
Washington, DC, CAI-Glackens
(WJ), no. 17 (C size)
PLATE 10
(BF) (MOAFL)

El Pozo Centra, Santiago,
1898
Pen and ink, wash,
Chinese white, and
crayon
21 × 16⅛ (53.3 × 40.9)
Prints and Photographs
Division, Library of Congress,
Washington, DC, CAI-Glackens
(WJ), no. 13 (C size)
PLATE 13
(MOAFL) (PAM)

Starving refugees from
Santiago congregating
at El Caney, 1898
Pen and ink, wash,
Chinese white, and
crayon
16⅛ × 21 (40.9 × 53.3)
Prints and Photographs
Division, Library of Congress,
Washington, DC, CAI-Glackens
(WJ), no. 2 (B size)
PLATE 14
(BF) (MOAFL)

Fleet of transports
just before the start,
Tampa Bay, June 13, 1898
Wash and graphite
12½ × 18 (31.8 × 45.7)
Prints and Photographs
Division, Library of Congress,
Washington, DC, CAI-Glackens
(WJ), no. 19 (B size)
PLATE 11
(MOAFL) (PAM)

Santiago de Cuba,
July 1898
Pen and ink, wash,
Chinese white, and
crayon
18¼ × 21⅜ (46.4 × 54.3)
Prints and Photographs
Division, Library of Congress,
Washington, DC, CAI-Glackens
(WJ), no. 12 (C size)
PLATE 12
(MOAFL) (PAM)

Surrender of the Spanish
forces to General Shafter,
July 1898
Pen and ink and wash
18¼ × 21 (46.3 × 53.3)
Prints and Photographs
Division, Library of Congress,
Washington, DC, CAI-Glackens
(WJ), no. 15 (C size)
PLATE 15
(BF) (MOAFL)

She wheeled about
and stamped her foot.
"Silence pigs!, she
screamed.," 1899
Charcoal, watercolor, and
opaque gouache on board
9 × 11 (22.9 × 27.9)
Museum of American
Illustration at the Society
of Illustrators, New York;
Gift of Joseph Chapin,
039.002
PLATE 18

Shop Girls, c. 1900
Pastel and watercolor
on illustration board
13⅜ × 14⅜ (34.6 × 36.5)
Lent by The Metropolitan
Museum of Art, Gift of
A. E. Gallatin, 1923 (23.230.1)
PLATE 43
(BF)

Edouard swore, and raved
like a madman. (censored),
1903
Photogravure
3½ × 5½ (8.9 × 14)
Museum of Art, Fort Lauderdale,
Nova Southeastern University;
Bequest of Ira Glackens,
91.40.310.a
PLATE 16

Edouard swore, and raved
like a madman. (published),
1903
Photogravure
3½ × 5½ (8.9 × 14)
Museum of Art, Fort Lauderdale,
Nova Southeastern University;
Bequest of Ira Glackens,
91.40.311
PLATE 17

Graft, 1903
Colored pastel
10 × 8 (25.4 × 20.3)
Museum of Art, Fort Lauderdale,
Nova Southeastern University;
Bequest of Ira Glackens,
91.40.19
PLATE 44

"Papa, carry me—take me
up in your arms.," c. 1904
Pencil, black ink with brush,
and charcoal on heavy
cream paper
12¹¹⁄₁₆ × 10 (30.2 × 25.4)
Corcoran Gallery of Art,
Washington, Gift of
Mrs. William J. Glackens,
wife of the artist, 43.15
PLATE 19
(BF) (PAM)

"Papa, carry me—take me
up in your arms.," 1904
Photogravure
5 × 3½ (12.7 × 8.9)
Museum of Art, Fort Lauderdale,
Nova Southeastern University;
Gift of the Sansom Foundation,
92.145
PLATE 20

Who is this Columbine?, 1904
Etching
9 × 5¾ (22.9 × 14.6)
Delaware Art Museum,
Wilmington, Gift of Helen
Farr Sloan, 1980; 1980-63
PLATE 21

Figure Sketches No. 2,
c. 1905–1910
Chalk
15 × 22¾ (38.1 × 57.8)
Smithsonian American Art
Museum, Washington, DC,
Gift of Mr. and Mrs. Ira
Glackens, 1972.56
PLATE 73

Beach, Coney Island, c. 1907
Illustration crayon, wash,
and Chinese white
22¼ × 29 (56.5 × 73.7)
Arkansas Arts Center
Foundation Collection, Little
Rock: Purchase, Mrs. Frank
Tillar Fund, 1995.040.002
PLATE 59
(MOAFL)

Patriots in the Making, 1907
Charcoal and watercolor
20¼ × 13¾ (51.4 × 34.9)
Collection of Patricia O'Donnell
PLATE 25
(MOAFL)

Afternoon at Coney Island,
c. 1907–1909
Chalk, watercolor, and gouache
14½ × 18⅝ (36.8 × 47.3)
Lent by The Metropolitan
Museum of Art, Gift of A. E.
Gallatin, 1915 (15.152.1)
PLATE 57
(PAM)

Coney Island Beach Scene,
c. 1907–1909
Ink and brush on machine-
made wove paper
8⅞ × 12¾ (21.8 × 32.4)
Corcoran Gallery of Art,
Washington, Gift of Anna
Meade Minnigerode, 1986.41.1
PLATE 58
(BF) (PAM)

Morning at Coney Island,
c. 1907–1909
Pencil, chalk, and wash
8 × 11½ (20.3 × 29.2)
Lent by The Metropolitan
Museum of Art, Bequest of
Charles F. Iklé, 1963 (64.27.8)
PLATE 56
(PAM)

Curb Exchange No. 1, 1907–1910
Carbon pencil, watercolor,
and Chinese white
24⅝ × 19³⁄₁₆ (62.6 × 48.7)
Georgia Museum of Art,
University of Georgia,
Athens; University purchase,
GMOA 1976.3449
PLATE 3

Curb Exchange No. 3, 1907–1910
Gouache and Conté crayon
26½ × 18 (67.3 × 45.7)
Museum of Art, Fort Lauderdale,
Nova Southeastern University;
Gift of the Sansom Foundation,
92.44
PLATE 4

Reclining Female Nude, c. 1910
Sanguine and blue pastels, and
chalk on gray paper laid down
10¹¹⁄₁₆ × 15¾ (27.2 × 40)
Corcoran Gallery of Art,
Washington, Gift of Mrs.
William J. Glackens, wife of
the artist, 48.51
PLATE 48
(BF) (PAM)

Self-Portrait from New York/
Woman with Apple sketchbook
92.59, c. 1910
Charcoal on paper
7½ × 4½ (19.1 × 11.4)
Museum of Art, Fort Lauderdale,
Nova Southeastern University;
Bequest of Ira Glackens, 92.59.a
PLATE 1

Study for "A Spring Morning in
Washington Square, New York,"
undated [1910]
Crayon
23½ × 18 (59.7 × 45.7)
Collection of Gerald and
Pearlann Horowitz
PLATE 23

A Spring Morning in
Washington Square, New York
Collier's Weekly 46, no. 12
(April 16, 1910)
Magazine cover with repro-
duction of illustration by
William Glackens
15 × 10¾ (38.1 × 27.3)
Helen Farr Sloan Library &
Archives, Delaware Art
Museum, Wilmington
L-2013-10
PLATE 22

Far from the Fresh Air Farm:
The crowded city street, with
its dangers and temptations,
is a pitiful makeshift playground
for the children, 1911
Crayon heightened with
watercolor
24½ × 16½ (62.2 × 41.9)
Museum of Art, Fort Lauderdale,
Nova Southeastern University;
Bequest of Ira Glackens,
91.40.152
PLATE 24

Albert C. Barnes, c. 1912
Black Conté crayon on tan
colored, medium thick,
machine-made, wove paper
8¾ × 5½ (22.2 × 14)
Collection of the Violette de
Mazia Foundation 1988.9.1
PLATE 2

Christmas Shoppers,
Madison Square, 1912
Crayon and watercolor
17½ × 31 (44.5 × 78.7)
Museum of Art, Fort Lauderdale,
Nova Southeastern University;
Bequest of Ira Glackens,
91.40.106
PLATE 26

Patrick Joseph went and bought
himself a grocery store on
Monroe Street, 1912
Ink and graphite on board
22½ × 16¼ (57.2 × 41.3)
Collection Brandywine River
Museum, Chadds Ford, Gift of
Jane Collette Willcox, 2003;
2003.2.3
PLATE 30

Washington Square, 1913
Charcoal, pencil, colored
pencil, gouache, and
watercolor
29⅛ × 22⅛ (74 × 56.2)
The Museum of Modern
Art, New York. Gift of Abby
Aldrich Rockefeller, 1940;
138.1940
PLATE 5

Beach Scene, c. 1914
Pastel and chalk
17¼ × 22 (43.8 × 55.9)
Lent by The Metropolitan
Museum of Art, Gift of
A. E. Gallatin, 1915 (15.151)
PLATE 63
(PAM)

Woman on a Sofa, c. 1920
Graphite and charcoal
7⅞ × 4¾ (20 × 12.1)
Museum of Art, Fort Lauderdale,
Nova Southeastern University;
Bequest of Ira Glackens,
91.40.36
PLATE 47

Portrait of Edith, c. 1925
Pastel
10 × 7¼ (25.4 × 18.4)
Museum of Art, Fort Lauderdale,
Nova Southeastern University;
Bequest of Ira Glackens,
91.40.42
PLATE 41

Early Sketch for "The Soda
Fountain," 1935
Graphite on lined paper
5 × 3½ (12.7 × 8.9)
Museum of Art, Fort Lauderdale,
Nova Southeastern University;
Gift of the Sansom Foundation,
92.142
PLATE 83

The Seine at Paris, undated
Charcoal
4¾ × 7 (12.1 × 17.8)
Museum of Art, Fort Lauderdale,
Nova Southeastern University;
Bequest of Ira Glackens,
91.40.167.a
PLATE 86

The Seine at Paris, undated
Drypoint
3 × 5½ (7.6 × 14)
Museum of Art, Fort Lauderdale,
Nova Southeastern University;
Bequest of Ira Glackens,
91.40.167.b
PLATE 85

Untitled (Figure Sketches),
undated
Conté crayon
16¼ × 20¼ (41.3 × 51.4)
Museum of Art, Fort Lauderdale,
Nova Southeastern University;
Gift of the Sansom Foundation,
97.28
PLATE 74

Selected Bibliography

ARCHIVES

AAA Archives of American Art, Smithsonian Institution

BFA Barnes Foundation Archives

JSA John Sloan Archives, Delaware Art Museum, Wilmington

Kraushaar Galleries Archives

PAFA Records, Pennsylvania Academy of the Fine Arts

YCAL Yale Collection of American Literature, Beinecke Rare Book and Manuscript Library, Yale University

Whitney Museum of American Art Archives, Edward and Josephine Hopper Research Collection

BOOKS AND PERIODICALS

"102nd Annual Exhibition" 1907
"102nd Annual Exhibition of the Pennsylvania Academy of the Fine Arts." *Philadelphia Inquirer*, January 20, 1907.

"Academy Bars Noted Artists" 1907
"Academy Bars Noted Artists." *New York Mail*, April 11, 1907.

Allyn and Hawkes 1987
Allyn, Nancy E., and Elizabeth H. Hawkes. *William Glackens: A Catalogue of His Book and Magazine Illustrations.* Exh. cat., Delaware Art Museum. Wilmington, 1987.

"The American Section" 1913
"The American Section. The National Art. An Interview with the Chairman of the Domestic Committee, Wm. J. Glackens." *Arts and Decoration* (March 1913): 159–162.

Armstrong 1899
Armstrong, Regina. "Representative Young Illustrators." *The Art Interchange* 43, no. 5 (November 1899): 109.

Armstrong 1900
Armstrong, Regina. "The New Leaders in American Illustration IV: The Typists: McCarter, Yohn, Glackens, Shinn and Luks." *The Bookman* 11 (May 1900): 244, 247.

"Around the Galleries" 1910
"Around the Galleries." *New York Sun*, April 7, 1910.

"The Art of Making Up" 1912
"The Art of Making Up." *New York Times*, March 17, 1912: 15.

"Art Notes" 1913
"Art Notes: Paintings by William Glackens." *New York Evening Post*, March 8, 1913.

"Art Notes" 1916
"Art Notes and Book Reviews." *Craftsman* 31, no. 2 (November 1916): 201.

"Artists Drop Work" 1908
"Artists Drop Work to Boom Roosevelt." *New York Times*, May 11, 1908.

"At the Daniel" 1916
"At the Daniel Gallery." *American Art News* 14, no. 33 (May 20, 1916): 2.

Babcock 1892
Babcock, N. P. "Of Winter Racing: It Is Practiced Regularly on Only One Track." *Lewiston Evening Journal* (February 26, 1892): 6.

Bailey et al. 2011
Bailey, Colin B., et al. *The World of William Glackens: The C. Richard Hilker Art Lectures.* New York: Sansom Foundation, 2011.

Barnes 1915
Barnes, Albert C. "How to Judge a Painting." *Arts and Decoration* 5, no. 6 (April 1915): 217–220, 246, 248–250.

Barnes 1925
Barnes, Albert C. *The Art in Painting.* Merion, PA: The Barnes Foundation Press, 1925.

Barnes 2000
Barnes, Albert C. *The Art in Painting.* Merion, PA: Barnes Foundation Press, 2000. Reprint of 1937 edition.

Barnes and de Mazia 1939
Barnes, Albert C., and Violette de Mazia. *The Art of Cézanne.* New York: Harcourt, Brace, 1939.

Barth 1980
Barth, Gunther. *City People: The Rise of Modern City Culture in Nineteenth-Century America.* New York: Oxford University Press, 1980.

Baudelaire 1981
Baudelaire, Charles. Translated by P. E. Charvet. *Baudelaire: Selected Writings on Art and Artists.* Cambridge: Cambridge University Press, 1981.

Baury 1911
Baury, Louis. "The Message of Proletaire." *The Bookman* 34, no. 4 (December 1911): 410.

Berman 1988
Berman, Avis. "Artist as Rebel: John Sloan versus the Status Quo." *Smithsonian Magazine* 19, no. 1 (April 1988), 77.

Berman 1990
Berman, Avis. *Rebels on Eighth Street: Juliana Force and the Whitney Museum of American Art.* New York: Atheneum, 1990.

Berman 2005
Berman, Avis. *Edward Hopper's New York.* Petaluma, CA: Pomegranate Communications, 2005.

"The Biggest Exhibition" 1917
"The Biggest Exhibition and, Incidentally, War." *Touchstone* 1 (June 1917): 164–173, 210.

Bigelow 1985
Bigelow, Stephanie S., ed. *Bellport and Brookhaven: A Saga of the Sibling Hamlets at Old Purchase South.* Bellport, NY: Bellport-Brookhaven Historical Society, 1985.

Bishop, Debray, and Rabinow 2011
Bishop, Janet, Cécile Debray, and Rebecca Rabinow, eds. *The Steins Collect.* Exh. cat., San Francisco Museum of Modern Art. New Haven and London: Yale University Press, 2011.

Black and Garland 1975
Black, J. Anderson, and Madge Garland. *A History of Fashion.* New York: William Morrow and Company, 1975.

Bonsal 1898a
Bonsal, Stephen. "The Fight for Santiago: The Account of an Eye-Witness." *McClure's Magazine* 11 (October 1898): 499–518.

Bonsal 1898b
Bonsal, Stephen. "The Night after San Juan: Stories of the Wounded on the Field and in the Hospital." *McClure's Magazine* 12 (December 1898): 118–128.

Brady 1901
Brady, Cyrus Townsend. "A Vaudeville Turn." *Scribner's Magazine* 30 (September 1901): 351–355.

Brown 1967
Brown, Charles H. *The Correspondents' War: Journalists in the Spanish-American War.* New York: Charles Scribner's Sons, 1967.

Breuning 1937
Breuning, Margaret. "Glackens and Schnakenberg." *American Magazine of Art* 30 (February 1937): 17.

Bullard 1968
Bullard, Edgar John III. "John Sloan and the Philadelphia Realists as Illustrators, 1890–1940." Master's thesis, University of California, Los Angeles, 1968.

"The Biggest Exhibition" 1917

Cabot Lodge 1898
Cabot Lodge, Henry. "The Story of the Revolution." *Scribner's Magazine* 23 (April 1898): 395.

Cahan 1899
Cahan, A. "Rabbi Eliezer's Christmas." *Scribner's Magazine* 26, no. 6 (December 1899): 661–668.

Camfield 1987
Camfield, William A. "Marcel Duchamp's *Fountain*: Its History and Aesthetics in the Context of 1917." *Dada/Surrealism* 16 (1987): 64–94.

Carbone 2006
Carbone, Teresa A. *American Paintings in the Brooklyn Museum: Artists Born by 1876.* London: D. Giles, Ltd., 2006.

Catalogue of the First Annual 1917
Catalogue of the First Annual Exhibition of the Society of Independent Artists. New York, 1917.

"Chicago" 1917
"Chicago." *American Art News* 15, no. 21 (March 3, 1917): 6.

Clark 1954
Clark, Eliot. *History of the National Academy of Design, 1825–1953.* New York: Columbia University Press, 1954.

"Class A's Entertainment" 1890
"Class A's Entertainment." *The Mirror* 9, no. 1 (February 1890).

Cloutier 1985
Cloutier, Nicole, et al. *James Wilson Morrice, 1865–1924.* Exh. cat., Montreal Museum of Fine Arts. Montreal, 1985.

Coleman 1989
Coleman, Elizabeth Ann. *The Opulent Era: Fashions of Worth, Doucet and Pingat.* Exh. cat., Brooklyn Museum. New York: Thames and Hudson, 1989.

Coyle 2011
Coyle, Heather Campbell. *Howard Pyle: American Master Rediscovered.* Philadelphia: Penn Press, 2011.

Crane 1899
Crane, Stephen. "Marines Signaling under Fire at Guantanamo." *McClure's Magazine* 12 (February 1899): 332–336.

Davidson 1938
Davidson, Martha. "The Gay Glackens: In Memoriam." *Art News* 37 (December 17, 1938): 22.

Dawson 2002
Dawson, Anne. *Idol of the Moderns: Pierre-Auguste Renoir and American Painting.* Exh. cat., Museum of Art. San Diego, 2002.

D'Souza and McDonough 2006
D'Souza, Aruna, and Tom McDonough. *The Invisible Flâneuse? Gender, Public Space, and Visual Culture in Nineteenth-Century Paris.* Manchester and New York: Manchester University Press, England 2006.

Dearinger 2000
Dearinger, David B., ed. *Rave Reviews: American Art and Its Critics, 1826–1925.* Exh. cat., National Academy of Design. New York, 2000.

DeCasseres 1932
DeCasseres, Benjamin. "Mouquin's." *American Mercury* 25 (March 1932): 366.

De Gregorio 1955
De Gregorio, Vincent J. "The Life and Art of William J. Glackens." PhD diss., Ohio State University, 1955.

De Marley 1980
De Marley, Diana. *Worth: The Father of Haute Couture.* London: Elm Tree Books, 1980.

de Mazia 1971
de Mazia, Violette. "The Case of Glackens vs. Renoir." *Journal of The Art Department* 2 (Fall 1971): 7.

DeShazo 1974
DeShazo, Edith. *Everett Shinn 1876–1953: A Figure in His Time.* New York: Clarkson N. Potter, Inc., 1974.

Dolkart and Lucy 2012
Dolkart, Judith F., and Martha Lucy. *The Barnes Foundation: Masterworks.* New York: Rizzoli USA in association with The Barnes Foundation, 2012.

Dombrowski 2006
Dombrowski, André. "The Emperor's Last Clothes: Cézanne, Fashion and 'l'année terrible.'" *Burlington Magazine* 148, no. 1242 (September 2006): 586–594.

Edmonds 1902
Edmonds, Franklin Spencer. *History of the Central High School of Philadelphia.* Philadelphia: J. B. Lippincott Company, 1902.

"The Eightieth Exhibition" 1905
"The Eightieth Exhibition of the National Academy of Design," *Brush and Pencil* 15, no. 2 (February 1905): 79–80.

Ely 1921
Ely, Catherine Beach. "The Modern Tendency in Lawson, Lever and Glackens." *Art in America* 10 (December 1921): 1332–1343.

Epstein 1999
Epstein, Stacey B. *Alfred H. Maurer: Aestheticism to Modernism.* Exh. cat., Hollis Taggart Galleries. New York, 1999.

Fairman 1993
Fairman, Deborah. "The Landscape of Display: The Ashcan School, Spectacle, and the Staging of Everyday Life." *Prospects* 18 (1993): 211.

Farr Sloan 1967
Farr Sloan, Helen. *American Art Nouveau: The Poster Period of John Sloan.* Lock Haven, Pennsylvania: Hammermill Paper Company, 1967.

Fink 1990
Fink, Lois Marie. *American Art at the Nineteenth-Century Paris Salons.* Cambridge, England: Cambridge University Press, 1990.

[FitzGerald] 1902
[FitzGerald, Charles]. "The Society and the Ten Deserters." *New York Evening Sun,* April 3, 1902.

[FitzGerald] 1903
[FitzGerald, Charles]. "Blunderbuss Illustration." *New York Evening Sun,* April 25, 1903.

[FitzGerald] 1904
[FitzGerald, Charles]. "A Significant Group of Paintings." *New York Evening Sun,* January 23, 1904.

Foshay 1984
Foshay, Ella M. *Reflections of Nature: Flowers in American Art.* Exh. cat., Whitney Museum of American Art. New York: Alfred A. Knopf, 1984.

"Four Painters" 1920
"Four Painters at Daniel Galleries." *American Art News* 18, no. 13 (January 17, 1920): 3.

Frank et al. 1934
Frank, Waldo, et al. *America and Alfred Stieglitz: A Collective Portrait.* New York: The Literary Guild, 1934.

Frank et al. 1979
Frank, Waldo, et al., eds. *America and Alfred Stieglitz: A Collective Portrait.* New York: Aperture, 1979. Reprint of 1934 edition.

Gallatin 1910
Gallatin, Albert E. "The Art of William J. Glackens: A Note." *International Studio* 40 (May 1910): lxviii–lxxi.

Gallatin 1916
Gallatin, Albert E. "William Glackens." *American Magazine of Art* 7, no. 7 (May 1916): 262.

Gambone 2009
Gambone, Robert L. *Life on the Press: The Popular Art and Illustrations of George Benjamin Luks.* Jackson: University Press of Mississippi, 2009.

Geczy and Karminas 2012
Geczy, Adam, and Vicki Karaminas. *Fashion and Art.* London and New York: Berg, 2012.

Gerdts 1994
Gerdts, William H. *Impressionist New York.* New York: Abbeville Press, 1994.

Gerdts 1996
Gerdts, William H. *William Glackens.* New York: Abbeville Press, 1996.

The Gilder 1910
The Gilder. "Palette and Brush: The Independent Artists." *Town Topics,* April 3, 1910, 16.

Glackens 1913
Glackens, William J. "The American Section: The National Art." *Arts and Decoration* 3, no. 5, Special Number (March 1913): 159–164.

Glackens 1957
Glackens, Ira. *William Glackens and the Ashcan Group: The Emergence of Realism in American Art.* New York: Crown Publishers, 1957.

Glackens 1972
Glackens, Ira. "By Way of Background." In *Drawings by William Glackens.* Washington: Smithsonian Institution Press, 1972.

Glackens 1983
Glackens, Ira. *William Glackens and The Eight. The Artists Who Freed American Art,* 2nd ed. New York: Horizon Press, 1983.

Glackens 1990
Glackens, Ira. *William Glackens and The Eight: The Artists Who Freed American Art,* 3rd ed. New York: Writers and Readers Publishing, 1990.

"Glackens's Recent Work" 1912
"Glackens's Recent Work." *American Art News,* March 16, 1912, 2.

"Glackens Art Seen" 1913
"Glackens Art Seen in His Recent Work." *New York Sun,* March 5, 1913.

Gordon 1958
Gordon, John. "Nude With Apple." *Brooklyn Museum Bulletin* 19 (Winter 1958): 6–9.

Gould 1995
Gould, Tony. *A Summer Plague: Polio and Its Survivors.* New Haven: Yale University Press, 1995.

Graham Gallery 1986
Van Dearing Perrine: First Decade on the Palisades (1902–1912). Exh. cat., Graham Gallery. New York, 1986.

Greely 1888
Greely, A. W. *Scribner's Magazine* 3, no. 4 (April 1888): 481–488.

Green 1976
Green, Eleanor. *Maurice Prendergast: Art of Impulse and Color.* Exh. cat., University of Maryland Art Gallery. College Park, MD, 1976.

Greenough et al. 2000
Greenough, Sarah, et al. *Modern Art and America: Alfred Stieglitz and His New York Galleries.* Exh. cat., National Gallery of Art, Washington. Boston: Little, Brown and Company, 2000.

Groom et al. 2012
Groom, Gloria, et al. *Impressionism, Fashion, and Modernity.* Exh. cat., The Art Institute of Chicago. Chicago, 2012.

Hall-Duncan 1979
Hall-Duncan, Nancy. *The History of Fashion Photography.* New York: Alpine Book Company, 1979.

Harris 2003
Harris, Luther S. *Around Washington Square: An Illustrated History of Greenwich Village.* Baltimore and London: Johns Hopkins University Press, 2003.

Haskell 1980
Haskell, Barbara. *Marsden Hartley.* Exh. cat., Whitney Museum of American Art. New York, 1980.

Henri 1910
Henri, Robert. "The Exhibition of Independent Artists." *Craftsman* 18, no. 2 (May 1910): 160.

Henri 1917
Henri, Robert. "'The 'Big Exhibition,' The Artist and the Public." *Touchstone* 1 (June 1917): 174–177, 216.

Henri 1960
Henri, Robert. *The Art Spirit.*
Philadelphia and New York:
J. B. Lippincott Company,
1960. Reprint of 1923 edition.

"The High Jinks" 1916
"The High Jinks of Artistry."
American Art News 14, no. 19
(February 12, 1916): 3.

Hills 1977
Hills, Patricia. *Turn of the
Century America: Paintings,
Graphics, Photographs,
1890–1910.* Exh. cat., Whitney
Museum of American Art.
New York, 1977.

Hoeber 1904
Hoeber, Arthur. "Art and
Artists: A Most Lugubrious
Show at the National Club."
*New York Globe and
Commercial Advertiser,*
January 20, 1904.

Hoeber 1908
Hoeber, Arthur. "Art and
Artists." *New York Globe and
Commercial Advertiser*
(February 5, 1908): 9.

Hoeber 1909
Hoeber, Arthur. "The Winter
Exhibition at the National
Academy of Design."
International Studio 36, no. 144
(February 1909): 135–138.

Hoeber 1910
Hoeber, Arthur. "Art and
Artists." *Globe and Commercial
Advertiser* (April 5, 1910).

Homer 1969
Homer, William Innes.
Robert Henri and His Circle.
Ithaca and London: Cornell
University Press, 1969.

Huneker 1908a
Huneker, James. "Around
the Galleries." *New York Sun,*
January 14, 1908.

[Huneker] 1908b
[Huneker, James]. "Eight
Painters. Second Article."
New York Sun, February 10,
1908.

Huneker 1910
Huneker, James. "Seen in
the World of Art: William
Glackens Shows His Versatility."
New York Sun, December 18,
1910.

Iskin 2007
Iskin, Ruth E. *Modern Women
and Parisian Consumer Culture
in Impressionist Painting.* New
York: Cambridge University
Press, 2007.

James 1968
James, Henry. *The American
Scene.* Bloomington: Indiana
University Press, 1968. Reprint
of 1904 edition.

Kaplan 1995
Kaplan, Katherine. *Flower
Paintings by William Glackens
and Alfred H. Maurer.* Exh.
cat., Kraushaar Galleries. New
York, 1995.

Kelly 1907
Kelly, Myra. "The Wiles of the
Wooer." *McClure's Magazine*
29 (September 1907): 541.

Kennedy et al. 2009
Kennedy, Elizabeth, et al.
ed. *The Eight and American
Modernisms.* Exh. cat., Terra
Foundation for American Art.
Chicago, 2009.

Kirstein 1944
Kirstein, Lincoln. "Battle
Art." *Magazine of Art,* 37
(May 1944): 104.

Kramer 1995
Kramer, Hilton. "Fodder
for a New Canon: Think
Friedman and Glackens."
New York Observer, June 12,
1995: 23.

"Landscapes" 1910
"Landscapes at Arts Club."
American Art News,
February 12, 1910: 6.

Lee 1901
Lee, Gerald Stanley. "Making
the Crowd Beautiful." *Atlantic
Monthly* 87 (1901): 240, 246,
248–249.

Lepape 1911
Lepape, Georges. *Les Chose
de Paul Poiret vues par George
Lepape.* Paris: Maquet for
Paul Poiret, 1911.

L. M. 1913
L. M. "Glackens at Folsom's."
American Art News 11, no. 22
(March 8, 1913): 7.

Lucy and House 2012
Lucy, Martha, and John
House. *Renoir at the Barnes
Foundation.* New Haven and
London: Yale University
Press, 2012.

MacAdam 2011
MacAdam, Barbara J.
*Embracing Elegance, 1885–
1920: American Art from the
Huber Family Collection.*
Exh. cat., Hood Museum of
Art, Dartmouth College.
Hanover, NH, 2011.

MacDonald et al. 2003
MacDonald, Margaret F.,
Susan Grace Galassi, Aileen
Ribero, and Patricia de
Montfort. *Whistler, Women
and Fashion.* New Haven
and London: Yale University
Press, 2003.

Marsh 1922
Marsh, Reginald. "So This Is
That Greenwich Village Where
All Those Queer Artists Live."
Harper's Bazaar (October 1922):
82–83.

Mather 1916
Mather, Frank Jewett. "Some
American Realists." *Arts and
Decoration* 7, no. 1 (November
1916): 13.

Mathews 1990
Mathews, Nancy Mowll.
Maurice Prendergast. Exh.
cat. Williams College Museum
of Art. Munich: Prestel-Verlag,
1990.

May and May 2011
May, Jill P., and Robert E.
May. *Howard Pyle: Imagining
an American School of Art.*
Urbana: University of Illinois
Press, 2011.

McBride 1938
McBride, Henry. "Glackens's
Memorial Exhibition." *New
York Sun,* December 17, 1938.

McCabe 1913
McCabe, Francis R. "Modesty
in Women's Clothes." *Harper's
Weekly,* August 30, 1913: 10–
12.

McCarthy 2013
McCarthy, Laurette. "American
Artists in the Armory Show."
In Stavitsky et al. 1913.

McCormick 1908
McCormick, W. B. "Art Notes
of the Week." *New York Press*
(February 9, 1908): 6.

McDonnell et al. 2002
McDonnell, Patricia, et al.
*On the Edge of Your Seat:
Popular Theater and Film
in Early Twentieth-Century
American Art.* Exh. cat.,
Frederick R. Weisman Art
Museum, University of
Minnesota. New Haven and
London: Yale University
Press, 2002.

McFarland 2005
McFarland, Gerald W. *Inside
Greenwich Village: A New
York City Neighborhood, 1898–
1918.* Amherst: University of
Massachusetts Press, 2005.

Mears 2009
Mears, Patricia. *American
Beauty: Aesthetics and
Innovation in Fashion.* New
Haven and London: Yale
University Press, 2009.

Merceron et al. 2007
Merceron, Dean L. et al.
Lanvin. New York: Rizzoli,
2007.

Merrill et al. 2003
Merrill, Linda, et al. *After
Whistler: The Artist and
His Influence on American
Painting.* Exh. cat., High
Museum of Art, Atlanta.
New Haven and London:
Yale University Press, 2003.

Milroy 1991
Milroy, Elizabeth. *Painters
of a New Century: The Eight
and American Art.* Exh. cat.,
Milwaukee Art Museum.
Milwaukee, 1991.

"Moderns" 1915
"Moderns at the Montross
Gallery." *Arts and Decoration* 5,
no. 7 (May 1915): 286.

Montgomery 1998
Montgomery, Maureen E.
*Displaying Women: Spectacles
of Leisure in Edith Wharton's
New York.* New York and
London: Routledge, 1998.

"Montross Gallery" 1918
"Montross Gallery Summer
Show." *American Art News* 16,
no. 33 (May 25, 1918): 2.

Mott 1962
Mott, Frank Luther. *American
Journalism, A History: 1690–
1960.* New York: Macmillan,
1962.

Myzelev and Potvin 2010
Myzelev, Alla, and John Potvin,
eds. *Fashion, Interior Design
and the Contours of Modern
Identity.* Farnham, Surrey,
England, and Burlington,
Vermont: Ashgate Publishing
Limited, 2010.

"News and Notes" 1913
"News and Notes of the Art
World." *New York Times,*
March 9, 1913.

"Notes" 1911
"Notes: The Pastellists."
Craftsman 19, no. 6 (March
1911), 639.

"Notes of the Studios" 1917
"Notes of the Studios and
Galleries." *Arts and Decora
tion* 7 (February 1917): 199–
200, 212–214, 216.

Notman 1907
Notman, Otis. "Men Who
Make Pictures for Books."
New York Times, February 9,
1907.

Oaklander 1996
Oaklander, Christine I. "Clara
Davidge's Madison Art Gallery:
Sowing the Seed for The
Armory Show." *Archives of
American Art Journal* 34, no.
3/4 (1996): 20–37.

O'Brian 1999
O'Brian, John. *Ruthless
Hedonism: The American
Reception of Matisse.* Chicago:
University of Chicago Press,
1999.

O'Connor 1939
O'Connor, John Jr. "The
Glackens Exhibition."
Carnegie Magazine 12
(February 1939): 275.

Pach 1912
Pach, Walter. "États-Unis." *L'Art
et les artistes* 15 (1912): 92.

Peiss 1986
Peiss, Kathy Lee. *Cheap Amuse-
ments: Working Women and
Leisure in Turn-of-the-Century
New York.* Philadelphia: Temple
University Press, 1986.

Pène du Bois 1914a
Pène du Bois, Guy. "A Modern American Collection." *Arts and Decoration* 4, no. 8 (June 1914). 304–306, 325–326.

Pène du Bois 1914b
Pène du Bois, Guy. "William Glackens, Normal Man." *Arts and Decoration* 4 (September 1914), 404, 406.

Pène du Bois 1915
Pène du Bois, Guy. "The Apron Strings." *Arts and Decoration* 5, no. 8 (June 1915): 339.

Pène du Bois 1931
Pène du Bois, Guy. *William Glackens*. Whitney Museum of American Art. New York, 1931.

Pène du Bois 1940
Pène du Bois, Guy. *Artists Say the Silliest Things*. New York: American Artists Group, 1940.

Perlman 1978
Perlman, Bennard B. *The Golden Age of American Illustration: F. R. Gruger and His Circle*. Westport, CT: North Light Publishers, 1978.

Perlman 1979
Perlman, Bennard B. *The Immortal Eight: American Painting from Eakins to the Armory Show, 1870–1913*. Westport, CT: North Light Publishers.

Perlman 1984
Perlman, Bennard B. *Robert Henri, Painter*. Exh. cat., Delaware Art Museum. Wilmington, 1984.

Perlman 1988
Perlman, Bennard B. "Drawing on Deadline: The Little-Known Saga of the Artists Who Sketched the Scoops." *Art and Antiques* (October 1988): 115–120.

Perlman 1991
Perlman, Bennard B. *Robert Henri: His Life and Art*. New York: Dover Publications, 1991.

Perrot 1994
Perrot, Philippe. *Fashioning the Bourgeoisie*. Translated by Richard Bienvenu. Princeton: Princeton University Press, 1994.

Philadelphia 1945
Clifford, Henri, John Sloan, and Everett Shinn. "Artists of the Philadelphia Press: William Glackens, George Luks, Everett Shinn, John Sloan." *Philadelphia Museum Bulletin* 41, no. 207 (November 1945): 1–32.

Philadelphia 1976
In This Academy: The Pennsylvania Academy of the Fine Arts, 1805–1976. Exh. cat., Pennsylvania Academy of the Fine Arts. Philadelphia, 1976.

Phillips et al. 1909
Phillips, Amy Lyman, et al. "Famous American Restaurants." *Good Housekeeping* 48 (January 1909): 22.

Poiret 1931
Poiret, Paul. *King of Fashion: The Autobiography of Paul Poiret*. Translated by Stephen Hadden Guest. Philadelphia: J. B. Lippincott Company, 1931.

Prieto 2001
Prieto, Laura R. *At Home in the Studio: The Professionalization of Women Artists in America*. Cambridge: Harvard University Press, 2001.

Principe 2008
Principe, Victor. *Bellport Revisited*. Charleston, SC: Arcadia Publishing, 2008.

[Roberts] 1913
[Roberts, Mary Fanton]. "Notes of General Interest." *Craftsman*, April 1913, 135.

Roberts 1939
Roberts, Mary Fanton. "Glackens." *Arts and Decoration* 49 (January 1939): 10.

Robertson et al. 2000
Robertson, Bruce, et al. *Twentieth-Century American Art: The Ebsworth Collection*. Exh. cat., National Gallery of Art. Washington, 2000.

Roskill 1970
Roskill, Mark. "Early Impressionism and the Fashion Print." *Burlington Magazine* 112 (June 1970): 390–393.

Royle 1899
Royle, Edwin Milton. "The Vaudeville Theatre." *Scribner's Magazine* 26, no. 51 (October 1899): 485–495.

Salpeter 1937
Salpeter, Harry. "America's Sun Worshiper.' *Esquire* 7, no. 5 (May 1937): 87–88, 190–192.

Sewell 1976
Sewell, Darrel. "Introduction." In *Philadelphia: Three Centuries of American Art*. Exh. cat., Philadelphia Museum of Art. Philadelphia, 1976, xviii.

Shinn 1945
Shinn, Everett. "William Glackens as an Illustrator." *American Artist* 9 (November 1945): 22.

Sims 1980
Sims, Patterson. *Maurice B. Prendergast: A Concentration of Works from the Permanent Collection. A 50th Anniversary Exhibition*. Exh. cat., Whitney Museum of American Art. New York, 1980.

Six Painters 1904
"Six Painters in a Club Show." *New York Mail and Express*, June 25, 1904.

Sloan 1977
Sloan, John. *Gist of Art: Principles and Practise Expounded in the Classroom and Studio*. New York: Dover Publications, Inc., 1977. Rev. ed. of 1939 printing.

Sontag 1982
Sontag, Susan, ed. *A Barthes Reader*. London: Hill and Wang, 1982.

"Sporting Dotlets"
"Sporting Dotlets." *The Mirror* 9, no. 1 (February 1890).

St. John 1965
St. John, Bruce, ed. *John Sloan's New York Scene: From the Diaries, Notes and Correspondence, 1906–1913*. New York: Harper and Row, Publishers, 1965.

Stansell 2010
Stansell, Christine. *The Feminist Promise, 1792 to the Present*. New York: Modern Library, 2010.

Stavitsky et al. 2013
Stavitsky, Gail, et al. *The New Spirit: American Art in the Armory Show, 1913*. Exh. cat., Montclair Art Museum. Montclair, NJ, 2013.

Steele 1988
Steele, Valerie. *Paris Fashion: A Cultural History*. New York and Oxford: Oxford University Press, 1988.

Stenz 1996
Stenz, Margaret. "The Spaces of Americanization: William Glackens' Paintings of Columbus Day, Washington Square." Unpublished paper, City University Graduate Center, May 28, 1996.

Stenz 1999
Stenz, Margaret. "Notes on the Ethnic Image in Ashcan School Paintings." *Journal of the CUNY PhD Program in Art History* 4 (Spring 1999), brickhaus.com/amoore/magazine/ash.html.

Stern et al. 1983
Stern, Robert A. M., Gregory Gilmartin, and John Montague Massengale. *New York 1900: Metropolitan Architecture and Urbanism 1890–1915*. New York: Rizzoli International Publications, 1983.

Sterngass 2001
Sterngass, Jon. *First Resorts: Pursuing Pleasure at Saratoga Springs, Newport and Coney Island*. Baltimore: Johns Hopkins University Press, 2001.

Titherington 1899a
Titherington, Richard. "Our War with Spain, Part 6." *Munsey's* 20 (March 1899): 895–916.

Titherington 1899b
Titherington, Richard. "Our War with Spain, Part 7." *Munsey's* 21 (April 1899): 40–59.

Titherington 1899c
Titherington, Richard. "Our War with Spain, Part 8." *Munsey's* 21 (May 1899): 258–278.

Tottis et al. 2007
Tottis, James, et al. *Life's Pleasures: The Ashcan Artists' Brush with Leisure, 1895–1925*. Exh. cat., Detroit Institute of Arts. London and New York: Merrill Publishers, 2007.

Townsend 1910
Townsend, James B. "The Independent Artists." *American Art News*, April 9, 1910, 2.

Trachtman 2003
Trachtman, Paul. "Degas and His Dancers." *Smithsonian Magazine*, April 2003, online.

Vorse 1899
Vorse, Albert White. "The Play's the Thing." *Scribner's Magazine* 26 (August 1899): 167–178.

Washington 1993
Revisiting the White City: American Art at the 1893 World's Fair. Exh. cat., National Museum of American Art and National Portrait Gallery. Washington, 1993.

[Watson] 1913
[Watson, Forbes]. "Art Notes." *New York Evening Post*, March 8, 1913.

Watson 1923
Watson, Forbes. "William Glackens." *The Arts* 3, no. 4 (April 1923): 250.

Watson 1939
Watson, Forbes. "William Glackens." *Magazine of Art* 32 (January 1939): 7.

Wattenmaker 1975
Wattenmaker, Richard J. *Puvis de Chavannes and the Modern Tradition*. Exh. cat., Art Gallery of Ontario. Toronto, 1975.

Wattenmaker 1988
Wattenmaker, Richard J. "William Glackens's Beach Scenes at Bellport." *Smithsonian Studies in American Art* 2, no. 2 (Spring 1988): 74–94.

Wattenmaker 1991
Wattenmaker, Richard J. *William Glackens: The Formative Years*. Exh. cat., Kraushaar Galleries. New York, 1991.

Wattenmaker et al. 1993
Wattenmaker, Richard J. *Great French Paintings from the Barnes Foundation: Impressionist, Post-Impressionist and Early Modern*. New York: Alfred A. Knopf, 1993.

Wattenmaker 1994
Wattenmaker, Richard J. *Maurice Prendergast*. New York: Harry N. Abrams, 1994.

Wattenmaker 2004
Wattenmaker, Richard J. "The Sketchbook Studies of William Glackens." *Archives of American Art Journal* 44, nos. 1–2 (2004), 2–47.

Wattenmaker 2010
Wattenmaker, Richard J. *American Paintings and Works on Paper in the Barnes Foundation*. New Haven and London: Yale University Press, 2010.

Weber 2001
Weber, Bruce. *Homage to the Square: Picturing Washington Square, 1890–1965*. Exh. cat., Berry-Hill Galleries. New York, 2001.

Weinberg and Barratt 2009
Weinberg, H. Barbara, and Carrie Rebora Barratt, eds. *American Stories: Paintings of Everyday Life, 1765–1915*. Exh. cat., The Metropolitan Museum of Art. New York, 2009.

Weinberg et al. 1994
Weinberg, H. Barbara, et al. *American Impressionism and Realism: The Painting of Modern Life, 1885–1915*. Exh. cat., The Metropolitan Museum of Art. New York, 1994.

Weintraub 1999
Weintraub, Laural. "Vaudeville in American Art: Two Case Studies." *Prospects* 24 (1999): 343.

Wharton 1913
Wharton, Edith. *The Custom of the Country*. New York: Charles Scribner's Sons, 1913.

Whistler 1967
Whistler, James Abbott McNeill. *The Gentle Art of Making Enemies*. New York: Dover Publications, 1967. Reprint of 1892 edition.

Wilson 1896
Wilson, Woodrow. "General Washington." *Harper's New Monthly Magazine* 93 (July 1896): 172.

Zilczer 1974
Zilczer, Judith. "'The World's New Art Center': Modern Art Exhibitions in New York City, 1913–1918." *Archives of American Art Journal* 14, no. 3 (1974): 2–7.

Zilczer 1984
Zilczer, Judith. "The Eight on Tour." *American Art Journal* 16, no. 3 (Summer 1984): 44–45.

Zurier 2006
Zurier, Rebecca. *Picturing the City: Urban Vision and the Ashcan School*. Berkeley, CA: University of California Press, 2006.

Zurier et al. 1995
Zurier, Rebecca, et al. *Metropolitan Lives: The Ashcan Artists and Their New York*. Exh. cat., National Museum of American Art. Washington, 1995.

Index

Note: Page numbers in italic type indicate illustrations.

Photography Credits

Every effort has been made to locate the copyright holders for the works of art illustrated in this catalogue.

PLATES: Plates 1, 4, 6, 9, 16, 17, 20, 24, 26, 27, 29, 41, 44, 47, 49, 52, 54, 60, 74, 76, 83, 85, 86, 90, 93, 102, 103, MOAFL; plate 2, Courtesy Violette de Mazia Foundation; plate 3, Georgia Museum of Art, University of Georgia, University purchase; plate 5, The Museum of Modern Art, New York; plates 7, 96, Terra Foundation for American Art, Chicago/Art Resource, NY; plate 8, Photograph © 2013 Carnegie Museum of Art, Pittsburgh; plates, 21, 22, Delaware Art Museum, Wilmington, USA/Bridgeman Art Library; plates 10–15, Library of Congress; plate 18, Courtesy of Society of Illustrators; plates 19, 48, 58, 89, Corcoran Gallery of Art; plate 23, Mr. and Mrs. Gerald Horowitz; plate 25, Courtesy Patricia A. O'Donnell; plates 28, 40, Wadsworth Atheneum, Hartford, Connecticut; plate 30, Brandywine River Museum; plate 31, Fine Arts Museums of San Francisco; plate 32, Courtesy Mr. Ted Slavin; plate 33, Cleveland Museum of Art; plates 34, 37, 43, 56, 57, 63 © The Metropolitan Museum of Art. Image Source: Art Resource, NY; plates 35, 62, 80, Images © 2013 The Barnes Foundation; plate 36, New Britain Museum of American Art; plates 38, 65, 100, Courtesy London Collection; plate 39, Courtesy of the Board of Trustees, National Gallery of Art, Washington; plates 42, 78, Digital Image © Whitney Museum of American Art, NY; plate 45, Photography © The Art Institute of Chicago; plate 46, Barney A. Ebsworth; plates 50, 79, Brooklyn Museum; plate 51, Photo © Sheldon Museum of Art; plates 53, 94, Courtesy Private Collection; plate 55, Milwaukee Art Museum, Photo: John Nienhuis; plate 59, Arkansas Arts Center Foundation Collection: Purchase, Mrs. Frank Tillar Fund; plate 61, Collection of the New Jersey State Museum, Museum Purchase FA1984.34. Reproduced with permission; plate 64, Curtis Galleries; plate 66, The Phillips Collection, Washington, DC; plate 67, Cedarhurst Center for the Arts; plate 68, Albright-Knox Art Gallery; plate 69, The Nelson-Atkins Museum of Art, Kansas City, Missouri. Bequest of Frances M. Logan, 47–109. Photo: Jamison Miller; plates 70, 82, 84, Courtesy of the Pennsylvania Academy of Fine Arts;

plate 71, Bowdoin College Museum of Art, Brunswick, Maine, Gift of Stephen M. Etnier, Honorary Degree, 1969; plate 72, Collection of the Newark Museum, 25.1167; plate 73, Smithsonian American Art Museum; plate 75, © Chrysler Museum of Art; plate 77, The Snite Museum of Art, University of Notre Dame; plate 81, Courtesy Alan and Elaine Kolodkin; plates 87, 88, © The Huntington Library, Art Collections & Botanical Gardens, San Marino, California; plates 91, 92, Courtesy Sansom Foundation; plate 95, Courtesy Kraushaar Galleries, New York; plate 97, Courtesy John H. Surovek Gallery; plate 98, High Museum of Art, Atlanta; plate 99, Parrish Art Museum, Water Mill, N.Y.; plate 101, The Butler Institute of American Art, Youngstown, Ohio

INTRODUCTION: Fig. 1, Delaware Art Museum, Wilmington, USA/Bridgeman Art Library; figs. 2, 3, 4 MOAFL Archives

EARLY YEARS: Fig. 1, Archives of American Art, Smithsonian Institution; figs. 2, 7, Delaware Art Museum, Wilmington, USA/Bridgeman Art Library; fig. 3, MOAFL; figs. 4, 6, MOAFL Archives; fig. 5, Courtesy Kraushaar Galleries, New York; fig. 8, Courtesy of the Pennsylvania Academy of Fine Arts

DRAFTSMAN: Figs. 1, 2. 3, 7, 8, MOAFL; figs. 4, 5, 6 Delaware Art Museum, Wilmington, USA/Bridgeman Art Library

URBAN ARCADIA: Fig. 1, MOAFL Archives; fig. 2, Photo © Sheldon Museum of Art; figs. 3, 4, Digital Image © Whitney Museum of American Art, NY; fig. 5, Courtesy Kraushaar Galleries, New York; fig. 6, Courtauld Institute; figs. 7, 10, Delaware Art Museum, Wilmington, USA/Bridgeman Art Library; figs. 8, 9, 14, MOAFL; figs. 11, 15, Smithsonian American Art Museum; fig. 13, The Connecticut Historical Society, Hartford, Connecticut

WOMEN: Figs. 1, 2, Delaware Art Museum, Wilmington, USA/Bridgeman Art Library; fig. 3, Photo © Sheldon Museum of Art; fig. 4, Courtesy of the Pennsylvania Academy of Fine Arts; fig. 5, New Britain Museum of American Art; fig. 6, The Butler Institute of American

Art, Youngstown, Ohio; fig. 7, Digital Image © Whitney Museum of American Art, NY; fig. 8, MOAFL; fig. 9, © The Metropolitan Museum of Art. Image Source: Art Resource, NY

ADVOCATE: Figs. 1, 2, 4, 5, 6, Images © 2013 The Barnes Foundation; fig. 3, MOAFL

SHORE SCENES: Fig. 1, Brooklyn Museum; figs. 2, 3, 9, MOAFL; fig. 4, Archives of American Art, Smithsonian Institution; fig. 5, Courtesy Bellport-Brookhaven Historical Society. Photography by Cara Phillips; fig. 6, Courtesy Dr. Richard Berman and the Bellport-Brookhaven Historical Society. Photograph by Julia Edey Paige; fig. 7, Courtesy Bellport-Brookhaven Historical Society. Photograph by Frances Toms; fig. 8, Photograph courtesy the Paige Family and Bellport-Brookhaven Historical Society; fig. 11, Courtesy of the Pennsylvania Academy of Fine Arts; fig. 12, Images © 2013 The Barnes Foundation

FASHION: Figs. 1, 10, MOAFL; figs. 2, 5, Fashion Institute of Technology|SUNY, Gladys Marcus Library Dept. of Special Collections and FIT Archives; fig. 6, © The Metropolitan Museum of Art. Image Source: Art Resource, NY; fig. 7, Photograph by Jacques Henri Lartigue © Ministère de la Culture–France/AAJHL

FRENCH ART: Fig. 1, National Museum of Art Architecture and Design, Oslo; fig. 2, Musée d'Orsay, Paris. Erich Lessing/Art Resource, NY; fig. 3, Museum of Fine Arts, Boston; figs. 4, 5, 8, Images © 2013 The Barnes Foundation; fig. 6, © 2013 Artists Rights Society (ARS), New York/ADAGP, Paris–RMN (Musée d'Orsay)/Hervé Lewandowski; fig. 7, Private Collection/Peter Willi/The Bridgeman Art Library; fig. 9, Philadelphia Museum of Art, Pennsylvania, PA, USA/The Bridgeman Art Library

STILL LIFE: Figs. 1, 4, MOAFL; figs. 2, 7, Images © 2013 The Barnes Foundation; fig. 3, Terra Foundation for American Art, Chicago/Art Resource, NY; fig. 5, Courtesy Sansom Foundation; fig. 6, Courtesy of the private collection of James M. Seneff, Winter Park, Florida © Christie's Images; fig. 8, Courtesy Kraushaar Galleries, New York